759 BECK

Beckett, W. The story of painting.

1994 (3596/)

						2
	*					
		· · · · · · · · · · · · · · · · · · ·				

THE STORY OF PAINTING

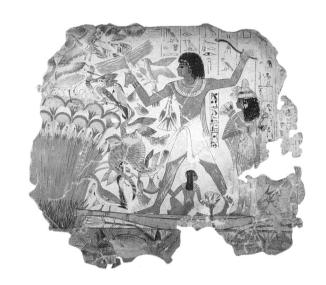

THE STORY OF PAINTING

SISTER WENDY BECKETT
Contributing Consultant PATRICIA WRIGHT

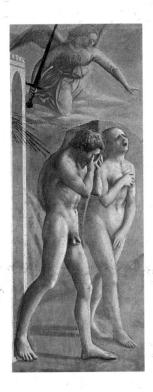

Crangoville ON L9W 2M2

LITTLE BROWN (CANADA)

BOSTON • TORONTO • NEW YORK • LONDON
IN ASSOCIATION WITH THE NATIONAL GALLERY OF ART, WASHINGTON, D.C.

A DORLING KINDERSLEY BOOK

Project editors Janice Lacock,
Edward Bunting, Susannah Steel
Art editors Claire Legemah, Tassy King
Editor Joanna Warwick
Assistant editor Neil Lockley
Senior editor Gwen Edmonds
Managing editor Sean Moore
Managing art editor Toni Kay
Production manager Meryl Silbert

All views and interpretations expressed in this book are the authors'

Author's Acknowledgments

I dedicate this book to Toby Eady. With him I would like to associate all at Dorling Kindersley who worked so hard on it, especially Sean Moore, who commissioned the book and Patricia Wright, my gifted co-writer; Gwen Edmonds, Janice Lacock, Susannah Steel, and Edward Bunting who laboured with such patience to get it right.

Note on painting titles

In *The Story of Painting* we have used authentic titles for paintings where they are known or, in their absence, one that will serve as well, e.g. *Still Life with Peaches*. Where paintings have a popular title that was obviously not formulated by the artist, the title appears in quotation marks, e.g. *"The Arnolfini Marriage"*. For ancient works we use a simple description, not set in italics, e.g. Fresco with dolphins.

First published in Canada in 1994 by Little, Brown and Company (Canada) Limited, 148 Yorkville Avenue, Toronto, Ontario, M5R 1C2

© 1994 Dorling Kindersley Limited
Text © 1994 Sister Wendy Beckett & Patricia Wright
All rights reserved. No part of this publication may be
reproduced, stored in a retrieval system, or transmitted
in any form or by any means, electronic, mechanical,
photocopying, recording or otherwise, without the
prior written permission of the copyright owner.

Canadian Cataloguing in Publication Data

Beckett, Wendy
The story of painting: the essential guide to
the history of western art

Includes index. ISBN 0-316-70264-1

1. Painting, European. 2. Painting, American. I. Title.

ND450.B4 1994 759 C94-931591-5

Colour reproduction by GRB Editrice s.r.l. Printed in Italy by A. Mondadori Editore, Verona

Donatello, Florentine heraldic lion, 1418–20

Mantegna, ceiling fresco in the Gonzaga Palace, c. 1470

FOREWORD

Art has long been a passionate concern to me, and I have often been puzzled by media questions as to why this is so, and when my interest began. It seems to me that we are all born with the potential to respond to art. Unfortunately, not all of us have the good fortune to have this potential activated, as it were. This book is my faltering attempt to offer the security of a knowledgeable background, which will help to make whatever art we see more accessible. Some people are certainly held back from a fearless gaze at painting because they fear their own ignorance. Truly to look remains one's personal responsibility, and nobody else's response (and certainly not my own) can be a substitute. But knowledge must come to us from outside, from reading, listening, and viewing. If we know that we know, we can perhaps dare to look. Love and knowledge go hand in hand. When we love, we always want to know, and this book will succeed if it starts the reader on the track that leads to more reading, greater knowledge, greater love, and, of course, greater happiness.

Pisanello, *Duke of Rimini* (portrait medal), 1445

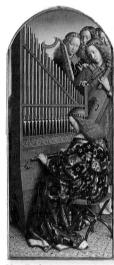

Van Eyck, Musicians from the Ghent Altarpiece, 1432

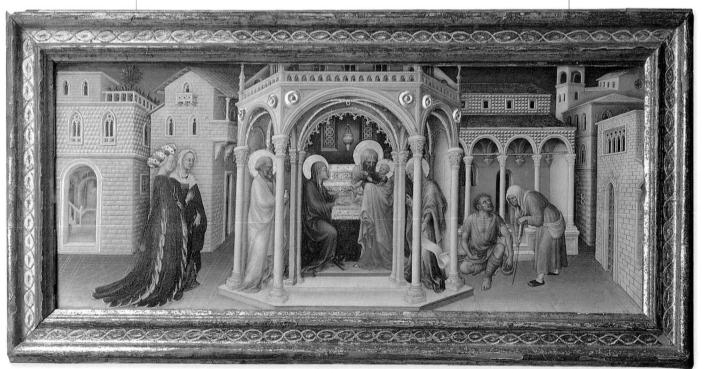

Gentile da Fabriano, The Presentation of the Child in the Temple, 1423

Giotto, Madonna and Child

Paolo Uccello, Study of a Chalice

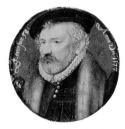

Nicholas Hilliard, *The Artist's Father* (miniature)

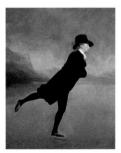

Sir Henry Raeburn, *The* Rev. Robert Walker Skating

CONTENTS

Introduction: Painting Before Giotto 8

The First Paintings 10 The Ancient World 12 Early Christian and Medieval Art 24

GOTHIC PAINTING 36 Early Gothic Art 40 International Gothic Style 54

Innovation in the North 60

Late Gothic Painting 71

THE ITALIAN RENAISSANCE 78

The Early Renaissance 82 Renaissance Venice 106 The High Renaissance 116 The Italian Mannerist Period 139

The Northern Renaissance 148

Dürer and German Portraiture 152 Northern Mannerism 163 Northern Landscape Tradition 166

BAROQUE AND ROCOCO 172

Italy: A Catholic Vision 176
Flemish Baroque 186
Spanish Baroque 193
A Dutch Protestant Vision 200
France: A Return to Classicism 216
Rococo 224

NEOCLASSICISM AND ROMANTICISM 236

The British School 240
Goya 248
The Neoclassical School 253
The Great French Romantics 259
Romantic Landscapes 264

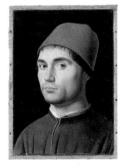

Antonello da Messina, Portrait of a Young Man

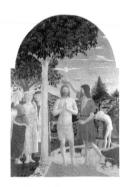

Piero della Francesca, The Baptism of Christ

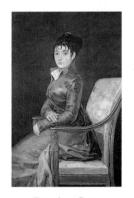

Francisco Goya, Doña Teresa Sureda

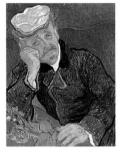

Vincent van Gogh, Dr. Gachet

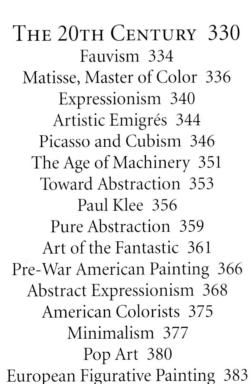

Glossary 390 Index 391 Picture Credits 398

Epilogue 388

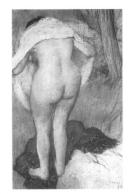

Edgar Degas, Girl Drying Herself

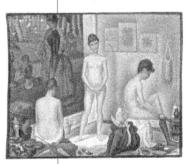

Georges Seurat, Les Poseuses

Ernst Ludwig Kirchner, Berlin Street Scene

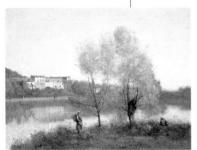

Camille Corot, Ville d'Avray

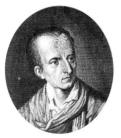

Anton Mengs, Portrait of Winkelmann

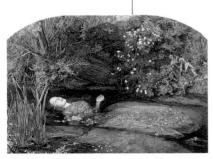

Sir John Everett Millais, Death of Ophelia

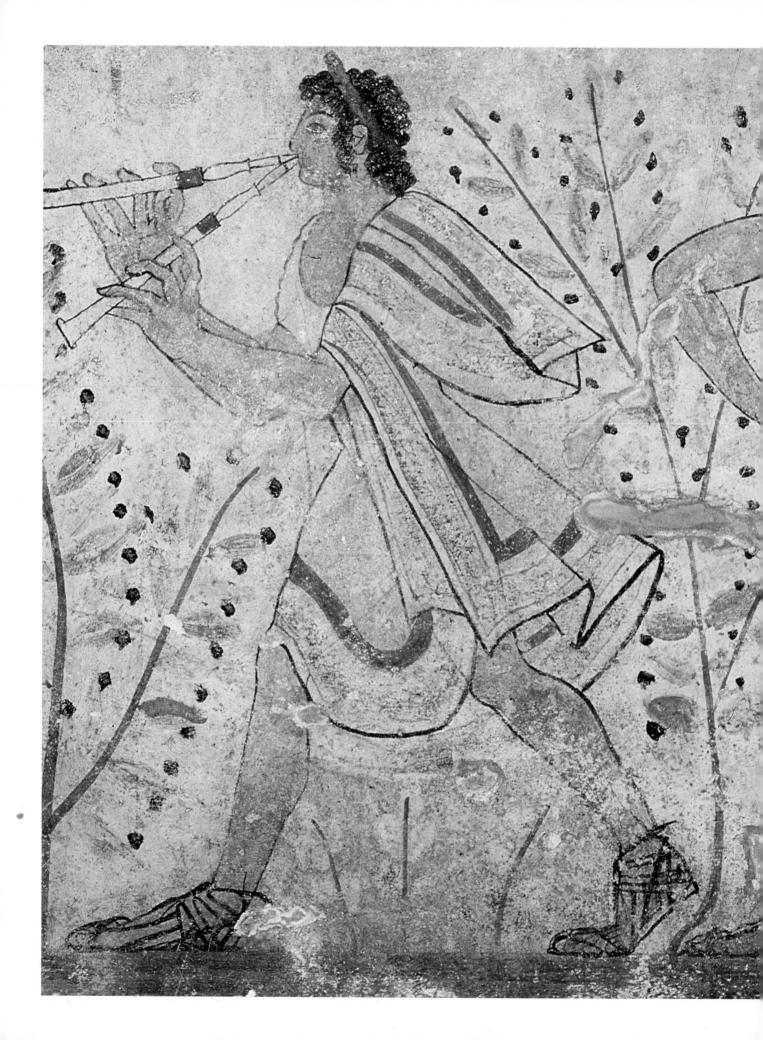

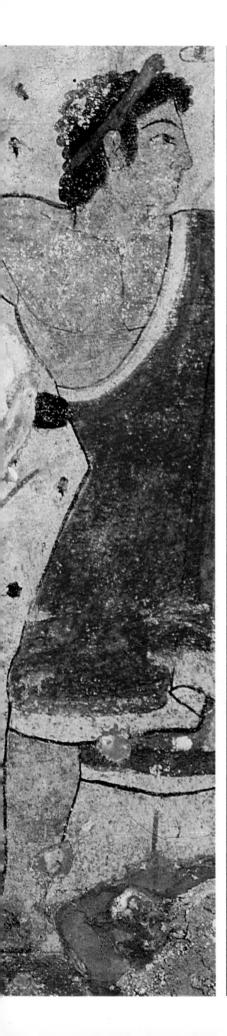

INTRODUCTION

PAINTING BEFORE GIOTTO

Our word "history" comes, by way of Latin, from the Greek word *historien*, which means "to narrate", and that word comes from another Greek word, *histor*, "a judge". History not only tells a story, but it passes judgment on it, puts it in order, and gives it meaning. The story of painting is one that is immensely rich in meaning, yet its value is all too often hidden from us by the complexities of its historians. We must forget the densities of "history" and simply surrender to the wonder of the story.

The preface to our story opens with the earliest examples of Western painting, created by our first artistic ancestors: Paleolithic man. From here to Giotto – with whom the story really begins – we pass through the ancient worlds of Egypt and Greece, the great Roman Empire, and the early Christian and Byzantine worlds, and we close with the magnificent illuminated manuscripts created by European monks during the Middle Ages.

THE FIRST PAINTINGS

That art is truly our birthright can be seen from its ancient beginnings. It does not begin in history, but actually in prehistory, thousands of years ago. Our Paleolithic ancestors, living between 30,000 and 8,000 BC, were small, hairy, and unlettered, and even archaeology can say little about them with certainty. But one thing is radiantly clear, and that is that these

The paintings on the walls of the Altamira caves were the first to be discovered in modern times, in 1879. The caves are near Santander in northern Spain. The discovery had such fundamental implications for archaeology that it was at first dismissed as a forgery. This great bison (1) is painted on the ceiling of a long, narrow corridor leading from a subterranean cave in Altamira. It does not stand alone. A whole herd surges majestically across the roof, one animal overlapping another – horses, boars, mammoths, and other creatures, all the desired quarry of the Stone Age huntsman. They assert a powerful animal presence, despite the confusion.

Stone Age cave dwellers were artists, and not only artists in that they could describe in visual terms the animals with which they came into daily contact—such art may be no more than illustration. Cave painting is much more than this: it is art in the grand manner, great art, manifested in works of subtlety and power that have never been surpassed.

CAVE PAINTING TECHNIQUE

The caves are fully underground, and therefore permanently in darkness. Archaeologists have discovered that the artists painted with the aid of small stone lamps, filled with animal fat or marrow. The initial designs were engraved into the soft rock, or thin lines of paint were blown onto the wall through a hollow reed. To make colored paint, the artists used ochre, a natural mineral that could be crushed to a powder that would yield red, brown, and yellow pigments, while black may have been made from powdered charcoal. Powdered pigments were either rubbed onto the wall with the hands,

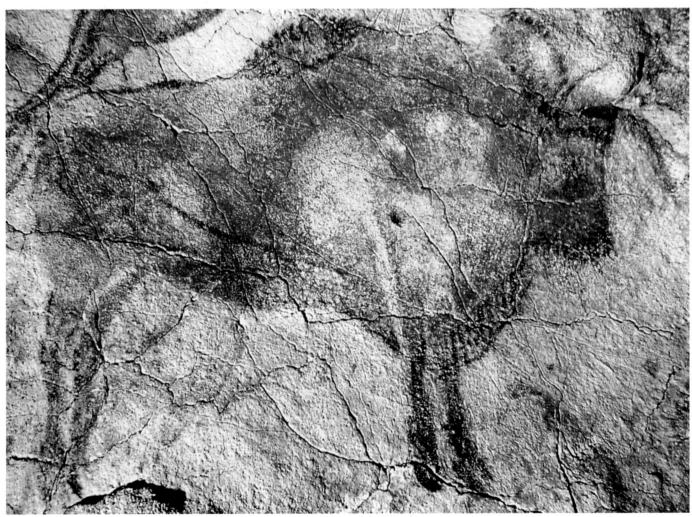

1 Bison from Altamira cave, c. 15,000-12,000 BC, 77 in (195 cm) (bison length only)

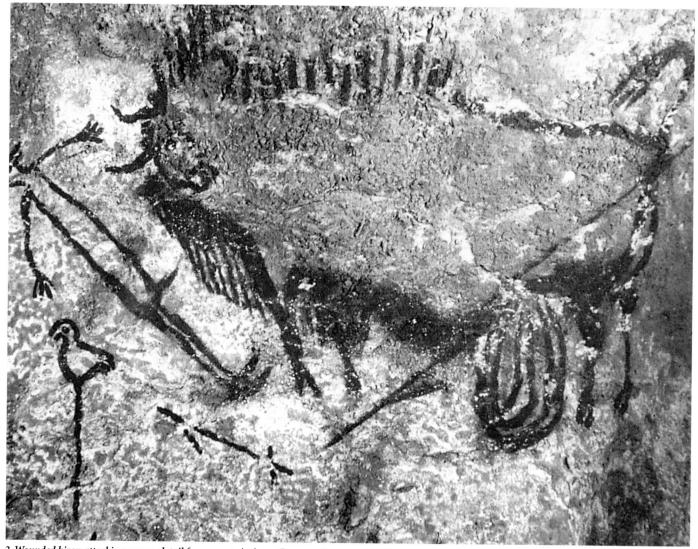

2 Wounded bison attacking a man, detail from cave painting at Lascaux, France, c. 15,000-10,000 BC, 43 in (110 cm) (bison length only)

producing very delicate gradations of tone akin to soft pastel painting, or mixed with some form of binding fluid, such as animal fat, and applied with crude reed or bristle brushes. The means were simple, yet the effect, especially in the strange silence of the cave, is overwhelming.

SIGNIFICANCE OF THE CAVE PAINTINGS

It is thought that these paintings had some deep importance to prehistoric society. The bison seems to be almost quivering with power as it displays its massive chest, dense hindquarters, and short, thin legs. It brandishes an aggressive pair of horns. Was this animal sacred to some ritual? We may never know the true significance of the cave paintings, but they almost certainly served a ritualistic, even magical function. How much the art was produced for its own sake – and this cannot be entirely ruled out – will remain a mystery.

The extraordinary naturalism and anatomical accuracy in the portrayal of animals in these paintings is believed to be connected with the purpose they served. The artists were also hunters, and their lives depended on the animals whose images they painted in the caves. Is it possible that these hunter-artists believed that by accurately depicting the

animals' power, strength, and speed, they would acquire magical power? With this they might be able to take control of the animal's spirit and remove its strength before the hunt. Many of the paintings show the animals wounded or pierced with arrows, and some examples even show evidence of actual physical attacks on the painted image.

The naturalism with which animals are painted and drawn does not extend to the portrayal of humans – perhaps for this very reason. People are rarely represented, but when they are, it is by the crudest recognizably human shape, or more often by symbolic forms, as can be seen in the image of the prostrate man in this startling painting (2), which dates from between 15,000 and 10,000 BC. It is in the most celebrated of all the sites of ancient cave paintings: the Lascaux caves in the Dordogne, France. The sticklike man is lying in front of a bristling, disemboweled bison. Below him is a figure that looks as if it could be a bird, or possibly a totem or banner displaying an image of a bird. The painting has an awesome power: we have to confess our ignorance of its meaning, yet this lack of knowledge does not affect our response – unless, indeed, it deepens it. In this alone, prehistoric art is representative of all art to follow.

THE ANCIENT WORLD

Strangely enough, it is a long time before painting rises again to the quality of the cave art of Stone Age society. The Egyptians were interested mainly in architecture and sculpture, and in many of their paintings, particularly those that decorated their tombs, they gave drawing precedence over color.

The Egyptians loved the terrestrial world too much to believe that its pleasures necessarily ended with death. Egyptians believed that the rich and the powerful, at least, could enjoy the pleasures of life in perpetuity, as long as the image of the deceased was reproduced on their tomb walls. Much Egyptian painting, therefore, was done for the sake of the dead. It is possible, however, that the Egyptians did not feel that great expense was required to ensure a good afterlife, and that they chose painting as a labor-saving and cost-cutting device. Instead of the expensive art of the sculptor or the stone carver, a cheaper art form – painting – was employed. It is certain, at any rate, that the ceremonial, formal painting style used for tomb walls was not the only one available. We now know that living (and wealthy) Egyptians had murals in their homes, and that these were done in richly textured, painterly styles. Unfortunately, only small fragments of these murals survive.

ANCIENT EGYPTIAN TOMB PAINTING

Perhaps one of the most impressive images from Egyptian tombs is that of the "Geese of Medum" (3), three majestic birds from the tomb of Nefermaat (a son of Sneferu, the first pharaoh of the 4th dynasty) and his wife Itet, dating from over 2,000 years before Christ. The geese form only a detail in a pictorial frieze in a tomb at the ancient town of Medum, but already they hint at the vitality and power of the sculptural triumphs to come in the years ahead. Another Egyptian tomb painting, from the tomb of Ramose, shows a funeral procession of Lamenting Women (4). Ramose was a minister under two pharaohs of the 18th dynasty, Amenhotep III and Amenhotep IV (Akhenaten). The women in the painting are flat and schematic (look at their feet), but their anguished gestures vibrate with grief.

Some paintings, or fragments, have been preserved from a variety of other cultures of ancient Europe: Minoan, Mycenaean, and Etruscan. Then came the civilizations of Greece and Rome. From a modern point of view, a feature common to almost all ancient painting traditions is a shortage of examples surviving today.

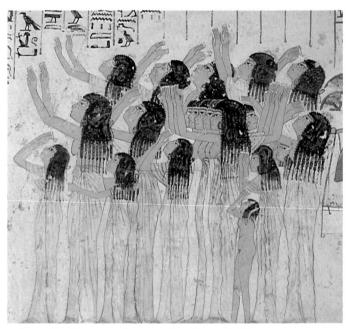

4 Lamenting Women, wall painting from the tomb of Ramose, Thebes (Egypt), c. 1370 $_{\rm BC}$

To the ancient Egyptians it was the "eternal essence" that mattered: what constituted their view of constant, unchanging reality. Thus their art was not concerned with the changeable variation of externals for visual appeal, and even their keen observations of nature (evidently painted from memory) were subject to rigid standardization of forms, often becoming symbols. It is not from any kind of "primitivism" that their scenes appear decidedly unreal – their technical skill and evident understanding of natural forms makes this clear enough. It is, rather, the direct consequence of the essentially

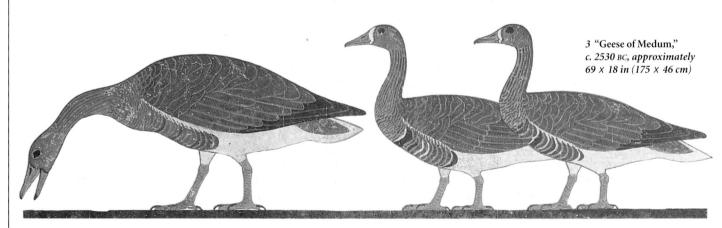

intellectual function of their art. Each subject was shown from whatever angle would make it most clearly identifiable, and according to a rank-based scale, large or small dependent on social hierarchy. This resulted in a highly patterned, schematic, and almost diagrammatic appearance. This over-riding concern with clarity and "thorough" representation applied to all subject matter: hence, the human head is always shown in profile, yet the eyes are always drawn from the front. For this reason, there is no perspective in Egyptian paintings – everything appears two-dimensional.

STYLE AND COMPOSITION

Most Egyptian wall paintings, as in this example, a *Fowling Scene* (5) from a nobleman's tomb in Thebes, were created with the *fresco secco* technique. In this method, tempera (see glossary, p.390) is applied to plaster that has been allowed to dry first, unlike the true *buon fresco* technique in which the

6 Pharaoh Tuthmosis III, Egyptian painting on a drawing board, c. 1450 BC, 14½ in (37 cm) high

figure was organized within the so-called "rule of proportion," a strict, geometric grid system that ensured the accurate repetition of the Egyptian ideal form on any scale and in any position. It was a foolproof system, regulating the exact distances between parts of the body, which was divided into 18 equal-sized units and placed in relation to fixed points on the grid. It even specified the exact width of the stride in walking figures, and the distance between the feet (which were both shown from the inside view) in standing figures. Before beginning a figure, artists would first draw a grid of the required size onto the surface, and then fit the figure within it. A surviving 18th-dynasty wooden drawing board shows the Pharaoh Tuthmosis III drawn within such a grid (6).

It was not only tombs that the Egyptians decorated: they also painted sculpture. This beautiful painted limestone

sculpture of the *Head of*Nefertiti (7), who was
wife of the Pharaoh

Akhenaten, is thought to have been a workshop model, because it was found in the ruins of a sculptor's studio. It is as poignant as a Botticelli head (see p.94), with the same touching and exquisite wistfulness. It shows a loosening of the rigid conventions that governed earlier (and 7 Head of later) Egyptian art, because Nefertiti, Akhenaten broke with the с. 1360 вс traditional style. During his reign, paintings, carvings, and sculptures that were produced were refreshingly graceful and original.

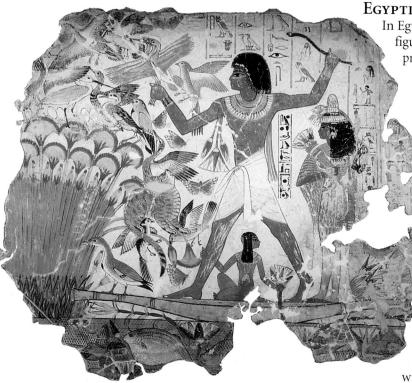

5 Fowling Scene from the tomb of Nebamun, Thebes, Egypt, c. 1400 BC, 31 in (81 cm) high

painting is made on wet plaster (see p.46). The wildlife of the papyrus marshes and Nebamun's retriever cat are shown in great detail, yet the scene is idealized. The nobleman stands in his boat, holding three birds he has just caught in his right hand, and his throwing-stick in his left. He is accompanied by his wife, who appears in an elaborate costume with a perfumed cone on her head, holding a bouquet. Between Nebamun's legs squats the small figure of his daughter, picking a lotus flower from the water (this is an example of how, as mentioned above, it was conventional for figures to be shown large or small according to their status). Originally this painting was only one part of a larger work, which also included a fishing scene.

AEGEAN CULTURES OF THE BRONZE AGE

The Bronze Age Minoan civilization (3000–1100 BC), named after the mythical King Minos, was the earliest to develop in Europe. Its home was the small island of Crete, in the Aegean Sea between Greece and Turkey, and its

society developed roughly in parallel to that of its African neighbor, Egypt. Despite their proximity and certain shared influences, Egyptian and Minoan cultures remained very separate, though the latter was to have

enormous influence on the art of ancient Greece, Crete formed the center, both culturally and geographically, of the Aegean world. Also in parallel with Minoan civilization was that of the Cyclades, an Aegean island group. Idols have been recovered from this society (8), objects whose ancient, quasi-neolithic forms are reduced to the barest abstraction, but still retain the magical power of the fetish. Here we have a weird forerunner of the abstract art of our own century, in which the human body is seen in geometrical terms with an immense raw power, contained and controlled by linear force. Originally the idols had painted eyes, mouths, and other features.

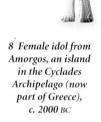

MINOAN AND MYCENAEAN ART

Minoan art is largely represented by its carvings and painted pottery, and it is

not until 1500 BC, during the great "Palace period," that we see paintings at all, and generally these have only survived in fragments. Although a certain degree of Egyptian stylization is apparent in the schematic repetition of human figures, for instance, Minoan representation reveals a naturalism and suppleness largely absent in Egyptian art. The Minoans took inspiration from nature and their art exhibits an astonishing degree of realism. They were a seafaring civilization and their paintings reflected their knowledge of the oceans and of sea creatures, such as dolphins.

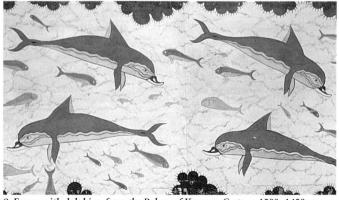

9 Fresco with dolphins, from the Palace of Knossos, Crete, c. 1500-1450 BC

10 "Toreador Fresco" from the royal palace at Knossos, Crete (restored detail), c. 1500 BC, 31½ in (80 cm) high including borders

This lively example (9) is from the Palace of Knossos, which was excavated in the first two decades of the 20th century. Another recurrent Minoan theme is bull jumping, a ritual thought to be connected with Minoan religion. A second work from the royal palace of Knossos, the "Toreador Fresco" (10), is one of the best-preserved Minoan paintings, although fragmentary. The fragments have been pieced together to reveal three acrobats, two girls (they are fair-skinned), and a darker-skinned man somersaulting over a magnificent bull. The usual interpretation of this picture is as a "time-lapse" sequence. The girl on the left is taking hold of the bull's horns in preparation to leap; the man is in mid-vault; the girl on the right has landed and steadies herself with arms outstretched, like a modern gymnast.

The Mycenaean civilization was a Bronze Age culture of mainland

Greece. It came to succeed the

ancient Minoan culture in
Crete, emerging around
1400 BC to became the
dominant culture on
the island. Its history and
legends form the background to the writings
of the Greek poet Homer
(c. 750 BC), whose epic
poems, the *Odyssey* and the *Iliad*, reflect the "heroic age":
the end of the Mycenaean
period. One of the most

enduring images from Mycenaean art is this funeral mask (11), thought for a time to be of the Mycenaean King Agamemnon, who, in Homeric legend, was the leader of the Greeks in the Trojan Wars. All that is certain is that it is a death mask, and that it was taken from one of the royal tombs of the Mycenaean period, in the 16th century BC. Besides a certain love of gold, it reveals the immense dignity of the Mycenaean image of humankind. This highly expressive mask is a great iconic depiction of what it means to be a human being.

Fragments of Mycenaean paintings found at two sites (Tiryns and Pylos) in Greece represent what must have been impressive mural cycles. Many of the Mycenaean and Minoan murals were not frescoes in the usual sense of the word, but, like the Egyptian murals, were produced by applying tempera paint (see glossary, p.390) to plaster that had already dried. Subjects of Mycenaean murals included scenes from everyday

11 Funeral mask from the royal tombs at Mycenae, c. 1500 BC

life, as well as depictions of the natural world. Mycenean art was rather solemn in nature in comparison with Minoan art. These two traditions formed the background from which the art of the Greeks later emerged.

The Mycenaean civilization collapsed around 1100 BC. Its ending marks the end of the Bronze Age in Greece. There followed a period of around 100–150 years, known as the "Dark Age," about which less is known in Aegean culture. After that, prehistory ended, and the period of written history began. Around 650 BC, archaic Greece emerged as Europe's most advanced civilization.

GREECE'S NEW VISION

Like their Cretan predecessors, the Greeks were far less conscious of the tomb than the Egyptians. They have left us a number of bronze statuettes, which are highly esteemed. But their painting – an art on which their writers assure us they lavished great skill - is almost totally lost. One of the reasons for this is that, unlike the Egyptians, the Minoans, and the Mycenaeans, who painted only murals, the Greeks painted mainly on wooden panels that

have perished over time.

The Roman scholar Pliny
the Elder (AD 23/4–79),
whose detailed descriptions of
Greek painting and the ancient
world greatly influenced successive generations, is the major source of information
on Greek painting. In every other school of art, the
truth of such descriptions can be judged by the painting that
survives. This is not true of Greek painting, and so the value
of what Pliny said can never be assessed.

Almost our only hint of the beauty of Greek painting is in the relatively minor, especially utilitarian art of vase painting. The word *vase*, first used as a broad term for ancient Greek pottery in the 18th century, can be misleading. The Greeks never made vases purely for decorative purposes, as can happen today, but always had a specific purpose in mind. Greek potters made a range of products, in a variety of shapes, such as storage jars, drinking vessels, bottles for perfume and ointment, and containers for liquids used in ceremonies.

In the Greek vase paintings we can see a concern with anatomy, and a preoccupation with the human figure, which became the central motif of Greek art and philosophy. We see a departure from what the Egyptian tomb paintings showed, with their preconceived formulas for representing the world, and a whole new way of viewing art opens up with respect to what the eye can see, and what the mind dictates.

STYLES IN GREEK VASE PAINTING

If vase painting is a minor art, then it has some major practitioners. The Athenian artist Exekias, who lived about 535 BC, signed at least two of his black-figure pots as their "painter," and his style, with its poetry and perfection of balance, is instantly recognizable. It is worth noting that he made the pottery as well as its decoration. Exekias's work is important because it reveals the direction representational art would take, signifying the leap from a "hieroglyphic" symbolic representation of objects in the world to one that attempted to show the world as it really appears. This is particularly evident in his treatment of the boat's sail in this superb kylix (a shallow, two-handled drinking cup),

Dionysos in His Boat (12). Dionysos, the god of wine, vegetation, and fruitfulness, lies stretched out in repose as he carries the secret of wine to humankind. His symbolic vines twirl around the mast and soar

fruitfully into the sky, a wonderful adaption to the difficult circular composition of the kylix. The ship, with its gleaming sail, glides majestically over the pink and orange world of Heaven and Earth, where dolphins swim and play around the sacred presence, and the scene is alive with an amazing sense of wholeness.

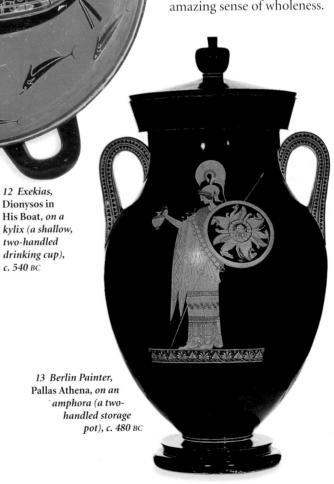

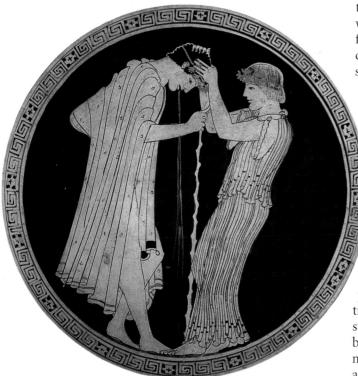

14 Brygos Painter, "The End of the Party" on a drinking bowl, c. 490 $_{
m BC}$

Greek vase painting is typically concerned with storytelling, and many vases carry images of incidents recounted in Homer's *Iliad* and *Odyssey*, written in the 8th century BC.

Vases decorated with narratives date from times preceding Homer to the Classical Greek period, which succeeded the Archaic period around 480 BC, and indeed long beyond.

We cannot fully appreciate Greek vase painting unless we see both the image and the vase as a whole. A key figure in the Odyssey, Pallas Athena, the guardian deity of Athens, appears on a lidded shoulder amphora (a storage pot with two handles) by an anonymous artist whom scholars have named the Berlin Painter, around 480 BC (13). The darkly gleaming, black-glazed curve of the jar makes the goddess seem to retreat from our gaze, while allowing us to glimpse her in her stately sweetness. She is shown holding out a jug of wine to Hercules, who is on the other side on the jar, both keeping their privacy inviolate, yet communicating. It is a wonderfully controlled and reverent work, both simple and complex.

The amphora is an example of the red-figure technique, invented around 530 BC, which succeeded black-figure pottery. In the red-figure technique,

the "figures" were not painted; instead, the black background was painted around them, leaving the red clay color to stand for the figures, which were then painted with anatomical details. Greater naturalistic effects were possible, and the vivid scenes depicted on the vases became more and more complex and ambitious. A good example of this new development is the painting from the interior of a drinking bowl (14) made by the potter Brygos (the artist is known simply

made by the potter Brygos (the artist is known simply as the Brygos Painter). Although the subject matter – a woman holding the head of a drunken youth while he is sick – is not appealing, the figures are presented with subtlety and dignity. The woman's clothing in particular gives her a tender grace.

PORTRAYING THE HUMAN FORM

The way the Greeks represented the human body had a direct influence on the development of Roman art, and all later Western art. Since we can no longer see many Greek paintings themselves, we have to rely on Greek sculpture to trace the progress of the human nude. Early Greek statues, such as the 6th-century BC Kouros shown here (15), were based on the grid system of the ancient Egyptians. (Kouros means a young man, and in the sculpture of the time it means a statue of a standing youth.) Gradually the lines softened, as shown in the 5th-century BC "Kritios Boy" (16), named after the sculptor Kritios, in whose style it was made. Eventually we see the realistic musculature of classical 5th-century BC statues, such as the Discus Thrower (17). This is a Roman copy of the original by the Greek sculptor Myron.

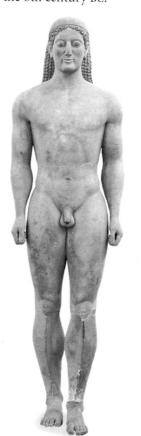

15 Kouros (statue of a standing youth), late 6th century BC

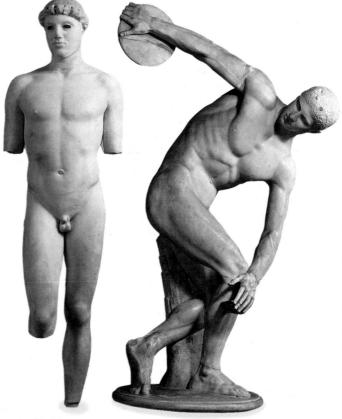

16 "Kritios Boy," c. 480 BC

17 Discus Thrower (Roman copy), original c. 450 BC

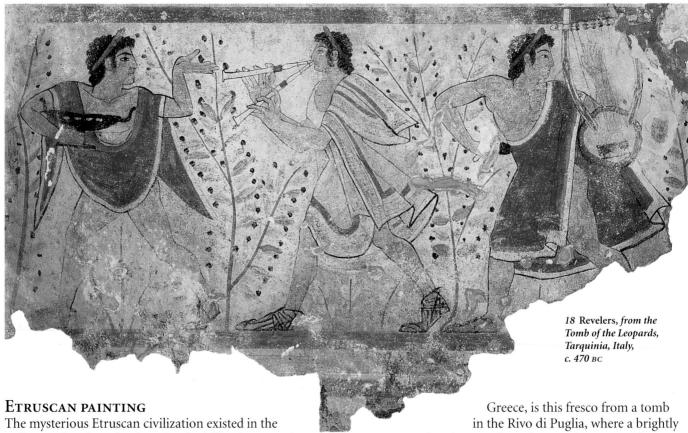

The mysterious Etruscan civilization existed in the Italian peninsula at the time Greek civilization spread to southern Italy in the 8th century BC. Once thought to have come from Asia Minor, it is now more commonly believed to have originated in Italy. Its art was influenced by Greek art, but maintained a style of its own, which the Greeks valued highly. Some early Etruscan art, as typified by a wall painting from the Tomb of the Leopards at Tarquinia (18), displays a joyful quality. The men, who may be dancing, carry a cup of wine, a double flute, and a lyre.

However, much of the surviving art has a slightly sinister edge to it, an awareness of the uncontrollable nature of life and all its implications. Among some impressive Etruscan tomb paintings, contemporary with the classical period in colored procession of *Mourning Women* (19) advances with implacable force. They form a fascinating contrast to the mourning women in Ramose's tomb (see p.12). The Egyptian women grieve over the human loss that death brings with it, while the Etruscans mourn the remorseless and inescapable advance of fate.

Painting in classical greece

The most significant Greek painter of the early classical period (c. 475–450 BC) is Polygnotos, who has been credited with being the first to give life and character to the art of painting. None of his pictures survive, but Pliny left a description of his "Discus Thrower." The most important

Greek painting surviving from the 4th century BC is The Rape of Persephone (20), on the wall of a tomb in the same burial complex as that of Philip II of Macedon, who died in 356 BC. Full of the vitality and naturalism of art at that time, this haunting image shows how the Greeks explained the seasons. Persephone is the daughter of Demeter, goddess of fertility. Persephone is carried off by Hades to the underworld, from which she will emerge as the new growth of spring. The great cycle of the seasons is tapped by this painting, and the myth lives on through it.

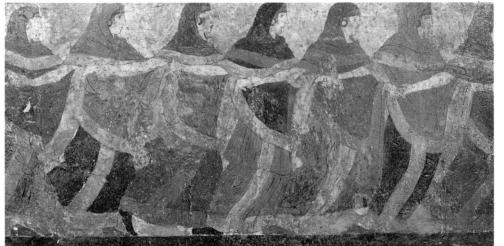

19 Mourning Women, from a tomb at Rivo di Puglia, Italy (detail), late 5th century BC, height 22 in (55 cm)

20 The Rape of Persephone, from a tomb at Vergina, Greece, c. 340 $_{
m BC}$

HELLENISTIC ART

By the time of his death in 323 BC, Alexander the Great (356–323 BC) had extended his Empire as far as the Middle East, conquering Greece's old enemy Persia, and also Egypt. However, the empire was then divided up among Alexander's generals, who established a series of independent states,

throughout which there spread a new cosmopolitan culture, blending that of both East and West. This is known today as Hellenistic culture, and it prevailed in the Mediterranean region until well after the Roman Empire became the

dominant power. Its heart was Athens but its other important centers (ruled by Greek kings and speaking

Greek) were in Syria, Egypt, and Asia Minor. A Roman mosaic known as the "Alexander Mosaic" (21), found at the House of the Faun at Pompeii, is known to have been based on a Hellenistic painting. It depicts the Battle of Issus, fought between Alexander and the Persian King Darius III in 333 BC. The scene is violent and lively, and the artist displays sophisticated technical skills (he knows about foreshortening – see glossary, p.390) that gives the work a great immediacy of impact. Hellenistic culture soon developed a love of "art

for its own sake." The Eastern influence led to a more decorative, sumptuous art, and religious elements retired to the background. In their place were paintings of gardens (including, arguably, the first landscapes), still lifes, portraits, and everyday scenes of contemporary life. The popularity of this tendency, curiously dubbed "baroque" by historians (see p.172), is recorded by Pliny, who wrote that art could be found in barbers' and cobblers' shops, as well as palaces.

An overwhelming concern of Hellenistic artists was "truth" to reality, and they tended to depict dramatic, often violent action. They developed a style that paralleled the vivid literary tradition of the Roman poet Virgil (70–19 BC). A definitive example of the artistic philosophy of Hellenistic

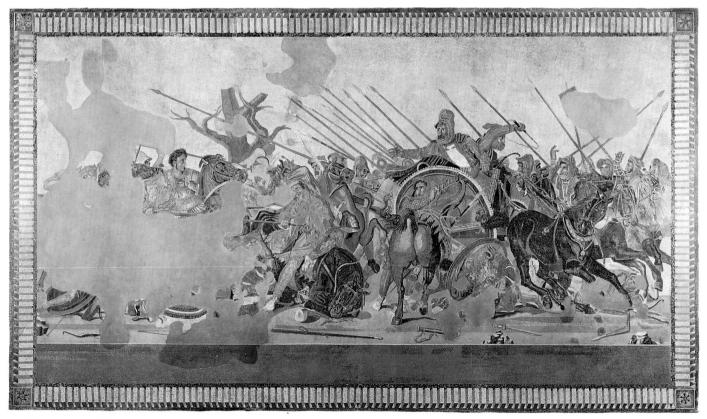

21 "Alexander Mosaic" (Roman copy of a late Hellenistic painting), c. 80 BC

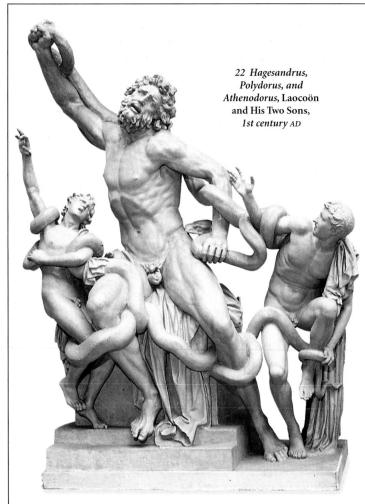

art, dating from the 1st century AD, is Laocoön and His Two Sons (22). This sculpture depicts a horrifying scene from Virgil's Aeneid, in which a Trojan priest named Laocoön and his two sons were strangled by two sea snakes. This was a punishment from the gods because Laocoön had tried to warn the Trojans about the Greeks' wooden horse. Without the warning, the Trojans were tricked, pulling the horse into their city and bringing about their own downfall. This is a sculpture, not a painting, but it does give us some hint of what Hellenistic painting must have been like. The sculpture was rediscovered in 1506 and had a strong influence on many Renaissance artists, including Michelangelo (p.116), who referred to it as "a singular miracle of art." Among those who were inspired by it was the Mannerist El Greco (see p.146), who is known to have produced three paintings featuring the Laocoön story.

PAINTINGS OF THE ROMAN EMPIRE

Hellenistic styles continued to exert strong influences on artists long past the official end of the Hellenistic period, set by historians at the Battle of Actium in 27 BC. Soon after this battle the Roman Republic, under Caesar Augustus, was transformed into an Empire and became the dominant power in the Western world for three centuries and more. All Hellenistic paintings that survive today are from the Roman period, many being by Roman artists who copied Hellenistic paintings. These 1st-century Roman paintings reveal an

unprecedented naturalism and a relaxed, lyrical quality. These features are especially evident in this beautiful and modern-looking wall painting from the Roman town of Stabiae, *Young Girl Gathering Flowers (23)*. (Stabiae was a small resort, less well known than Pompeii or Herculaneum, that was destroyed together with these towns in the same eruption of the volcano Vesuvius in AD 79.) The young woman glides gently away from us with a poignant charm. We do not see her face, as if she were deliberately withholding from us the unearthly beauty that seems appropriately associated with the ethereal flowers she plucks. She vanishes into the mists and eludes us, leaving behind her only a suggestion of what Roman painting may have been like.

The happy accident that left us the young girl makes it even more painful to realize how much we must have lost. We can easily forget the vulnerability of painting, and how easily master works can be destroyed.

ILLUSIONISTIC WALL PAINTINGS

We also have a substantial number of examples of Roman paintings from Pompeii, but many of these are clearly works of provincial artists. Massively influenced by Greek painting (which the Romans admired as much as Greek sculpture and copied for wealthy houses), these do not necessarily reflect

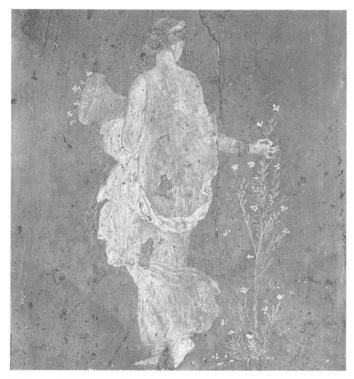

23 Young Girl Gathering Flowers, c. 15 BC-AD 60, height 12 in (30 cm)

the achievements of more talented painters. Still, these works have great charm. It is to their credit that the Romans, even in the small remaining sample of their homes that we can look at today, commissioned so many paintings.

The Romans' interest in landscape, as such, is likely to be Hellenistic in origin. Roman artists were also probably continuing a Hellenistic tradition when they embellished the interior walls of houses with illusions of expensive decorative facings and slabs of colored marble. Such skills were applied in the palaces of the Caesars on the Palatine Hill.

What sets Roman art apart from Hellenistic influences is an interest in facts – in places, faces, and historical events. Roman artists were specially interested in space (which may shed an interesting light on the collective Roman psyche). They also knew how to open up space on a wall by means of mock images of porticoes, architraves, and parapets, which themselves framed illusions of landscapes and figures.

This wall painting (24), from the hall of the Villa of Livia in Prima Porta, just outside Rome, is a charming example of an artist's attempt to create an illusion of a garden, as though the wall did not exist. Painted in the fresco technique, it shows birds, fruit, and trees in realistic detail. A low trellis separates us from a narrow patch of grass. Beyond that is another low wall, before the fruit trees begin.

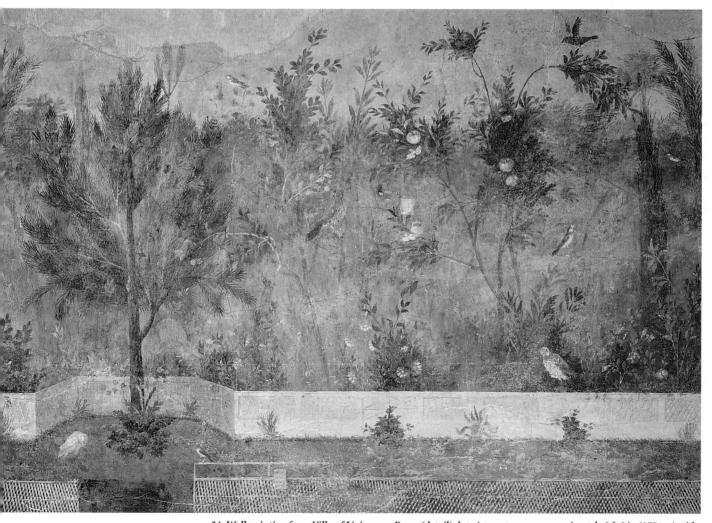

24 Wall painting from Villa of Livia, near Rome (detail), late 1st century AD, approximately 9 ft 2 in (275 cm) wide

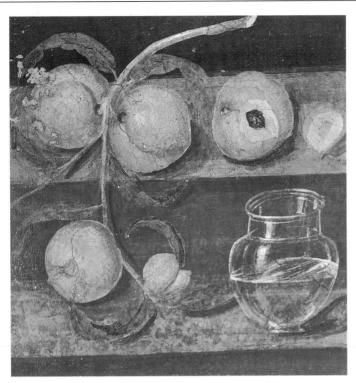

25 Still Life with Peaches, c. AD 50, approximately $13\frac{1}{2} \times 14$ in $(34 \times 35$ cm)

This illusionism is seen not only in large-scale wall paintings, but also in small works, such as this remarkably fresh and modern-looking still life of peaches and a jug of water, painted in about AD 50, in Herculaneum (25). It reveals an understanding of natural light, where the artist has attempted to show the various effects of light falling onto and through objects, and displays consistent use of chiaroscuro (the depiction of light and dark) as a means of giving volume to form and enhancing the illusion of reality. Once again, this skill is first seen in Hellenistic work, revealing the extent to which ideas were imported into Rome.

ROMAN PORTRAITURE

The wall painting known as "The Baker and His Wife" (26), a 1st-century work from Pompeii, is now thought not to portray a baker, but a lawyer and his wife. (Archaeologists are still trying to establish who owned the house in which this mural was found.) But, whoever this young couple was, the portrait remains essentially Roman, with all the interest concentrated on their personalities. The husband, a slightly uncouth, gawky, earnest young man, looks at the viewer with anxious appeal, while the wife looks away into the distance, musing and holding her writing stylus to her delicately pointed chin. Both seem lonely, as if their differently directed gazes reveal something of their marriage. They live together, but they do not share their lives, and there is an added

poignancy; the house of Neo (whatever his profession may prove to be, we do know that this was the name of the building in which the painting was situated) was still unfinished at the time of the eruption, so it is possible that this lonely marriage was of tragically short duration.

THE FAIYUM MUMMIES

Perhaps the most compelling Roman painting has an equal claim to be called Egyptian: the two cultures blended together with an eerie aptness when European realism met African lyricism during the Roman control of North Africa. Excavations have unearthed mummies from the cemetery in Faiyum, a town (today, a district rather than a town) near Cairo. These mummies are protected in a variety of wrappings ranging from papier-mâché to wooden boxes. With each mummy is a panel on which a portrait of the deceased is painted in encaustic (a medium consisting of pigments suspended in hot wax). This mummy case (27) is known to have been made for the body of a man named Artemidorus, for this name is inscribed on it. The silhouettes below his portrait show Egyptian deities.

The Faiyum portraits show all ages, from young to old, but those of young adults are the most touching. It may be that they were intended to give a sense of the individual's nature, his or her spirit, rather than the outer appearance, and for this purpose, some may have been idealized. Yet this *Bearded Youth (28)*, whose large eyes look so solemnly into ours, seems hauntingly real. Whether he looked like this or not, it is easy to believe that this was what he was like within.

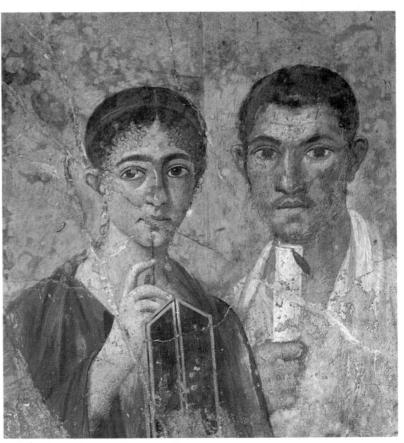

26 "The Baker and His Wife" ("Neo and His Wife"), 1st century AD, 201/2 x 23 in (52 x 58 cm)

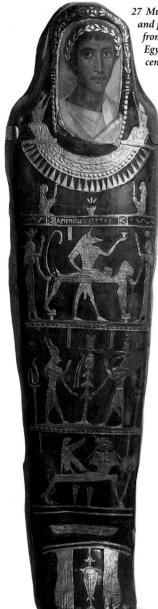

27 Mummy case and portrait, from Faiyum, Egypt, 2nd century AD

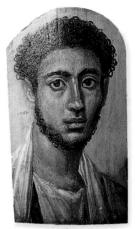

28 Bearded Youth, 2nd century AD, 8½ x 17 in (22 x 43 cm)

is carved into the likeness of a scroll that twists in a spiral up the column. The "scroll" is more than 600ft (180m) in length and contains over 2,500 human figures. It shows a series of scenes from Trajan's triumphant campaigns in Dacia (the present-day Romania). The examples shown on this page depict soldiers and builders at work constructing the walls of a fortification (29). The reliefs are shallow and have a painterly feel to them. They make up a continuous and clearly intelligible narrative, leading the "reader" through 150 episodes in succession.

During the 16th century the carvings on this column were an important inspiration and influence for the artists of the Renaissance (see p.80), who regarded the column's dense carvings as an idealized, three-dimensional demonstration of what two-dimensional art was really about.

29 Detail from Trajan's Column, AD 113

ROMAN SCULPTURE

Long after the ancient Roman civilization had disappeared, examples of its sculpture have continued to be visible in all parts of the empire. In Rome itself, the great narrative reliefs on Trajan's Column and the Arch of Titus in the Forum were on display to visitors and inhabitants of the city. Trajan's Column is as tall as a ten-story building and stands on a pedestal two stories high. It was built in AD 113 to honor the Emperor Trajan, a gilded statue of whom (replaced in the 16th century by a statue of St. Peter) was placed at the top. The marble outer surface of the column

EARLY CHRISTIAN AND MEDIEVAL ART

The great Roman empire was in decline by the early 2nd century AD, and by the 3rd century its political life had degenerated into chaos. When the Emperor Diocletian divided the empire in half, splitting East from West, the final collapse of the Western section

In Rome, in the network of ancient burial chambers known as the catacombs, there is a series of wall paintings dating from the time when the Christians were persecuted in the 3rd and 4th centuries AD. In style, these paintings bear the marks of the continuing Greco-Roman tradition. Unimpressive as art, this figure (30) is nonetheless deeply moving as an image of faith. It carries a secret charge of conviction that compensates for any technical incompetence.

THE FIRST GOLDEN AGE OF BYZANTINE ART

In 313, after 300 years of Christian persecution, the Emperor Constantine recognized the Christian church as the official religion of the Roman Empire. Early Christian art differed from the Greco-Roman tradition in subject matter more than style. Later, in the east, it evolved into Byzantine art, as artists turned away from Greco-Roman style to develop an entirely new style. The importance of Byzantine art is seen in

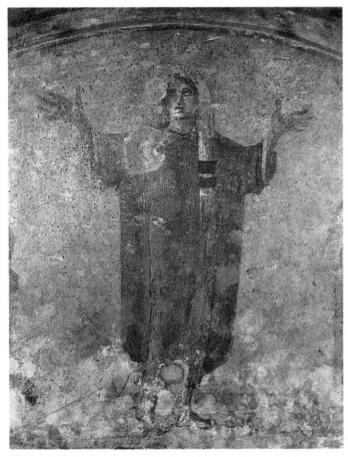

30 Wall painting from catacombs of Rome, 3rd century, $10\frac{1}{2} \times 16$ in $(27 \times 40$ cm)

was set in motion. In the 5th century, the Western empire succumbed to the Germanic barbarians. In the East, at Byzantium, a new, Christian-based empire slowly emerged, destined to endure for a thousand years, and with it a new art form, born out of Christianity.

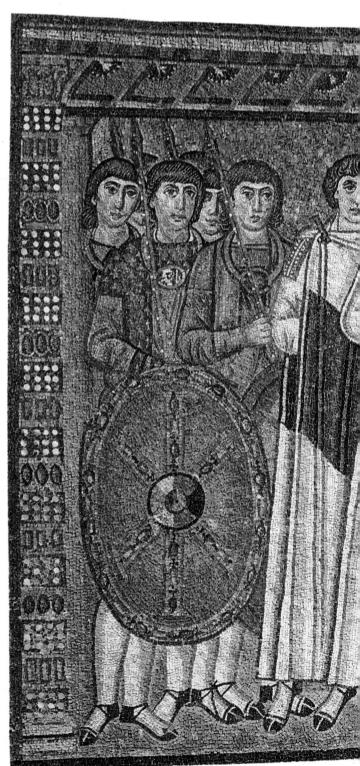

its profound influence on Gothic art (see pp.36–77). It was the first part of a tradition that was to remain predominantly Christian, and was to run right through the Middle Ages to the time of the Renaissance.

The emotional yet straight-faced intensity of the "Faiyum" paintings of 2nd-century Egypt (see p.22) lingers on into the early Christian mosaics created between 526 and 547 in the church of San Vitale, Ravenna, capital of the area liberated from the Goths by Byzantium. These mosaics achieved a maturity of stylistic convention – restrained elegance,

emotional austerity, and a "frozen," authoritative solemnity that would form the basis for all Byzantine art. The artist who created the image of *Justinian and His Attendants* (31) gave us a great and lordly image of a mid 6th-century Byzantine emperor. Slender, imperious, remote, and exalted, Justinian is shown with his bishop, clergy, and a representative section of his army: an image of the united forces of church and state, and an echo of the deification of kings practiced during the Roman Empire. All Justinian's princely qualities are also seen, in due proportion, in his

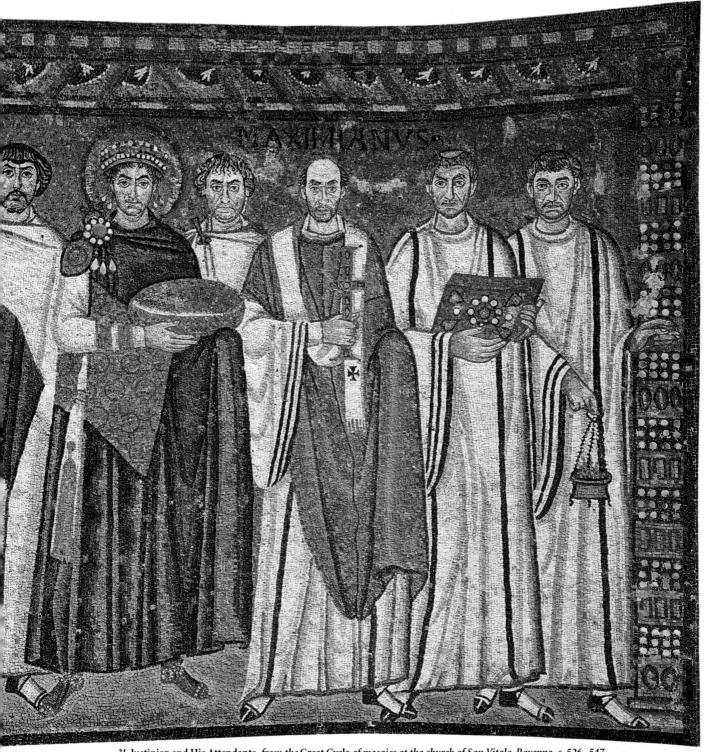

31 Justinian and His Attendants, from the Great Cycle of mosaics at the church of San Vitale, Ravenna, c. 526-547

attendant lords. They gleam far above us, both materially and spiritually, aloft on the Basilica walls. There is an equally glittering companion mosaic on the other side of the altar, depicting Justinian's wife, the Empress Theodora.

That same century, we can find both the emotional intensity of Faiyum and the priestly remoteness of Ravenna, in an icon from the Monastery of St. Catherine on Mount Sinai. Icons, a great tradition within the life of the Eastern church, were religious images, usually of Christ, the Madonna, or the saints. They were painted on small and often portable panels for devotional purposes, and each detail of the image could be charged with a special religious significance. The *Virgin and Child Enthroned Between St. Theodore and St. George* (32)

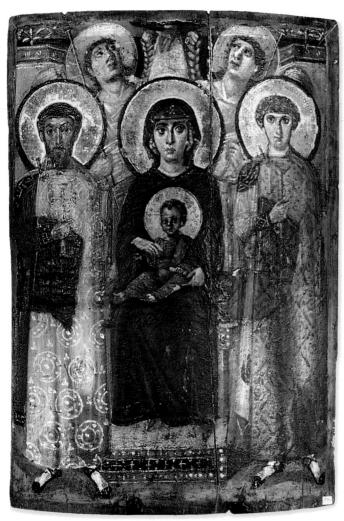

32 Virgin and Child Enthroned Between St. Theodore and St. George, icon from Mount Sinai, c. 6th century AD, 19 x 27 in (48 x 68 cm)

has all the sacred beauty that gives icons their unique power. Mary has wide eyes, which are intended to suggest her purity of heart: she is a woman of vision, one who sees God. She does not look at the small King on her lap: as her Lord, the Child can, as it were, fend for Himself, and it is on us that the Virgin bends her sternly maternal look. The two accompanying saints are dear to the Eastern church tradition – George, the holy warrior and dragon killer (though here his sword is sheathed), and Theodore, less well known to us today, another

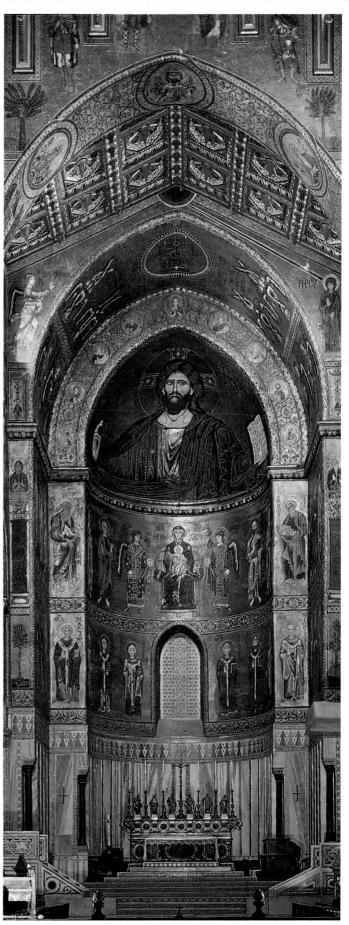

33 Christ as Ruler of the Universe, Cathedral of Monreale, Sicily, c. 1190

warrior. Both saints wear the uniforms of the Imperial Guard, but as weapons each now holds a Cross. The angels behind the throne look upward, alerting us to the hand of God that beckons and announces the Child. The Child holds in His hand a symbolic scroll. God is silent; only the angels see Him, though the eyes of the saintly figures seem to suggest that they sense the divine presence. The four halos of the Madonna, Child, and saints form a Cross and alert us to the message that the closed scroll must contain. It is a strange, mystical work, and this kind of painting continues to this day in Eastern churches.

THE SECOND GOLDEN AGE OF BYZANTINE ART

In the 8th and 9th centuries, the Byzantine world was torn with bitter controversy over the use of pictures or carvings in religious life. Any human image that was at all realistic could be seen as a violation of the commandment not to worship any "graven image." In 730, Emperor Leo III decreed any image of Christ, the Virgin, or any saint or angel, in human form, to be illegal. The decree gave power to religious militants known as iconoclasts (image breakers) who saw to it that, for over a century, religious art was restricted to nonhuman imagery such as leaves or abstract patterns. There was a steady migration of Byzantine artists to the West.

When the law was abolished in 843, and human images were tolerated again, resumption of contact with the artists of the West led to a renewed influence of classical form and illusionistic qualities.

This mosaic, from the apse (a domed recess behind the altar) of the Cathedral of Monreale, Sicily (33), is a large-scale, quintessentially Byzantine work in which the figure of Christ is huge and authoritative. He looms out at us from the sanctuary, a great, luminous image of power; not the gentle Jesus, but the "Judge." Beneath Him, the enthroned Madonna with Child, and the standing figures of archangels and saints, are all seen, rightfully, as small. They are beautiful, but relatively unimportant. The golden background of the mosaic is one of the most distinctive features of Byzantine art and continued into the Gothic era (see p.40).

INTIMATE ICON

Not all Byzantine art was on such a grand scale. One of the most beautiful small icons from the period is the so-called "Vladimir Madonna" (34). This was probably painted in Constantinople in the 12th century and later taken to Russia. The position of the Virgin and Child, their faces touching tenderly, introduces a new note in sacred art. Previously the two figures had appeared as symbols of the Christian faith — Christ and His Mother not sharing any emotional closeness. Here they appear in their intimate, human relationship.

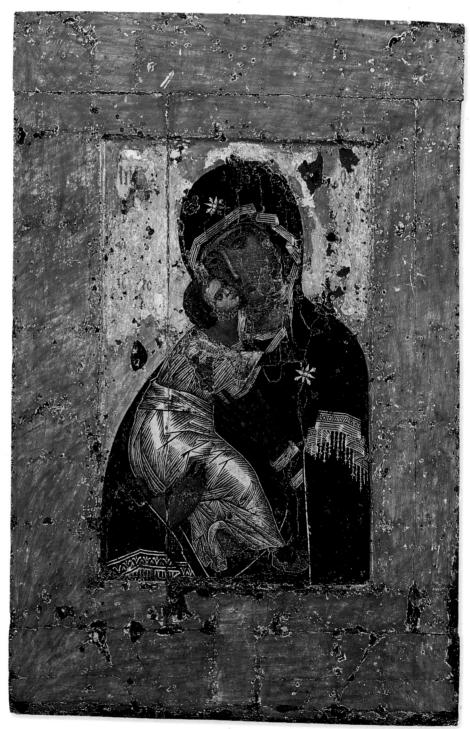

34 "Vladimir Madonna," c. 1125, 21 x 30 in (53 x 75 cm)

RUSSIAN ART

Russia was converted to Christianity in the 10th century, and eventually took over the Byzantine tradition, making it very much its own. The most exquisite example of this meeting of two very dissimilar cultures, at the highest point in the development of Russian Byzantine art, is surely this vivid *Trinity* (35), painted by Andrei Rublev (c. 1360–1430). Rublev is the most famous of Russian icon painters. The figures represent the three angels that appeared to Abraham in the Old Testament. This is grace made visible, and it is this Byzantine heritage that gives special poignancy to the mysterious works of El Greco (see p.146) 300 years later.

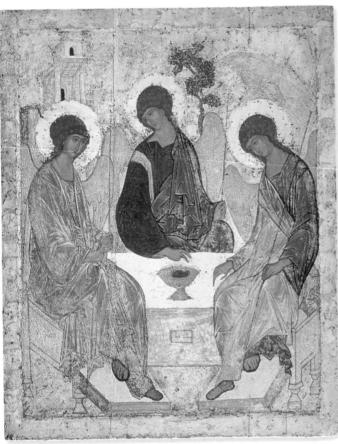

35 Andrei Rublev, Trinity, c. 1422–27, 44 x 55 in (112 x 140 cm)

THE "DARK AGES" IN WESTERN EUROPE

Despite its pejorative implication, the phrase "Dark Ages" is sometimes used to refer to the early Middle Ages in European civilization, up to the beginning of the High Middle Ages around 1100. The thousand-year period from 400 to 1400 was a time of gradual mingling of influences from the Greco-Roman tradition, Christianity, and Byzantine art, as well as the growing Celtic and Germanic cultures of the North. Far from being an artistically barren or regressive period filling the empty space between the Roman empire and the Renaissance, as was believed for centuries, it was a period of development and metamorphosis within the stronghold of Christianity. The "Dark Ages" held the seeds of future scientific and technical innovation and prepared the way for such things as the coming invention of printing.

36 David and Goliath, fresco at Tahull, Spain, c. 1123

The art of the Western church was less mystical and more human than that of the Byzantine empire, and throughout the Middle Ages, painting was the preferred manner of popular religious instruction, at a time when a large majority of people were illiterate. Even the poorest church buildings covered their walls with brightly colored biblical stories, often to spectacular effect. In the tiny Catalan church of Santa Maria, at Tahull, Spain, the 12th-century frescoes have only four main colors: white, black, ochre, and vermilion, with touches of blue and orange. This passionate simplicity is repeated in the forms as David sways forward to decapitate an inert Goliath (36). David, in adolescent garb, is slight, dreamy, and defenseless, while Goliath, immense in his huge armor, is the consummate worldling whom the children of God, even poor shepherds such as the young David, defeat.

ILLUMINATED MANUSCRIPTS

The art of the nomadic barbarian peoples who had conquered the West was mostly object based, small scale, and portable. After conversion to Christianity, it was logical that this highly decorative art form should be translated into a religious art that is also small scale and portable: the illuminated manuscript. This most accessible and perhaps even most lovely of early medieval artifacts has been discussed by some critics as

being the work of craftsmen, but where do we draw the line? The original meaning of the Latin word ars was "craftsmanship," the exact equivalent of the Old High German word kunst, which originally meant knowledge or wisdom, and by extension came to mean a craft or skill. The discipline of a trained eye and a trained hand was essential to create an object either for delight or for function or – the continual desire of the creator – for both. The distinction between aristocratic art and plebeian craft is only a modern one. It dwindles away into insignificance when we look at the work of the great "craftsmen" of the Middle Ages.

THE CAROLINGIAN EMPIRE

The single most powerful political figure in Europe in the early Middle Ages was Charlemagne. His contemporary name translates to "Charles the Great," and Charlemagne is a version of the Latin for this. The adjective relating to his time is Carolingian.

Charlemagne's armies took control of extensive territories in northern Europe from 768 to 814. With his military might, he was responsible for the enforcement of Christianity in the North, and for a revival of the art of antiquity that had flourished before the collapse of the Roman Empire in the West 300 years earlier.

When Charlemagne was crowned emperor of what is now France and Germany in 800, he became a great patron of the arts. He was fluent in Latin and could understand Greek, though he could hardly write at all. He wanted his artists to reflect both the Christian message and the magnificence and importance of his own empire. For his court at Aachen,

he recruited the greatest scholar known in Europe at that time, Alcuin of York, an Englishman from Northumbria.

Charlemagne commissioned several glorious sets of illuminated Latin Gospels. Some of the work that these contain has an almost classical majesty, a magnificent serenity. The emperor sent artists to Ravenna (see p.25), where they could study the early Christian and Byzantine murals and mosaics, whose style offered itself as more appropriate to the religious development of the new empire than did the pagan art of Greece and Rome. He may have employed Greek artists to work on some of the illuminated Gospels. The Byzantine influence, together with elements from early Christian,

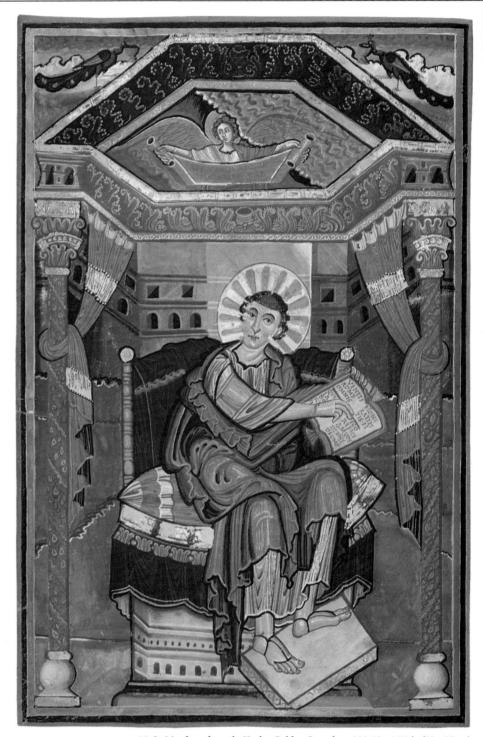

37 St. Matthew from the Harley Golden Gospels, c. 800, $10 \times 14\frac{1}{2}$ in $(25 \times 37 \text{ cm})$

Anglo-Saxon, and Germanic art, are seen in these illuminated manuscripts. These traditions combined to produce the Carolingian style, embodied in this painting (37) from the *Harley Golden Gospels*. This book was produced under Charlemagne and takes its present name from a collector, Lord Harley, who once owned it. St. Matthew writes his Gospel in a setting that displays a rather lopsided perspective, but is eminently balanced emotionally. He leans forward to listen to the Holy Spirit, calmly collected, half smiling. His emblem, an angel, hovers above him with equal poise, and expressing the same quiet happiness.

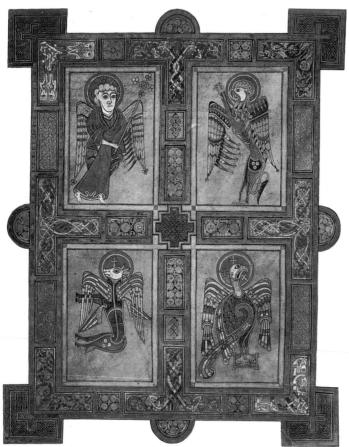

38 Symbols of the Evangelists, from the Book of Kells, c. 800, $9\frac{1}{2} \times 13$ in $(24 \times 33$ cm)

CELTIC ILLUMINATION

The missionary zeal of the Christian church, which spread its influence across Europe, is seen at its most intense in the relatively tiny Christian stronghold of Celtic Ireland, which had converted to Christianity in the 5th century. Advanced Celtic monastic communities were also established in Britain and northern Europe. The intricate art that was created in all these communities reveals a blend of Celtic and Germanic styles. In their convoluted manner, the Celtic manuscripts appeal to us across the centuries with a remarkable intensity.

There can be few works of art more exquisite in every sense than the *Book of Durrow*, the *Lindisfarne Gospels*, or the *Book of Kells*. This last, created by Irish monks on the island of Iona in the 8th and early 9th centuries, and later taken to the monastery of Kells in Ireland, is possibly the greatest work of manuscript illumination ever created. The figurative images have an iconic strength, as we see in the page that shows the symbols of the four evangelists: Matthew's angel, Mark's lion, Luke's ox, and John's eagle (38).

ILLUMINATED INITIALS

But the true glory of the *Book of Kells* is in the illuminated initials. Here intricacy becomes so integrated, so wild yet so controlled – a marvelous paradox – that it is impossible even to imagine how such lacelike perfection could have been drawn by the unaided human hand. One of the most

wonderful initial pages presents the words *Christi autem generatio* ("the birth of Christ") from St. Matthew's Gospel. The word *Christi*, shortened to "*XPI*," fills most of the page; *autem* is abbreviated as *h*, while *generatio* is spelled out (40).

The shortened form of the name of Christ is made out of the two characters XP, the Greek letters *chi* and *rho*. This is the symbolic abbreviation known as the *Chi-Rho*. The entire ornate pattern is based upon the material form and spiritual meaning of these two characters.

The whole page is densely covered with a network of lines, faces, shapes, and animals (human figures are not often the main focus of Irish illuminations). There are three figures of men (or angels), three being the mystic trinitarian number; there are butterflies, cats playing with mice (or are they kittens?), and a fine otter, upside down and clutching a fish in its mouth. But we have to search these creatures out, disguised as they are by a glorious swirl of geometric patterning. The floating human faces, glimpsed here and there amid the tracery, make clear to us that the central and all-encompassing reality in life is Christ. His very name, even in its abbreviated form, simply subsumes all else.

The ambitious approach of this page is more easily appreciated if we compare it with its equivalent in the *Lindisfarne Gospels (39)*. This manuscript was produced in Northumberland, in northern England, shortly before 698, by the monk Eadfrith. Here too the illumination is magnificent, but it is much less complicated in its layout and scope.

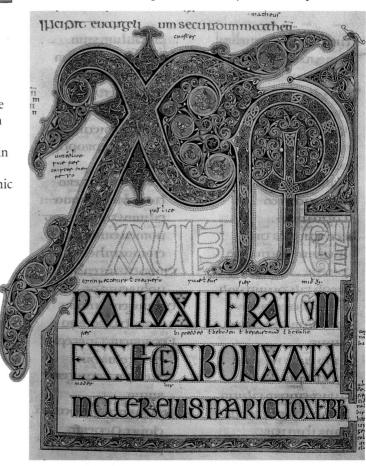

39 Chi-Rho page from the Lindisfarne Gospels, c. 690, $10 \times 13\frac{1}{2}$ in $(25 \times 34$ cm)

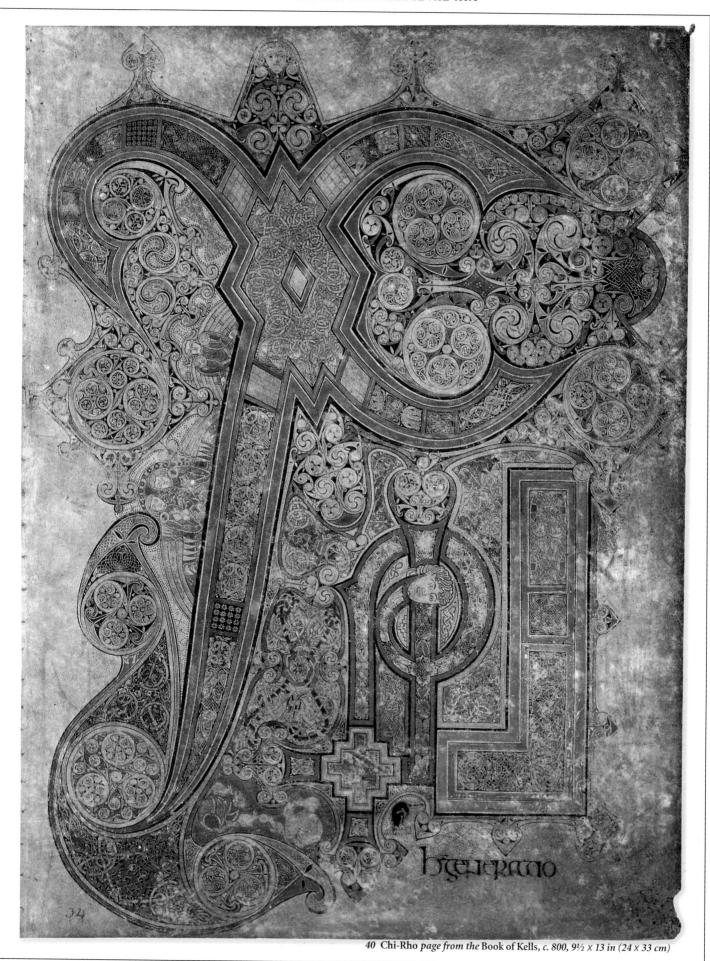

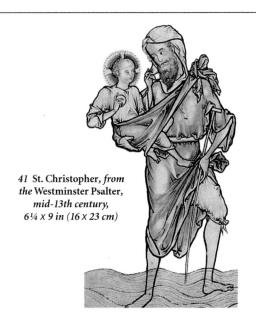

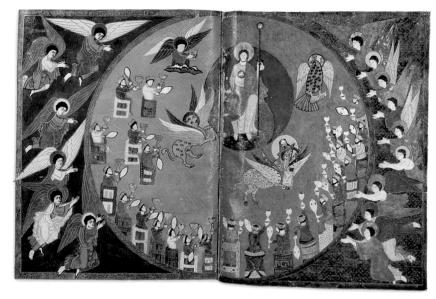

43 Christ and the 24 Elders, from the Apocalypse of Beatus, c. 1028-72, 22 x 14½ in (55 x 37 cm)

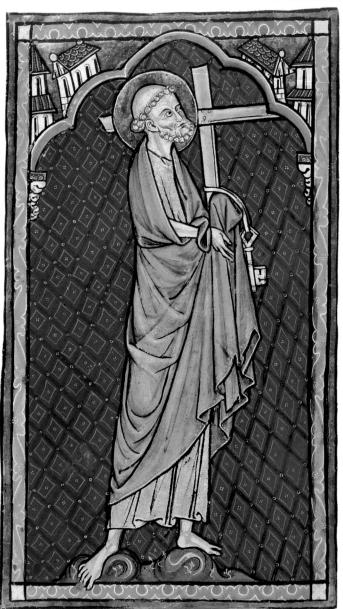

42 St. Peter, from the Oscott Psalter, c. 1270, 7½ x 12 in (19 x 30 cm)

SPANISH ILLUMINATION

The very smallness of manuscript art gives it an intimacy that can prove tremendous. The most dramatic of medieval illuminations tend to be Spanish. The book of Revelation, the final and apocalyptic book of the Bible, provided a never-failing source of blazingly powerful images. The monk Beatus, who lived in the 8th century at Liebana in Spain, wrote a commentary on the Apocalypse (as Revelation is also known) that entranced the visual imaginations of a whole series of painters for centuries to come. Here is how another monk (probably Spanish or Spanish-trained), who worked at the monastery of Saint-Sever in Gascony, envisioned Christ and the 24 Elders in an 11th-century copy of Beatus (43). Around the outer edge of a great circle containing Christ and His blessed are the souls of the saints, pure and free as birds. There is a wonderful exhilaration in the image of the elders, including the four evangelists, waving their goblets to toast the triumphant Lord, while the winged saints stretch out longing hands toward the celestial glory.

English illumination

Like the Irish monks, the British also produced manuscripts of great beauty, this being one of the very few periods in which the least visual of national groups, the English speakers, attained international fame as artists. Matthew Paris, who died in 1259, was a monk at the flourishing Abbey of St. Albans, just outside London, and his 42 years in the cloister were mainly distinguished by a series of books that he not only wrote, but illustrated, giving them the benefit of his remarkable draftsmanship. In this example from the Westminster Psalter, the patron saint of travelers, St. Christopher (41), is shown carrying the Christ Child across the river.

Another outstanding work from St. Albans, known as the *Oscott Psalter (42)*, illustrated by an artist who is not named, shows the same nervous delicacy of line, with an elegance and psychological subtlety that enchant the viewer. St. Peter, identifiable by the keys he holds and the fact that he stands on a rock, is one of ten saints depicted in the psalter.

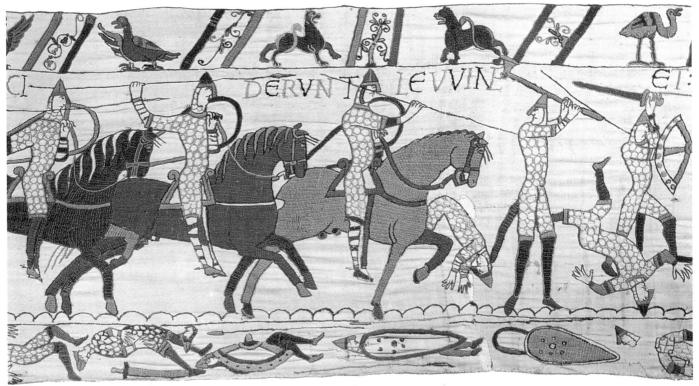

44 The Death of Harold's Brothers, from the Bayeux Tapestry, c. 1066-77 (detail)

45 Page from the St. Denis Missal, c. 1350, 6¼ x 9 in (16 x 23 cm)

English embroidery

The so-called *Bayeux Tapestry* is not really a tapestry, but a woolen embroidery supported by cloth. For a long time it was thought to have been made in Normandy for Queen Matilda, wife of William the Conqueror, by her "court ladies." However, it has recently been proved to have been commissioned by Bishop Odo, William's half-brother, and made in England. It displays the same jerky animation that we find in English manuscripts. A sort of Anglo-Saxon glorified comic strip, it tells its exciting story of the Norman Conquest of England with economy and charm. It takes the form of a long cloth frieze, with upper and lower borders that provide a commentary on the action in the main panel. In this particular scene (44), the brothers of the English King Harold are slain by Norman soldiers. The top border is given over to decorative, almost emblematic animals, while the bottom one is filled with images of dead soldiers and an assortment of their abandoned weapons and armor.

French Illumination

A lovely missal (a book of texts for church services through the year) survives from the 14th century at the abbey of St. Denis in Paris. It is by a follower of Jean Pucelle, an illuminator with a workshop in Paris. One page shows liturgical text for the feast day of St. Denis (45), with a magnificent pictorial "O" and two other miniatures telling of the saint's relationships with the royal family. Even if we do not know the legends about the stag that hid in a church when pursued by Prince Dagobert, and how the prince and his father King Clotaire are eventually reconciled through a dream appearance of St. Denis, we can still enjoy the pale and meticulous figurines, living out their holy adventures in the missal.

ROMANESQUE PAINTING

In an illustration in a mid 13th-century French Bible moralisée (biblical text with moralizing commentary), God the Father is seen as an architect (46). This work shows the increasing return to the natural-looking style of Roman art (see p.20) – especially visible in the relaxed drapery and the suggestion of volume beneath – a style that would reach unprecedented heights of realism in Gothic painting. Although, as was typical of medieval paintings, the artist did not leave us his name, the picture has an almost Giottoesque power (see p.46). Almost 600 years later, William Blake would also show God bending over a compass in an illustration in his book *The* Ancient of Days (47). But Blake's God is narrowed by geometry, and this artist is rebelling against the rule of cold law, glorying in the majesty of a strong, free deity. God strides through space, barely contained by the brilliant blue and scarlet borders of the human imagination. The great swirls of His royal robes recall the sculptural pleats on the figures in Reims Cathedral. God is utterly intent upon his creative work, putting forth every effort of his mighty will to control and discipline the

wild waters, stars, planets, and earths of His world. He will soon, we feel, send it spinning into space, but first, He orders it. He labors with barefoot concentration, the perfect integrator of art and skill.

When the Florentine artist Giotto (see p.46) started producing frescoes in the early 14th century, his genius was so massive that he changed the course of European painting. However, the illuminators' art did not come to an immediate end. Contemporary with Giotto and past his time, influenced but yet distinct, the manuscript artists continued with their intricate craft, reaching greater heights precisely because Giotto had set them free from any imaginative limitation.

47 William Blake, illustration from The Ancient of Days, 1794

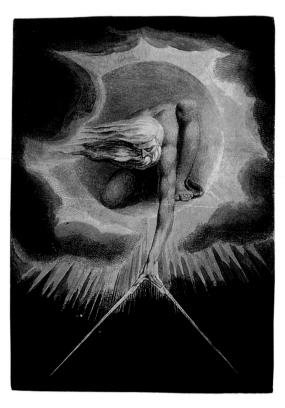

CLASSICAL INFLUENCES

Other works that can be seen to prefigure Giotto's naturalism include the paintings and mosaics of the Italian artist Pietro Cavallini (active 1273–1308). He worked mainly in Rome, and Giotto would have seen examples of his art there early in his career. Cavallini's style was strongly influenced by classical Roman art. Unfortunately, his work has been preserved for us, for the most part, only in fragments.

This example is a detail from his best surviving fresco, in the church of Santa Cecilia in Trastevere, Rome (48). The three seated apostles shown here form part of a larger group surrounding the figure of Christ in the Last Judgment. In the unidentified but youthful apostle in the center, we see a sweetness and a gravity that has great human appeal as well as a supernatural power. He is an accessible saint, yet still incontrovertibly a "saint."

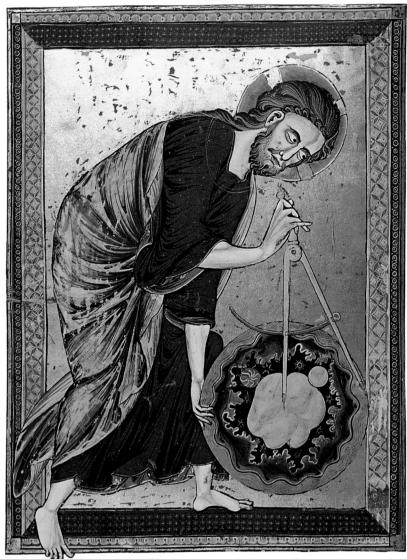

46 God the Father as Architect, illustration in a French Bible moralisée from the mid-13th century, 10 x 13½ in (25 x 34 cm)

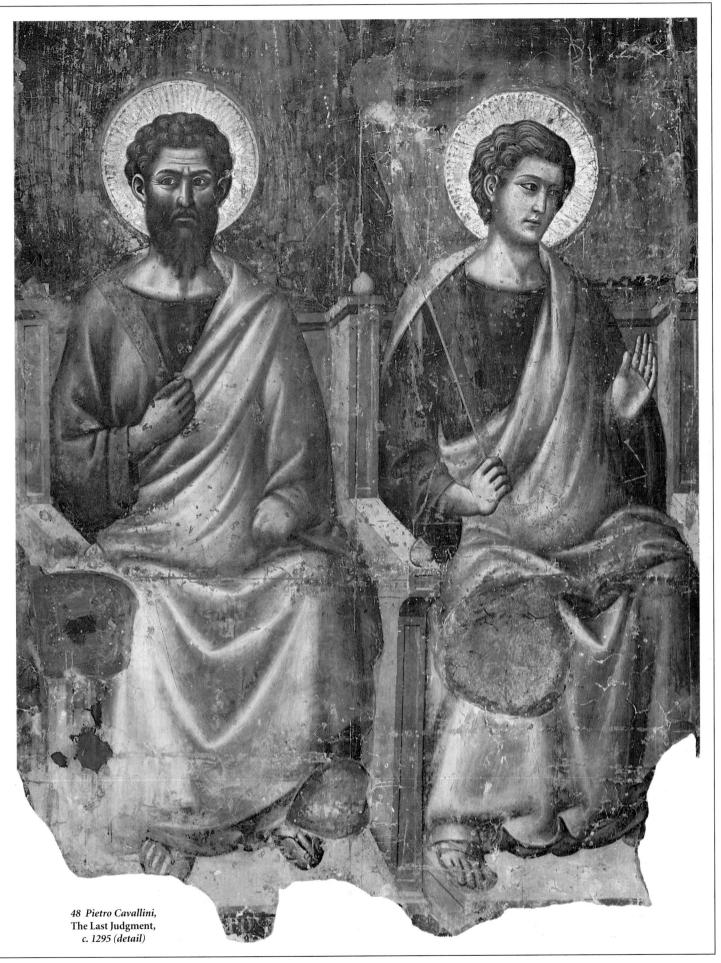

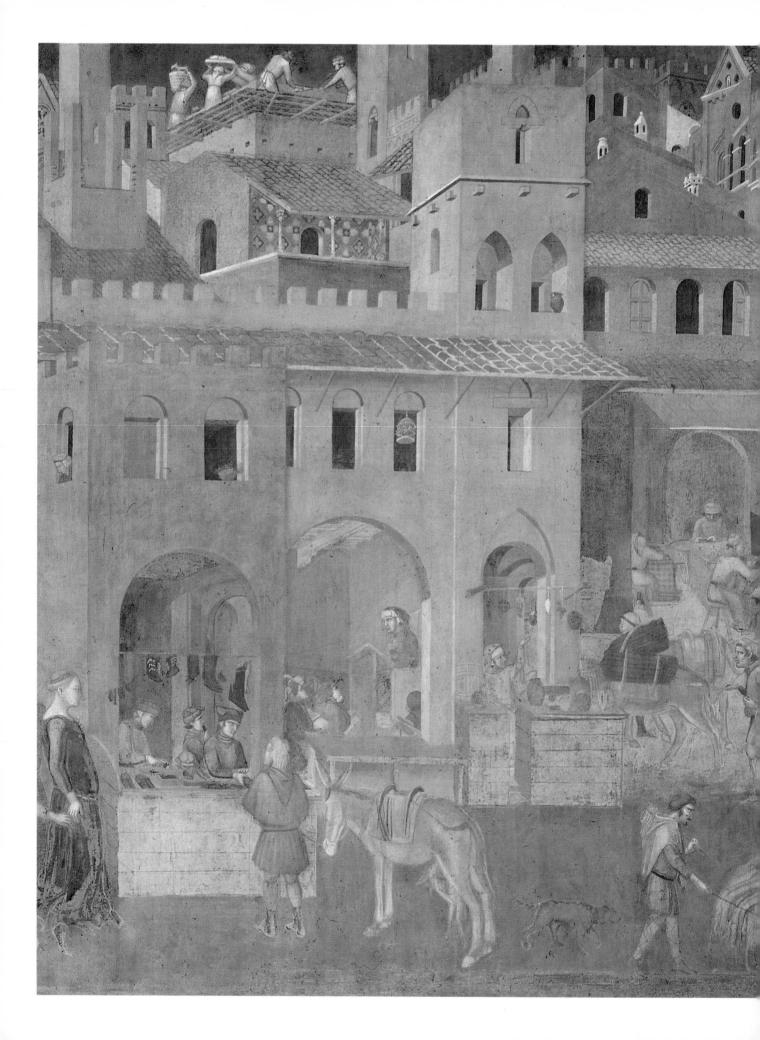

GOTHIC PAINTING

 ${
m The}$ Gothic style began with the architecture of the 12th century, at the height of the Middle Ages, when Europe was putting the memory of the Dark Ages behind it and moving into a radiant new era of prosperity and confidence. At the same time, Christianity was entering a new and triumphant phase of its history, and so the age of chivalry was also the time of the building of the magnificent Gothic cathedrals, such as those in the northern French towns of Chartres, Reims, and Amiens. In the realm of painting, the change to the new style became visible about a century after the first of these cathedrals rose. In contrast to the Romanesque and Byzantine styles, the most noticeable feature of the art of the Gothic period is its increased naturalism. This quality, which first appeared in the work of Italian artists in the late 13th century, became the dominant painting style throughout Europe until the end of the 15th century.

GOTHIC TIMELINE

The Gothic era in painting spanned more than 200 years, starting in Italy and spreading to the rest of Europe. Toward the end of this period there were some artists in parts of the North who resisted Renaissance influences and kept to the Gothic tradition. As a result, the end of the Gothic timeline overlaps with both the Italian and the Northern Renaissance timelines (see pp.80–81, 150–51).

CIMABUE,
MAESTA, 1280-85
Although this painting shows strong
Byzantine influences, Cimabue's
work marked a departure from
that tradition in the more threedimensional rendering of space
and the apparent humanity of his
Madonna. In addition, the drapery
is much softer than that in
Byzantine art (p.42).

GIOTTO, DEPOSITION OF CHRIST, C. 1304–13

Giotto's art heralded an entirely new tradition of painting, and his art even belongs in some ways to the Renaissance. This fresco from the Arena Chapel, Padua, is a good example of his characteristic psychological intensity, spatial clarity, and solidity of form (p.47).

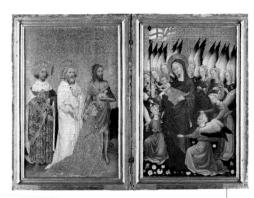

Wilton diptych, c. 1395

Although little is known about the origin of this work, it is a perfect example of the courtly International Gothic style that swept Europe at the end of the 14th century. The rich blue and the crowded composition of the panel showing the Virgin surrounded by angels contrasts with the simplicity of the left-hand panel, with its gold background (p.54).

1290

1310

1330

1350

1370

1390

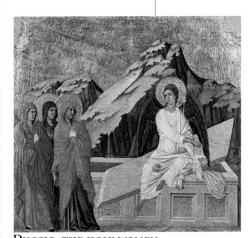

DUCCIO, THE HOLY WOMEN AT THE SEPULCHRE, 1308–11 Duccio's most celebrated work is his wonderful Maestà altarpiece. It still impresses, even thoug

Maestà altarpiece. It still impresses, even though now dismembered and partially dispersed, with its huge Virgin in Majesty. It was free-standing, and the back showed scenes from the life of Christ (p.45).

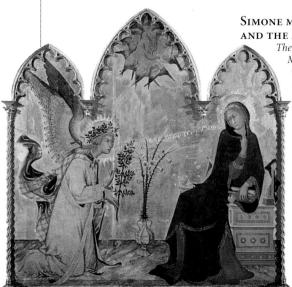

Simone martini, the angel and the annunciation, 1333

The Sienese artist Simone Martini painted several versions of the Annunciation. In this glittering example, the fluid lines of the draperies of the Virgin and the angel clearly reveal the solid forms beneath them a characteristic feature of Gothic painting (p.50). The similarly named Angel of the Annunciation, a diptych panel showing the angel without Mary, is another display of Martini's consummate skill in the portrayal of drapery (p.51).

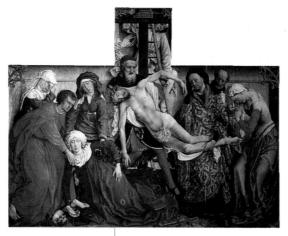

ROGIER VAN DER WEYDEN, DEPOSITION, C. 1435

In the hands of this great Flemish artist, the removal of Christ's body from the Cross is a moment of intense emotional drama. Everyone in the scene is overwhelmed by grief, though each expresses it differently (p.67).

ROBERT CAMPIN, PORTRAIT OF A WOMAN, C. 1420–30 Northern artists began to show individual personalities in their head-and-shoulders portraits of wealthy townsfolk (p.61).

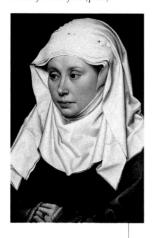

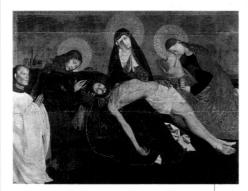

MASTER OF AVIGNON PIETA, PIETA, C. 1470

Depictions of the Pietà, the Virgin Mary viewing or holding the dead body of her Son, abound in Gothic art. This poignant 15th-century version was created by an anonymous artist in France (p.66).

HIERONYMUS BOSCH, TEMPTATION OF ST. ANTHONY, 1505 Bosch stands out among his peers for the bizarre and fantastic images that appear in many of his paintings (p.72).

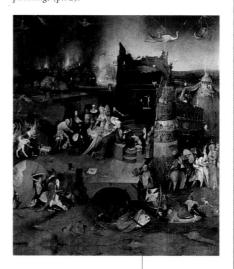

1410

1430

1450

1470

1490

1510

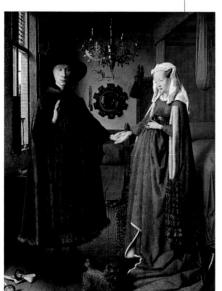

Jan van Eyck, The Arnolfini Marriage, 1434

Van Eyck was one of the first artists to exploit the new medium of oil paint. In this double portrait, one of his most famous paintings, he uses it to great effect in the realistic rendering of light and shadows. The unifying result of this treatment was extremely original in its time. The interior domestic setting is found in many of the paintings of contemporary Netherlandish artists (p.65).

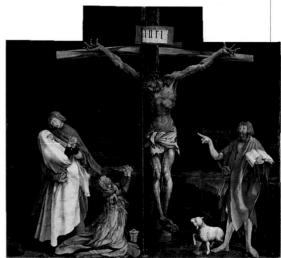

MATTHIAS GRÜNEWALD, CRUCIFIXION, C. 1510–15 The German artist Grünewald typifies the emphasis on horrific suffering of some late Gothic art. His Crucifixion

scene has a harrowing intensity (p.76).

39

AMIENS CATHEDRAL

This cathedral, with its pointed arches and ornate stonework, is typical of the High Gothic architecture of 13th-century France. Building work commenced in 1220.

THE MIDDLE AGES

Gothic art belongs chiefly to the last three centuries of the Middle Ages. The Middle Ages extended from the fall of Rome in 410 to the start of the Renaissance in the 15th century.

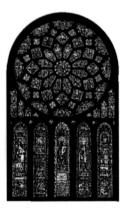

STAINED GLASS

The Gothic cathedral at Chartres attracted the most accomplished makers of stained glass. It has three rose windows, a popular Gothic feature. In the windows under the north rose (above), completed c. 1230, are the figures of St. Anne, holding the Virgin Mary as a child, and four Old Testament figures, including David and Solomon.

Early Gothic Art

In the early Gothic period, art was produced chiefly for religious purposes. Many paintings were teaching aids, to make Christianity "visible" to an illiterate population; others were displayed, like icons (see p.27), to enhance contemplation and prayer. The early Gothic masters created images of great spiritual purity and intensity, and, in doing so, preserved the memory of the Byzantine tradition. But there was much that was new as well: strikingly persuasive figures, perspective, and a wonderful elegance of line.

The term "Gothic" denotes a period of time rather than describing a set of identifiable features. Although there are certain recognizable characteristics of Gothic style, Gothic art's numerous manifestations are easier to make sense of if we bear in mind that the period spanned over 200 years, and that its influence spread throughout Europe. The Italians were the first to use the term "Gothic," and they used it as a derogatory word

were the first to use the term "Gothic," and they used it as a derogatory word for art that was produced during the late Renaissance (see p.139), but that was of a medieval appearance. The word was a reference to the "barbaric past" – in particular to the Goths, a Northern, Germanic people of ancient times whose armies had invaded Italy and sacked Rome in the year 410. Eventually the word "Gothic" lost its derogatory overtones and was adopted as a broad term describing the new style of architecture and art that emerged after the Romanesque period (see p.34) and before the Renaissance.

THE INFLUENCE OF GOTHIC ARCHITECTURE

The innovation that separates the churches of the Gothic period from the Romanesque architecture was a new type of ceiling construction, the ribbed vault. With this strengthening structure, the supporting walls no longer needed to be so massive. In addition, flying

buttresses were employed as load-bearing devices on the outside of the building, so that not all the weight of the roof needed to be supported by the columns and walls. Thus the walls could be thinner and large parts could be given over to glass, allowing in more light.

A common misconception about Gothic architecture is that the pointed arch was one of its innovations. In fact, such arches were not new, but enjoyed much greater popularity in Gothic designs than at any earlier time. More variable in shape than semicircular arches, they offered architects greater freedom of choice.

The first churches to be built in the Gothic style were in France, notably at Notre Dame in Paris, St. Denis in Paris, and at Chartres. A less elaborate, but similar, style appeared in England, for instance at Salisbury; and Gothic churches were also built in Germany, Italy, Spain, and the Netherlands. In all of them there was a startling

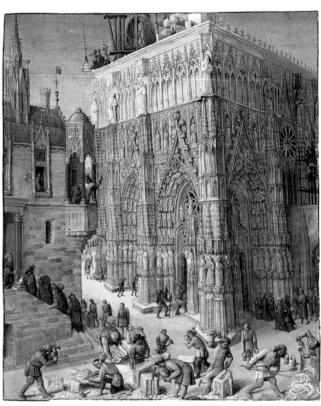

49 Jean Fouquet, The Building of a Cathedral, from a 15thcentury manuscript copy of the writings of the 1st-century Jewish historian Josephus

and revolutionary use of stained glass. Colored light now flooded the interior, creating a new and unearthly atmosphere. While before each colored panel had to be held in place by stonework, Gothic craftsmen learned to make a mesh of lead tracery to hold the glass in place. The art of making stained glass windows reached its greatest height in the church of Sainte Chapelle in Paris (50), where windows make up three-quarters of the wall area.

EMERGENCE OF GOTHIC PAINTING

Gothic painting has its beginnings in Italy. Painting in 13th-century Italy was still dominated by Byzantine art, which was known in Italy as "the Greek manner." Painting was much slower to assimilate the Gothic influence than architecture and sculpture. It was not until the end of the

13th century that the Gothic style appeared in painting, in the brilliant panel paintings of Florence and Siena. Early Gothic painting displayed a greater realism than had been found in Romanesque and Byzantine art. There is an obvious fascination with the effects of perspective and in creating an illusion of real-looking space.

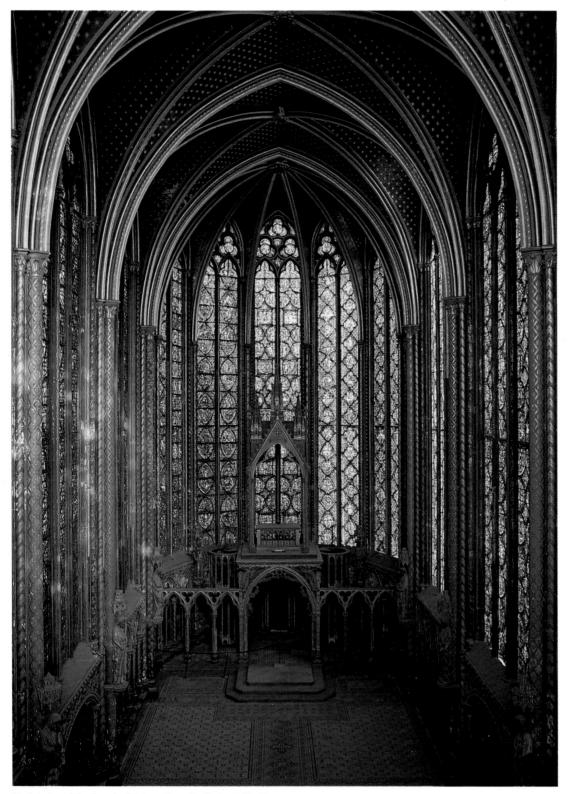

50 Interior of the church of Sainte Chapelle, Paris, 1243-48

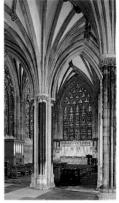

RIBBED VAULTS

The ribbed vaulting and delicate pointed arches of the Lady Chapel in Wells Cathedral, England, are typical of the Gothic style. So too is the light that streams into the chapel through the large windows. This part of the cathedral was completed in 1326.

SCULPTUR

This figure of Simeon holding Christ is from the exterior of the north transept of Chartres Cathedral. It illustrates the shift from the rigid Romanesque style of sculpture toward more personalized and elegant figures, typified by the folds in the drapery. This was echoed in Gothic painting.

St. francis of assisi

St. Francis (christened Giovanni di Bernadone... 1182-1226) had a profound influence on the Gothic era and was a popular subject in Gothic paintings. His love of nature (as illustrated above) is reflected in many works of art. He founded the Franciscan Order in 1210-the first order of friars. Instead of staying in their country abbeys, the Franciscans took Christianity to the people of the towns. The Basilica at Assisi was built shortly after the saint's death, in memory of him. Many important Italian painters, including Cimabue, decorated its interior.

Many of the pictures show a sinuous elegance and delicacy. Other characteristics of the Early Gothic style are an interest in pictorial storytelling, and a heightened, often passionate, expression of spirituality.

TURNING AWAY FROM BYZANTINE ART

The most prominent artist working in Florence at the end of the 13th century was Cimabue (Cenni di Peppi, c.1240–c.1302), who is traditionally held to be Giotto's teacher. So many works have been attributed to him that his name has almost come to represent a group of like-minded artists rather than an individual, though we know he existed.

Although Cimabue remained a painter in the Byzantine style, he went a long way toward liberating himself from the flatness of traditional icon painting, and in doing this he took the first steps in the quest for realism that has played such a fundamental role in Western painting.

We know that in 1272 Cimabue traveled to Rome, which was then the main center in Italy for muralists. The mural painters and mosaic makers of that time were particularly interested in creating a greater naturalism in their work,

THE STREET OF THE STREET STREET IN

51 Cimabue, Maestà, 1280-85, 7ft 5 in x 12 ft 8 in

(225 x 386 cm)

52 Duccio, Maestà, main front panel, 1308–11, 13 x 7 ft (396 x 213 cm)

OTHER WORKS BY CIMABUE

Crucifix (Church of San Domenico, Arezzo)

Virgin and Child Enthroned (Church of Santa Maria dei Servi, Bologna)

> St. Luke (Upper Church, Basilica of San Francesco, Assisi)

St. John (Pisa Cathedral, Pisa)

Virgin and Child With Six Angels (Louvre, Paris)

The Gualino Madonna (Galleria Sabauda, Turin) and Cimabue may well have shared their concern. Cimabue is best known for his Maestà (51), originally on the altar of the church of Santa Trinità in Florence. The word maestà means "majesty," and was used to refer to a painting of the Madonna and Child in which the figure of Mary sits on a throne and is surrounded by angels. Cimabue's Maestà has a great sweetness and dignity, surpassing in emotional content the rigid, stylized figures of the Byzantine icon. The handling of the soft texture of the drapery, together with the "open," three-dimensional space created by the inlaid throne on which the Madonna and Child sit all this is new and exciting.

DUCCIO AND THE SIENESE SCHOOL

Regardless of all the developments he initiated, Cimabue's work still has a certain flatness if we compare it with the works of the great, and almost contemporary, Sienese painter Duccio (Duccio di Buoninsegna, active 1278-1318/19).

During the 13th and 14th centuries the city of Siena vied with Florence in the splendor of its arts. If Giotto (see p.46) revolutionized Florentine art, then Duccio and his followers were responsible for their own smaller, but very significant, revolution to the south. Duccio is a painter of tremendous power. His greatest work was his Maestà, commissioned for Siena Cathedral in 1308 and installed there in 1311 with great ceremony. A chronicler recorded the

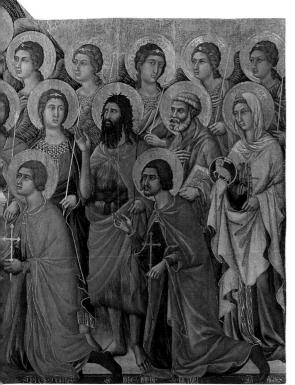

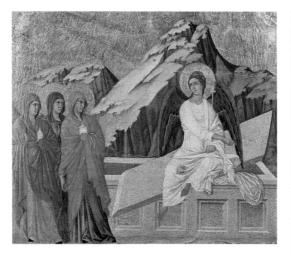

53 Duccio, The Holy Women at the Sepulchre (from the Maestà), 1308-11, 21 x 40 in (53 x 102 cm)

festivities: "The Sienese took [the Maestà] to the cathedral on the 9th June, with great devotions and processions ... ringing all the bells for joy, and this day the shops stayed closed for devotions." It is extraordinary that this great work was in later times cut up and sold, at least in part because it was no longer appreciated. The beneficial result of this cultural folly is that museums all around the world now have panels from the Maestà.

Duccio's Maestà was painted on both sides; the front was in three parts. The main panel (52) showed the Mother and Child enthroned. surrounded by angels and saints. At the base of the main panel ran a predella (a pictorial strip along the bottom), decorated with scenes from Christ's childhood. A corresponding strip at the top displayed scenes from the last years of the life of the Virgin. Both these strips are now lost. The reverse was painted with scenes from the life of Christ (26 are known).

Among the scenes from the back of the Maestà that remain in Siena is The Holy Women at the Sepulchre (53). It is the moment in the Passion when the three Marys discover Christ's empty tomb and are told by the Angel Gabriel that He has risen. This painting is a work of such powerful austerity and grace that we become conscious of the urgency of its Christian message.

It is not the psychology of the women that interests Duccio (as it would Giotto), but the wonder of the sacred interaction between them at this all-important point in the story of the Passion. The figures in the painting sway toward one another, yet there is never actual contact. We are being shown a world of inwardness that none of us can understand, not even the artist himself. The wonderful self-containment and detachment of Duccio's work is one of his most distinctive qualities.

RECONSTRUCTING THE MAESTA

Duccio's masterpiece was dismantled in 1771, and individual panels can now be seen in a number of cities, including Washington, New York, and London. as well as Siena.

Art historians have made a visual reconstruction of the work by matching the grain of the wood and wormholes. However, because some sections have disappeared we still cannot envisage the exact arrangement of the whole work.

ITALY

During the Gothic period the independent states of the Italian peninsula were generous and competitive patrons of the arts. The political map of Italy changed many times this one dates from 1450. In earlier times, the Papal States had occupied a larger area in the north, and the southern mainland was part of the Kingdom of Naples, which was taken over by Sicily in 1443. The Papal States and the north of Italy were both parts of the Holy Roman Empire.

Contemporary arts

1264

Italian philosopher and theologian Thomas Aquinas begins writing his *Summa Theologica*

1290s

Cavallini (see p.34) creates a series of mosaics in Santa Maria in Trastevere, Rome, and some frescoes in Santa Cecilia in Trastevere, Rome

1296

Building work commences on Florence Cathedral

1307

Dante (see p.47) begins writing his epic poem *The Divine Comedy* He seems to paint from a distance, whereas Giotto (see p.46) wholly identifies with his stories, creating real dramas and involving us as he tells them. Although the stiffly formal composition of the front of the *Maestà* reveals strong ties with the Byzantine tradition, the influence of Northern Europe (which Duccio received secondhand through the sculpture of Nicola and Giovanni Pisano, see p.46) can be seen in the graceful, undulating forms of the figures – an early example of the refined charm that characterizes the whole period of Gothic art.

With Duccio, we see a real change of style, and his influence was greater than Cimabue's. His figures seem to have volume, and their robes relax into fluid, sinuous lines, which also describe the forms beneath. Though the panels on the reverse of the *Maestà* are small, they are painted with an epic sense of scale and a bold simplicity new to Italian painting. The *Maestà* is the only extant work we know to be by Duccio, although not all of it is by his hand. As far as we know, he always worked on a small scale.

JESUS CALLING THE APOSTLES

Another small panel from the predella on the reverse of Duccio's masterpiece, *The Calling of the Apostles Peter and Andrew (54)*, is a luminous and bare image of tremendous power.

Duccio divides the world into three: a great golden heaven, a greeny gold sea, and a rocky shore, where Jesus stands at the picture's edge. At the center are the two brothers Andrew and Peter, stunned by the incursion of the miraculous into their workaday existence. They have fished all night in vain; Jesus shouts to them to cast their net to one side, and they humor the stranger by obeying Him. The net comes up laden with fish, but they hardly seem to look at it. Peter turns questioningly to Jesus while Andrew stands motionless, looking out at us.

The clothes of the two disciples are pale in hue, whereas Jesus, in token of His spiritual profundity, wears blood crimson to symbolize His Passion and purple to indicate His royal status; the gold edging of His robe outlines His figure, dividing it from the golden background.

MARCO POLO

In 1271, Marco Polo, a Venetian merchant, traveled to China with his father and uncle. This French miniature shows the Polos receiving their safe-conduct documents from Kublai Khan, the emperor of the Mongol empire in China. While acting as an ambassador for Kublai Khan, Marco Polo saw lapis-lazuli stone being extracted from quarries in Afghanistan.

being extracted from quarries in Afghanistan. This was to become an important pigment in Italian painting. When Polo returned to Italy in 1295, accounts of his travels provoked a fashion for all things oriental.

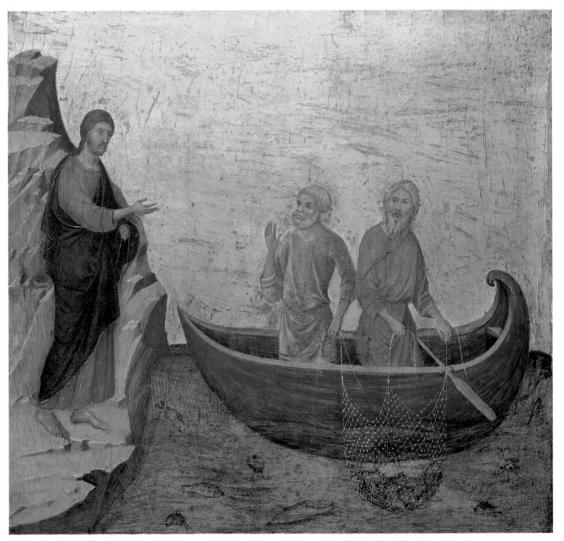

54 Duccio, The Calling of the Apostles Peter and Andrew (from the Maestà), 1308/11, 18 x 17 in (46 x 43 cm)

THE CALLING OF THE APOSTLES PETER AND ANDREW

In this panel from his *Maestà*, Duccio portrays the scene from Christ's life when He summons the two Galilean fishermen, Peter and his brother Andrew, to be His disciples. He is calling them to become "fishers of men" and bring new followers to Christ.

JESUS' CARVED HALO
The halo as a symbol of divinity was originally attributed to the sun gods Apollo, Mithras and Helios, and signified the sun's radiance and power. It first appeared in Christian art in the 4th century. Here, Christ's halo is carved into the wooden panel – a feature of Gothic panel painting, which would also often incorporate precious stones. The patterned surface of the halo attracts and reflects light, thereby intensifying its radiance and distinguishing it from the background.

CHRIST CALLING

Duccio portrays Jesus as a regal, authoritative figure. With His hand outstretched toward the two fishermen Peter and Andrew, He does not exactly invite, but gently commands. He stands barefoot on the rock, a symbol for the Church, and communes with Peter, whose name, meaning "the rock," was chosen by Jesus.

THE APOSTLE ANDREW

Andrew is shown in the moment of the revelation of his faith. While his brother Peter (who, according to the Scriptures, was always the active one) confronts Jesus, Andrew appears to be listening to another, unseen calling. As he pauses in his task of hauling in the nets laden with fish, he stands transfixed, with an expression of slow comprehension dawning on his face.

THE FISHING NET

The net comes up full, and this suggests that the apostolic mission will be richly rewarding. Although clearly suspended in the water, the net is superimposed over the transparent green sea (enlivened by the layer of warm gold beneath). Duccio shows little concern with three-dimensional space – the boat is a kind of wooden "envelope" slicing into the water with just enough depth to accommodate the two fishermen.

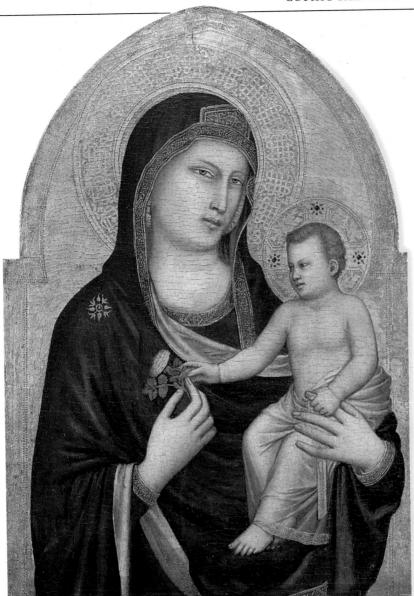

55 Giotto, Madonna and Child, probably c. 1320/30, 24½ x 34 in (62 x 85 cm)

EARLY SCULPTURE

Guido da Como
(active 1240–60) was
a contemporary of the
sculptors Nicola and
Giovanni Pisano. However,
his work belongs to the
earlier, rigidly stylistic
tradition. His figures, such
as these riders and their
horses, lack physical vitality.

GIOTTO

Duccio was a reinterpreter of Byzantine art. His great Florentine contemporary, Giotto (Giotto di Bondone, c. 1267-1337), transformed it. His revolutionary approach to form, and his way of depicting realistic "architectural" space (so that his figures are in scale in relation to his buildings and the surrounding landscape), mark a great leap forward in the story of painting. Gothic painting is widely regarded as reaching its height in Giotto, who so splendidly subsumed and reinvigorated all that had gone before. For the first time, we have in European painting what the historian Michael Levey calls "a great creative personality." The true age of the "personalities," however, was the Renaissance, and it is not without cause that writers on the Renaissance always begin with Giotto. Giantlike, he straddles two periods, being both of his

time and before his time. His dates, however, place him firmly in the time we call Gothic, with its climate of spiritual grace and delight in the freshness of color and the beauty of the visible world. Gothic artists learned to depict a solidity of form, while earlier painters had shown an essentially linear world that was lacking in bulk and thin in substance despite spiritual forcefulness.

INFLUENCES ON GIOTTO

We know that Giotto went to Rome in 1300 and painted a fresco in the Lateran Palace. He understood the innovations of Pietro Cavallini (see p.34), the Roman artist whose strong, beautiful frescoes and mosaics show an amazing grasp of naturalism. Giotto's frescoes did not assimilate the Roman influence from within the Byzantine style, as Cimabue's panel paintings did; they went further, and transcended it. The real world was primary for Giotto. He had a true feeling for natural form, a wonderful sculptural solidity, and an unaffected humanity that changed the course of art.

Equal with Giotto in stature and innovation, and massively important to the way Giotto visualized his world, were Italy's greatest sculptors of the period, Nicola Pisano (d. 1278) and his son Giovanni (c. 1250 until after 1314).

Nicola Pisano came to live in Tuscany, Giotto's native province, in 1250. He was devoted to studying the sculptures of classical Rome, but more importantly, he brought with him a new and vital influence: the Gothic art of Northern Europe. The French court of Anjou, which had established itself in Naples in c. 1260, had brought a new influence to Italian sculpture (see column, p.41). Pisano's own art showed a convincing solidity of form and human individuality (see column, right), far removed from the rather wooden, stylized nature of all other sculpture that existed in Tuscany in his time (see column, left).

If we look at Giotto's paintings in direct relation to Pisano's sculpture, Giotto's pictorial "leap" is partly explained: sculptural form and space have entered the flat space of painting, and the paintings breathe, released once and for all from the rigid and stylized Byzantine tradition.

Giotto's panel paintings are necessarily physically smaller than his frescoes, but in them he seems to transcend size. Even a small *Madonna* and Child (55) has a weight of human significance that makes it seem large. Mary looks out on us with tender dignity, and the Child, kingly in person, sits on her arm as on a throne. Yet we are not kept at a distance: we approach with reverence, but we can identify with the emotion.

GIOTTO'S FRESCOES

The Arena Chapel in Padua is decorated with Giotto's greatest surviving work, a cycle of frescoes painted about 1305–06 showing scenes from the life of the Virgin and from the Passion. The frescoes run all the way around the chapel.

Giotto's Deposition of Christ (56), which is one of the frescoes on the north wall of the Arena Chapel, is the end of the same adventure we see starting in Duccio's Calling of the Apostles (see p.44). Giotto has called all his forces into play in this visualization of one of the great episodes in the story of Christ. In contrast to the towering, remote heights of Duccio's and Cimabue's enthroned Madonnas, Giotto brings the action down to our human eye level, creating a startling truthfulness and transforming the familiar event into a humanly real, intensely moving drama. The great square is vibrant with activity, with saintly mourners, each clearly distinct and intent on a specific action. His Mother, a woman of almost masculine determination (Giotto always

depicts her as tall and stately), clasps the dead body to her, controlled and tragic. Mary Magdalene humbly holds His feet, contemplating through her tears the marks of the nails. St. John makes a wild gesture of despairing grief, flinging back his arms, offering his breast to the terrible reality. The older men, Nicodemus and Joseph of Arimathea, stand to the side, reticent, mournful, while Mary's companions, who supported her at the foot of the cross, wail and lament and shed the tears that she does not. Such a bloodstained earth is no place for the angels, but they swoop and somersault with the roarings of their sorrow.

One lone and leafless tree on the arid hillside behind hints at the horror of the death, yet the darkened blue of the sky has a secret luminosity. Giotto and his contemporaries knew, even if the wildly passionate angels do not, that Christ would rise again. The strange self-possession of the Virgin may spring from this prophetic inner certainty, and it is a measure of Giotto's narrative conviction that we should ponder these

DANTE

Dante Alighieri (1265-1321) is one of Italy's greatest poets. His most famous work, the Divine Comedy, was considered innovative because it was written in Tuscan (the language of the common people) rather than Latin. The allegorical poem was divided into three parts and told the story of the poet's journey through Hell, Purgatory, and Paradise. It is filled with detailed descriptions of real people as well as legendary ones. Giotto, for example, appears in the Purgatorio section. Here, Dante is shown reading from the Divine Comedy.

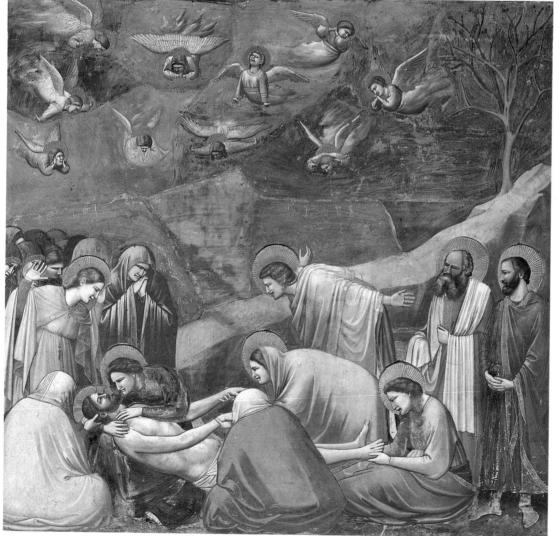

56 Giotto, Deposition of Christ, c. 1304-13, 6 ft 7 in x 7 ft 7 in (200 x 230 cm)

Nicola Pisano's *Allegory* of *Strength* is one of the supporting column figures from the Baptistery pulpit at Pisa, Italy. Completed

in 1260, the pulpit is acknowledged as Pisano's masterpiece. Many of Pisano's sculptures had a strong influence on Giotto.

GIOTTO'S CAMPANILE

Although we now think of Giotto primarily as a painter, he was also a skilled architect and sculptor. In 1334 he was appointed architect of Florence's city walls and fortifications. He also designed a campanile (bell tower) for the cathedral, although when it was built (above), only the lower sections were completed to Giotto's original specifications.

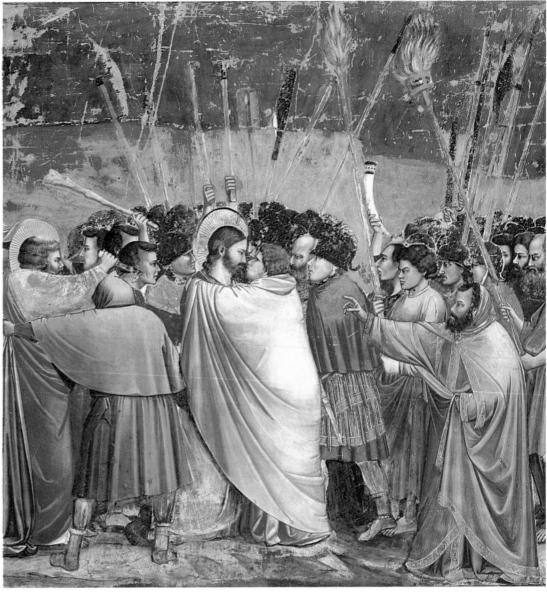

57 Giotto, The Kiss of Judas, c. 1305-06, 6 ft 1 in x 6 ft 7 in (185 x 200 cm)

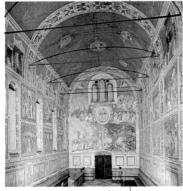

ARENA CHAPEL
The Arena Chapel in Padua
was founded by Enrico
Scrovegni in 1303 to atone
for the sins of his father,
a notorious usurer. The
chapel contains many of
Giotto's finest frescoes,
including The Kiss of Judas.

possibilities. The very color and forms, so clear, solid, and whole, so forthright, reassert this mystic certainty, without any concession to the apparent hopelessness. Six centuries afterward, the great French artist Henri Matisse (see p. 336) was to say that we need not know the Gospel story to catch the meaning of a Giotto painting: it carries its own truth within.

MOMENT OF BETRAYAL

Giotto has a startling power to organize the excitement of a scene around a central image. *The Kiss of Judas (57)*, another fresco from the Arena Chapel, sways and surges, every actor alive and functioning, either for or against Christ. Torches blaze and weapons whirl. But at the heart there is only a tragic stillness,

as Jesus looks into the mock-friendly eyes of His disciple Judas, and truth confronts falsehood with sorrowful love. The betrayer and the betrayed form the solid center, with the jaundiced yellow of Judas's cloak billowing over the figure of Christ as if to swallow Him up. As in all Giotto's work, the heads are of the utmost importance, the natural focal point of the human dramas.

Time and again in the cycle, it is the facial expression, the direction of the eyes, sheer body language that expresses the emotion. Artists working in the Byzantine style had a formula for the head: they painted a three-quarter view, and so the characters looked sideways. The effect of this was to exclude any personal involvement with the viewer or among themselves. But for Giotto, art was all about involvement.

THE KISS OF JUDAS

Judas Iscariot was the apostle who betrayed Jesus to the authorities, and then, unable to live with the consequences of his action, hanged himself. Giotto's painting depicts the moment when Judas identifies Jesus to the high priests and soldiers, with a kiss.

A FROZEN MOMENT

Christ and Judas provide the only still part in this impassioned scene. Christ is an image of constancy, His calm brow and steady eye contrasting with Judas's already troubled, frowning face. Giotto has suspended time, and Jesus' searching gaze silently communicates both foreknowledge that He is being betrayed, and understanding of Judas's heart.

PETER DEFENDS JESUS

All action draws our attention to the main figures of Christ and Judas. The swords and torches either fan out from them, almost as an extended halo, or sway toward them. The gesticulating priest on the right is counterbalanced by the apostle Peter on the left, who, in his anger, has cut off a soldier's ear.

THE ARREST

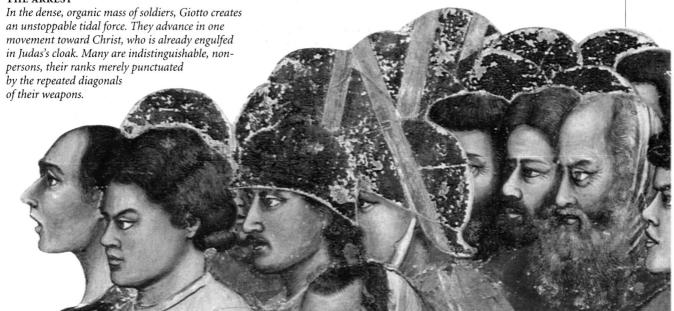

OTHER WORKS BY GIOTTO

Stigmata of St. Francis (Louvre, Paris)

Madonna Enthroned (Uffizi, Florence)

Dormition of the Virgin (Staatliche Museen, Berlin-Dahlem)

John the Baptist Cycle (Peruzzi Chapel, Santa Croce, Florence)

Crucifix (Museo Civico, Padua)

Combining gothic elements

The most quintessential Gothic artist is Simone Martini (c. 1285–1344). Of the Sienese painters, he is the only one who can be said to have rivaled his teacher, the great Duccio. As Simone was, artistically, a direct descendant of Duccio, his art still held links with the Byzantine tradition of remote spirituality. It also acknowledged Giotto's spatial innovations and the elegant Gothic style of Northern Europe (represented by France), which was by then popular in Siena. As early as 1260, the French monarch, Robert of Anjou, brought his court to Naples, and before 1317, Simone was called to the court to paint a commission for the

king. Simone was greatly

influenced by the art

with its characteristic elegance and courtly refinement, which distinguished the French Gothic tradition from the early Italian developments. The influence of Northern Gothic style (see p.60) on Italian art is strongest in Simone's work: his concern with graceful form and with uninterrupted, free-flowing line and pattern; the mannerisms and delicate gestures of his figures; and the "precious" quality and craftsmanship of his paintings reveal him as the definitive artist of the "Gothic-Italian" genre, and an early exponent of the International Gothic style (see p.54).

GOTHIC GRACE

Simone's figures have an extraordinary physical fluidity: whether angelic or human, they sway and sweep across the scene, dazzlingly beautiful, like some magical inhabitants both of our

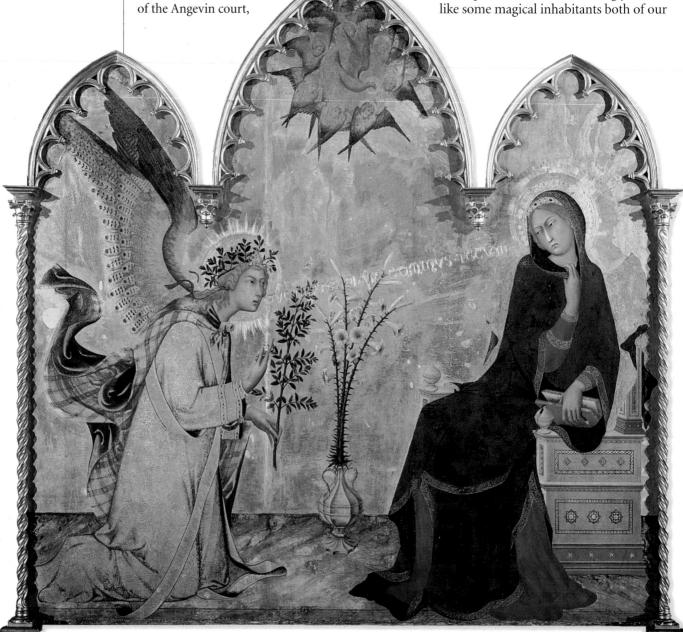

58 Simone Martini, The Angel and the Annunciation, 1333, 10 ft x 8 ft 8 in (305 x 265 cm)

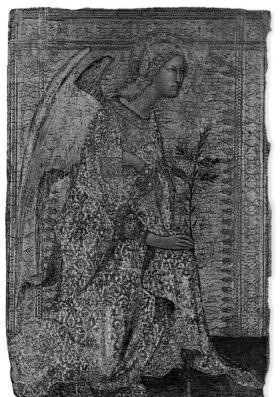

event, is believed to have been a diptych, the right panel of which is now lost. It contained the Virgin, to whom the angel extends an arm, holding an olive branch. The absence of the Virgin is almost a felix culpa (happy mischance) since we are each forced to take her place, entering into the silent drama.

FAMILY CONFLICT

Simone's graciousness and love of beautiful clothes are not superficial. He can combine them with an electric sense of conflict. *Christ Discovered in the Temple (60)* is an extraordinary evocation of the generation gap, as the Child Jesus and His Mother oppose each other with dismaying incomprehension, and St. Joseph tries ineffectually to bridge the gap between them. This is the chilling moment when Jesus reaches that crucial stage in growing up, when we come to realize that even those we love and trust do not understand, and cannot be expected to. We are each alone, each unique, and this can cause problems in even the best of families.

59 Simone Martini, The Angel of the Annunciation, c. 1333, $8\frac{1}{2} \times 12$ in $(22 \times 30.5$ cm)

world and of Heaven; feet are firmly on the earth, yet the whole being breathes the enchantments of another reality. There is no artist quite like Simone, both in the great daring of his color combinations and in the persuasive force with which he invites us to enter the world of his singular imagination. This applies equally to his later, more intensely passionate works. His sense of drama is poignantly clear in The Angel and the Annunciation (58) in the Uffizi Gallery, Florence. In it we see Mary shrinking, almost aghast at the solemnity of being asked to bear God's Son.

But even at this moment of profound spiritual bewilderment, Mary sways with the Gothic grace that is so characteristic of Simone's art. She is all in blue, usually understood to symbolize the heavens. The angel is a dazzle of golden color. The observer is aware of a sacred encounter in which Heaven and earth become one. Mary and the angel lock eyes, each affecting the other. *The Angel of the Annunciation* (59), another version of the same

60 Simone Martini, Christ Discovered in the Temple, 1342, 14×20 in $(35 \times 50$ cm)

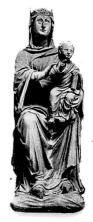

CULT OF THE VIRGIN

When the cathedral at Chartres was rebuilt in the Gothic style after a fire in 1194, it was dedicated to Christ's Mother. This set a trend among new churches and was part of the growing cult of the Virgin. Many Gothic artists also chose the Virgin as their subject, which is reflected in the numerous Annunciation paintings and her prominence in Crucifixion pictures. This sculpture, completed c. 1330, in the Opera del Duomo in Florence, is by Arnolfo di Cambio.

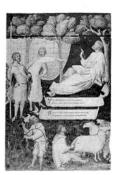

Petrarch

Francesco Petrarca (Petrarch, 1304–74) was an Italian poet, famous for his Canzoniere, a collection of poems inspired by his idealized love for a woman named Laura. He was a friend of Simone Martini, whom he mentions in two of his sonnets. Simone returned the compliment by painting this frontispiece to Petrarch's copy of Maurius Servius Honoratus's Commentary on Virgil.

61 Pietro Lorenzetti, St. Sabinus Before the Governor, c. 1342, 13 x 14³/₄ in (33 x 37.5 cm)

THE LORENZETTI BROTHERS

If Simone is a worthy disciple of Duccio, then his contemporaries, the two Lorenzetti brothers, Pietro (active 1320–48) and Ambrogio (active 1319–48), are stamped with the mark of Giotto, though both are Sienese. They represent Giotto "Duccioed," painting great columnar forms that yet have a tender grace. Their paintings reveal a stronger affinity with Giotto's unique psychological vitality than with the conscious elegance and refined craftsmanship of their own most illustrious contemporary, Simone Martini. Both brothers died suddenly in 1348, probably victims of the terrible European epidemic, the Black Death (see p.58).

There is near-monumentality as well as a great gentleness in Pietro Lorenzetti's panel painting of *St. Sabinus Before the Governor (61)*. Sabinus, one of the four patron saints of Siena, refuses to offer sacrifice to the strange little idol as directed by the Roman Governor of Tuscany. The white-clad figure of the saint, who exudes an air of calm stillness and resolution, commands our attention, while the seated figure of the governor is depicted with his back to the observer. We are aware of spaciousness, both literally and of the mind.

Ambrogio, the younger brother, combines the weighty and the perceptive in his small painting *The Charity of St. Nicholas of Bari (63)*. It depicts the moment in the legend when the saint throws the three golden balls into the bedroom of the daughters of an impoverished aristocrat.

62 Ambrogio Lorenzetti, Allegory of Good Government: Effects of Good Government in the City and the Country, 1338-39, 46 x 8 ft (14 x 2.4 m)

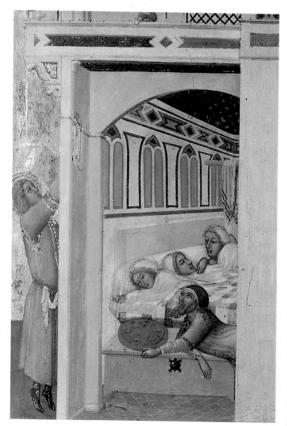

63 Ambrogio Lorenzetti, The Charity of St. Nicholas of Bari, c. 1332, 8 X 11¾ in (20 X 30 cm)

The balls (from which we derive the pawnbroker's sign) will serve as dowries for the girls. Their father looks up, stunned, and the eldest daughter raises an astonished head as well.

PANORAMIC LANDSCAPE

The masterpiece of early landscape painting that is Ambrogio's particular claim to fame is his fresco depicting the *Effects of Good Government in the City and the Country (62)*, commissioned for the interior of the Palazzo Pubblico in Siena. Never did any state have its ideal so superbly set before it. The Lorenzetti vision is of a world blissfully ordered, painted with remarkable naturalism and sharp observation, based on the city of Siena itself. A companion painting, representing the consequences of bad government in the city, is also in the Palazzo Pubblico, but is, unfortunately, badly damaged.

This sort of bird's-eye, panoramic view is so familiar to us today, though more commonly in the form of a photograph, that we may not realize the extraordinarily avant-garde nature of this painting. It is the first attempt to show a real place in a real setting with its real inhabitants, and to make this wholly secular theme appear as jewellike and precious as anything religious. This is not Bethlehem or Nazareth, but the actual worldly city of Siena, with its streets and shops and its patchwork of fields. Parts of the present-day town can even be recognized.

The panorama is painted from a variety of viewpoints and the buildings are not in scale with the figures. It depicts a time of peace, in which commerce, industry and agriculture are all shown to be flourishing, and the inhabitants, who are depicted in a variety of pursuits, are clearly contented.

PALAZZO PUBBLICO
Building work on the
Palazzo Pubblico (town
hall) in Siena began
in 1298. Ambrogio
Lorenzetti's panoramas
of the city were painted
on its interior walls.

Contemporary arts

1322

Consecration of Cologne Cathedral, one of Germany's great Gothic buildings.

1330

Andrea Pisano begins work on the bronze doors of the Florence Baptistery.

1348

Italian poet Boccaccio starts writing *The Decameron*, a collection of 100 short stories told by evacuees from a plague-bound city.

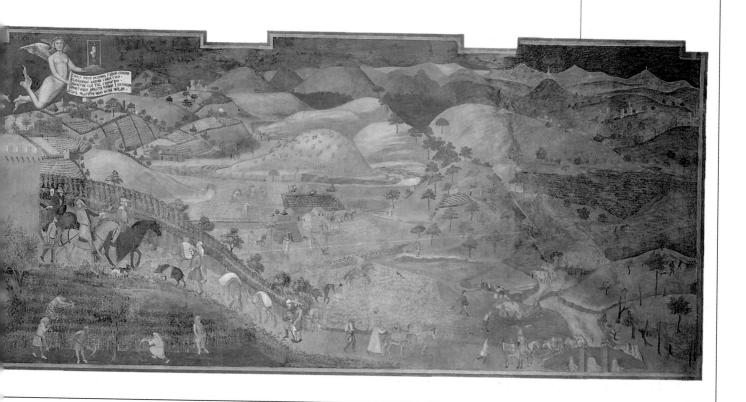

International Gothic Style

By the end of the 14th century, the fusion of Italian and Northern European art had led to the development of an International Gothic style. For the next quarter of a century, leading artists traveled from Italy to France, and vice versa, and all over Europe. As a consequence, ideas spread and merged, until eventually painters in this International Gothic style could be found in France, Italy, England, Germany, Austria, and Bohemia.

FROISSART'S
CHRONICLES
In the mid-14th century

the French cleric Jean Froissart wrote a history of contemporary wars. The chronicle was richly decorated throughout; this illustration shows the Battle of Crécy, which took place in 1346. The battle was one of a series fought by France and England between 1337 and 1453, a period referred to as the Hundred Years' War. By 1360, the English, under Edward III, had captured much of northern France and profited financially while the French suffered. However, gradually the French regained territory and had reconquered

DIPTYCH

most of France by 1453.

Diptychs are paintings in two, normally equal, parts, often linked together with hinges. Most Gothic diptychs depict the praying figure of the owner or donor of the painting in one panel, and the Madonna and Child in the other. The influence of Simone Martini (see p.50) had spread far. He had left Italy in either 1340 or 1341 to work at the papal court, which was then in Avignon, France (see column, right). His extreme pictorial refinement was very much to the court's taste. The International Gothic style had a particularly courtly and aristocratic flavor, infused with a specially Flemish concern for naturalistic detail and, unlike the diverse strands of early Gothic art, it had a distinct and unified character. One classic example of the

truly International style is the Wilton Diptych (64) now kept in the National Gallery, London. This exquisitely delicate, self-consciously monarchial work has proven impossible to attribute, and difficult to date. In fact, it could have been painted at any time during the reign of

Richard II (1377–99) and, even more significantly – attesting to its truly international style – scholars have been unable to agree on the nationality of the artist, only that he could have been English, French, Flemish, or Bohemian. The title of the painting is not original: it was once housed at Wilton House in Wiltshire, England.

The Wilton Diptych depicts Richard II of England kneeling before the Madonna and Child. He is accompanied by two English saints, Edmund (carrying an arrow) and Edward the Confessor (holding a ring); the third figure is John the Baptist. All the angels wear jewels in the form of a white hart, the personal emblem of King Richard. The painting may be intended to emphasize Richard's "divine right" (royal authority) as confirmed by the blessing he receives from the Christ Child. It also contains a clear reference to the Epiphany, with three kings worshiping the infant Jesus.

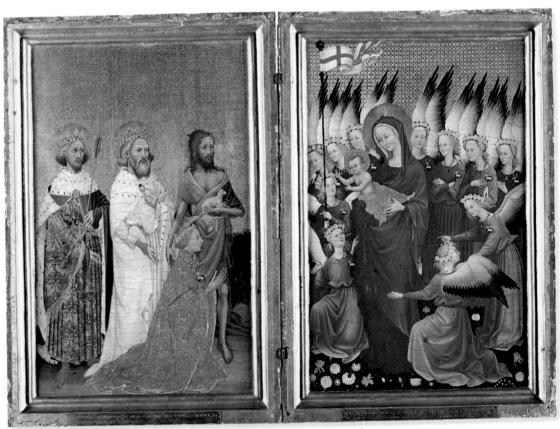

64 Anonymous, The Wilton Diptych, c. 1395, 11½ x 18 in (29 x 46 cm) each panel

65 The Limbourg Brothers, August, from Les Très Riches Heures du Duc de Berry, 1413–16, 8 x 11½ in (20 x 29 cm)

Masters of Illumination

The ancient art of book illumination (see pp.28–33) was still the prevailing form of painting in France at the beginning of the 15th century. It reached new heights, however, in the work of the Limbourg brothers, Pol, Herman, and Jehanequin, exponents of the International Gothic style. They came from Gelderland, a province of the Netherlands, but worked in France. They were the only other Gothic painters to take such orderly joy as that shown by Ambrogio Lorenzetti (see p.52) in the city and its environment, its people, and its rulers. The Limbourg

1416, probably of the plague. The Limbourgs' joint masterpiece, Les Très Riches Heures, was commissioned by the wealthy and extravagant manuscript collector, the Duc de Berry (see column, right).

brothers all died suddenly in

Les Très Riches Heures is one of a genre of 15th-century illustrated prayer books known as "books of hours." The "hours" were prayers to be said at one of seven hours of the day. A book of hours would naturally contain a calendar, and this became the opportunity for a display of the illuminator's talent. Sadly, this particular example was unfinished at the time of the Limbourgs' and the Duc de Berry's deaths.

Each month is marked by an enchanting scene, usually showing appropriate seasonal activities. In August (65) we see courtly lovers riding to hunt with their falcons, while the great white ducal castle gleams in the distance and the peasants swim happily in the winding stream. The blue upper part of the painting shows an astrological hemisphere. With its mixture of courtly refinement and everyday reality, this miniature is representative of many in the book.

The Garden of Eden (66) was painted separately from the rest of Les Très Riches Heures and inserted into it later. It is a great enclosed circle showing the world as it was intended to remain before Adam and Eve's fall from grace. The whole story of the loss of Eden and human self-will is set graphically before us. Adam and Eve are finally ejected from the lush greenery of Eden onto a dangerous rocky shore. The Limbourgs' consciousness of tragedy is no less

> acute for being so chivalric in its manner. For all their elegance, they are as aware as all great artists that pain is our human lot.

66 The Limbourg Brothers, The Garden of Eden from Les Très Riches Heures du Duc de Berry, 1413-16, 8 x 8 in (20 x 20 cm)

MANUSCRIPT ILLUMINATION

This 15th-century illumination shows a lady painting the Virgin and Child. Women of the upper classes were not expected to work, but activities such as illuminating and weaving were acceptable occupations.

DUC DE BERRY

Jean, Duc de Berry, was a younger brother of Charles V of France. He ordered the building of a number of castles and filled each with specially commissioned works of art, including tapestries, paintings, and jewels. He is reputed to have owned 1,500 dogs.

POPE MARTIN V

The election of Pope Martin V in 1417 ended a period of crisis in the Western church known as the Great Schism (1378-1417), during which rival French and Italian popes held office. There were disagreements even before the Schism, and for 67 years (1309-76) the papal court was relocated from Rome to Avignon in France. During

this period, Avignon

became an important

center for artists.

OTHER WORKS BY GENTILE

Madonna with St. Nicholas and St. Catherine (Staatliche Museen, Berlin-Dahlem)

Madonna and Child (Metropolitan Museum of Art, New York)

Coronation of the Virgin (John Paul Getty Museum, Malibu)

Virgin and Child (Orvieto Cathedral)

Annunciation (Pinacoteca Nazionale, Perugia)

Coronation of the Virgin with Saints (Brera, Milan)

GENTILE DA FABRIANO

International Gothic art is also exemplified by the well-traveled and influential Italian artist Gentile da Fabriano (c. 1370–1427), who helped spread the International Gothic style across extensive areas of Italy. He crams every sector of his great panels with romantic activity, delighting, with his affectionate detail, in the sheer variety of a world he does not present too realistically, but just realistically enough to be convincing. It is a novelist's world, rich in human interest and engagingly plotted.

Most of Gentile's works, on which his reputation was made in his own lifetime, have not survived. Of those that are still known today, the most extraordinary is *The* Adoration of the Magi (67).

thousands, or so it seems, throngs the stage, providing constant interest and animation, but without any confusion of the story line. The Magi – the three kings from the East (see also column, p.98) - have come to adore the Christ Child with all their exotic retinue: camels, horses, dogs, dwarfs, and courtiers. But all attention is focused on the tiny figure of Christ, leaning forward from His Mother's clasp to lay a loving hand on the great hulking mass of the old king kneeling before Him.

As in the case of Simone Martini's Angel of the Annunciation (58), the elaborate and sumptuously decorated, vaulted Gothic frame is an integral part of the work and has direct bearing on the compositional structure. The Adoration was commissioned by Palla Strozzi, the richest man in Florence, for the church of Santa Trinità.

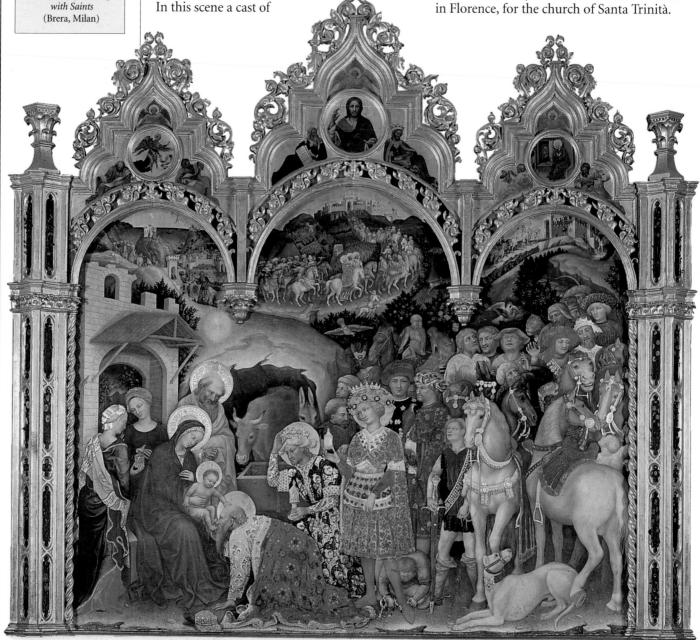

67 Gentile da Fabriano, The Adoration of the Magi, finished 1423, 9 ft 4 in x 9 ft 10 in (285 x 300 cm)

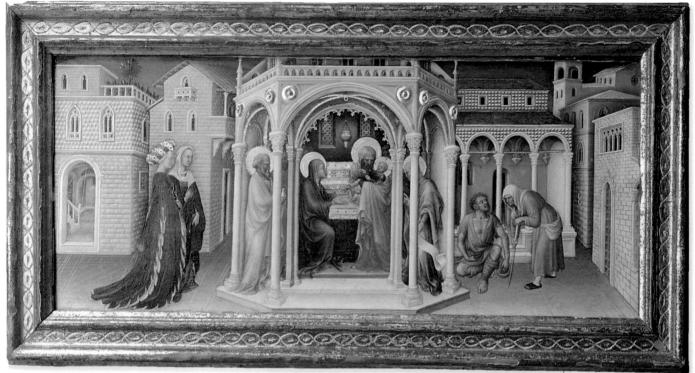

68 Gentile da Fabriano, The Presentation of the Child in the Temple, 1423, 26 x 10 in (65 x 25 cm)

The strong anecdotal feeling in Gentile da Fabriano's work is also clear in *The Presentation of the Child in the Temple (68)*. The sacred event is the central feature of the painting, but on either side life goes on, with two stately women gossiping and beggars seeking alms.

PAINTER AND MEDALIST

This same lucidity of Gentile's is also seen in his fellow Italian artist Antonio Pisanello (c. 1395–1455/6). For decades it was thought that almost all of his frescoes had perished. Happily, a number have recently been uncovered in Mantua.

His panel painting *The Virgin and Child with Saints George and Anthony Abbot (69)* shows an extraordinary confrontation. The almost savage rusticity of St. Anthony the Hermit, in his rust-colored cloak, is contrasted with the urban sophistication of St. George, attired with the utmost modishness from large white hat to elaborately spurred bootlets. (St. George has no halo, but this is more than compensated for by his hat.)

Yet, despite the bizarre fascination of these two saintly figures, never for a single moment does Pisanello let us forget the importance of the Virgin and Child. They hang in the air, enclosed in what seems to be the circle of the sun, and it is they who integrate and give meaning to the scene.

69 Antonio Pisanello, The Virgin and Child with Saints George and Anthony Abbot, mid-15th century, $11\frac{1}{2} \times 18\frac{1}{2}$ in $(29 \times 47 \text{ cm})$

of Gentile [da Fabriano] used to say that his hand in painting corresponded to his name. 22

Giorgio Vasari, Lives of the Painters, 1568

PISANELLO MEDAL
Pisanello was as famous for
his portrait medals as he
was for his paintings. The
medals carried a likeness of
the patron on one side and
an allegory or landscape on
the reverse. This example,
produced c. 1445, shows
the Duke of Rimini.

MASTER OF THE ROHAN HOURS

Although the identity of the creator of the Rohan Hours (active 1410-25) is unknown, he is thought to have been responsible for a number of French miniatures and panel paintings. The majority of the manuscripts illustrated in his workshop were Books of Hours. The Rohan Hours was so called because it belonged to the Rohan family during the 15th century.

THE BLACK DEATH

In 1347, the plague, known as the Black Death, spread down the trade routes from China. By 1348, it had taken hold in most of Europe. The key symptoms were glandular swellings and black boils, leading to a swift but painful death.

In some towns, the population was reduced by 40 percent; whole villages were wiped out. The severity of the epidemic led to heightened religious fervor and an obsession with death. This illustration shows the Angel of Death indiscriminately destroying all classes of people, as did the Black Death.

70 The Master of the Rohan Hours, The Dead Man Before His Judge, c. 1418-25, $7\frac{1}{2} \times 10\frac{1}{2}$ in $(19 \times 27 \text{ cm})$

THE BLACK DEATH AND THE ARTS

Some Gothic art clearly shows the impact of the great medieval disaster: the Black Death. This epidemic, now though to be of bubonic and pneumonic plague, devastated Europe from 1347 to 1351, claiming almost a third of the population. Many contemporaries viewed the Black Death as a judgment from God on the corruption of His people. This provoked a wave of popular enthusiasm, not, unfortunately, for religion itself, but for the "comfort religion" that excessive penances, like flagellation, provide. Artists, such as the Master of the Rohan Hours, reflected their interest in death and judgment in their work. The terrible realism of the miniature illumination *The Dead Man Before* His Judge (70), for example, presents a striking contrast with the Limbourgs' miniatures (see p.55). Here, the unknown artist shows his unflinching consciousness of the meaning and inevitability of death. The painting, despite its archaic perspective and spatial ambiguities, is

extremely impressive. The horror of such death is intensified by the way the pock-marked and rotting corpse fills the page, seeming near to us, and striking even the most casual of viewers with a sense of holy dread.

The dead man's last prayer is written in Latin on a white scroll: "Into Thy hands I commend my spirit; thou hast redeemed me, O Lord, the God of truth."

God holds a globe and a sword as symbols of His power as both creator and Supreme Judge. In response to the dead man's prayers, He replies in French: "For your sins you shall do penance. On judgment day you shall be with Me."

The small figures at the top left of the miniature depict St. Michael, aided by his army of inconspicuous angels, attacking a devil who is attempting to take possession of the dead man's soul, represented by an adolescent nude.

SIENESE ASSURANCE

Other examples of contemporary art in the International Gothic style seem to be unaffected by the terror of the Black Death. Indeed, there seems to be a happy inner security in many of the Gothic painters that

is infinitely poignant. It may have a fouch of the fairy tale about it, as it does in the delightful Sienese master Sassetta (Stefano di Giovanni, 1392–1450), whose panel painting *The Meeting of St. Anthony and St. Paul (71)* shows the enduring influence of French illuminated manuscripts. The two hermits meet in a "Red Riding Hood" sort of forest, and embrace as simply as children, affirming their love.

The panel is one of a series telling the story of St. Anthony Abbot, said to be the founder of monasticism. At the top, we see St. Anthony, who at the age of 90 abandoned his hermit life after having a vision, setting out to visit St. Paul the Hermit, who was by then 113. On his journey he encounters a centaur (half man and half horse), a symbol of paganism. St. Anthony blesses him and converts him to Christianity.

The foreground of the picture shows the story's conclusion as the two saints exchange fond greetings, their staffs lying on the ground beside them (St. Anthony's staff is always shown as a T-shaped crutch) as they lean forward onto each other.

For almost all of Sassetta's life, the Sienese people lived peacefully (apart from a short period in the 1430s) under a republican government. This meant that they could enjoy a fertile relationship with their rival, the bigger and more powerful neighboring city of Florence.

Sassetta was the most important Sienese artist of the 15th century. His art was steeped in the Sienese Gothic tradition, but he happily absorbed influences from the great, innovative Florentine artists of the day, such as Masaccio (see p.82) and the sculptor Donatello (see p.83).

71 Sassetta, The Meeting of St. Anthony and St. Paul, c. 1440, 14 x 19 in (35 x 48 cm)

CHAUCER

By 1500, the language of the English court had changed from French to English. The change to the use of English is seen much earlier in the writings of Geoffrey Chaucer. Born in 1343 to a wealthy London family, he became one of King Edward III's attendants, a position that enabled him to travel and earn enough money to write. His most famous work, The Canterbury Tales, describes a wonderful cross-section of 14thcentury society, while for the first time using a poetic language that could be understood by everybody in the country.

OTHER WORKS BY SASSETTA

St. Thomas Aquinas Before a Crucifix (Vatican Museum, Rome)

St. Francis Renounces His Earthly Father (National Gallery, London)

The Mystic Marriage of St. Francis (Musée Condé, Chantilly)

The Journey of the Magi (Metropolitan Museum of Art, New York)

The Burning of Jan Geus
(National Gallery of Victoria, Melbourne)
The Betrayal of Christ
(Detroit Institute

of Arts)

THE NETHERLANDS In the 15th century, the area shown above (with modern boundaries) was known either as the Low Countries or the Netherlands. Flanders (shaded) was the center of artistic activity. Netherlandish and Flemish were used interchangeably, although the latter refers to the smaller area of Flanders.

Innovation in the North

In the 15th century the International Gothic style developed in two directions. Both could be called revolutions. One was in the South, in Florence, and was the birth of the Italian Renaissance (see p.82). The other took place in the North, in the Low Countries, where painting went through an independent but equally radical transformation: this was the beginning of the Northern Renaissance movement (see p.148).

The new form of painting that appeared in the Netherlands at the beginning of the 15th century was distinguished by a depth of pictorial reality that had not been seen before. It rejected the seductive elegance and overtly decorative elements of the International Gothic style, and whereas before, in the sacred painting of the 14th century, there was a sense of the viewer being offered glimpses of Heaven – of putting

an insignificant foot in the door, so to speak — the Flemish painters brought the sacred down to our real world. Instead of depicting a form of high drama for which the world served as a kind of grand stage, artists chose to portray real-life domestic interiors — living rooms and bedrooms that revealed the commonplace belongings of everyday human existence. We find a growing peace with the world and one's place in it in

the work of the Northern painters. Robert Campin (active 1406–44), one of the earliest great Northern innovators and the teacher of van der Weyden (see p.67), is now believed to be the artist known as the Master of Flémalle. (This name is derived from a group of panel paintings that were thought to have originated in an abbey at Flémalle-lez-Liège.) In fact, Campin lived and worked in Tournai (both these places were in Flanders).

The sacred in the everyday

In his *Nativity* (72), Campin presents an intense abundance, a world crowded with individuals and the unromantic realities of being alive. He portrays a puny newborn Christ, a sullen midwife, coarse shepherds, and a cow in its rickety stable, yet everything is solid, lovely, true, and despite its realism, all is pervaded by a deep though unself-conscious faith.

Even more striking is Campin's *Virgin and Child Before a Firescreen* (73), where simple domesticity is emphasized by the wickerwork firescreen that provides the Virgin's halo. By tradition, International Gothic style indicated holiness with a golden circle.

The painting's upper left-hand corner contains a view of a town seen through the open window. Little landscapes like this were

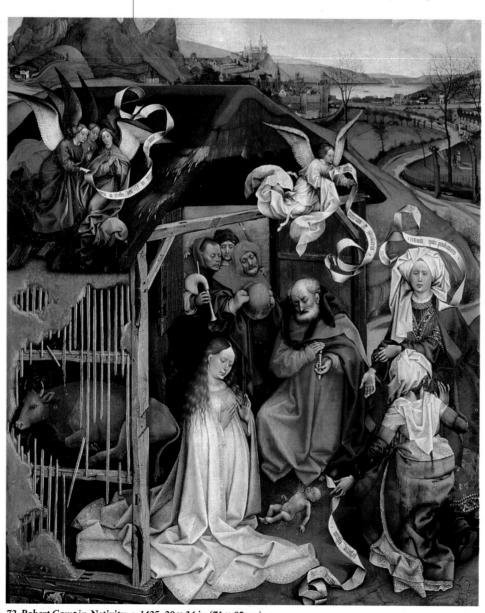

72 Robert Campin, Nativity, c. 1425, 28 x 34 in (71 x 85 cm)

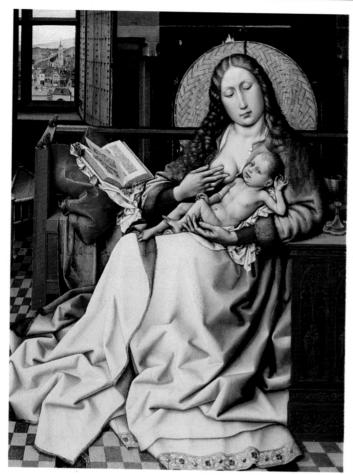

73 Robert Campin, The Virgin and Child Before a Firescreen, c. 1430, $19\frac{1}{2} \times 25$ in $(49 \times 63$ cm)

often seen in Netherlandish painting, and the idea of encapsulating the world through a window was later attractive to Italian artists.

Spirituality and reality are now brought together, and the setting is Campin's own world: the bourgeois interior. Once we have an alliance of the sacred and the commonplace, it becomes possible for representational painting in all its specificity to express the sacred. The close attention given to ordinary objects – each awarded absolute clarity – invested them with a quality of silent, mystical significance. There is an aura of mystery here as the seemingly ordinary becomes startling and powerfully present, and this is fully applicable to portraiture.

Up to this time, portraiture as we understand it today had not existed since antiquity. Paintings that resembled "portraits" had served specific functions, such as recording an event. Robert Campin was the first to look at people with a new artistic eye, bringing out the psychological individuality of the subject. His *Portrait of a Woman (74)*, with its animated face peering out from a plain white headdress, shows his mastery of light effects. His focus is sharp, forcing us to look at what he paints.

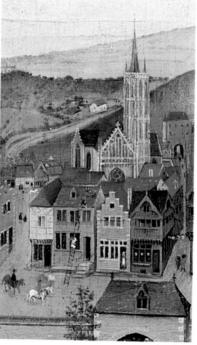

GLIMPSE OF A TOWNSCAPE
This detail from Virgin and Child Before
a Firescreen shows a miniature landscape
glimpsed through the open window.
Campin depicts a busy town dominated
by a Gothic-style church. The gabled
buildings are typical of contemporary
Netherlandish architecture.

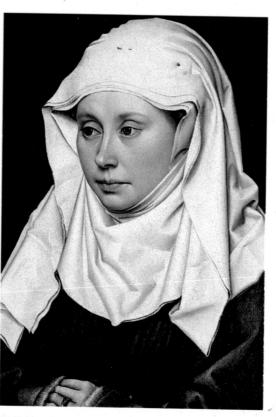

74 Robert Campin, Portrait of a Woman, c. 1420–30, 11 x 16 in (28 x 40 cm)

MASTER OF...

The term "Master of." as in the "Master of Flémalle," is used by art historians to identify an anonymous artist or one whose identity was doubtful at one time. Sometimes the full title describes the vicinity where the artist worked, while in other cases it refers to some aspect of the artist's work, describing style or content. It does not imply any value judgment of the work.

CHIVALRY Many medieval paintings illustrated chivalry, which was part of the contemporary concept of knighthood. Gradually the basic forms of chivalry, with an emphasis on valor, honor, courtesy, loyalty, and chastity, gave way to the courtly love inspired by Arthurian romances. This was a movement toward the idea of unfulfilled desire - love as a religion in itself. On this painted Flemish shield, a lady stands before a kneeling knight who vows to honor her or die.

Symbols in religious painting

A number of symbolic images appear frequently in religious paintings of this period. A small sampling could include:

Apple - sin, and the fall of man Apple held by Christ - salvation Boar - lust Coins - vanity Dove - Holy Spirit Fountain - eternal life Grapes - Blood of Christ Lily - purity, especially used for Virgin Mary Lion - Resurrection Pelican - Christ's Passion (the pelican was thought to shed its blood for its young) Olive branch - peace

75 Follower of Robert Campin, Madonna and Child with Saints in an Enclosed Garden, c. 1440/60, 58½ x 47 in (150 x 120 cm)

The portrait is a good example of the new style of painting in the Netherlands. Portraits began to reveal less of a family look and more of the individuality of the sitter. Campin introduced a new facial type that continued in van der Weyden (see p.67).

In Madonna and Child with Saints in an Enclosed Garden (75), a follower of Campin attains the same comforting assurance that

Campin showed in his *Nativity* (see p.60). The enclosed garden in which Mother and Child are shown with a group of saints is the Garden of Paradise – a "managed" Paradise. A walled or fenced garden is a traditional symbol of the virginity of Mary.

A NEW REALISM

This inner certainty reaches its peak in Jan van Eyck (1385–1441), a contemporary of Campin and one of the enduring influences on his century. He had an eye almost miraculously responsive to every detail of his world, not just in that he saw it, but that he understood

its value. Van Eyck's natural habitat was one of luminous clarity; he saw the most ordinary things with a wonderful sharpness and a great sense of their awesome beauty. We know little about him personally, but he is the most overwhelming of painters in the convictions he enables us to share.

Like the 17th-century Dutch painter Vermeer (see p.208), van Eyck takes us into the light, and makes us feel that we too belong there. Van Eyck's meticulously detailed *Adoration of the Lamb* (76) is part of a huge altarpiece; painted

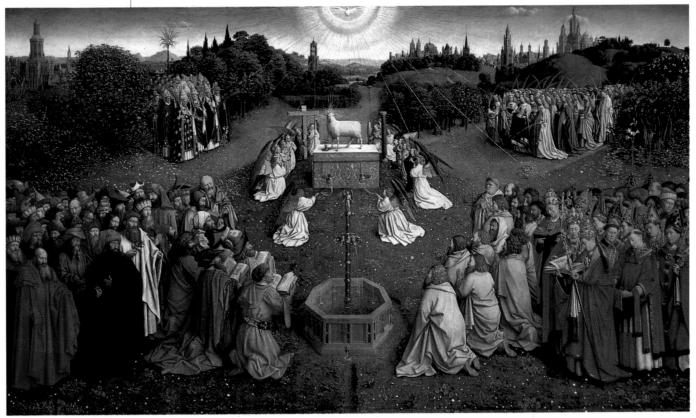

76 Van Eyck, Adoration of the Lamb (detail), completed 1432, 93 x 53 in (235 x 135 cm)

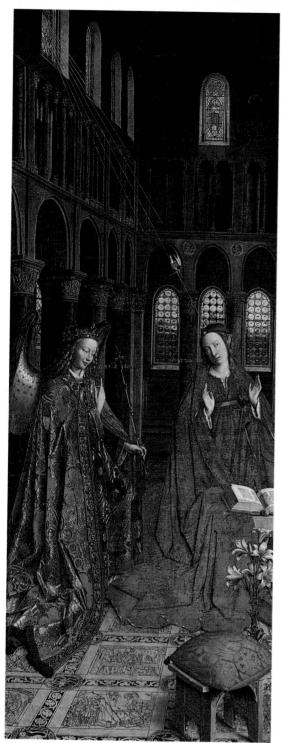

77 Jan van Eyck, Annunciation, c. 1434/36, 14½ x 37 in (37 x 95 cm)

on both sides, it is the largest and most complex altarpiece produced in the Netherlands in the 15th century. This monumental work still hangs in its original setting, the Cathedral of St. Bavo in Ghent, drawing the worshiper deeper and deeper into the sacred world it makes visible. There has been much debate over the parts the two van Eyck brothers, Jan and Hubert, played in the creation of the *Ghent Altarpiece*: whether

Jan, about whom we have the most information, was mostly responsible, or whether it was Hubert, about whom we know almost nothing. For what it is worth, Hubert is given precedence in the inscription. It reads: "The painter Hubrecht Eyck, than whom none was greater, began this work, which his brother Jan, who was second to him in art, completed at the behest of Jodoc Vijdt..."

This panel shows the sacrificial Lamb on the high altar, its sacred blood pouring into a chalice. Angels surround the altar, carrying reminders of the Crucifixion, and in the foreground gushes the fountain of life. Coming from the four corners of the earth are the worshipers, a diverse collection that includes prophets, martyrs, popes, virgins, pilgrims, knights, and hermits. It is likely, as with many great religious works of the time, that van Eyck would have been advised by a theologian, and these figures seem to represent the hierarchy of the Church. Set in a beautiful, lush landscape, the holy city gleams on the horizon, its outline very much that of a Dutch city; the church on the right is probably Utrecht Cathedral. This is a detail from the vast altarpiece, but its very perfection and accuracy, its convincingness, explain why this mystic vision has taken such a hold on the affections of those who see it. The Ghent Altarpiece envelops the viewer in a mood of contemplation, but any more rigorous analysis becomes a massive intellectual effort. We can move more easily into a smaller painting, such as his long, slender Annunciation (77).

Symbolic light in van eyck

As we look at the *Annunciation*, we become warmly conscious of the gentle radiance of the light, illuminating everything it embraces, from the dim upper roofing to the glancing gleam of the angel's jewels. The clarity would be too intense were it not also soft, an integrating, enveloping presence. This diffused presence, impartial in its luminescence, is also a spiritual light, surrogate of God Himself, who loves all that He has made.

The symbolism goes even deeper: the upper church is dark, and the solitary window depicts God the Father. Below though, wholly translucent, are three bright windows that remind us of the Trinity, and of how Christ is the light of the world. This holy light comes in all directions, most obviously streaming down toward the Virgin as the Holy Spirit comes to overshadow her: from this sacred shadow will arise divine brightness. Her robes swell out as if in anticipation, and she answers the angelic salutation "Ave Gratia Plena" ("Hail, full of

Annunciation Paintings

Van Eyck was only one of many artists to paint an annunciation scene, and the subject was popular throughout the Renaissance. The paintings depict the moment described in St. Luke's Gospel when the angel Gabriel announces to the Virgin that she will bear a son, and that he is to be named Jesus. Van Eyck's version, in which the encounter takes place in an ecclesiastical interior, is typical of northern paintings: Italian Renaissance painters often set the scene in an exterior. Many works include a dove, often shown in a ray of light that slants down onto Mary, representing the Holy Spirit descending to her.

MUSIC

During the Gothic period, a number of developments in music took place, including improvements in musical notation and the appearance of the first printed music (c. 1465). New instruments evolved in the 15th century in the form of spinets and virginals. This painting was one of the outer images on van Eyck's Ghent Altarpiece.

COPIED ELEMENTS
In this book illustration
(attributed to a later
Flemish painter),
elements derived from
"The Arnolfini Marriage"
include the inscription,
mirror, beads, and brush.

grace") with a humble "Ecce Ancilla Domini" ("Behold the handmaid of the Lord"). But with charming literalness, van Eyck writes her words reversed and inverted, so that the Holy Spirit can read them. The angel is all joy, all smiles, all brightness: the Virgin is pensive, amazed, unbejeweled. She knows, as the angel apparently does not, what will be the cost of her surrender to God. Her heart

will be pierced with grief when her Child is crucified, and we notice that she holds up her hands in the symbolic gesture of devotion, but also as if in unconscious anticipation of a piercing.

The angel advances over the tiles of a church, where we can make out David slaying Goliath. (Goliath represents the power – ultimately fruitless – of the Devil.) The message the angel gives Mary sets her forth on her own road to the giant-slaying that is her motherhood and holiness.

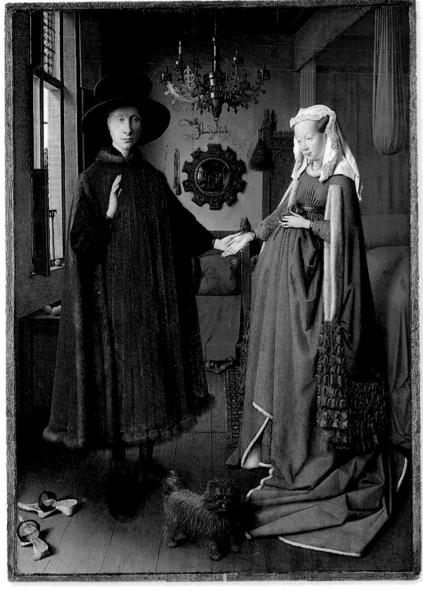

78 Jan van Eyck, "The Arnolfini Marriage," 1434, 231/2 x 321/4 in (60 x 83 cm)

OIL: A NEW PAINTING MEDIUM

The van Eycks started their careers as manuscript illuminators. The often miniature detail and exquisite rendering found in van Eyck paintings, including the *Annunciation*, reveal a strong affinity with this art form. However, the single factor that most distinguishes the van Eycks from the art of manuscript illumination was the medium they used.

For many years Jan van Eyck was wrongly credited with the "discovery of painting in oil." In fact, oil painting was already in existence, used to paint sculptures and to glaze over tempera paintings. The van Eycks' real achievement was the development – after much experimentation – of a stable varnish that would dry at a consistent rate. This was created with linseed and nut oils and mixed with resins.

The breakthrough came when Jan or Hubert mixed the oil into the actual paints they were using, instead of the egg medium that constituted tempera paint. The result was brilliance, translucence, and intensity of color as the pigment was suspended in a layer of oil that also trapped light. The flat, dull surface of tempera was transformed into a jewellike medium, at once perfectly suited to the representation of precious metals and gems and, more significantly, to the vivid, convincing depiction of natural light.

Van Eyck's inspired observations of light and its effects, executed with technical virtuosity through this new, transparent medium, enabled him to create a brilliant and lucid kind of reality. The invention of this technique transformed the appearance of painting.

A MARRIAGE PORTRAIT

"The Arnolfini Marriage" (78) is a name that has been given to this untitled double portrait by Jan van Eyck, now in the National Gallery, London. It is one of the greatest celebrations of human mutuality. Like Rembrandt's "Jewish Bride" (see p.204, another picture that had no known title of its maker's giving), this painting reveals to us the inner meaning of a true marriage.

The bed, the single burning candle, the solemn moment of joining as the young groom is about to place his raised hand in his betrothed's, the fruit, the faithful little dog, the rosary, the unshod feet (since this is the ground of a holy union), and even the respectful space between Giovanni Arnolfini and his wife, Giovanna Cenami, are all united in the mirror's reflection. All these details exalt us and at the same time make us aware of the human potential for goodness and fulfillment.

"THE ARNOLFINI MARRIAGE"

This title has traditionally been given to this painting because it was thought to be a form of "marriage certificate" for Giovanni Arnolfini and Giovanna Cenami, who married in Bruges in 1434. He was an Italian merchant, she the daughter of an Italian merchant. Their grave, youthful faces both have a lovely responsibility that is typical of van Eyck.

SYMBOLIC CANDLE

The solitary flame burning in bright daylight can be interpreted as the bridal candle, or God's all-seeing eye, or simply as a devotional candle. Another symbol is St. Margaret (the patron saint of women in childbirth), whose image is carved on the high chairback.

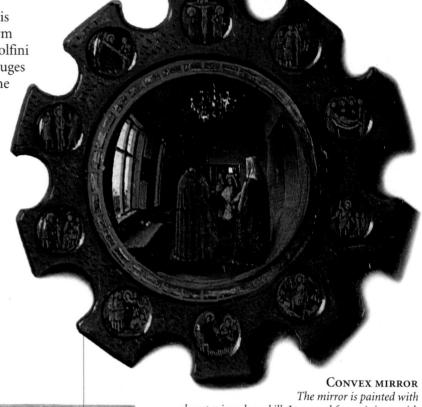

The mirror is painted with almost miraculous skill. Its carved frame is inset with ten miniature medallions depicting scenes from the

life of Christ. Yet more remarkable is the mirror's reflection, which includes van Eyck's own tiny self-portrait, accompanied by another man who may have been the official witness to the ceremony.

AN ELABORATE SIGNATURE

As today, marriages in 15th-century Flanders could take place privately rather than in church. Van Eyck's Latin signature, in the Gothic calligraphy used for legal documents, reads "Jan van Eyck was present," and has been interpreted by some as an indication that the artist himself served as a witness.

SYMBOL OF FAITHFULNESS

Almost every detail can be interpreted as a symbol. The companion dog is seen as a symbol of faithfulness and love. The fruits on the window ledge probably stand for fertility and our fall from paradise. Even the discarded shoes are not thought to be incidental, but to signify the sanctity of marriage.

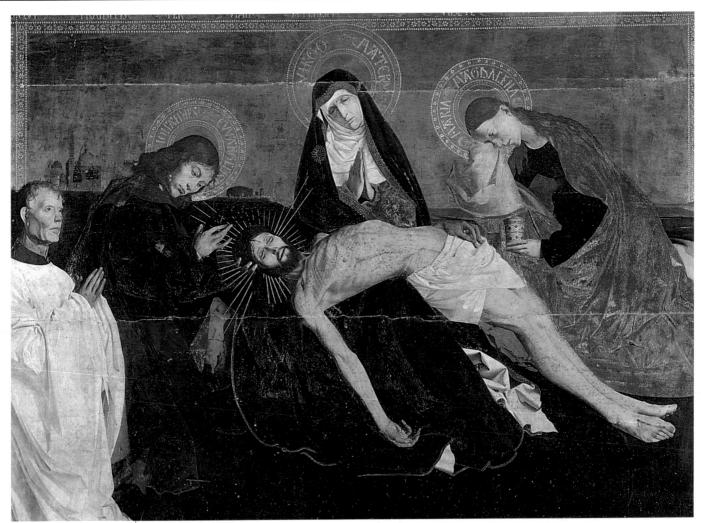

79 Master of the Avignon Pietà, Pietà, c. 1470, 7 ft 1 in x 5 ft 3 in (215 x 160 cm)

TAPESTRIES

During the 15th century, Arras and Tournai, in Flanders, were important centers for the profitable tapestry industry. The Devonshire Hunting Tapestries were woven on the looms of Tournai between 1425 and 1430. Their subject matter appears to be related to the marriage of Henry VI of England to Margaret, the daughter of King René of Anjou.

THE SPREAD OF NATURALISM

The new realism of the Netherlands had begun to spread in the first quarter of the 15th century, and by the 1450s its influence was widespread throughout northern Europe and as far as Spain and the Baltic. The Pietà (79), painted by an unknown artist in Avignon, France, retains the flat golden background of early Gothic and Byzantine painting, but we hardly notice. Our attention is completely absorbed by this passionate meditation on the death of Christ. It takes place in no earthly location, only in the heart of the praying and kneeling donor on the left. For sheer impact, this wonderful and terrible painting is unsurpassed until we meet the Passion scenes of Bosch (see p.72). We can see that the Gothic era was a freely emotional period, one that accepted tears as a natural expression of humanity's frail vulnerability.

The strangely named Petrus Christus (1410–72/3) is another Fleming with a mysterious sense of emotional truth. He was a follower of van Eyck (who was possibly his teacher) and many of his works reveal his debt to the older Fleming.

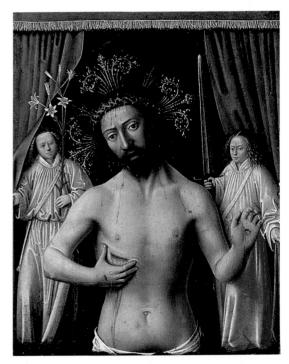

80 Petrus Christus, The Man of Sorrows, c. 1444-72/3, 33/8 X 41/2 in (8.5 X 11.5 cm)

To van Eyck's influence was added that of Antonello da Messina (see p.111), whose art Petrus Christus certainly knew. This led Christus to somewhat "Italianize" van Eyck's style. The tiny picture *Man of Sorrows (80)* in Birmingham, England, shows the crucified Jesus wearing His crown of thorns and displaying three of His wounds. He is flanked by two angels, one of whom holds a lily and the other a sword, symbolizing innocence and guilt. This is the Last Judgment, at which every man must face his judge: it captures the attention of the viewer, making it impossible to avoid the reality of the Passion and, ultimately, its significance for us.

THE INFLUENTIAL VAN DER WEYDEN

Rogier van der Weyden (1399/1400–64) is another giant of the Northern Renaissance movement. He was a pupil of van Eyck and Campin, and became the most influential Northern artist of the first half of the 15th century. Though he began his career relatively late (in his late twenties), he was very successful and had a large workshop with many assistants. The success of his art at the court of Philip the Good, Duke of Burgundy (see right), ensured the popularity of his style. His paintings were exported to other parts of Europe, reaching Castille, Spain, in 1445 and Ferrara, Italy, in 1449, and his fame became widespread.

Van der Weyden was a master of expressing human emotion; he moves us in a way that van Eyck cannot. Perhaps the best example of this is his *Deposition (81)*. It is of its nature an emotional subject; the handling of any dead body is a disturbing experience, let alone that of a young man executed in the full flower of his beauty, and this young man is, of course, Christ. But no artist has ever imbued this scene with more majestic pathos than van der Weyden. Like a great sculptured frieze, the holy mourners spread across the surface of the painting. Christ and His mother echo the same position: He falls from the cross physically dead; she falls to the ground emotionally dead.

Van der Weyden explores all the degrees and kinds of grief, from the controlled and grave anguish of St. John on the left, prominent in pink, to the anguished abandon of Mary Magdalene on the right, a striking color composition of red, palest yellow, and purple.

The extravagance of the emotion never escapes the artist's control. All remains firmly believable, and we are swept into an experience that is at once beautiful and terrible.

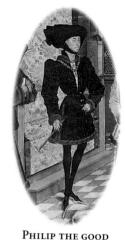

The Duke of Burgundy, Philip the Good (1396-1467), was a brother of the Duc de Berry (see p.55) and another great patron of the arts. As Duke of Burgundy he was also the Count of Flanders. In 1425, he employed van Eyck as his official court painter and equerry. Later, van der Weyden, too, received the patronage of the Duke's court. Philip is said to have prided himself on his appearance – here he wears the popular fashion of the period.

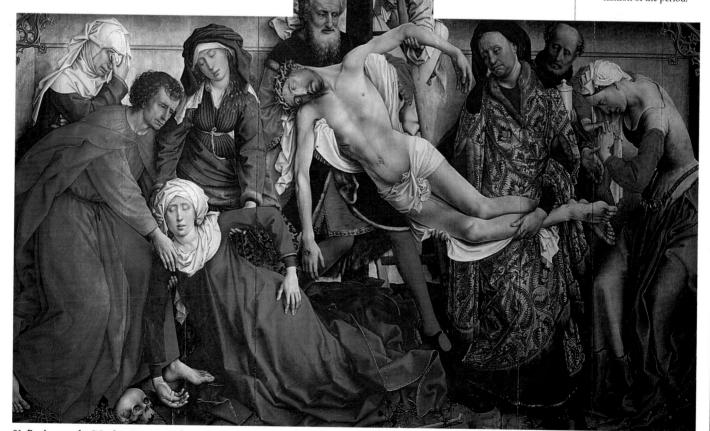

81 Rogier van der Weyden, Deposition (The Descent from the Cross), c. 1435, 8 ft 6 in x 7 ft 3 in (260 x 220 cm)

OTHER WORKS BY VAN DER WEYDEN

The Sforza Triptych (Musée des Beaux Arts, Brussels)

Lamentation for Christ at His Entombment (Uffizi, Florence)

Francesco d'Este (Metropolitan Museum of Art, New York)

Portrait of Jean de Gros (Art Institute of Chicago)

GUILDS

In medieval Europe, most tradespeople and artisans, including painters, belonged to a guild. These men (above) would have been members of the glassblowers' guild. Guilds served to keep a particular craft profitable, protect standards, and provide social benefits. They were a vital part of city life, and members were often represented on town councils. Some of the large guilds, representing several crafts, were split into confraternities, each with a patron saint.

OTHER WORKS BY VAN DER GOES

The Adoration of the Kings (Staatliche Museen, Berlin-Dahlem)

The Fall of Man (Kunsthistorisches Museum, Vienna)

Death of the Virgin (State Museum, Bruges)

Donor with Saint John the Baptist (Walters Art Gallery, Baltimore)

POWERFUL PORTRAITURE

The compositional structure of the *Deposition*, with its shallow space and cropped shape, deliberately excludes any distracting background, thereby concentrating all attention on the dramatic scene. A similar effect is achieved in another van der Weyden painting, his *Portrait*

of a Lady (82). Here, the stark background focuses all our attention on the sitter. The subject has a haunting quality, a sense of almost painful reserve, as if she was willing to give the artist only her exterior. Yet he has circumvented her resistance and brought us into contact with the emotional character of the woman.

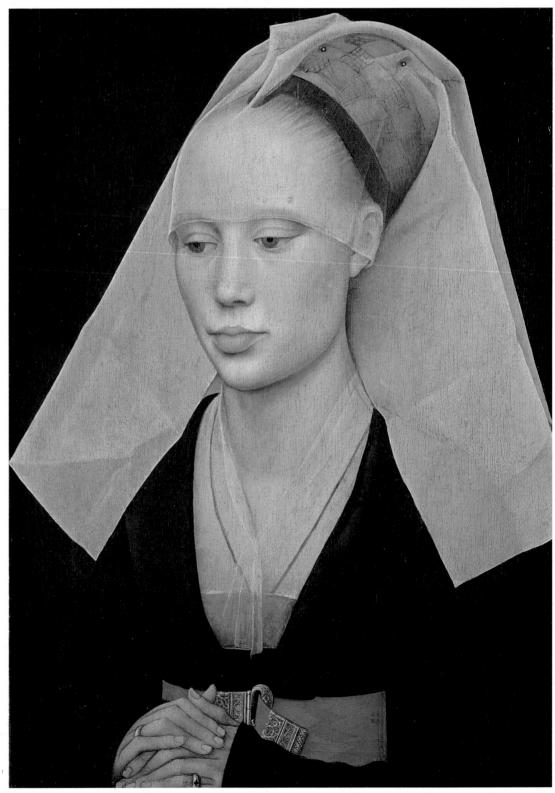

82 Rogier van der Weyden, Portrait of a Lady, c. 1460, 103/4 x 141/2 in (27 x 37 cm)

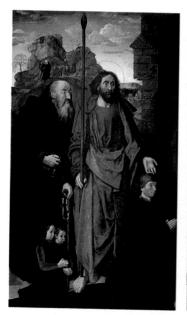

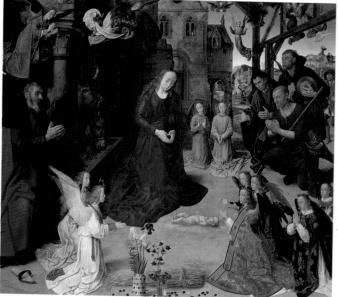

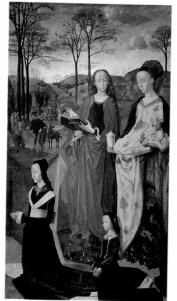

83 Hugo van der Goes, The Portinari Altarpiece, c. 1476, 55 x 100 in (140 x 254 cm) each wing, 10 ft x 8 ft 4 in (305 x 254 cm) central panel

Her unadorned clothing and downcast gaze suggest modesty. To the modern observer she has an exceptionally high forehead; in fact, this was the fashion, achieved by plucking the hairline.

It has been suggested that the woman is Marie de Valengin, the daughter of Philip the Good, Duke of Burgundy (see p.67), but this identification is somewhat doubtful.

A GRAND SCALE

Hugo van der Goes (c. 1436–82) is an extraordinary painter and produced paintings on a surprisingly large scale, both literally and in the unprecedented monumentality of the figures. His most famous work, *The Portinari Altarpiece (83)*, now in the Uffizi, Florence, was to prove very influential in Italy, where it decorated the church of the Hospital of Santa Maria Nuova in Florence. It was commissioned by a Florentine banker, Tommaso Portinari, who lived in Bruges and acted as the Flanders agent for the powerful Italian de' Medici family (see pp.93, 97). The dimensions of the painting, which when open measures over 8 ft (2.5 m) long, were dictated by a Florentine precedent.

Van der Goes is said to have died of religious melancholia, and knowing this, we may persuade ourselves that we see a barely controlled passion in his work. But without this biographical information, it may simply strike us as immensely dignified. Like the wings, the central panel, *The Adoration of the Shepherds*, shows two different scales in use, with the angels strangely small in comparison to the rest of the scene. This was a common device in medieval painting; it makes it easy to spot the important characters.

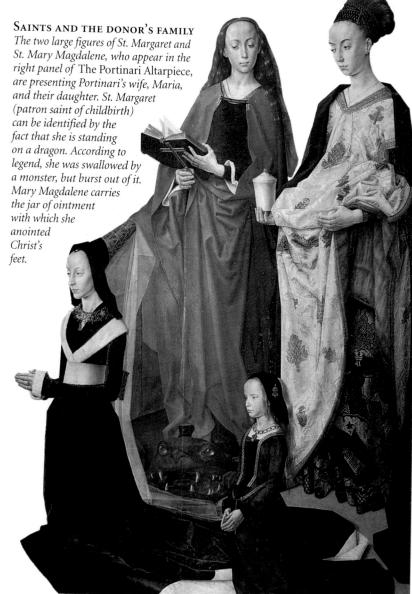

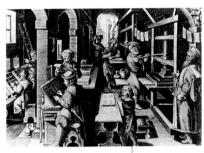

PRINTING

Around 1440, the German goldsmith Johannes Gutenberg invented movable type. This method of making type using individual letters revolutionized the spread of written information, as printed books became more easily available. Now, once a page of type was assembled, multiple copies could be printed, then the letters could be broken up and reassembled for another page. Movable type was soon in use across Europe. It spelled the end for illuminated manuscripts. This illustration shows printers in Gutenberg's workshop.

SHRINE BY MEMLING

One of Memling's most famous works is the Shrine of St. Ursula. The carved wooden casket is in the shape of a Gothic chapel with six painted panels. Each panel tells the myth of St. Ursula's pilgrimage to Rome with 11,000 virgins from England. On their return they were massacred by pagans from Cologne. The shrine is now the centerpiece of the Memling Museum in Bruges, Belgium.

MEMLING'S PLACIDITY

Van der Goes's vision is immensely powerful, and his paintings combine the gravity of van Eyck and the emotional intensity of van der Weyden. Certainly the power in his work is absent in that of the other Flemings, such as Gerard David (see p.71) and Hans Memling. Memling (also known as Memlinc; c. 1430/35–94)

was possibly trained in the workshop of van der Weyden (see p.67), but also contains influences from Dieric Bouts (see below), a follower of van Eyck. Although a German by birth, Memling settled in Bruges, Flanders, and it was there that he lived and worked. In fact, he worked so successfully that he became one of Bruges' wealthiest citizens.

Memling is a gentle artist, unobtrusively regarding the world about him and sharing his response with us. His *Portrait of a Man with an Arrow* (84) is immediately likeable. Various possibilities have been suggested as to the meaning of the arrow: something about his kindly and mild countenance seems to rule out

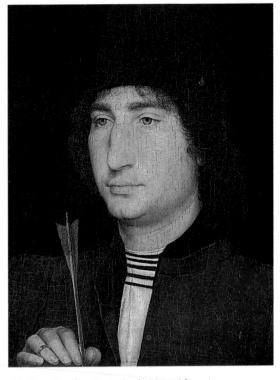

84 Hans Memling, Portrait of a Man with an Arrow, c. 1470/5, 10¼ x 12¾ in (25 x 32 cm)

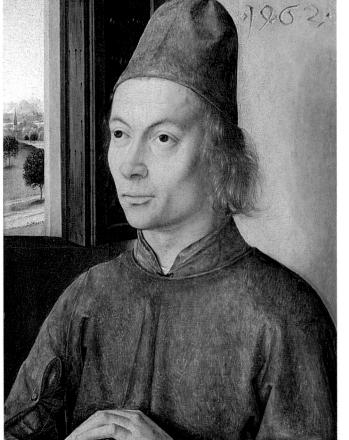

85 Dieric Bouts, Portrait of a Man, 1462, 8 x 12½ in (20.5 x 31.5 cm)

the possibility that he is a soldier. We are shown a very human gentleman, but one with firm and sensual lips. This small masterpiece grows on us the longer we contemplate it.

There could not be a greater contrast than between this and the work of Memling's contemporary, Bosch (see p.72), in whose work we often find a face that appears harsh with suppressed hatreds.

A van der weyden follower

Of all the Northern painters, the greatest influence on the Dutch-born painter Dieric Bouts (c. 1415–75) was van der Weyden (see p.67), who may have been his teacher. Bouts did most of his work in Louvain, Flanders, where he was appointed the official city painter in 1468. His paintings are recognizable for their solemn dignity and deeply religious feeling. The spare composition and simple rendering of the drapery folds in Bouts's sensitively painted and elegant Portrait of a Man (85) are typical. He was an accomplished landscape painter, and here we get a glimpse of a landscape through the open window.

LATE GOTHIC PAINTING

Gerard David, Hieronymus Bosch, and Matthias Grünewald were all early 16th-century artists and contemporaries of the other Northern artists Albrecht Dürer, Lucas Cranach, and Hans Holbein (see pp.148–162). However, the paintings of the former artists maintain connections with the Gothic tradition, while the latter were strongly influenced by the Italian Renaissance (see p.79). Thus the two strands of Gothic and Renaissance art coexisted and combined in Northern Europe in the first half of the 16th century.

Gerard David (c. 1460–1523) was Memling's natural successor in Bruges at the end of the 15th century, and was a highly successful artist with a busy workshop. He is a wholly delightful painter, whose childlike Madonna makes an immediate and unforced emotional appeal. In *The Rest on the Flight into Egypt (86)*, she holds grapes for her baby, symbol of the wine of His adult Passion, yet her quiet and abstracted

expression is not one of foreboding. She seems enwrapped with her baby Jesus in a timeless reverie, while all the burden is borne by the active St. Joseph in the background, and the watchful ass.

The distinct early 15th-century style of the Low Countries, which we see in the paintings of Campin and van Eyck (see pp.60–65), comes to its peak in David's paintings. We find in him the

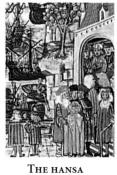

The Hanseatic League was formed in the 14th century as an association of German towns to protect its merchants in foreign parts and to extend trade. It grew to encompass 200 cities in Germany, the Low Countries, and England. Hansa merchants exported wool, cloth, metals, and furs to the East, and imported pigments, raw materials, silk, spices, and a variety of other oriental goods into Europe.

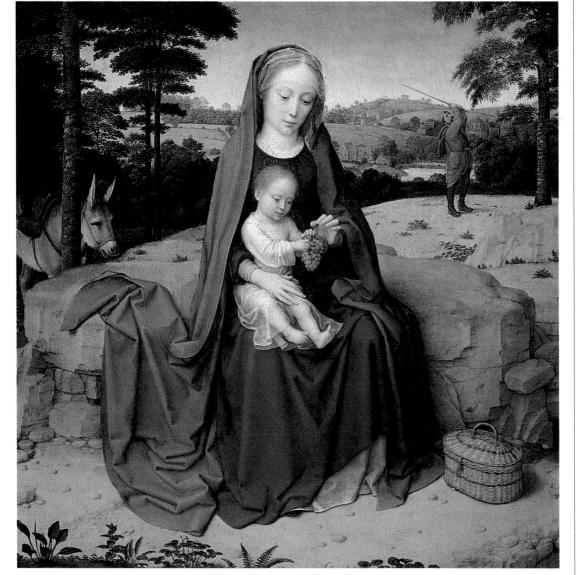

86 Gerard David, The Rest on the Flight into Egypt, c. 1510, 17½ x 17½ in (45 x 45 cm)

BRUGES

Until the late 15th century, Bruges was the hub of international commerce in northern Europe. Bruges was an independent commune, and the city was also the headquarters of the Hanseatic League. Although self-governing, the city was, like the rest of Flanders, under the overlordship of the Dukes of Burgundy until 1477. Bruges lost its trading dominance after the River Zwijn became unnavigable, and Antwerp assumed its position of influence.

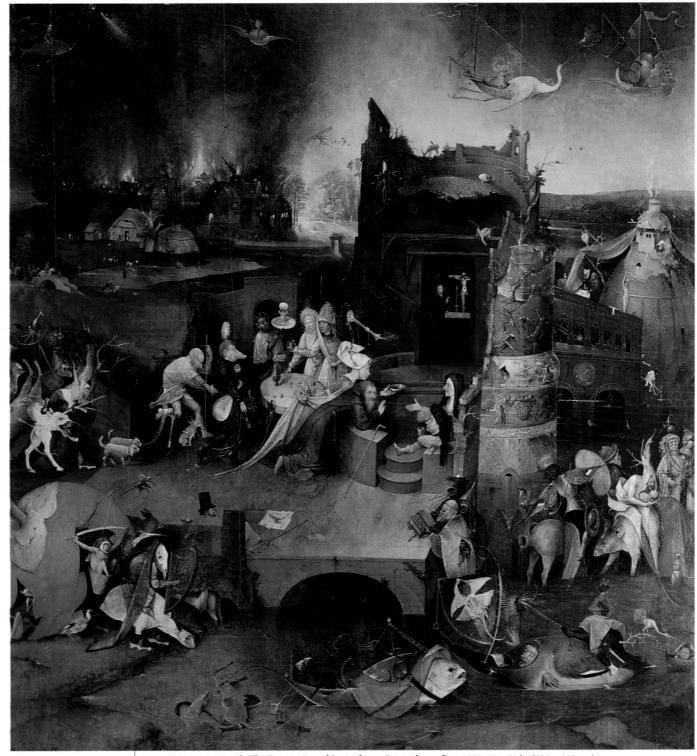

87 Hieronymus Bosch, The Temptation of St. Anthony (central panel), c. 1505, 47 x 52 in (120 x 132 cm)

St. anthony

This early Christian hermit (c. 251–356) appears in a number of Bosch paintings. He is regarded as the founder of Christian monasticism and lived most of his life in seclusion in Egypt. monumental qualities of the Northern tradition, vitalized by a new pictorial vision, that would influence Quentin Massys and Jan Gossaert (see p.163). In these two, the divergent traditions of North and South come together again though this happened later, when Italian Renaissance art was exerting an enormous and compelling influence. Northern art kept its sharp veracity, but with Italian modulations.

THE UNIQUE VISION OF BOSCH

The extraordinary painter Hieronymus Bosch (c. 1450–1516) stands apart from the prevailing Flemish traditions in painting. His style was unique, strikingly free, and his symbolism, unforgettably vivid, remains unparalleled to this day. Marvelous and terrifying, he expresses an intense pessimism and reflects the anxieties of his time, one of social and political upheaval.

Very little is known about Bosch, which somehow seems fitting since his work is so enigmatic. We know that he adopted the name of the Dutch town of s'Hertogenbosch (near Antwerp) as his own, that he belonged to an ultra-orthodox religious community called the Brotherhood of Mary, and that in his own day he was famous. Many of his paintings are devotional, and there are several on the theme of the Passion. He is especially famous for his fantastic, demon-filled works, one of which is *The Temptation of St. Anthony (87)*.

The central panel of this triptych illustrates the kneeling figure of St. Anthony being tormented by devils. These include a man with a thistle for a head, and a fish that is half gondola. Bizarre and singular as such images seem to us, many would have been familiar to Bosch's contemporaries because they relate to Flemish proverbs and religious terminology. What is so extraordinary is that these imaginary creatures are painted with utter conviction, as though

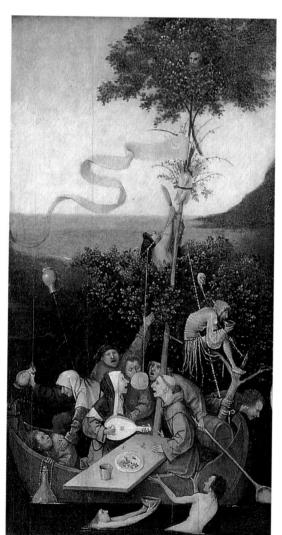

89 Hieronymus Bosch, The Ship of Fools, c. 1490–1500, 13 x 23 in (33 x 58 cm)

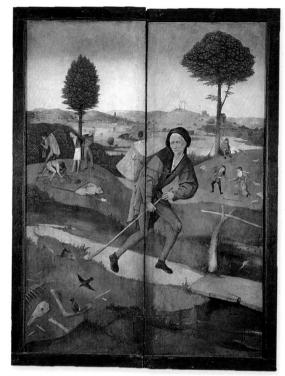

88 Hieronymus Bosch, The Path of Life, c. 1500–02, 35½ x 53 in (90 x 135 cm)

they truly existed. He has invested each bizarre or outlandish creation with the same obvious realism as the naturalistic animal and human elements. His nightmarish images seem to possess an inexplicable surrealistic power.

Even a more naturalistic painting like The Path of Life (88) contains sinister elements. Apart from the dog snarling at the povertystricken old man, and the animal bones and skull in the foreground, robbers attack a traveler in the background, and a gallows is visible on the skyline above the old man's head. The Path of Life is on the outer face of the wings of a triptych. The three inside panels display Bosch's tragic view of human existence, dwelling upon the triumph of sin. Man's exile from paradise is shown on the left, the infinite variation of human vice in the center, and its consequence - exile to Hell - on the right.

ILLUSTRATED ALLEGORIES

In *The Ship of Fools (89)*, Bosch is imagining that the whole of mankind is voyaging through the seas of time on a ship, a small ship, that is representative of humanity. Sadly, every one of the representatives is a fool. This is how we live, says Bosch – we eat, drink, flirt, cheat, play silly games, pursue unattainable objectives. Meanwhile our ship drifts aimlessly and we never reach the harbor. The fools are not

OTHER WORKS BY

The Garden of Earthly Delights (Prado, Madrid)

Adoration of the Kings (Metropolitan Museum of Art, New York)

> Christ Mocked (National Gallery, London)

Last Judgment (Akademie der Bildenden Künste, Vienna)

Christ Carrying the Cross (Museum of Fine Arts, Ghent)

of the moster of the monstrous... the discoverer of the unconscious.?

Carl Gustav Jung, on Hieronymus Bosch

Mummers like these, who appear in a 14th-century French illumination, were a common sight in the Middle Ages in the towns of northern Europe. They were masked players who traveled around in groups and put on entertainments and mystery plays in the streets and private houses. The religious community that Bosch belonged to is also known to have performed mystery plays.

DEATH AND THE MISER

This moralistic panel from Bosch's middle phase is an example of the 15th-century Flemish insistence on exposing the folly and vices of humanity. Religious sects proliferated in the Low Countries at that time, and Bosch belonged to one with strongly orthodox beliefs.

Unseen crucifix

At the heart of this painting is the battle for the miser's soul. His guardian angel pleads – perhaps in vain – for his salvation and attempts to guide the dying man's attention to the small crucifix off to the upper left, unseen by the miser and ignored.

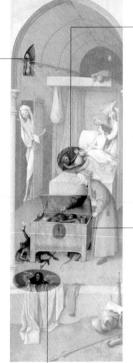

A FINAL TEMPTATION

A grotesque devil, understanding the miser's weakness, proffers a bag of gold in the hope of securing the miser's soul. We are left to draw our own conclusions as to the outcome of this human drama, but the gesture of compulsive greed made by the dying man, still eager for material gain, suggests the battle is already lost.

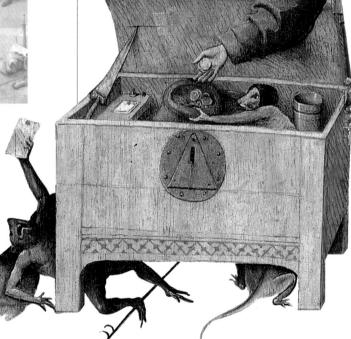

Self-portrait?

In the foreground, a small demon looks sideways at us amid the miser's discarded silks with an expression often seen in Bosch paintings – lean, pinched, and hopeless. It has been suggested that this is a sardonic portrait of Bosch himself.

Money - the focal point

Lust, gluttony, and material greed were ranked among the worst vices and were popular subjects of 15th-century religious sermons. The strongbox is given a prominent position, as the cause of the miser's probable damnation. He does not seem to see, as Bosch ensures we do, that the strongbox is alive with malicious, verminous creatures from the underworld, and that he carrries his key next to his rosary in vain.

irreligious, since prominent among them are a monk and a nun, but they are all those who live "in stupidity." Bosch laughs, and it is a sad laugh. Which one of us does not sail in the wretched discomfort of the ship of human folly? Eccentric

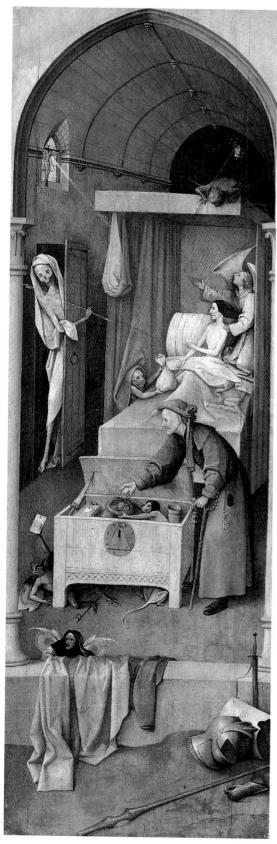

and secret genius that he was, Bosch not only moved the heart, but scandalized it into full awareness. The sinister and monstrous things that he brought forth are the hidden creatures of our inward self-love: he externalizes the ugliness within, and so his misshapen demons have an effect beyond curiosity. We feel a hateful kinship with them. *The Ship of Fools* is not about other people. It is about us.

A MORAL TALE

Another of Bosch's panel paintings, *Death and the Miser* (90), is a warning to anyone so obsessed with grabbing at life's pleasures that they have lost all sense of retribution. As a result, the worldly one is not prepared to die. Who can feel indifferent to this fable? In a long, concentrated format Bosch sets out the whole painful scenario.

The naked and dying man has been a person of power: at the bed's foot, strewn by a low wall, lies his discarded armor. His riches have come through combat; the sick man has fought for his wealth and stored it close to him. The miser appears twice, the second time in full health, simply dressed because he hoards his gold, dense with satisfaction as he adds another coin. Demons lurk everywhere. Death puts a leering head around the door (notice the sick man's surprise: death is never expected), and the final battle begins. It is one he must wage without his armor. Behind him stands a pleading angel. Before him, even now proffering gold, lurks a demon. Above the bed, expectant and interested, peers yet another demon. The outcome of the story is left undecided. We hope desperately that the miser will relinquish empty possessiveness and accept the truth of death.

Grünewald's dark vision

The final flowering of the Gothic came relatively late, in the work of the German artist Matthias Grünewald (his real name was Mathis Neithart, otherwise Gothart, 1470/80-1528). He may have been an exact contemporary of Dürer (see p.152), but while Dürer was deeply influenced by the Renaissance, Grünewald ignored it in his choice of subject matter. Much of his work has not survived to this day, but even from the small amount that has come down to us, it is possible to see Grünewald as one of the most powerful of all painters. No other painter has ever so terribly and truthfully exposed the horror of suffering, and yet kept before us, as Bosch does not, the conviction of salvation. His Crucifixion (91), part of the many-paneled Isenheim Altarpiece,

90 Hieronymus Bosch, Death and the Miser, c. 1485/90, 12 x 36½ in (30.5 x 93 cm)

PHILIP II

The Spanish King
Philip II (1527–98)
was an admirer of the work
of Bosch and amassed a
substantial collection of
his paintings. The son of
Emperor Charles V,
Philip brought Spain out
of the Middle Ages and
into the Renaissance era.
He commissioned
many works by
Titian (see p.131).

PANEL PAINTINGS

While painting on wooden panels was widespread across Europe, the timber used varied. In Italy poplar was the most common. North of the Alps there was a greater choice of wood, and oak, pine, silver fir, linden, beech, and chestnut were all used. Italian panels were left rough at the back while Northern European panels were beautifully finished. Those from Bruges were often stamped with a seal.

World's END
As at the end of most centuries, a number of people feared that the world would end in 1500. As a result, apocalyptic images of death were widespread.

typhoon of unrestrained art, which carries you as it passes... you leave it in a state of lasting hallucination.

J. K. Huysman on Grünewald's Crucifixion

MEDIEVAL MEDICINE Up until the Renaissance, medical knowledge was rudimentary. Diseases and ailments were usually treated with herbal cures, blood-letting by leeches, or by supernatural "cures." Superstition dictated, for example, that sickness could be avoided by carrying holy relics or texts taken from the Bible. This illustration, dating from the 14th century, shows a very docile patient undergoing a primitive lobotomy operation.

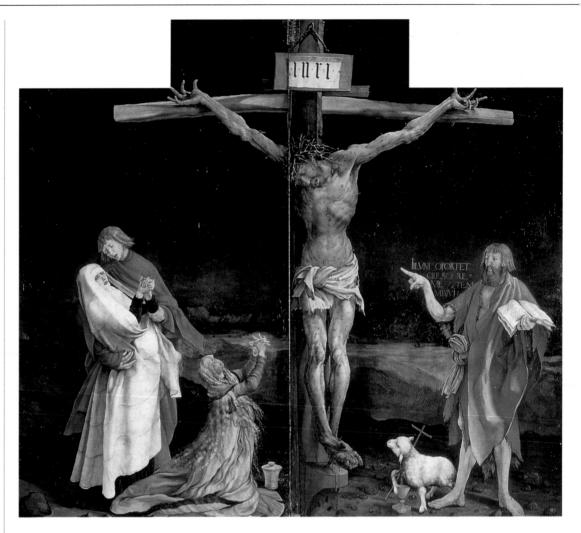

91 Matthias Grünewald, Crucifixion, c. 1510-15, 10 ft × 8 ft 10 in (305 × 270 cm)

is now kept in Colmar. It was commissioned for the Antonite monastery at Isenheim and was intended to give support to patients in the monastic hospital. Christ appears hideous, his skin swollen and torn as a result of the flagellation and torture that He endured. This was understandably a powerful image in a hospital that specialized in caring for those suffering from skin complaints.

The more accessible *Small Crucifixion* (92) engages us very directly with the actual death of the Savior. The crucified Lord leans down into our space, crushing us, leaving us no escape, filling the painting with his agony. We are hemmed in by the immensities of darkness and mountain, alone with pain, forced to face the truth. The Old Testament often talks of a "suffering servant," describing him in Psalm 22 as "a worm and no man": it is of Grünewald's Christ that we think. In this noble veracity, Gothic art reached an electrifying greatness.

92 Matthias Grünewald, The Small Crucifixion, c. 1511/20, 18 × 24 in (46 × 61 cm)

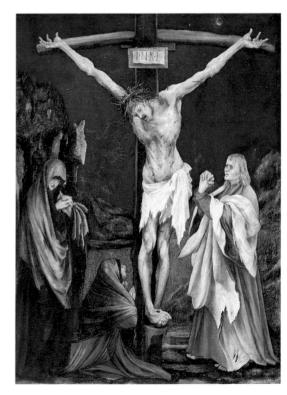

Crucifixion

This is the central panel of Grünewald's large, multipaneled *Isenheim Altarpiece*. It is an extraordinary record of intense and disfiguring human suffering. Because he worked in a hospital, Grünewald based his image of suffering on the patients whose torments he witnessed. These were mostly sufferers from skin diseases, which were common at the time.

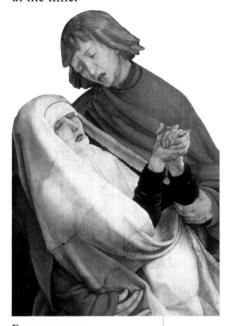

FAMILY GRIEF Divided from the stoic figure of John the Baptist by the monstrous dying Christ are the traumatized relatives and friends. Mary collapses into herself, either swooning from exhaustion or from a need to shut out the vision of her crucified son. Grünewald originally painted her as an upright figure, but later arched her body into this pitiful state. She is supported by the despairing St. John the Evangelist.

AGONY VISUALIZED

Grünewald takes the Gothic concern with suffering, sin, and mortality to its furthest extreme. Here in graphic detail is Christ the victim, physically repulsive in His brutalized condition and far removed from the heroic, athletically beautiful Christs of the Renaissance. Grünewald's vision is one of horror, a metaphor for the supreme cruelty and degradation of which humanity is capable, and by the same token, of the supreme mercy of Christ's benediction.

PHYSICAL PAIN The crossbar of the crucifix is a simple, roughhewn branch, bending under the weight of the dying man. Christ's arms are abnormally elongated and His hand, contorted into a physical scream, seems both a desperate reproach and a surrender to God.

St. john's prophecy

St. John the Baptist stands barefoot, wearing the animal skins that symbolize his time in the wilderness, and carrying a book. He seems unbowed by the horror of the moment and is unshakable in his prophetic conviction – inscribed against the night sky – "He will increase while I decrease." John delivers the Christian message of hope and redemption, balancing the desolation of the scene.

LAMB OF GOD

The lamb, used as a sacrificial animal by the Jews, was adopted by the early Christians as a symbol of Christ's sacrifice. It is associated with St. John, who on seeing Jesus declared, "Behold the Lamb of God." The lamb normally holds a Cross and its sacrifical blood flows into a chalice.

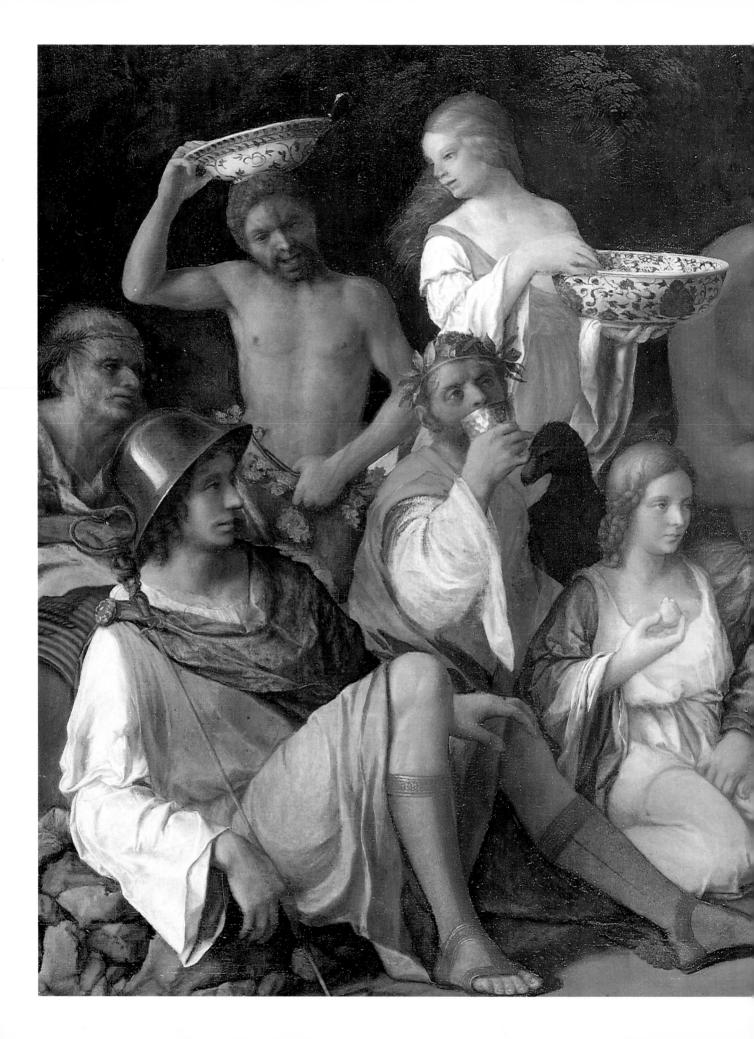

THE ITALIAN RENAISSANCE

In the arts and sciences as well as society and government, Italy was the major catalyst for progress during the Renaissance, the rich period of development that occurred in Europe at the end of the Middle Ages. Because of the number of different fields in which it applied, "Renaissance" is a word with many layers of meaning. Accordingly, Renaissance painting cannot signify any one common or clearly definable style. Since Gothic painting had been shaped by the feudal societies of the Middle Ages, with its roots in the Romanesque and Byzantine traditions, Renaissance art was born out of a new, rapidly evolving civilization. It marked the point of departure from the medieval to the modern world and, as such, laid the foundations for modern Western values and society.

Italian Renaissance Timeline

The Renaissance in Italy started gradually, its beginnings being apparent even in Giotto's work, a century before Masaccio was active (see p.46). The quest for scientific precision and greater realism culminated in the superb

balance and harmony of Leonardo, Raphael, and Michelangelo. The influence of Humanism (see p.82) is reflected in the increase of

secular subjects. In the final phase of the Renaissance, Mannerism became the dominant style.

Masaccio, ADAM AND EVE, 1427 Leonardo wrote that Masaccio "showed by his perfect works, how those who take for their inspiration anything but Nature - mistress of all masters - weary themselves in vain". In 1830, Eugène Delacroix wrote of him: "Born in poverty, almost unknown during the best part of his short life, he carried out single-handed the greatest revolution ever known in painting." This revolution was his vision of the world: of mortal beings portrayed with honesty and tenderness, living and breathing in a terrestrial world of

air, light, and space (p.83).

PIERO DELLA FRANCESCA, RESURRECTION OF CHRIST, C. 1450 Clarity and dignity characterize Piero's art. Influenced by Roman Classicism and Florentine innovation, his paintings combine complex mathematical structures with brilliant color and crystalline light (p.102).

LEONARDO DA VINCI, VIRGIN OF THE ROCKS, c. 1508 A true Renaissance man, Leonardo was a great painter as well as a sculptor, architect, inventor, engineer, and an expert in such fields as botany, anatomy, and geology. His distinctively lyrical art reveals his compelling belief in nature as a source of inspiration (p. 120).

1420 1440 1460 1480 1500

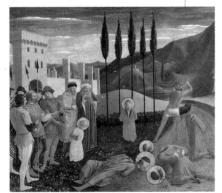

FRA ANGELICO, BEHEADING OF ST. COSMAS AND ST. DAMIAN, 1438–40 This is part of the predella (a strip along the lower edge) of the altarpiece in the priory of San Marco, Florence. Fra Angelico's paintings have a delicate grace that belies their dynamism. There are elements of Gothic style, but the figures move in real, observed landscapes and are defined by natural light (p.90).

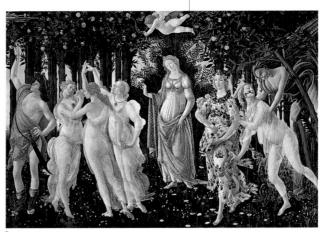

SANDRO BOTTICELLI, PRIMAVERA, C. 1482
Botticelli is known best for his secular paintings – elaborate pagan allegories and mythological scenes. But his paintings are recognizable for their sheer beauty of line, free of discord. His art is notable for its peculiarly gentle, wistful melancholy. As he aged, this deepened to an anxious sadness; his figures became emaciated, sometimes with tortured expressions. This was possibly a reaction to contemporary political and religious tensions (p.94).

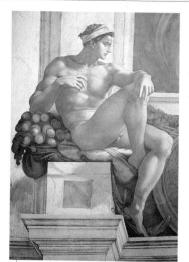

MICHELANGELO, IGNUDO (NUDE) FROM THE SISTINE CHAPEL, C. 1508–12

Michelangelo is another "giant" of the High Renaissance. However, in contrast with the lyricism of Leonardo's paintings, Michelangelo's art is characterized by gravity. Created on an epic scale, it is peopled with superhuman forms, of severe athletic beauty (p.122).

Titian, venus and adonis, c. 1560

Titian was the greatest of the Venetian artists and one of the world's supreme artists, with a profound influence on the development of Western painting. His late works are unsurpassed in their haunting and fragile beauty, strikingly suggestive of some 20th-century art (p.134).

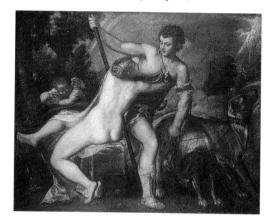

EL GRECO, MADONNA AND CHILD WITH ST. MARTINA AND ST. AGNES, C. 1597–99

El Greco is the great religious Mannerist. His passionate vision surpasses the stylish manipulations of later Mannerists. After travels in Venice and Rome, he settled in Toledo in Spain. His work displays a mystic fervor that accurately represents the religious intensity of Counter-Reformation Spain (p.145).

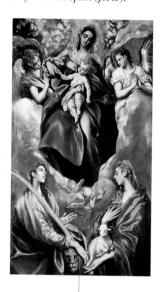

Correggio, venus, satyr, and cupid, c. 1514–30

Correggio's imagery can seem too sweet for modern tastes. But beneath the outward charm is a tough appreciation of sensual truth (p.142).

1540

1560

1580

1600

RAPHAEL, BINDO ALTOVITI, C. 1515 Raphael was a successor to Leonardo, whose early influence on him was profound. Raphael was also attracted to classical art, so that his paintings possess heroic grandeur and his portraits a new, graceful spontaneity (p.128).

TINTORETTO, THE CONVERSION OF ST. PAUL, C. 1545

The Venetian artist Tintoretto was a leading late Renaissance painter. After studying briefly under Titian, he evolved a distinctive, dynamic style with startling contrasts of color and tone, sweeping vistas, and dramatic movement. His paintings exhibit a religious intensity and a passionate "expressionism" that move him into the realm of Mannerism, away from the Classicism of the High and Early Renaissance (p.134).

Brunelleschi and florentine architecture

The cupola of Florence's Cathedral is considered to be the greatest triumph of the architect Filippo Brunelleschi. It has a diameter of 150 ft (45 m), and the marble ribs on the exterior exert a powerful centripetal force which supports the whole structure. Its eight faces are held in place by the continuously selfsupporting masonry system, which is in itself a remarkable feat of structural engineering. The dome was completed in 1418, becoming the focal point of the city and proclaiming Florence to be the cultural capital of the Renaissance.

HUMANISM

Humanism was an important cultural movement of the Renaissance, in which prime importance was given to human reason rather than to God's revelation. Erasmus (see p.154) was its great theorist. Classical Latin and Greek texts were the main sources, but Humanist education also included the liberal arts, such as grammar, rhetoric, poetry, and ethics. Humanistic thinking was brought to the world of diplomacy by Machiavelli and to architecture by Alberti (see p.88).

THE EARLY RENAISSANCE

The name "Renaissance" – meaning "rebirth" – is given to a period of broad cultural achievement spanning three centuries. The idea of rebirth lies at the heart of all Renaissance achievement: artists, scholars, scientists, philosophers, architects, and rulers believed that the way to greatness and enlightenment was through the study of the golden ages of the ancient Greeks and Romans. They rejected the more recent, medieval past, which constituted the Gothic era. Instead of this, inspired by Humanism, they looked to the literary and philosophical traditions, and the artistic and engineering achievements, of Greco-Roman antiquity.

Renaissance painting began in Italy in the middle of the 13th century, and its influence rapidly spread throughout Europe, reaching its peak at the end of the 15th century. Renaissance artists believed their art was a continuation of the great antique tradition of Greece and Rome, an insight that originally came from Giotto (see p.46). With his joyful spiritual vision, Giotto is like the Gothic artists. But his ability to present stories from the Bible as very naturalistic, human dramas and his way of depicting his figures as solid, weighty characters were Renaissance qualities. Giotto showed what could be done, how an artistic vision could encompass the exciting new understanding of Humanism and Classicism, which were to be so important to Renaissance artists. With antiquity as a model and Giotto as a guide, painters of the early Italian Renaissance entered a new phase of pictorial representation, based on the reality of human existence.

MASACCIO AND FLORENCE

Of course the transition from Gothic to Renaissance did not happen overnight, but it can come as a surprise to see that the next great Italian painter after Giotto (who died in 1337) was not born until 1401, and therefore was not active until nearly a century after Giotto's death.

This gap is largely explained by the Black Death (see p.58), the first spread of which devastated Europe in the 14th century, reaching Italy first in 1347 and sweeping across Europe over the next four years. The consequences were farreaching, and in addition to the enormous loss of life, medieval society underwent great changes. Artistic revolution in the North, in

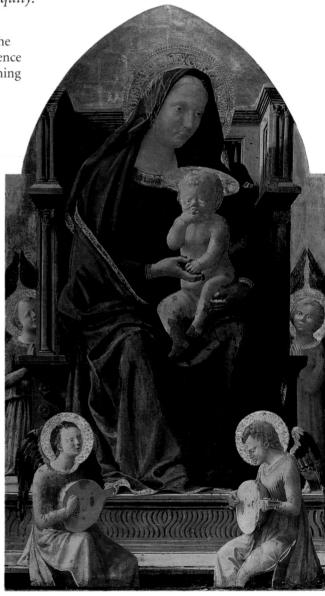

93 Masaccio, The Virgin and Child, 1426, 29½ in × 53 in (75 × 135 cm)

the Low Countries (see pp.60–70), was leading painting in new directions through its increasing naturalism, secularism, and technical mastery. In the South, it seemed as if Giotto had never been. Miraculously, there was a second spring with the birth of the Florentine painter

Masaccio (Tomasso de Giovanni di Simone Guidi, 1401–28). It is Masaccio who is the revolutionary founder of Renaissance painting. Of the Italian painters, he was the one who really saw what Giotto had initiated and made it accessible to all who followed.

Masaccio is forever young because he died when he was 27. Yet his art seems to be outstandingly mature. His name is a nickname, meaning something like "Tom the Hulk," and his art is hulking, too. But it is the hulk of genius, monumental, strong, and convincing, true heir to the humanity and spatial depth of Giotto. One of his early works, painted for a church in Pisa, has an almost architectonic concentration. In The Virgin and Child (93), the central panel of a now scattered polyptych (multiple painting), the Madonna is sculptural in her blocky dignity, seated on a throne of classic weight, shadowed and austere, with her Child completely stripped of Byzantine kingliness. This Jesus is a real baby, sucking his fingers and staring into space. It represents the antithesis of the courtly refinement of the International Gothic style of Gentile da Fabriano, for instance (see p.56). Yet the pathos is heightened, not diminished: there is strength and vulnerability, beautifully combined, and even the angel musicians have a chubby earnestness.

LINKS WITH SCULPTURE

As Giotto was influenced by the sculpture of the Pisanos (see p.46), so was Masaccio by their Florentine sculptural descendants, the senior artists Donatello (Donato di Niccolo, 1386-1466, see right) and Lorenzo Ghiberti (1378–1455, see column, p.102). The great influence of sculpture on early Renaissance painting, and inherently on the development of the Western tradition in painting, cannot be overstressed. Masaccio's understanding of threedimensional form, architectural space, and perspective owed a great debt to the technical and scientific achievements pioneered by Donatello, Ghiberti, and the Florentine architect Brunelleschi (Filippo di Ser Brunelleschi, 1377-1446, see column, left). Sculptural realism lies at the heart of Renaissance painting, culminating in the epic monumentality of Michelangelo's art during the High Renaissance (see p.120).

As Giotto translated Pisano's carvings into pictorial form, Masaccio drew inspiration from Donatello's freestanding sculptures and reliefs, and applied sculptural considerations to his paintings, creating images of convincingly solid objects in a feasible space, using optical perspective. More significantly, he applied the sculptor's understanding of the effects of real

light falling onto objects and filtering through spaces, surpassing Giotto's already monumental leap toward understanding and reinventing the world through painting.

From now on, the lovely play that can characterize the finest Gothic art (though less often that of Giotto or Duccio) disappears. Masaccio lives in a wholly serious world. His *Adam and Eve Expelled from Paradise* (94), in Florence's Brancacci Chapel, wail with unselfconscious horror, blinded with grief,

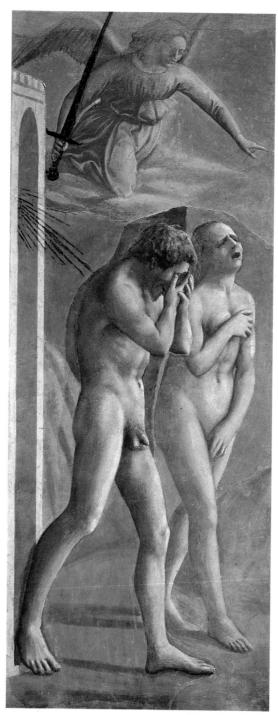

94 Masaccio, Adam and Eve Expelled from Paradise, c. 1427, 35½ x 81 in (90 x 205 cm)

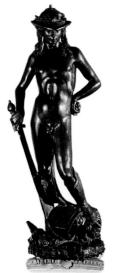

Donatello's david

Donatello was one of a group of brilliant sculptors who led the way for painters in the early Renaissance (see also p.105). He visited Rome, where he was inspired by the freedom of movement achieved in the nude figures of classical sculpture, and

afterward (c. 1434) created this bronze figure of the young King David. This overtly sensual work was one of the first nude statues of the Renaissance.

RESTORATION OF FRESCOES

Time and the elements, in particular modern pollution, have caused serious deterioration in the surface of many of the frescoes produced during the Renaissance. As a result, to repair the damage and to prevent more from occurring, many famous works. including Masaccio's Brancacci Chapel frescoes and Michelangelo's Sistine Chapel ceiling (see p.122), have been substantially restored. This has resulted in some controversy: not all art critics and historians are in agreement that the work has been sensitively carried out. Some argue that the tonal values of the work have

been ignored.

THE TRINITY

The doctrine of the Trinity – of God as three separate beings, yet remaining one entity – lies at the heart of the Christian "mystery." It is first mentioned in Matthew's Gospel (28: 19) as comprising Father, Son, and Holy Spirit. Masaccio's *Trinity* was commissioned for the church of Santa Maria Novella in 1425. It was covered over in 1570 with a panel painting by Vasari (see p.98), and only rediscovered in 1861.

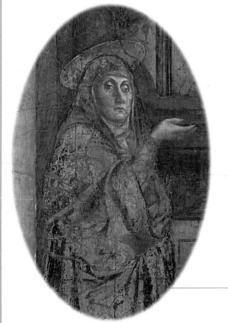

Mother of Christ

Mary the Virgin is the only one of the nondivine beings who looks directly out at us. She stands upright and dry-eyed, and points with a gesture both implacable and supplicating toward her crucified Child, giving the viewer a concentrated glance of terrible reproach.

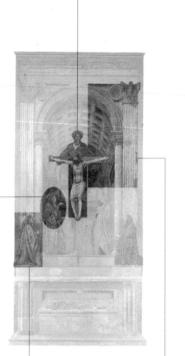

THE TRINITY

Masaccio's Trinity is part of a Renaissance pictorial tradition in which the Father is generally depicted as an aged and bearded patriarch, standing behind and above the crucified Son. He is often shown supporting both ends of the crossbar of the crucifix, thus echoing His Son's sacrifice. Between them hovers the white geometry of the Holy Spirit, traditionally depicted as a dove (see p.101). The Holy Spirit is the third person of the Trinity, but is here perhaps the most eye-catching in the sheer brilliance of the white smudge that bisects the fresco.

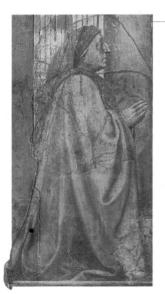

THE DONORS

The figures of the Trinity, and of Mary and St. John, appear as solidly real as the two donors. Yet the donors are both included in and excluded from this timeless scene. Spatially they belong: they share the same scale (traditionally donors were shown on a specially reduced scale) and are bathed in the same light that illuminates the interior of the vault. But symbolically the donors remain "outside" the scene, because they have been positioned on a lower step, as though on the predella (a painted border strip) of an altarpiece, which locates them firmly in the world of the viewer.

PERSPECTIVE

Vasari recorded his admiration for Masaccio's Trinity when he described its sophisticated spatial structure as: "a barrel vault drawn in perspective, and divided into squares with rosettes that diminish and are foreshortened so well that there seems to be a hole in the wall." Masaccio had interpreted Brunelleschi's (p.82) theories of perspective with such clarity that in the past it was believed that Brunelleschi was actually directly involved in the production of the painting.

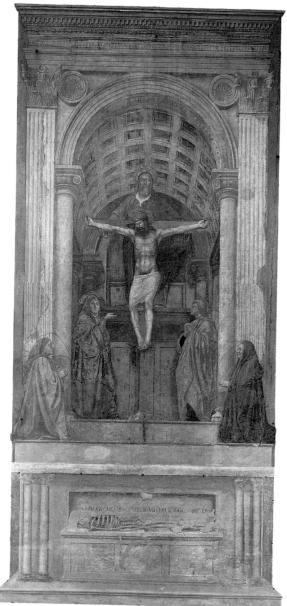

95 Masaccio, The Trinity, 1425, 10 ft 4in x 22 ft (315 x 670 cm)

unaware of anything but their loss of happiness. Eve is so sheerly ugly as she screams aloud from misery that we are startled into attention and into pity.

Masaccio's trinity

What distinguishes Masaccio is his majesty; there never was a more massive, more dignified, more noble, and yet more human painter. The wonder of this painting of *The Trinity* (95) is that it shows us six *human* images. Central are the Father and Son. Although they are in the most moving way human (a real, suffering Jesus showing compassion for His fellow men and women as He dies, and a real Father upright in His splendid dignity as He holds up the Crucifix and shows us His surrendered Son) in Their

majesty, we can well accept that these two figures are divine. Divinity is by definition a mystery, something we cannot comprehend, but Masaccio makes the mystery of the Trinity humanly accessible. Below the great central vertical pole of the Trinity, symmetrically fanning out on either side, are the four non-divine actors in the drama. Only one – Mary – is looking directly out of the picture. Balancing the figure of Christ's mother, on the other side of the Cross is St. John, equally massive, equally solid, though he is looking not toward us, but toward Christ.

Beyond them, sealing in the picture, are the donors – large, profiled, solidly present as the viewers' representatives. At the very bottom of the painting there is a seventh character: the skeleton, representing Adam and Everyman. This is the human truth that underlies all religious dogma. Above the skeleton, on the stone wall of the narrow tomb in which it lies, is written the inscription "I was once what you are and what I am you will become." The universal nature of Masaccio's *Trinity*, encompassing the wide realm of mortal decay and spiritual salvation, belongs to a medieval tradition.

There is an immense authority about this young artist. St. Peter Healing with His Shadow (96) is one of a pair of scenes from the Brancacci Chapel cycle, situated at either side of the altar. (The other is The Distribution of the Goods of the Church, and the pair share a common perspective.) St. Peter strides toward the viewer down a narrow street of houses built in the Florentine style. One man in his entourage, wearing the short smock of a stonecutter, might be intended

as a portrait of Donatello; another, younger man, his beard not yet grown, might be Masaccio's self-portrait (he is positioned facing directly out of the picture in the manner of self-portraits of the time.) Peter's shadow is rendered with remarkable confidence in view of the fact that, prior to this, no technique for painting shadows had been developed. The cripples are depicted with a vividness and individuality astonishingly advanced for the early 15th century.

Masaccio's concerns with the true appearance of things earned him this singular appraisal from the art historian Vasari (see p.98):

THE BRANCACCI CHAPEL

Several of Masaccio's frescoes cover the upper walls of the Brancacci family chapel in the church of Santa Maria del Carmine in Florence. This cycle of frescoes became a model for Florentine artists in the late Renaissance, including Michelangelo (see p.120).

OTHER WORKS

BY MASACCIO
Crucifixion of St. Peter
(Staatliche Museen,
Berlin-Dahlem)
Virgin with St. Anne
(Uffizi, Florence)
Tribute Money
(Brancacci Chapel,
Florence)

96 Masaccio, St. Peter Healing with His Shadow, 1425 (detail of fresco)

RELEVANCE OF SAINT MATTHIAS

One of the saints in Masolino's altarpiece is Matthias (99). The work was commissioned for the church of Santa Maria Maggiore in Rome. This was the church where the relics of the saint were preserved. Matthias was a 4th-century pope who, according to legend, ordered the building of the church on the direct instruction of the Virgin Mary, appearing to him in a vision.

"With regard to painting we are indebted most of all to Masaccio, who first painted people's feet actually standing on the ground, and by doing so eliminated that awkwardness, common to all artists before him, of having the figures standing on tiptoe. We must also be grateful to him for having given his figures such liveliness and relief that he deserves the same credit as if he had invented art itself."

THE "SMALLER" ART OF MASOLINO

Masaccio's greatness can best be seen if we compare him with Masolino (Tommaso di Cristoforo Fini da Panicale, 1383– c. 1447), nearly 20 years his senior, with whom he often worked. (It has been suggested that "Masolino," also a nickname, was coined to mark the difference between "Big Tom," Masaccio, and "Small Tom," Masolino.) He is unfairly seen as small, but only in comparison. On his own, he is still temperamentally in the Gothic era, as we

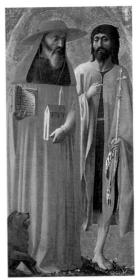

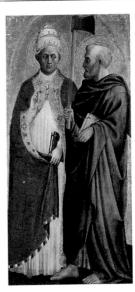

99 Masolino, St. Liberius and St. Matthias, c. 1428, 21½ x 45 in (55 x 115 cm)

The best proof of Masolino's ability to grow can be seen in a comparison between two panels, *St. Jerome and St. John the Baptist (98)* and *St. Liberius and St. Matthias (99)*, which hang to either side of an altarpiece. All four saints have a hulking presence typical of Masaccio – they certainly stand with their feet flat on the ground – yet it is now fairly certain that the former panel is largely by Masaccio, while the latter is mainly the work of Masolino. (Previously, both were attributed to Masaccio.)

The Venetian artist Domenico Veneziano (Domenico di Bartolomeo di Venezia, active c.1438–61) was one of the most important painters working in Florence in the early Renaissance. His importance lies not so much in his personal achievement as in the breadth and significance of his influence – for he was the teacher of Piero della Francesca (see p.100).

What we find so beautifully in Domenico is a splendor of light that emanates from a single source, breathing air into the space and unifying forms within it. He gives us the first radiant indication of that water-born silveriness that is one of the Venetian gifts to the visual world. Domenico also had a dazzlingly original mind. We admire – rightly – the great Masaccio; we love the limpid Domenico. His *St. John in the Desert (100)* is a magical work. Light pours in blinding clarity over a glittering barrenness,

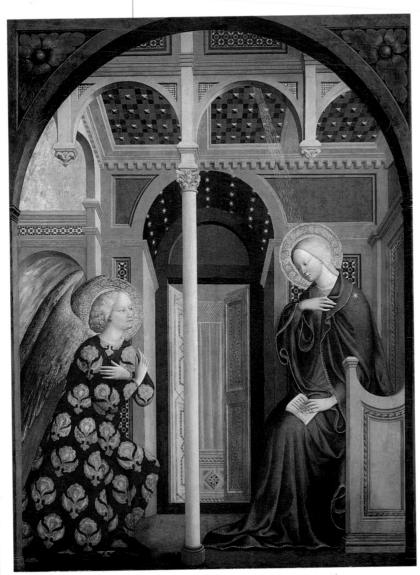

97 Masolino, Annunciation, probably c. 1425/30, 45 x 581/4 in (115 x 148 cm)

THE MARZOCCO
This heraldic lion, known as the Marzocco, and the fleur de lys that it holds, were symbols of the Republic of Florence.
The sculpture was made by Donatello in 1418–20. It was commissioned for the papal apartments at Santa Maria Novella, but is now in the Bargello Museum in Florence.

100 Domenico Veneziano, St. John in the Desert, c. 1445, 12¾ x 11¼ in $(32.5 \times 28.5 \text{ cm})$

with the tender, naked saint the only softness to be seen. He is stripping off his worldly clothes, like a young athlete getting ready for the race. That the race is very present to him, and that it is a contest of the spirit, is sublimely clear. But if it is an all-demanding vocation to which this slender youth is called, it is one lived in the exhilaration of a high plateau.

There is a strange relationship between this classical-looking nude, with his medieval golden halo, and his setting in a landscape reminiscent of Netherlandish (even Byzantine) art; this juxtaposition illustrates the meeting of spiritual, pagan, and physical worlds. This is a deeply Renaissance way of visualizing the story, as we can see if we compare it with the painting of the same subject by Giovanni di Paolo (c. 1403–83). This is Giovanni's *St. John the Baptist Retiring to the Desert (101)*, an archaic and bewitching Gothic fantasy that sends the youthful saint out like a young adventurer to seek his heavenly fortune.

101 Giovanni di Paolo, St. John the Baptist Retiring to the Desert, c. 1454, 15½ x 11¾ in (39 x 30 cm)

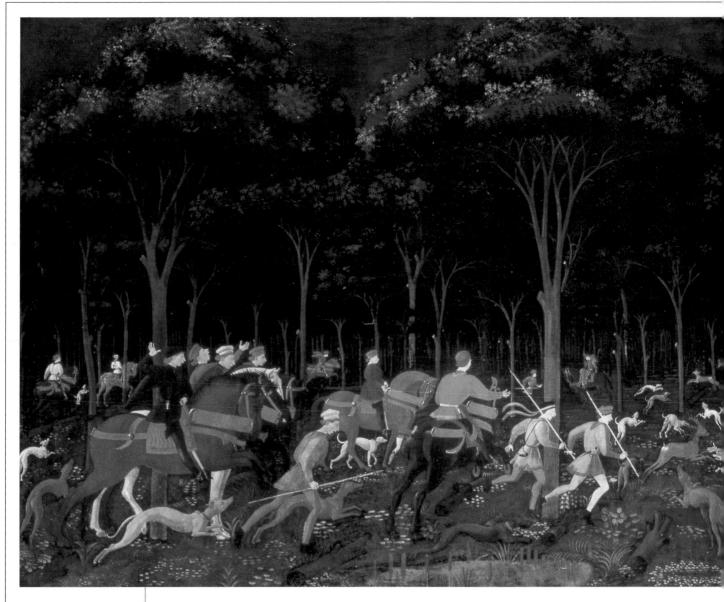

Alberti

The Florentine artist, architect, and antiquarian Leon Battista Alberti (1404–72) was one of the first to construct a formula of perspective that could be applied to two-dimensional paintings.

PERSPECTIVE: SCIENCE INTO ART

The Renaissance concept that most gripped the Florentine artist Paolo Uccello (Paolo di Dono, 1397–1475), whose name is also a nickname (*uccello* means "bird" – given to him for his love of birds), was not so much that of light as perspective. Significantly, he was apprenticed with the architect Ghiberti (see column, p.102) at the beginning of his career.

In a story recounted by Vasari, Uccello once worked all night on this science, whereby the confusion of the world could be ordered into submission. His wife reported him crying out in ecstasy, "Oh, how great is this perspective!" and, on being called to bed, saying that he would not leave his "sweet mistress perspective." He seized upon it with an intellectual passion that might have produced a rather rigid art.

Put very simply, the art of perspective is the representation of solid objects and threedimensional space in accordance with our optical perception of these things (and in direct opposition to a purely symbolic or decorative form of representation.) We see the world "in perspective": objects appear smaller as they recede into the distance; the walls of a corridor or an avenue of trees, for instance, appear to converge as they stretch into the distance. The laws of perspective are based upon these converging lines meeting eventually at a single, fixed "vanishing point," which may be visible – such as when an avenue of trees stretches as far as the eye can see – or is an imagined "vanishing point" – as when the converging lines of a room continue, in our imagination only, beyond the far wall.

One of Uccello's greatest works, which demonstrates his fascination with perspective, is *The Hunt in the Forest (102)*. Everything in it is organized upon a distant and almost unseen stag, a vanishing stag: the vanishing point. The bright little hunters, with their horses, hounds,

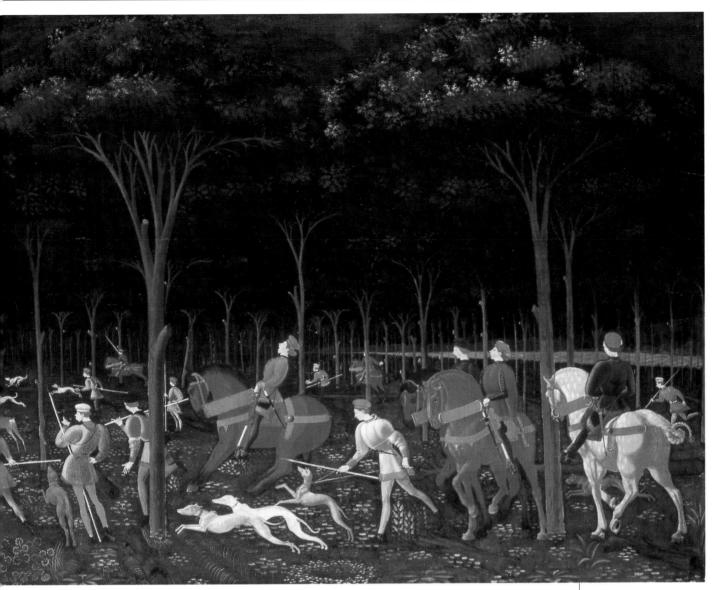

102 Paolo Uccello, The Hunt in the Forest, 1460s, 70 \times 29½ in (178 \times 75 cm)

and beaters, run from all sides among the slim, bare trunks of a darkly wooded landscape. While all this activity is frenzied, it is exquisitely purposeful and sane. Throughout this painting, we feel Uccello's comfort and his poetry.

Uccello was not the first Florentine to explore perspective. Brunelleschi, the architect who built Florence Cathedral's revolutionary dome (see p.82), demonstrated linear perspective as an element in architectural design in about 1413. However, it was Leon Battista Alberti (see columnleft) who pioneered its application to painting. His 1435 treatise *On Painting* had a widespread influence on contemporary artists. How widespread it was is something that we can never really prove. The fact remains that after Uccello, Brunelleschi, and above all Alberti, every artist had become alerted to the potential of this astonishing new insight.

THE VANISHING POINT

That Uccello's Hunt in the Forest demonstrates an effective rendering of perspective is shown in this miniature version. Lines have been added artificially to draw attention to features of the general composition that lead the eye to the vanishing point. At this point, the leading stag is disappearing into the forest.

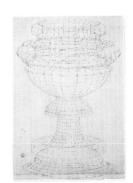

Uccello's studies

The complex perspective framework of Uccello's paintings was the result of meticulous study. In this drawing of a chalice, he tackles the perspective problems of drawing a rounded object in three-dimensional space.

103 Fra Angelico, The Beheading of St. Cosmas and St. Damian, c. 1438–40, $18 \times 14 \frac{1}{2}$ in $(46 \times 37 \text{ cm})$

SACRA CONVERSAZIONE

Fra Angelico's Virgin and Child Enthroned with Angels and Saints is an early example of a quintessentially Renaissance format: the sacra conversazione. Instead of being separated out into individual, hierarchical panels along a common frontal plane, the saints appear to have abandoned their niches, and, having stepped forward, they form a group in "sacred conversation" around the enthroned Virgin and Child. A popular variation was the marriage of St. Catherine to Christ, and many were painted as thanksgivings for victory.

THE DEVOUT ART OF FRA ANGELICO

The Dominican monk Fra Angelico (Fra Giovanni da Fiesole, c. 1400–55) was active at about the same time as Masaccio. He painted with great religious gravity and in remarkably luminous tones, but he is insufficiently seen as the bold experimenter that he truly was – not in theme, but in manner.

Despite the implications of his name, there is a satisfying humanity about Fra Angelico that takes pleasure in the substance of the material world. No questions are left unanswered in his Beheading of St. Cosmas and St. Damian (103). It is a scene of intense chromatic brightness, every form and hue bathed in the relentless light of a summer morning. The landscape is wholly realized, from the clarity of the white towers to the tall, dark cypresses and the receding swoops and rises of a hilly countryside. The two saints wait, blindfolded against the brightness and horror, and the three already decapitated sprawl in the messy scarlet of their blood, each head rolling on the grass in its hoop of halo. It is real death, painted without recourse to melodrama, but seen with the half-smile of a total believer.

It is tempting to look at the *Virgin and Child Enthroned with Angels and Saints (104)* and regard it as charming but conventional, since the graceful, sinewy lines and strong local color are derived from the Gothic tradition. But a closer look reveals that Fra Angelico was fully aware of the progressive tendencies in painting – of perspective and use of light especially – and the

104 Fra Angelico, The Virgin and Child Enthroned with Angels and Saints, c. 1438–40, 7 ft 3 in × 7 ft 6 in (220 × 229 cm)

SAN MARCO AND THE DOMINICANS

The Dominican order, of which Fra Angelico was a member, moved to the convent of San Marco in Florence in 1436. It was funded by Cosimo de' Medici, who also donated more than 400 classical texts to the library. It was at San Marco that Fra Angelico painted many of his best-known frescoes, including *The Annunciation*.

Luca della robbia

Much admired in his time, Luca della Robbia (1400–82) was a Florentine sculptor. He carved the beautiful marble cantoria (choir gallery) for Florence Cathedral in 1431–38. The carvings illustrate the 150th Psalm and depict angels, boys, and girls playing musical instruments, singing, and dancing.

OTHER WORKS BY FRA ANGELICO

The Madonna of Humility (National Gallery of Art, Washington)

> The Annunciation (Convent of San Marco, Florence)

St. James Freeing Hermogenes

(Kimbell Art Museum, Fort Worth, Texas)

Virgin and Child with St. Dominic and St. Peter Martyr (Church of San

Domencino, Cortona)

Virgin and Child (Cincinnati Art Museum)

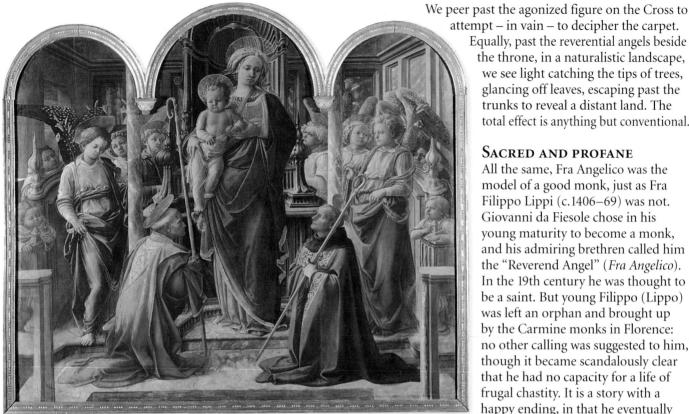

105 Fra Filippo Lippi, Virgin and Child, c. 1440-45, 8 ft x 7 ft 1 in (244 x 215 cm)

sculptural influence on his representation

OTHER WORKS BY FRA FILIPPO LIPPI

Virgin and Child (Walters Art Gallery, Baltimore)

Madonna and Child (Uffizi, Florence)

Adoration in a Wood (Staatliche Museen, Berlin-Dahlem)

Equally, past the reverential angels beside the throne, in a naturalistic landscape,

we see light catching the tips of trees, glancing off leaves, escaping past the trunks to reveal a distant land. The total effect is anything but conventional.

SACRED AND PROFANE

All the same, Fra Angelico was the model of a good monk, just as Fra Filippo Lippi (c.1406–69) was not. Giovanni da Fiesole chose in his young maturity to become a monk, and his admiring brethren called him the "Reverend Angel" (Fra Angelico). In the 19th century he was thought to be a saint. But young Filippo (Lippo) was left an orphan and brought up by the Carmine monks in Florence: no other calling was suggested to him, though it became scandalously clear that he had no capacity for a life of frugal chastity. It is a story with a happy ending, in that he eventually met a woman to cherish (incidentally,

a nun who had been "conventized" in much the same unthinking fashion as he was encouraged in his choice) and both were dispensed from their vows, and their marriage blessed.

Lippi's version of the Virgin and Child (105) surrounded by angels and saints may be compared with that of his truly devout brother in religion (see p.91). Lippi painted his version some years after Masaccio produced his frescoes in the

Brancacci Chapel in Florence (see p.85), and these were a crucial influence on

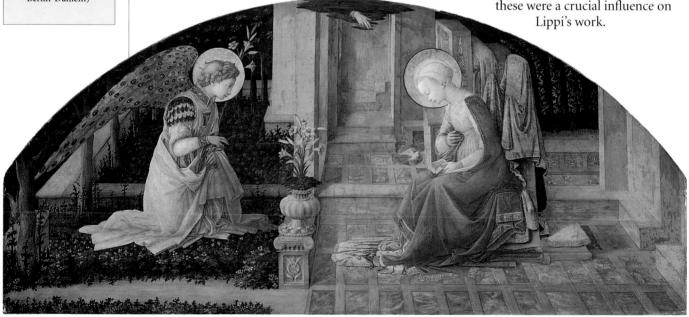

106 Fra Filippo Lippi, Annunciation, c. 1448–50, 60 x 27 in (152 x 68 cm)

However, the monumentality of form Lippi learned from Masaccio was to be tempered with a delicacy and sweetness similar to that found in Fra Angelico's paintings, and the serene mystical quality of his later paintings reveal growing Netherlandish influences in Italy.

Lippi's Virgin has a rounded physical presence, statuesque and forbidding despite its fullness, and the chubby Child looks rather disparagingly down on the kneeling St. Frediano. The angels too are heavily present, crowded in upon one another in a confusion of light-filled space. There is too much going on. The marbled walls behind push down on us, and the jeweled brightness of material and form takes on an almost claustrophobic weight. But when he simplifies his scene, it is rare to find a painter more moving than Fra Lippi.

His Annunciation (106) is a heavenly little work, with diaphanous veilings exquisitely rendered, and a lovely tenderness in the pure and gentle girl and her angelic messenger. This panel is thought to have been part of the bedroom furniture of some great noble, possibly Piero de' Medici (who patronized Lippi). The Medici family emblem – three feathers in a diamond ring – appears carved in stone beneath the vase of lilies, and in the companion piece, Seven Saints (108), all the saints are "connected" with the Medici: name saints of the family males. The seven sit dreamily on a marble garden seat, only St. Peter Martyr, with his emblematic hatchet in his head, looking glum.

That saints in general are happy seems a congenial belief to Filippo. His own son, the model for many of the Infant Jesus images, was himself to become a painter and likewise

(1457–1504), was orphaned at ten and brought up by Botticelli (see p.94), who had been taught by Lippi senior. Filippino's work shows that Lippi tendency to happiness, shadowed by the Botticelli sense of human frailty. There is a quivering gentleness in Filippino that is uniquely his own. *Tobias and the Angel (107)* is a moving work, but it floats ethereally before us, scarcely seeming to acknowledge the earth.

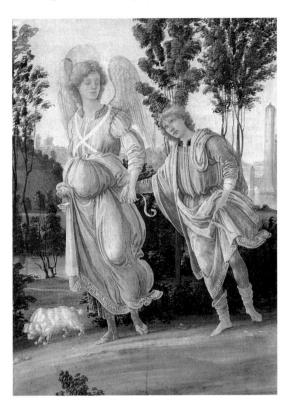

107 Filippino Lippi, Tobias and the Angel, probably c. 1480, 9 x 1234 in (23.5 x 32.5 cm)

Cosimo de' medici The Medici family dominated Florentine political life for much of the 15th and 16th centuries. The glorious epoch of the family began with Cosimo (1389-1464) who commissioned work from Ghiberti, Donatello, and Fra Angelico. His descendent, Cosimo I (1519-1574), depicted above, became Duke of Florence in 1537. He was a skilled but ruthless soldier who managed to annex the republic of Siena to Tuscany in 1555. He too was a great patron of the arts and had his own collection of Etruscan antiquities. This portrait, painted in 1537, is by Jacopo Pontormo (see pp.139-141).

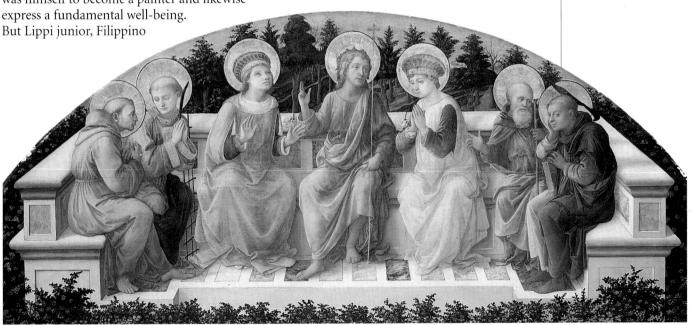

108 Fra Filippo Lippi, Seven Saints, c. 1448-50, 60 x 27 in (152 x 68 cm)

NEO-PLATONISM

This was a school of philosophy in which elements of the classical Greek systems of Plato, Pythagoras, and Aristotle were combined. It was first established in the 3rd century, but during the 15th century it was revised and made compatible with Christian belief. Neo-Platonism entailed a view of the universe in which ideas were more important than things, and the belief that the soul is endowed with virtues and is capable of an inner ascent to God. Cosimo de' Medici founded the Platonic Academy of Florence in 1459, employing the foremost theorist and classics translator of the time, Marsilio E. Ficino.

Anatomical Exactitude

The work of the Florentine artist Antonio Pollajuolo (c. 1432-98) and his brother Piero (c. 1441–94/6) influenced that of Botticelli. According to Vasari (see column, p.98), Antonio was one of the first artists to carry out dissections of the human body in order to study the underlying systems and structures. The Martyrdom of St. Sebastian, completed in 1475 and from which this detail is taken, clearly shows the results of this research.

BOTTICELLI: LYRICAL PRECISION

After Masaccio, Sandro Botticelli (Alessandro di Moriano Filipepi, 1444/5–1510) comes as the next great painter of the Florentine tradition. The new, sharply contoured, slender form and rippling sinuous line that is synonymous with Botticelli was influenced by the brilliant,

precise draftsmanship of the Pollaiuolo brothers (see column, left), who trained not only as painters, but as goldsmiths, engravers, sculptors, and embroidery designers. However, the rather stiff, scientifically formulaic appearance of the Pollaiuolos' painting of *The Martyrdom of St. Sebastian* (see column left), for instance, which

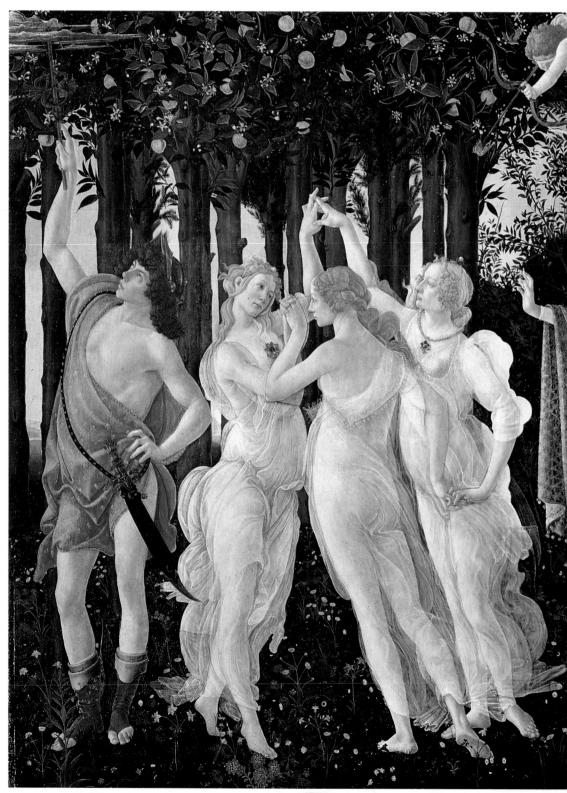

109 Sandro Botticelli, Primavera, c. 1482, 10 ft 4 in x 6 ft 9 in (315 x 205 cm)

clearly follows anatomical dictates, finds no place in the paintings of Botticelli. His sophisticated understanding of perspective, anatomy, and the Humanist debate of the Medici court (see column p.82) never overshadows the sheer poetry of his vision. Nothing is more gracious, in lyrical beauty, than Botticelli's mythological paintings Primavera and The Birth of Venus (see p.96), where the pagan story is taken with reverent seriousness and Venus is the Virgin Mary in another form. But it is also significant that no one has ever agreed on the actual subject of Primavera (109), and a whole shelf in a library can be taken up with different theories;

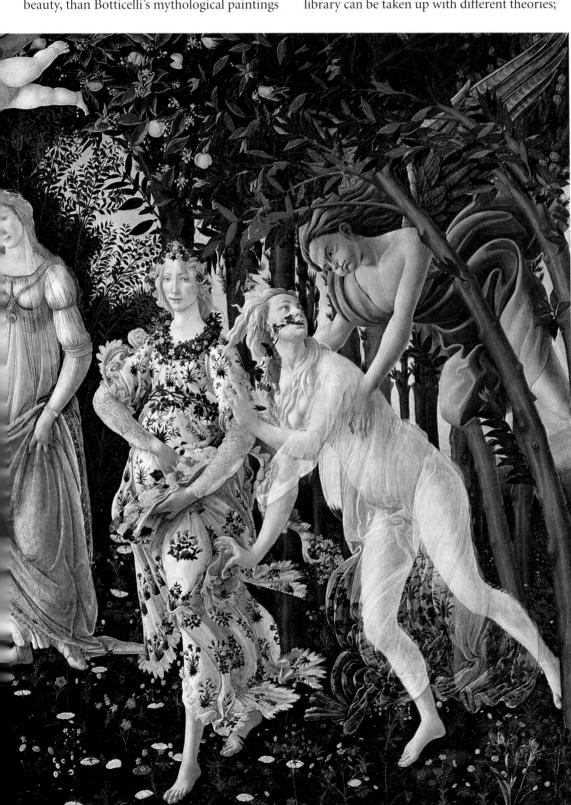

appears almost as if haunted by the idea of communicating the unembodied values of touch and movement.

B. Berenson, The Italian Painters of the Renaissance, 1896

MYTHICAL

Botticelli's Primavera is an allegory on the harmony of nature and humankind and contains many mythical figures, including Venus (the link between nature and civilization) and Mercury. At the extreme right of the painting, the figure of Zephyr (the west wind of spring) is seen chasing Chloris, who is then transformed into Flora, the goddess of flowers. A blindfolded Cupid shoots his arrows at the Three Graces (the handmaidens of Venus) who were believed to represent the three phases of love: beauty, desire, and fulfillment, This illustration shows a woodcut of Cupid, who was one of the most popular figures in Renaissance art.

THE BIRTH OF VENUS

This secular work was painted onto canvas, which was a less expensive painting surface than the wooden panels used in church and court pictures. A wooden surface would certainly be impractical for a work on this scale. Canvas is known to have been the preferred material for the paintings of nonreligious and pagan subjects that were sometimes commissioned to decorate country villas in 15th-century Italy.

THE WEST WIND

Zephyr and Chloris fly with limbs entwined as a twofold entity: the ruddy Zephyr (his name is Greek for "the west wind" is puffing vigorously, while the fair Chloris gently sighs the warm breath that wafts Venus ashore. All around them fall roses – each with a golden heart - which, according to legend, came into being at Venus's birth.

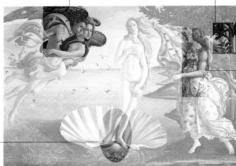

THE SHELL

Botticelli portrays Venus in the very first suggestion of action, with a complex and beautiful series of twists and turns, as she is about to step off her giant gilded scallop shell onto the shore. Venus was conceived when the Titan Cronus castrated his father, the god Uranus - the severed genitals fell into the sea and fertilized it. Here what we see is actually not Venus's birth out of the waves, but the moment when, having been conveyed by the shell, she lands at Paphos in Cyprus.

Nұмрн

The nymph may well be one of the three Horae, or "The Hours," Greek goddesses of the seasons, who were attendants to Venus. Both her lavishly decorated dress and the gorgeous robe she holds out to Venus are embroidered with red

and white daisies, yellow primroses, and blue cornflowers all spring flowers appropriate to the theme of birth. She wears a garland of myrtle - the tree of Venus - and a sash of pink roses, as worn by the goddess Flora in Botticelli's Primavera (p.94–95).

Wooded shore

The trees form part of a flowering orange grove - corresponding to the sacred garden of the Hesperides in Greek myth - and each small white blossom is tipped with gold. Gold is used throughout the painting, accentuating its role as a precious object and echoing the divine status of Venus. Each dark green leaf has a gold spine and outline, and the tree trunks are highlighted with short diagonal lines of gold.

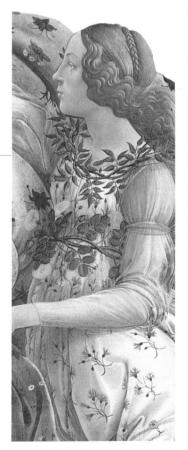

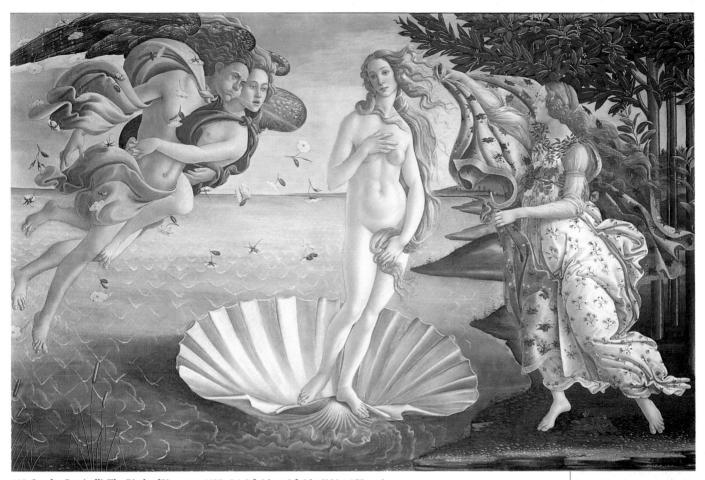

110 Sandro Botticelli, The Birth of Venus, c. 1485–86, 9 ft 2 in \times 5 ft 9 in (280 \times 175 cm)

but though scholars may argue, we need no theories to make *Primavera* (109) dear to us. In this allegory of life, beauty, and knowledge united by love, Botticelli catches the freshness of an early spring morning, with the pale light shining through the tall, straight trees, already laden with their golden fruit: oranges, or the mythical golden apples of the Hesperides?

At the right, Zephyr, the warm wind of spring, embraces the Roman goddess Flora, or perhaps the earth nymph Chloris, diaphanously clad and running from his amorous clasp. She is shown at the moment of her metamorphosis into Flora, as her breath turns to flowers that take root over the countryside. Across from her, we see Flora as a goddess, in all her glory (or perhaps her daughter Persephone, who spends half her time beneath the earth, as befits the patron saint of flowers) as she steps forward clad in blossoms. In the center is a gentle Venus, all dignity and promise of spiritual joy, and above her, the infant Cupid aims his loving arrows. To the left, the Three Graces dance in a silent reverie removed from the others in time also, as indicated by the breeze that wafts their hair and clothes in the opposite direction from Zephyr's gusts. Mercury, the messenger of the

gods, provides another male counterpart to the Zephyr. Zephyr initiates, breathing love into the warmth he brings to a wintry world, and Mercury sublimates, taking the hopes of humanity and opening the way to the gods.

Everything in this miraculous work is profoundly life-enhancing. Yet it offers no safeguards against pain or accident: Cupid is blindfolded as he flies, and the Graces seem enclosed in their own private bliss. So the poetry has an underlying wistfulness, a sort of musing nostalgia for something that we cannot possess, yet something with which we feel so deeply in tune. Even the gentle yet strong colors speak of this ambivalence: the figures have an unmistakable presence and weight as they stand before us, moving in the slowest of rhythms. Yet they also seem insubstantial, a dream of what might be rather than a sight of what is.

This longing, this hauntingly intangible sadness is even more visible in the lovely face of Venus as she is wafted to our dark shores by the winds, and the garment, rich though it is, waits ready to cover up her sweet and naked body. We cannot look upon love unclothed, says *The Birth of Venus (110)*; we are too weak, maybe too polluted, to bear the beauty.

LORENZO DE' MEDICI Succeeding in 1469 as head of the Medici family, Lorenzo "Il Magnifico" (the Magnificent) was a courageous, if autocratic, leader. He was a patron of the arts and assisted many artists, including Michelangelo and Leonardo da Vinci. Botticelli had some patronage from Lorenzo, but his chief patron was a cousin of Il Magnifico called Lorenzo di Pierfrancesco de Medici, or "Lorenzino."

THE MAGI

The Gospels speak of wise men from the east coming to Bethlehem, led by a star, when Christ was born. In the 2nd century these wise men (Latin: magi) became the subject of popular legends. They were thought to be kings, names were invented for them, and they were depicted as representing the three ages of man (youth, maturity, and old age). One was usually black, personifying Africa. By the 16th century, the Magi had acquired royal retinues, often including the family of the painter's patron.

Giorgio vasari Although a competent

painter and architect, Vasari (1511-74) earned lasting fame as an art historian and critic. This illustration shows the frontispiece of his most famous work, known as The Lives of the Artists. Published in 1550, the book issued the first real critical appraisal of artists as individuals and gave biographical details about them. Vasari also established the Accademia del Disegno, one of the first academies of art in Europe, which

was supported by the great

patron Cosimo de' Medici.

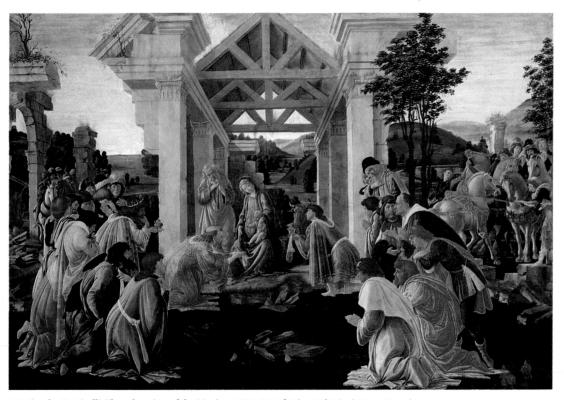

111 Sandro Botticelli, The Adoration of the Magi, c. 1485–86, 9 ft 2 in × 5 ft 9 in (280 × 175 cm)

Botticelli accepted that paganism, too, was a religion and could bear profoundly philosophical significance. His religious paintings manifest this belief by converging all truths into one.

He seems to have had a personal devotion to the biblical account of *The Adoration of The Magi (111)*, setting it in a ruined classical world. This was not an uncommon Renaissance device, suggesting that the birth of Christ brought fulfillment to the hopes of everyone, completing the achievements of the past.

But no painter felt this with the intensity of Botticelli. We feel that he desperately needed this psychic reassurance, and that the wild graphic power of his *Adoration*'s great circles of activity, coming to rest on the still center of the Virgin and her Child, made visible his own interior circlings. Even the far green hills sway in sympathy with the clustered humans as if by magnetic attraction around the incarnate Lord.

Botticelli was not the only Florentine to be blessed or afflicted by an intensely anxious temperament. In the 1490s, the city of Florence was overtaken by a political crisis. The Medici government fell, and there followed a four-year period of extremist religious rule under the zealot Savonarola (see column, facing page). Either in response to this, or possibly out of some desire of his own for stylistic experimentation, Botticelli produced a series of rather clumsylooking religious works – the *San Bernabo Altarpiece* is an example.

THE STRANGE WORLD OF PIERO DI COSIMO

Piero di Cosimo (1462–1521) did not live. like Botticelli, in the enlightened ambience of the Medici court. He was a man who actively required some sort of seclusion so as to conserve his energies and explore his preoccupations. (He even went so far as to live on boiled eggs, we are told, cooking them 50 at a time, so as to be free of the mundane concerns of the mere body.) Yet in The Visitation with St. Nicholas and St. Anthony Abbot (112), he displays a wonderful sense of the body, its weight and presence. When he shows the Virgin Mary, still bewildered by the angelic annunciation of her sacred pregnancy, coming to greet her elderly cousin Elizabeth, also blessed with a miraculous pregnancy, the two women approach each other with a touching reverence.

Each is primarily conscious of the child in her womb, and Elizabeth is about to cry out to tell Mary that the unborn John the Baptist within her has leapt for joy at the nearness of the unborn Jesus. Piero merely shows us the two touching each other with a wondering reverence, yet the profundities are all the more present for being unexpressed.

But, as in all Piero's pictures, there are strange elements here. The women are flanked by two elderly saints: St. Nicholas, identifiable by the three golden balls at his feet (the dowry he anonymously threw into the house of an impoverished father of three marriageable

daughters, see p.53); and St. Anthony Abbot, whose unromantic emblem of a pig rootles happily in the background. To the right, behind Elizabeth, a furious scene, swarming with violence, depicts the massacre of the innocents, and in the shadows behind Mary, we find a quiet and almost insignificant nativity. Do the saints, engrossed in their reading and writing, "see" these things in their minds? What is actually happening and what is imagined?

Piero leaves us with engrossing problems to ponder. "The strangeness of Piero's brain," as Vasari (see column, left) described it, is seen even more in his nonreligious paintings like this mysterious *Allegory* (113), with its mermaid, comical white stallion, and winged maiden, standing on a tiny island and holding the beast by a thread. We look with delight, but never find an answer. Piero's interest in animals and the exotic is revealed in many of his paintings. He included a snake in his *Portrait of Simonetta Vespucci*, a satyr and a dog in *Mythological Scene*, and various animals in his *Hunting Scene*.

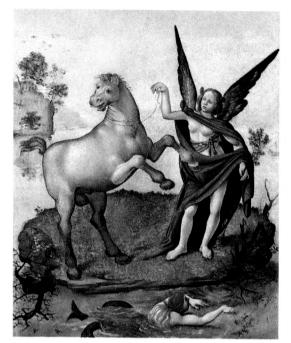

113 Piero di Cosimo, Allegory, c. 1500, 17¹/₃ x 22 in (44 x 56 cm)

112 Piero di Cosimo, The Visitation with St. Nicholas and St. Anthony Abbot, c. 1490, 6ft 2 in x 6ft ½ in (189 x 184 cm)

SAVONAROLA

This medallion of the Dominican friar, reformer, and martyr Girolamo Savonarola (1452-98) was made by Ambrogio della Robbia. As prior of San Marco, Savonarola strongly criticized the Medici government. Then, in 1494, Piero de' Medici's regime was overthrown and Savonarola became the effective leader of Florence. He set up a popular government, based on a council of 3,200 citizens, which aimed to enforce religious observance in all aspects of daily life. Unfortunately, in the years that followed, the city was afflicted by famine, plague, and war, which so reduced his popularity that he was asked to leave. He was declared a heretic, and in 1498 he was hanged and his body burned.

MAJOLICA WARE

A type of tin-glazed earthenware known as majolica ware (or maiolica ware) was popular in Italy during the Renaissance. The name is derived from Majorca, the island off Spain through which the pottery was originally imported from North Africa and the Near East. This example is by Nicola da Urbino, one of the finest Majolica painters.

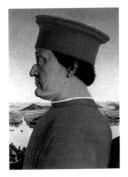

THE DUKE OF URBINO

One of Piero della Francesca's patrons was the first Duke of Urbino, Federigo da Montefeltro, whose portrait he painted (above). The Duke led several armies during the territorial battles of the 15th century, but was also a renowned scholar. His palace at Urbino was one of the important small courts of Italy and contained his extensive library.

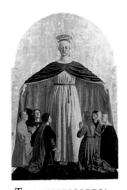

The misericordia

The Compagnia della Misericordia was founded in Florence in the 13th century to carry out missions of mercy, such as transporting the sick to hospitals, and the dead to burial. In 1445, the organization commissioned Piero della Francesca to paint an altarpiece for Borgo Sansepolcro. The central figure in the work is the Madonna of Mercy, who was patroness of the Misericordia. The organization is still active today.

PIERO DELLA FRANCESCA'S SOLEMN GENIUS

The "other" Piero is far better known, and with justice. It can come as a shock to learn that the present admiration for Piero della Francesca (c. 1410/20-92) is of comparatively recent origin. His intensely still and silent art went out of fashion not long after his death, and its sublime restraint of expression was seen as inadequacy. Yet Piero della Francesca is one of the truly great masters of all time. He was born in the small town of Borgo Sansepolcro in Umbria, central Italy. In Piero's wide vision we can see the lovely defining light and sculptural form of Masaccio (see p.82) and Donatello (see p.83), brilliant clarity of color, together with a new interest in "real" landscape, which was influenced by his master Domenico Veneziano (see p.86) and by Flemish artists. When his eyes dimmed in later life, Piero turned increasingly to his other abiding interest, mathematics, and as a branch of mathematics, perspective (see p.88). He was also a theorist, and, like Alberti (see p.88), wrote two treatises on the mathematics of art.

RELIGIOUS LANDSCAPES

The Baptism of Christ (114) takes place in an eternal dimension, even though those little streams and terraced hills are purely Umbrian. Piero's admiration of ancient art, which he studied in Rome around 1450, is manifested in the dignity and classical form of Christ, and of St. John and the angels. The tall and slender column of manhood that is Jesus, Son of the Most High, is paired with the tall and slender column of the tree. The tree in turn is

aligned with the majestic figures of the waiting angels. John the Baptist is another vertical, a slightly inclining one, solemnly performing his sacramental baptism with water from the river that, as told in legend, has stopped flowing at Christ's feet. A disrobing penitent, leaning forward, both continues and varies the vertical theme. A group of theologians debates, clothes brightly reflected in the stilled water.

The invisible element, the Holy Spirit, is all-pervading, as a pure, crystalline early morning light, and in material form as a dove hovering horizontally with outspread wings, sanctifying the baptism with golden rays (only

barely visible now), that shine down over Christ's head. The dove is the only presence in the baptismal group that could be reflected in the limpidity of the waters, but is not; it is unseen by all eyes but our own. There is such poetry in the sunlight and the high sky, the flowers, and the simple brightness of the garments that it is impossible not to believe, as Piero does, that we who contemplate the scene are literally blessed.

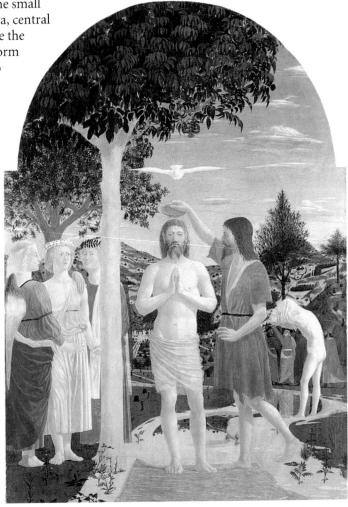

114 Piero della Francesca, The Baptism of Christ, 1450s, 46 x 66 in (117 x 168 cm)

Even a detail like the great overarching mass of foliage in the trees overhead seems to be weighted with holy significance. But Piero never presses home any symbolism, he never intrudes to put forward an interpretation. It has been remarked that everything in this picture is mathematically calculated to give the maximum impact, and one can even draw diagrams to show the underlying intelligence behind the structure. But our response comes immediately, affected unconsciously by this intelligence. Piero has that rare gift: he is effective – his pictures work; and he affects – we are moved by them.

THE BAPTISM OF CHRIST

This was originally the central panel of a large triptych. The rest of this triptych was painted by Matteo di Giovanni in about 1464. Piero's natural, almost casual depiction of this solemn ritual belies the work's sophisticated composition, and though its structure can be reduced to strict mathematical proportions, it is one of Piero's least mathematically controlled paintings.

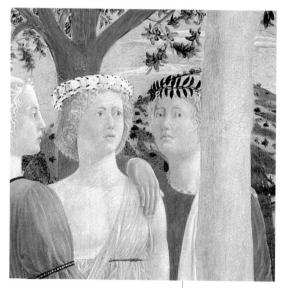

ANGELS

The compact trio of angels is divided from the mortal world by the tree. They stand together with a charming degagé air, holding hands, their large and lovely flat feet planted solidly on the grassy meadow. The angels are witnessing Christ's baptism and affirm its importance with serene certainty. Piero shows us only a glimpse of the wing of the far angel, in which a few flecks of gold are still visible, and the landscape visible beneath.

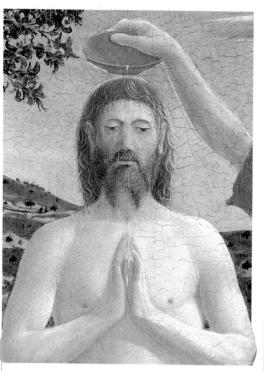

CHRIST

The ritual anointing is performed in the deep, silent absorption of prayer, signified by the quiet concentration of John and Jesus. Christ's body has the whiteness of a bleached shell, His outer cleanliness echoing His symbolic purification through baptism – presided over by the Holy Spirit in the form of a white dove. A kind of spiritual force field separates John from Christ. He moves toward Christ, yet his free hand does not enter the unbroken divide between them.

DISTANT TOWN

Piero shows us the small town of Borgo Sansepolcro, with its fortified towers appearing piteously small and insignificant in the distance. Piero's treatment of the distinctly Umbrian landscape immediately distinguishes him from his contemporaries and displays an unprecedented naturalism. It reveals the extent to which Piero was influenced by Netherlandish art.

BENDING FIGURE

The half-naked figure standing at the river's edge in the middle distance is stripping off his clothes in readiness for his own baptism. His nakedness is symbolic of his humility before the Almighty, and contrasts sharply with the extravagant and even kingly headgear and costume of the high priests, who stand farthest away and are given the smallest stature in Piero's hierarchy. The identity of the penitent is hidden – a temporary concealment hinting at the new life he will begin after baptism. His body - like Christ's - is bathed in a brilliant white light.

THE LEGEND OF THE TRUE CROSS

Several early Italian Renaissance frescoes depict the medieval legend that traces the history of the Cross from its beginnings as a branch of the Tree of Knowledge in the Garden of Eden until its recovery by the **Emperor Heraclius** in the 7th century. In Piero's version (see right), King Solomon orders the branch to be used in the building of his palace. However, because the branch is too large, it is used instead as a bridge across a stream. When the Queen of Sheba comes to visit Solomon, she worships the wood and then explains how she has had a vision that the wood will one day be used as the Cross for Christ's Crucifixion.

THE BAPTISTERY DOORS

In 1401, a competition was launched to produce a set of panels for the east doors of the Baptistery, a building next to the cathedral in Florence. Seven sculptors, including Brunelleschi (see column, p.82), were chosen to compete, using the Sacrifice of Isaac as a theme. The winner was Lorenzo Ghiberti (1378-1455). The subject was changed to the Life of Christ. This took Ghiberti 20 years to complete, and was finally installed on the north doors. Ghiberti then began the work that was actually installed on the east doors. These ten bronze panels, which include the one shown above, were called the "gates of Paradise" by Michelangelo.

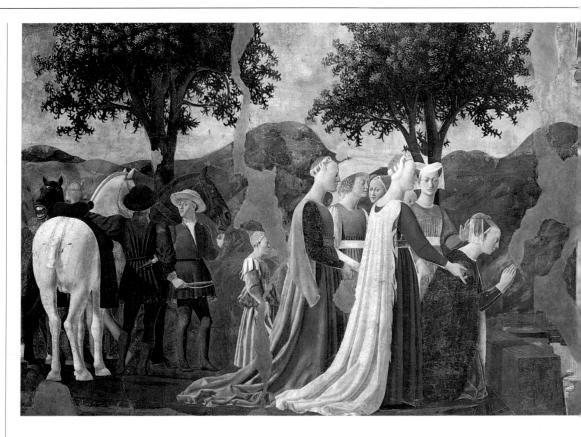

PIERO'S MASTERPIECES

Although Piero has a claim to being the perfect painter, every one of whose paintings is wonderfully good, his greatest work is the fresco that makes magnificent the church of St. Francis in the town of Arezzo, near Piero's birthplace. *The Story of the True Cross (115)* runs around the walls, telling all aspects of the legend, from the supposed beginning of the Cross as a

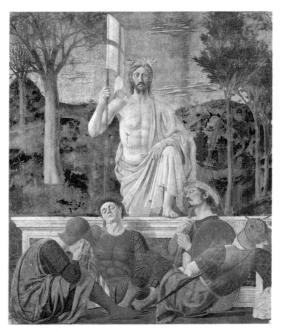

116 Piero della Francesca, Resurrection of Christ, early 1450s, 6 ft 9 in × 7 ft 5 in (205 × 225 cm)

tree growing in Paradise, up to the miraculous Finding of the Cross by St. Helena, the mother of Constantine the Great. The story is legend from start to finish, yet Piero treats it with such reverent solidity that archetypal truths are revealed. When the Queen of Sheba, proceeding in stately fashion toward her encounter with Solomon, "adores the wood of the Cross," the quiet passion of that bending neck tells us of the meaning of adoration, and its loveliness.

Although she and her maidens are cut from the same cloth pictorially (tall, willowy, swan-necked beauties) it is only the queen who understands the challenge of the holy and prostrates her regal self. Behind her the pages gossip, beside her the maids of honor look interestedly on. She alone has understood the full dimensions of the finding. As ever in Piero, there is an air of silence so profound as to halt all movement in its tracks, and immortalize the scene that is depicted.

Another work, the *Resurrection of Christ* (116), has actually been described as the greatest picture ever painted (its only rival for this honor being Velázquez's *Las Meninas*, see p.194). The two masterpieces are utterly different, Piero's having a unique sublimity. Its gravely heroic Christ, impassive and heraldic, enters life as a somberly compassionate Conqueror, lifting the sleeping world up onto a new plane of being. It was painted for the town hall of Borgo Sansepolcro – Italian for "the Holy Sepulcher."

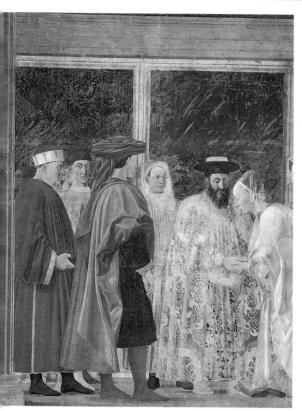

115 Piero della Francesca, The Story of the True Cross, c. 1452–57, 24 ft 6 in x 11 ft in (747 x 335 cm)

SOLIDITY IN MANTEGNA'S ART

There is something of Piero's silent massiveness in Andrea Mantegna (1431–1506), the first great artist from northern Italy. He belongs to the Florentine tradition in that his art showed the expressly Florentine concerns with scientific debate and classical aspiration, but as the leading artist of northern Italy he belonged also to that of nearby Venice. He is first heard of as a young man in Padua, struggling, by means of a lawsuit, to free himself from his teacher and adoptive father, Francesco Squarcione.

A sort of lonely freedom is basic to Mantegna's temperament, as we understand it, and there is something rather appropriate in his dual attempt to gain his legal independence and to plot with fierce intellectual clarity the frescoes on the walls of the Eremitani chapel. Although nearly all this work was destroyed or damaged during World War II, enough remains to indicate the almost awesome originality of his painterly approach.

The irony is that Mantegna would have claimed not originality, but a rigorous conservatism, and his art is a rejection of the more relaxed, painterly styles that were emerging in Venetian art. He may have benefitted from the teaching of Squarcione, who did at least possess an unrivaled set of antique drawings, but the sculptural quality of Mantegna's art makes it far more likely that he was influenced by local

examples of work by Donatello (see pp.83, 105). Many of Mantegna's paintings take on the appearance of a pictorial bas-relief akin to Donatello's and Ghiberti's sculpted panels (see p.102), and these works subsequently influenced High Renaissance painting, notably that of Raphael (see p.125).

For some, this sculptural bias has made Mantegna's art seem bloodless. It is severe, monumental, thought out from within. But it can strike us as all the more impressively emotional for that very need, experienced so intensely, to protect himself from the vulnerability of self-exposure. The task is impossible, since every major artist can only create from his own heart, and the attempt to conceal is as revealing as the desire to expose. Mantegna had left Padua to be court artist at Mantua when he painted *The Death of the Virgin (117)*, a great tableau where emotion is frozen into a sort of

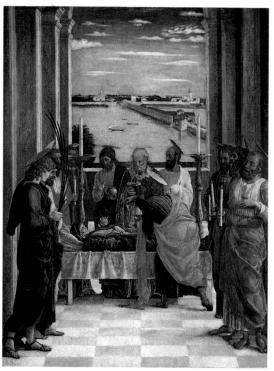

117 Andrea Mantegna, The Death of the Virgin, c.1460, 16½ × 21¼ in (42 × 54 cm)

icy passion. The apostles gathered around the bier are heavy with minutely observed grief. The Virgin is revealed with direct, personal simplicity in the humiliation of death. The drama is framed and given its context by the vast Mantuan landscape, which gleams in remote perfection behind the window. The waters lie still, the ramparts offer the pretense of human inviolability, and the serene sun bathes lakes, palaces, priests, and the dead Virgin in the same quiet light.

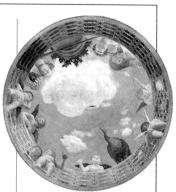

PERSPECTIVE SKILLS

This fresco was painted on a ceiling of the Gonzaga Palace in Mantua by Mantegna in 1465–74. In creating the illusion of an opening to the sky, the artist makes humorous use of Albertian perspective (see p.89), especially in the foreshortening of the winged figures.

OTHER WORKS BY PIERO DELLA FRANCESCA

Madonna of Mercy (Borgo Sansepolcro) Federigo da Montefeltro (Uffizi, Florence) The Nativity (National Gallery, London) St. Jerome in the Desert (Staatliche Museen, Berlin-Dahlem)

SINOPIA

This was a technique of using red ochre to draw initial guides for fresco painting. Each day, a section of the sinopia was plastered over and painted. The 1966 flood in Florence damaged a number of Renaissance frescoes. As part of the restoration work, some were removed from the walls on which they were created, thereby exposing the sinopia. This provided insight into the artists' working practices and showed that they often introduced changes between the drawing of the original guides and the final representations.

HOSPITAL OF THE INNOCENTS

This medallion of a swaddled infant decorates the facade of the Florentine hospital that was established to take in orphans and sick children. The hospital, which was completed in 1426, was designed and built by Brunelleschi (see p.82) and is often called the first Renaissance building.

118 Andrea Mantegna, Portrait of a Man, probably c. 1460, $7\frac{1}{2} \times 9\frac{1}{2}$ in $(19 \times 24$ cm)

Portraits of the gonzagas

Mantegna was commissioned to paint portraits of members of the influential Gonzaga family in Mantua. Even in these intimate pictures, which are unique for their historical immediacy, he always contrives to show us both the actual, which we can recognize, and the hidden ideal, which we can revere. This is apparent even in this small-

scale work, the *Portrait of a Man (118)*, where the unknown sitter is strongly individual and yet recalls to us the moral imperatives of duty and courage.

In his love for the solid reality of sculpture, Mantegna went so far as to perfect a form of grisaille (monochrome painting that imitates the effect and color of stone relief). The texture resembles stone, yet in his hands it was fully alive. He might have chiseled out the dramatic panel of *Judith and Holofernes* (119), where the Junoesque heroine stands impassively before the rigid folds of the tent in which she has murdered

This wonderful paradox, Mantegna's special gift, is fortuitously duplicated for us, for he painted another version (119), in somber richness of color. The stony non-color of the tent and the figures contained within its shade changes to a harmony of radiant pinks, oranges, ochres, and blue-greens. One work, in Washington (120), emphasizes the distancing; the other, in Dublin (119), the intensity. Both have a still and stately beauty that is unforgettable.

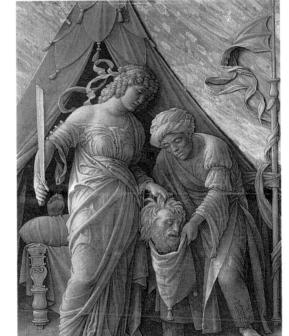

119 Andrea Mantegna, Judith and Holofernes, 1495–1500, 14½ x 19 in (37 x 48 cm)

T

THE GONZAGA FAMILY The Gonzaga court at Mantua was an important center for the arts. Ludovico Gonzaga was a generous patron who had traveled to the Medici court to gain ideas about leadership. This inspired him to undertake a plan of urban renewal, commissioning Alberti (see column, p.88) to build several churches. Another artist to benefit from Gonzaga patronage was Mantegna. The illustration above is a detail from a family portrait of the Gonzagas that he completed in 1474.

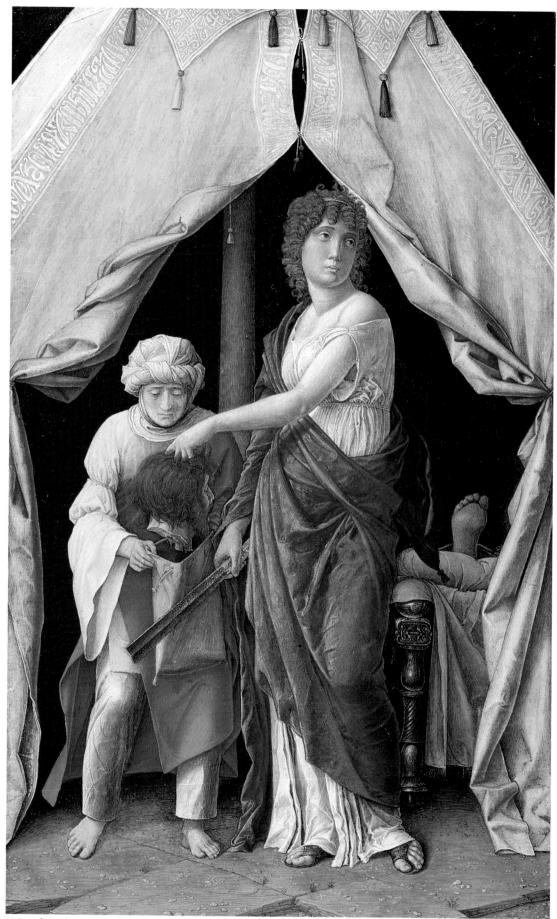

120 Andrea Mantegna, Judith and Holofernes, c. 1495, 7×12 in $(18 \times 30$ cm)

Donatello's Judith

As a close personal friend of Cosimo de' Medici, Donatello was given the artistic freedom to produce this highly controversial sculpture of Judith slaying Holofernes in 1456. The Jewish heroine who murdered the Philistine (Assyrian) general Holofernes to protect her people was meant to symbolize humility overcoming pride, but the bronze was considered too disturbing by many Florentines, who petitioned successfully for its removal from the Piazza della Signoria.

OTHER WORKS BY MANTEGNA

Crucifixion (Louvre, Paris)

St. Sebastian (Kunsthistorisches Museum, Vienna)

Dead Christ (Brera Gallery, Milan)

Virgin and Child with the Magdalen and St. John the Baptist (National Gallery, London)

Dido (Montreal Museum of Fine Arts)

The Dead Christ with Two Angels (Statens Museum for Kunst, Copenhagen)

Renaissance Venice

Painting that was produced in Renaissance Venice belonged to the northern Italian tradition and had an identity and genealogy all its own. While Venetian artists also explored problems of perspective and mathematics and were unavoidably influenced by the fertile art of Medician Florence – the heartland of the Renaissance – there emerged in Venice a new, essentially "painterly" tradition. Venetian painting showed less concern with sculptural form and hard-edged delineation, placing more emphasis on color and nuances of light. From the beginning, it contained a peculiarly gentle lyricism, quite distinct from the Florentine tradition.

The artist great enough to lead painting into its next phase, and in doing so, greatly influence the course of Western painting since, was Giovanni Bellini (c. 1427–1516). He belonged to a family of artists, composed of his father Jacopo (c. 1400–70/71) and his brother Gentile (c. 1429–1507). The two brothers were taught by their father (who had been a pupil of Gentile da Fabriano, see p.56) in accordance with the artistic tradition in Venice, in which skills were passed down through generations. The two generations of Bellinis became the most influential group of artists in northern Italy, and just as the early Renaissance

is bound up with 15th-century Florentine culture, the Bellinis were responsible for the distinctly Venetian heritage of the High Renaissance of the late 15th to early 16th centuries.

INFLUENCE OF MANTEGNA

Although Mantegna (see p.103) stands alone, he had, in fact, a close and fruitful relationship with the Bellini family of Venice. (He was even a literal relation, in that he married Nicolosia, sister to Giovanni and Gentile. She does not seem to have softened him much – he remained litigious and oversensitive to the end.) But the hard beauty of

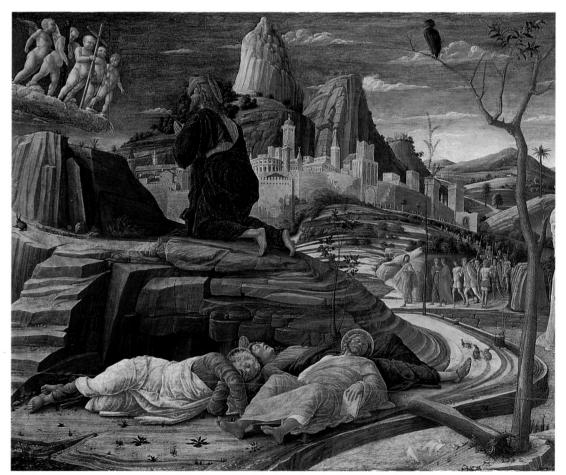

121 Andrea Mantegna, The Agony in the Garden, c. 1460, 32 x 25 in (81 x 63 cm)

VENETIAN TRADE

In the 16th century, Venice was an independent and imperial city with a state-owned arsenal of ships employing 10,000 workers. The city was the Italian gateway to the Mediterranean for trading in silks, pigments, and spices. Venice was renowned as the center of the pigment trade, and it is known that Raphael, for example, sent an assistant there from Rome to purchase particular colors.

AGONY IN THE GARDEN

This theme was popularized in the Renaissance by artists such as Bellini, Mantegna, and El Greco (see p.146). After the Last Supper and before His arrest, Christ retired to the Mount of Olives to pray. The "agony" is the contest between Christ's human weakness and His divine confidence and belief in His resurrection. In Renaissance paintings of this scene, Christ traditionally kneels on a rocky outcrop as the three disciples sleep.

Mantegna's own work certainly affected that of his brothers-in-law. Giovanni Bellini is one of the supreme painters of all the ages, able to accept the spare majesty of Mantegna and yet transform it into his own subtle sweetness. Sometimes we can actually watch influences being absorbed.

Both painters, coincidentally, have a version of The Agony in the Garden in the National Gallery, London. Mantegna's (121) is thought to have been painted about five years before Bellini's, and the younger artist, Bellini, always regarded his own work as lesser in quality. Yet the contest is very close; both paintings have a gaunt and rocky landscape setting, appropriate for the austerity of the drama. Both excel in figural perspective, showing the sleeping apostles in abrupt foreshortening. Both have the praying Christ half turned away, isolated on His jut of stone, bare feet vulnerable in His absorption upon His Father and His fate. In both paintings we see in the distance the approaching figures of the soldiers coming to arrest Jesus, led by the betraying disciple Judas.

But the two works are subtly different. It is not just that Mantegna is far more interested in the actual geophysical structure of the rocks, but that Bellini's world (122) is less aggressive, less confrontational. It may only be a question of degree, yet it modifies the feeling of the picture, makes it more tender, more visually ambiguous. It is here that Bellini's greatest gift is displayed: his sense of light in all its specificity.

It is sacred "time" in Mantegna, the "hour" of which Jesus spoke, removed from the mundane time of the normal day. Mantegna's sky, like his frozen and brooding city, is eternal. But Bellini shows us a real city faintly glimmering into visibility beneath the gentle skies of early morning. Light is beginning to flood with its warmth the cold night where Jesus has labored in painful prayer, and the angel of consolation, solid in Mantegna, floats solitary and ethereal in Bellini, a dawn apparition that will dissolve into cloud.

The mature Bellini understood light with mystical fervor. It had a sacred significance for him, one that he could share with us without ever lapsing into the explicit. Bellini is an extraordinary artist, a man sensitive to beauty, aware of the significance of form, and inspired by a passionate love, both of the visible and the invisible, that makes his work moving on every level. There is no Bellini painting that we cannot respond to with joy and a deeper understanding of what our existence is all about.

BELLINI FAMILY The Bellinis formed one of the most prominent and successful families of Renaissance painters. Father Jacopo's silverpoint sketchbook was the inspiration for many of Giovanni's paintings, which in turn inspired the young Giorgione and Titian. It featured mythological characters (such as Perseus with the head of the Gorgon, shown here), as well as classical, biblical, and imaginative subjects.

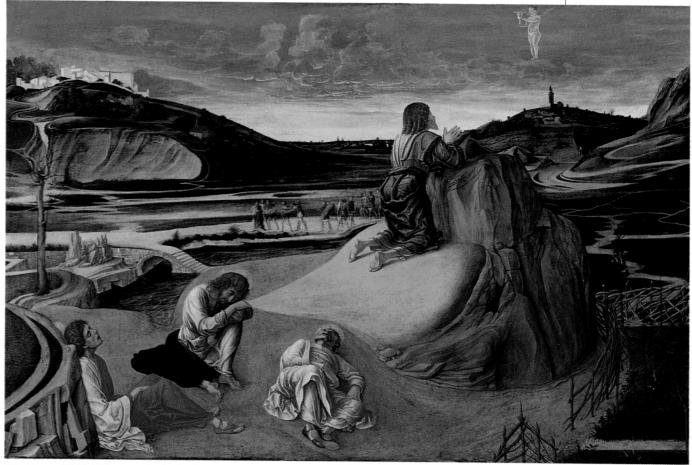

122 Giovanni Bellini, The Agony in the Garden, c. 1460, 50 x 32 in (127 x 81 cm)

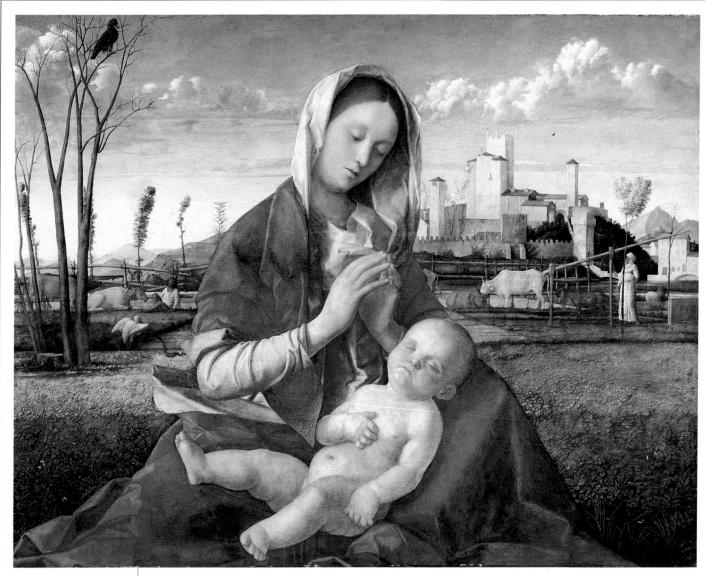

123 Giovanni Bellini, The Madonna of the Meadow, c. 1500-05, 34 x 261/2 in (86 x 67 cm)

St. JEROME

This detail from St. Jerome by Ghirlandaio (see p.121) shows equipment used to copy ancient texts. Jerome was a popular figure in Renaissance art, as he symbolized the ideal of the Humanist scholar. His great achievement was to translate the Bible into Latin.

The Madonna of the Meadow (123) may appear to be a typical Madonna, albeit a very enchanting one. But it is, in its understated manner, almost a revolutionary painting. Scholars have always pitted Florence against Venice, ever since Vasari, the great early art historian (see p.98), quoted his hero, Michelangelo, as lauding form above color, and deploring the Venetian concentration on the latter. In this sense, Giovanni Bellini is the "first" Venetian painter.

He initiates in us the awareness of a magical, enveloping brightness, a palpable light in which all colors shine at their loveliest. In this colorworld, there is no longer man and woman in the midst of nature, but humanity as part of nature, another expression of its truth. The very texture of the harsh soil, the low lattices, the defended well, all have an undemonstrative integrity that has some mysterious, inexplicable connection with the strong pyramid of Mother and Child at the center of the picture.

Madonnas are a common idiom in Renaissance painting. There was hardly an artist who did not attempt this great theme. We can understand why. The wonderful thing about the Madonna and Child theme is that it appeals both to the specifics of Christianity (where the humanity of Christ is a central mystery) and to the human values on which all religion is based, throughout the world.

Every painter had a mother. Every psyche has been affected by this fact. To explore this fundamental of human existence had an irresistible fascination for the artist. No one has ever been more sensitive to this fundamental subject than Bellini. Every one of his Madonnas has an aesthetic and a spiritual force that makes them all memorable. He understands, at an elemental level, the meaning of motherhood and childhood, and this is the basis of the conviction that we see behind his Madonnas. This is only a sample, but an excellent one.

Madonna of the Meadow

Bellini was famed for his paintings of the Madonna and Child. From his 65-year-long career, no fewer than 14 of the major works that survive center on this, his favorite theme. It is one of the most ancient of all religious subjects, yet Bellini was able to invigorate what had become a formula, an icon, with a fully convincing depiction of the sacred and the human.

OF DEATH

A large raven broods heavily over the meadows, a reminder of the ever-present figure of death. Death, however, assumes a small scale in comparison to the monumental serenity of the Madonna and Child, who affirm life after death. The bird perches high up in the small, thin, leafless trees that sway imperceptibly against the luminous pallor of the sky. Though its role is symbolic, the bird is integrated into the natural order of life.

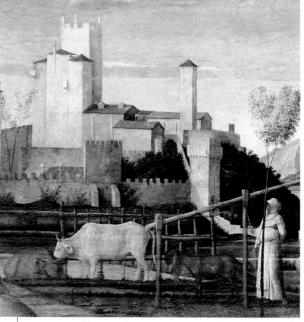

VENETIAN LANDSCAPE

On the right, divided from death by the towering figure of Mary, are the sober activities of life. Despite the gloomy presence of death, the daily life of the natural world goes calmly on. A farmer tends to the livestock in the field. Above them, an insubstantial line of cloud drifts slowly over the softly gleaming ramparts of the little city, whose concerns of government and commerce are rightly distanced from the great theme of life and death that Bellini dwells upon. And this is no walled garden, with cherubim and angels floating amid exotic flowers and cultivated hedgerows, but the real, solid world – Bellini's world – in the province of Venice.

MORTAL STRUGGLE

Easy to miss in the middle distance, and on the side of death, is a little egret, fighting with a snake. Wings raised in a threatening gesture, the egret circles the snake. This combat symbolizes the fight between good and evil. It may also refer to Christ's struggle before His sacrifice, and the reason for His sacrifice - the serpent's entry into the Garden of Eden. (It is interesting to note that there is also a pair of little egrets in the foreground of Mantegna's Agony in the Garden, see p.106.)

MOTHER AND CHILD

The blue and russet of Mary's robes are intensifications of the material world that surrounds her: earth and sky. She sits on bare earth, not as a queen enthroned in majesty (think of Duccio's Maestà, p.42), but as the Madonna of Humility, a 14th-century tradition. Though her robes form a pyramid and her scale is monumental, her humility appears real, and no mere pictorial convention. This is Bellini's greatness: the uniting of the symbolic and the real, drawn together by a common and natural light source, in chromatic harmony with each other, so that we believe in Mary all the more implicitly.

THE CITY STATES OF ITALY

During the Renaissance northern Italy was one of the wealthiest regions in Europe. Genoa and Venice both had populations of around 100,000 by 1400 and were the main centers of trade. Florence, with a population of 55,000, was the center for manufacturing and distribution. A sense of civic pride known as campanilismo ("love for the bell tower") was characteristic of the Italian city dweller.

Music in the renaissance

This painting by Lorenzo Costa, dating from c. 1500, shows a lute player and singers performing a frottola, a simple song for one or a group of voices with an instrumental accompaniment. During the 16th century it became the prevailing form of refined music. The frottola later developed into the madrigal.

OTHER WORKS BY BELLINI

Pietà (Brera Gallery, Milan)

St. Francis in Ecstasy (The Frick Collection, New York)

Virgin and Child Between St. John the Baptist and St. Catherine (Accademia, Venice)

The Doge Leonardo Loredan (National Gallery, London)

Virgin and Child (Museum of Art, New Orleans)

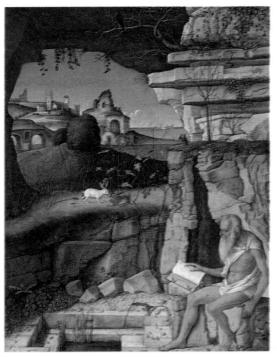

124 Giovanni Bellini, St. Jerome Reading, c. 1480/90, 15½ x 19½ in (39 x 49 cm)

There is this same magical involvement in his *St. Jerome Reading (124)*, where the center of attention is not the noble saint, still less his attendant lion comfortably snuggled at his back, but the wonderful white hare, nibbling at the leaves with the same disinterested attitude as the saint brings to his mental fodder, his book. St. Jerome, that renowned scholar, is oblivious, but the little animal is bright in the wintry sunlight, and makes us aware of the beauty of the created world, with its rocks, leaves, lagoons, and stones.

A splendid Bellini, *The Feast of the Gods (125)*, was modified into even greater splendor by no less an artist than Titian (see p.131). It is still quintessentially Bellini: all the gods are characterized and something of their legends and relationships given pictorial form, all in a golden light of high classical dignity. Another sign of his greatness as an artist is that having led the way for Giorgione and Titian (who heralded an entirely new phase of painting), the aging Bellini allowed himself to be led by the younger artists and, adapting his own style, produced masterpieces even in his eighties.

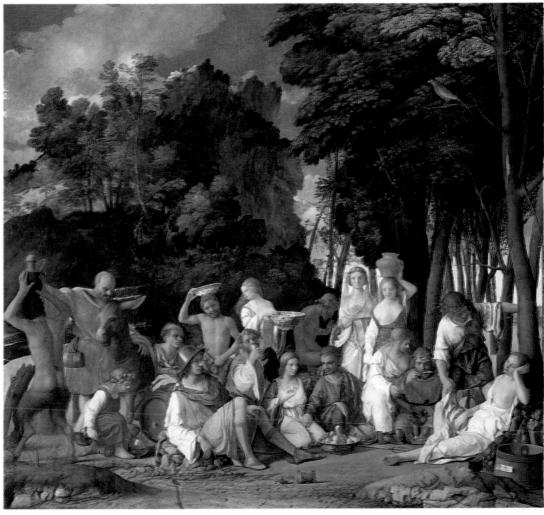

125 Giovanni Bellini, The Feast of the Gods, 1514, 6 ft 2 in × 5 ft 7 in (188 × 170 cm)

OIL PAINT AND THE FLEMISH INFLUENCE IN VENICE

If Bellini eventually outgrew Mantegna's influence, there were other, perhaps lesser artists, who were guided by it on their way to reaching their own summits, and to remaining there.

The Sicilian artist Antonello da Messina (c. 1430–79) is a rather perplexing figure, mainly because Vasari falsely credited him with the sole popularization in Italy of van Eyck's use of oil (see p.64). Antonello is the first important artist from southern Italy, but he did not belong to any Southern school; instead he found his influences abroad, in Flemish art.

Because the influence of Flemish art is strikingly visible in his paintings, Antonello provides an important bridge between Italy and the Netherlands. His visit to Venice in 1475, where he came into close contact with Giovanni Bellini, was to play a major role in the history of Venetian painting.

Some people, then, consider that Antonello introduced oil painting techniques, after they had already been mastered by the Flemish artists, to Venice. Others take the view that he had a sophisticated knowledge of the medium, having learned it in Naples, where he probably studied under a Flemish-influenced artist, and that this made the crucial impact on artists who were already experimenting with oil paints. The argument is not a terribly important one. Whatever the case, the result of this meeting of

127 Antonello da Messina, Virgin Annunciate, c. 1465, 13½ x 17¾ in (34 x 45 cm)

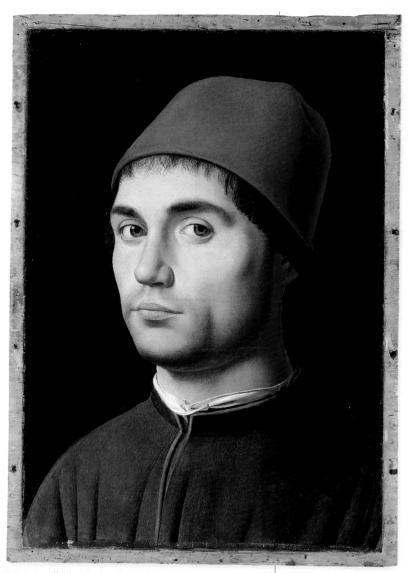

126 Antonello da Messina, Portrait of a Young Man, c. 1465, 10×14 in $(25 \times 35$ cm)

the traditions was that, in Italy, oil painting techniques were pioneered exclusively by Venetian artists before they spread to other artistic centers. Antonello himself needs no spurious claims to attention. From the example of Piero della Francesca (see p.100), and especially Mantegna, he learned the importance of solid truth telling. His forms are almost too clear and sharp; in them we see a "Flemish" intense scrutiny of detail contrasted with an Italian broad generosity of form. He bathes his forms in the most romantic of lights.

His *Portrait of a Young Man (126)* is lit from within, despite the unexceptional and pudgy face, and in a great work like the *Virgin Annunciate (127)*, there is a concentrated simplicity that makes the Virgin affect us with immense impact. Interestingly, the artist presents the Virgin as a devotional portrait, rather than showing the Annunciation itself.

Modern anatomy

In 1543, the Flemish professor Andrea Vesalio (1514–64) wrote his *De Humani Corporis Fabrica*, which became the first standard work of modern anatomy. It has been suggested that the drawings in the book were produced in Titian's studio in Venice.

Contemporary arts

437

Musical counterpoint developed by English musician John Dunstable

1450

Vatican Library founded

1459

Founding of Platonic Academy in Florence

1461

Building work starts on Palazzo Pitti in Florence

1484

Ficino's translations of Plato's writings are published

1495

Aldus Manutius establishes the Aldine Press in Venice to print classical Greek texts

FASCINATION WITH EXTERNALS

Carlo Crivelli (1430/5–c. 1495) also belongs to a Venetian artistic family. Like Antonello da Messina, he, too, has a clear-cut manner that is unmistakable, influenced by Mantegna but applying the fine wire of his outline in an almost mannered style. "Fashion" is the word that springs to mind.

Crivelli's art reveals an ardent interest in externals and their lucid perfections – perhaps also partly owing to the Flemish influence of Antonello – but never in the actual spiritual substances involved (surprising, since he painted only religious subjects).

It is rather in material substance that Crivelli excels, enthralling us with the rotundity of a pear or the angular swirl of a damask skirt, winning us over to share his delight in gorgeous things. When he attempts an emotional theme we may feel embarrassed, but on his own level, he is superb. His *Madonna and Child Enthroned*, with Donor (128) soars aloft with such elegance

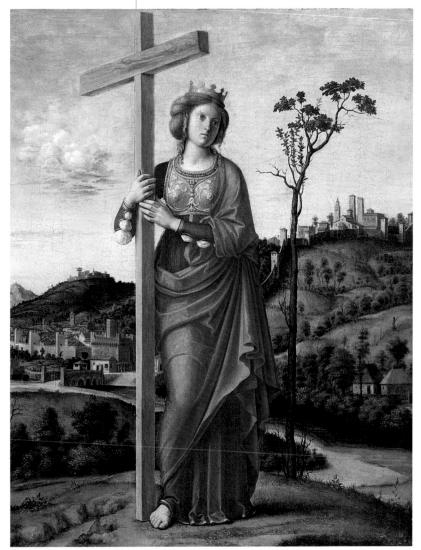

129 Cima da Conegliano, St. Helena, c. 1495, 12¾ x 16 in (32.5 x 40 cm)

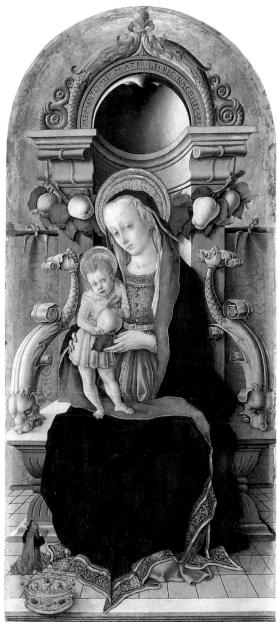

128 Carlo Crivelli, Madonna and Child Enthroned, with Donor, c. 1470, 21½ x 51 in (55 x 130 cm)

and wit (note the dragonlike arms of the throne: brutality subdued to the service of religion) that we may miss the tiny, kneeling donor. He is tacked onto the real interest of the artist, which is not holiness and people praying, but shapes and their self-assured interplay.

Cima da Conegliano (Giovanni Battista Cima, c. 1459/60–1517/18) lived all his life in the environs of Venice, in the small provincial town of Conegliano (from which his name is derived). The strongest influence on him was that of Mantegna, though from early in his career he was also influenced by Giovanni Bellini. Cima is not a great painter, and his work developed very little throughout his artistic life, but he has a spontaneous innocence, a sense of the fitting,

and a technical amplitude as well, that make his work very appealing. St. Helena (129) is a fine example of his work. She is tall and stately, with her slender Cross on one side and a slender living tree on the other, and dominates the green hills before which she appears. The hills are crowned by little cities where, we sense, her discovery of the True Cross (see column, p.102), however apocryphal, has changed the lives of the citizens. It is not by accident that she looms so large. Her stature is built into the picture's meaning as much as are her queenly bearing and her severe self-possession.

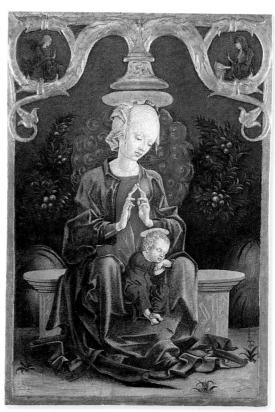

130 Cosimo Tura, Madonna and Child in a Garden, c. 1455, 14½ x 21 in (37 x 53 cm)

THE FERRARESE SCHOOL

Tura and Cossa, artists in the independent city-state of Ferrara (see column, p.115), were also admiring contemporaries of Mantegna. Cosimo Tura (c. 1430–95) is perhaps the greater of the two, with his highly original and easily recognizable blending of the suave and the exciting. Like Crivelli, he rarely goes deep, but he gives us a superbly integrated surface, with a similar metallic wiriness and hard-edged control. There is wit and a tenderness in *Madonna and Child in a Garden (130)*, exquisite in its form and its daring chromatic contrasts. The Virgin steeples her long, thin fingers over the sleeping child as if to make a refuge for him, and the rosy blooms that cluster behind her, like a cushioned

throne make us conscious that both these tender creatures of God are in need of cushioning: there are dark gleams from the night background, caused only by light catching on fruit and leaf, but the effect is subtly sinister.

Francesco del Cossa (c. 1435–c. 1477) has humanized this insouciant austerity. Though Cossa was Ferrarese, his *St. Lucy* (131) belongs to the Florentine tradition, infused with the hard-edged contours of Mantegna and tinged with the peculiar metallic quality of his contemporary, Tura – though the effect is a softer one, largely due to its being painted in the more gently luminous medium of oil paint.

Cossa's St. Lucy is so monumental, so luminously afloat in her golden air, it takes us time to realize the spray she holds is not of flowers, but two stalked eyes. The original Lucy was wrongly credited with being martyred by having her eyes torn out (see column right), and this grisly emblem always accompanies her depiction.

ST. LUCY

This early Christian, Italian martyr captured the imagination of several Renaissance artists. She is said to have survived many tortures - including burning and having her teeth pulled and her breasts cut off - before being killed by a dagger through the throat. A legend grew that she died from having her eyes pulled out, but this was a misinterpretation of her symbol of the eyes. The symbol in fact derived from her name, meaning "light."

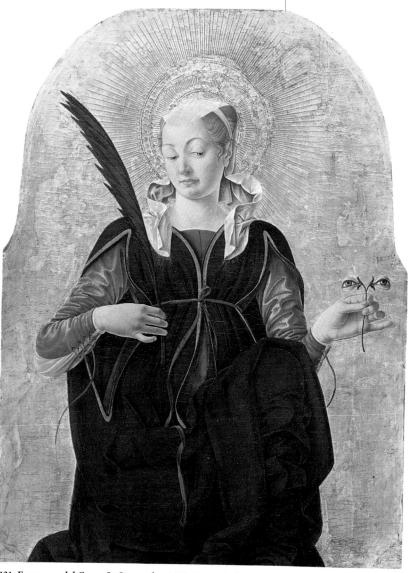

131 Francesco del Cossa, St. Lucy, after 1470, 22 x 31 in (56 x 79 cm)

STORY OF HASDRUBAL'S WIFE

Hasdrubal was a Carthaginian general who fought against the Romans in the second century BC. He surrendered to Scipio in 146 BC. His wife is reputed to have been so ashamed of his cowardice that she threw herself and her children into the fire at the temple where they were sheltering.

The workshops of Renaissance painters were busy for much of the time in the production of objects other than paintings and altarpieces, such as plates, chests (cassoni), beds, and coats of arms. Cassoni were carved, inlaid, painted chests for storing linen, clothes, and household items. Brides often used them to keep their trousseaux, and many cassoni were decorated with narrative paintings

THE FLIGHT

and family coats of arms.

After being warned in a dream that Herod was seeking to kill the infant Jesus, Joseph took Mary and the Child away to Egypt until after Herod's death. The story of their journey to Egypt was a popular theme in Renaissance art and often contained guardian angels and a dramatic evening landscape.

The last of the great Ferrarese artists, Ercole de' Roberti, maintained the Mantegna–Tura–Cossa sobriety and classic formality. *The Wife of Hasdrubal and Her Children (132)* may be an unusual subject (see column, left), but we respond immediately to the solidity of these three human creatures, anguished, in frantic motion, yet still with a semisculptural stillness.

CARPACCIO: THE STORYTELLER

Vittore Carpaccio (1455/65–1525/26), though essentially Venetian, was clearly influenced by the great artists of the Ferrarese school, and also by Giovanni Bellini's brother, Gentile. Carpaccio had probably been taught by the

Bellini patriarch, Jacopo, and was an assistant to Giovanni. The element that is peculiarly his own is that of storytelling, of which he had an instinctive mastery. The delicacy of detail in his work may suggest a medieval naïveté, yet he is a highly sophisticated painter who can use narrative simplicities as a pleasurable means to his ends.

Carpaccio can rise above the picturesque.

The Flight into Egypt (133) may not present us with wholly serious actors: Mary is most sumptuously clad and has obviously used some of her rose red silks to fashion a tunic for St. Joseph. But all lightheartedness

is forgotten in the glory of the setting. In a sunset sky of striking verisimilitude, we see why Carpaccio gives us the impression of being, despite all, a major artist. The light bathes an ordinary

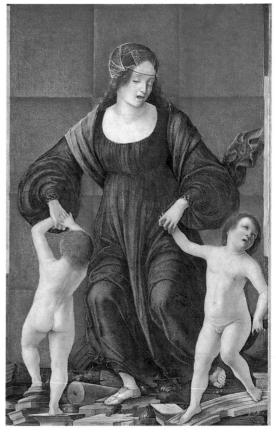

132 Ercole de' Roberti, The Wife of Hasdrubal and Her Children, c. 1480/90, 12 x 18½ in (30.5 x 47 cm)

lakeside town and its surroundings – unimpressive, undramatic, and yet completely satisfying and convincing. There can be a deliberately Gothic

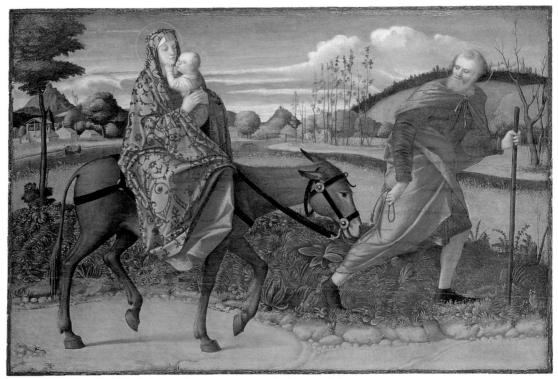

133 Vittore Carpaccio, The Flight into Egypt, c. 1500, 44 x 281/4 in (112 x 72 cm)

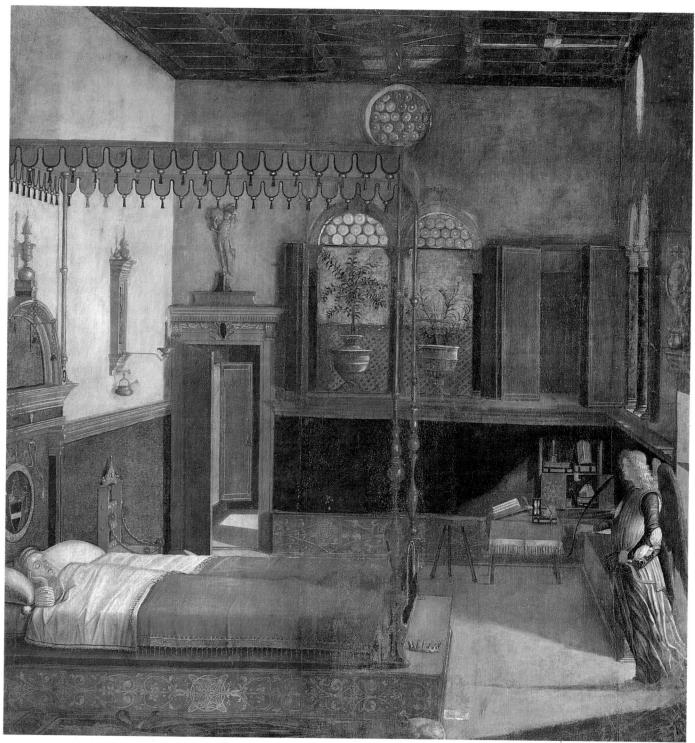

134 Vittore Carpaccio, The Dream of St. Ursula, 1494, 8 ft 8 in x 9 ft (265 x 275 cm)

charm in Carpaccio's legend cycles, as in the wholly delightful *Dream of St. Ursula (134)*. This is one of a series of paintings Carpaccio produced for the confraternity of St. Ursula. She was a legendary Breton princess who led a pilgrimage to Rome with 11,000 virgins, who had converted to Christianity. The story ends with the massacre of the entire company by villainous Huns (see column, p.70). The neat little bed and the sleeping saint have an enameled

charm that will happily survive her coming martyrdom, signified by the entering angel bearing the symbolic palm. Carpaccio's meticulous recording of the material world has provided historians with insight into the material reality of 15th-century Venice. This faithful representation of the visible world, composed of many tiny parts, reappears in the work of another Venetian artist in the 18th century, Canaletto (see p.234).

FERRARA

During the Renaissance, Ferrara became a lively center for the arts, and the court of the Este family encouraged individual artists from throughout Italy. Many impressive secular buildings were built in the city during the 15th century, including the Palazzo dei Diamanti.

SFUMATO

This term, derived from the Italian fumo, meaning "smoke," is particularly applied to the work of Leonardo da Vinci. It defines the gradual and imperceptible transition between areas of different color, without the use of sharp outlines. The capacity to blur over harsh outlines, especially in portrait paintings, was considered the sign of a highly skilled and distinguished painter.

Equestrian monuments

This monument to Bartolommeo Colleoni was begun by Verrocchio c. 1481 and completed after his death. During this period, riders on horseback were a popular subject for monuments. Their popularity is attributed to the influence of the classical statue of Emperor Marcus Aurelius that stood in the Campidoglio in Rome. Both Donatello and Verrocchio made works commemorating Renaissance soldiers.

THE HIGH RENAISSANCE

Since Renaissance means "new birth," it is obvious that it cannot stand still. Once something is born, it begins to grow. But never has there been growth as lovely as that of painting as it matured into the High Renaissance. Here we find some of the greatest artists ever known: the mighty Florentines, Leonardo da Vinci and Michelangelo; the Umbrian, Raphael; and, equal in might, the Venetians – Titian, Tintoretto, and Veronese.

By a happy chance, a common theme links the lives of four of the famous masters of the High Renaissance – Leonardo, Michelangelo, Raphael, and Titian. Each began his artistic career with an

apprenticeship to a painter who was already of good standing, and each took the same path of first accepting, then transcending, the influence of his master. The first of these, Leonardo da

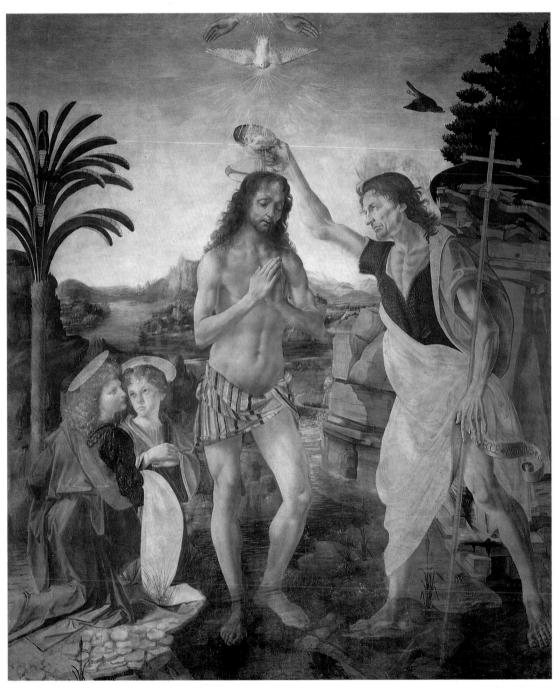

135 Andrea del Verrocchio, The Baptism of Christ, c. 1470, 5 ft x 5 ft 11 in (152 x 180 cm)

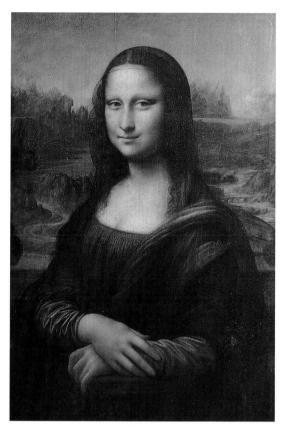

136 Leonardo da Vinci, Mona Lisa, 1503, 21 x 30½ in (53 x 75 cm)

Vinci (1452–1519), was the elder of the two Florentine masters. He was taught by Andrea del Verrocchio (1435–88), an engaging painter whose great achievement was his sculpture (see column, p.116). Verrocchio also had considerable influence on the early work of Michelangelo (see p.120). Verrocchio's best-known painting is the famous *Baptism of Christ (135)*, famous because the youthful Leonardo is said to have painted the dreamy and romantic angel on the far left, who compares more than favorably with the stubby lack of distinction in the master's own angel immediately beside him.

LEONARDO: RENAISSANCE POLYMATH

There has never been an artist who was more fittingly, and without qualification, described as a genius. Like Shakespeare, Leonardo came from an insignificant background and rose to universal acclaim. Leonardo was the illegitimate son of a local lawyer in the small town of Vinci in the Tuscan region. His father acknowledged him and paid for his training, but we may wonder whether the strangely self-sufficient tone of Leonardo's mind was not perhaps affected by his early ambiguity of status. The definitive polymath, he had almost too many gifts, including superlative male beauty, a splendid singing voice, magnificent physique,

mathematical excellence, scientific daring ... the list is endless. This overabundance of talents caused him to treat his artistry lightly, seldom finishing a picture, and sometimes making rash technical experiments. *The Last Supper*, in the church of Santa Maria delle Grazie in Milan, for example, has almost vanished, so inadequate were his innovations in fresco preparation.

Yet the works that we have salvaged remain the most dazzlingly poetic pictures ever created. The *Mona Lisa* (136) has the innocent disadvantage of being too famous. It can only be seen behind thick glass in a heaving crowd of awe-struck sightseers. It has been reproduced in every conceivable medium; it remains intact in its magic, forever defying the human insistence on comprehending. It is a work that we can only gaze at in silence.

Leonardo's three great portraits of women all have a secret wistfulness. This quality is at its most appealing in *Cecilia Gallarani* (137), at its most enigmatic in the *Mona Lisa*, and at its most

first object of the painter is to make a flat plane appear as a body in relief and projecting from that plane.**

Leonardo da Vinci

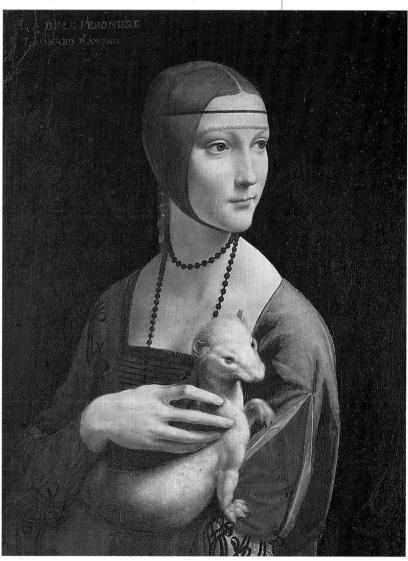

137 Leonardo da Vinci, Cecilia Gallarani, c. 1485, 15½ x 21½ in (39 x 54 cm)

LEONARDO'S

Between 1473 and 1518, Leonardo wrote a series of papers that were then collected together as his *Treatise on Painting*. One section, written in 1492, is devoted to linear perspective. The page shown here demonstrates

his technique for transferring a figure onto the sides of a curved vault. This technique prefigured the later style known as trompe l'oeil (paintings that "deceive the eye"). confrontational in *Ginevra de' Benci (138)*. It is hard to gaze at the *Mona Lisa* because we have so many expectations of it. Perhaps we can look more truly at a less famous portrait, *Ginevra de' Benci*. It has that haunting, almost unearthly beauty peculiar to Leonardo da Vinci.

A WITHHELD IDENTITY

The subject of *Ginevra de' Benci* has nothing of the Mona Lisa's inward amusement, and also nothing of Cecilia's gentle submissiveness. The young woman looks past us with a wonderful luminous sulkiness. Her mouth is set in an unforgiving line of sensitive disgruntlement, her proud and perfect head is taut above the unyielding column of her neck, and her eyes

seem to narrow as she endures the painter and his art. Her ringlets, infinitely subtle, cascade down from the breadth of her gleaming forehead (the forehead, incidentally, of one of the most gifted intellectuals of her time). These delicate ripples are repeated in the spikes of the juniper bush.

The desolate waters, the mists, the dark trees, the reflected gleams of still waters – all these surround and illuminate the sitter. She is totally fleshly and totally impermeable to the artist. He observes, held rapt by her perfection of form, and shows us the thin veil of her upper bodice and the delicate flushing of her throat. What she is truly like she conceals; what Leonardo reveals to us is precisely this concealment, a self-absorption that spares no outward glance.

Inventive sketches

Leonardo's sketches reveal a man with endless imagination and scientific interest. Along with anatomical studies and caricature, he also produced many mechanical drawings, inventing objects as diverse as war engines, water mills, spinning machines, tanks, and even helicopters (shown above).

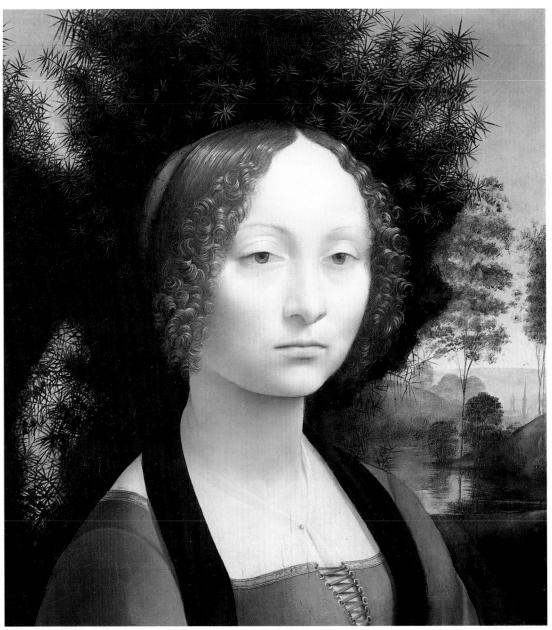

138 Leonardo da Vinci, Ginevra de' Benci, c. 1474, 14½ x 15½ in (37 x 39 cm)

Ginevra de' Benci

Leonardo's exquisite portrait of Ginevra de' Benci was described by Vasari (see p.98) as a "beautiful thing." It was originally larger, but was cut down (because of damage) to this powerfully compact format by later owners. The back of the panel depicts a wreath of laurel and palm encircling a juniper sprig (see right). The three are connected by a scroll bearing the inscription "She adorns her beauty with virtue."

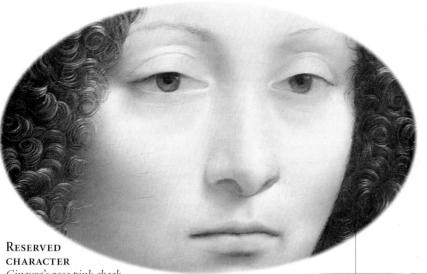

Ginevra's rose pink cheek and lips are painted with supreme delicacy and restraint. This effect is so subtle, so cool, that it admirably conveys her inner restraint, her firm control over her emotions. Her heavy, half-closed lids cast a shadow over the irises of her eyes, and the almost total absence of reflected light serves to reduce the communication between us and her. A slight cast in her left eye accentuates the lack of focus in her expression, and her gaze is directed over our shoulder.

SKIN UNDER THE BODICE
Ginevra's skin is rendered with absolutely smooth, "invisible" brushstrokes. This is achieved by working wet-in-wet, and by the use of glazes and loose, "oily" paint, so that the color and contours of each brushstroke blend imperceptibly to form a continuous, uninterrupted surface. It is seen through her diaphanous bodice, which is given only the slightest definition. If it were not for the gilt pin holding it together, we would perhaps not notice it at all.

JUNIPER LEAVES
The young woman's name, Ginevra, is related to the Italian word ginepro, meaning "juniper." Appropriately, Leonardo has set her pale, marblelike beauty against the dark, spiky leaves of a juniper bush. She is well described by spikiness, we may imagine, and the bitter appeal of the gin that comes from the juniper berry is also adumbrated by this setting.

Insubstantial Landscape
In contrast to the woman, with
her firm, sculptural presence, the
middle-distance landscape quivers
with uncertainty, rendered with thin,
fluid paint. Each brushmark is visible
over the next, and the trees are merely
thin stalks, their trunks painted with
delicate, tremulous brushstrokes.

OTHER WORKS BY LEONARDO

Annunciation (Uffizi, Florence)

The Last Supper (Santa Maria delle Grazie, Milan)

Madonna and St. Anne (Louvre, Paris)

The Benois Madonna (Hermitage, St. Petersburg)

Virgin and Child with a Vase of Flowers (Alte Pinakothek, Munich)

cannot live
under pressures
from patrons,
let alone
paint.

Michelangelo, quoted in Vasari's *Lives* of the Artists

MACHIAVELLI
Florentine statesma

The Florentine statesman Niccolo Machiavelli (1469–1527) is remembered as the author of *Il Principe* (The Prince, 1532).

(The Prince, 1532), a rational analysis of political power. His main argument was that a ruler must be prepared to do evil if he judges that good will come of it. After his death he developed a reputation as an amoral cynic, and this was reinforced by criticism from his enemies in Church and state. In the present century a more

balanced view prevails.

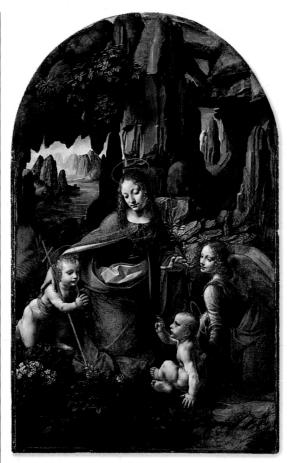

139 Leonardo da Vinci, Virgin of the Rocks, c. 1508, 47 × 75 in (120 × 190 cm)

INTERIOR DEPTH

We can always tell a Leonardo work by his treatment of hair, angelic in its fineness, and by the lack of any rigidity of contour. One form glides imperceptibly into another (the Italian term is *sfumato*; see column, p.116), a wonder of glazes creating the most subtle of transitions between tones and shapes. The angel's face in the painting known as the *Virgin of the Rocks* (139) in the National Gallery, London, or the Virgin's face in the Paris version of the same picture, have an interior wisdom, an artistic wisdom that has no pictorial rival.

This unrivaled quality meant that few artists actually show Leonardo's influence: it is as if he seemed to be in a world apart from them. Indeed he did move apart, accepting the French King Francis I's summons to live in France. Those who did imitate him, like Bernardino Luini of Milan (c. 1485–1532), caught only the outer manner, the half-smile, the mistiness (140).

The shadow of a great genius is a peculiar thing. Under Rembrandt's shadow, painters flourished to the extent that we can no longer distinguish their work from his own. But Leonardo's was a chilling shadow, too deep, too dark, too overpowering.

MICHELANGELO: A DOMINANT FORCE IN FLORENCE AND ROME

Michelangelo Buonarroti (1475–1564), on the contrary, exerted enormous influence. He too was universally acknowledged as a supreme artist in his own lifetime, but again, his followers all too often present us with only the master's outward manner, his muscularity and gigantic grandeur; they miss the inspiration. Sebastiano del Piombo (c. 1485–1547), for example, actually used a drawing (at least a sketch) made for him by Michelangelo for his masterwork, *The Raising of Lazarus*. Masterwork it is – yet how melodramatic it appears if compared with Michelangelo's own painting,

Michelangelo resisted the paintbrush, vowing with characteristic vehemence that his sole tool was the chisel. As a well-born Florentine, a member of the minor aristocracy, he was resistant to coercion at any time. Only the power of the pope, tyrannical by position and by nature, forced him to the Sistine Chapel and the reluctant achievement of the world's greatest single fresco. His contemporaries spoke about his terribilità, which means, of course, not so much being terrible as being awesome. There has never been a more literally awesome artist than Michelangelo: awesome in the scope of his imagination, awesome in his awareness of the significance – the spiritual significance – of beauty. Beauty was to him divine, one of the ways God communicated Himself to humanity.

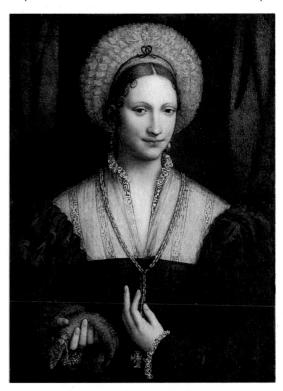

140 Bernardino Luini, Portrait of a Lady, c. 1520/25, 22½ x 30½ in (58 x 75 cm)

141 Domenico Ghirlandaio, The Birth of John the Baptist, c. 1485-90 (detail of fresco panel)

Like Leonardo, Michelangelo too had a good Florentine teacher, the delightful Domenico Ghirlandaio (c. 1448–94). Later, he was to claim that he never had a teacher, and figuratively, this is a meaningful enough statement. However, his handling of the claw chisel does reveal his debt to Ghirlandaio's early influence, and this is evident in the cross-hatching of Michelangelo's drawings a technique he undoubtedly learned from his master. The gentle accomplishments of a work like The Birth of John the Baptist (141) bear not the slightest resemblance to the huge intelligence of an early work of Michelangelo's like The Holy Family (142 also known as the Doni Tondo). This is somehow not an attractive picture, with its chilly, remote beauty, but its stark power stays in the mind

Michelangelo, The Holy Family, when more accessible paintings have been forgotten. c. 1503, 47 in (120 cm) diameter

Pope julius ii On becoming pope in 1503, Julius II reasserted papal authority over the Roman barons and successfully backed the restoration of the Medici in Florence. He was a liberal patron of the arts, commissioning Bramante to build St. Peter's Church, Michelangelo to paint the Sistine Chapel, and Raphael to decorate the Vatican apartments.

OTHER WORKS BY MICHELANGELO

The Pietà (St. Peter's, Rome)

Bacchus (The Bargello, Florence)

Bruges Madonna (Church of Onze Lieve Vrouwe, Bruges)

> Entombment (National Gallery, London)

Martyrdom of St. Peter (The Vatican, Rome)

SIBYLS

These were female seers of ancient Greece and Rome. They were also known as oracles. Like the Jewish prophets of the Old Testament, many sibyls had their sayings recorded in books. Jewish prophets spoke unbidden, whereas sibyls tended to speak only if consulted on specific questions. They sometimes responded with riddles or rhetorical questions.

THE SISTINE CHAPEL

All the same, it is the Sistine ceiling that displays Michelangelo at the full stretch of his majesty. Recent cleaning and restoration have exposed this astonishing work in the original vigor of its color. The sublime forms, surging with desperate energy, tremendous with vitality, have always been recognized as uniquely grand. Now these splendid shapes are seen to be intensely alive in their color, indeed shockingly so for those who liked them in their previous dim grandeur.

The story of the Creation that the ceiling spells out is far from simple, partly because Michelangelo was an exceedingly complicated man, partly because he dwells here on profundities of theology that most people need to have spelled out for them, and partly because he has balanced his biblical themes and events with giant ignudi, naked youths of superhuman grace (143). They express a truth with surpassing strength, yet we

do not clearly see what this truth actually is. The meaning of the *ignudi* is a personal one:

it cannot be verbalized or indeed theologized, but it is experienced with the utmost force.

SEERS AND PROPHETS

There is the same power, though in more comprehensible form, in the great prophets and seers that sit in solemn niches below the naked athletes. Sibyls were the oracles of Greece and Rome (see column, left). One of the most famous was the Sibyl of Cumae, who, in the *Aeneid*, gives guidance to Aeneas on his journey to the underworld. Michelangelo was a heavyweight intellectual and poet, a profoundly educated man and a man of utmost faith; his vision of God

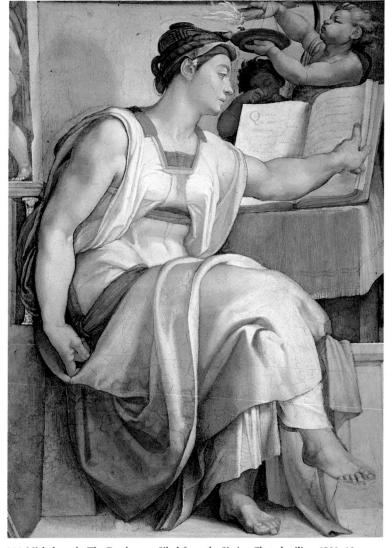

144 Michelangelo, The Erythraean Sibyl from the Sistine Chapel ceiling, 1508-12

was of a deity all "fire and ice," terrible, august in His severe purity. The prophets and the seers who are called by divine vocation to look upon the hidden countenance of God have an appropriate largeness of spirit. They are all persons without chitchat in them.

The Erythraean Sibyl (144) leans forward, lost in her book. The artist makes no attempt to show any of the sibyls in appropriate historical garb, or to recall the legends told of them by the classical authors. His interest lies in their symbolic value for humanity, proof that there have always been the spiritual enlightened ones, removed from the sad confusions of blind time.

The fact that the sibyls originated in a myth, and one dead to his heart, which longed for Christian orthodoxy, only heightens the drama. At some level we all resent the vulnerability of our condition, and if only in image, not reality, we take deep comfort in these godlike human figures. Some of the sibylline seers are shown as aged, bent, alarmed by their prophetic insight.

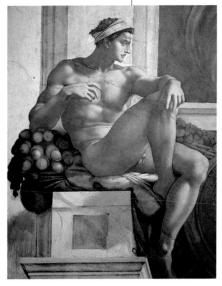

143 Michelangelo, Ignudo from the Sistine Chapel ceiling, 1508–12

The Erythraean Sibyl

In the Sistine Chapel, sibyls from the ancient Greek and Roman culture are "twinned" with Old Testament prophets. The God of the Jews spoke to the prophets. The sibyls, too, were wise women with superior spiritual inspiration, capable of explaining God's message to all

humanity. The prophets proclaimed to the Jews

alone, whereas the sibyls prophesied to the Greeks. The Erythraean Sibyl lived

in the town of Erythrae in Ionia (in what is now southwest Turkey). There were many others, such as, for instance, the Egyptian Sibyl.

FLOWING ROBE

Michelangelo's original colors are believed to have had a startling, luminous quality. The Sistine Chapel frescoes gradually darkened with the passage of time. and in the present century three attempts have been made - the latest from 1980 to 1990 - to restore their original appearance.

Symbolic light

The cherub holds a lit torch, and the flame that issues from it looks almost like a fiery bird, the Holy Spirit come before His Pentecostal time. Significantly, the sibyl has not needed to wait for the lamp to be lighted: her light is from within, and her sureness of vision is contrasted with a dim little cherub, who rubs his eyes with baby fists.

PENSIVE HEAD

The sibyl leans forward, lost in her book. She turns the page with the calm deliberation of one who "sees," one in command, touched by divine clairvoyance. She is inspired and infallible, and her stately head is undaunted by what she reads. Her role as illuminator and interpreter "to spread good tidings to all the nations" (Mark 16: 15) is evidenced by the opened book, turned outward for all to see.

TURNING THE PAGES OF TIME

The great stature of the pacific sibyl reassures us at a subliminal level, and maybe all the more effectively for that. She needs only one muscular arm to turn the pages of the future; the other hangs in relaxation. She is poised to rise and act, yet remains still, concentrating on her reading. The book rests on a lectern covered with a blue cloth, symbolizing its divine content. The colors sing in splendor, pinks glazed to whiteness by the intensity of the light.

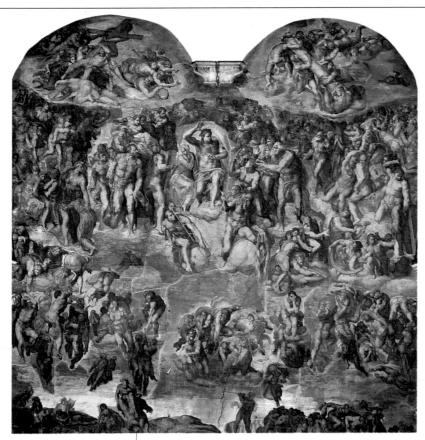

145 Michelangelo, The Last Judgment, west wall of Sistine Chapel, 1536–41, 44 × 48 ft (13 m 43 cm × 14 m 61 cm)

The implicit sense of God's majesty (rather than His fatherhood) is made explicit in the most alarming *Last Judgment (145)* known to us. It is Michelangelo's final condemnation of a world

he saw as irredeemably corrupt, a verdict essentially heretical, though at that time it was thought profoundly orthodox. His judging Christ is a great, vengeful Apollo, and the power in this terrible painting comes from the artist's tragic despairs. He paints himself into the judgment, not as an integral person, but as a flayed skin, an empty envelope of dead surface, drained of his personhood by artistic pressure. The only consolation, when even the Virgin shrinks from this thunderous colossus, is that the skin belongs to St. Bartholomew, and through this martyr's promise of salvation we understand that perhaps, though flayed alive, the artist is miraculously saved.

As grandly impassive as the Erythraean Sibyl is the heroic Adam in *The Creation of Adam* (146), lifting his languid hand to his Creator, indifferent to the coming agonies of being alive.

Influences on Raphael

After the complexities of Leonardo and Michelangelo, it is a relief to find Raphael (Raffaello Sanzio, 1483–1520), a genius no less than they, but one whose daily ways were those of other men. He was born in the small town of Urbino, an artistic center (see p.100), and received his earliest training from his father. Later, his father sent him to Pietro Perugino (active 1478–1523) who, like Verrocchio and Ghirlandaio, was an artist of considerable gifts. But while Leonardo and Michelangelo quickly outgrew their teachers and show no later trace of influence, Raphael

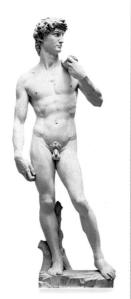

Michelangelo's david

Michelangelo began work on the colossal figure of David in 1501, and by 1504 the sculpture (standing 14 ft 3 in/4.34 m tall) was in place outside the Palazzo Vecchio. The choice of David was supposed to reflect the power and determination of republican Florence and was under constant attack from supporters of the usurped Medicis. In the 19th century, the statue was moved to the Accademia.

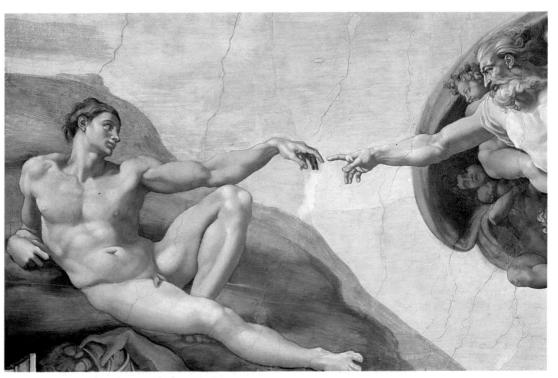

146 Michelangelo, The Creation of Man from Sistine Chapel ceiling, 1511-12

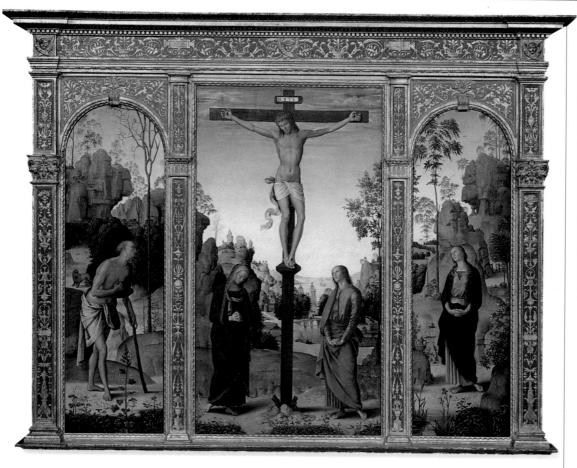

had a precocious talent right from the beginning and was an innate absorber of influences. Whatever he saw, he took possession of, always growing by what was taught to him. An early Raphael can look very like a Perugino. In fact, Perugino's Crucifixion with the Virgin, St. John, St. Jerome, and St. Mary Magdalene (147) was thought to be by Raphael until evidence proved it was given to the church of San Gimigniano in 1497, when Raphael was only 14. It is undoubtedly a Perugino, calmly emotional, and pious rather than passionate. A fascinating context for this scene of quiet faith is the notorious unbelief on the part of the artist, who was described by Vasari as an atheist. He painted what would be acceptable, not what he felt to be true, and this may account for the lack of real emotive impact.

EARLY RAPHAEL

There are still echoes of the gentle Perugino in an early Raphael like the diminutive *St. George and the Dragon (148)*, painted when he was in his early twenties; the little praying princess is very Peruginesque. But there is a fire in the knight and his intelligent horse, and a nasty vigor in the convincing dragon that would always be beyond Perugino's skill. Even the horse's tail is electric, and the saint's mantle flies wide as he speeds to the kill.

147 Pietro Perugino, Crucifixion with the Virgin, St. John, St. Jerome, and St. Mary Magdalene, c. 1485, center 22½ × 40 in (57 × 102 cm)

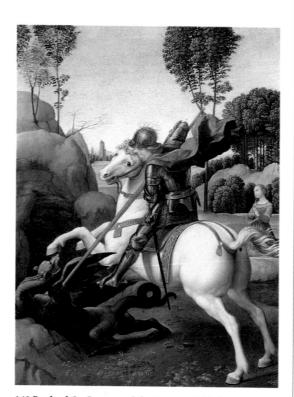

148 Raphael, St. George and the Dragon, 1504–06, $8\frac{1}{2} \times 11$ in $(22 \times 28$ cm)

OTHER WORKS BY RAPHAEL

The Ansidei Madonna (National Gallery, London)

> Sistine Madonna (Gemäldegalerie, Dresden)

Baldassare Castiglione (Louvre, Paris)

> Pope Leo X with Two Cardinals (Uffizi, Florence)

The Belvedere Madonna (Kunsthistorisches Museum, Vienna)

Virgin and Child with a Book (Norton Simon Museum, Pasadena)

EXPLORER'S GLOBE

The 15th century saw an unprecedented enlargement of the known world as explorers opened up the New World of the Americas as well as the Far East. The explorers' maps made possible the production of the first terrestrial globe in 1492 (above). Painters were able to take advantage of the exotic pigments that were shipped into Italian ports.

ST. GEORGE

The portrayal of St. George and the dragon in art symbolizes the conversion of a heathen country to Christianity. Often the place of conversion would be represented by a young woman. St. George is patron saint of several European cities, including Venice, and was made patron of England in 1222.

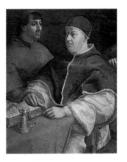

POPE LEO X As the second son of the Medicean ruler Lorenzo the Magnificent (see p.97), Pope Leo X (1475–1521) had an easy passage to high office. He is best remembered as a patron of the arts, and he established a Greek college in Rome. He encouraged the work of artists such as Raphael (who painted this portrait). Despite his undoubted inadequacies, as the spiritual head of Christendom he was of central importance in his understanding of the human need of great art and architecture. Such worldliness undoubtedly helped provoke the

Reformation (see p.169).

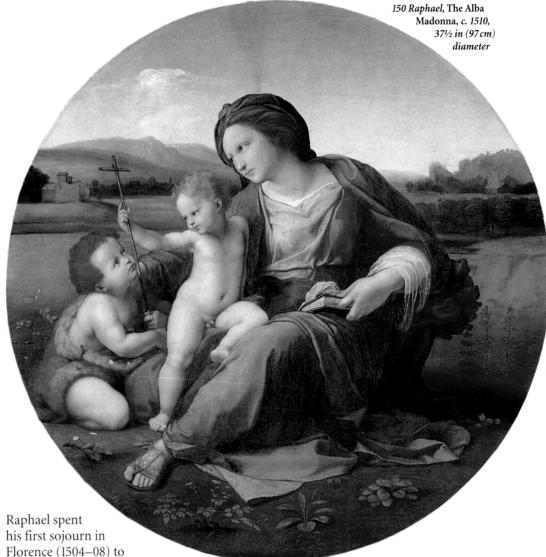

sublime purpose. At that time

Leonardo and Michelangelo were both working there, and as a result, Raphael adopted new

working methods and techniques particularly influenced by Leonardo - and his paintings took on a more vigorous graphic energy. We may think we see a hint of what he took from Leonardo in a work like the Small Cowper Madonna (149), with its softness of contour and perfection of balance. Both faces, the Virgin's almost smiling, almost praying, wholly wrapped up in her Child, and that of the Child, wholly at ease with His Mother, dreamily looking out at us with abstracted sweetness, have that inwardness we see in Leonardo, but made firm and unproblematic. Behind the seated figures we see a tranquil rural landscape with a church perched on a hill.

Raphael returned to the subject of the Madonna and Child several times, each time in an intimate, gentle composition. The Alba Madonna (150), on the other hand, has a Michelangelic heroism about it; tender as always in Raphael, but also heavy; masses wonderfully composed in tondo form; a crescendo of emotion that finds its fulfillment in the watchful face of Mary. The world stretches away on either side, centered on this trinity of figures, and the movement sweeps graciously onward until it reaches the farthest fold of Mary's cloaked elbow. Then it floods back, with her bodily inclination toward the left, and the meaning is perfectly contained: love is never stationary, it is given and returned. Raphael's life was short, but while he lived he was one of those geniuses who continually evolve and develop. He had an extraordinary capacity (like, though greater than, Picasso's) to respond to every movement in the art world, and to subsume it within his own work.

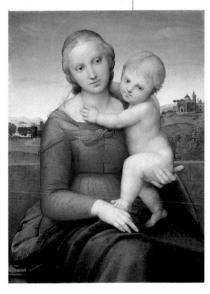

149 Raphael, Small Cowper Madonna (detail), 1505, 17½ × 24 in (45 × 60 cm)

THE ALBA MADONNA

Like Bellini, Raphael became a *Madonnière* – a painter of Madonnas. Depicted like Bellini's *Madonna of the Meadow* (see p.109) in an open landscape, *The Alba Madonna* is an example of the Renaissance "Madonna of Humility" tradition. However, all comparison with Bellini ends here, and it is the influence of Michelangelo that is more evident in *The Alba Madonna*, not least in its tondo format – derived from Michelangelo's *Holy Family*

(c. 1503), which Raphael saw in Rome (see p.121).

CHRIST CHILD The Alba Madonna is not as representative of Raphael's treatment of the subject as the Small Cowper Madonna (see left), which exhibits all the sensual warmth of human love that exists between a mother and her baby. Here the Christ Child is depicted as a kind of baby crusader upright and courageous, a child with a man's understanding of the difficulties of human existence. By comparison, the chubby figure of St. John, dressed in a drab lamb's fleece to remind us of his future in the

wilderness, appears unsophisticated and truly childlike. HEROISM
The relatively
close tonal range
and restrained palette

of The Alba Madonna is perfectly suited to her self-contained, gentle heroism. It is wholly unlike the rosy glow and brilliant hues of the Small Cowper Madonna. The Alba Madonna's whole demeanor, as well as her quietly mournful gaze, expresses dignity, spiritual strength, and solidity. She meditates

on a small wooden cross that symbolizes Christ's Crucifixion.

Umbrian countryside

MADONNA'S FOOT

The military style of the sandal worn by the Madonna emphasizes her warriorlike demeanor. Like her Son, she assumes a heroic stance. The ground on which she sits is sprinkled with small flowers, some in bloom. The petals are painted delicately over the primary layer of green earth. The flowers that St. John has gathered are anemones that grow behind him. Around the picture from where he kneels are a white dandelion, what could be another anemone, a plantain, a violet, and three lilies, not yet in bloom.

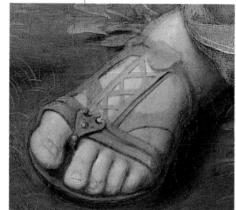

Beyond the statuesque figure of the Madonna, in the open Umbrian landscape, is a small wood filled with odd, tightly foliaged trees. Beyond the wood, still farther into the distance, are tiny horsemen. The activities of the horsemen, too minute to make out, are reduced almost to nothingness by the giantlike form of the Madonna, her remote gaze echoing their physical distance and their essential irrelevance.

THE SCHOOL OF ATHENS

Raphael's fresco contains portraits of many classical philosophers. In the center stand Plato and Aristotle, the two great philosophers of antiquity. To their left Socrates is seen in argument with several young men. The old man seated on the steps is Diogenes. Other philosophical figures are identifiable, including Pythagoras, shown bottom left, explaining his proportion system on a slate, and, on the extreme right, Ptolemy, depicted contemplating a celestial globe.

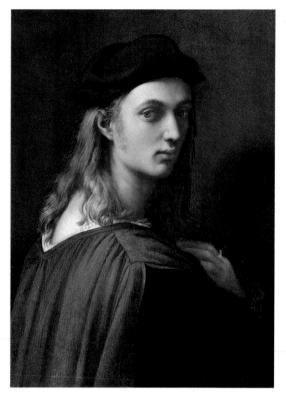

151 Raphael, Bindo Altoviti, c. 1515, 17¹/₃ x 23¹/₂ in (45 x 60 cm)

Since Vasari (see p.98) described the picture commissioned by *Bindo Altoviti* (151) as "his portrait when young," historians have liked to think that this radiant youth was Raphael himself. He was indeed said to be unusually handsome, pensive, and fair, which is exactly what this portrait shows us. But it is now agreed that it is Bindo when young, and since he was at this time a mere 22 (and Raphael 33, with only five years left to him), this is not an "imagined" youth but a real boy who takes up so self-conscious a stance before the painter.

Raphael is one of the most acute of all portraitists, effortlessly cleaving through the external defenses of his sitter, yet courteously colluding with whatever image the ego would seek to have portrayed. This duality, looking beneath the surface and yet remaining wholly respectful of the surface, gives an additional layer of meaning to all his portraits. We see, and we know things that we do not see; we are helped to encounter rather than to evaluate.

Bindo Altoviti was beautiful, successful (as a banker), and rich—rather like Raphael himself. There may have been some feeling of fellowship in the work, as the noble countenance is sensitively fleshed out for us. Half the face is

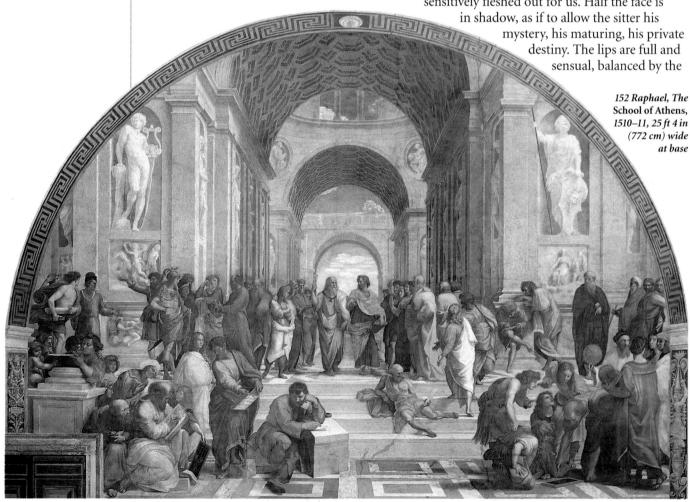

deep-set eyes with their confrontational stare, almost defiant. The ruffled shirt is half covered by the young man's locks, calculatedly casual, at odds in their dandyish profusion with the plain beret and the rich but simple doublet. He holds a darkened hand dramatically to his breast, maybe to show off the ring, maybe to indicate psychic ease.

But Raphael has not given him the real world for his setting. Bindo Aldoviti stands in a nowhere place of luminous green, outside the scope of time in his eternal youth, fearless because he is protected by art from human uncertainties.

There is an aptness in the areas of darkness in which the great doublet sleeve loses itself. For all his debonaire poise, this is a young man threatened. For the viewer who knows how short Raphael's own life was to be, the thought that this might be a self-portrait is seductively plausible. There is a sense in which every portrait is one of the self, since we never escape our own life enough to see with

divine vision what is objectively there: this shows us both men, painter and banker, "when young."

Raphael is out of favor today; his work seems too perfect, too faultless for our slipshod age. Yet these great icons of human beauty can never fail to stir us: his Vatican murals can stand fearlessly beside the Sistine ceiling. *The School of Athens* (152), for example, monumentally immortalizing the great philosophers, is unrivaled in its classic grace. Raphael's huge influence on successive artists is all the more impressive considering his short life.

THE HIGH RENAISSANCE IN VENICE

There is always a happy sureness, a sense of belonging, of knowing how things work, in Raphael, and it is this confidence that seems most to distinguish him from that other genius who died young, the Venetian Giorgione (Giorgio da Castelfranco, 1477–1510).

Giorgione achieved far less than Raphael (and his life was still shorter). Even the few works said to be by him are often contested, yet he has a hauntingly nostalgic grace found nowhere else in art. He trained in the workshop of the great Venetian painter Giovanni Bellini (see p.107), whose softness of contour and warm, glowing color continue in Giorgione's work. He does not belong, as Raphael does, to

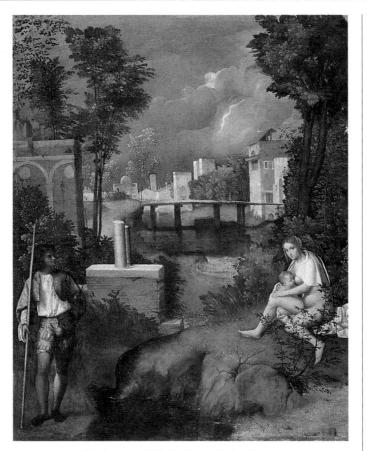

153 Giorgione, The Tempest, 1505–10, 28¾ x 32½ in (71 x 75 cm)

this world, not even in the rarefied way that we find in his great successors, Titian (see p.131) and Tintoretto (see p.134). His alliance is to another spirit, yet one to which we instinctively respond, even if we do not always understand the logic of his works.

The Tempest (153) is one of the most arguedover works in existence. Its importance in relation to the development of Venetian painting lies in the predominance of landscape for its own sake. Fortunately, everyone accepts that this painting is by Giorgione, but who is this motionless soldier, brooding quietly in the storm, and who is the naked gypsy, feeding her child and apparently unaware of any company? Attempts to read the scene as a novel version of the flight into Egypt are usually foiled by the inexplicable fact of the woman's nakedness. Despite this, countless scenarios have been provided, all ingenious and all of them making some sense.

Elucidation has not been helped by scientific analysis, which reveals that the first draft of the work included a second naked woman, bathing in the stream. The "real meaning" may elude us, but perhaps that elusiveness is the meaning. We are shown the world lit up with the startling clarity of a sudden flash of lightning, and in that revelation we are able to behold mysteries that were hitherto concealed within the darkness.

BALDASSARE CASTIGLIONE

This portrait by Raphael is of the Renaissance diplomat and writer Baldassare Castiglione. He was employed in the service of a number of Italian dukes in the early 16th century. His treatise Il Cortegiano, published in 1528, described the court at Urbino and defined the correct etiquette for courtiers to learn. Another feature of the book was its popularization of Humanist philosophy (see p.82, column).

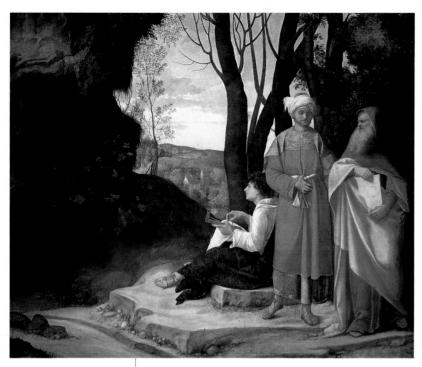

154 Giorgione (finished by Sebastiano del Piombo), The Three Philosophers, c. 1509, 55½ x 48 in (141 x 121 cm)

The intensely poetic nature of the few undoubted Giorgiones brought a quality into Venetian High Renaissance art that it was never completely to lose. Even though finished by Michelangelo's friend Sebastiano del Piombo, The Three Philosophers (154) shows the potency of this lyrical richness. The actual subject matter seems not to have mattered to the artist. He apparently began by intending a picture of the Magi (see p.98), the three eastern kings who saw the star at Christmastide and journeyed to the manger. The Magi were also believed to be astronomers, star gazers, and from this Giorgione traveled mentally to the concept of philosophical search, plotting the stars with a sextant and pondering on their meaning.

Here too are the three ages of man, with the work being embarked upon by the serious youth, held mentally and debated by the man of maturity, and stored in material form by the elderly sage, glorious in his silken raiment.

Every detail of the three has a psychological significance: the boy is dressed in springtime simplicity, and he is solitary, as is often a youthful circumstance. Who can share his dreams and hopes? The two adult men turn inward to themselves, seeming to converse, yet both as lonely as the passionate boy. They are elders, no longer fervent, but they bring to their problem a weighty earnestness.

The philosopher at the center has the look of a man of affairs as he holds his hands free for work. Beside him, the older man grasps the visible sign of his thinking, a sky chart. The three human figures occupy only a half of

BIRTH TRAYS

Like cassoni (see p.114), birth trays were another unusual form of Renaissance art. These colorfully painted wooden trays were used to carry gifts to new mothers and were then preserved as family heirlooms. This example, from the first half of the 15th century depicts the triumph of love. Its 12-sided shape is typical of the period.

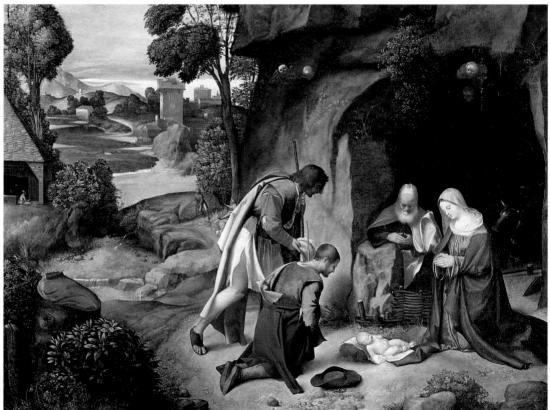

155 Giorgione, The Adoration of the Shepherds, c. 1505/10, 43½ x 36 in (112 x 91 cm)

the picture, though. The rest – the part that gives them their significance – is tree and rock. In the rock is a dark cave, and beyond it, a rich landscape burnished by the late sun.

Two possibilities are open: to venture into the unknown, the dark cave, or to move out into the familiar beauty of the countryside; to go within, into the spirit, or to go without, into the world and its rewards. Each man, alone, faces the invitation, seriously debating the wiser course, not consulting, but responsibly considering.

It is the landscape, with its autumnal ambience, that gives the work its poignancy. Scholars tells us that the old man's beard suggests to them the philosophies of Aristotle, that the middle figure wears the oriental dress reminiscent of Islamic thought, and that the sextant in the boy's motionless hand indicates the new natural philosophy that we now call science, but the information, true or not, seems irrelevant. The point is the poetry, the touch of interior gravity, the choice.

FORERUNNER OF TITIAN

A perfect example of Giorgione melting into Titian, who certainly finished some of Giorgione's paintings after his early death, is *The Adoration of the Shepherds (155)*, also called *The Allendale Nativity*. The balance of opinion now gives this solely to Giorgione, but it could equally be by Titian. In a way, the subject of the painting, or at least the focus of the artist's greatest interest, is the evening light, and this emphasis on light and landscape, first influenced by Giorgione, remained one of Titian's most enduring concerns. It unifies all it touches, and although there are certain activities taking place in the background, the overriding impression is of stillness and silence.

The business of the normal world has come to a stop. Parents, Child, and shepherds seem lost in an eternal reverie, a prolonged sunsetting that will never move to clocktime. Even the animals are rapt in prayer, and the sense of being shown not an actual event, but a spiritual one, is very persuasive. Giorgione transports us beyond our material confines, without denying them.

TITIAN: THE "MODERN" PAINTER

Titian (Tiziano Vecellio, c. 1488–1567), who was Giorgione's successor, was destined to have one of the longest life spans in artistic history – in contrast to Giorgione and Raphael – and was one of those few very fortunate artists (Rembrandt and Matisse were two others) who changed and grew at every stage, reaching a climactic old age. The early Titian is wonderful enough; the later Titian is incomparable.

Before working with Giorgione, Titian spent time in the workshop of Giovanni Bellini (see p.107). Bellini's mastery of oil painting techniques, which had transformed Venetian painting, was of huge importance to Titian's art – and by the same token, to the direction of subsequent Western painting. It is in Titian's paintings that we find a freedom prophetic of the art of today: the actual material of the paint is valued for its inherent expressive qualities – in harmony with, but distinct from, the narrative of the paintings. Titian is perhaps the most important of all the great painters of the Renaissance. Unlike his predecessors, who were trained as engravers, designers for goldsmiths, and other crafts, he devoted all his energies to painting, and as such was a forerunner of the modern painter.

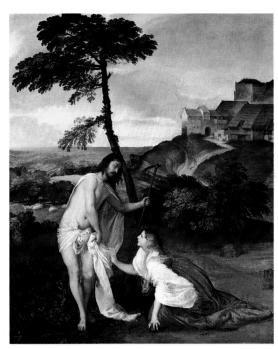

156 Titian, Christ Appearing to the Magdalen (Noli me Tangere), c. 1512, 36 × 42¾ in (91 × 110 cm)

Christ Appearing to the Magdalen (Noli me Tangere) (156) shows the youthful Titian delighting in the human interplay between the ardent Magdalen, all rich and spreading drapery, and the austere Christ, who withdraws from her with infinite courtesy.

Christ almost dances in resurrection freedom; she is recumbent with the heaviness of earthly involvements. A little tree tells us that newness of life has only just begun, and a great world stretches away toward the blue hills, remote, witnessing, leaving Mary Magdalene to her own choices. There is a touch of loneliness in the picture, a hint too of Giorgionesque nostalgia for a lost poetry. But fundamentally the mood has an earthly vigor.

OTHER WORKS BY

Sacred and Profane Love (Borghese Gallery, Rome)

> Bacchanal of the Andrians (Prado, Madrid)

Venus of Urbino (Metropolitan Museum of Art, New York)

> The Rape of Europa (Isabella Stewart Gardner Museum, Boston)

Franciscan Friar with a Book (National Gallery of Victoria, Melbourne)

A Young Man (Staatliche Museen, Berlin-Dahlem)

Titian self-portrait

This painting was completed by Titian toward the end of his life, when he was revered as an artist of great magnitude. He had revolutionized oil painting techniques, and was to be a great influence on artists such as Tintoretto and Rubens. He was ceremonially buried in Santa Maria dei Frari in Venice.

Noli me tangere

Titian's painting (see left) depicts the biblical story of Christ appearing before Mary Magdalene after His Resurrection. He forbids her to touch Him (Noli me tangere) but asks her to tell the disciples that He is risen. Mary mistook Him for a gardener, so He is shown holding a hoe.

Ranuccio Farnese

Ranuccio Farnese (1530–65) was the grandson of Pope Paul IV and belonged to one of the most influential families in Italy. This portrait was painted in 1542. By then the boy already held the privileged position of Prior of the Order of the Hospital of St. John of Jerusalem (the "Knights of Malta"), whose emblem, the Maltese Cross, is emblazoned on his cloak. Titian painted another portrait of a young aristocrat in 1542, the infant Clarissa Strozzi. Both pictures evince a warm sympathy for youth. They are full of the poignant realization of the tension between the playful world of childhood and the adult responsibilities awaiting the sitter in later life.

Vision of Youth

At the top of the painting, above the curving swell of the satin, Titian admits the true reality of the unadorned boy, who belongs still to the realm of childhood. He has a child's fresh, unmarked skin, and his eyes are bright with reflected light. Bashfully, he does not meet our gaze, and his still-unformed mouth expresses a habitual amusement. In sharp contrast to the military paraphernalia weighing him down, we see the tender chubbiness of an untried adolescent.

Military symbol

The heraldic cross on Ranuccio's coat is given a metallic sheen. Thick white paint has been dragged over the graduated grays of the cross and has been applied unmixed, to create the sharpest highlights. This is the Maltese Cross, the emblem of the Knights of Malta, an order of chivalry founded in the 13th century. The order's original purpose was to administer a hospital in Jerusalem for soldiers wounded in the Holy Land while on service in the Crusades.

Boy's TUNIC

The immediate focal point of this marvelous painting is the boy's brilliant red and gold satin tunic, contrasting with the warm, peachy flush of his cheeks. The rich cloth dazzles and shimmers in the light falling on the boy's chest, the red almost bleached out so that bright gold and silver remains, like the plumage of a bird. We are reminded of the tender vulnerability of the boy by the many small crimson slits that, in conjunction with the weapons, create an undercurrent of violence and pain.

BELT AND CODPIECE

At the bottom of the painting we see the attributes of manhood – the prominent, highlighted codpiece, closed but potent for the future: many family hopes hang upon this and his putative heirs – and the clutter of belts and sword, whose steely glint is picked out in small, dotlike strokes. Titian's portrait is built upon the contrast between the innocence of youth (Ranuccio is about 12) and the outward trappings of someone belonging to one of Italy's most powerful aristocratic families.

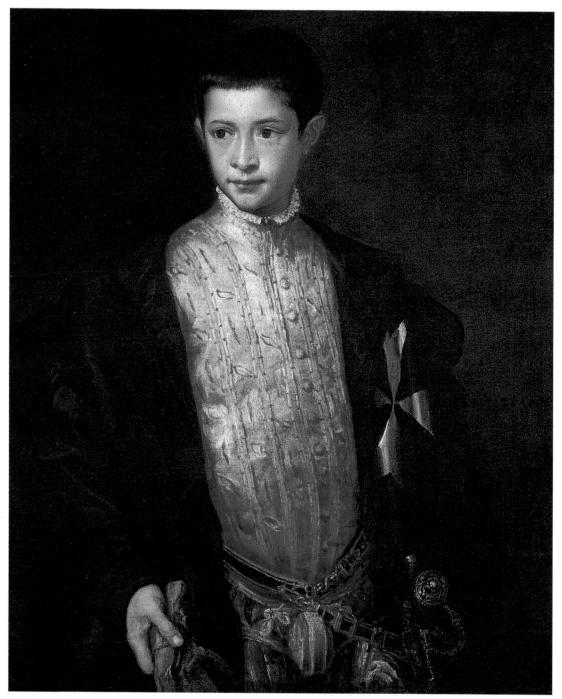

157 Titian, Ranuccio Farnese, 1542, 29 x 35 in (73 x 90 cm)

TITIAN'S PORTRAITURE

This portrait (157) from Titian's middle years shows an artist of far greater depth of spiritual insight. Now he is not reveling in the sheer technique that turns thought into image; now he is painting from his own depths, and we feel the image arises almost spontaneously.

Ranuccio Farnese (157) portrays a very young man, splendid in his courtly attire. A silver cross gleams on one breast and light sparkles on the poignard below it. But the heraldic and warlike aspects are in shadows: what is real to the boy is the glove in his other hand, a hand visibly bare,

prepared to take on the burden of living, both unafraid and unprotected. He has not yet grown into his years, and the look of expectancy on the young face is full of an unformed innocence.

We admire the dignity that Titian has seen as appropriate, but we are also touched by the all-enveloping blackness in which Ranuccio is like a small, lighted candle.

Titian's insight is almost frightening in its realism. What he does, with superb technical skill, is show us the truth of an individual with all the attendant weakness, and yet produce a picture that is supremely beautiful.

VENUS AND OTHER MYTHS

Mythological subjects featured strongly in Titian's later work, especially in the poesie, a series of paintings he made for Philip II of Spain. Venus is a particularly popular figure in Renaissance art, appearing in the works of Botticelli, Giorgione, Bronzino, and Correggio as well as Titian. The Roman goddess of love and fertility, Venus is the mother of Cupid, the little god of love.

ITALIAN BANKING

The first modern bank had opened in Venice in the 12th century. However, during the Renaissance, Florentine banks became the most important in Europe, many having branches around the continent. The influential Medici family owed much of its wealth and power to its banking activities. These gold florins (above) were minted and circulated in Renaissance Florence.

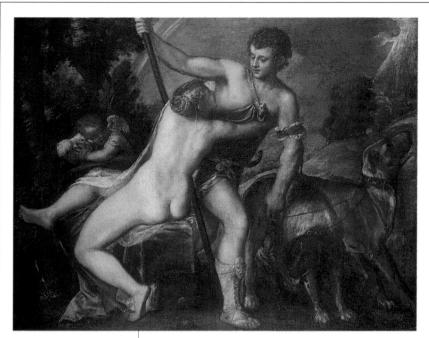

158 Titian, Venus and Adonis, c. 1560, 53½ x 42 in (135 x 106 cm)

THE LATE TITIAN

At the very end of his life, Titian painted many mythological scenes, as deeply poetic as those of the long-dead Giorgione, but with a deeper and sadder tone. Sometimes he would repeat a composition, as if seeking the total expression of some unrealized vision. One such repeated theme is that of *Venus and Adonis* (158), in which the goddess of love pleads with the young and beautiful Adonis to stay with her, knowing in prophetic insight that he will be killed while

hunting. Adonis will not listen, will not – typical of inexperience – believe that he can die. He is every young man going off to war or to adventure, and Venus is every woman striving to hold him back. There is a painful irony in that she is the one being who is most desired of all men, most lovely of the gods and most loved; but the excitement of the hunt has greater charm for Adonis even than sexual bliss, and he impatiently rebuffs her. There is even a sense of older woman/younger man, another irony, since Venus is immortal and Adonis merely thinks himself so, with tragic results.

It is the quivering color tones that make late Titian so marvelous, the soft and shimmering beauty of the flesh. Venus shows us her superb back and buttocks, beguilingly rounded, full of promise. Adonis is a hard and virile counterpart to her softness. Her coiled hair suggests her deliberateness – this is no disheveled lady of the bedchamber, and indeed they are sleeping outdoors, under a brooding sky. The great hounds, wiser than their master, sense something amiss, and even Cupid weeps with pity.

EMOTIONAL INTENSITY

So supreme an artist is Titian that it is surprising to read that Ruskin, that most insightful of Victorian critics, thought he was surpassed by Tintoretto (1518–1594). Tintoretto's original name was Jacopo Robusti, but he came to be known as *Il Tintoretto*, meaning "little dyer," after his father's profession. In a city as small as Venice, all artists knew one another, and it is no

Nude children, often winged, known as putti

(plural of the Italian putto, meaning a little boy) appeared in many early Renaissance paintings and sculptures. Often meant to depict angels and cupids, they originally graced the art of the ancient Greeks and Romans. This bronze statue of a putto with a dolphin was fashioned by Verrocchio c. 1470. (see p.116).

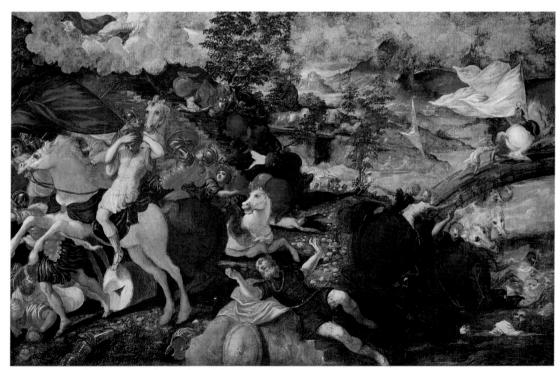

159 Tintoretto, The Conversion of St. Paul, c. 1545, 7 ft 9 in x 5 ft (235 x 152 cm)

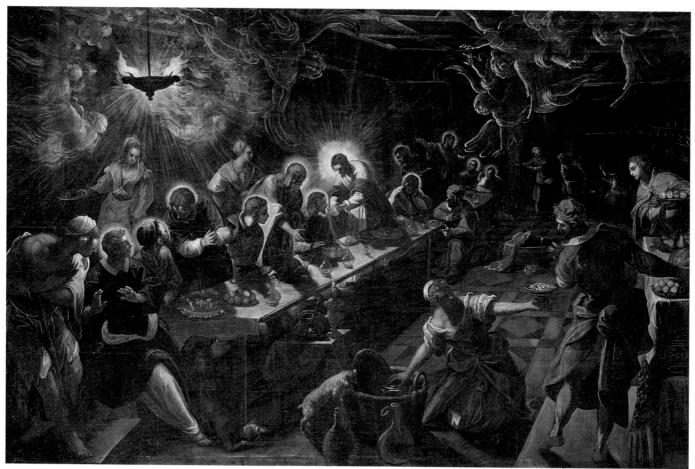

160 Tintoretto, The Last Supper, 1592-94, 18 ft 8 in x 12 ft (569 x 366 cm)

surprise to learn that Tintoretto, about 30 years Titian's junior, declared his ambition was to combine Titian's color with Michelangelo's drawing. "Drawing," as Michelangelo would haughtily agree, is hardly the word to use for Venetian chromatic unities: form coalesces out of light, very softly. Tintoretto, though, was an almost "hard" Venetian, in that he painted in a fury of inspiration, dashing down his first ideas and scumbling them into a whole.

The passion of his attack makes its tempestuous presence seen: there is constant excitement and a sense of the tremendous. Only a gigantic talent could hold this trembling emotion and keep it both genuine and humble, and all the major Tintorettos do indeed affect us with their total honesty and their overwhelming emotional force. A very early work, painted when he was in his twenties, *The Conversion of St. Paul (159)*, shows this extravagance of imaginative power.

Most painters show the conversion of St. Paul as dramatic, since the not-yet saint was thrown bodily from his horse and received the divine message lying terrified on his back. But none of the other works has the wild turbulence of Tintoretto's scene. The whole visible world breaks into chaotic disfunction, as the divine

erupts into our normality. On the right, a horse stampedes away with rider and streaming banners; on the left, another horse screams and rears, while its stricken rider is dazzled by the heavenly brightness above. Mountains surge, trees toss, men stagger and fall, the skies darken with ominous clouds. Paul lies in the center, overshadowed by his fallen horse. But he does not panic; he stretches out his desperate hands, passionate for salvation.

Many of his most potent images are still in their Venetian settings. The Last Supper (160) is still in the chancel of San Giorgio Maggiore (see right). It is an idiosyncratic version of the Last Supper, the meal commemorated every time the Eucharist (Holv Communion) is celebrated. Little is shown of the interaction between the apostles (we have to look hard to find Judas, usually a focal point). Tintoretto's one interest is in the gift of the Eucharist, and although many things are happening around this miracle, with cats, dogs, and servants included in the scene, all is insubstantial except for Christ and the food of Heaven. There is a feeling that only Christ is truly real. Angels flicker and fade in the flashes of His glory, and human presence takes on some sort of nebulous coherence only when

PALLADIAN ARCHITECTURE

The influential architect Andrea Palladio (1508–80) produced a number of buildings in Vicenza, but perhaps his most famous work is San Giorgio Maggiore in Venice. Begun in 1565, the church has the facade of a classical temple.

CHRIST AT THE SEA OF GALILEE

The contrast between Duccio's picture (see p.44) of the scene in which Christ first summons Peter and Andrew and Tintoretto's extraordinary painting could not be greater. Once again we see Christ at the Sea of Galilee, here in the middle of a violent storm. He stands on the water and calls to His amazed apostles. But as

Duccio's panel painting was all certainty and calm – the moment of revelation, frozen in time and silent – Tintoretto's canvas reveals an uncertain world, filled with danger, doubt, and confusion.

The painting is largely composed of sharp, jagged shapes and wild zigzagging movement. Not least among these is the boat, whose mast is exaggeratedly curved into a thorn shape, bending almost to breaking point in the wind. The fishermen are picked out in rough, dry daubs of paint. Only two have halos: Peter (with the brighter halo), who, with all sense of personal danger lost, leaps into the water toward Christ, and another apostle, who steers the boat toward shore.

STILL POINT

Amid the violence of the storm, only the figure of Christ and the upright tree are still. All else is in turmoil. The little branch growing out of the side of the tree is flowering – a symbol of hope – and seems untroubled by the violent storm. Its graygreen leaves and tiny white petals are painted with single, thick daubs of paint.

STORMY SEA

The thrashing waves echo the drama of the storm-filled sky, with its glancing, flashing light and rolling clouds. Earth colors have been added to the greens and grays of the turbulent waves, and the warm red ground shows through, linking the water to the solid earth, thereby increasing its sense of destructive might. The sharp zigzag of waves, razor-edged with thick white paint, leads our eye back and forth between Christ and the boat, and gives the impression of the earth opening up.

VISIONARY FIGURE

Christ's robes are rapidly painted, with great bravura (His halo is a quick white swirl). The thick, creamy paint forming His lower robes gives them solidity, and their strange metallic pink is made by crimson glazes over the top. Tintoretto's Christ belongs to an essentially visionary world: His body lacks substance. His feet are merely outlines in white paint, with the green of the sea showing through, and His finger melts into the distant shore.

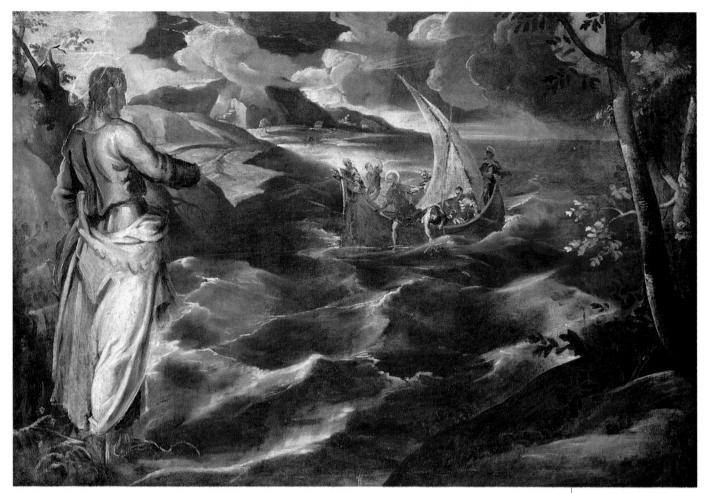

161 Tintoretto, Christ at the Sea of Galilee, c. 1575/80, 5 ft 6 in x 3 ft 10 in (168 x 117 cm)

haloed with holy brightness. There is not a moment's pretense of realism, only of underlying and sacred meaning. We either take this to heart or find it too intense.

A late Tintoretto shows *Christ at the Sea of Galilee (161)*. It is a work of immense emotional intensity. Far from presenting a frozen moment in time, it shows more than could be conveyed in a flickering instant. It is as if life could never stay still long enough to reveal what is sacred. Instead, Tintoretto paints a timeless scene of confrontation. Christ stands on the surface of a wildly tossing sea and calls His disciples. He is taut with summons, a solitary figure of majestic instancy, beckoning His divine invitation.

The apostles are a dim mass of anxious humanity, battered by the wild sea, helpless under the storm clouds. The voice of Jesus releases them from their fearful anonymity. Peter leaps joyfully into the waters, eyes fixed only on Jesus. The ugly trenches of the waves lie between servant and Master, but Tintoretto has no doubt at all that the two will meet. Violence is powerless in the presence of God, and in consequence has no authority over a seeker after God. Tintoretto shows nature as a thing almost

of torn paper, threatening and yet defanged. In an interesting touch, we are not shown the face of Christ, only His averted profile. Peter, who looks upon Him fully, can dare the leap of faith.

Even in a lovely secular work like *Summer* (162), there is an ecstatic, springlike vitality in Tintoretto's paintings that makes the very corn "immortal wheat" in the words of the 17th-century English cleric and mystic poet Thomas Traherne. This earthly image is reminiscent of the third great Venetian artist, Veronese.

OTHER WORKS BY TINTORETTO

Crucifixion (Scuola di San Rocco, Venice)

Bearded Man (National Gallery of Canada, Ottawa)

Resurrection (Queensland Art Gallery, Brisbane)

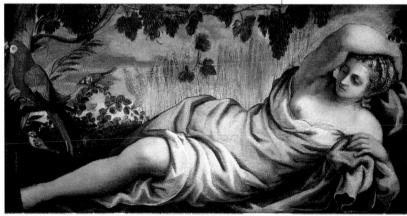

162 Tintoretto, Summer, c. 1555, 76 x 42 in (194 x 106 cm)

OTHER WORKS BY VERONESE

Marriage At Cana (Louvre, Paris)

The Family of Darius Before Alexander (National Gallery, London)

Christ in the House of Levi (Accademia, Venice)

Venus and Adonis (Art Museum, Seattle)

An Astronomer (National Gallery of Zimbabwe, Harare)

Seated Dog (Nasjonalgalleriet, Oslo)

VERONESE'S MATERIAL WORLD

Veronese (Paolo Caliari, 1528–88) has been called the first "pure" painter, in that he is practically indifferent to the actuality of what he paints, and totally taken up with an almost abstract sensitivity to tone and hue. His works glow from within, decorative art at its noblest.

Veronese may not be as profound an artist as Titian or Tintoretto, but it is easy to underestimate him. His fascination for the way things look, their capacity for ideal beauty, raises his art to a high level. He shows not what is but what, ideally, could or should be, celebrating materiality with a magnanimous seriousness.

To take the superficial so earnestly is to raise it to another order of being. His *St. Lucy and a Donor* (163) does not really show us a martyr; he expects us to know the story of this saint and provide the context ourselves. What he does show is the glory of young womanhood, all satins and silks and sunlit beauty. Her lovely face is enraptured, slightly timid, and a closer

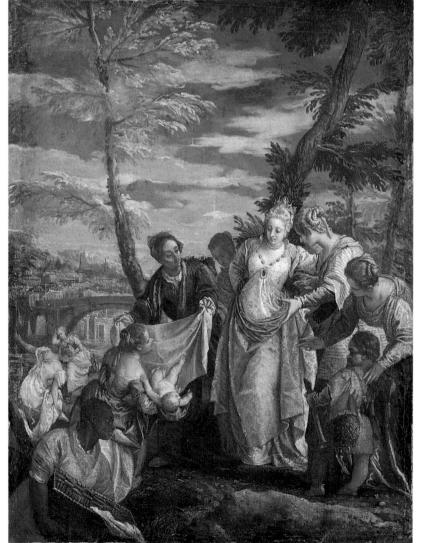

164 Paolo Veronese, The Finding of Moses, probably 1570/75, 17½ \times 23 in (45 \times 58 cm)

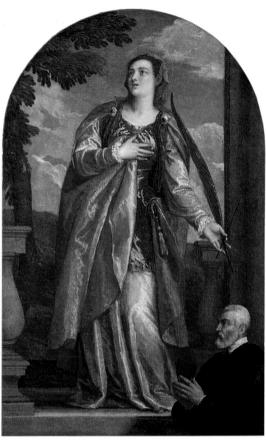

163 Paolo Veronese, St. Lucy and a Donor, probably c. 1580, 3 ft 9 in × 5 ft 11 in (115 × 180 cm)

inspection of the martyr's palm, held away from her, shows her usual emblem, an eye. But the allusion could not be more reticent, more present for form's sake. We see the elderly donor more as an admirer in the worldly way than as a devotee of St. Lucy's cult. The work is one of great amplitude, of confidence, and bodily delight.

The Finding of Moses (164) shows the same healthy and hopeful nature: there is an obvious and unaffected pleasure in the sheer opulence of the dress of Pharaoh's daughter and of her maidens. Everybody, including the infant Moses, is good-looking, elegant, and happy. The characters in the scene all look refreshingly uncomplicated. Trees balance the landscape to left and right. The lady looks affectionately at the attractive child. The biblical scene as such has solemn overtones, but not for Veronese. What delights him is its beautiful humanity.

It is easy to underestimate Veronese, to see him as a superb decorator producing colorful tableaux. But he carries decoration to the point where it reveals the intensity of experienced beauty and becomes powerful art in its own right. Veronese's work glows out at us with an awareness of the potential of a material world that is supremely beautiful.

The Italian Mannerist Period

Like "Renaissance," the term "Mannerism" applies to a broad and diverse movement, and to a certain artistic standpoint, rather than any one style. It developed out of the High Renaissance, which was in decline by the early part of the 16th century and lasted roughly 60 years, between 1520 and 1580. Mannerist art was influenced by the work of such High Renaissance artists as Michelangelo and Raphael (who died in 1520).

The word "Mannerism" is derived from the Italian word *maniera*, which in the 16th century meant "style" in the sense of elegance. Because of this implication of elegance, Mannerism has long been a somewhat misleading term that has caused much confusion and disagreement among art historians. Nevertheless "style," in this sense of the word, does constitute a crucial element of Mannerism, while Mannerist painting is also often highly "mannered" in the modern sense of the word. Mannerist painting is characterized by its self-consciously sophisticated, often contrived or exaggerated elegance, its heightened or sharp color combinations, its complex and highly inventive composition, and the technical bravado and the free-flowing line favored by its painters.

EARLY MANNERIST PAINTING IN FLORENCE

The High Renaissance was exceptionally rich in minor painters, artists whose work often slid imperceptibly into Mannerism as they exaggerated their styles, intent upon creating excitement in the viewer. Even if this sounds contrived and self-conscious, there is nevertheless an emotional charge in the great Mannerists that can be highly effective.

Rosso (Giovanni Battista di Jacopo, 1494–1540) was known in France, where he emigrated, as Rosso Fiorentino, "the Florentine." He was a deeply neurotic man, and his art was almost wantonly a flouting of normal expectations. He employed bold, dissonant color contrasts, and his figures often filled the entire picture frame. *Moses and the Daughters of Jethro (165)*, for example, is a fantastic jumble of nude bodies – huge, agitated, Michelangelo-like wrestlers, with a pale, terrified, half-stripped girl standing aghast amid the carnage. Rosso is painting an idea of violence, rather than specifics, and he does so succinctly and expertly.

Pontormo (Jacopo Carucci, 1494–1556) was also an oversensitive and neurotic man. He was sometimes known to withdraw completely from the world in order to live in seclusion. Like Rosso, his art is excitable and strange, striking us with a sort of enjoyable agitation.

Pontormo and Rosso were taught by the gifted Florentine Andrea del Sarto (1486–1531), whose soft forms, gentle colors, and emotional gestures provided a counterbalance to the rigorous athleticism of Michelangelo in Rome. His smudgy sweetness was influential, moving the Classicism of the High Renaissance toward a new Mannerist expression.

THE LAURENTIAN LIBRARY

In 1523 the Medici family commissioned Michelangelo to design a library that would hold 10,000 books and manuscripts. This, the Laurentian Library, became a forerunner of Mannerist architecture. It was 1559 before Michelangelo designed the staircase, which is recognized as a masterpiece of decorative architecture inspired by classical forms.

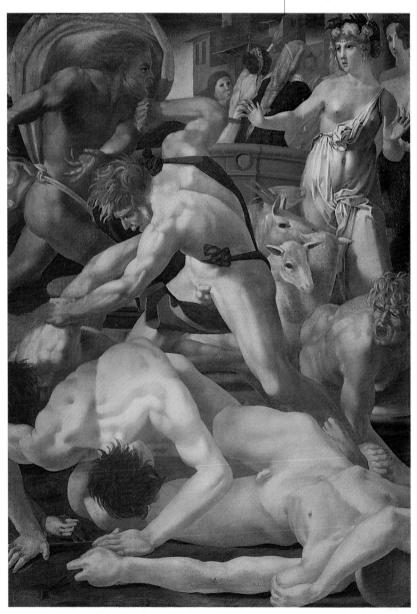

165 Rosso, Moses and the Daughters of Jethro, c. 1523, 46 x 63 in (117 x 160 cm)

SANTA FELICITA

The Church of Santa Felicita in Florence contains the Capponi Chapel, which houses Pontormo's *Deposition* as its altarpiece. The facade of the church was remodeled in 1564 with a porch added by Vasari to support the corridor connecting the Palazzo Vecchio with the Pitti Palace.

The essentially monochrome *Portrait of a Young Man (167)* is a good example of the subtle use of color in Andrea del Sarto's work – and some contemporaries rated him as one of the four best painters of his time.

Pontormo's masterpiece is his *Deposition* (166), painted for the altarpiece of a private chapel in Florence. Its strangely luminescent quality and lucid, unearthly light were created partly to compensate for the darkness of the chapel, but also reflect the work's emotional intensity. There is an overriding sense of vulnerability and

There is an overriding sense of vulnerability and with the Pitti Palace. loss, and this makes the contrast between the beautifully

166 Pontormo, Deposition, c. 1525/28, 6 ft 3 in x 10 ft 3 in (190 x 312 cm)

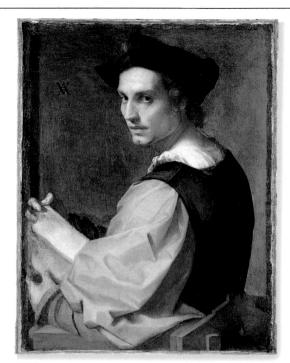

167 Andrea del Sarto, Portrait of a Young Man, c. 1517, 22½ × 29 in (57 × 73 cm)

athletic, long-limbed, classical bodies and the facial expressions of anxiety and confusion all the more pitiful. Pontormo's portrait of *Monsignor della Casa (168)* is brilliantly observed, with the prelate's long, aristocratic face giraffelike above his auburn beard. He is hemmed in by the walls of his room, rigid and defensive, challenging the onlooker with his arrogance, and yet so pleasingly decorative to view.

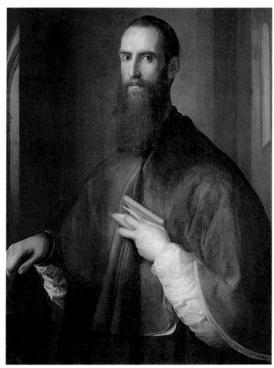

168 Pontormo, Monsignor della Casa, c. 1541/44, 31 x 40 in (79 x 102 cm)

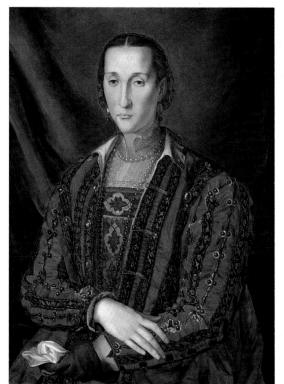

169 Agnolo Bronzino, Eleanora di Toledo, c. 1560, 26 x 34 in (65 x 85 cm)

Bronzino's Chill Vision

Pontormo was the teacher and almost the fosterfather of the strangely brilliant Agnolo Bronzino (1503-72). In Pontormo's reclusive moods Bronzino, too, was barred entrance. This may have been because Pontormo, who was deeply religious in a fanatic manner, picked up disturbing undercurrents in his protégé's work. There is a cold brilliance in Bronzino that can be very unappetizing, even when we admire his skill.

The court did not find him unattractive, however: his icy and rather bitter portraits were much admired in his day, and he became the leading Mannerist painter in Florence. His portrait of Eleanora di Toledo (169) shows her opulently dressed, dripping with costly pearls and grimly displeased.

Bronzino's Allegory with Venus and Cupid (170) used to be known as Venus, Cupid, Folly, and Time. It was commissioned by Cosimo I of Florence as a present for Francis I. The painting was described by Vasari as a many-sided allegory about sensual pleasure and a variety of unspecified dangers that lurk beneath the surface. Some have seen it as referring to incest, inherently perverse. But in 1986 a doctor suggested an extremely plausible explanation of the allegory, arguing that it was a reference to syphilis. The tortured figure on the left is an intricately worked illustration crammed with the clinical symptoms of the disease and one or

two of the side effects of treatments that were used in the 16th century. The allegory, by this reading, is that illicit love is attended by Fraud, who offers a honeycomb. A child representing the deceived will rushes to enjoy pleasure. The result of the ignorant embrace is syphilis. Time exposes the sickness by pulling away the blue backcloth, to reveal the truth that is hidden from Venus and Cupid.

Spirituality of correggio

A Renaissance painter with a Mannerist mind was Correggio (Antonio Allegri, c. 1489-1534), who lived in Parma. He was one of the very great artists, intensely physical and yet steadily aware of light and its spiritual significance. Correggio was a follower of Mantegna (see p.103), and that inner solidity keeps his excesses reasonable and, still more, lovable.

A turning point in the development of Correggio's artistic identity came after a stay in Rome as a young man, where he saw the work of Michelangelo (see p.120) and Raphael

CONTEMPORARY

1542

University of Pisa founded by Cosimo de' Medici

Hotel de Bourgogne, the first covered theater, opens in Paris

1553

The violin begins to develop into its modern form

1561

The English philosopher Francis Bacon is born

The catacombs of Rome are discovered

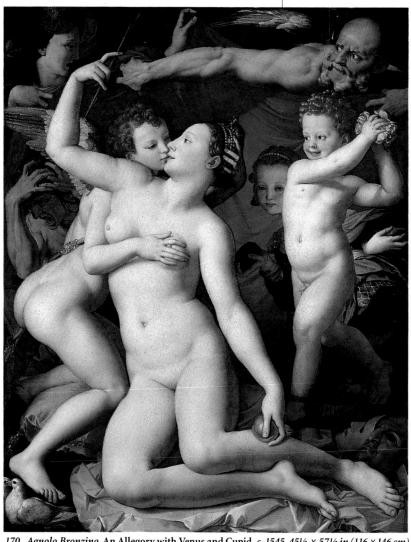

170 Agnolo Bronzino, An Allegory with Venus and Cupid, c. 1545, 45½ x 57½ in (116 x 146 cm)

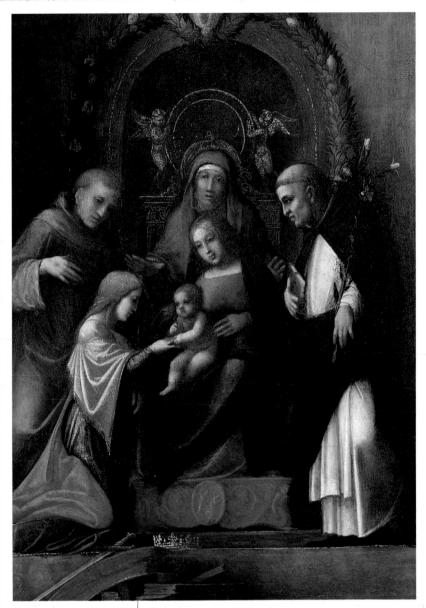

171 Correggio, The Mystic Marriage of St. Catherine, c. 1510/15, $8^{1/4} \times 11$ in $(21 \times 28$ cm)

OTHER WORKS BY CORREGGIO

Salvator Mundi (National Gallery of Art, Washington)

Adoration of the Shepherds (Gemäldegalerie, Dresden)

Assumption of the Virgin (dome fresco, Parma Cathedral)

Jupiter and Io (Kunsthistorisches Museum, Vienna)

Holy Family with the Infant St. John (Los Angeles County Museum of Art) (see p.124). He soon became the leading artist in Parma. His *Venus, Satyr, and Cupid (172)* has a complete sensual abandon, yet there is an innocence in its fleshliness, a feeling of living in the age before the expulsion from Eden. Each body reflects the moonlight individually and differently, the proportions subtly wrong, but thereby all the more morally reassuring.

There is precisely the same sort of fleshly sweetness in his religious pictures, such as *The Mystic Marriage of St. Catherine (171)*. The legend, that Catherine had a vision in which the Child Jesus betrothed her with a ring, is no longer thought of as literally true, yet it has a deeper meaning, one of consecration, and above all, of the vow of chastity. St Catherine kneels, oblivious to her saintly partner, who

leans forward with an expression of deep reverence. Indeed the whole painting, small but emotionally expansive, is infused with a profound awareness of the sacred.

Correggio was important as a precursor of Mannerism rather than as a Mannerist artist himself. In fact, his greatest contributions to Mannerism and the Baroque (see p.176) are his wonderful illusionistic ceiling frescoes, which are painted inside the domes of great churches in Parma.

Unfortunately, these frescoes defy reproduction. We have to stand inside Parma Cathedral, looking up into the light-filled *Assumption of the Virgin*; we have to be there in the church of San Giovanni Evangelista, tilting our heads in awe at *The Vision of St. John the Evangelist*. Only experience enables us to appreciate the skill of foreshortening and the overwhelming impression of actuality, which were to culminate in the technical wizardry of the Mannerists.

THE ELEGANCE OF PARMIGIANINO

Parmigianino (Girolamo Francesco Maria Mazzola, 1503–40) was an artist of the utmost elegance, subsuming all reality in sheer grace. *The Madonna with the Long Neck (173)* is his best-known and most typical picture. Mary is a swanlike lady, set amid a wholly improbable scene of ruins and curtains, elongated not only

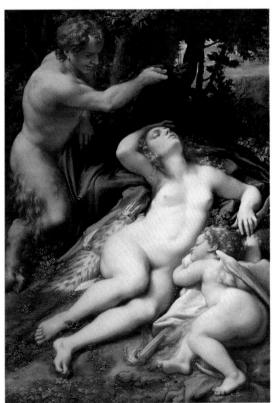

172 Correggio, Venus, Satyr, and Cupid, 1524/25, 48½ in × 6 ft 3 in (124 × 190 cm)

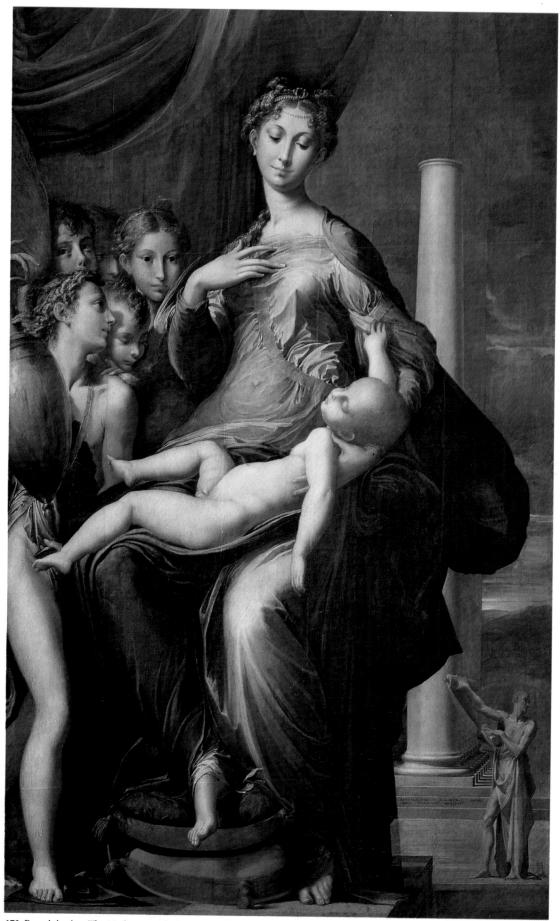

173 Parmigianino, The Madonna with the Long Neck, 1534–40, 52 \times 85 in (132 \times 215 cm)

GRINDING PIGMENTS

This red ochre drawing by Parmigianino shows a workshop assistant grinding pigments. During their apprenticeships, artists learned to identify, grind, and blend the pigments. In oil painting the pigments would be suspended in vegetable oils derived from linseed, walnuts, sunflower seeds, poppy seeds, or other plant sources. Using a buildup of differentcolored pigments on the canvas imparted a light and liquidity that would be impossible using egg tempera.

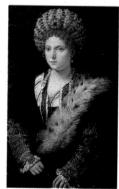

ISABELLA D'ESTE Recognized during the Renaissance for her exceptional talent and intellectual ability, Isabella d'Este (1474-1539) was a great patron of literature and art. She gathered a coterie of intellectuals, one of whom was Baldassare Castiglione (see p.129), to educate her, and employed the great artists of the time, including Correggio. There are portraits of her by a number of artists, notably Leonardo and Titian (shown above).

Lucrezia borgia As daughter of the Borgia Pope Alexander VI, Lucrezia (1480-1519) had her marriages arranged to further the political careers of her father and brother. As wife of the Duke of Ferrara she presided over a lively court and was patroness to a number of artists, including Dosso Dossi. Her modern reputation as a woman of easy virtue has overshadowed the real achievements of her patronage and charity.

of neck but of person, with a long, elegant Child on her lap, insecurely posed but unworryingly so, since this is a world where the vulgarities of gravity do not apply. A long-legged angel, ravishingly beautiful, is only the first of a throng of similar exquisites. Everything sweeps upward, like the background pillar, as if floating heavenward and bearing us all along in its sweep.

Dossi in Ferrara

Dosso Dossi (c. 1490–1542), from Ferrara, is touched with the same light of fantasy as Parmigianino (see p.142). He was court painter to Lucrezia Borgia (see column, left), and there has been speculation that it is she who was the inspiration behind the magical Circe and Her Lovers in a Landscape (174). It is an enchanting picture in a double sense, not least because of the possible initial misreading of Circe's body. Her left leg is modestly cloaked, but at first it can seem strangely absent, as if she strides across from another world into ours. The men magicked into animals have both pathos and humor, with a touch of cruelty congenial to the Borgia ménage. Yet Circe has a yearning face, and perhaps the strongest note in the picture is one of sadness and desire.

LOTTO IN VENICE

There is this same strain of sadness in Lorenzo Lotto (c. 1480–1556), a highly idiosyncratic painter who mingles his sadness with a disinterested human curiosity. He always gives us a slanting view, provocative and thoughtful, colored by

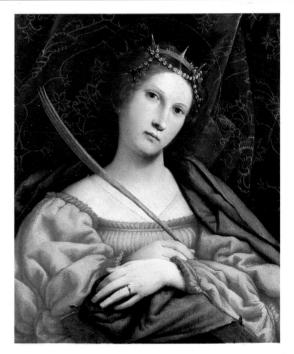

175 Lorenzo Lotto, St. Catherine, c. 1522, 20 x 22½ in (50 x 57 cm)

Giovanni Bellini's continuing influence in Venice. Lotto is famous especially for his portraits, where his weird and original insights found splendid scope, but even in an apparent religious image, there is the same enigmatic and offbeat inventiveness. *St. Catherine* (175) tilts her charming head to one side and regards us thoughtfully. She has generously hidden from us her spiked wheel, covering it with the rich folds of her green mantle, and she rests her

hands comfortably on its rotundity. The artist clearly suspects that her neck cross is essentially as much adornment as is her pearled crown, yet we believe in her totally. We may not believe in this Catherine as a saint, but that she is a real woman whom Lotto painted comes across with great clarity.

BECCAFUMI IN SIENA

Domenico Beccafumi (1485–1551) was the last great Sienese artist of the High Renaissance, just as Dossi was the last great Ferrarese. He is not an easy painter, with his sudden transitions from dark to light, his oddly proportioned figures, and his unusual acidic colors reminiscent of the Florentine Mannerist Rosso Fiorentino (see p.139). Beccafumi's figures can seem to loom up at us, disconcertingly, and his use of perspective, though sophisticated,

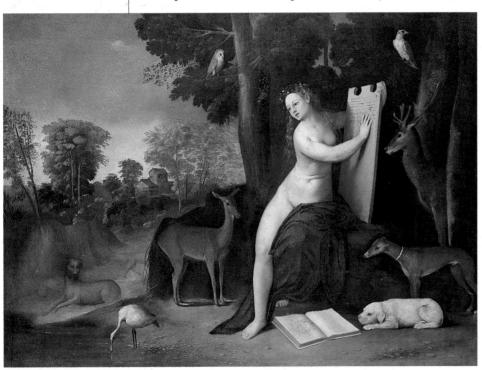

174 Dosso Dossi, Circe and Her Lovers in a Landscape, c. 1525, 53½ x 39½ in (136 x 101 cm)

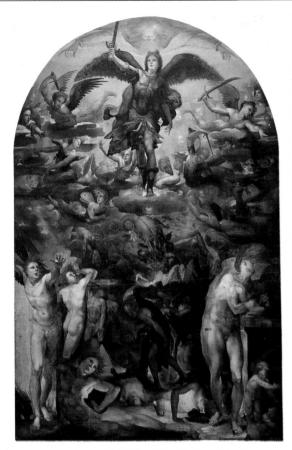

176 Domenico Beccafumi, The Fall of the Rebel Angels, c. 1524, 7 ft 5 in x 11 ft 4 in (225 x 345 cm)

is personal to himself. *The Fall of the Rebel Angels* (176) is a tangle of dimly lit forms, hallucinatory in its horror, yet shot through with the memories of Sienese graciousness (see p.43).

EL GRECO: PASSIONATE VISIONARY

The greatest Mannerist of them all is the Spanish painter El Greco (Domenicos Theotokopoulos, 1541–1614, called "El Greco" because he was born in Crete). His artistic roots are diverse: he traveled between Venice, Rome, and Spain (settling in Toledo). The Christian doctrines of Spain made a crucial impact on his approach to painting, and his art represents a blend of passion and restraint, religious fervor and Neo-Platonism, influenced by the mysticism of the Counter-Reformation (see p.176, 187).

El Greco's elongated figures, ever straining upward, his intense and unusual colors, his passionate involvement in his subject, his ardor and his energy, all combine to create a style that is wholly distinct and individual. He is the great fuser, and also the transfuser, setting the stamp of his angular intensity upon all that he creates. To the legacies of Venice, Florence, and Siena, he added that of the Byzantine tradition, not necessarily in form but in spirit (although he did in fact train as an icon painter in his early years in

177 El Greco, Madonna and Child with St. Martina and St. Agnes, 1597–99, 40½ × 76 in (103 × 194 cm)

Crete). El Greco always produces icons, and it is this interior gravity of spirit that gives his odd distortions a sacred rightness.

The Madonna and Child with St. Martina and St. Agnes (177) sweeps us up from our natural animal level, there at the bottom with

GALILEO GALILEI

The foremost philosopher, physicist, and astronomer of the Renaissance was Galileo (1564–1642). He held an heliocentric view of the world (believing that the world revolved around the sun) and was considered a heretic by the Church. He developed a telescope (shown above) that was powerful enough to show the mountains and valleys of the moon.

In 1633 he was put under house arrest for his astronomical teachings; later he was forced to disown them publicly. St. Martina's pensive lion and St. Agnes's lamb, balancing with unnatural poise on the branch of her arm. Martina's palm of martyrdom acts like a signal, as do the long, impossibly slender fingers of Agnes.

We are drawn irresistibly up, past the flutter of cherubic wing and the rich swirl of virginal robe, kept to the pictorial center by those strangely papery or sheetlike clouds peculiar to El Greco. Up, up, rising through the curve of Mary's cloak, we are drawn to the heart of the work, the Child and, above Him, the oval serenity of the Madonna's countenance. We are continually on the move, but never left to our own devices. We are guided and directed by El Greco, with praying figures at the corners to hold us in the right position.

Unresolved questions

Such a dramatic and insistent art can seem too obtrusive: we may long to be left to ourselves. But this psychic control is essential to El Greco, the great – in the nicest sense – manipulator. Even when we cannot really understand the picture, as in the *Laocoön* (178), we have no doubt that something portentous is taking place and that we are diminished to the extent we cannot participate. The literal reference to the Trojan

priest and his sons is clear enough (see p.20). But who are the naked women, one of whom seems to be double-headed? Even if the extra head is indicative of the work being unfinished, it is still uncannily apposite. *The Laocoön* was overpainted after El Greco's death, and the "second head" that looks into the painting was obliterated, while the two standing frontal nudes were given loincloths. Later, these features were restored to the form that we see now.

The serpents seem oddly ineffectual, thin and meager; we wonder why these muscular males have such trouble overcoming them. And we feel that this is an allegory more than a straightforward story, that we are watching evil and temptation at work on the unprotected bodies of mankind. Even the rocks are materially unconvincing, made of the same non-substance as the high and clouded sky.

The less we understand, the more we are held enthralled by this work. It is the implicit meaning that always matters most in El Greco, that which he conveys by manner rather than by substance, gleaming with an unearthly light that we still, despite the unresolved mysteries, do not feel to be alien to us. No other of the great Mannerists carried manner to such height or with such consistency as El Greco.

OTHER WORKS BY

Lady in a Fur Wrap (Pollock House, Glasgow)

The Burial of Count Orgaz (Church of Santo Tome, Toledo)

The Resurrection (Prado, Madrid)

St. Bonaventura (National Gallery of Victoria, Melbourne)

St. Francis in Ecstasy (Museum of Fine Arts, Montreal)

> St. Peter in Tears (Nasjonalgalleriet, Oslo)

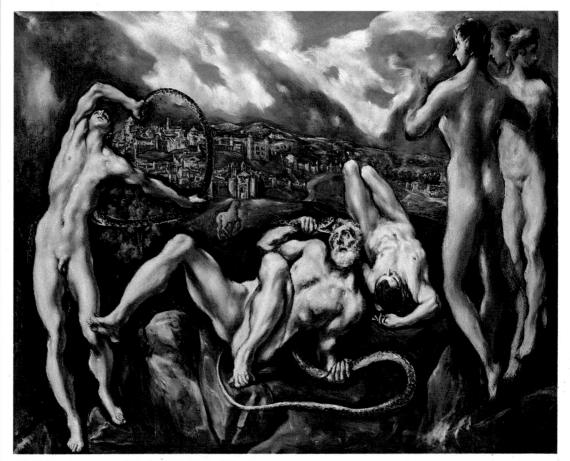

178 El Greco, Laocoön, c. 1610, 68 x 54 in (173 x 137 cm)

Laocoön

El Greco's painting depicts events best known to us from Virgil's *Aeneid*, but El Greco probably knew them from the Greek writer Arctinus of Miletus. Laocoön tried to dissuade the Trojans from letting in the treacherous wooden horse (which led to the sacking of Troy). In the Arctinus version Laocoön, a priest, was killed by serpents sent by Apollo for breaking his priestly rule of celibacy (in Virgil the gods intervened openly on the Greek side).

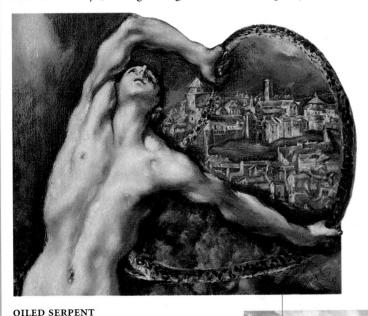

El Greco's wonderful circular invention of the boy wrestling with the serpent creates a powerful physical tension. We are kept in suspense as to whether the boy will end the same way as his brother lying dead on the ground. El Greco's unique and unorthodox style admits an unprecedented freedom. Around the boy's outstretched arm there is a broad band of black, which has no spatial "meaning" as such, and which emphasizes the rigidity of the arm and the desperate efforts of the boy. The line flows around the strange, stone-colored figures.

A spanish troy

The allegorical horse in the middle distance trots toward the city, which is spread out under a glowering, doom-laden sky. It is a beautiful landscape, in which the vibrant red-earth ground is covered with a lattice of silvers, blues, and greens. However, this is not the ancient city of Troy, but El Greco's hometown of Toledo in Spain. El Greco painted Laocoön during the time of the Spanish Catholic Counter-Reformátion, and his allegorical drama, of transgressing mortals and vengeful gods, set unequivocally in his own modern Spain, is an indication of the orthodoxy of the artist's religious beliefs.

Mystery witnesses

The figures who appear to watch the scene with indifference are a mystery. One, a woman, seems to be two-headed, with one head looking out of the painting. The figures could be Apollo and Athena, come down to witness the judgment on Laocoön.

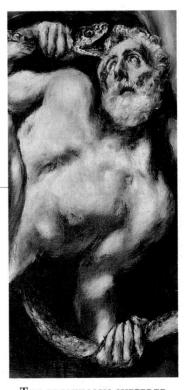

The eponymous sufferer The anguished head of Laocoön is an example of the artist's characteristic light, rapid, feathery brushwork. Where skin meets skin – in between toes, lips, nostrils – he has applied crimson or vermilion, breathing life and a suggestion of lifeblood into the deathlike steely grays of the flesh.

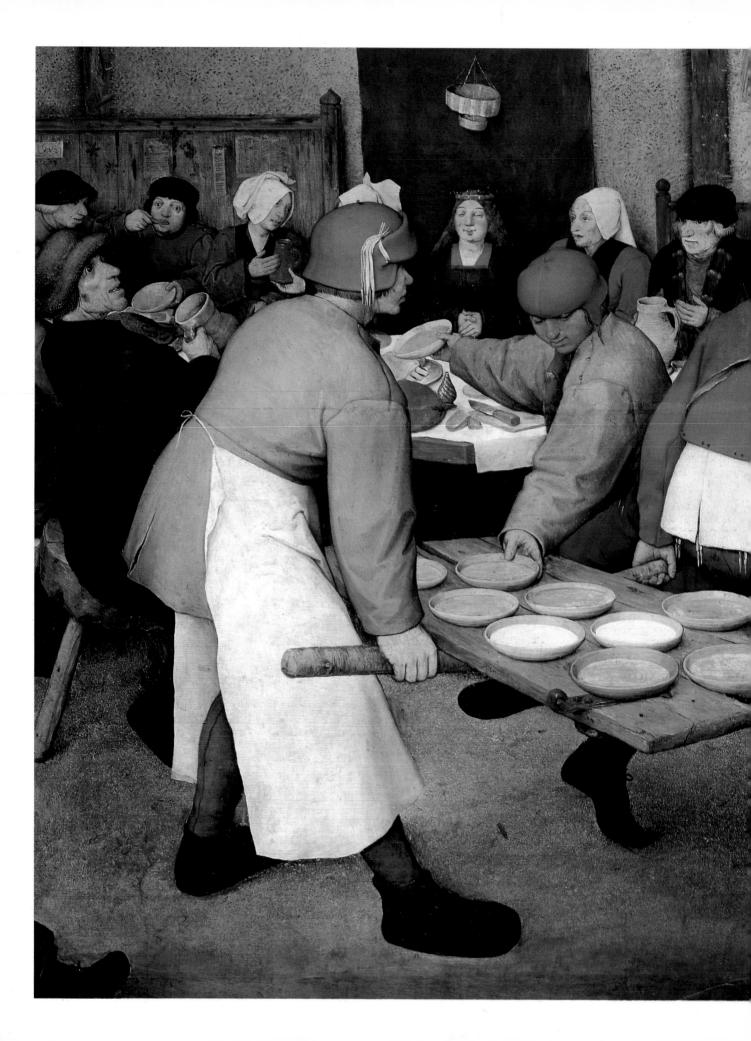

THE NORTHERN RENAISSANCE

Having closed the Gothic chapter with the anguished realism of Matthias Grünewald in order to concentrate on that most momentous of movements, the Italian Renaissance, we now return to the North, picking up the thread where we left off.

The 16th century heralded a new era for painting in the Netherlands and Germany. Northern artists were influenced by the great innovations in the South; many artists traveled to Italy to study; and the Renaissance concern with bringing modern science and philosophy into art was also evident in the North. There was, however, a difference of outlook between the two cultures. In Italy, change was inspired by Humanism, with its emphasis on the revival of the values of classical antiquity. In the North, change was driven by another set of preoccupations: religious reform, the return to ancient Christian values, and the revolt against the authority of the Church.

NORTHERN RENAISSANCE TIMELINE

The Renaissance in the North crystallized around the intense vision and realism of Dürer's work. Other painters in both Germany and the Netherlands followed the Northern impulse for precise observation and naturalism in the fields of landscape painting (Patinir and Brueghel) and portraiture (Holbein). As in Italy, the Northern Renaissance ended with a Mannerist phase. Mannerism was to last about a generation longer in the North than it did in Italy, where it was outmoded by 1600.

Albrecht dürer, Madonna and Child, C. 1505

Dürer's work is characterized by an intense scrutiny that enabled him to depict the innermost depths of his subjects. He sees through to the heart of his subject, whether his theme is portraiture or religious (p.153).

Lucas cranach, crucifixion with the converted centurion, 1536

In the course of his long career, Cranach developed two styles. Popular paintings such as nudes were sold privately to wealthy patrons, and court paintings were produced on official commission. These were either portraits or religious works. This Crucifixion, which alludes to the Gospel story of the centurion, shows Cranach tackling the task of devotional work. His sincerity is compromised by his own personal commitment to Humanism and his support for the Reformation, which questioned the value of religious imagery (p.158).

1500

1515

1530

1545

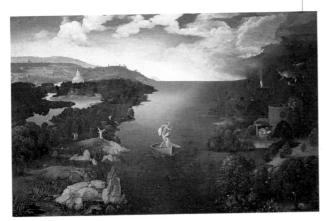

JOACHIM PATINIR,

CHARON CROSSING THE STYX, 1515-24

Elements of Gothic style are visible in Patinir's work from the early Northern Renaissance. Charon, the mythical ferryman, is taking his passenger to Hades, the Greek equivalent of Hell, which is depicted as a war-torn landscape with burning buildings and tortured, despairing people in the manner of Hieronymus Bosch (see p.72). This work is, at the same time, an early foreshadowing of the Northern landscape tradition (p.166).

HANS HOLBEIN THE YOUNGER, CHRISTINA OF DENMARK, 1538

In the work of Holbein, we find the other face of portrait painting, in contrast to that of Dürer. Holbein was able to show the surface, without close inquiry into the inner life of the sitter. This distanced approach suited his work as a court and diplomatic portraitist to Henry VIII of England. Christina was not a queen, but the Duchess of Milan and a member of the Danish aristocracy. She granted Holbein an audience of only three hours in which to sketch for this powerful picture (p.160).

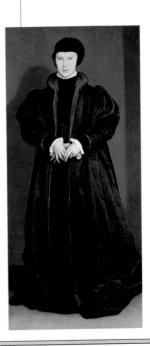

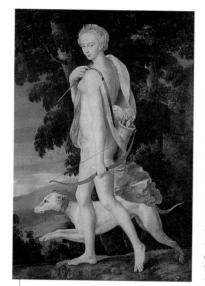

SCHOOL OF FONTAINEBLEAU, DIANA THE HUNTRESS, C. 1550

The Gothic castle at Fontainebleau outside Paris was developed by King Francis I (1514–47) as a cultural and artistic center. The king employed artists and sculptors from Italy, and Fontainebleau became an entry point through which Southern influence made its way into Northern Europe. The poets of the School of Fontainebleau treated Diana as the most important of the gods, more so even than Venus. The way Diana is painted shows well the sinuous line and decorative pose that appeared in so much Mannerist art (p.164).

Wtewael was one of the leading Mannerist painters in the Northern Netherlands. His work shows a preoccupation with elegant figure painting, in which the subjects are invariably seen in distorted poses and a characteristically acidic range of colors. This scene has the typically artificial Mannerist setting, a fantasy woodland populated with elegant creatures (p.165).

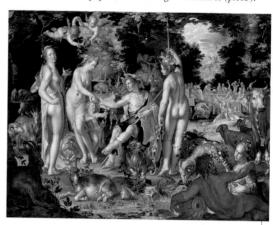

PIETER BRUEGHEL, THE WEDDING FEAST, 1567–68

This is one of a number of works in which Brueghel took as his theme the life of the contemporary peasant. For a sophisticated intellectual, it was an extraordinary achievement to enter so profoundly into the crude vitality of these scenes. Despite their rough humor, Brueghel's peasant scenes exude an almost guilty compassion for the degradation in which the peasants lived (p.168).

1560

1575

1590

1610

PIETER BRUEGHEL, HUNTERS IN THE SNOW, 1565

It was part of Brueghel's universality that he excelled in landscapes as well as focusing closely on human nature. In 1565 he painted a series of landscapes linked to months of the year, thus continuing the tradition of calendar illustrations seen in the "books of hours" (see p.55). In the books of hours, peasant activities were shown in alternate panels with scenes from court life. In Brueghel's series, only the peasant scenes are known, at least today. Another of this series is Gloomy Day (see p.171).

BARTHOLOMEUS SPRANGER, VULCAN AND MAIA, C. 1590

Frankly sensuous poses, attenuated figures, and a strong element of fantasy make this a quintessential work of Mannerism (p.165).

Dürer and German Portraiture

OTHER WORKS BY DÜRER

Young Girl Wearing a Beret (Staatliche Museen, Berlin-Dahlem)

A Young Man (Palazzo Rosso, Genoa)

Virgin and Child (Alte Pinakothek, Munich)

Salvator Mundi (Metropolitan Museum of Art, New York)

> Adam (Prado, Madrid)

Adoration of the Trinity (Kunsthistorisches Museum, Vienna) Dürer was so great an artist, so searching and all-encompassing a thinker, that he was almost a Renaissance in his own right – and his work was admired by contemporaries in the North and South alike. The 16th century saw the emergence of a new type of patron, not the grand aristocrat but the bourgeois, eager to purchase pictures in the newly developed medium of woodcut printing. The new century also brought an interest in Humanism and science, and a market for books, many of which were illustrated with woodcuts. The accuracy and inner perception of Dürer's art represent one aspect of German portraiture; another is seen in the work of that master of the court portrait, Holbein.

Impressive though others may be, the great German artist of the Northern Renaissance is Albrecht Dürer (1471–1528). We know his life better than the lives of other artists of his time: we have, for instance, his letters and those of his friends. Dürer traveled, and found, he says, more appreciation abroad than at home. The Italian influence on his art was of a particularly

Venetian strain, through the great Bellini (see p.106), who, by the time Dürer met him, was an old man. Dürer was exceptionally learned, and the only Northern artist who fully absorbed the sophisticated Italian dialogue between scientific theory and art, producing his own treatise on proportion in 1528 (see top of column, p.153). But although we know so much about his doings, it is not easy to fathom his thinking.

Dürer seems to have united a large measure of self-esteem with a deep sense of human unfulfillment. There is an undercurrent of exigency in all he does, as if work was a surrogate for happiness. He had an arranged marriage, and friends considered his wife, Agnes, to be mean and bad-tempered, though what their real marital relations were, nobody can tell. For all his apparent openness, Dürer is a reserved man, and perhaps it is this rather sad reserve that makes his work so moving.

The Germans still tended to consider the artist as a craftsman, as had been the conventional view during the Middle Ages. This was bitterly unacceptable to Dürer, whose *Self-Portrait* (179) (the second of three) shows him as slender and aristocratic, a haughty and foppish youth, ringletted and impassive. His stylish and expensive costume indicates, like the dramatic mountain view through the window (implying wider horizons), that he considers himself no mere limited provincial. What Dürer insists on above all else is his dignity, and this was a quality that he allowed to others too.

Even a small and early Dürer has this momentousness about it. His *Madonna and Child (180)*, which manifestly follows the Venetian precedent of the close-up, half-figure portrait, was once thought to be by Bellini. To Dürer, Bellini was an example of a painter who could make the ideal become actual. But Dürer can never quite believe in the ideal, passionately though he longs for it. His Madonna has a portly, Nordic handsomeness, and the Child a snub nose and massive jowls. All the same, He holds His apple

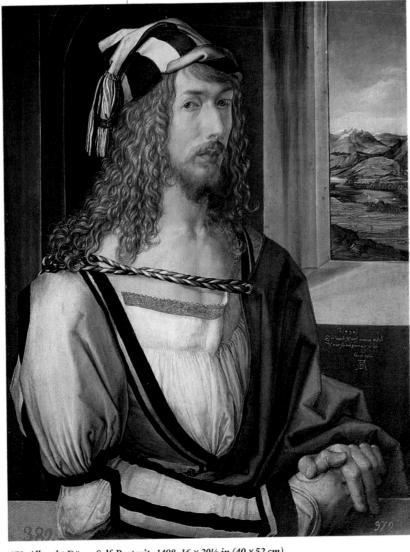

179 Albrecht Dürer, Self-Portrait, 1498, 16 x 20½ in (40 x 52 cm)

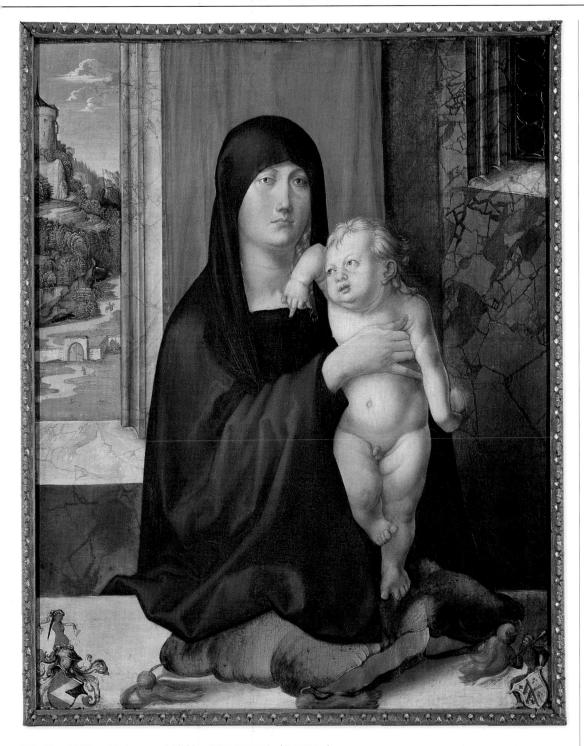

180 Albrecht Dürer, Madonna and Child, c. 1505, 16 x 20 in (40 x 50 cm)

in exactly the same position as in Dürer's great engraving of Adam and Eve, and this attitude is pregnant with significance. The Child seems to sigh, hiding behind His back the stolen fruit that brought humanity to disaster and that He is born to redeem. On one side is the richly marbled wall of the family home; on the other, the wooded and castellated world. The sad little Christ faces a choice, ease or the laborious ascent, and His remote Mother seems to give Him little help. Beautiful though the work is in color, and

fascinating in form, it is this personal emotion that always makes Dürer an artist who touches our heart, somehow putting out feelers of moral sensibility.

There is an almost obsessive quality about a great Dürer. One feels the weight of a sensibility searching into the inner truth of his subject. It is this inwardness that interests Dürer, an inner awareness that is always well contained within the outer form (he is a great portrait painter) but that lights it from within.

the perfection of form and beauty is contained in the sum of all men.

Dürer, Four Books on Human Proportions, 1528

Dürer woodcuts In 1498 Dürer produced his first great series of woodcuts: a set of illustrations for the Apocalypse (the book of Revelation). He would complete more than 200 woodcuts during his lifetime. The illustration above is a detail of one of these, The Four Horsemen of the Apocalypse. This is an allegorical representation of War, Hunger, Plague, and Death.

ART IN GERMANY AND THE LOW COUNTRIES

During the High Renaissance a number of Italian artists visited Northern Europe, but were generally critical of Northern art. Despite this, the North had a strong tradition of learning and the arts. There were many lively centers of artistic and intellectual achievement, such as Vienna, Nuremberg, and Wittenberg. Certainly by Dürer's time a Renaissance in the North was overdue.

GERMAN WOOD SCULPTURE

German art of the 16th century was greatly influenced by the medieval tradition of detailed wood carving. In the 16th century, the stylistic emphasis shifted toward more linear and animated figures, and linden became the most popular carving wood. This example, known as The Virgin of Sorrows, is by the great southern German artist Tilman Riemenschneider, one of the supreme wood carvers of Renaissance Germany.

Erasmus

Desiderius Erasmus (1466-1536), the Dutch Humanist and philosopher, was one of the leading figures of the Northern Renaissance. He traveled widely and became a professor at Cambridge and Oxford universities, where he met many of Europe's most influential intellectuals. He prefigures the religious teachings of Luther but came to abhor the extremism of the reformers themselves. This bizarre, doodled self-portrait is in one of his notebooks.

Having rejected the Gothic art and philosophy of Germany's past, Dürer is the first great Protestant painter, calling Martin Luther (see column, p.156) "that Christian man who has helped me out of great anxieties." These were secret anxieties, that hidden tremulousness that keeps his pride from ever becoming complacent. Although there is no reason why any Catholic artist should not have painted *The Four Apostles* (181), nor why such an artist should not equally

have chosen first John and Peter (indisputably biblical apostles), then Paul and Mark (mere disciples, not ordained by Christ in the Gospel story, though they were great preachers of the Word), it strikes a definitely Protestant note.

These four embody the four temperaments: sanguine, phlegmatic, choleric, and melancholic. Dürer had a consistent interest in medicine and its psychological concomitants, since in some way he found humankind mysterious.

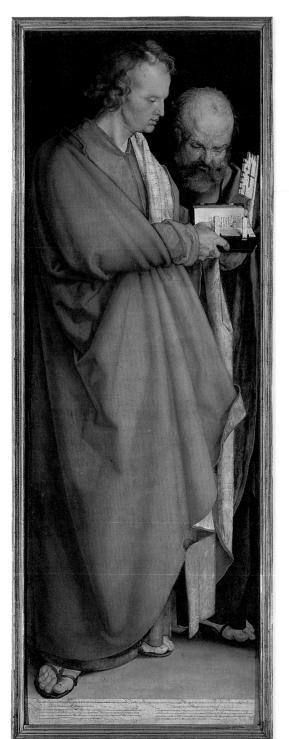

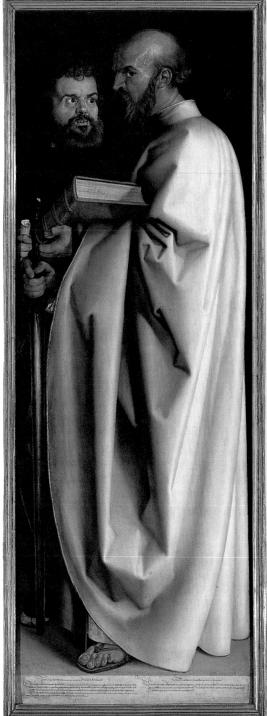

181 Albrecht Dürer, The Four Apostles, 1523–26, 30 x 29½ in (75 x 215 cm) (each panel)

THE FOUR APOSTLES

Together the four apostles make a whole, just as the four temperaments meet within an individual. Dürer is depicting many things at once: the wholeness of humanity, the unity that makes a church, the need to live united without a hierarchy, the interests of various kinds of men. The painting is infinitely satisfying, full, strong, almost sculptural in its awareness of space. The four stand against a black background, heroic in their individualism and their comradeship.

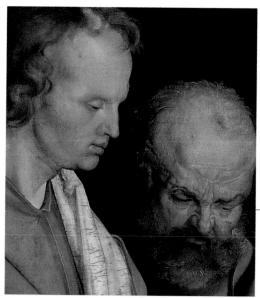

JOHN AND PETER

John is the sanguine man, hopeful and at peace, his ruddy cheeks matched by the full, flowing red of his cloak and by the auburn curls on his handsome head. As the writer of one of the Gospels, he holds a book. Peter, the phlegmatic, holds his papal keys impassively. He stands with bald head shining, face inexpressive, his body hidden behind John's impressive bulkiness. (There is surely a touch of acid wit in so diminishing the impulsive Peter, the appointed keeper of the keys.)

PAUL AND MARK

Mark is the choleric man, with angry eyes aglare. He is looking away to the right, almost as if to ward off danger. Masking him is the melancholic Paul, a tall brooder, who holds his Gospel closed and is watching us suspiciously out of the corner of his eye. Paul is visually redeemed by the amplitude of his flowing white garments, so creamy and so heavy that they fall in deep, shadowed folds. Shadows are part of melancholy, yet they have great dignity.

Monogram and year

Dürer's distinctive "AD" monogram appears on virtually all his work. As if to emphasize his non-Italian, Germanic identity, he usually ignored the common practice of adding a Latin phrase to the signature. On the rare occasions when he did, he described himself as "Albertus Durer Noricus" -Albrecht Dürer of Nuremberg.

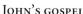

JOHN'S GOSPEL St. John's normal attribute is a chalice, the cup used at the Last Supper and, in symbolic form, at communion. Dürer departs from tradition by using St. John's Gospel as an attribute. The open page shows the first words of a chapter, which on close inspection prove to be the German text of Luther's Bible translation, another indication of Dürer's Protestant sympathies.

182 Albrecht Dürer, The Painter's Father, 1497, 16 x 20 in (40 x 50 cm)

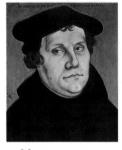

Martin Luther

This portrait of the religious reformer Martin Luther (1483–1546) is by Cranach. In 1517 Luther drafted 95 theses opposing the contemporary

the contemporary emphasis on ritual and denouncing the decadence of the Church. In 1521 Luther (then under house arrest) translated the New Testament into German. By 1546 much of Germany had been converted to Protestantism. Dürer came from a Hungarian family of goldsmiths, his father having settled in Nuremberg in 1455. In *The Painter's Father (182)*, Dürer shows the face with respectful sensitivity. The technique is pencillike, precise, and inquiring; the description achieved has a hard brilliance. However, the rest of the picture may be incomplete, or not all Dürer's work. The rudimentary background is a far cry from the detailed one in Dürer's own *Self-Portrait* (see p.152), and the sitter's clothing is hardly more than sketched in.

THE SEDUCTIVE NUDES OF CRANACH

Lucas Cranach the Elder (1472–1553), born one year after Dürer, is as self-determined as Dürer but without his spiritual concentration. From an early stage in his career, Cranach was able to obtain copies of Dürer's woodcut prints, and his familiarity with these was to have lasting influence on his painting, with its sharp definition and brilliant color.

Cranach was almost two painters in one – artistically schizophrenic, as it were. His most popular works are the decidedly seductive nudes with which he delighted his aristocratic patrons. These coy creatures have the rare distinction of fitting in with modern tastes, being slender, free-spirited, and even kinky. They have a sort of refined sexuality, but it is also cold and teasing: we are tempted to think that Cranach did not really care for women and may even have feared them. His *Nymph of the Spring (183)* has hung

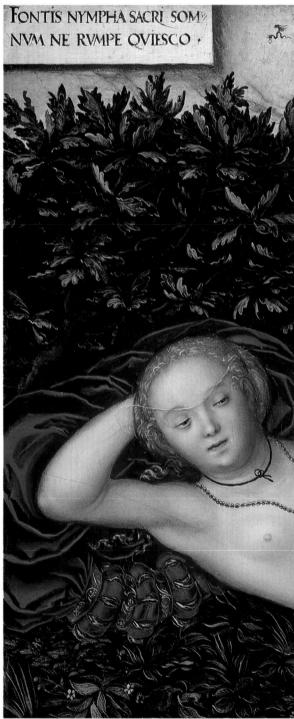

up her hunting arrows, but the presence of a pair of partridges (birds of Venus) suggests that it is the human heart that she hunts. A distinctly diaphanous wisp of silk draws attention to her loins by "covering" them, she wears her jewelry provocatively, and she is clearly only pretending to be asleep, propped up on the thick, sensual velvet of her dress. She sprawls before us, part of the landscape and in a sense its essence. A Latin inscription on the upper left reminds us that this is a nymph of a sacred fountain. She is not a

secular image, despite her alluring nakedness. We are warned not to break, not to shatter her holy slumbers. Love, Cranach is telling us, is something we have to approach with delicate reverence. A meaningful landscape surrounds her. Close by is the mysterious, symbolic cave in the rock – again, an image of sacred sexual symbolism, the female hollow. Beyond that there is the world of commerce and battle, church and family, in which the sacred realities of sex are played out in actual life.

THE HOLY

This was a confederation of kingdoms and principalities across Europe, though the German lands were always the chief component. The emperor was elected by the German princes together with a number of archbishops.

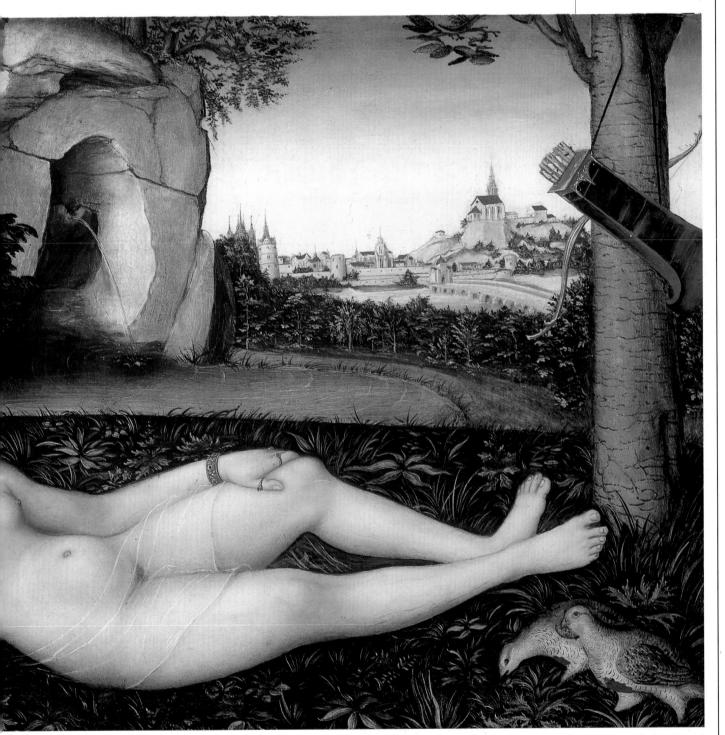

183 Lucas Cranach the Elder, The Nymph of the Spring, after 1537, 29 x 19 in (73 x 48 cm)

OTHER WORKS BY CRANACH

A Lady of the Court as Judith (Museum of Fine Art, San Francisco) The Golden Age (Alte Pinakothek, Munich)

Herodias (Museum of Fine Arts, Budapest)

Samson and Delilah (Metropolitan Museum of Art, New York)

The Nymph of the Fountain (The Walker Art Gallery, Liverpool)

CRANACH'S COURT PAINTINGS

The other Cranach was also in great demand at the German courts, these being the excessively (and superficially) religious mini-courts of the Germanic states. He had a large workshop, which was busied with the production of copies of his more successful or popular pictures. His religious scenes are not always very convincing, even if the orthodoxy is impeccable: the soldier in his *Crucifixion with the Converted Centurion (185)*, a Teuton down to his monstrous feathered hat and studded armor, seems out of place beneath the Cross.

His portraits of these same Teutons, though, when the religious trappings are left aside, can be hypnotically powerful. He painted a great many court portraits, always ornately extravagant and materially decadent in mood. The fanatic precision of the dress, the elaboration of necklaces and rippling hair, and, above the grandeur, the wistful child face, make his *Princess of Saxony (184)* one of the most appealing images of the child in art.

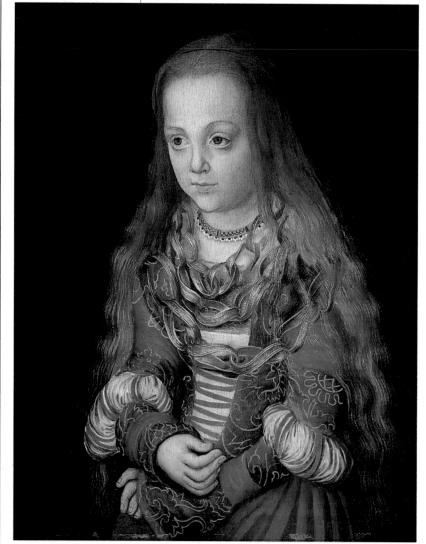

184 Lucas Cranach the Elder, A Princess of Saxony, c. 1517, 131/2 x 17 in (34 x 43 cm)

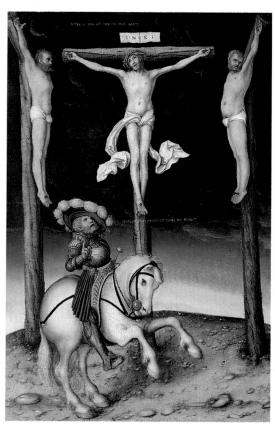

185 Lucas Cranach the Elder, The Crucifixion with the Converted Centurion, 1536, 14 × 20 in (35 × 50 cm)

She is both regal and vulnerable, a princess in her splendid attire of golden chains and her scarlet-and-white dress, and a child in her open-eyed and wondering innocence. Cranach perplexes the eye with the intermingling of her soft, waving hair with her golden chains, an apt symbol for a princess.

HANS HOLBEIN THE YOUNGER

Cranach's little girl, overdressed and overdecorated, makes an interesting contrast with Holbein's little boy (186), who carries the splendor of his attire without question. The boy is, of course, not some anonymous Saxon, however noble, but the only son of the mighty King Henry VIII of England.

Hans Holbein (1497/8–1543) was educated in his father's studio in Augsburg, but early in his career he left his native Germany for Basel in Switzerland. It was in Basel that Holbein met the reformist scholar Desiderius Erasmus (see column, p.154). Erasmus provided an entrée to English court circles, where Holbein eventually received royal patronage from King Henry VIII.

The English penchant for the portrait found its complete satisfaction in Holbein's shrewd, subtle, and respectful eye, his infinitely accurate and yet ennobling hand. The small Edward was the apple of his fearsome father's eye.

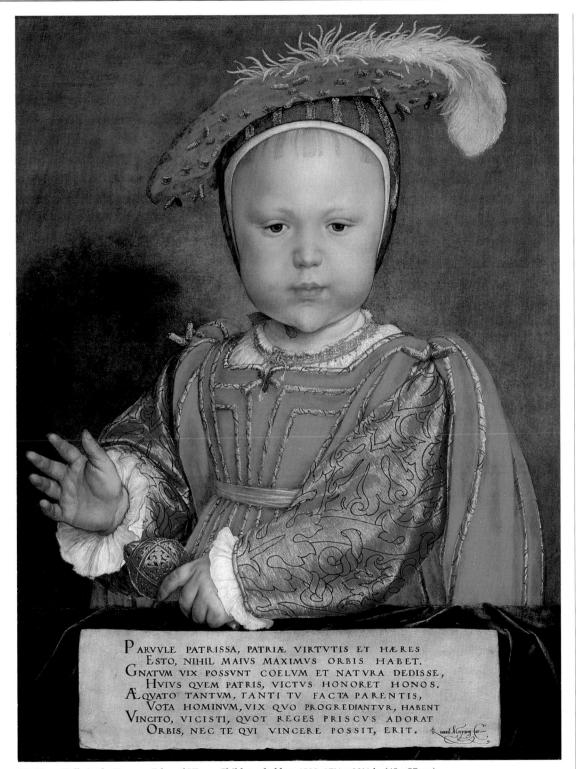

186 Hans Holbein the Younger, Edward VI as a Child, probably c. 1538, 171/3 x 221/2 in (45 x 57 cm)

Holbein shows him as an apple: round, sweet, wholesome, red. It is hard to believe that Edward, who died at 15, was genuinely so bouncing a baby, but Holbein makes us credit both his health and his natural dignity. This is a princely baby, the all-important son whom Henry had sought with such savage desire in a marital history that left its mark on Europe. Holbein's intense interest in human personality, the facial

characteristics that distinguish one individual from another, might seem to have little scope in dealing with a child. A child, after all, is not yet a fully achieved personality: he or she is essentially potential. Yet it is precisely this potential that Holbein shows. This face has all the soft indeterminacy of a baby, united into the hard reality of a ruler. It is the child as future king, royal child, Edward VI.

CONTEMPORARY

1512

First use of the word "masque" to denote a poetic drama

1515

The first nationalized factories for the production of tapestries are opened in France

1520

The Royal Library of France founded by King Francis at Fontainebleau

1549

Court jesters appear in Europe

FREDERICK THE WISE Lucas Cranach spent most of his career as the court painter to Frederick the Wise, Elector of Saxony. The Electorate of Saxony was an independent state with a hereditary title (although part of the Holy Roman Empire, see p.157), which Frederick inherited in 1486. He was an intelligent, forwardthinking man who founded the University of Wittenberg and invited Luther to lecture on religious reform. He was also a great patron of artists and poets.

HOLBEIN AS COURT PAINTER

Holbein left the city of Basel in 1526 to go to England, where he became court painter to Henry VIII. His first visit lasted seven years, and he painted many portraits of the English aristocracy. As court painter he was employed to paint the prospective wives of the king, but only managed to complete pictures of Anne of Cleves and Christina of Denmark, above, whom Henry did not marry. He also painted a mural of Henry VIII with Queen Jane Seymour. This hung in the royal Whitehall Palace and was destroyed when the palace burned down in 1698.

OTHER WORKS BY HOLBEIN

An Englishman (Kunstsammlung, Basel)

A Woman (Institute of Art, Detroit)

Sir Thomas Godsalve and His Son John (Gemäldegalerie, Dresden)

Henry VIII (Fundaçion Thyssen-Bornemisza, Madrid)

A Merchant of the German Steelyard (Royal Collection, Windsor Palace)

Lady Margaret Butts (Isabella Stewart Gardner Museum, Boston)

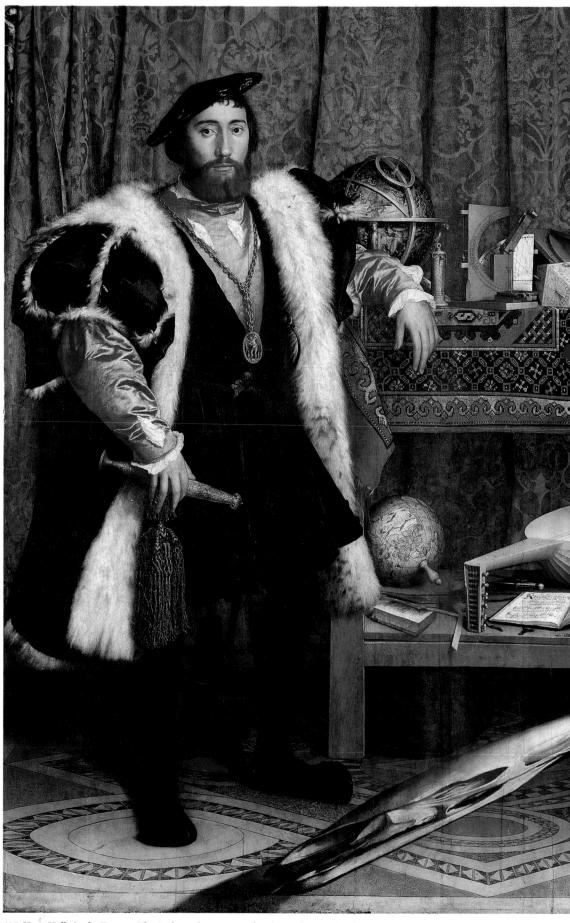

187 Hans Holbein the Younger, The Ambassadors, 1533, 6ft 11 in x 6ft 9½ in (210 x 206 cm)

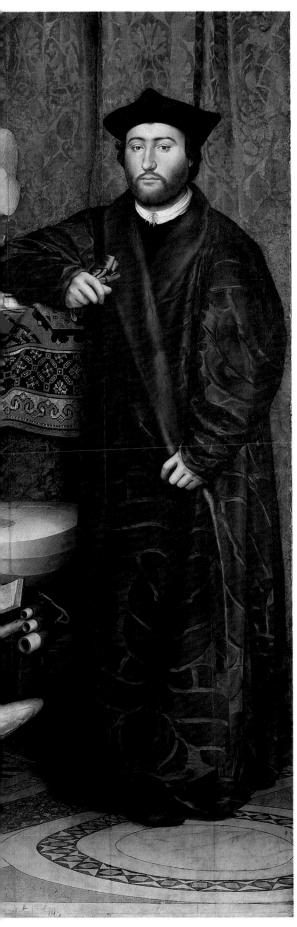

AN ELABORATE VANITAS

In his portraits of the adult rich and powerful, we see the full extent of Holbein's scope. *The Ambassadors (187*, originally named *Jean de Dinteville and Georges de Selve*) is a memorial to two extremely wealthy, educated, and powerful young men. Jean de Dinteville (on the left) was the French ambassador to England in 1533, when the portrait was painted, and was aged 29.

On the right is Georges de Selve, an eminent scholar who had recently become a bishop; he was just 25. He was not a diplomat at the time of the painting, but later became French ambassador to Venice, at that time ruled by Spain.

This picture fits into a tradition of works that show learned men with their books and instruments. Between the two Frenchmen stands a table that has an upper and a lower shelf.

Objects on the upper shelf represent the study of the heavens, while those on the lower shelf stand for the educated pursuits on earth. At the left end of the upper shelf is a celestial globe – a map of the sky – in a frame that can be used to calculate astronomical measures. Next to it is an elegant portable brass sundial. Next is a quadrant – a navigational instrument for calculating the position of a ship as it travels, by measuring the change in the apparent position of fixed stars. To the right of this is a polyhedral (multisided) sundial, and then another astronomical instrument, a torquetum, which, along with the quadrant, was used for measuring the position of heavenly bodies.

Almost unnoticed, in the top left corner of the painting, a silver crucifix is seen, representing the goal of salvation, not forgotten amid the splendor and advanced scientific knowledge.

On the lower shelf at the left is a book, which proves to have been a recent guide to arithmetic for merchants (published in 1527). Behind it is the globe, representing geographical knowledge. The try square emerging from the book probably represents the skill of mapmaking. The lute was the chief courtly instrument of the time and stands for the earthly love of music. At the end of the bent-back tip, one string can be seen to be broken, representing the sudden breakage of death. Beneath the lute, next to a pair of compasses, is a copy of a Lutheran hymn book. The flutes beside them were popular instruments for all levels of society.

To this grand image of youth in its prime, Holbein has slashed across the foreground his reminder of human mortality. We realize that this strange shape, when viewed from a certain angle, is actually a human skull that has been cunningly distorted by stretching it sideways in so-called anomorphic projection.

RENAISSANCE MINIATURES

In the 16th century, Henry VIII relaunched the 15th-century fashion for miniature paintings. Nicholas Hilliard (1547-1619) became the most successful miniature portraitist, using his skills as an artist and as a jeweler to create exquisite masterpieces. Generally, miniaturists concentrated on the head and shoulders only, and used bright colors for details. This simple miniature is of Richard Hilliard, the artist's father.

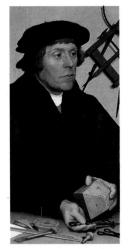

NICOLAUS KRATZER

Holbein and Nicolaus Kratzer struck up a friendship in 1527 when working together on a ceiling in Greenwich Palace. Kratzer was an astronomer and an astrologer and is said to have lent Holbein the instruments we see in The Ambassadors. In 1519, he was appointed "Astronomer and Deviser of the King's Horologes," and in this post he encouraged Henry VIII to popularize science and mathematics. This portrait is by Holbein and shows Kratzer working on a polyhedral sundial.

SIR BRIAN TUKE

Sir Brian held the court appointment of Governor of the King's Post under Henry VIII. He is credited with having brought Holbein to England to paint his portrait. He was 57 years old at the time, and the Latin words on the folded paper reflect his acceptance of imminent death. During the Renaissance a man's life was often cut short by the ravages of the plague or the enmity of his monarch. Unusually, Sir Brian Tuke managed to maintain both his health and his sovereign's favor.

Most of Holbein's portraits are of lords and ladies, but there are a few that reveal more of his private life. One such is the haunting *Portrait of the Artist's Wife with Katherine and Philipp (188)*. Artists have always painted their families, but this is the saddest version on record. He lived very little with his wife and children in Basel (the reasons for this may have been political, religious, or financial), but this tragic little trio has all the withering marks of the unloved.

The dim-eyed wife presses down on the children, plain, pale little beings, all unhappy and all ailing. Holbein, that superb manipulator of the human face, cannot have meant to reveal their wretchedness and expose his neglect with such drastic effect. It is as if his art is stronger than his will, and for once Holbein is without defenses.

We might describe him as an un-Germanic German, since he left for Switzerland when he was still a teenager and then worked in England for Henry VIII. While Dürer and those influenced by Dürer (which includes practically all German

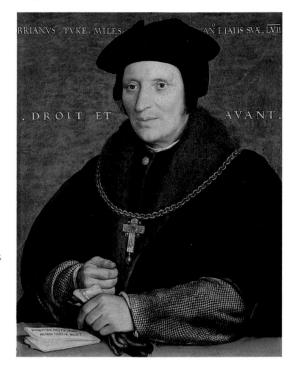

189 Hans Holbein the Younger, Sir Brian Tuke, c. 1527, 15½ x 19½ in (39 x 49 cm)

Renaissance artists except Holbein) had an intense interest in the personal self of the sitter, Holbein was essentially discreet. A court painter par excellence, he always maintains a dignified distance. We see the sitter's exterior, what he or she looked like, but we never pass into the inner sanctuary. The sole exception, which is what makes it so extraordinarily interesting, is this painting of his wife and children. Here his courtly shield is down, perhaps because of the artist's personal sense of guilt. He was not a good husband or father, and while he can carry off any other portrait with superb technical aplomb, he catches his breath and opens the inner door when he paints the family that he abandoned and neglected.

A much more characteristic Holbein is *Sir Brian Tuke* (189), with his clever, sensitive face, his air of unflinching probity, the tenseness of his half-smile and his clenched hand. A folded piece of paper on the table quotes a biblical passage in which Job appeals to God for rest from anxiety. We would know, without having sufficient knowledge to recall that Tuke served Henry VIII, that here was a man who was noble but imperiled – though in fact, he flourished.

Holbein's work is never cold nor lacking in involvement, as we can see in *The Ambassadors*, *Christina of Denmark*, and *Sir Brian Tuke*; but he protects his sitters from psychological exposure and, indirectly, protects himself. What a contrast with Dürer, who always leaves both the sitter and himself open to the most personal scrutiny.

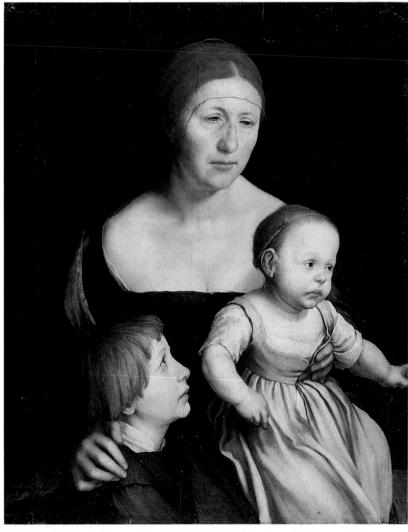

188 Hans Holbein the Younger, The Artist's Wife with Katherine and Philipp, c. 1528, $26 \times 30 \%$ in $(65 \times 77 \text{ cm})$

Northern Mannerism

The Italianate influence on the Northern painters, who had been nurtured in the Gothic tradition, initially produced a sometimes uneasy mixture of styles. On the one hand, it resulted in a convincing monumentalism, seen, for example, in the art of Jan Gossaert (see below) and Lucas Cranach the Elder (see p.156). On the other hand, it encouraged the Northern Mannerist trend. This can be characterized by a rather superficial, even contrived, Italianate gloss.

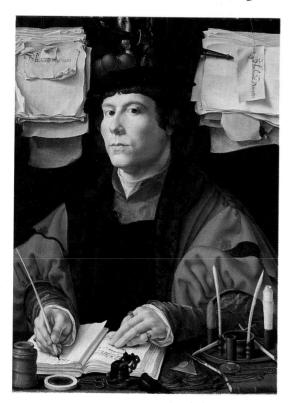

190 Jan Gossaert (Mabuse), Portrait of a Merchant, c. 1530, 19×25 in (48×63.5 cm)

Two Netherlandish painters straddle the divide between the Gothic and Renaissance worlds: Gossaert and Patinir (see p. 166) The first of these, Jan Gossaert (c. 1478–1532), even bridges the North/South divide, in that he worked in Italy, where he was influenced by Michelangelo and Raphael (both working there at that time), and invented an Italian-sounding name, "Mabuse," from his native town of Maubeuge in the province of Hainaut.

So here we see an artist from the Netherlands, with a heritage of van Eyckian observation (see p.64) and van-der-Weydenish sincerity (see p.67), but with a desire to be flamboyantly classical, as it were. He can be extremely moving when he finds a theme that suits his strange blend of talents and intentions. The mixture works well enough in his *Portrait of a Merchant (190)*, painted about 20 years after Grünewald's *Crucifixion* (see p.76), despite the perceptible

clash between the spirit of Northern realism and this intense, masculine, Italianate face. The portrait stands apart from much of Northern portraiture of the time, which formed a strong and distinct tradition of its own, with a direct and realistic attitude to nature, and a resistance to the classical influences coming from Italy.

There is the same feeling of jarring, but wonderfully so, in Gossaert's *Danaë* (191), in which a Flemish housewife, demure and expectant, sits in an Italianate classical arcade, the divine gold (for Jove came to her in this disguise) filtering down to her like thickened light.

OTHER WORK BY GOSSAERT

A Man with a Rosary (National Gallery, London)

> Virgin and Child (Musée Marmottan, Paris)

A Gentleman (Statens Museum for Kunst, Copenhagen)

Portrait of Anna de Bergh (McNay Art Institute, San Antonio, Texas)

A Woman as the Magdalen (Museum Mayer van der Bergh, Antwerp)

Adam and Eve (Fundaçion Thyssen Bornemiza, Madrid)

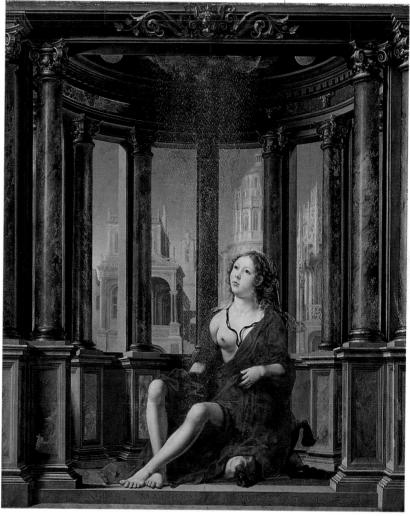

191 Jan Gossaert, Danaë, 1527, 371/2 x 45 in (95 x 115 cm)

THE COURT OF FONTAINEBLEAU

One of the most distinguished artists at the court of Fontainebleau was Francesco Primaticcio, who between 1530 and 1560, created elegant sculptures as well as paintings such as the one shown above, The Rape of Helen. The style of the painting is self-consciously sensuous and elegant, placing emphasis on the female nude, which was to symbolize the secularization of art in the 16th century.

SCHOOL OF FONTAINEBLEAU

If France can be considered to be part of the "North," as it is at least in the sense of being non-Italianate, then Jean Clouet (1485/90–1540/1) and the School of Fontainebleau are notable examples of a painterly Renaissance in the North. The patronage of the French King Francis I attracted Italian artists to the royal court at Fontainebleau. Francis sought for himself the haughty, kingly image that

Italian Mannerist artists created for their sitters. The Florentine artist Rosso Fiorentino (see p.139) and later Francesco Primaticcio (1504–70; see column, left), who was born in Bologna and trained at Mantua, brought their cultivated influence to the Fontainebleau Court.

Clouet, a native Frenchman and court painter to King Francis I (or it may have been François Clouet, his son) has given us the quintessential king in his *Francis I (192)*. The portrait is all majestic bulk, with any human frailties not so much hidden as frozen out of countenance. It is an icon, a diplomatic effigy, alarming in its careless assumption of superhuman stature.

The School of Fontainebleau based its practice on the elegancies of Italian visitors like Rosso, and all its practitioners (many of whom are by now anonymous) may be from the South, yet there is a languid realism that is different from Italian Mannerist chic. There is, too, a touch of the clumsy, not very Gallic, but extremely Northern.

Diana the Huntress (193), with her leaping mastiff and the enveloping forest, is a true wood nymph, innocent of the coyness of a Cranach hunting nude (see p.157) and striding out with lovely animal vigor.

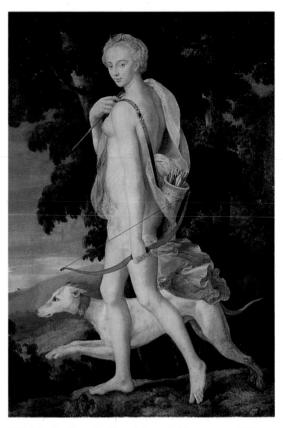

193 School of Fontainebleau, Diana the Huntress, c. 1550, 52 x 75 in (73 x 97 cm)

192 Jean Clouet, Francis I, c. 1525, 28¾ x 38 in (73 x 97 cm)

SPREAD OF MANNERISM IN THE NORTH

This elongated, elegant, and slightly unreal form of art was not confined to Fontainebleau. Its elegance appealed to the aristocratic North in general, and there are some supreme examples outside the confines of Paris.

Joachim Wtewael (or Uytewael, 1566–1638) was one such example from the Northern Netherlands (what is known today simply as the Netherlands). He was born in Utrecht, and in his early career he traveled in Italy and France before settling down in Utrecht. He became an important exponent of the Mannerist style in his country, though he tended to ignore the advances in naturalism being achieved by his contemporaries, such as Dürer and Cranach.

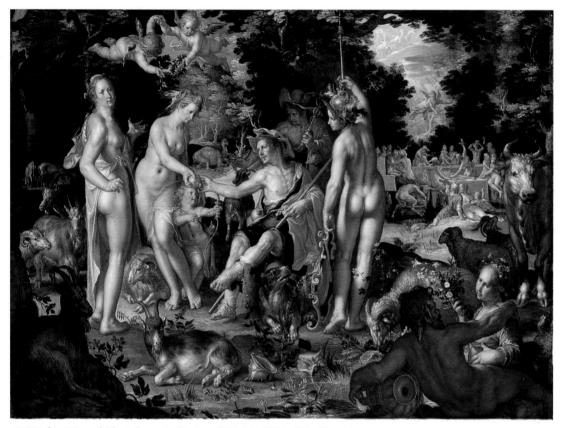

194 Joachim Wtewael, The Judgment of Paris, c. 1615, 29 x 211/2 in (75 x 55 cm)

Wtewael's *The Judgment of Paris* (194), in which the Trojan shepherd prince Paris awards the golden apple to the goddess he considers the most beautiful, is a highly Mannerist concoction. The self-conscious poses of the three divine ladies, the suave gestures of Paris as he makes his all-important choice, even the attendant animals with their delicate horns and slender legs, recall that world of mythical romance in which Mannerism flourishes.

Another eminent painter in the Mannerist style was the Flemish artist Bartholomeus Spranger (1546–1611). Born in Antwerp, he too traveled in Italy and France when young. He worked in Vienna, then settled permanently in Prague. In 1581 Spranger became court painter to the Emperor Rudolf II, and he had much influence on the Academy of Haarlem.

Spranger's Vulcan and Maia (195) has an almost disturbingly erotic force. Maia is looped across the knee of the massive and saturnine Vulcan, like a living bow to which he will fit his arrow. One long, intrusive finger stabs her in the heart, and she writhes suggestively under its impact. In some ways a rather unpleasant picture, it is nevertheless strong and, in a weird way, beautiful. There is a lightness, an aristocratic innocence, about the art of Fontainebleau, which vanishes once Mannerism moves from the sunlit groves of courtly Paris to the dark,

Teutonic forests of the true North. An almost sinister quality pervades the art of Spranger and his followers, never overpowering but flavorsome, almost gamy.

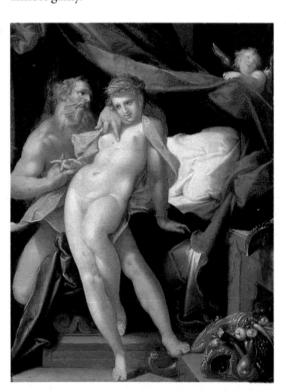

195 Bartholomeus Spranger, Vulcan and Maia, c. 1590, 7×9 in $(18 \times 23$ cm)

THE WARS OF RELIGION

After the death of the French King Henry II in 1559, his wife Catherine de' Medici (above) was pushed into the forefront of French politics. She grew fearful of the growth of Protestantism and is believed to have given the order for the St. Bartholomew's Day Massacre on August 24th. 1572. In the six days of violence that ensued. thousands of Protestants were butchered. There are many works of art that commemorate this horrific event.

Calvinism

The basic doctrine of the French religious reformer Jean Calvin was that man's destiny is preordained by God and only He can offer salvation. Calvin differed from Luther (see p.156) in rejecting the doctrine of Christ's real presence in the communion bread and wine. From 1541 he lived in exile in Geneva, where he established a college to train Calvinist pastors. Although severe, Calvinism embraced the ideas of democracy and social responsibility.

ALCHEMY

During the 16th and 17th centuries the science of alchemy underwent a revival in northern Europe. Alchemists believed it was possible to turn base metal into gold and argued that through this process they would discover a way to make human society perfect. They also believed that a magician (the Magus) controlled the universe and would use charms, symbols, and charts to contact the hidden forces of the world.

Northern Landscape Tradition

Landscape painting became one of the most enduring and characteristic features of Northern painting throughout the 16th century. Before this, there had been the small cameo landscapes, spied though windows and doorways of the earlier interior scenes (see p.61). These delightful features now began to attain their rightful scale, and as they did so they became a sort of large-scale stage for all the small activities of humankind. Yet it is not until Brueghel appears that we see the truly Flemish, lyrical understanding of nature, unlocked from its servitude to human concerns and shown in all its glory.

The Flemish artist Joachim Patinir (c. 1480—c. 1525) is one who provided links between the Gothic world and the Renaissance. While Jan Gossaert (see p.163) had been a link between North and South, Patinir mediated between past and future. He has a Gothic imagination, a profoundly medieval sense of the world—that small ball held in the divine hand—but he has also a prophetic sense of distance and the spaciousness of true landscape. We can see Dürer in him, Dürer's prints being available to him at that time (see p.153). We also catch a glimpse of the medieval illuminated manuscripts (see p.28). *Charon Crossing the Styx (196)*, with its vision of Hell as war, shows his style well.

THE GERMAN LANDSCAPE

Albrecht Altdorfer (c.1480-1526), like his fellow German, Lucas Cranach the Elder (p.156), was, for the most part, a stay-at-home. He may well have seen some of the topographical watercolors that Dürer brought home with him after his roamings across the Alps. After Altdorfer's own trips along the Danube River, landscape was to become his passion. Altdorfer's landscapes are of a peculiarly Germanic character, bristling with wild forests and lonely, wolf-infested glades. They are fearsome, though magnificent, and they even contain the hint of irrationality overcoming sobriety. Altdorfer does maintain control, but we feel the threat.

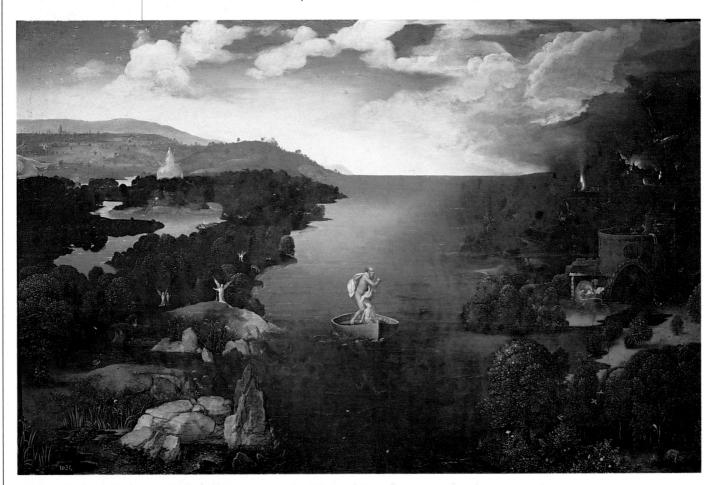

196 Joachim Patinir, Charon Crossing the Styx, 1515-24, 40 x 25 in (102 x 63 cm)

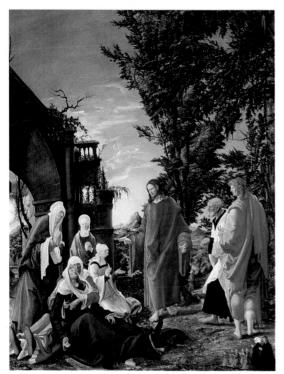

197 Albrecht Altdorfer, Christ Taking Leave of His Mother, perhaps 1520, 43 × 55 in (110 × 140 cm)

Danube Landscape (198) is one of the first examples of a painting that is content to have no human beings in it at all. It stands or falls by the sheer quality of the sky, the trees, the distant river, the blue mountains. We are offered a romantic substitute for mankind, one purer and more open to the ethereal heavens. Altdorfer believes in the sacramental value of what he paints, and it is his conviction that convinces.

But he can also people his landscapes, and with remarkable effect. Christ Taking Leave of His Mother (197) has an extraordinary, gawky power. The vague gestures toward graciousness fall completely flat, and we see that almost comic awkwardness of the enormous feet of the supportive mourner. We also see that there is a sad dichotomy between the ruined castellations on the left, on the side of the women, and the wild encroachments of the forested world of the men on the right. There seems to be a painful absence of communication, an accepted harshness, and we come to a painful realization that this is of the essence of any saying of good-byes. This striking scene makes a rough, embarrassing, ardent picture that is quite unforgettable.

Altdorfer is an unexpected painter with many more personae in his repertoire than we might expect. Surprisingly, he has a feel for allegory, which has produced some of the most enchanting small paintings in all Northern art (there is a wonderful example in the Gemäldegalerie in Berlin). This art is landscape based but uses the landscape to make some mysterious moral point. We can never quite comprehend the meaning of an Altdorfer work – there is always an elusive element – which is perhaps one of the reasons why he remains so consistently a source of delight and interest.

PIETER BRUEGHEL THE ELDER

The only rival to Dürer as greatest of the Northerners is a so-called peasant painter, Pieter Brueghel (1525–69). Born in Breda in the Flemish province of Brabant, he was the forefather of a whole tribe of painterly Brueghels, Jans and Pieters; but none ever takes our breath away with wonder as does Pieter the First. The "peasant" nickname is particularly unbecoming in that he was a traveled and highly cultivated man, friend of Humanists and patronized by the learned Cardinal Granvella. Despite his

OTHER WORKS BY ALTDORFER

Nativity (Staatliche Museen, Berlin-Dahlem)

Farewell of St. Florian (Uffizi, Florence)

The Beautiful Virgin of Regensburg (The Church of St. Johannes, Regensburg)

Lot and His Daughters (Kunsthistorisches Museum, Vienna)

Landscape with a Footbridge (National Gallery, London)

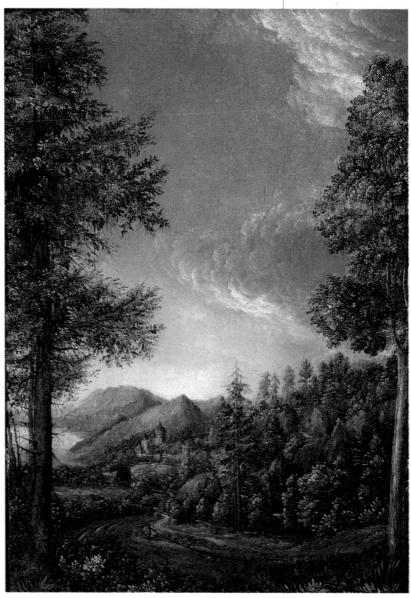

198 Albrecht Altdorfer, Danube Landscape, c.1520-25, 8½ x 11¾ in (22 x 30 cm)

OTHER WORKS BY BRUEGHEL

The Beggars (Louvre, Paris)

The Triumph of Death (Prado, Madrid)

Massacre of the Innocents (Royal Collection, Hampton Court Palace)

The Land of Cockaigne (Alte Pinakothek, Munich)

The Three Soldiers (Frick Collection, New York)

Children's Games (Kunsthistorisches Museum, Vienna)

Wedding Dance (Detroit Institute of Arts)

The Parable of the Blind (Nazionale di Capodimonte, Naples)

> Harbor of Naples (Galleria Doria Pamphili, Rome)

travels to France and Italy around 1553, the strongest influences on his work were from Bosch (see p.72) and Patinir (see p.166). In Breughel's paintings we see a continuation of the Netherlandish tradition: from Bosch's fantastic inventions (which later, in Brueghel's hands, resided in a more gently comic nature); and from Patinir's reverent and passionate landscapes. Brueghel's paintings are supremely un-Italianate, and the classical quest for the ideal form finds no place in his art.

The only relevant application of Brueghel's nickname is that he not infrequently painted peasants, works that some think satirical but that others regard as carrying a heavy weight of compassion and affectionate concern.

The famous Wedding Feast (199) certainly shows us the round and stupid faces of the guests, the fat and silly bride drunk with complacency beneath her paper canopy-crown, the table agog with intent eaters. But our smile, like Brueghel's, is a painful one. She is so pathetic, the poor, plain young woman in her little hour of triumph, and if the guests are gobbling down their food, we see the food, humble plates of porridge or custard, served on a rough board in a decorated but realistic barn.

These are the poor, the downtrodden, these their wretched celebrations. The child licks with lingering gusto at her empty bowl, and the piper, who yet must play until he receives his food, stares at the porridge with the longing of the truly hungry. Only the insensitive would find *The Wedding Feast* comic. There is a very real sense in which our reactions to *The Wedding Feast* put us morally to the test. This is a wholly serious subject, the degradation of the working class, treated with disinterested humor, which we

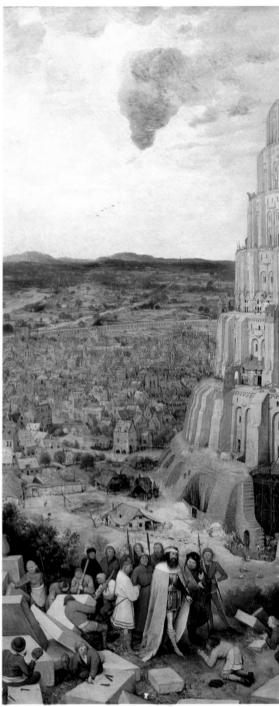

are meant to see through. Not to understand Brueghel's great concern and compassion condemns us.

The Tower of Babel (200) has a horrifying complexity, dwarfing the human figures in their authoritarian pride, reducing the most gigantic of labors to the pointless scurrying of ants. This is Babel, and it is our own local experience: the humans are both pathetic and doomed in their conceits. Brueghel was a highly educated and sophisticated painter, with a scholar's insight into myth and legend. His version of the ancient story of the Tower of Babel is far removed from

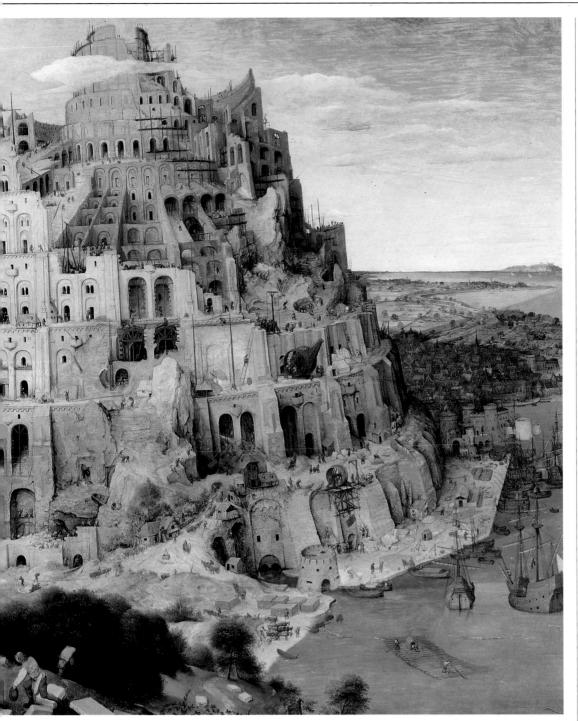

200 Pieter Brueghel, The Tower of Babel, 1563, 61 x 44½ in (155 x 114 cm)

a mere illustration of a biblical passage. Brueghel, in fact, never works on the surface but always in depth. Whether it is the fall of Icarus in Greek myth or the building of Babel in biblical story, it is meaning that concerns him, visual meaning.

But the great glory of Brueghel, his real claim to be ranked among the world's greatest, lies in his landscapes, in particular the set of months, à la the Limbourg brothers (see p.55), that he painted for a wealthy citizen of Antwerp. One of these is *Gloomy Day* (see p.170). Only five remain, but they have never been surpassed for

their truth, their dignity, and their mysterious spiritual power. Brueghel never forces a moral. The most reticent of painters, he merely exposes the vastness of nature that surrounds our everyday life, so that we will respond to the challenge of reality. But it is a most delicate challenge, one that makes demands on our imagination.

This is the world, Brueghel tells us, in all its diversity, majesty, mystery, and beauty. How do we respond to it? The intense pleasure that these pictures provide should not mask from us their deep moral seriousness.

THE REFORMATION

The term "Reformation" describes the period of ecclesiastical dispute between the papacy and the various national churches of Europe throughout the 16th century. The nailing of Luther's 95 theses to the door of the Schlosskirke in Wittenberg is considered the catalyst that resulted in the reform of the Roman Catholic church and the establishment of the Protestant churches. The final agreement was that a nation should follow the religion of its sovereign. This woodcut shows rival Protestant and Catholic preachers competing for followers.

THE TOWER OF BABEL

A version of the ancient story of the Tower of Babel is told in chapter 11 of the book of Genesis. The people ambitiously set out to build a tower to reach the heavens. As a punishment for their pride, God confused the people's language so they could not understand one another, and He scattered them over the face of the Earth. In art, the idea of linguistic confusion is shown in the different races of people, and the tower is seen in a chaotic and unfinished state.

GLOOMY DAY

Brueghel's innovative portrait of a landscape in the grip of winter is one of a series of paintings based on the Northern seasonal calendar. It represents the dark, cold winter months of February and March, and follows the Northern pictorial tradition (derived from illuminated manuscripts) of the labors of the months (see p.55).

Mountainous landscape

The wild, violent face of nature is given concrete form in the jagged mountaintops and glowering black storm clouds on the far horizon. Shown at a distance, it remains a threatening and ever-present force that dictates daily existence. The somber blacks and chilling whites provide a cool background to the red-browns and warm umbers of the peasants' habitat and assert the contrast between the wild and the domesticated. Comforting wisps of smoke trailing from chimneys are matched by the icy puffs of frozen clouds above the mountain range.

CARNIVAL TIME

Near a group of men absorbed in the February task of pollarding willows is another intimate group that provides more clues to the time of year. A man is greedily eating the Carnival fare of waffles, and the child's paper crown – common dress-up for Epiphany and Shrovetide (Carnival) processions – and lantern also denote Carnival. Our attention is first caught by the bright red and light tan of the clothing of the three figures, then led downward and along the shore, then up again, to rest finally at the horizon and thundering sky.

THE VILLAGE

From our vantage point we see the peasants' vulnerable position and their insectlike activities within this great celebration of raw nature. If we look closely, we can find touches of bawdy humor typical of Brueghel: to the left a man urinates against the wall of an inn (following his own, smaller, dictates of nature, perhaps).

FOUNDERING SHIPS

Like the village scene, this detail is not immediately apparent at first sight. The terrible catastrophe of ships crashing on the rocks is depicted as merely another incidental detail within the greater drama of the landscape. We see the irony (even if the villagers cannot) of their innocent attempts to "harness" nature by pollarding their willows, while the the destructive might of nature passes unheeded beyond them.

201 Pieter Brueghel, Gloomy Day, 1565, 64 x 46 in (163 x 117 cm)

Gloomy Day (201) is about the dark days of February and March, lightened only by the Carnival festivities. Yet we sense instinctively that this painting is about far more than the end of winter. Brueghel shows us a vast, elemental universe, through which a wild river rages. Overhead, the sky is in tumult, a great, wild mass of cloud, threatening and descending. The villagers may labor, or they may play: their activities seem so small within the vast context of human reality. Lightning glints on tree trunks and village roofs. The foreground is relatively bright, which is, of course, the illusion that human activity is intended to create. Immersed in our work or play, we easily forget the threat of nature's violence and of the dark.

Hunters in the Snow (202) is both sensuously overwhelming, the very feel of the cold made visual, and emotionally expanding. The mysterious space of the valley and its mountain, its lakes, and its bare trees, its tiny inhabitants and its far-ranging birds, all lies before our view. Like the gods themselves, we look upon "the world." Every detail informs us of the season as the bonfire blazes and the hounds slink wearily home. The dazzle of white conceals the details but reveals the wholeness, with only humanity at leisure to play, and only the young at that. The grandeur of Brueghel's vision is one that he is able to share with the viewer completely.

He takes us into an awareness of what it means to live in the physical world, its mountains, valley, and rivers, its snows, its birds, its animals, its trees. No other painter has such a breadth of vision, so unencumbered by the persona. We feel this is not what Brueghel saw (and what we now see), but what actually and objectively is. This is his great and unique contribution to art.

THE LEGEND OF FAUST

Between 1507 and 1540 numerous references were made in German society to a dealer in the black market by the name of Faust, who was said to have made a pact with the devil. Faust

became a renowned magician and charlatan and was driven from town to town until he disappeared. The first printed Faust story appeared in 1587, and its anti-Catholic sympathies fueled the troubles of the Reformation. The legend was truly popularized in the 17th century by the playwright Christopher Marlowe, whose version was performed throughout Europe. In the 19th century, it was made into a classic of German literature by the poet Goethe.

202 Pieter Brueghel, Hunters in the Snow, 1565, 63¾ x 46 in (162 x 117 cm)

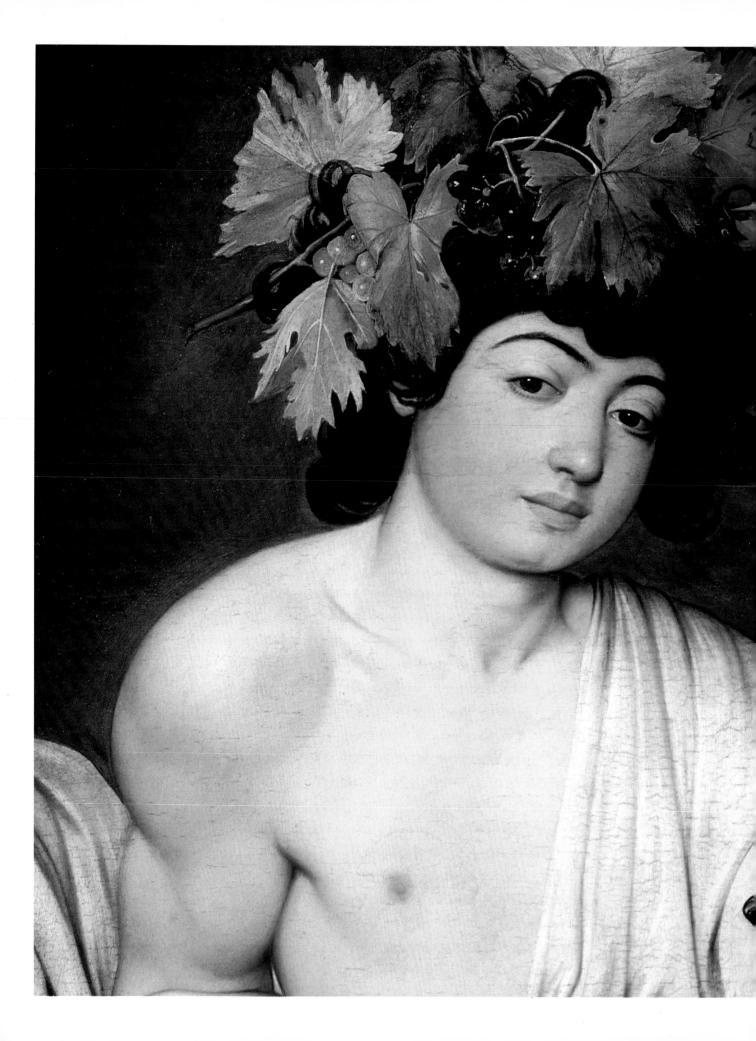

BAROQUE AND ROCOCO

Originally a Portuguese word meaning rough or irregularly shaped, "Baroque" came into use as an art term – not a complimentary one – from the world of pearl fishing. The Baroque style was a new direction in the arts that emerged in Rome at the turn of the 17th century, partly as a reaction to the artificiality of the Mannerist style of the 16th century. The new art was committed both to genuine emotion and to the imaginatively ornamental. Human drama became a vital element in Baroque paintings, typically acted out with highly expressive, theatrical gestures, lit with striking chiaroscuro and featuring rich color combinations.

The Rococo style developed as a successor to the Baroque in a wide range of arts, including architecture, music, and literature as well as painting. Its emphasis was on lightness, decoration, and stylistic elegance.

The Rococo style emerged in Paris in the early 18th century, and soon spread to the rest of Europe.

BAROQUE AND ROCOCO TIMELINE

The Baroque period in painting corresponds roughly to the 17th century. In Italy and Spain, the Catholic church, in its campaigning, Counter-Reformation mood, put pressure on artists to seek the most convincing realism possible. In the North too, Rembrandt and Vermeer, each in their separate ways, pushed forward the limits of realism. Rococo art began with Watteau and became the ruling European style for most of the 18th century.

Caravaggio, the death of the virgin, 1605/06

Caravaggio's religious works were executed in true Counter-Reformation spirit. Nevertheless, the unprecedented realism in this work caused its rejection by the priests who had commissioned it (p.177).

Poussin, the holy family on the steps, 1648

Poussin's deeply classical sense of balance is revealed in every corner of this composition, particularly in the pyramidal shape of the Holy Family and the plinthlike step supporting them. Despite the classical feel, the work's emotional force and spiritual intensity place it well within the mainstream of Baroque art (as opposed to the Neoclassicism of the 18th century, p.216).

REMBRANDT, SELF-PORTRAIT, 1659

Realism was crucial to Baroque painting, and Rembrandt provides a prime example of Dutch portraiture of the Baroque period. This self-portrait shows us a face stripped of all pretensions – the artist is looking earnestly at himself and painting what he sees, producing great art from personal failure (p.202).

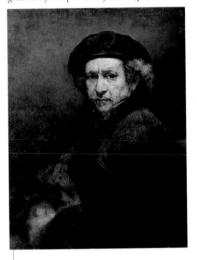

1600

1620

1640

1660

1680

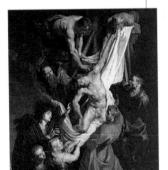

RUBENS, DESCENT FROM THE CROSS, 1612–14

THE CROSS, 1012–14 Rubens, a Flemish Catholic, was one of the greatest painters of all time. His work is supremely balanced and yet passionate (p.186).

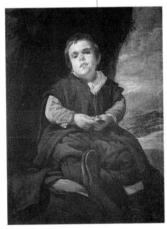

Velazquez, francisco lezcano, 1636–38

Velázquez was court painter at the Royal Court of Spain, immortalizing its royalty and senior court personalities, including the dwarves (jesters), whom he portrayed with his characteristic dignity (p.196).

VERMEER, KITCHEN MAID, 1656–61 Vermeer's use of light gave his paintings a silent clarity, the sensation of a moment preserved, of the recording of that precious quality of simply existing. His choice of subjects was undramatic -

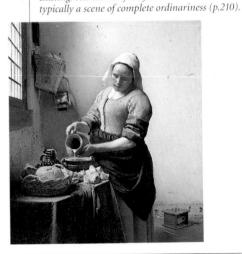

WATTEAU, "EMBARKATION FOR CYTHEREA," 1717 Rococo art began in Paris, where

Watteau settled as a young man. He initiated the Rococo era and invented a new genre, known as fêtes galantes. This painting shows some of its key features: an openair scene crowded with wistfully depicted lovers. They have just taken their vows at the shrine of Venus and are ready to leave the island. Although the fêtes galantes approach might suggest an admiration for frivolity, there is an underlying sadness in all of Watteau's works (p.224).

Hogarth, a scene from the beggar's opera, 1728/29

While Rococo fashions ruled in London, one British artist was independently building a new genre – satirical painting. Hogarth's narratives, though humorous, were profoundly moral. (p.235).

Tiepolo, wedding allegory, c. 1758

The Venetian artist Tiepolo was the most celebrated and sought-after painter of his time, admired for his soaring imagination and mastery of composition. His most famous work is perhaps the fresco cycle in the Residenz at Würzburg. This magnificent ceiling fresco is in the Rezzonico Palace (now a museum) in Venice (p.232).

Fragonard, blindman's buff, probably c. 1765

Fragonard, too, following Watteau and Boucher, was a Rococo painter. In this open-air scene, an innocent game takes place in a carefree atmosphere, but the players are overshadowed by the landscape (p.228).

1700

1720

1740

1760

1780

Canaletto, venice: the basin of san marco on ascension day, c. 1740

Canaletto is famous for his accurate and elaborately detailed records of city views. He painted within the Rococo tradition, and Venice is a supremely Rococo city, both fantastical and imaginative. Yet Canaletto is more interested in straightforward architecture and elegance of proportion than in fantasy. His work foreshadows the Neoclassical art that belongs to the late 18th century (p.234).

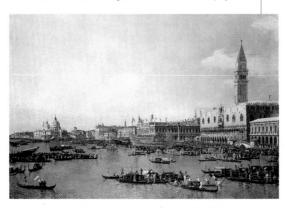

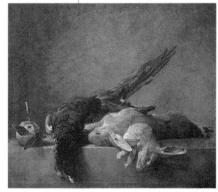

Chardin, Still Life, c. 1760/65

Chardin was an artist of the Rococo period who would not allow the frivolous tone of the art of his time to influence him. His sober and restrained pictures often contain a moral or spiritual meaning. Sometimes it is an explicit one, contained in the action of the painting, but otherwise, as here, the message is conveyed simply in the solemn, sacramental atmosphere (p.231).

THE SCULPTURE OF BERNINI

The Italian sculptor and architect Gianlorenzo Bernini (1598-1680) was influential in the formation of Baroque style. Bernini designed the sweeping twin colonnades that surround the piazza in front of St Peter's church in Rome. He described these as "like the mother church embracing the world." Between 1645 and 1652, he completed this sculpture (above) of St. Teresa of Avila, a religious reformer, for the Cornaro family chapel. The elegance of St. Teresa's draperies and the drama of her facial expression embody the essential "realist" characteristics of Baroque sculpture.

Italian architecture

The rebuilding of Rome in the 16th century under the pontificate of Sixtus V transformed the architectural vista of the city. The most sucessful architect of the time was Carlo Maderno (1566-1623) who designed the quintessentially early Baroque facade of St. Peter's in 1603. Francesco Borromini (1599-1667) was a contemporary of Bernini and Maderno, but his best work is seen in the smaller churches, such as San Carlo alle Quattro Fontane.

ITALY: A CATHOLIC VISION

During the Renaissance, Florence and Venice had dominated the art world, but during the Baroque period Rome became the great artistic center, visited by artists from all over Europe. Having survived the Protestant Reformation, the Catholic church emerged more vigorous than ever as a result of its own parallel process of revitalization, the Counter-Reformation. As Catholics, artists in Italy were required to endorse the authority of the Church and to make the scriptures a palpable reality to its people. The heightened emotional content and the persuasive realism of Baroque painting provided the means.

Like the Church, painting now underwent its own kind of reformation. The new style was not given the name Baroque until the 19th century, and for 200 years it was simply thought of as a form of post-Renaissance Classicism, associated especially with Raphael (see p.126). Italian artists in the 17th century moved away from the complexities of Mannerism to a new style of painting that had more in common with the grandeur of form of the High Renaissance. Pioneering this change were two artists of far-reaching importance: Caravaggio, the great proto-realist, working in Rome, and Annibale Carracci, the founder of the classical landscape tradition, in Bologna (see p.182).

CARAVAGGIO: BEAUTY IN TRUTH

The art establishment of the 19th century scorned Baroque painting, and perhaps the first and the greatest painter to be affected by this scorn was Caravaggio (Michelangelo Merisi da, 1573–1610), who moved to Rome from Milan in around 1592.

Caravaggio's early works consisted largely of genre paintings (see glossary, p.390), such as *The Lute Player (203)*: a youth so full, rich, and rosy that he has been mistaken for a girl. It is without doubt a girlish beauty, curls seductive on the low forehead, gracefully curving hands fondling the gracefully curved lute, soft lips parting in song or invitation. Perhaps some viewers found this charm frightening, with

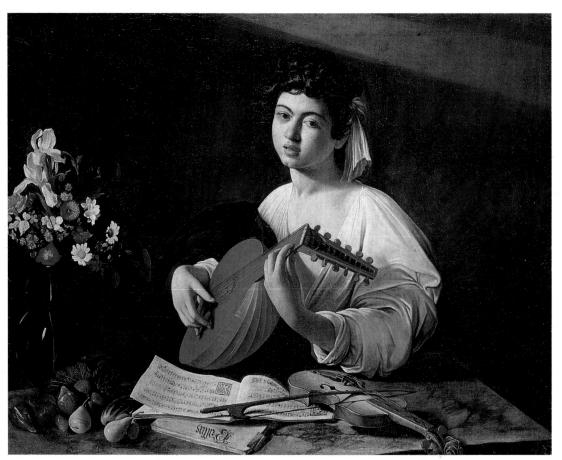

203 Caravaggio, The Lute Player, c. 1596, 47 x 37 in (120 x 94 cm)

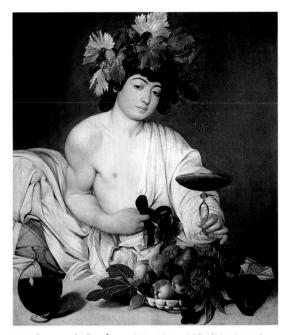

204 Caravaggio, Bacchus, 1590s, 33½ x 37 in (85 x 94 cm)

its air of decadence, of pleasure up for sale: but Caravaggio does not approve or, for that matter, disapprove of this young man: he presents him with an underlying sadness, a creature whose favors will fade, like the fruit and the flowers, and whose music will end in the darkened room.

Bacchus (204) may well be the same model, but here in classical guise, the young wine god holding out the cup of pleasure. But corruption and decay are never far away: the wormhole in the apple, and the overripe pomegranate, remind us of the transience of all things. Light and darkness, good and evil, life and death: the chiaroscuro of his style plays masterfully with these fundamental realities.

OFFENDING RELIGIOUS SENSIBILITIES

Viewers may have been alarmed by the sensuality of The Lute Player, but what really drew condemnation was the uncompromising realism of Caravaggio's religious works. The Carmelite priests who commissioned The Death of the Virgin (205) rejected it, finding it indecent. There was a rumor that the model for the Virgin had been a drowned prostitute. It is certainly a shocking picture, light striking with brutal finality upon the plain and elderly face of the corpse, sprawled across the bed with two bare feet stuck out unromantically into space, and the feet are dirty. What shocks us is the sense of real death, real grief, with nothing tidied up or deodorized. If Mary was human, then she really died; the lack of faith was that of the horrified priests who rejected this masterpiece, not that of the artist. A poor, aged, worn Virgin makes perfect sense theologically, and so does the intense grief of

the apostles. This woman was all they had left of their Master. Mary Magdalene is huddled in sorrow, and the men mourn in their different but equally painful manner. Mary is not shown in the customary way, ascending to Heaven in glory; we are confronted with both a human corpse and human loss. Above the body swirls a great scarlet cloth, mutely hinting at the mystery of being Mother of a divine Son: blood red for passionate love, for virtual martyrdom, for the upward movement of her soul. There is a copper bowl at the Magdalen's feet: she has been washing the body. Every realistic detail makes the work more and not less religious, one of the great sacred icons of our culture, with immense impact.

THE LIFE OF CARAVAGGIO

Caravaggio earned a reputation as a violent and irrational man and was known to the police for offenses including assaults and stabbings. In 1606, he was forced to flee Rome after killing a man, and spent the rest of his life in exile in Naples, Malta, and Sicily. He was eventually found by his enemies and disfigured in a fight for his life. He died of malaria in 1610.

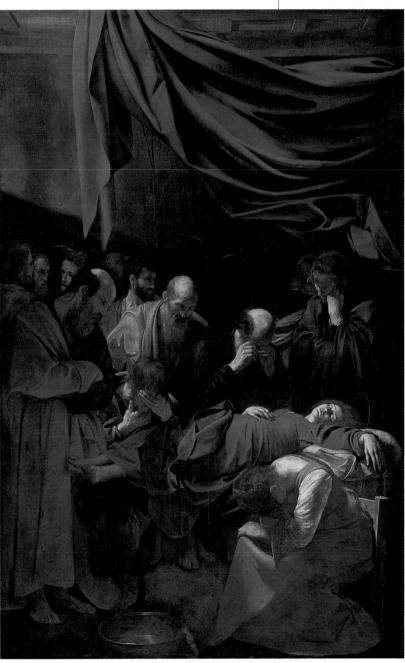

205 Caravaggio, The Death of the Virgin, 1605/06, 8 ft x 12 ft 2 in (244 x 370 cm)

OTHER WORKS BY CARAVAGGIO

St. John the Baptist (Nelson Gallery, Kansas City)

David with the Head of Goliath (Prado, Madrid)

Narcissus (Galleria Nazionale d'Arte Antica, Rome)

Medusa (Uffizi, Florence)

Victorious Love (Staatliche Museen, Berlin-Dahlem)

Crucifixion of St. Andrew (Cleveland Museum of Art, Ohio) Caravaggio lived the life of an "avant-gardist" – liberated from convention, both in his art and in his life. Earlier artists had not been models of virtue, but he was astonishing in his freedom from constraint, his quarrels and rages, and even his one killing, bringing him much merited disfavor. Yet, however wild his life, down to the miserable and early death on a lonely seashore, there is nothing wild or undisciplined about his painting. It has an overwhelming truthfulness that, merely in itself, is beautiful.

It is almost impossible to overestimate the influence of Caravaggio. For the first time, as it were, an artist looked at the full reality of human existence, its highs and its lows, its glories and its sordid materiality. He accepted this and loved it into great art. If we respond to Rembrandt in his human truthfulness, it is to some extent because Caravaggio first responded as an artist to the full spectrum of real life. He was able to deal only with the simple truthfulness of his eye: equally influential was his awareness of the importance of light and dark, the chiaroscuro, which he introduced to European painting, and which was dominant for centuries to come.

PALPABLE ASTONISHMENT

The Supper at Emmaus (206) still has its power to shock, with the strangely "unspiritual" Christ, a youth with plump, pointed face and loose locks, unbearded and undramatic. Why should Christ not look like this? The unpretentious face allows the drama to be inherent in the event.

The basket of fruit, balanced on the edge of the table, spells out the significance of Christ's apparition – nothing is left of our earthly securities if death has lost its absoluteness.

Caravaggio's way of homing in on the essentials – or perhaps of bringing them up to, and through, the invisible barrier of the picture plane, into the space occupied by the viewer – made a profound impression upon his contemporaries. He told his story through every element in the work, not least light and shadow. From Jesus, light spreads outward; Caravaggio can tell his story by means of simple effects that nature itself provides. After Caravaggio, a new emphasis on reality, on natural drama, and on the infinite fluctuations of light can be seen in nearly every artist. Like Giotto, like Masaccio, Caravaggio was an art-historical hinge.

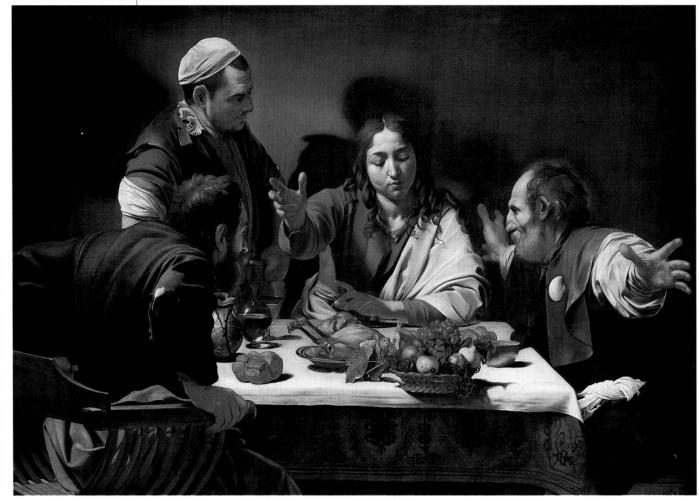

206 Caravaggio, The Supper at Emmaus, 1600–01, 77 x 55 in (195 x 140 cm)

THE SUPPER AT EMMAUS

After His Resurrection, Jesus meets two of His disciples walking on the road from Jerusalem to Emmaus. Caravaggio shows the moment when, at supper that evening, Jesus reveals Himself to the disciples in the breaking of the bread. It is the manner in which He blesses the supper that suddenly unveils to them that this is their "dead" master, come back to them. Their astonishment is breathtakingly portrayed, while the innkeeper looks on, baffled and uncomprehending.

SUDDEN REACTION

The disciple on the right (the shell he wears is the badge of a pilgrim) makes the more dramatic gesture as he recognizes Jesus. His outstretched arms echo the Crucifixion, and one dramatically foreshortened arm appears to stretch right out of the picture toward the viewer. This contrasts with the equally sudden but more contained reaction of the other disciple, on the left, whose tattered elbow seems to protrude from the picture, but in a more restrained way.

A YOUTHFUL CHRIST

The image of Christ is that of a young man, almost a youth. Caravaggio may have been influenced by paintings by Leonardo in his unusual depiction of Christ without a beard. He is serene and remote, having transcended the agonies leading up to and during His Crucifixion, and the difficulties of mortal life. He appears, as stated in Mark's Gospel, "in another likeness." Amid the rich, dark tones and the enveloping shadows, His face is flooded in a clear light, which falls from the left (Caravaggio's customary light source). Although the innkeeper stands in the path of the light, his shadow misses Christ, falling instead onto the back wall.

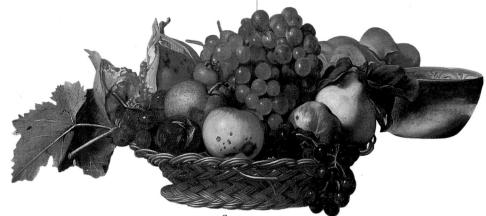

STILL LIFE

The basket of fruit – subtly past its best and teetering on the edge of the table – projects into "our" space, insisting on our attention and rightful admiration. The mostly autumnal fruits are chosen for their symbolic meaning, though the Resurrection was in spring. The pomegranate symbolizes the crown of thorns, and the apples and figs man's original sin. The grapes signify the Eucharistic wine, symbolic of the blood of Christ.

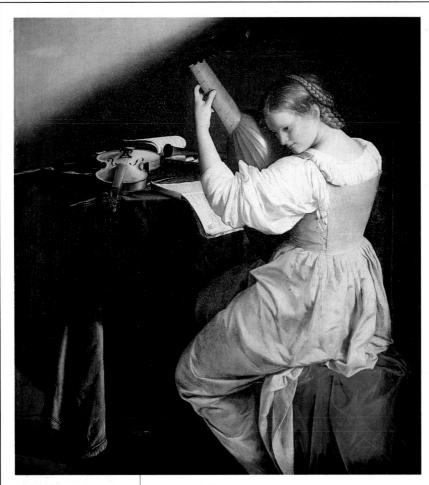

207 Orazio Gentileschi, The Lute Player, probably c. 1610, 50½ × 56½ in (129 × 144 cm)

Women artists

Artemisia Gentileschi was one of the first important women artists whose work it is possible to attribute with certainty. As women were excluded from life classes with nude models (which formed the basis of traditional academic training), they were at a disadvantage. Other female artists, such as Rachel Ruysch (1664-1750) and Judith Leyster (1609-60), were painting during this period, and the work by Rachel Ruysch shown above is typical of the detailed flower paintings of the Baroque era.

FATHER AND DAUGHTER

We can see Caravaggio's profound influence even on a relatively unadventurous painter like Orazio Gentileschi (properly Orazio Lomi, 1563–1639). Although Gentileschi's *The Lute Player (207)* is emphatically feminine and very different from Caravaggio's lascivious boy, she too is caught by the light, held in its beams amid the slanting darkness, lovely and fresh in her innocent music making.

The innocent and rightful desire of feminist art critics to reinstate women artists in the canon has perhaps rather unbalanced our appreciation of Orazio's work. He is a splendid artist, sensitive and strong. The lute player gleams seductively out of the shadows and is totally convincing. It is only because his daughter has been wrongfully slighted (many of her works were incorrectly attributed to her father) that we pass over him to dwell on the work of his daughter, Artemisia (1593–1652/53).

She was a precociously talented painter, and almost as passionate and powerful as her father. In fact she is closer in nature to Caravaggio. Yet she is not incapable of producing a gentler image, as when she portrays herself as the allegory

of painting (208). Perhaps the fact that the legendary originator of the art of painting (Pittura) was a woman enabled her to make this exception. This is an unglamorized self-portrait but a delightful one, the round face of the woman intent upon her work and her gown green in the Caravaggioesque light.

Despite the unpretentious approach, the passion and intensity of her paintings make Artemisia almost unique among female artists before the 20th century. It may be - as modern historians like to speculate – because she was raped by one of her father's friends, and this left her with a special insight into violence and betrayal. Like any woman artist, she had to battle against the unexpressed absolutes of her culture, which included the belief in a "natural" inferiority of women, and this too may have fueled the fire with which she depicts Judith Slaying Holofernes (209). The head of the oppressor (see p.105, column) is being visibly sawed off and palpable blood is oozing sickeningly down the mattress.

It is hard to avoid sexist generalities, to avoid saying that it is because she is a woman that she immerses us in the material practicalities of a slaughter. It is a human characteristic to be able to imagine an event in all its dimensions, which is what Artemisia does. She makes us aware of both the courageous heroism of Judith, saviour of her people, slayer of the tyrant, and of what it means to slay another human being.

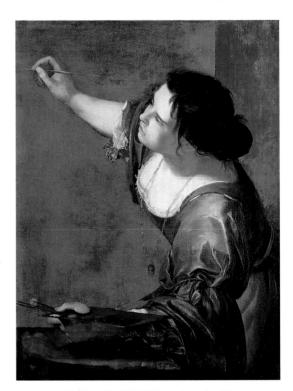

208 Artemisia Gentileschi, Self-Portrait as the Allegory of Painting, 1630s, 38 x 29 in (74 x 97 cm)

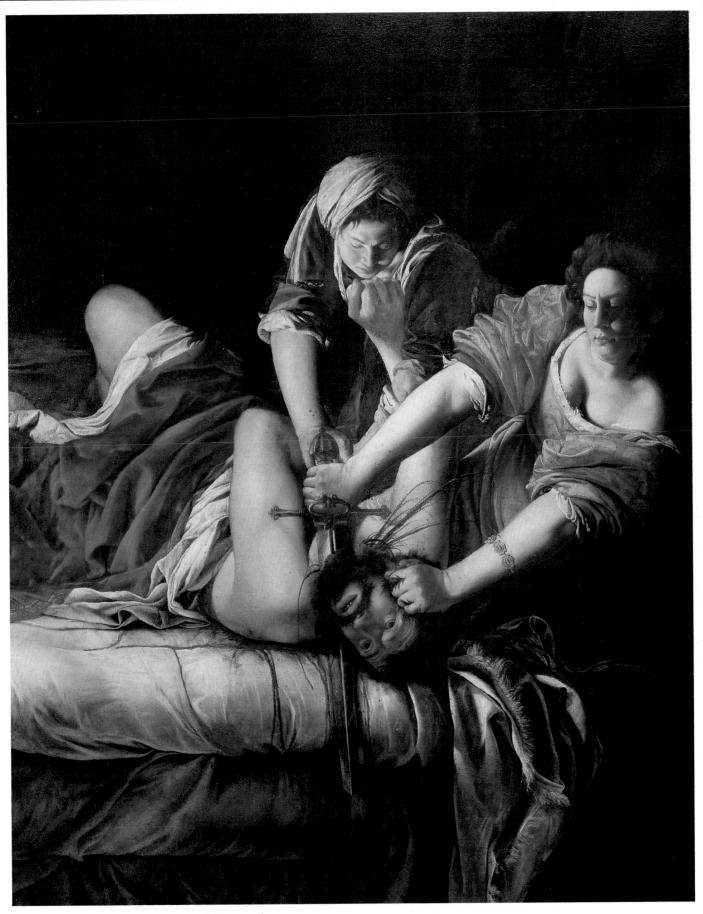

209 Artemisia Gentileschi, Judith Slaying Holofernes, c. 1612–21, 5 ft 4 in x 6 ft 7 in $(163\times 200~cm)$

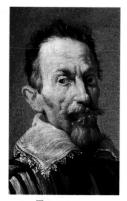

THE BIRTH OF OPERA

In keeping with the aesthetic beliefs of the High Baroque period, opera aimed to be a fusion of all possible artistic forms (instrumental music, singing characters, and drama). The first documented example of an opera is La Dafne by Jacopo Peri (1561-1633). The art of opera reached its maturity with Claudio Monteverdi (1567–1643), who wrote Orfeo in Mantua in 1607. The first public opera house was opened in 1637 in Venice. In the same year, Monteverdi resumed writing for the stage after a 30-year break. This portrait of Monteverdi (above) is

THE CARRACCI FAMILY

The Carracci family of Bologna was also influenced by Caravaggio – as who was not – but here the influence is a subtle one. This talented family of artists comprised two brothers, Agostino (1557–1602) and Annibale (1560–1609), and their cousin Ludovico (1556–1619). They were interested less in the clash of light and shade than in that of temperaments. It was the drama they had in common with Caravaggio, but with differing emphases.

The greatest of the three was Annibale, who combined classical strength with realistic observation. Annibale united High Renaissance monumentalism with Venetian warmth and strong color, and in his paintings he achieved a form of dignified naturalism that could express the idealism, and delicacy of sentiment, that Caravaggio's revolutionary realism could not. There is unforced nobility in his painting of Domine Quo Vadis? (210) ("Where are you going, Lord?"), the question that St. Peter asked when he fled Rome in fear of persecution and met with a vision of Christ going the other way. No dirty feet here, and yet we are conscious of the confrontation, and that it is taking place in a real setting; idealized figures, though strong and convincing, but bare earth and unromantic trees. The touch of the ideal kept it more acceptable than the stark vision of Caravaggio, and this accessibility had an aptness in the time of the Counter-Reformation (see p.187).

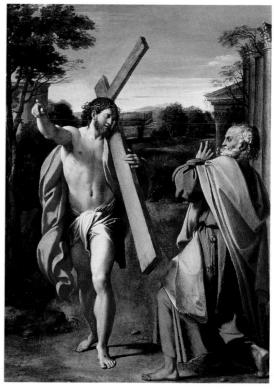

210 Annibale Carracci, Domine Quo Vadis?, 1601–02, 22 × 30½ in (56 × 77 cm)

THE CLASSICAL LANDSCAPE

The peaceful landscape, The Flight into Egypt (211), is an example of the Carraccis' far-reaching legacy. The classical landscape tradition begins here, where harmony, classical balance, and idealism – where all is well with the world –

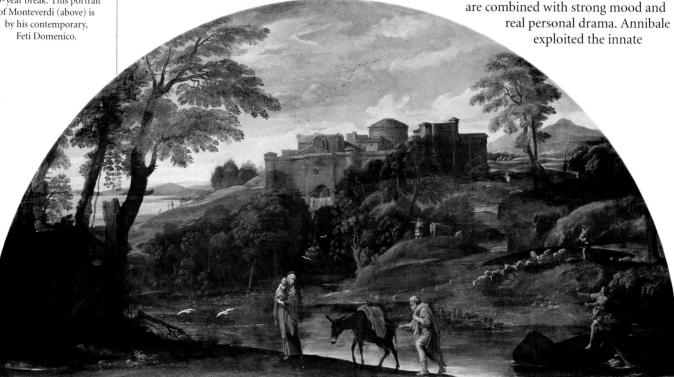

211 Annibale Carraci, The Flight into Egypt, c. 1603, $88\frac{1}{2} \times 47\frac{1}{2}$ in (225 × 121 cm)

expressive potential of the landscape, through nuances of light and atmosphere, so that it played as important a role as the narrative about which the painting ostensibly revolves.

Domenichino (Domenico Zampieri, 1581–1641) was a pupil of the teaching academy founded by the Carraccis in 1582. His interests lay increasingly in Classicism and landscapes as he developed, but he knew how to put these techniques to religious effect. *Landscape with Tobias Laying Hold of the Fish (212)* takes the story of the magical fish (see column, right) and sets it in a world so large, so full of potential, that the parrative is swallowed whole.

ELSHEIMER: FROM GERMANY TO ITALY

By the 17th century Northern Europe possessed a strong realist tradition of landscape and genre painting (though in the long run, Italian landscape was more influential). One of the many Northerners working in Italy at the beginning of the 17th century was the German landscape painter Adam Elsheimer (1578–1610). His paintings combine Northern clarity and an eye for the "truth" with the Southern quest for the idyllic. Another scene from the story of Tobias appears in *Tobias and the Archangel Raphael Returning with the Fish (213)*. This painting was for many years attributed to Elsheimer but is now thought to be by a later artist imitating Elsheimer's style. Tobias is depicted gingerly

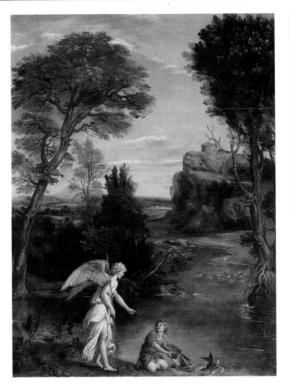

212 Domenichino, Landscape with Tobias Laying Hold of the Fish, perhaps c. 1617-18, 13¾ × 17¾ in (34 × 45 cm)

making his way homeward with his huge fish. The artist is attracted to the mysterious romance of nature, and this is a work of wonderful silence, as boy and protective spirit move through the lonely evening.

Elsheimer's style. Tobias is depicted gingerly lonely evening.

213 After Adam Elsheimer, Tobias and the Archangel Raphael Returning with the Fish, mid-17th century, 11 × 7½ in (28 × 19 cm)

TOBIAS AND THE MIRACULOUS FISH

The book of Tobit is in the Apocrypha. included in the Bible by the Orthodox and Catholic churches Tobit, the father of Tobias, loses his sight after sparrow droppings fall in his eyes while he is asleep. Believing his death to be imminent, he sends Tobias to collect a debt owed to him. The Archangel Raphael accompanies Tobias, without revealing his identity. While bathing in the

Tobias, without revealing his identity. While bathing in the Tigris River, Tobias is attacked by a great fish, which he catches and guts, under Raphael's instructions. He burns the heart and liver, later using these to exorcise demons from his wife Sarah. Once home, he uses the burned gall of the fish to restore his father's sight.

Contemporary arts

1606

First open-air opera, in Rome

1615

Inigo Jones becomes England's chief architect

1616

Death of Shakespeare

1632

Building work begins on the Taj Mahal in India

1642

All theaters in England are closed by order of the Puritans

1661

The Royal Academy of Dance is founded in France by Louis XIV

1665

Bernini completes the high altar canopy (baldachin) for St. Peter's, Rome

1667

John Milton begins to write *Paradise Lost*

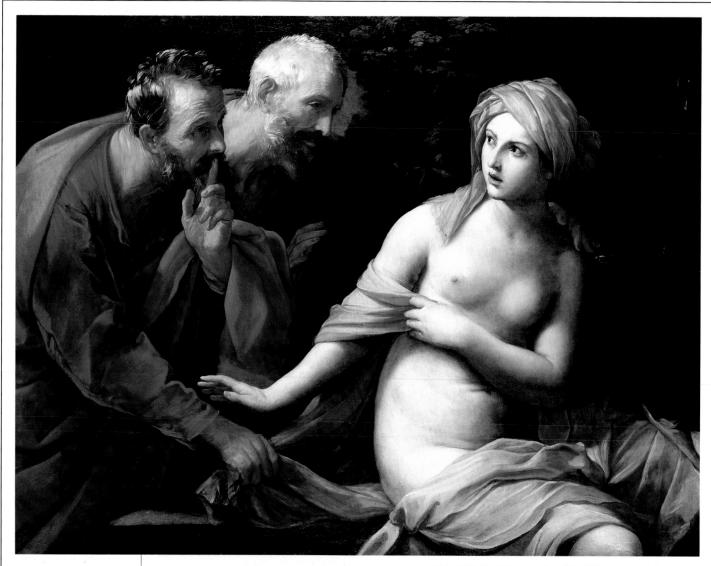

OTHER WORKS BY GUIDO RENI

Massacre of the Innocents (Pinacoteca, Bologna)

St. Peter (Kunsthistorisches Museum, Vienna)

Charity (Metropolitan Museum of Art, New York)

Bacchus and Ariadne (Los Angeles County Museum)

Ecce Homo (Fitzwilliam Museum, Cambridge, England)

Christ Crowned with Thorns (Detroit Institute of Art)

A Sibyl (Palais des Beaux-Arts, Lille)

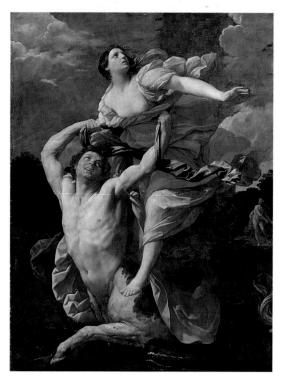

214 Guido Reni, Susannah and the Elders, c. 1600–42, 59 × 46 in (150 × 117 cm)

THE NEGLECTED MASTER

One former pupil of the Carracci Academy came to eclipse the Carracci family in fame, both in the city of Bologna and throughout Europe. This was Guido Reni (1575–1642), a man of reclusive temperament, whom the German poet Goethe considered a "divine" genius. Reni has had the misfortune to lose his fame over the years, as our civilization has become increasingly secularminded and his works seem too emphatic in their piety.

The truly "Baroque" nature of his paintings brought Reni much of the contempt later expressed for Baroque art. It is an unfair judgment, and it is slowly being rectified as the wonderful pictorial emotion and the genuine seriousness of this great painter are progressively being understood again.

215 Guido Reni, Deianeira Abducted by the Centaur Nessus, 1621, 6 ft 4 in x 9 ft 8 in (194 x 295 cm)

To take one example of Reni's religious work, *Susannah and the Elders (214)* is a painting that confounds the ignorance of prejudice. The story is about a Jewish heroine who is surprised when bathing by two religious elders, who try to blackmail her into immorality. Susannah displays the opposite of surface piety: she faces her tormentors with the indignation of the innocent. She sees no reason for fear, trusting in God and her own blamelessness.

Reni is equally powerful in mythological works. Deianeira Abducted by the Centaur Nessus (215) is a work of thrilling majesty. Hercules is on a journey with his wife, Deianeira, when they come to a river, where the ferryman is the centaur Nessus. He takes Hercules across first, then tries to ravish Deianeira. The picture shows him ready to gallop off with her on his back. Bodies gleam in the sunlight: the man-beast hard and straining, the abducted woman vulnerable in her fleshly softness. Garments fly, clouds gather, a great equine leg is paralleled by the slender human form, the nearness underscoring the cruel unlikeness. Deianeira casts an anguished glance upward to the gods, one arm reaching out for help. On every level, visual and emotional, this is a painting that learns from Raphael and Caravaggio alike.

Human drama in guercino

Like Reni, Guercino (Giovanni Francesco Barbieri, 1591–1666) also fell into disrepute. Perhaps this is even less reasonable, for he is one of the great narrative painters, a draftsman of infinite ability and a superb colorist as well, especially in his earlier years. The name by which we know him was a sort of nickname and is best translated as "Squinty." It indicates a disability, but no man ever used a squint to better effect. He was influenced by the Carracci, and like the Carracci also, by Venetian painting.

Character, interaction, passions in conflict: these are things that Guercino portrays with total confidence. *Christ and the Woman Taken in Adultery (215)* makes its point mainly through the gestures of the hands, as Jesus and the accusers signal their difference of principle (see column, below right). The noble head of Christ, imperturbably calm amid the hubbub, is just sufficiently unidealized to make the incident seem credible. Guercino shows us divine love as a great force of compassion, infinitely demanding and infinitely forgiving.

Guercino is an intensely dramatic artist, playing with light and shade with dazzling skill. We are moved by meaning in his work, but also by its sheer visual beauty.

draftsman and a most felicitous colorist; he is a prodigy of nature, a miracle.

Carracci on Guercino in a letter of 1617

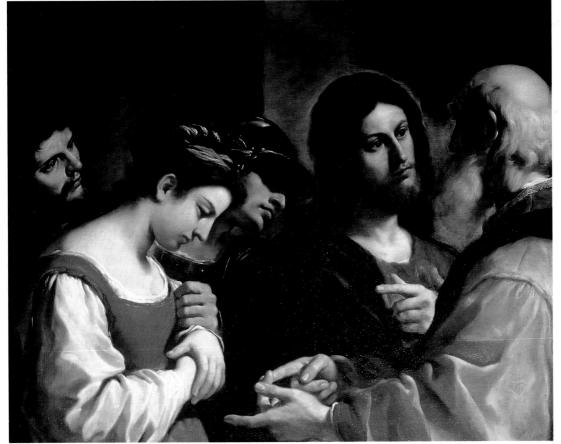

216 Guercino, Christ and the Woman Taken in Adultery, c. 1621, 48 x 38½ in (122 x 98 cm)

THE WOMAN TAKEN IN ADULTERY

This story is told in St. John's Gospel. Temple officials and members of the Pharisee sect try to trick Jesus into giving judgment (so that they can accuse Him of usurping authority). They bring before Him a woman who has been caught in the act of adultery, punishable in Roman law by stoning. Jesus pauses, writing with one finger in the dust, then replies, "He that is without sin among you, let him cast the first stone." At this the accusers leave the scene. Jesus finally says to the woman, "Go, and sin no more.'

THE DIVISION OF THE NETHERLANDS

A truce agreement of 1609 divided the strife-torn Netherlands into two parts: the United Provinces (known to us today as the Netherlands, or Holland), which was freed from Spanish rule; and the Southern Netherlands (roughly the present-day Belgium, including Flanders), which still belonged to Spain. This division was given formal recognition by the Treaty of Münster, in 1648.

Flemish Baroque

 $\it In$ the 17th century, Flanders was the main stronghold of Catholicism in an otherwise Protestant northern Europe. It remained under Spanish rule when the Northern Netherlands won independence, and the greatest outside influences on Flemish art were Spain and the Counter-Reformation. This is clearly seen in both Rubens and van Dyck.

For a century, Spain had been the major military force in Europe. It had used its power to back the might of the Catholic Church in Northern Europe – precisely where Catholicism was under the strongest attack from the Protestant Reformation. In the Netherlands, when the North won its independence, Flanders remained within the Catholic fold, in an ever-closer relationship with Spain. The two Catholic countries had in

common the religious idealism of the Counter-Reformation, and, linked as they were by their history, they shared similarities in their art. At the start of the 17th century, as a result of this consolidation with Spain, industry in Flanders flourished, and the arts, which were centered in Antwerp, benefited from the increasingly prosperous culture.

The greatest of the Northern Baroque painters was the Antwerp-based Peter Paul Rubens (1577 −1640). He has something of Domenichino's largeness of spirit (see p.183), but greatly magnified. The wonderful mixture of Italian grandeur and Flemish lucidity and feeling for light climaxes in the paintings of Rubens. His work is infused with a kind of Catholic Humanism that admits sensuous delight along with religious sentiment, and it has an energetic, optimistic spirituality.

In 1600 Rubens went to Italy to study. He traveled widely over the next decade, notably to Spain, where he became friends with a Spanish artist who was 22 years his junior and who was of perhaps even greater stature: the incomparable Velázquez (see p.194).

Rubens wrote, "I consider the whole world to be my native land," and this confident generosity of spirit, this cosmopolitan view of the world, is manifested in his works. So expansive was his genius that he easily took the elements that he admired of the High Renaissance masters and assimilated them into his own strongly independent vision. His paintings reveal a supremely confident use of color – always rich and generous – that he learned from studying the works of the great Venetian, Titian. His figures have a massiveness of form that runs in a clear line back to Michelangelo.

217 Peter Paul Rubens, Descent from the Cross, 1612–14, 10 ft 2 in x 13 ft 9 in (310 x 420 cm)

RUBENS'S RELIGIOUS WORKS

Rubens spent some time in Rome and the influence of his Italian contemporary, Caravaggio (see p.176), proved to be an enduring one. This revealed itself most emphatically in Rubens's religious paintings, to which, in true Baroque form, Rubens gave popular appeal and an utterly physical presence. We cannot always tell from an artist's religious painting how personal is his faith: probably we can never tell, faith being so

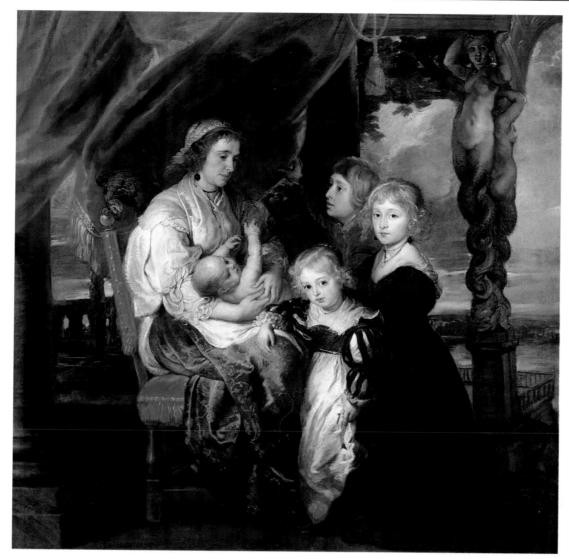

218 Peter Paul Rubens, Deborah Kip, Wife of Sir Balthasar Gerbier, and Her Children, probably 1629/40, 5 ft 10 in × 5 ft 5¼ in (178 × 165 cm)

integral a part of our nature. But we know that Rubens cherished his religion and tried to live by it. We can imagine that we see this earnestness in his wonderfully energetic *Descent from the Cross (217)*. Here we can see Caravaggio's influence, in the dramatic lighting and humane realism, but also that of Michelangelo, in the muscular, classical form of the dead Christ.

The painting still hangs in Antwerp Cathedral, for which it was painted, a great descent indeed, as the limp body (the only nonactive element in the picture) drops down the whole length of the frame. All the activity is kept central, a thick and vital column of emotion and movement, passion expressing itself physically, all the light kept steady on the deadness of Christ. His weight presses down almost unbearably, His death making it impossible for love to reach out. The mourners feel with despair that they have had something of their own life taken away in the Crucifixion of their Lord.

RUBENS AS A PORTRAITIST

But Rubens is no escapist. He never flatters the truth into acceptability: he reveals what defects he sees, though sitters may not have recognized them when displayed for all to see in a portrait.

One of his great group portraits, *Deborah Kip*, *Wife of Sir Balthasar Gerbier*, *and Her Children* (218), shows a family that is not happy. The three older children are grim and questioning, the little girls looking out at us with hesitant reserve. They are beautiful children, but they are tense – as is the elder brother, leaning tautly forward. The baby is unaware of tension, but the mother seems lost in her sadness.

The father of the family was a cruel and unprincipled man, and Rubens does not gloss this over. Deborah Kip is gloriously dressed in damasks and silks, but the family stands in a setting of ominous clouds. The glow and the beauty are observed, but with foreboding. There is deep sentiment, but no sentimentality.

THE GERBIER FAMILY

Rubens was introduced to Sir Balthasar Gerbier, who gave him a job as an intermediary to the Duke of Buckingham, (aide to King Charles I). Sir Balthasar officially held the post of Charge of the Duke of Buckingham's Correspondence, but had a reputation as a scoundrel and a debtor. Rubens's portrait of his family (see left) exposes the somber mood and air of tension that surrounds the Gerbier family.

THE COUNTER-REFORMATION

This was a movement that took place within the Catholic Church at the time of the Protestant Reformation (see p.169). The Roman church found itself in need of reform, particularly so if it was to win back regions that had turned Protestant. Pope Paul III (1468-1549, shown above) summoned the Council of Trent (1545-63), which redefined Catholic doctrines and introduced disciplinary reforms. New religious orders, including the Jesuits, were founded to lead the counteroffensive against the Protestants. Later, the more rational types of church reform were replaced by the paranoia of the Inquisition (see p.197), which used extreme measures against Protestant "heretics."

OTHER WORKS BY

Portrait of Justus Lipsius (Museum Plantin Moretus, Antwerp)

Adoration of the Kings (The chapel of King's College, Cambridge, UK)

The Oration of Henri IV (Australian National Gallery, Canberra)

The Triumph of Archduke Ferdinand (The Hermitage, St. Petersburg)

Allegory of Eternity (Fine Arts Gallery, San Diego)

Death of Seneca (Alte Pinakothek, Munich)

Portrait of Hélène Fourment (Louvre, Paris)

AN AMBASSADOR'S SKILL

Rubens's vitality and tenderness – an unusual combination – could make him seem unlikely to be a success as a political artist. But his genius was immense and he was a highly successful ambassador for his country, the Spanish Netherlands, so he was used to moving in the highest political circles.

Almost all the crowned heads of Europe knew personally, and valued aesthetically, the great Rubens. He was the obvious choice for Marie de' Medici, the widowed Queen Mother of France, who needed artistic help in her state of rivalry with her own son, Louis XIII.

Louis came of age in 1614 and duly became king but, like many a parent, unfortunately, Marie was unable to accept her son as a functioning adult, and she clung tenaciously to her status. The French court came to be beset with the political problems arising from this sordid rivalry. Louis was forced to have his mother exiled to the provinces, and she was not allowed to return until 1620. She moved into the Luxembourg Palace, a splendid Baroque building on the left bank of the Seine, whose refurbishment and decoration became her main occupation for the next five years.

Her plan was to commission two cycles entailing some 48 vast canvases altogether.

One was to illustrate the romance and triumph of her career, the other the events of her late

husband's. Marie de' Medici had never been beautiful and was always overweight. King Henri IV had indeed been a hero, but the only cycle to come near completion was the one focusing on Marie. No other artist but Rubens could have carried this off without becoming ludicrous. The series is far from ludicrous: it is magnificent. Without eliding the truth, merely gently shading it, Rubens provides one splendid canvas after another, making a mountain of art out of a molehill of fact.

His method is splendidly exemplified in *The Apotheosis of Henri IV and the Proclamation of the Regency (219)*, which is set in terms of classical myth. Rubens's lips may have twitched as he painted this, but his artist's hand is rock steady. It is a beautiful, vibrant picture, completely integrated, one of the great narratives of art.

Facing *The Apotheosis of Henri IV* at the opposite end of the long gallery in which the cycle was originally housed was *The Queen Triumphant*, a brilliant piece of court portraiture. Other memorable successes were *The Education of the Princess, The Disembarkation at Marseilles*, and *The Birth of the Dauphin*.

If weaknesses in the cycle are looked for, they are to be found in a small minority of the paintings. *Louis XIII Comes of Age*, for instance, appears to lack conviction, and this is thought to be indicative of the lingering hostility between the officially reconciled royal figures.

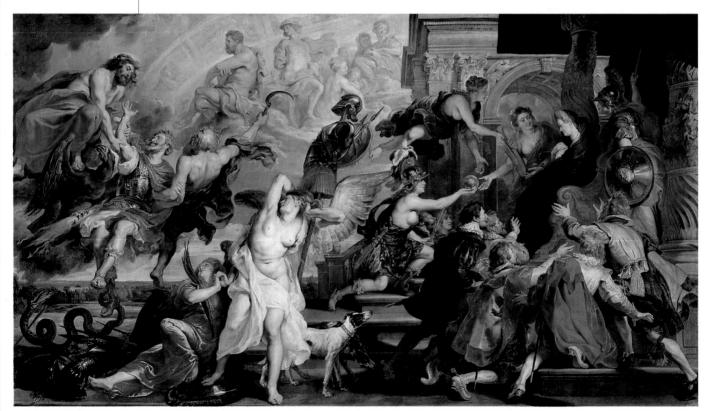

219 Peter Paul Rubens, The Apotheosis of Henri IV and the Proclamation of the Regency, c. 1621/25, 23 ft 10 in x 13 ft 11 in (727 x 391 cm)

THE APOTHEOSIS OF HENRI IV

Rubens conceived the *Apotheosis of Henri IV* as the climactic work in a great cycle depicting events in the career of Marie de' Medici. It is a huge canvas, 24 feet wide and over 13 feet high (7 m by 4 m), commissioned for Marie de' Medici's palace, where it stretched across the entire end wall of the gallery in which it was hung. Its full title, *The Apotheosis of Henri IV and the Proclamation of the Regency*, explains the double nature of the composition. With great success, Rubens has depicted two separate events (both proclaimed on the same day) within one canvas: the death of the king (who was assassinated in 1610) and the regency of his widow.

REGENCY OF MARIE DE' MEDICI On the right-hand side, the embattled Spirit of France kneels and offers the orb to the unwilling widow (depicted in deep mourning). Above her, a figure representing the regency offers her a rudder. The French aristocracy, and the heavenly graces, plead with her to overcome her humble reluctance.

Apotheosis of Henri IV

On the left, Henri IV is taken up to Heaven where he will be deified (the meaning of apotheosis). He is carried by Saturn (sickle in hand), the god of time and death, who delivers him to Jupiter, the supreme god of power, leaning down from Olympia to receive him. Jupiter's eagle, bearing a thunderbolt in its claws, symbolizes the ascending soul. The serpent, shot through with arrows, is an allusion to the king's assassin.

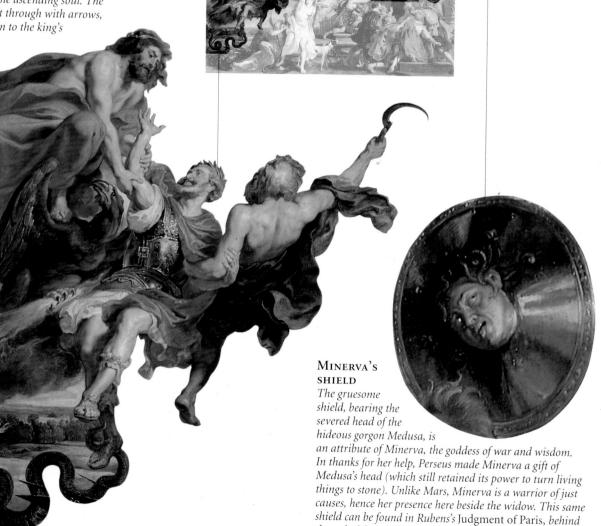

the naked figure of Minerva (see p.190).

THE INFANTA ISABELLA

The Spanish Infanta (Princess) Isabella (1566-1633) was also Archduchess of Austria. She and the archduke were joint regents of the Spanish Netherlands (i.e., the Southern Netherlands, including Flanders). In 1628 she sent her court painter, Rubens, to Madrid, where he met Velázquez (see p.194). On the death of her husband, Isabella adopted the habit of the Poor Clares (a religious order), as can be seen in this etching from a painting by van Dyck.

JACOB JORDAENS

The Flemish painter Jacob Jordaens (1593-1678) had a flourishing studio of his own and became the leading figure painter in Flanders after the death of Rubens. He used the impasto technique (thickly applied opaque paint that reveals the marks of the brush) in many of his paintings. The people he paints are usually robust and earthy.

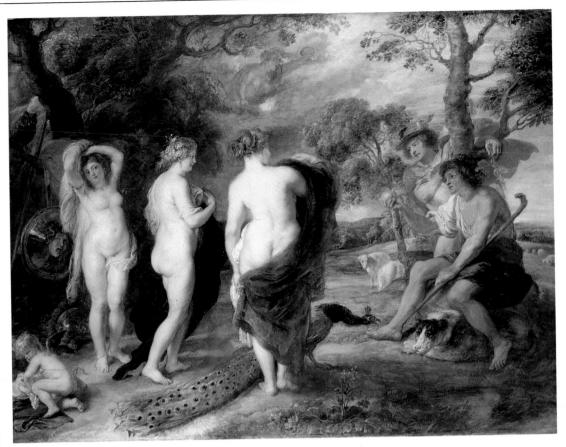

220 Peter Paul Rubens, The Judgment of Paris, 1635–38, 76 x 57 in (194 x 145 cm)

THE RUBENS LOOK

Rubens is unfortunate in that today's attitude toward the fat is in direct opposition to that of the 17th-century Flemings. They loved a full-bodied woman, and most of Rubens's superb nudes are too large for our taste. But he is very much more than the painter of the fair and fat.

Rubens was the most fortunate artist in history: handsome, healthy (until gout in later life), well educated, sensible, good-humored, wealthy, an innate diplomat and recognized as such by the crowned heads of Europe, twice married, both times with blissful success so much so that he openly celebrated it in his paintings - and one of the greatest and most influential artists ever born. He used all his gifts with unselfish industry, climaxing his good fortune by being a thoroughly good man. It is typical of his happy career that at a young age he became court portraitist at Mantua in Italy (see column, p.104) and that in 1609, at 32, he became court painter to the Infanta Isabella and Archduke Albert in Brussels (see column, left).

The glory of Rubens's work is its vigor, its happy and profound consciousness of the significance of being alive and alert, of never wasting what a context offers. But as well as that, there is what one can only call a sweetness in him, shown most remarkably by the Rubens

"look." People in his paintings tend to give one another a look of wholehearted trust, an acceptance of difference and a confidence in its worth. An example is *The Judgment of Paris* (220). Paris looks at the naked goddesses with a lovely reverence – the Rubens "look." It is returned by

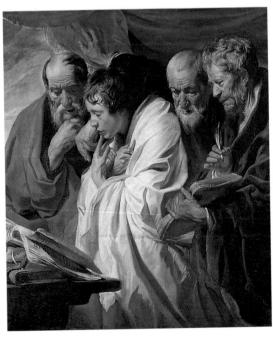

221 Jacob Jordaens, The Four Evangelists, c. 1625, 46¼ x 52½ in (118 x 134 cm)

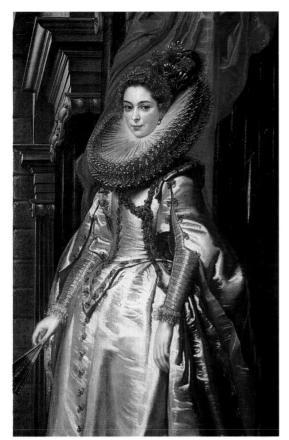

222 Peter Paul Rubens, Marchesa Brigida Spinola Doria, 1606, 38¾ × 60 in (99 × 152 cm)

Venus, innocently amazed at her victory. It has been remarked that her surprise is justified; that Juno, with her back arched above her furs, is the true winner. (The third goddess, Minerva, seems to look on with amused curiosity.) The legend takes on a special significance, quite apart from preceding the Trojan war. What interests this supremely balanced painter is the encounter between what could have been a vulgar youth and an unclad queen. Rubens lends the scene dignity and graciousness.

JORDAENS - RUBENS'S SUCCESSOR

Rubens ran a workshop in Antwerp, with a large stable of assistants. One artist who is known to have worked with him in Antwerp is Jacob Jordaens (1593–1678), who gained a great deal from his association with Rubens and flourished over the years, producing coarse-grained but vital works. Jordaens's *The Four Evangelists* (221) is painted with vigor: the thick brushwork is very different from Rubens's technique.

Jordaens worked best as a painter of genre works and typically chose modest subjects; but after Rubens's death in 1640, it was he who filled the post of Antwerp's leading artist, perpetuating Rubens's influence and producing a great many public works over his long career.

VAN DYCK'S GRAND ELEGANCE

The closest to Rubens in gift, and at times in style, in the North, was Anthony van Dyck (1599–1641). In his youth, Rubens had a very aristocratic elegance that reminds us of van Dyck. An example from his early twenties is his regal-looking portrait of *Marchesa Brigida Spinola Doria* (222), in which the face, gentle in its self-assurance, proclaims the work of Rubens.

Van Dyck can manage just as much grandeur, skillfully deploying all his arts to make his own *Marchesa* (223), of the great Grimaldi family, appear almost immortal in her lofty state. In his portraits, van Dyck suppresses the "earthiness" and animal vitality so forceful in Rubens's paintings, and in its place we find an elegance and psychological presence that his aristocratic subjects doubtless found pleasing. The slave who holds the parasol is humankind: the lady is on another plane – yet not quite. Somehow van Dyck manages to make us believe in his lady, with a subtlety not evident in Rubens's portrait.

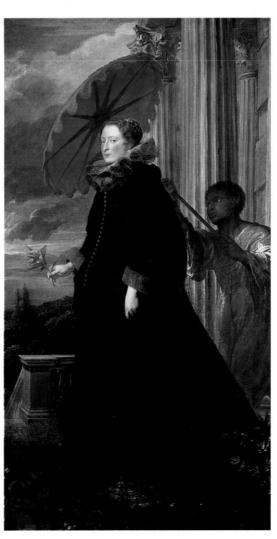

223 Anthony van Dyck, Marchesa Elena Grimaldi, 1623, 52 x 95 in (133 x 241 cm)

PETER PAUL RUBENS

Rubens (1577-1640) made an early start to his career, becoming a Master of the Guild of St. Luke at Antwerp in 1598. From 1609-21, he was court painter to Albert and Isabella, the rulers of the Spanish Netherlands (see opposite), with an annual salary of 500 florins (guilders). After Albert's death in 1621. Rubens became an adviser and diplomat for Isabella. He also worked in Paris on a cycle of pictures for Marie de' Medici (see p.188). In 1629 he visited the court of Charles I of England, winning the praises and confidence of the king.

VAN DYCK

The great 17th-century master portrait painter Sir Anthony van Dyck (1599-1641, shown above) achieved renown as an artist in the service of royalty and the aristocracy. His patrons included Prince William of Orange (see p.215) and Charles I of England (see p.192). The elongated figures of his subjects, with their air of remoteness and self-confidence. established a pioneering "English" portrait tradition.

THE COURT OF CHARLES I

King Charles I of Great Britain and Ireland (1600-49) may have been an imperfect and fatally flawed ruler, but as a connoisseur of the arts he had no royal equals. His court was enlivened by regular masques and dances, and he was renowned as a man who would pay large sums to the great artists of the day, such as van Dvck (whom he knighted). His royal patronage had a stimulating effect on art and architecture throughout England.

OTHER WORKS OF VAN DYCK

Cornelius van der Geest (National Gallery, London)

Henrietta Maria (The Royal Collection, Windsor Castle)

Marchesa Giovanna Cattaneo (The Frick Collection, New York)

The Drunken Silenius (Gemäldegalerie, Dresden)

Daedalus and Icarus (Art Gallery of Ontario, Toronto)

A Lady of the Spencer Family (Tate Gallery, London)

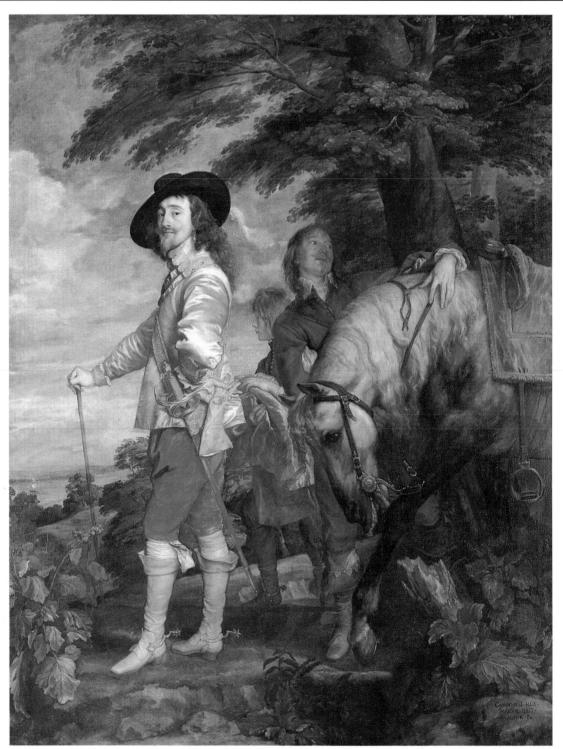

224 Anthony van Dyck, Charles I of England Out Hunting, c. 1635–38, 6 ft 9½ in x 8 ft 8½ in (207 x 266 cm)

Portrait painting was a lucrative business, and van Dyck really excelled at it. Like Rubens (in whose Antwerp workshop he briefly worked), he traveled extensively, enjoying an illustrious career before settling in 1632 in England. It was at the court of Charles I, that doomed monarch, that his gifts flourished, influencing generations of portrait painters in England and throughout the rest of Europe. The diminutive king starred in many of van Dyck's paintings, in a variety of

symbolic roles, sometimes in armor, and sometimes on horseback. One portrait in the Louvre, *Charles I of England Out Hunting (224)*, is the greatest piece of public relations ever created. By sheer force of genius, van Dyck presents us with an icon of the heroic, of the grave scholar king who yet loves the chase. Noble tree, noble seat, noble monarch: van Dyck integrates the three into a most memorable image. Charles knighted him, and we feel he deserved it.

Spanish Baroque

 $P_{
m ainting}$ in 17th-century Spain was profoundly influenced by the Church, at least partly because of the religious zeal of the Spanish Hapsburg dynasty. King Philip II and his two successors, Philip III and IV, maintained religious orthodoxy by means of the dreaded Spanish Inquisition, a council for the persecution of all forms of "heresy," including Protestantism. Spanish Baroque art was largely devotional in nature, though the period can boast a little court painting and some mythological, genre, and still-life work.

Despite the tense atmosphere of religious conformity presided over by the Hapsburg regime, Caravaggio's liberating influence (see p.176) is fairly widespread in Spanish painting in the early part of the 17th century. Caravaggio's rich contrasts and dark palette were well suited to the Spanish tradition, in which a tendency toward grim and graphic realism was already well established, especially in religious sculpture (see column, p.198).

"Caravaggism" found an early exponent in Jusepe de Ribera (1591–1652), who painted with dark colors and, often, disturbingly sinister undercurrents. Ribera went to Italy – first to Rome, where he absorbed Caravaggio's influence, then to Spanish-ruled Naples. He remained in Italy for the rest of his life and

enjoyed great success. There is more piety, and sensual pleasure, in Ribera's religious paintings than in those of Caravaggio and, equally, a deeper level of pain and suffering. There is a terrifying degree of pain in this mythological work (225), in which Apollo punishes Marsyas by skinning him alive. Marysas, who was a skilled flautist, had challenged Apollo to a music contest, but had lost. As victor, Apollo was allowed to choose the punishment.

Ribera found his models among urchins and beggars, and portrayed them as they really were. His beggar-boys, even his philosophers, confront us with all their physical imperfections: rotting teeth, deformed limbs, dirty skin, and aged flesh, breathing a harsh and unprecedented social realism into 17th-century painting.

225 Jusepe de Ribera, The Flaying of Marsyas, 7ft 8in x 6ft (234 x 183 cm)

SPAIN IN THE 17TH CENTURY

From the reign of Philip II (1556-98) onward, the Hapsburg monarchy had to struggle to keep control over Spain's vast empire. At the beginning of the 17th century, the country was in economic decline due to the number of wars it had to fund. It was also weakened by the loss of land to France under the Treaty of the Pyrenees in 1659, and by several serious outbreaks of the plague. · At the same time, Spain experienced an intellectual and artistic renaissance.

Don QUIXOTE

Miguel de Cervantes (1547-1616) was the most successful Spanish novelist of the 17th century. His most famous work, Don Quixote, was written while he was in prison in Seville. The novel is a satire on the current fashion for chivalry but also portrays the theory of the human ideal and the frailty of man. The two characters represent the many fluctuating features of insanity, and the detailed descriptions of the Spanish countryside give the book a powerful resonance. By 1605 the book was in print in Madrid; this

illustration (above) shows the popular 1608 edition.

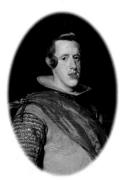

PHILIP IV OF SPAIN

Although he was a discerning patron of the arts, King Philip IV of Spain (1605-65) took little interest in politics. He left the administration of his realms to his minister, Count Olivares (1587-1645). Velázquez (1599-1660) became court painter in 1623. The king often ordered several variants of one picture (usually, only the colors of the clothes would be altered). Since Velázquez was notoriously slow in his work, a studio of copyists was employed to reproduce the master's work. This portrait of the young king may be by Velázquez, or merely by a copyist.

OTHER WORKS BY VELAZQUEZ

Cardinal Don Ferdinand of Austria (Prado, Madrid)

The Rokeby Venus (National Gallery, London)

The Infanta Maria Teresa (Kunsthistorisches Museum, Vienna)

The Moorish Kitchen Maid (National Gallery, Edinburgh)

Count Olivares (The Hermitage, St. Petersburg)

The Infante Balthasar Carlos (The Wallace Collection, London)

The Painter Juan de Pareja (Metropolitan Museum of Art, New York)

VELAZQUEZ: SPANISH GENIUS

When Diego Velázquez (1599–1660) first made his bid for painterly glory (just out of his teens), he was influenced by Caravaggio (see p.176). There is the same sureness of form and control of light, but beyond this, all real comparison ends. Velázquez was unique, one of the very greatest of painters, and he developed a vision of human reality that owed little to outside influence.

The only image of royalty comparable to the van Dyck portraits of the Stuart King Charles I (see p.192) is that given by Velázquez of the Hapsburgs, whom he served as court painter; but, again, the comparison is a superficial one. Velázquez did not merely glorify his king and

court, though he did that as a matter of course; he was also oddly intent on rising in social status. In time he did win his way to a mild friendship with Philip IV. The king was a poor politician (see column, left), but his saving grace was that he did appreciate the genius fate had sent him as court painter and rewarded him accordingly.

The sheer beauty of Velázquez's court paintings, official statements in an age without photography of what the monarch and entourage looked like, undoes all attempts at labeling. *Las Meninas* (226) ("the maids of honor") is now hung in the proudest place, behind bulletproof glass – visibly the greatest treasure of its great museum, the Prado, Madrid.

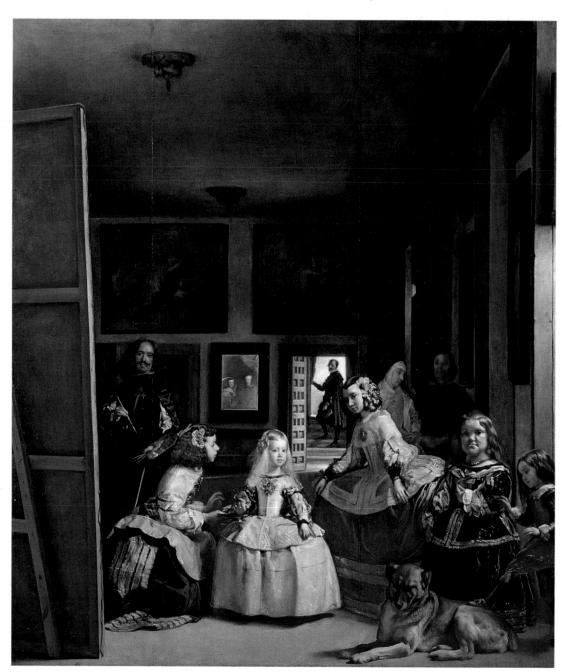

226 Diego Velázquez, Las Meninas, 1656, 9 ft ½ in x 19 ft 5 in (276 x 320 cm)

Las Meninas

At one level, this picture is easy to read: at the center is the little princess, the Infanta Margarita Teresa, with her maids clustered around her, her tutors, page, and dwarf in attendance, and her gigantic dog. From the dog we work our way up by stages to the distant reflection of the king and queen. Here is the whole world of the inner court, presented obliquely, in reverse order of importance. Painted for the king's private summer quarters, this work is both a portrait of his young daughter and a sophisticated, innovative tribute to the king himself. It portrays a single moment, each figure responding to the entrance of the king.

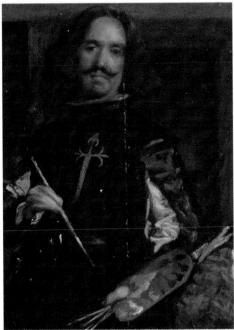

SELF-PORTRAIT
The painter, Velázquez himself, stands at the far left, intent upon a canvas looming impressively upward, while the large copies of Rubens's paintings behind him are diminished (there is irony here) by the shadows. The red cross on Velázquez's chest signifies his subsequent knighthood and was added to the painting two or three years later.

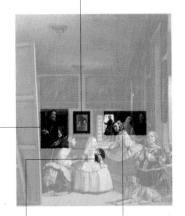

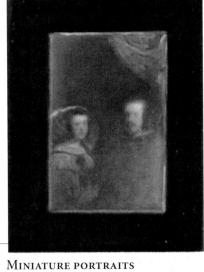

MINIATURE PORTRAITS
In the rear mirror, our attention drawn to it by the silhouetted courtier, we see a reflection of the king and queen. Whether it actually reflects them, or the painting Velázquez is working on, nobody knows for certain. Secure in their position, the royal pair can easily afford to become a mere reflection behind their child. Even as pale shadows, they can dominate, surely the subtlest of compliments.

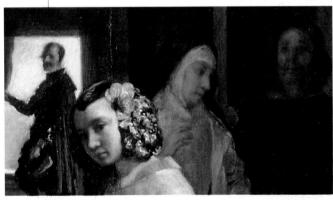

COURT LIFE
There is a sense of life as actively lived, life held still for a passing moment — not a moment of special significance, however; merely one of the thousands passing every hour, and this one lives on. The figures of the Infanta's entourage appear and recede in a vast cave of shadows. All have been identified as historical personages except for the man standing quietly on the right.

COURT JESTERS

Since medieval times, dwarves were employed as jesters in the courts of Spain. Philip IV's favorite was a dwarf named Sebastiano de Morra. The dwarves' feelings as human beings were generally ignored, and they had to endure the jokes and insults of the courtiers. It was usually the king who chose the names of his jesters, often giving them mock titles of ludicrous grandeur.

Earlier in his career, Velázquez had contributed to the grand projects inaugurated by Philip IV. These included a splendid new palace, the Buen Retiro, built in 1631–35, in whose many rooms some 800 paintings were hung. Its principal ceremonial room, known as the Hall of Realms, contained 27 paintings by Spanish artists, including Velázquez's Surrender of Breda, along with a number of works by Zurbarán (see p.197). The king's next project was the Torre de la Parada, a hunting lodge on the grounds of the Pardo Palace. Velázquez, despite the king's increasing interest in foreign artists, contributed portraits of the young crown prince Balthasar Carlos and two of the court dwarves, one of whom, Francisco Lezcano (228), is shown here.

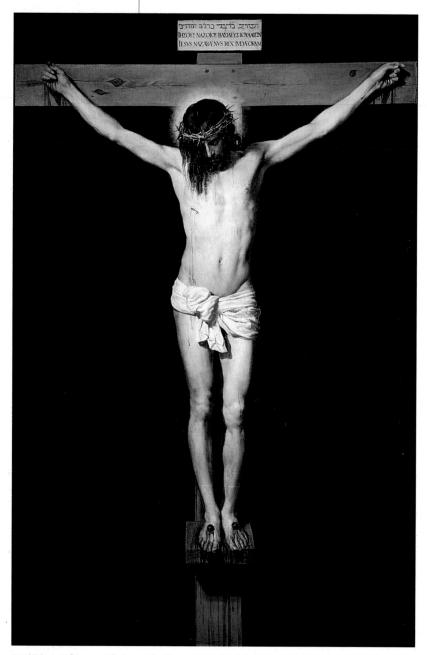

227 Diego Velázquez, Christ on the Cross, 1631–32, 5 ft 6½ in x 8 ft 1 in (169 x 250 cm)

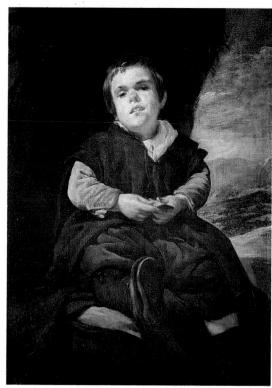

228 Diego Velázquez, Francisco Lezcano, 1636–38, 32½ × 42 in (83 × 107 cm)

Velázquez's use of paint intrigued his royal friends. They pointed out to one another, quite intelligently, that his pictures had to be viewed at a distance, when the rough and apparently glancing dabs of color would suddenly, miraculously, integrate themselves into the image. Lace, gold, the glitter of light jewels, the rosy flush of a young cheek, the weary droop of an aged head: Velázquez could catch them all and hold them for us to see. He could do this with a religious image: no *Christ on the Cross (227)* has a more mournful human dignity than his.

He could teach us that the court dwarf (228), who often served as a jester (see column, left) and a figure of fun, had the same tragic dignity and unalienable humanity as the dying Jesus.

He could take a theme from mythology and show us that paganism, too, is a religion and so draws its force from the movements of the human spirit. *The Forge of Vulcan (229)* is a masterpiece of contrasts between two kinds of being. On the one hand, there is the luminous, epicene, and effeminate youth, visitant from another world, blandly confident of his ability to make himself understood. On the other, there is the team of blacksmiths, male to their core, wiry and astonished – and yet at the same time clearly unimpressed. The two worlds meet with mutual incomprehension and with mutual disinterest, yet Velázquez laughs so low in his chest that the joke may go unheard.

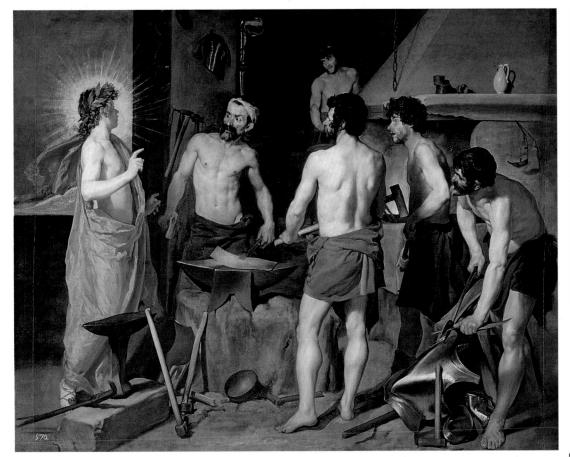

229 Diego Velázquez, The Forge of Vulcan, 1630, 9 ft 6 in x 7 ft 4 in (290 x 223 cm)

ZURBARAN: A SACRAMENTAL CALM

Francisco Zurbarán (1598–1664) was a contemporary of Velázquez and worked in Velázquez's native town of Seville. The two were largely unlike in style, except that Zurbarán's paintings display that pleasing solidity of form and plasticity of paint found in Velázquez's early

work (see p.196). It is in still life that we find Zurbarán at his finest. *Still Life with Oranges* (230) has a sacramental monumentality, a modest certainty of the value of things, the fruit laid out on an altar, the flower silent beside the humble mug, three images bathed in sunlight and conveying an indescribable sense of the sacred.

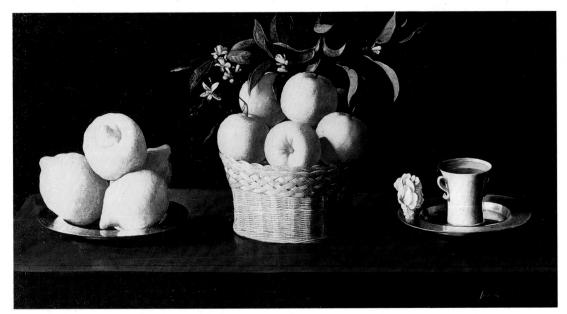

230 Francisco Zurbarán, Still Life with Oranges, 1633, 42 x 23 ½ in (110 x 63 in)

THE FORGE OF VULCAN

In Roman mythology Vulcan was the god of fire and the blacksmith of the gods. Apollo has witnessed Vulcan's wife, Venus, having an affair with Mars and has come to the forge to tell Vulcan. Apollo is usually shown with a glowing halo. Vulcan is surrounded by his assistants. In mythology, these are Cyclopes (one-eyed giants), but they are usually depicted as men with normal eyes.

THE SPANISH INQUISITION

Introduced in the 15th century by King Ferdinand and Queen Isabella, this became a terrifying ordeal for all Protestants, Jews, and Islamics. Dominican monks were given the task of seeking out heretics (anyone who did not openly support the Catholic faith). The monks instituted a type of trial known as the auto-da-fé (act of faith), which ended either in "recantation" or a public burning of the "heretic" at the stake. This illustration shows a heretic being led away to her death.

SPANISH RELIGIOUS SCULPTURE

In 17th-century Spain, religious sculpture became an important artistic movement. One famous example is the Dead Christ in the Capuchin Monastery at El Pardo, carved by the sculptor Gregorio Fernandez and commissioned by Philip III. Christ's body lies on an altar cloth and the drama of his pain is realistically re-created with open wounds and streaks of red blood against the brown wood of the body. The carvings, which were often carried in church festival processions, became increasingly popular as the cult of the Passion developed. The obsession with realism culminated in the use of real hair, eyelashes, and eyebrows on the figures' faces.

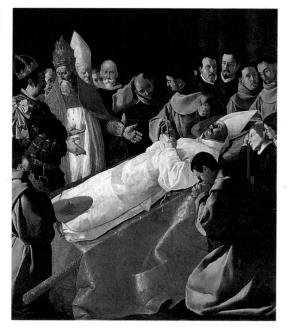

231 Francisco Zurbarán, The Lying-in-state of St. Bonaventura, c. 1629, $7 ft 5 in \times 8 ft 2 in (225 \times 250 cm)$

The Lying-in-state of St. Bonaventura (231) has the same weight of lucid significance, of "event" that is uneventful. The work hovers between time and eternity, intent upon the unseen that gives the seen its meaning. The human actors in the drama (and we might say that the dead saint is the most vital of these) are spotlighted against profound darkness. The mystery of our journey from birth to death becomes almost tangible.

MURILLO: A FORGOTTEN MASTER

The next great 17th-century Spanish master after Velázquez and Zurbarán is another artist who lived in Seville, Bartolomé Esteban Murillo (1617–82). Sadly, Murillo is easy to misjudge; at his weakest, which is not all that infrequent, he has a softness that can only be called sentimental. The mistake is to take the weak Murillo as the only Murillo. It is true that he is never as strong or as deep as Velázquez or Zurbarán, but he has his own gentle strengths and depths. Murillo can make us catch our breath with his unworldly but convincing images.

Because of our modern desire to face life whole, with all its cruelty, Murillo is often accused of being too idealistic, too anodyne. Our desire for realism runs contrary to Murillo's personal world of family love and understanding. Some of our surprise may come from the realization, unexpected, that sweetness can be made to work. *The Holy Family (232)*, with its tenderly involved St. Joseph and the absence of anything resembling heavy symbolism, has a charm that increases the longer the picture is looked at. The small mongrel and the cosseted child are both painted with the insight of love.

But we can perhaps best appreciate the genuine if not monumental gifts of this artist in one of his rare secular works. *Two Women at a Window (233)* is a splendid image, reticent, creamily beautiful, certain of its own understanding of the two figures. One of them is

almost certainly a duenna – an older woman employed by the family to be both a governess and a chaperon. She is laughing, but we are not shown her laughter: only her creased-up cheeks, flushed with mirth. Her twinkling eyes assure us that what makes the young woman smile to herself, unaffected, makes the older woman crinkle up with sardonic glee. She sees more, and understands with sharper wit, than the pretty child, and Murillo shows us this with the most delicate understatement.

In this wonderful picture, the great strong vertical of the shutter, and the equally strong horizontal of the window ledge, frame the two women. The girl, who is the emotional center of the picture, looks out at life with ironic detachment, but Murillo, and the older woman, know that her practical options are severely circumscribed.

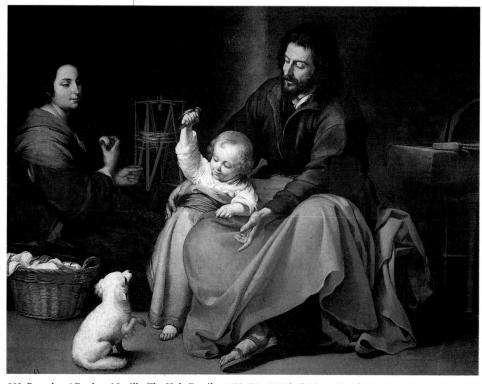

232 Bartolomé Esteban Murillo, The Holy Family, 1650, 74 x 56½ in (188 x 145 cm)

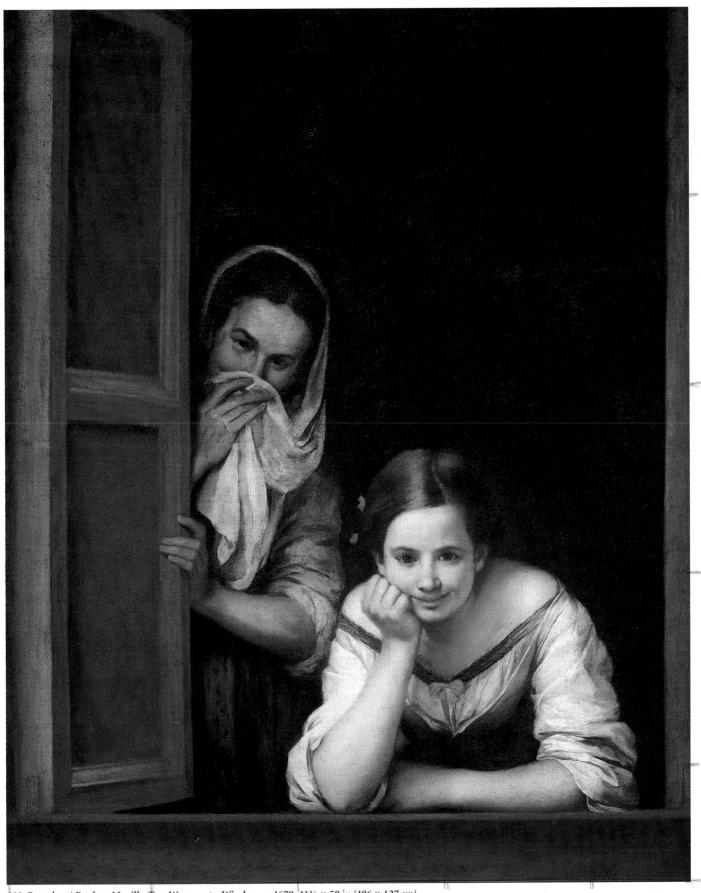

233 Bartolomé Esteban Murillo, Two Women at a Window, c. 1670, 41¾ x 50 in (106 x 127 cm)

THE UNITED PROVINCES

This name was first used in 1579, when the Protestant states of the Northern Netherlands declared independence from Spanish rule. Warfare raged until the truce of 1609 (see p.186). It took 39 years for Spain and the other Catholic powers to recognize the new Protestant state and finally sign the Treaty of Münster (in 1648). Holland was the richest of the United Provinces, and its name has come to be used for the whole country, though the official name today is the Netherlands.

THE BLINDING OF SAMSON

The story of Samson is told in the Old Testament book of Judges. Samson's enemies, the Philistines, seeking a chance to kill him, enlist Delilah to seduce him. She succeeds in getting him to give away the secret of his enormous strength (his hair), and while he is asleep, she lets them cut off his hair. As a consequence, his strength deserts him, leaving him helpless. The Philistines put out Samson's eyes and imprison him. Eventually he manages to exact revenge by pulling down the pillars supporting the roof of the house in which he is being held.

A DUTCH PROTESTANT VISION

The United Provinces of the Northern Netherlands claimed their independence in 1579, but it took 30 years of armed conflict to drive the Spanish from their soil. A treaty was signed in 1648, and this Protestant region, with its Reformation affinities and Northern realist heritage, now evolved its own tradition. Life was lived out in a dramatic atmosphere,

first of revolution and later of the fight to defend the hard-won freedom. A new order began, based on social justice and spiritual austerity. Churches were stripped bare for Calvinist worship, and in painting, there was renewed emphasis on realism and simple, everyday things.

It can be difficult to realize that Rubens (1577–1642, see p.186) and Rembrandt (van Rijn, 1606–1669) were contemporaries, their lives overlapping for the first half of the 17th century. Both lived in the Low Countries, though Rubens was based at Antwerp in Flanders, and Rembrandt at Amsterdam in the North, in the country that was known then as the United Provinces, and today is called "the Netherlands" or, more conversationally, "Holland".

Rubens seems to belong to an older age, more classical and international. Rembrandt is emphatically a Dutchman, and his vision comes primarily from himself and not from antiquity. Both are magnificent, but it is Rembrandt to whom we feel closest, perhaps because of his fascination for the self-portrait, which makes us able to "read" him at every stage of his emotional life. The human face fascinated him from the beginning, a fortunate circumstance that brought him many lucrative commissions. However, it is never the externals that intrigue Rembrandt, whether in his own face or that of others. It is the inner workings of the mind, an obsession that eventually lost him his successful position and the respect of his peers. Yet in Rembrandt's paintings, the two worlds of inner and outer are not in opposition. It is precisely through the body, so wonderfully conjured up in the medium of paint, that Rembrandt unveils to us the nature of the sitter, even the passing moods, as well as the deep-seated attitudes.

Rembrandt was a miller's son; in other words, he came from a middle-class background. This was significant of his times, for alongside the independence struggle, Dutch society was changing and the middle class was growing. As it grew it created a strong new demand for realistic paintings, such as serious institutional portraits and images of working life. Rembrandt was one of those born painters who started young

and was recognized almost at once. His earliest work, with its love for melodrama and keen interest in the humanity of his models, is essentially merely a hint at what is to come. His painting of a biblical story, *The Blinding of Samson (234)*, is superbly done; we flinch involuntarily from the sinister, silhouetted shape of the sword about to jab into a defenseless eye,

and we tremble to see the tumultuous violence that is raging within the dark and claustrophobic spaces of the cave. Samson writhes in anguish, Delilah flits away, half gloating, half horrified, and the pressure builds so high that it threatens to topple over into farce. We can see the same "overweight" of story in the early self-portraits, too.

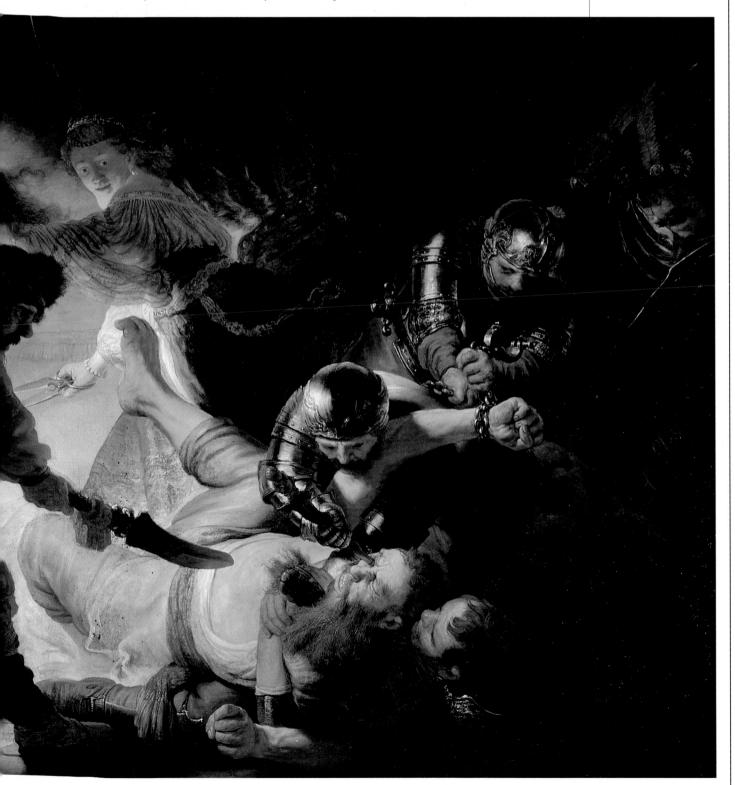

234 Rembrandt, The Blinding of Samson, 1636, 9 ft 10 in × 7 ft 9 in (300 × 236 cm)

OTHER WORKS BY REMBRANDT

The Night Watch (Rijksmuseum, Amsterdam)

Two Scholars Disputing (National Gallery of Victoria, Melbourne)

Aristotle Contemplating the Bust of Homer (Metropolitan Museum of Art, New York)

The Apostle Peter (National Museum, Stockholm)

Portrait of Marten Looten (Los Angeles County Museum)

Adoration of the Shepherds (National Gallery, London) The Self-Portrait at the Age of About 21 Years (235), dark and secretive, shows Rembrandt in early adulthood, perhaps deliberately acting the part of the "artist." In his midlife self-portraits he is more reflective, obviously successful, and quietly confident, gazing dispassionately out at us. A late work (236), ten years before his death in relative poverty, shows a face stripped of all pretensions, looking earnestly, not at us, but at himself, judging himself not unkindly but with disinterested truthfulness. It is one of the most moving confessions of personal inadequacy ever made, great art won from personal failure.

PORTRAIT INTERPRETATION

Rembrandt is essentially a master story teller. Sometimes, even in the portraits, he simply puts into our grasp the materials of the "story" and trusts us to enter into it by ourselves. *Portrait of a Lady with an Ostrich-Feather Fan (237)* haunts us with its tranquil sadness, its bravery and

236 Rembrandt, Self-portrait, 1659, 261/4 x 33 in (66 x 83 cm)

235 Rembrandt, Self-portrait at the Age of About 21 Years, c. 1627, $6\frac{1}{4} \times 8$ in $(16 \times 20$ cm)

wisdom. Where do we see all this? Why should we be certain that the unknown lady has a history of sorrow and of exceptional joy? Rembrandt merely puts her before us, with light lingering as if with love on the once-beautiful face, the acceptant hands, the great, free sweep of the feather. Sometimes, though, he plays out

237 Rembrandt, Portrait of a Lady with an Ostrich-Feather Fan, c. 1660, 32½ × 39 in (83 × 100 cm)

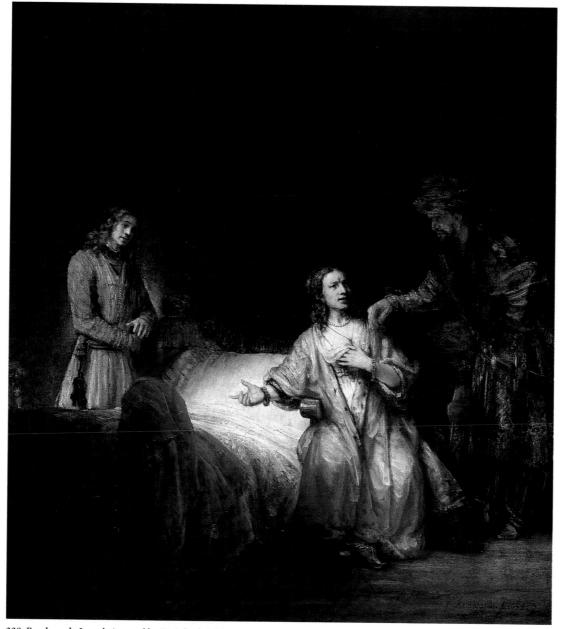

238 Rembrandt, Joseph Accused by Potiphar's Wife, 1655, 38½ x 41¾ in (97 x 105 cm)

the story for us, counting upon our educated knowledge of the context. *Joseph Accused by Potiphar's Wife* (238) is an incident from the book of Genesis that has intrigued many artists. Old Potiphar, his young wife, and a handsome young Jewish slave: the outcome is as might be expected, except that Joseph is one of the heroes, and he repulses his master's wife and her advances. Woman scorned that she is, the wife accuses Joseph of attempted rape.

Rembrandt makes no distinction here between virtuous and vicious: all merit his compassion. Central is the wife, shifty of eye, false of gesture, clearly not really expecting to be believed. Sad in the shadows, Potiphar listens, and as clearly, does not believe. He knows his wife, and knows his servant. Chivalry ties his hands. The miracle

is that Rembrandt makes us see all this marital interplay, and the sorrow of it, neither party able to be truthful with each other, yet hating the falseness. Ignored amid the passionate privacies of husband and wife, Joseph waits for his public disgrace. He is wholly unassertive, unaggressive, and – most movingly – unself-pitying. He too understands that Potiphar cannot afford to ignore his wife's histrionics, and in a sense, it is only Joseph, the victim, who is capable of accepting the situation. Without a single overt sign, Rembrandt makes us aware that Joseph commits his cause to God, and rests in peace. The wife is isolated in her finery, concerned only with herself. Even the hand meant to gesticulate toward her rapist is not directed at him, but at his red cape hanging over her bed. Her other hand

REMBRANDT'S ETCHINGS

Etching is a method of engraving in which the image is scratched onto a waxy coating on a metal plate, using a needle. The plate is then immersed in acid, which eats ("etches") into the metal where the image has been scratched. The technique is more versatile than the earlier metal-engraving process, as it enables the artist to alter the tone during the procedure. Etching reached its greatest heights as an art form with Rembrandt. who made his first etching in 1628. He enjoyed experimenting with different-textured papers and inks, and often reworked his etchings several times. His etchings cover a variety of subjects, including portraits, biblical stories, and scenes of daily life.

THE QUESTION OF ATTRIBUTION

In recent years many paintings that were thought to be by Rembrandt have been reattributed to other artists who worked in his workshop. Since the beginning of the 20th century over a third of the 988 "Rembrandts" have been reattributed. Experts check the color, brushwork, and subject matter to confirm the correct artist. Today many of Rembrandt's old workshop assistants are gaining new respect for having produced renowned paintings.

New discoveries

Rembrandt's The Jewish Bride was recently cleaned and unveiled in its new condition at the Riiksmuseum, Amsterdam in 1993 During the cleaning process restorers subjected it to analysis by X-ray, microscope, and infra red spectroscopy. They discovered that the artist had originally depicted a more erotic pose with the woman sitting on the man's lap, which was then a symbol of sexual intimacy. Rembrandt's changes gave infinitely deeper meaning to this celebration of married love.

presses painfully to her breast. She is suffering, not only from her sexual rejection by a younger man, but from her own awareness of her life. Rembrandt involves us in her personality, just as he does in the unbelieving husband, who reaches out, not to her, but to her chair, the material realm where these two have their only contact. Joseph is lost in the gloomy vastness of the chamber, yet a faint nimbus (an emanation of light) enhaloes him.

Rembrandt has allowed light and color to tell us the meaning of the event and make it move us with its inextricable human complexity and its profound sadness, redeemed only by blind faith in an unseen Providence.

JEWISH BRIDE?

Perhaps the greatest and most profound of all Rembrandt's works is the mysteriously entitled "Jewish Bride" (239). This is our title, since Rembrandt left the work unnamed, and it is a suitable title because no viewer can help but be stirred by the picture's sense of the sacred, and the biblical garb suggests that the couple are

Jewish. Who these two people are we shall probably never know, but they are clearly married. Both are past their first youth; they are plain in looks and rather careworn, though splendidly attired in oriental garb.

The husband enfolds his wife with an embrace of heartbreaking tenderness. One hand is on her shoulder and the other on the gift of his love, the golden chain that hangs on her breast. This chain is gold, it is his gift; it is still a chain. It is this aspect of love, that it binds, that its wonder is inseparable from its weight, that seems to preoccupy the woman. She is weighing up the responsibilities of loving and being loved, of receiving and of giving. It is not by chance that her other hand rests upon her womb, since children are the ultimate responsibility of married love.

Love binds, love weighs, love is the most serious experience that we can ever know in our life. It is Rembrandt's awareness of this profound truth, and the glorious visual beauty with which he makes it accessible to us, that makes the "Jewish Bride" so unforgettable.

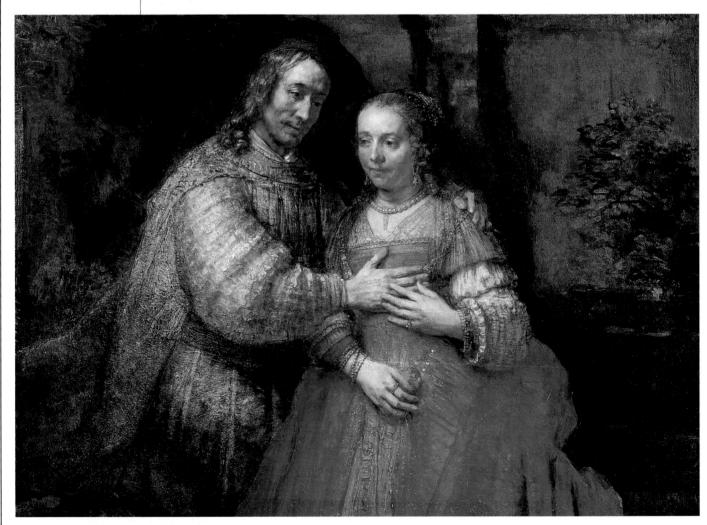

239 Rembrandt, "The Jewish Bride", 1665-67, 66 x 48 in (168 x 122 cm)

"The Jewish Bride"

"The Jewish Bride" is one of Rembrandt's late works, and one of his most beautiful. Its superb harmony, of red and gold and warm browns, is built around the most profound and compassionate insight into human relationships. It received its current title only in the 19th century, a title that implies that this could be an imaginary portrayal of one of the celebrated biblical marriages: Tobias and Sarah, for instance, or Isaac and Rebekah. But the couple's dress and jewelry, together with the powerful sense of two distinct, living personalities, suggests rather that it is a portrait of an unknown couple.

AUTHENTIC EXPRESSION

Despite the opulence and beauty of the wedding costumes, the overwhelming impact of this great painting lies in its simple emotional authenticity. The groom is a little care worn, his hair is thinning, and there are lines around his mouth and eyes. He makes no grand displays of devotion, and there is no sense of male victory but rather a quiet certainty as he inclines his head toward her, lost in thought almost as though listening to her thoughts. They do not formally address us as witnesses to their betrothal, and the intimacy is such that we feel we are intruding upon a very private moment.

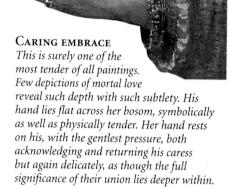

SHIMMERING SLEEVE

The great billowing sleeve swells out like soft golden armor. The paint is heavily built up, and Rembrandt has used short, staccato brushstrokes to re-create the many little pleats and folds that shimmer in the light. Touches of thick white paint provide the brightest points. Thick, encrusted paint glints and shimmers across the surface of the canvas, and one senses that their costumes are stiff and heavy, expensively brocaded. The bride's jewelry is picked out in dots and blobs of paint, again highlighted with white.

DUTCH STILL-LIFE TRADITION

By 1640 the basic type of Dutch still life had been established. The composition would usually consist of a table against a blank background with the objects on the table placed in a general upward and diagonal direction. The table contents would commonly be glasses, silver plates, and the remains of a sumptuous meal conveying the idea of vanity and the transience of human life.

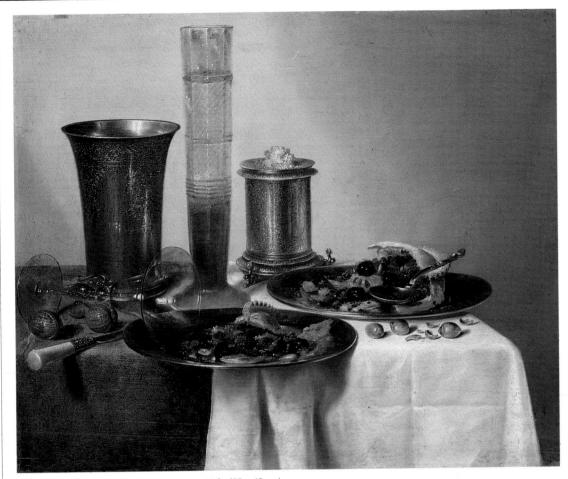

240 William Heda, Still Life, 1637, 21½ x 17¾ in (55 x 45 cm)

THE TULIP TRADE

The tulip first appeared in Europe around the mid-16th century, imported from Turkey by the Austrian ambassador. Trading began in 1634 and speculating on future bulbs eventually led to the great crash in 1637, when investors lost huge sums of money. At one stage during the tulipmania, a single bulb could sometimes attract extortionate amounts. This illustration shows one of the oldest types of tulip, the Gesneriana.

THE DUTCH STILL-LIFE TRADITION

Humankind, fashioned from earth and spirit, and forever struggling toward the goal of integration, fascinated Rembrandt; still life did not greatly attract him, yet in his own milieu we find some wonderful examples of this genre.

A still life may be said to make a statement, while Rembrandt asks a question. And yet there is infinite curiosity in a work like Heda's (Willem Claesz, 1597–1680). His *Still Life* (240) of a tablecloth, silvery in the light, gleaming with goblets and glasses and wide plates and littered with the remnants of a meal, is painted with the utmost dignity and respect.

De Heem (Jan Davidsz, 1606–1683/84) paints a *Vase of Flowers (241)* as time defied, nature held eternally in a radiant present for our delectation; it is the other pole of the genre. Heda is silent, and de Heem sings aloud with pleasure: both enhance for us the meaning of the ordinary, achieving the same effect, in their own smaller fashion, as does Rembrandt. One might suspect that something in the Dutch temperament responds to the quietness of a still life. It demands from the artist the ability to discard the heights and lows of drama; which suggests, does it not, the flatness of the Dutch landscape?

RADIANT TRANSPARENCY

One of the glories of a great still life is that it is as great in the parts as it is in the whole. This is the aftermath of a meal, but the uneaten nut is a whole world in itself, the fallen glass has a radiant transparency, and we can pick out every detail of the scene with increasing pleasure. Notice how the light gleams on the edge of the knife blade, how the tankard changes in tone when we see it through the bell-shaped end of the glass. Heda shows refraction changing the outline of the tankard and the play of light.

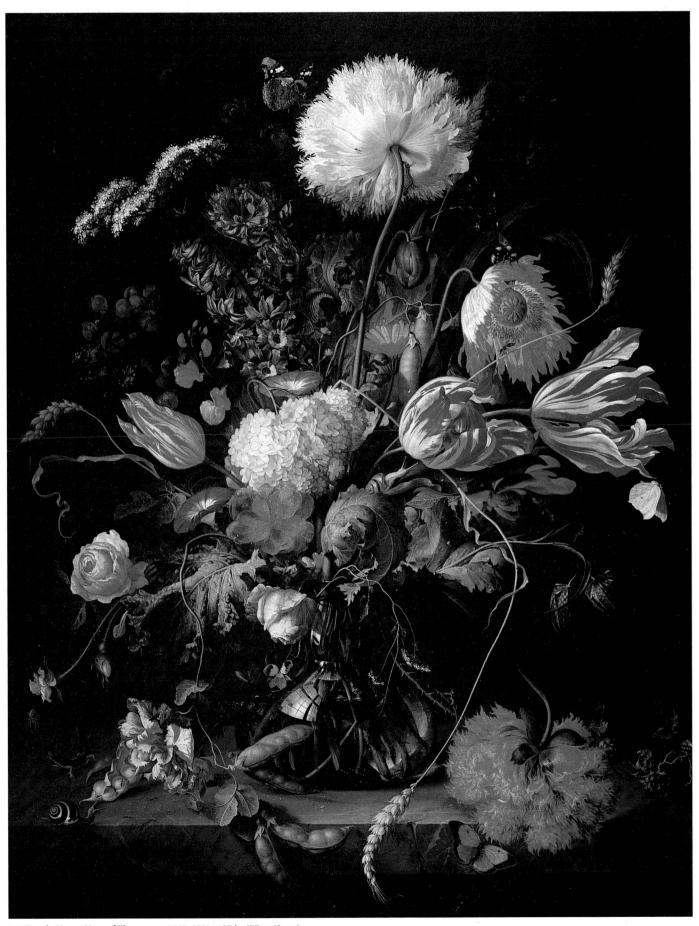

241 Jan de Heem, Vase of Flowers, c. 1645, 22½ x 27 in (57 x 68 cm)

DELFT POTTERY

Initially Delft pottery was simply an imitation of imported Chinese pottery, but by the end of the 17th century it had acquired its own independent reputation. Delft ware is blue and white, and as well as dishes, tiles, and vases, more unusual pieces were made, such as this water cistern in the shape of a house. Examples of Delft pottery can be found in countries that once belonged to the Dutch empire, such as Surinam in South America, and Indonesia.

OTHER WORKS BY VERMEER

The Little Street (Rijksmuseum, Amsterdam)

A Lady with Her Maid (The Frick Collection, New York)

> Interior with an Astronomer (Louvre, Paris)

Interior with a
Music Lesson
(The Royal Collection,
Windsor Castle)

Head of a Girl with a Pearl Earring (Mauritshuis, The Hague)

> Interior with a Girl at a Window (Gemäldegalerie, Dresden)

THE SILENCE OF VERMEER

There is something about the reverent awareness of the still life painter that reminds one of the great solitary of 17th-century Holland, Jan Vermeer (1632–75). He was not literally solitary, having 11 children and a powerful family of in-laws, but none of the hubbub that must have filled his small house is ever evident in his miraculous paintings, far less any suggestion of family.

Vermeer does not need brightness in his paintings. Woman Holding a Balance (242), for example, has the shutters almost closed, with light stealing obliquely around the edges. It catches the downy fur on the lady's jacket, the decorated linen that falls gracefully around her

tilted head, the pearls gleaming on the shadowed table. It glances off a finger here and a necklace there, but it insists only on its silence. Silence "expresses" the purity of what exists: pure because it exists. This picture has some symbolism in that the lady is testing her empty balance, and the picture behind her shows the *Last Judgment* (see right).

But the meaning is equally in the "balance" that we experience in the actual painting: darkness and light are held in dynamic equilibrium, and in fact the picture as a whole displays a variety of balances – warm human flesh against the silky and furry garment, the unstable human hand against the frozen certainties of metal.

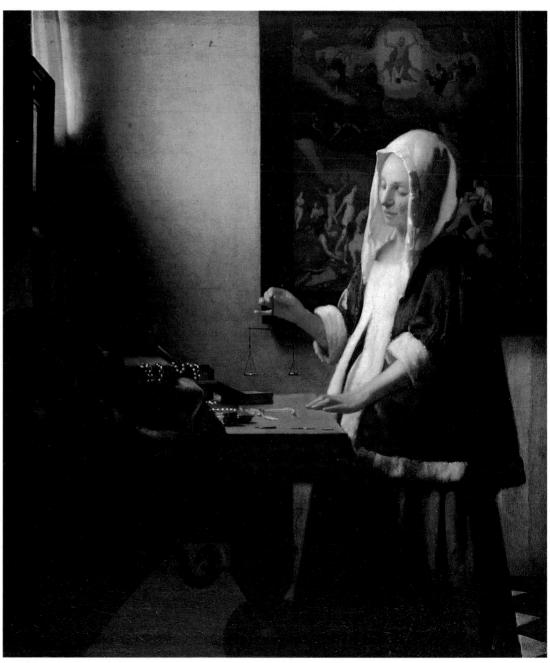

242 Jan Vermeer, Woman Holding a Balance, c. 1664, 15 x 16¾ in (38 x 42 cm)

Woman Holding a Balance

This painting is also known as Woman Weighing Gold. It is a solemn, allegorical work, in which a young woman stands before the symbols of her material wealth, weighing them for their value, whilst behind her, in the painting on the wall, the figure of Christ can be seen "weighing" souls. The young woman is clearly pregnant, and it is significant that the two strongest accents of warm orange/gold do not emanate from her jewels or her gold but from the small window, high up in the wall,

from which the light falls directly onto her stomach. It is tempting to read deeper meaning into this, as comparisons with annunciation paintings (see for example pp.50, 63, 86, and 92) unavoidably spring to mind.

MOOD OF CONTEMPLATION

Her knowing expression, with gently tilted head and almost closed eyes, shows her to be more than just idly enjoying her treasures. Rather, she is at a moment when she contemplates the meaning of value itself. She is dressed richly but simply, her head covered by a plain white hood that is "beaded" with drops of light. On the wall opposite her is a mirror, suggestive of her quiet self-contemplation.

The painting on the wall is a version of the Last Judgment possibly by the 16th-century Flemish altarpiece painter Jean Bellagambe (c. 1480-c. 1535). The air of serenity and contentment in the quiet room contrasts with the pitiful chaos of the damned, who are painted as flat, dim silhouettes behind the intensely vital, living form of the woman.

A SIMPLE BALANCE

The woman will weigh her gold and pearls on a delicate brass balance with a gesture of infinite grace. The balance is rendered so finely that in parts it is barely visible, and touches of glimmering light shine on the empty pans. This is appropriate since we are again reminded of the other, final

FAMILY VALUABLES

A rich blue tablecloth has been pushed back, and scattered over the table top, spilling out of jewelry boxes, is her collection of pearls and gold. Each little orb consists of a single droplet of light, made from individual touches of paint that are jewel like in themselves. The flat coins, or gold weights, are given a sense of roundness by just the slightest highlight.

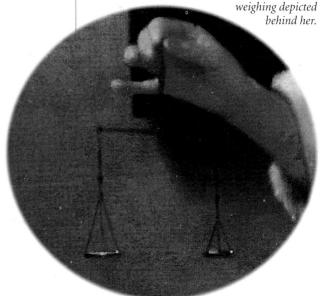

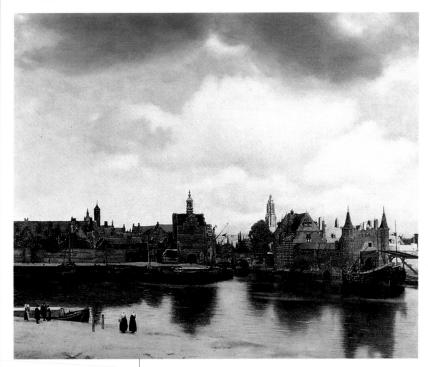

243 Jan Vermeer, View of Delft, 1658, 46 x 39 in (117 x 100 cm)

Camera obscura

The camera obscura (Latin, "dark chamber") was a device used to create an accurate reproduction of a panoramic view or an interior. A pinhole would be made in one side of the box, allowing light to enter. The rays would cross as they passed through the hole and would then fan out, creating an upsidedown reduced image on the wall. The artist could then paint a scene with accurate perspective. Vermeer is thought to have used a cubicle-type camera obscura to paint his interiors. A portable camera obscura known as the tent-type (shown above) was also popular.

We come to believe that Vermeer's pictures have a reality – not like everyday reality, but greater, less fragile. It is his unique triumph to concentrate with absolute – or so it seems – optical fidelity on the minutiae of material things. Every texture has its complete integrity in painterly form. He elides, of course, but we are unaware of it, and this sense of total truth, offered to us through a reverence for what is bodily present, effortlessly acquires a sense of the spiritual.

TRANSCENDING THE CITY

The French writer Marcel Proust, who centred his whole literary work upon the recovery, alive and powerful, of memory, thought *View of Delft (243)* the greatest work ever painted. On one level, it appears so unassuming: a topographical setting-out of the appearance of this Dutch city. Vermeer is not inventing, only describing. But he takes the bare facts of the city and its approaches and, without manipulation, renders them transcendent.

That city shining out at us across the water is both Delft and the heavenly Jerusalem, the city of peace. It offers profound variety, not in extravagance but in its simple mixture of roofs and towers, of churches and houses, of sunlit areas and swathes of lovely shadow. Overhead, the sky arches, the rain clouds lift and disperse, the lofty area of blue almost visibly grows.

The tiny figures on the near quayside are vital: they are us, not in the holy city yet, still sundered and yearning, but with great hope.

Boats are moored and no obstacle presents itself. It is the utter ordinariness of the scene that is so piercingly evocative of the Paradise world. Even when Vermeer paints a Kitchen Maid (244) he bathes the kitchen in a quiet radiance. She is merely pouring out milk, but there is a sense of luminous stillness, of time gently slowed, of body translucent with soul, of secular holiness. The simplicities of her yellow bodice and her blue working apron gleam out at us, not beautiful in themselves, but beautiful because light makes all it shines on share its own brightness. Her plain, broad, peasant face is lost in absorption with her task, rather as we think Vermeer must have been as he painted her. He is one of the artists who is immediately accessible, which makes his years of neglect all the more astonishing.

Hals's bravado

Frans Hals (c.1582/83–1666) also knew neglect, but his case is not the same as Vermeer's. We can sympathize with the bewilderment, for example, of the wealthy Coymans family at seeing the finery of young *Willem Coymans* (245) depicted by a rash dribble of paint, with rough slashes pleating his linen sleeve and a rather brutal sensuality lightly informing his face. Willem himself, however, may well have liked his portrait very much indeed (Hals's patrons tended to be delighted with his versions of them).

Willem has a daredevil gallantry, a look of dissipated splendour that any young man might find highly appealing to his self-esteem. Hals does not delve deep into personality like Rembrandt (see p.200) or contemplate all sitters under the noble light of Vermeer (see p.208).

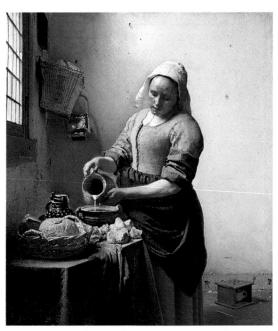

244 Vermeer, Kitchen Maid, 1656-61, 1734 x 16 in (45 x 40 cm)

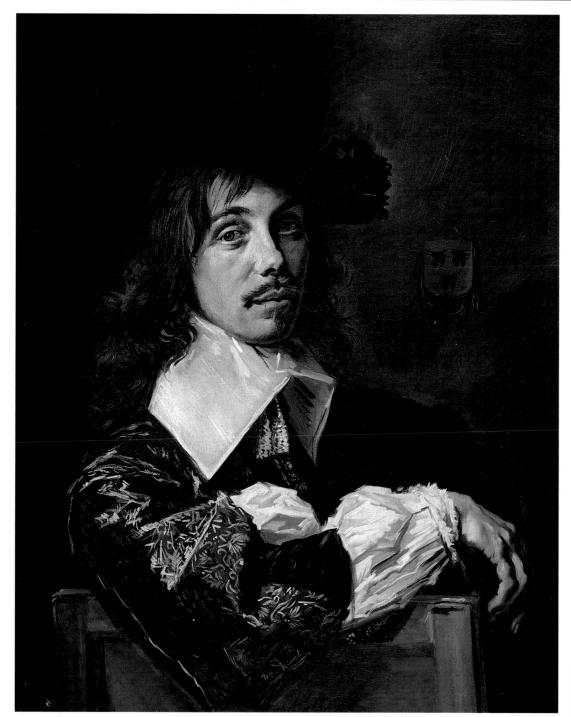

245 Frans Hals, Portrait of Willem Coymans, 1645, 25 x 301/2 in (63 x 77 cm)

He first made his reputation with a series of portraits, ranging from the celebrated *Laughing Cavalier* to a variety of low-life sketches of gypsies and drunkards, which were all painted in the years 1620–25 and were all delightful renderings of the nuances of expression in the sitters' smiling or leering faces. Hals' family came from Antwerp in Flanders and moved to Haarlem, in the Protestant North, when he was just a child. One is tempted to imagine what he would have produced had he stayed in the Catholic South, where his inclination towards

extravagant display would certainly have found a wider field of expression than that of portraiture. Hals paints what he sees, with a sort of daredevil carelessness. He leaps upon the tightrope of pictorial art, rarely stumbling, but astonishing us with his emphatic facility. He achieves "the mostest with the leastest", to adapt the words of an American general.

Much of the work of Hals appeals to us because of its light, virtuoso quality, but in his impoverished old age he rose to a gravity that puts the stamp of greatness on his work.

OTHER WORKS BY HALS

Isaac Abrahamsz Massa (Art Gallery of Ontario, Toronto)

A Man (Metropolitan Museum of Art, New York)

A Fisher Boy (National Gallery of Ireland, Dublin)

The Merry Drinker (Rijksmuseum, Amsterdam)

Johannes Acronius (Staatliche Museen, Berlin-Dahlem)

The Laughing Cavalier
(Wallace Collection,
London)

ALLA PRIMA TECHNIQUE

Until the 17th century most artists who used oils underpainted their surfaces first, to achieve a consistent surface. Frans Hals was one of the pioneers of the alla prima (Italian for "at first") technique in which the paint is applied directly to the ground without underpainting. The effect of this technique is clearly visible in the broad brushstrokes and spontaneous textural qualities of much of Frans Hals's work. With the development of better pigments in the 19th century, the technique became more popular.

COURTYARD SCENES

In the new Protestant society of the United Provinces, domestic scenes were becoming increasingly popular and replacing traditional religious themes. At this time a new genre of painting was created by Pieter de Hooch: the courtyard scene. Many of his paintings were of invented scenes, using a number of open doorways to create an interesting perspective. Some painters chose to capture the last days of a building that was due to be demolished.

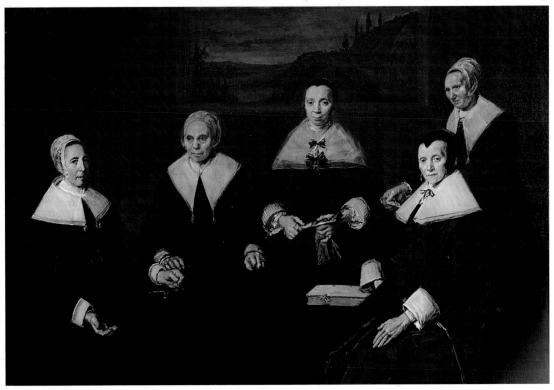

246 Frans Hals, The Women Regents of the Haarlem Almshouse, 1664, 8 ft 2 in × 5 ft 7 in (250 × 170 cm)

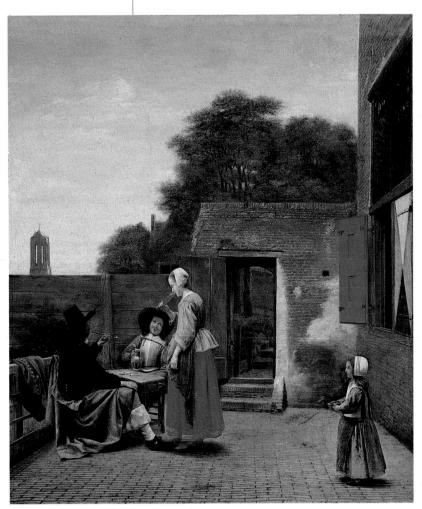

247 Pieter de Hooch, A Dutch Courtyard, c. 1660, 23 x 27 in (58 x 68 cm)

His Women Regents of the Haarlem Almhouse (246), painted shortly before the artist's own almshouse death, is a totally serious picture. He has forgotten the ego that spurred him on to witty bravura. Here he shows us not merely the outward look of these tired and elderly women, but something of their individual personalities, and something of their corporate attitude to the responsibilities of their office.

DUTCH GENRE PAINTING

Pieter de Hooch (1629–84) has the uneasy distinction of making us aware of how great is Vermeer. De Hooch is a semi-Vermeer – all the ingredients but lacking the magic. It is as if some of Frans Hals' worldly confidence had seeped into the work, making it parochial.

Yet of course, it is the celebration of the parochial that gives de Hooch his charm, a very real charm, inadequate only in comparison with the very greatest of his contemporaries. A Dutch Courtyard (247) has an enchanting immediacy, with its occupants "snapped" as if by a camera. The sense of reality is seductive; at any moment the girl, we feel, will go inside through the open door, and we will go with her. The illusion is of a merely temporary pause in activity, of daylight and weather, of work and play.

This feeling of time held still and on the point of moving forward is also the beauty of *The Skittle Players Outside an Inn* (248) by Jan Steen (1626–79). Much of his work has a coarse vitality,

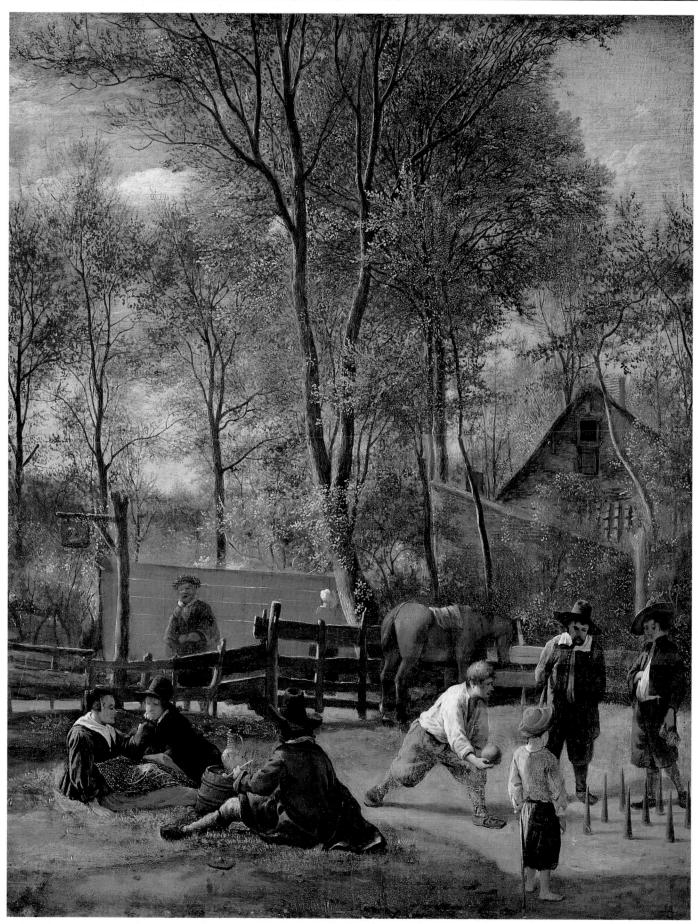

248 Jan Steen, The Skittle Players Outside an Inn, c. 1652, $10 \frac{1}{2} \times 13$ in $(27 \times 33$ cm)

OTHER WORKS BY VAN RUISDAEL

The Jewish Cemetery (Detroit Institute of Arts)

The Waterfall (National Gallery of Canada, Ottawa)

The Watermill (National Gallery of Victoria, Melbourne)

Rough Sea (Museum of Fine Arts, Boston)

Vessels in a Fresh Breeze (National Gallery, London)

View of the Castle of Bentheim (National Gallery of Ireland, Dublin)

Castle in a Park (University of California, Los Angeles)

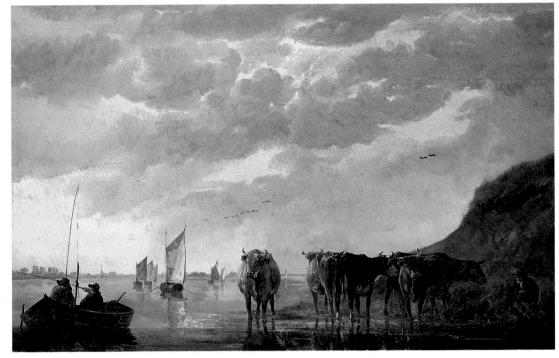

249 Albert Cuyp, Herdsman with Cows by a River, c. 1650, 29 x 17 3/4 in (73 x 45 cm)

with peasants junketing and a general air of happy vulgarity. But this painting is marvelous, evocative of an evening in early summer, with the viewer made privy to a moment of calm enjoyment. Calm enjoyment is also the constant theme of Albert Cuyp (1620–91), the enjoyment being mostly on the part of cows, which are

washed in a heavenly golden radiance, inhabiting a natural paradise on our behalf (249). The herd stands peacefully in the stillwaters, the ships move past them slowly into the light. It is essentially a communication of serenity. Sunlight and its bovine enjoyers do not seem the stuff of great art, and this is one of the

enchantments of the Baroque. It makes its beauty out of the ordinary with great gusto. Often the focus is on the land or sea, flat fields becoming as spaciously beautiful as the romantic mountains of earlier or later art.

Jacob van Ruisdael (1628/9–82), can take a Forest Scene (250), a tangle of trees and glimpsed water, a great dead horizontal of stricken branch and root, dark skies forming and humankind departing, and without tidying it up or making a moral, give us a moving depiction of the tangle of our complex and vulnerable lives. He has a greater weight than any other Dutch landscape artist. There is almost a sense of a tragic dimension, but never one without hope. His uncle, Salomon van Ruisdael (c.1600–70), works the same magic with river scenes.

Pieter Saenredam (1597–1665), focusing on another aspect of the workaday, takes us into the great spaces of church interiors, like

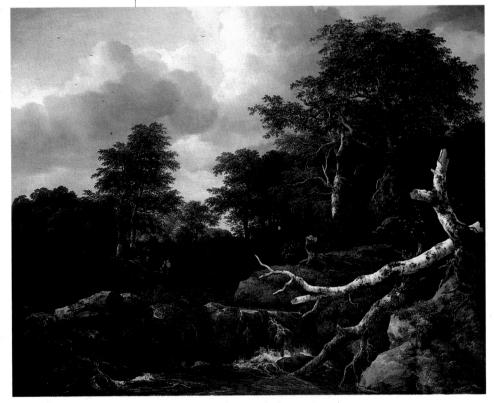

250 Jacob van Ruisdael, Forest Scene, c. 1660/65, 51½ x 41 in (130 x 105 cm)

251 Pieter Saenredam, The Grote Kerk, Haarlem, 1636–37, 32¼ x 23½ in (82 x 60 cm)

The Grote Kerk, Haarlem (251). The play of light on these silent architectural masses has an almost Vermeerish profundity, a strange immediacy. It would be easy to get carried away into speculation about the meaning of "interiors," which these pictures seem to be about, and so it is useful to remember that Saenredam, who specializes in church interiors, somehow also manages to get the same "inner" quality when he paints church exteriors.

The Dutch seemed to have an insatiable love for the actualities of their surroundings: their Calvinism, however tolerantly held, makes the idea of explicitly religious painting unappealing, and we can feel a great weight of quasi-religious significance being quietly removed, to rest upon landscape, still life, and portraiture. There was still room for the so-called "history" painting genre, but the most popular narrative painting was that of Gerard Dou (1613–75).

Dou's works were small, exquisitely finished, and technically perfect. Although this praise sounds rather mechanical, there is no doubt that, at his best, Dou well deserved his reputation. These small, jewel like pictures still delight and allure: it may be for the sheer contrast between their tiny size and their intensity of focus. Dou had been Rembrandt's pupil, but he seems to have taken little of the master's spirit. The cluttered but brilliant cave interior of *The*

Hermit (252) has Dou's own technical intricacy but nothing of Rembrandt's spiritual intensity, and they remain essentially genre works.

252 Gerard Dou, The Hermit, 1670, 13½ x 18 in (34 x 46 cm)

WILLIAM III OF ORANGE

As stadholder (ruler) of the United Provinces, William III of Orange (1650-1702) rescued his country from the hands of Louis XIV in the Franco-Dutch wars of 1672-79. He was a sincere Calvinist and a respected patron of the arts. He had grown up in the uncertain climate of the rule of the anti-Orange party led by Johann de Witt. In the revolution of 1672 he overthrew his enemies and became stadholder.

He became king of Britain and Ireland in the "Glorious Revolution" of 1688, when the Whigs and Tories invited him to invade the country and claim the throne for himself and his wife Mary (daughter of the British King James II).

The grand tour

A favorite pastime of the young rich in the 17th and 18th centuries was to go on the Grand Tour. Accompanied by a servant, a young aristocrat would tour Europe, culminating in a stay in Italy to appreciate the arts of classical antiquity. This 18th-century caricature shows a horrified father meeting his fashionable returning son.

Recognized as the greatest French Baroque sculptor, Pierre Puget (1620-94) originally trained as a ship's sculptor in Marseilles. His earliest work is on the portals of the town hall in Toulon, completed in 1656. He created his most famous work, the Milo of Crotona, for Louis XIV's palace at Versailles. The sculpture shown above, The Assumption of the Virgin, is now in Marseilles.

France: A Return to Classicism

Dutch painters loved landscape, and they acquired great skill in its depiction, but the great names in landscape painting in the 17th century were French. Foremost among these were Nicolas Poussin and Claude Lorrain, who both lived for years in Italy and were strongly influenced by Italy's natural Classicism, however dissimilar they were in other ways.

The lure of Rome, the heartland of the Baroque style, was strong in the first half of the 17th century, so much so that the French painting tradition, which was classical at heart, was considerably weakened by the exodus of artists. Among these was Nicolas Poussin (1594–1665), who enjoyed considerable fame in Rome and painted many important works there. It took the persuasive powers of Louis XIII and his chief minister, Cardinal Richelieu (see p.223), to entice Poussin back from Rome in 1640.

The king had made previous attempts to rejuvenate the French tradition in painting, but he had met with little real success. A tradition still existed, and was even growing, in France,

and it was both delicate in palette and dignified in approach. But the French School did not develop until Poussin's arrival from Rome. His art drew on Carracci's legacy of Venetian harmony and ideal beauty (see p.182). In Italy, he had studied the High Renaissance masters, together with antique sculpture, and he was also influenced by the arch-classicist Domenichino (see p.183), who was 13 years his senior and who ran a successful workshop in Rome.

Poussin's art represents a rejection of the emotional aspects of Italian Baroque, but at the same time sacrifices none of the Baroque's spiritual intensity and richness - which distinguishes him from Neoclassical art (see p.256).

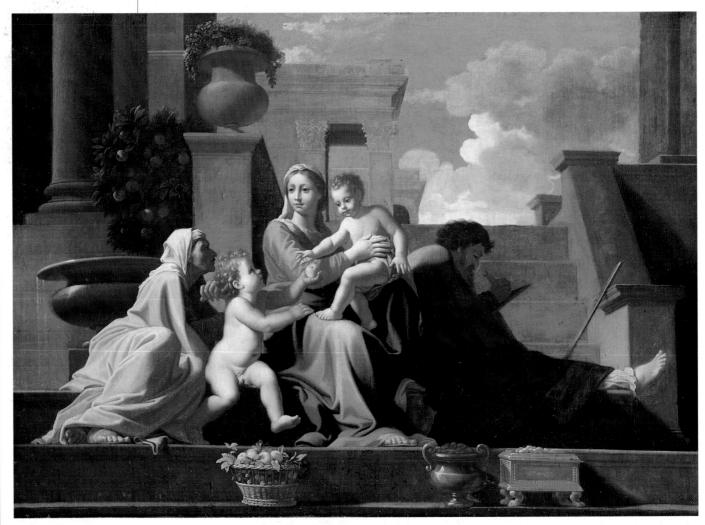

253 Nicolas Poussin, The Holy Family on the Steps, 1648, 381/2 x 27 in (98 x 68 cm)

In a sense, his aims in painting have more in common with those of the Renaissance artists (see pp.79–138). Poussin brought to the Baroque an austere, restrained Classicism, combined with a clear, glowing light.

He is an artist of the utmost intelligence, achieving total integration of every element within his pictures. But it is a visual intelligence, a massive understanding of beauty, so that what could be daunting in its orderliness is radiant with supreme grace. This great painterly intellect moves us rather than convinces us. In the words that John Donne, the 17th-century English poet, used to describe his beloved, it could be said of Poussin that his "body thought." It is this wonderful incarnation of vision in actuality that makes Poussin supreme.

AUSTERE BEAUTY

The Holy Family on the Steps (253) might seem, at first viewing, not a landscape work at all. This is, broadly, quite correct: the concentration is upon the five human figures in the center. But they form a great equilateral triangle, based upon the long, low step that acts as a plinth and a barrier. Mary is a sacred plinth herself, a holy barrier that holds Jesus up for us to see but is His earthly safeguard. So protected, the naked Child leans down to His nude cousin, little John the Baptist, who is untended by his own mother, St. Elizabeth, all of whose longing attention is fixed upon Mary's Child.

Balancing her, humbly seated in shadow, sits St. Joseph, whose elegant feet emerge into astonishingly clear light. Three objects line the lower margin: a basket of fruit, symbolic of the world's fertility that will spring from this family – a fertility of grace. Near Joseph, as if under his care, are two containers – a classical vase, reminiscent of the Greeks, and a box, which recalls the eastern kings and their costly gifts.

Material riches lie at the base, then, and from here the painting soars up, the eye being led by balustrade and pillar, to the porticos that open on infinity and the endless sky. The Holy Family is clearly not sitting on the steps of a real building: this is more an idealized version of an entrance, though it lacks symmetry. The glories of this world are asymmetrical; only the perfect balance of the Holy Family has the beauty of pure rationality. The center is an apple offered to the Holy Child by our representative, John.

The fruit of the fall is here redeemed, and the discreet orange trees indicate that redemption has now happened. There is fruit galore, fruit for us all. Mary holds Jesus almost as if he is living fruit, and at once we pick up eucharistic resonances. In Poussin there is always subtlety

254 Nicolas Poussin, Self-Portrait, 1650, 29 x 38 in (73 x 97 cm)

upon subtlety, but at no time is it either forced subtlety or mere conceptual cleverness. He takes his concepts into his own depths, and there he finds their proper form. This painting is of an ascent, powered by the insistent verticals and made credible by the exquisite placement of continual stepping-stones of horizontals.

The austere *Self-Portrait* in the Louvre (254) makes no concessions to vanity. Poussin looks out gravely, with his fleshy nose and secretive eyes, and his lips shut with that firmness so obvious in all his work. He encompasses himself with canvases that are also geometrical intensifiers. His background, he implies, is one of severe order. Yet the only actual picture we see – a young woman being embraced – has a romantic charm. The other rectangles of canvas, as well as the door, are blank, and all the frames are blank. While seeming to expose himself, Poussin is actually preserving his secrecy.

NICOLAS POUSSIN

Poussin aimed to achieve a unity of mood in each picture by developing his theory of modes. According to this theory, the subject and the emotional situation of the painting dictate the appropriate treatment. Poussin also used a miniature stage set to practice composition and lighting for his paintings.

THE SUN KING Louis XIV of France (1638–1715) reigned as an

absolute monarch at a time of great growth and development in the history of France. He is known as the Sun King because he was seen as a new sun god who shines upon everyone and is omnipresent. The king believed that his powers were ordained by God and that he was the incarnation of the state. He would make all decisions by consulting only a few very close ministers, and his favored style (Classicism) was imposed on all new buildings. His most lasting symbol (a monument to his own splendor) is the Palace of Versailles, which was begun in 1669 and became the residence of the court in 1682.

OTHER WORKS BY POUSSIN

The Crossing of the Red Sea (National Gallery of Victoria, Melbourne)

Venus Presenting Arns to Aeneas (Art Gallery of Ontario, Toronto)

The Nurture of Jupiter (Dulwich Picture Gallery, London)

> The Triumph of Neptune (Philadelphia Museum of Art)

Apollo and Daphne (Alte Pinakothek, Munich)

Acis and Galatea (National Gallery of Ireland, Dublin)

SHEPHERDS AND ARCADIA

To educated people in the 17th century the name Arcadia readily evoked the pastoral tradition, that easygoing genre of poetry that had developed in parallel with epic writing since the time of the classical Greeks. The tradition stems from the carefree, open-air life that was supposedly enjoyed by shepherds and shepherdesses, who spent all summer guarding their flocks. Consequently they had plenty of time in which to play their flutes and compose love poems, which they might sing to one another, perhaps in a contest.

Best remembered of the pastoral poets were Theocritus in Sicily and Virgil in Italy, whose *Eclogues* are the best remembered of all. Arcadia is mentioned in the *Eclogues*, and occasionally in literature since the Renaissance.

The phrase "et in Arcadia ego" cannot be traced to any known source in the classics. It means either "I, the one who is dead, was once in Arcadia too," or "I, Death, am in Arcadia too." The Italian painter Guercino (see p.185) made a painting with this same theme in 1620.

Poussin himself produced two paintings on the "Death in Arcadia" theme. The first (the Chatsworth version) was painted between 1630 and 1632. In it, a group of shepherds discovers with shock that a tomb, with its disturbing message, exists in their idyllic countryside. They are shown leaning forward in a tense attitude, confronting the fearsome discovery. In the version shown here (the Louvre version, 255), originally entitled *Happiness Subdued by Death* and painted in 1638–40, the shepherds form a more relaxed group around the tomb. Instead of reacting dramatically they seem to be pondering the meaning of the inscription. Each of the four shepherds is expressing his or her own personal emotional response. Without overemphasis, Poussin makes us clearly aware of those vulnerable humans in all their individuality.

Poussin's Arcadia is a silent place; even the shepherds seem to be communicating by gesture rather than by word. They seem to have found, to their bewilderment, their first evidence of death. It is evidence, too, that their beautiful country has a history, has been lived in and died in, and yet this history has been completely forgotten. They puzzle out the inscription on the tomb with wonder and fear.

What gives this picture its force, of course, is its relevance to our own personal histories. We pass a milestone in human maturity when we come to an emotional understanding of death and of our own relative insignificance in the context of human history. Countless generations lived before us and will live after us. In all the magnificence of their youthful beauty, the shepherds must accept this.

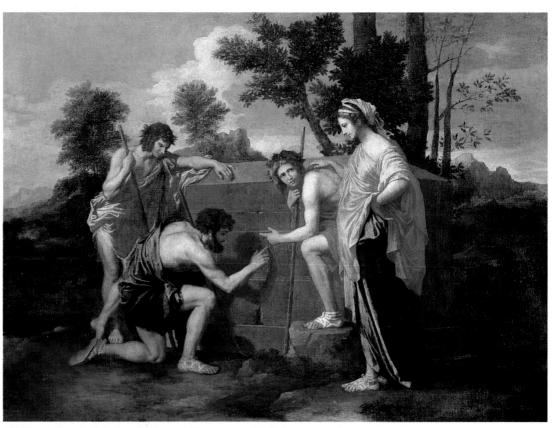

255 Nicolas Poussin, Et in Arcadia Ego, c. 1638–40, 47½ x 33½ in (121 x 85 cm)

Et in Arcadia Ego

Historically, Arcadia was the central plateau of the mountainous region of southern Greece and was inhabited by shepherds and hunters. But Arcadia was also an earthly paradise, a pastoral idyll celebrated by poets and artists as early as the 3rd century BC. It was the home of romantic love, ruled over by Pan, the rustic god of "all things": flocks and herds, woods and fields. Its native shepherds and shepherdesses shared their simple paradise with nymphs, satyrs, centaurs, and the bacchantes.

SILENT COMMUNICATION

The shepherds and shepherdess respond in different ways to the discovery of death. Some are content to ponder its significance, while others question and decipher. All, however, are silent, revealing their sadness or curiosity through individual gestures and expressions. One young shepherd looks up at the young woman beside him with an especially urgent communication, as though struck with sudden realization of his own immortality.

LANDSCAPE

Although this is one of Poussin's mature works, his treatment of the landscape is not as stylistically developed as is his treatment of form and color throughout the rest of the painting. The line of trees and foliage serves primarily to enclose the scene and act as a backdrop to the main focus of attention, which centers on the discovery of a tomb.

"I too was once in arcadia"

The inscription is the central focal point of the whole work. All our attention is directed to it, reinforced by the puzzled gestures of the shepherds as they run their fingers over the tomb as though hoping to discover its mysterious identity. The painting takes on the nature of an elegy as they quietly and solemnly contemplate the significance of the words (see left).

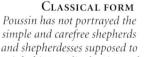

inhabit Arcadia, but instead classically formed, sober and dignified figures from antiquity. The young woman manifests the classical ideal, with her smooth brow and fine nose, the proportions of her head to her body, and above all, her noble, statuesque bearing. In her figure, we can see Poussin's distinctive late handling of color. It is sharp, strong, and clear, and the artist's growing passion for order and clarity is paramount. The four figures form a tight cluster

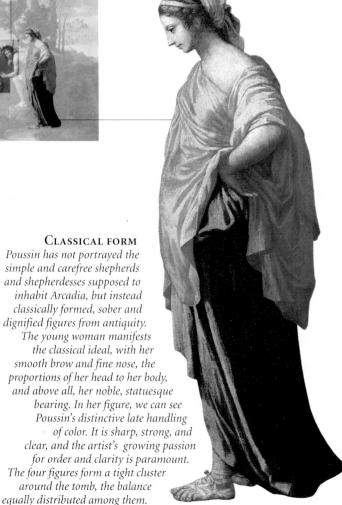

OTHER WORKS BY

The Finding of Moses (Prado, Madrid)

Landscape with the Shepherds (City Art Gallery, Birmingham, UK)

Apollo and the Muses on Mount Helion (Museum of Fine Arts, Boston)

The Expulsion of Hagar (Alte Pinakothek, Munich)

Landscape at Sunset (Louvre, Paris)

The Sermon on the Mount (Eaton Hall, Chester) The Funeral of Phocion (256) shows Poussin's landscape art at its most profound. There is a story in this painting, one of those classic tales of great moral meaning that were so dear to him. Phocion was an Athenian general who argued for peace at a time when the majority was for war with Macedon. His enemies used Athens's democratic system to have him condemned.

Poussin shows this victim of judicial murder being carried to his burial by a mere two faithful slaves. They carry him through a world teeming with antique activity. Behind them the great city can be seen, with its temple, its domed capitol proclaiming Athenian order, its inhabitants peacefully busy at their rightful occupations.

Yet all this outward stability is made into a lie by the sad pair in the foreground, moving disconsolately through the wholly civilized terrain on their uncivilized task. Justice has been flouted, cruelty and envy have triumphed: the great pacific state apparatus grinds on with massive and unreal dignity. The eye is entranced by the sheer intelligibility and interest of the scene, by the nobility of the concept and the beauty of its execution. It is as intense as any poetry, yet the poetry is always epic. Poussin can daunt, but he is worth all our effort.

CLAUDE'S PASTORAL IDYLLS

Claude (Claude Gellée, 1600–82), whose Frenchness was marked by adding "Lorrain" to his name, was a fellow inhabitant of Rome with Poussin. Claude too is a very great artist, but not an intellectual. Where Poussin thought out a work, Claude used his intuition. One understood the classic world, the other entered it by imagination: both visions are wonderful.

Claude is forever making us free of the classical paradise-that-never-was (or at least, not literally) so that it is subliminally the essence of his work. He sees the landscape of the Roman Campagna (a low-lying plain surrounding Rome) as bathed in a golden light, a place in harmony with the nymphs or else with the heroes of the Bible. We feel it is much the same for Claude whether we gaze across the wooded hills with Paris and the three goddesses he must assess to find the most beautiful in The Judgment of Paris (257), or with the biblical Isaac and Rebekah, who have come to celebrate their marriage in Landscape with the Marriage of Isaac and Rebekah (258). The "subject" is not what the title indicates. Paris and Isaac and Rebekah are excuses. pretexts for his venture into the lovely lost world of pastoral poetry.

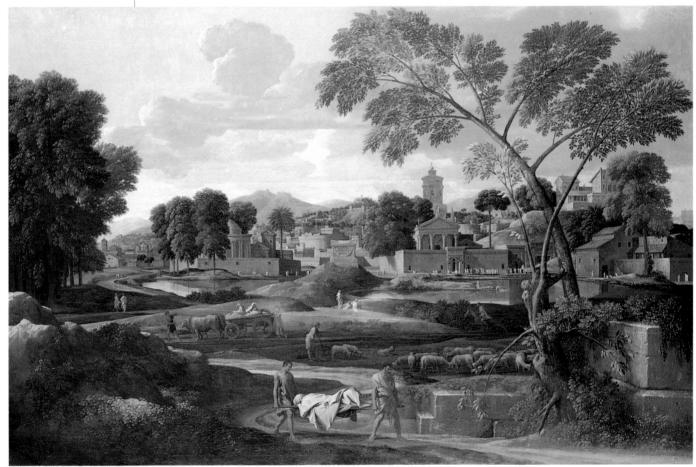

256 Nicolas Poussin, The Funeral of Phocion, 1648, 28 x 18½ in (71 x 47 cm)

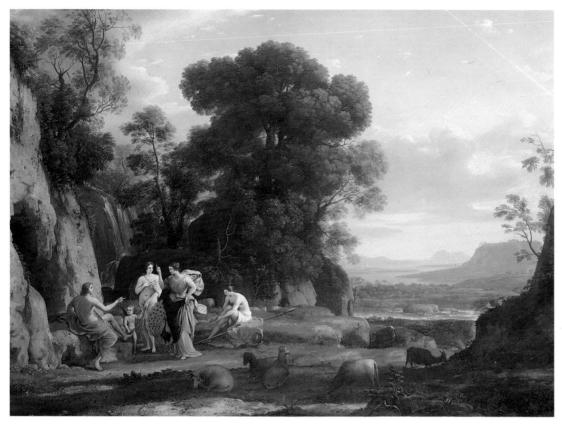

257 Claude Lorrain, The Judgment of Paris, 1645/46, 59 x 44 in (150 x 112 cm)

Both landscapes are made glorious by their trees, by the amazing sense they provide of immense spaciousness. The eye roams untrammeled to the distant hills and follows the curves of the shining waters. It is not a real landscape, but its power to arouse emotion is real.

To the modern eye, The Marriage of Isaac and Rebekah might seem to work better than The Judgment of Paris if only because Claude's great weakness is thought to be his painting of the human figure. In The Marriage the tiny human forms dancing and feasting in the glade are as removed from us in space as they are in time. We stand on a height looking down, and although in the Bible this marriage was an important event for the continuance of the "seed of Abraham," it is the landscape that matters here, that dwarfs the human celebrants into relative insignificance. Claude clearly recognized this by his very title. Yet the landscape, so shadowed, so immemorial, does not fight the theme of marriage; it reinforces it.

In *The Judgment of Paris* we are much closer to the drama. The four actors (five if we include the infant Cupid, who clings to his mother) are fairly large and also fairly individualized. The painting captures a moment at the start of the judgment. Juno, as queen, is the first of the three goddesses to speak, putting her case as the most beautiful to Paris. He is perching rather insecurely

on his rock, almost dislodged by the vigor of her approaches. Minerva, as befits a wise woman, abstracts herself from the scene and in so doing becomes its appropriate but unwitting center. It is on her white body, as she leans forward to tie her sandal, that Claude's golden light so lovingly lingers.

THE JUDGMENT OF PARIS

At the wedding of the Greek hero Peleus to his bride Thetis, all the gods are invited except Eris, goddess of Strife. In revenge she throws down a golden apple inscribed "to the fairest," insisting that Paris, son of the king of Troy, must award the apple to one of three goddesses: Minerva, Venus or Juno Venus promises Paris the love of any woman he chooses and describes Helen, wife of the king of Sparta, Paris accordingly awards the apple to Venus, then abducts Helen and carries her back to Troy. This act provokes the Trojan war - in which Paris is fatally wounded.

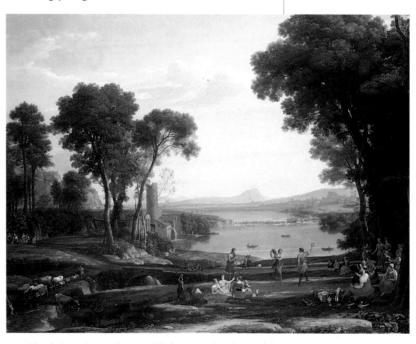

258 Claude Lorrain, Landscape with the Marriage of Isaac and Rebekah, 1648, $77\frac{1}{2} \times 58\frac{3}{4}$ in $(197 \times 149 \text{ cm})$

THE CLAUDE GLASS

Named after Claude Lorrain, the Claude Glass was used in the 17th and 18th centuries by landscape painters. A small, convex glass mirror backed in black or silver would be used to reflect the landscape in miniature and in terms of light and shade. This restraining of the colors enabled the artist to assess the relative tonality between different parts of the landscape. The 18th-century Claude Glass shown above is in a lined carrying case.

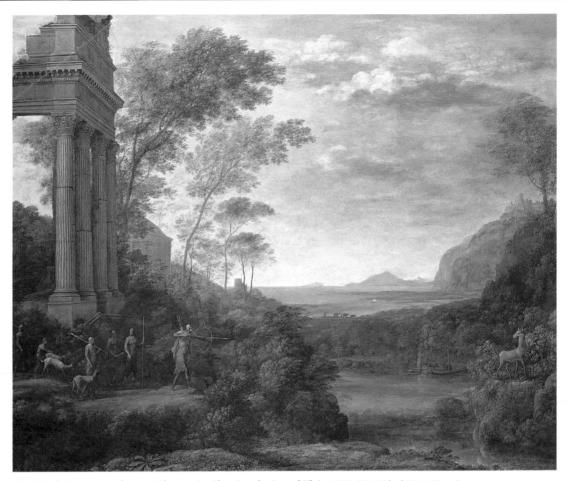

259 Claude Lorrain, Landscape with Ascanius Shooting the Stag of Silvia, 1682, 59 x 47 in (150 x 120 cm)

Very occasionally theme matters in Claude, as in his last painting, *Landscape with Ascanius Shooting the Stag of Silvia (259)*. Here again is the whole lovely expanse of nature, but this time

it is all affected by the dreadful certainty that murder is to be done and the balance of the Italian pre-Roman peace destroyed. Claude homes in on the tension of the one moment when Ascanius would still be able, if he chose, to hold back the arrow. The world waits in fear, and stag and man are locked in puzzled questioning. We need not know the legend to guess what will happen. We have indeed destroyed our sacred stag and brought down upon ourselves the end of peace. All the tragedy of the daily newspaper is implicit in this great painting.

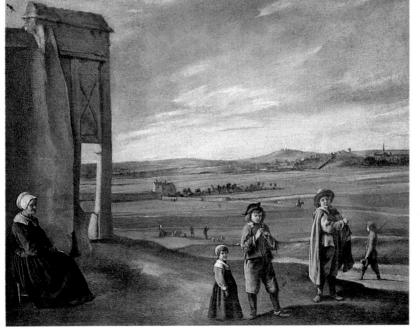

260 Louis Le Nain, Landscape with Peasants, c. 1640, 22½ x 18½ in (57 x 47 cm)

The art of the everyday

Poussin, sublime by nature, said that those who painted "mean subjects" did so because of "the weakness of their talents." This obviously has no reference to Claude, but it might indicate why the le Nain brothers and Georges de la Tour were relatively unappreciated. The le Nains took for their subject the humble lives of the peasants. *Landscape with Peasants (260)*, by Louis le Nain (1593–1648) has, in fact, a lovely sweep of dullish scenery that seduces by its resolute lack of excitement. Peasants stand or sit, quiet amid the quietness, unaffected as is the painter by any need to become "interesting."

LIGHT AND DARKNESS

Georges de la Tour (1593–1652) did not exactly choose "mean subjects," but he painted with a light-and-shade duality that relates to the Caravaggesque tradition (see p.177), and he did so in a manner that verges on the simplistic. His forms are sparse, his design bare. He was a provincial painter, and his unusual freedom from accustomed conventions might well have seemed inadequate or "mean" to a classicist. *The Repentant Magdalen (261)* concentrates with semibrutal fierceness on the legendary period that the Magdalen, who had been a sinner,

spent in lamenting her past. But it seems rather to be the picture of abstract thought. The Magdalen is shown as lost in profound musing, her hand caressing the skull, a "vanitas" motif, which is repeated in its mirrored reflection. The candle – the only source of light – is masked by the dome of bare bone, and the Magdalen does not so much repent as muse. With great daring, the major part of the picture is more darkness, with the young woman looming up out of the shadow like a second Lazarus. It is a work hard to forget, yet its power is difficult to explain. Vulgar? Or spiritually intense?

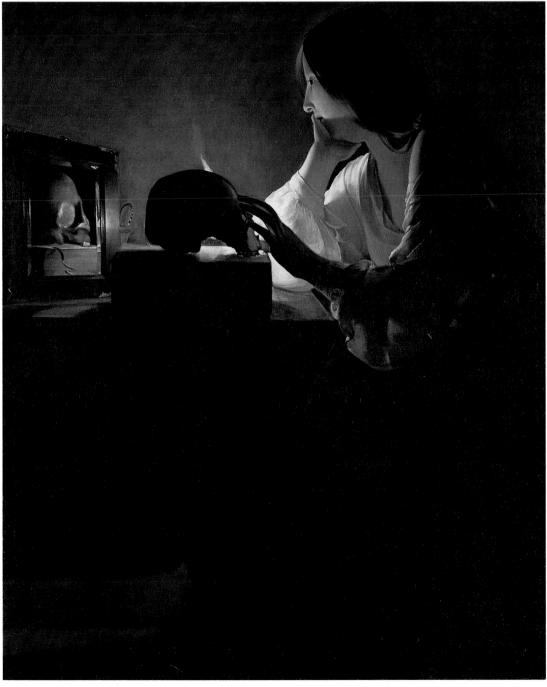

261 Georges de la Tour, The Repentant Magdalen, c. 1635, 36½ x 44 in (93 x 113 cm)

THE PHILOSOPHY OF DESCARTES

Regarded as the founder of modern philosophy. Descartes (1596-1650) was a French philosopher and mathematician. His Discourse on Method, published in 1637, explains the basis of his theory of dualism - "I think therefore I am." He argued that reason reigns supreme and that it is vital to systemize knowledge. The idea of God is so complex that no man could have invented it and so God must have planted the idea into man's mind.

CARDINAL

Under Louis XIII, France was a weak country, with the Protestant population forming a state within a state. Richelieu (1585-1642) became minister of state in 1624, and his first task was to reduce the power of the Huguenots. He was to remain a vital pioneering force in France until the ascendency of Louis XIV. and he survived many plots against his life. He died leaving Louis XIV in a position of absolute power over a stronger and more unified country.

Contemporary arts

1710

Sir Christopher Wren completes St. Paul's Cathedral, London

1711

The first European porcelain is made at Meissen, near Dresden in Saxony

1719

The English novelist Daniel Defoe publishes Robinson Crusoe

1729

Johann Sebastian Bach composes the St. Matthew Passion

1742

Handel composes The Messiah

1759

In France, Voltaire writes Candide

FETES GALANTES

Watteau arrived in Paris in 1702 and soon made a reputation as the inventor of a new artistic genre known as fêtes galantes. The name means "a feast of courtship" and was coined by members of the French Academy in 1717. It applies to any open-air scene with a mixed company, such as musicians, actors, and flirtatious lovers, all enjoying themselves outdoors. Many of Watteau's contemporaries favored the genre, using it to portray the manners and fashions of the aristocracy.

Rococo

With Antoine Watteau we move into the Rococo era. This style evolved in France and became a dominant influence in 18th-century art throughout most of Europe. The word was not a flattering term (few art labels ever have been); it was coined in the early 19th century, deriving from the French word rocaille. This was the name of a style of interior decoration that made use of shell patterns and other ornamental stonework. Rococo art was thought of as thin, lightweight, not the serious art of the past.

The Rococo style emerged in the early 18th century as an exaggeratedly decorative variation of the Baroque. Perhaps, at first, only the French took it seriously; its first great champion was Jean Antoine Watteau (1684–1721). There is an underlying sadness in his pictures that gives a

painful note to all his airs and graces, a wistfulness that belongs more to the 17th than the 18th century. Watteau was born in Flanders and lived most of his short life in exile in France. His work evinces a poignant sense of never belonging, of having no lasting stake in the world, that is

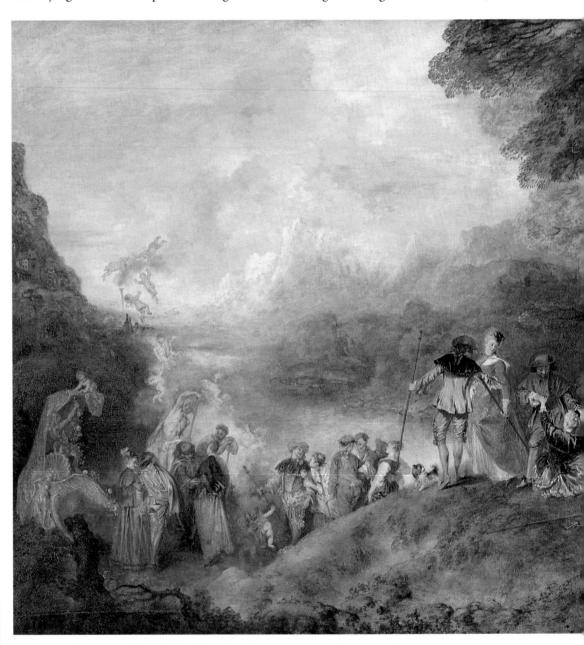

262 Jean Antoine Watteau, "Embarkation for Cytherea," 1717, 76 x 50½ in (194 x 129 cm)

specific to Watteau's own circumstances but has a moving relevance to us all. His training and early artistic development took place outside the confines of Paris, which is lucky for us, since the Parisian art world was becoming increasingly academic. He studied in Luxembourg under Claude Audran. Here he was fully able to absorb Rubens's great *Life of Marie de' Medici* cycle (see p.188), and we can see something of the sensual dynamism of Rubens – only in miniature form – in Watteau's delicate paintings.

LOVE AND PATHOS

Watteau was the inventor of a new art genre (though few ever could make his poetic use of it): *fêtes galantes*, in which lovers sang and danced and flirted, always on the edge of loss.

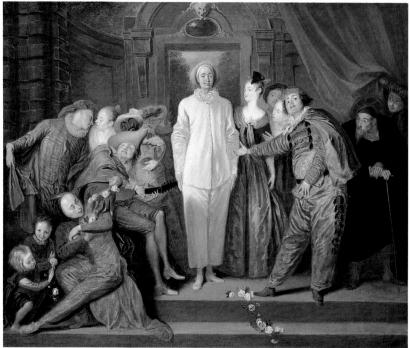

263 Jean Antoine Watteau, Italian Comedians, probably 1720, 30 x 25 in (76 x 63 cm)

This example, "Embarkation for Cytherea" (262), is in fact misnamed, but has been so immemorially. It shows lovers leaving, not embarking for, the fabled isle of lovers, where they have made their vows to the shadowy Venus who is hidden in the undergrowth. The act of taking vows has made them into inseparable pairs, but they leave with reluctance. Never again will love be so accessible and so certain: in leaving the seclusion of Venus and her bower they set all at risk and jeopardize their happiness. Watteau has no need to make this explicit. His pairs of lovers are satiated with fulfillment, yet move sadly and slowly. Love does not bring joy.

Watteau's other famous theme differs only at the literal level: his many scenes featuring the troupes of actors, Italian or French, who entertained the court. These two nationalities had different approaches to drama, but both traditions were based on the theme of love and its disappointments. *Italian Comedians* (263) has its jester and its gaily posturing actors, its pretty ladies, and its flirtations. But at the center is the strange, tragic figure of Pierrot, taller than anyone else, starkly visible in his silken whites, motionless and heraldic.

There is even a blasphemous echo of Pilate presenting Christ to the mockery of the people, and it is impossible to say that Watteau did not explicitly intend this echo. No crown of thorns, but a crown of flowers lies neglected and rejected on the steps. All gleams, and there is laughter, but we are strangely chilled.

COMMEDIA DELL'ARTE

The Italian commedia dell'arte began as an antiliterary form of theater based on improvisation, with juggling and acrobatics. It had a set of stock characters, the foremost of which were a rich. foolish old man and his clever servant Harlequin. Two others were Columbine and Pierrot, the latter being the embodiment of outspoken simplicity. With its antiestablishment character it was banned by the French nobility in 1687. In 1716 the Italian actors were recalled by the Duc d'Orléans, Louis XV's Regent from 1713 to 1723. Scripts were eventually written for the commedia dell'arte; these had a delicate verbal style, and often an erotic undercurrent.

DIANA BATHING

Diana (known as Artemis to the Greeks) has several identities: as chastity, and more commonly, as the huntress, in which guise she appears in this painting. To the Romans, she had three personifications: Diana for the earth, Hecate for the underworld, and Luna for the moon - which explains the crescent moon she wears in her hair.

ATTENDANT NYMPH

Boucher has chosen to depict Diana after the hunt; to have shown her in active pursuit of game would not have suited his temperament at all. Instead, we are presented with what is essentially a boudoir scene, a fine young lady seated on her expensive silks and pampered by her handmaiden except that this happens to be the goddess Diana, attended by a reverent nymph who dries her feet, as she rests in a secluded woodland glade.

PEARLS

This detail reveals how the surface of the painting is covered in a network of fine cracks. The smooth, uninterrupted finish of Diana's perfect skin seems all the more delicate. Pearls suggest the moon, both in their gentle gleam and their lovely rotundity, and these are Diana's only ornaments. She needs nothing else, suggests Boucher; her godhood is apparent.

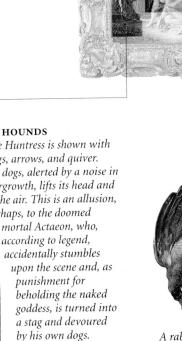

SPOILS OF THE HUNT

A rabbit and two doves have been strung onto Diana's dainty bow. Diana was often depicted in opposition to Venus, the goddess of love. Here, Venus's attribute of a pair of doves - symbols of love and lust - has been vanquished by chastity. The birds' earthy, vital nature contrasts sharply with Diana's unearthly, pure skin.

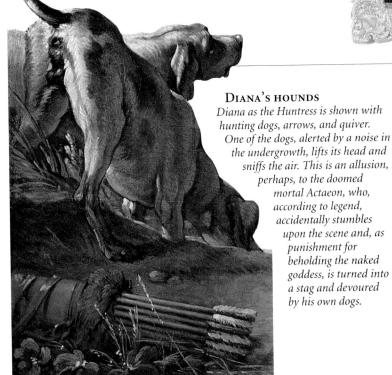

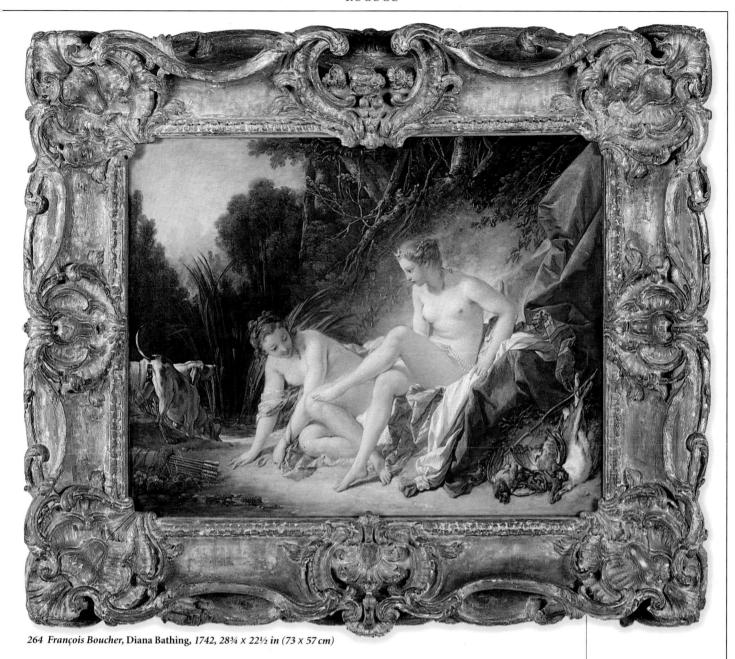

BOUCHER'S SOLID STYLE

After Watteau came François Boucher (1703–70), a fuller and more solid painter, less magical but more robust. This contrast may be the outward reflection of the fact that he was in relatively better health than Watteau, whose constitution was frail. Boucher demonstrates the Rococo fear of the solemn, and his art – more than that of Watteau – reveals the truly Rococo spirit of decoration.

Yet, despite this ornamental spirit, Boucher's entrancing ladies, who are usually shown sweetly displaying to us their naked charms, are not trivial. At his best, Boucher succeeds in making us share in his worship of the female body, its vulnerable roundness, and its essential innocence. There is far more to Boucher than appears at first viewing. He is a great celebrator,

and a work like his masterpiece, *Diana Bathing* (264), celebrates not only the firmly rounded goddess and her eager companion, but the civilized terrain of parkland as well. This is a cultured landscape, in which the savagery of nature has been tamed.

At the start of the 20th century Boucher was held in very low esteem, seen merely as a decorator and an artist of charm but little substance. His work, in fact, is very out of key with contemporary attitudes, especially feminism. Strangely, however, he has been creeping up in critical esteem as the spirit of his work – which is genuinely reverential – becomes more apparent to the discerning eye. Creative beauty in all its forms moved him emotionally, and his eye dwells as lovingly on the dogs and the riverbank as it does on the nymphs.

MADAME DE POMPADOUR

As official mistress of the French King Louis XV, Madame de Pompadour was a powerful figure in French artistic life. She was a great patron of the arts, commissioning a number of painters and poets, and had a huge influence on the king's policies. She also founded the military school and the porcelain factory at Sèvres.

OTHER WORKS BY FRAGONARD

The Meal on the Grass (Museé de Picardie, Amiens)

The Good Mother (Museum of Fine Arts, Boston)

A Boy as Pierrot (Wallace Collection, London)

The Useless Resistance (National Museum, Stockholm)

Bathers (Louvre, Paris)

(Louvre, Paris)

Washerwoman

(St. Louis Art Museum)

The New Model (Musée Jacquemart André, Paris) Boucher never ogles, but – and in this respect he is akin to Rubens – he lifts his hat and sweeps low the plumes. *Venus Consoling Love (265)* floats deliciously onto the canvas, one naked goddess and three naked children. They have an eerie similarity, all four, to the fatly feathered pair of nesting birds among the reeds. Nothing here is real or meant to be. But the sense of pleasure in ideal beauty is very real, and makes the work into much more than a triviality.

BEFORE THE REVOLUTION

Fragonard (Jean-Honoré, 1732–1806) followed Boucher. He came from the town of Grasse in southeastern France, which was and is the center of the French perfume industry. Fragonard was a rapid and spontaneous painter. He was as skilled as his teacher Boucher in sharing his pleasure in young women and their bodies, but more alert to their emotions.

Fragonard had a keen and endearing sense of human folly, especially when set in the expanses of the natural world. In his *Blindman's Buff* (266), a children's game is merrily being played by adults. Despite the light, bright and airy atmosphere there is a sense of foreboding in the painting. The gathering clouds that dominate

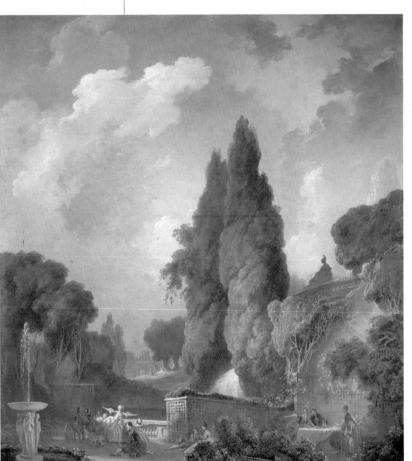

266 Jean-Honoré Fragonard, Blindman's Buff, probably c. 1765, 6ft 6 in x 7 ft 1 in (198 x 216 cm)

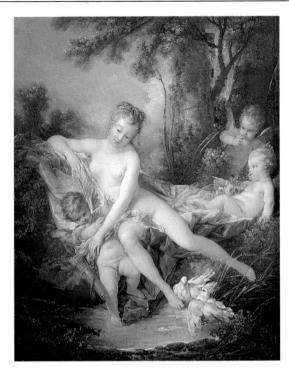

265 François Boucher, Venus Consoling Love, 1751, 33 x 42 in (84 x 107 cm)

half the canvas suggest to us, yet surely not explicitly to the painter, that the French Revolution was to come before his death. The revolution had very unfortunate consequences for Fragonard, as it ruined his patrons and deprived him of commissions. After 1793, despite previous success, he lived in obscurity for the rest of his life.

A Young Girl Reading (267) is aglow with the softest of umbers, the rich color darkening and paling as it follows the girl's youthful contours. Her back is supported by a sort of maternal abundance of rosy pillow, but there is an almost horizontal element in the board under her arm except where her charming sleeve has overlapped its rigid outline. She is intent upon her book, as unprotected as any Boucher nymph.

The sweetness of A Young Girl Reading, its almost Renoirish charm (see p.298), should not blind us to its strength and solidity. There is a geometrical framework to the softness of the adolescent reader: a strong, vertical swathe of yellow-brown wall, and the gleaming horizontal bar of the armrest. It is this ability to transcend decoration that distinguishes Fragonard. Look at the girl's neck and bosom: delicious frills and ribbons, and the crinkling descent of the silks, yet there is the firm basis of a real, plump, human body. As in Blindman's Buff, the literal theme of this picture is held in an unstated context of solemnity. Like Boucher, Fragonard is more profound than he seems, and his genuine sensitivity is becoming increasingly apparent.

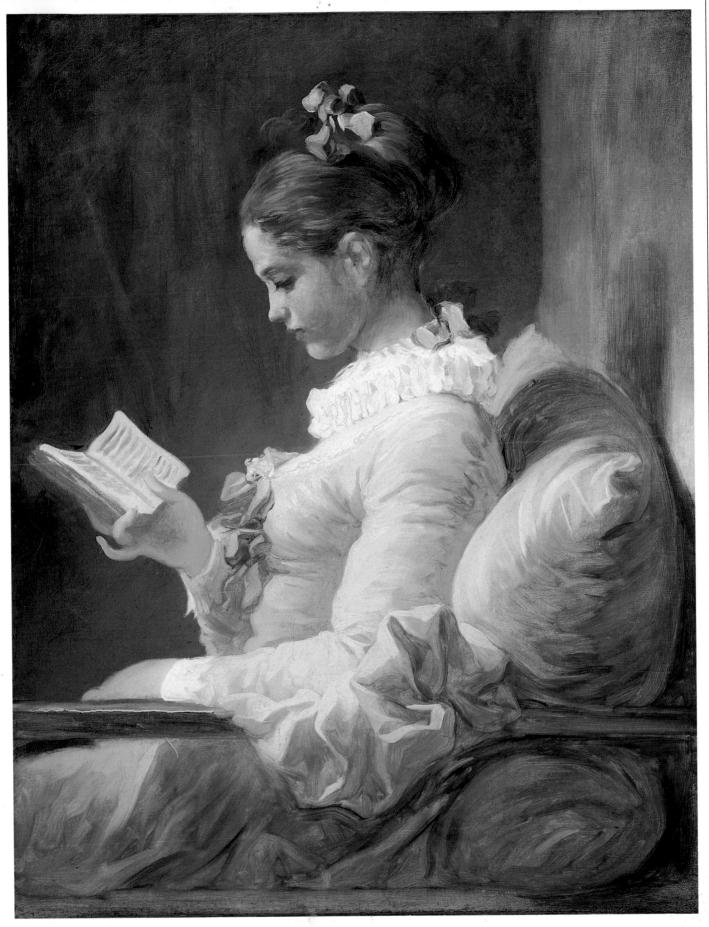

267 Jean-Honoré Fragonard, A Young Girl Reading, c. 1776, 26 x 32 in (65 x 81 cm)

SEVRES PORCELAIN

In the early part of the 18th century, hard-paste porcelain became highly fashionable. In 1738 Robert and Gilles Debois from Chantilly offered their porcelain-making services to the French royal household. They were paid 10,000 louis and given part of the castle at Vincennes to set up the factory. The company moved to Sèvres in 1753, and Louis XV and Madame de Pompadour began to commission work.

Sèvres porcelain is identifiable by the richness of the colors and the quality and opulence of the gilt decoration. The three most popular colors were bleu de roi (dark blue), bleu céleste (light blue, illustrated above), and rose Pompadour (pink).

Other works by Chardin

Still Life with the Ingredients of Lunch (Musée des Beaux Arts, Carcassone)

Vase of Flowers (National Gallery, Edinburgh)

Girl with a Shuttlecock (Uffizi, Florence)

The Governess (National Gallery of Canada, Ottawa)

Soap Bubbles (National Gallery of Art, Washington D.C.)

Woman Working on a Tapestry (National Museum, Stockholm)

CHARDIN: WEIGHT AND SOBRIETY IN A ROCOCO ERA

Jean-Baptiste-Siméon Chardin (1699–1779), who is so unlike the pleasure-loving Fragonard, taught the young Fragonard before he found a more congenial mentor in Boucher.

Chardin is categorized as "Rococo" only by date, as it were. Despite his charming choice of subjects, frequently painting small children and young servants, he did not have it in him to create other than from his depth. *The Attentive Nurse* (268) simply shows a young nursemaid

preparing the supper egg. She stands in the kitchen engrossed in her task, a colored column of lovely rectitude. The table is laid as for a sacrament: the bread and the goblet take on a sacred significance, and the great white water pitcher has baptismal import.

None of the mysterious significance contained in *The Attentive Nurse* is overt. It is simply that the scene has overtones. The whites here – the cloth, eggs, pitcher, and towel – are so pure; and the pinky oranges in the petticoat and the bread, picked up and intensified in the floor and bowl,

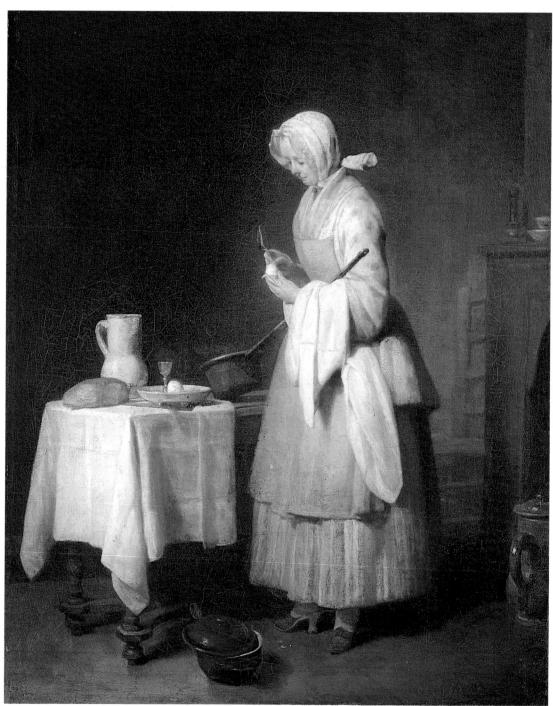

268 Jean-Baptiste-Siméon Chardin, The Attentive Nurse, probably 1738, 14½ x 18 in (37 x 46 cm)

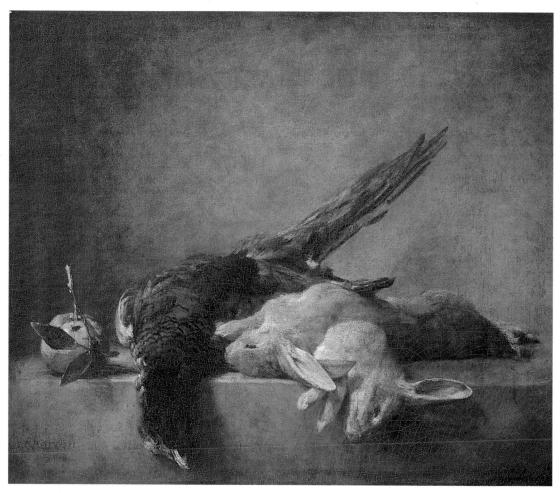

269 Jean-Baptiste-Siméon Chardin, Still Life with Game, c. 1760/65, 23½ × 20 in (60 × 50 cm)

are so ruddy with the goodness of health, that we feel unable to accept the work at face value. Often in Chardin there are underlying moral messages or implications, as we see in *The House of Cards (269)* (life's instability and the child's ignorance of it) or *Soap Bubbles* (not illustrated – the uselessness, the vanity in the biblical sense, of most human activities). But, paradoxically, the more explicit the moral, the less its effect.

It is the implicit moralities, like the sacramental overtones of the nurse with her egg, or the similar message contained in one of the great still lifes (269) (from one of the greatest of all the still-life painters) that most move us. The slaughtered bird and hares, all small and harmless creatures, lie in solemn state on their altar of the kitchen ledge. A dusky shadow glimmers on the wall, and the slab seems lit from within. Chardin is paying homage to a ritual sacrifice, offered on our behalf. And not only the animals: the vegetable world, too, is one of sacrifice, and Chardin duly bows his head before it.

Chardin never ventured upon what his age would have considered a major theme: his work is essentially domestic, quiet, undramatic. It is his treatment that makes his themes major.

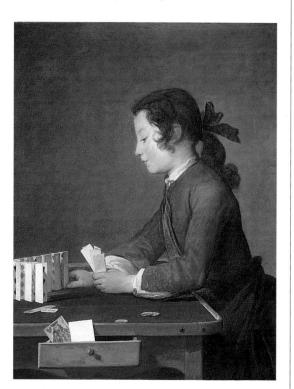

270 Jean-Baptiste-Siméon Chardin, The House of Cards, c. 1735, 26¼ × 32¼ in (66 × 82 cm)

Rococo architecture

The most complete examples of Rococo architecture are to be found in southern Germany and in Austria. The palaces of the princes, and the Catholic churches, are often good examples. A fine Rococo building in Bavaria (Germany) is the Residenz (bishop's palace) in Würzburg, designed by Balthasar Neumann and built in 1719-44. It contains the famous Kaisersaal (Imperial Room), with ceiling frescoes by Tiepolo (see p.232).

Louis XIV FURNITURE

During the reign of Louis XIV great developments occurred in French furniture making. One of the most successful furniture designers was André Charles Boulle (1642-1732), who became director of works at Versailles. Boulle employed a vast army of workers to create his distinctive masterpieces, using extremely high-quality materials such as silver, ivory, and tortoiseshell for the inlays. Another feature of Boulle furniture was the heavy bronze-gilt mounts (illustrated above).

OTHER WORKS BY TIEPOLO

Time Unveiling Truth (Museum of Fine Arts, Boston)

The Banquet of Cleopatra (National Gallery of Victoria, Melbourne)

Fortitude and Wisdom (Dulwich Picture Gallery, London)

Institution of the Rosary (Art Institute of Chicago) Adoration of the Kings (National Gallery

of Canada, Ottawa)

Young Woman with a Macaw (Ashmolean Museum, Oxford)

TIEPOLO AND ITALIAN ROCOCO

The Italians also had their great Rococo artists, especially in Venice, where the sway and sparkle of the omnipresent waters make a fitting setting. Giambattista Tiepolo (1696–1770) is the quintessential master of this style; all the decorative vitality and glowing color of the Venetian tradition finds its culmination in him. His exuberance is held under masterly control; he has a natural gaiety that is supremely imaginative and capable of flights of visual wit that have never been excelled.

Tiepolo's greatest work was done mostly in fresco. In these vast, soaring compositions the sheer extent of space to be covered draws his stupendous best. There is, therefore, a pleasing congruity in his often being commissioned to paint ceilings. This he did with enormous panache and skill, something we may miss if we see his work in a museum, where it has been removed from above our heads and pallidly hung upon a wall.

But the great ceiling at the Museo ca Rezzonico in Venice (271) still remains in place, arching superbly over our heads and worth any amount of neck craning. It was painted to

celebrate the marriage of two Venetian princely houses, the families of Ludovico Rezzonico and Faustina Savorgnan, which Tiepolo does in a delightful allegory. Ludovico, the bridegroom, leans expectantly forward, the lion of St. Mark at his side, holding aloft the banner that shows the two coats of arms united into one. Apollo, the sun god, surges forward in his chariot, bringing the modest bride. Fame blows her trumpet, goddesses, putti, and birds rejoice, and in the distance the goddess of fertility, half concealed, contemplates the face of the child that will be conceived. The mirror of the future is still blank, but the glory Tiepolo has created makes it impossible to believe that there can be anything ahead but glory.

Tiepolo borrowed the motif of Apollo's chariot and horses from the ceiling of the Kaisersaal at the bishop's palace in Würzburg (see p.231), his masterpiece of 1750–53. Tiepolo brings the same radiant conviction to mythological subjects too. The theme of the painting that is currently entitled *Queen Zenobia Addressing Her Soldiers (272)* has been the subject of much speculation. It is now known to have been commissioned by the Zenobio family of Venice

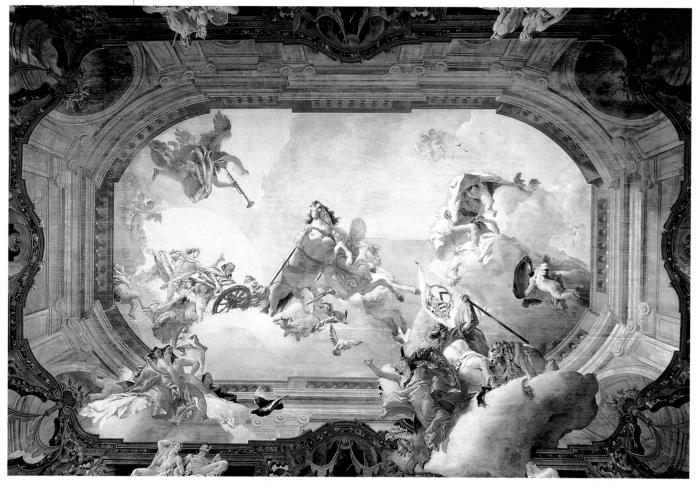

271 Giambattista Tiepolo, Allegory of the Marriage of Rezzonico to Savorgnan, 1758

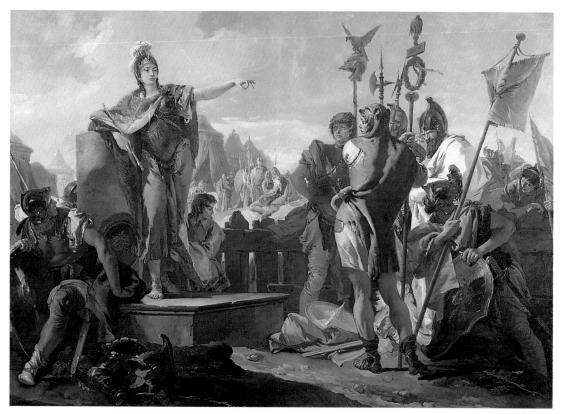

272 Giambattista Tiepolo, Queen Zenobia Addressing Her Soldiers, c. 1730, 12 ft x 8 ft 7in (366 x 262 cm)

and that the helmeted female figure is Queen Zenobia. She was an extremely powerful, 3rd-century ruler of Palmyra, but we do not need to know the story behind the painting to appreciate its power. What Tiepolo shows us with brilliant force is the confrontation of male and female, but, in 18th-century terms, reversed. It is the woman who dominates, the men who listen submissively. The woman is all-powerful and dynamic, while the men, despite their masculine bulk, await her commands passively. It is a sparkling

LATE ROCOCO IN VENICE

and witty work, yet wholly serious.

The Rococo, dying out in the rest of Europe as it became increasingly regarded as frivolous, still found great painters in Venice. The best Venetian art shows the real strength of Rococo, its wonderful energy. Francesco Guardi (1712–93), with his lyrical capriccios (imaginary landscape arrangements, half real and half surreal) is one of the last of this school. The most famous of a family of painters, his art is loose and impressionistic, airy and delightful. We may not totally believe in his architecture, but we accept its fantasy on its own terms. If he shows us

A Seaport and Classical Ruins in Italy (273), we take uncomplicated pleasure in its cloudy grandeur, a fitting site for the imagination to play in. What charms us in Guardi is his ability both to convince intellectually (we believe we are seeing a real place) and to enchant us romantically (we also feel that this is a poetic creation). Poetry that convinces us is the most enduring.

TIEPOLO DRAWINGS While it is for his paintings that Tiepolo is most famous, the many sketches he left behind have a considerable reputation of their own. Tiepolo would tirelessly sketch out the characters, and then they would be transferred to his ceiling masterpieces. This sketch (shown above) illustrates Tiepolo's ability to use chiaroscuro (depiction of light and shade) and his grasp of perspective. The woman is believed to be Truth, a mythical personification who appears in several of Tiepolo's paintings.

273 Francesco Guardi, A Seaport and Classical Ruins in Italy, 1730s, 70 x 48 in (178 x 122 cm)

OTHER WORKS BY

Venice: St. Mark's Square (Fitzwilliam Museum, Cambridge, England)

> Rome: The Arch of Constantine (Royal Collection, Windsor Castle)

London: St. Paul's Cathedral (Yale Center For British Art, New Haven, Conn)

Rome: Ruins of the Forum with the Campidoglio in the Foreground (National Gallery of Victoria, Melbourne)

Вешотто

Canaletto's nephew Bernardo Bellotto (1721-80) caused much confusion in the 18th century by calling himself Canaletto. He trained with his uncle in Venice but left in 1747 for the courts of northern Europe, particularly Dresden and Warsaw. His work was considered so reliable that architects rebuilding Warsaw after World War II copied buildings and details from his pictures.

PORTRAITS OF CITIES

An early exponent of a new stylistic current leading to a renewed Classicism – but an artist who was still very much a part of the Rococo world – was the Venetian landscape painter Canaletto (Antonio Canale, 1697–1768). He was born only one year after Tiepolo (see p.232) and several years before Guardi (see p.233) – both quintessential Rococo artists – yet his art can be seen as rigorously Neoclassical.

Canaletto adopted the city portrait as his chosen subject early in his career and stuck to it, becoming famous in his lifetime for his accurate and elaborately detailed records of city views. Since many of Canaletto's paintings are of his birthplace, Venice itself, a fantastical and imaginative city, they may indeed have a Rococo exterior, but the spirit is pure sobriety.

A splendid example of Canaletto's feeling for texture, for slate and stone and wood, with distant water and high sky, is seen in this behind-the-scenes view of Venice, sloppy and untidy, yet all held in the context of the loveliest of cities. *The Stonemason's Yard* (274) even sounds unromantic, yet Canaletto has seen the yard as a wonderful setting for the interplay of light and shadow, declivity and height.

Venice: The Basin of San Marco on Ascension Day (275) is bathed in the hard light of a classical sun. Its verticals are severe and perfectly balanced, and its architectural masses are unmistakably solid; yet Canaletto paints with such love and appreciation of his city that the result is beguiling. There is no atmospheric poetry here, except for the lyrical quality of the sky.

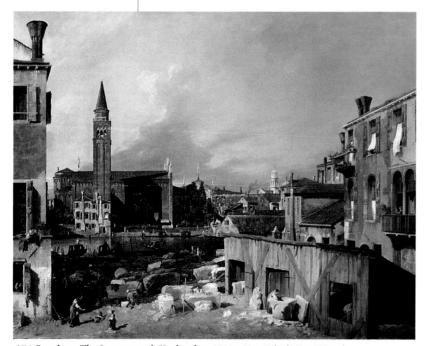

274 Canaletto, The Stonemason's Yard, c. late 1720s, 64 x 49 in (163 x 125 cm)

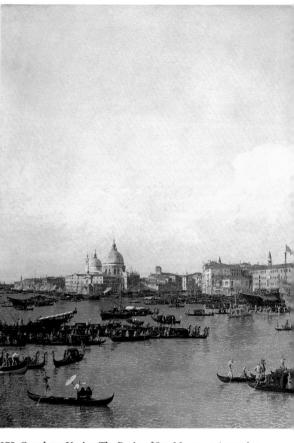

275 Canaletto, Venice: The Basin of San Marco on Ascension Day, probably c. 1740, 72 x 48 in (183 x 122 cm)

Canaletto was especially admired by English visitors to Venice, who responded immediately to his rationality. He went to England in 1745 and lived there for ten years, producing many views of London, though these were unappreciated.

His nephew, Bernardo Bellotto (see column, left), sometimes also known, confusingly, as Canaletto, imitated his more famous uncle. The two are hard to distinguish, and one could argue (to my view, falsely) that to see a Canaletto is to see a Bellotto. Yet Bellotto is a more detailed painter, a great master of extent, in which the air seems crystal clear and we possess the view like a god. This divine amplitude characterizes both uncle and nephew, so characteristic of them both that the confusion of their identities is almost inevitable.

HOGARTH: FOUNDER OF AN ENGLISH TRADITION

The British taste for art was less visual than factual. British patrons liked portraits of themselves, as well as landscape views of their homes and estates and of foreign cities they visited. Ironically, William Hogarth (1697–1764), Britain's first major artist, though a truthful and vigorous portrait painter, made his name in the unusual genre of pictorial satire, which was also congenial to his countrymen,

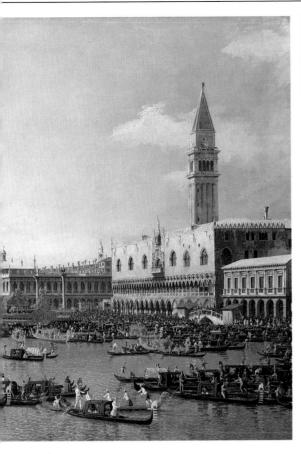

and which Hogarth took to new heights, creating an entirely new art form. Hogarth was a lively and dogmatic man, and greatly opposed to the "Italianate" Rococo styles that were popular in London at this time. He was a decided nationalist and, finding the English art scene to be hopelessly provincial, contributed to the development of Britain's earliest art institutions. He was all for building a truly British tradition, one that did not take its lead from the continent but instead reflected the British way of life.

In his portraiture, Hogarth broke new ground in depicting the rising English middle class in ways that had previously been reserved for nobility, and his keen sense of human absurdity drew him irresistibly to satire as a suitable and lucrative means for social and judicial commentary. He tends to see his subject as if it were a piece of theater.

A Scene from the Beggar's Opera (277) istaken from the great satirical play by John Gay, written in 1728. Captain Macheath, the highwayman, stands grandly in the center, while his two ladyloves plead with their villainous, hypocritical fathers. Hogarth gets the utmost enjoyment out of the twofold satire, of good and bad not being what they seem, and of a man in love with two women who gets himself in a tangle. This is the witty Hogarth, but he also has a deeper side.

276 William Hogarth, The Graham Children, 1742, 6 ft x 5 ft 4 in (183 x 163 cm)

The Graham Children (276) can bear comparison with the works of the great Velázquez (see p.194) in its sense of immediacy, of sharing with us a particular moment in time. The painting shows four children who, with their cat and their caged bird, sparkle happily out at us. Only after a time do we glimpse the deeper implications of this scene: the cat, electric with desire, is after the bird, and its lively chirping, which the children take to be a response to their own music, is in reality a frantic cry for their protection. Only the baby sees what the cat is up to, and as a baby, does not understand. Hogarth is showing us innocence threatened, and the shadow falls on the laughing children too.

Hogarth Engravings

William Hogarth
(1697–1764) trained as an
engraver and popularized
the use of a sequence of
anecdotal pictures to
portray social and moral
issues. He saw himself
as the defender of the
common man and the
upholder of sensible British
values in the face of French
fashions and mannerisms.

The engraving shown above is of *Gin Lane*, a fictitious street in which the dire consequences of gin drinking are clearly demonstrated. The work was completed by Hogarth in 1751 and is one of a pair, the other illustrating the noble qualities of British beer. Engravings such as these sold for one shilling and were popular across the social spectrum.

277 William Hogarth, A Scene from the Beggar's Opera, 1728/29, 24×20 /4 in $(61 \times 51 \text{ cm})$

NEOCLASSICISM AND ROMANTICISM

Neoclassicism was born out of a rejection of the Rococo and late Baroque styles, around the middle of the 18th century. Neoclassical artists wanted a style that could convey serious moral ideas such as justice, honor, and patriotism. They yearned to re-create the simple, dignified style of the art of classical Greece and Rome. Some succeeded, but the movement suffered from its spirit of academic narrowness.

Romanticism began in the same era, but it was an approach that had to do with the modern rather than the antique, and it was about wildness and expression rather than control. Romantic artists had no fixed laws relating to beauty or the proprieties of subject matter. Instead, Romanticism was a creative outlook, a way of life.

A vast gulf existed between these two outlooks, and the debate between them was long and at times bitter; but in the end, Romanticism emerged as the dominant artistic movement of the first half of the 19th century.

NEOCLASSICISM AND ROMANTICISM TIMELINE

Neoclassicism began in the middle of the 18th century (well before the Rococo style finally went out of use) and was in decline by the early 19th century. Likewise, early traces of Romanticism in painting are found in the 1740s; for instance, in Gainsborough. Romantic painting became a recognized movement by the 1780s, continuing into the mid-19th century.

JOHN SINGLETON COPLEY, THE COPLEY FAMILY, 1776–77

Copley's portrait of his own family is an example of the effects of European Neoclassical influence (chiefly that of Reynolds) on an artist arriving from the New World. When living in America, Copley had been known for his unvarnished but convincing realism. In England, in response to the prevailing fashion, he idealized and made his figures elegant, but in the event all too often diminishing his original insight (p.246).

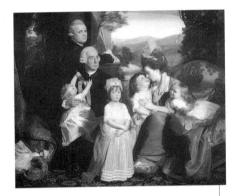

GEORGE STUBBS, MARES AND FOALS, 1762

By specializing, George Stubbs attained a degree of distinction that guaranteed him lasting fame. He dedicated himself to the horse, and this is one of his many horse pictures that leave humans out altogether. It gives a glimpse of these wild creatures as superior beings to whom the landscape truly belongs (p.247).

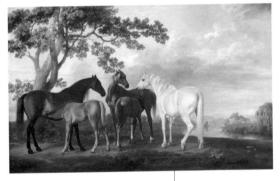

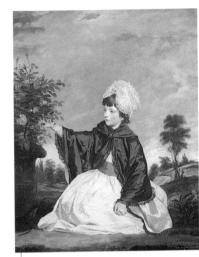

SIR JOSHUA REYNOLDS, LADY CAROLINE HOWARD, 1778

Reynolds was England's leading academic painter and possibly the best portraitist. He is an eclectic painter, leaning heavily to the classic, which gives dignity to his pictures of contemporary aristocrats. Here he gives an atmosphere of grandeur, almost heroism, to a simple portrait of a child (p.244).

1740

1750

1760

1770

1780

1790

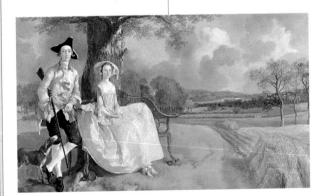

THOMAS GAINSBOROUGH, MR. AND MRS. ANDREWS, 1749

This unforgettable portrait haunts us with its startlingly original treatment. The poses and facial expressions are individual and convincing, and yet paradoxically the two figures are made to look like dolls or porcelain figures. They are positioned in the corner of the composition, allowing two-thirds of the painting to be devoted to landscape. Nature is an important element in all of Gainsborough's portraits, and he had a profound influence on the English landscape painters of the 19th century, notably Constable (p.240).

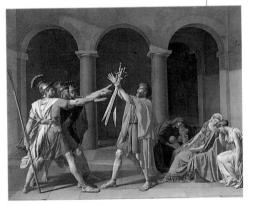

Jacques-louis david, the oath of the horatii, 1784–85

This was the first really famous image from the Neoclassical school. David was on the side of the Revolution when it came in 1789, and this subject evoked revolutionary patriotism. The composition is carefully orchestrated: for instance, the exaggerated weakness and softness of the women on the right contrast with the rigid, heroic pose of the three young men on the left (p.253).

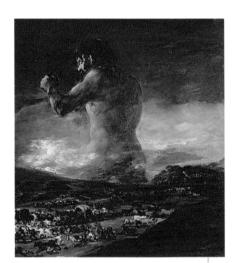

Francisco Goya, colossus, 1810–12

Goya was influenced, when first at the Spanish royal court, by the Neoclassicist Anton Raphael Mengs, but over the years of his career he moved more and more in the direction of Romanticism. He is an artist of the very greatest stature and exercised considerable influence on the development of Romanticism throughout Europe. The Colossus is an example of Goya's ability to realize an image that seems to come from our inner consciousness, powerful but with no single, unambiguous message (p.252).

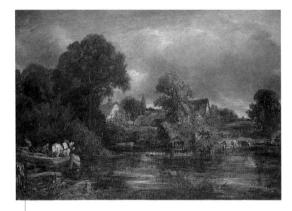

JOHN CONSTABLE, THE WHITE HORSE, 1819

This is one of the Suffolk scenes that have become part of the canon of great paintings in the English landscape tradition.
Constable's work has a unique freshness. There is a brilliant use of broken color, with an immediacy and convincing truth. With his robust, workaday scenes from the countryside near his home, Constable breached classical rules on what constituted the "correct" sort of landscape to paint (p.270).

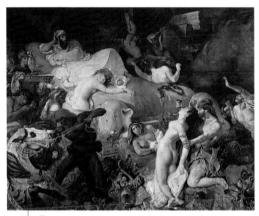

EUGENE DELACROIX, DEATH OF SARDANAPALUS, 1827

Delacroix's Romanticism has a solid underpinning of the classic. Rubens and Géricault encouraged him to see the emotional effect of strong color. This painting shows the energy and exoticism of his work, but he always retained a certain detachment and inner control (p.261).

1800

1810

1820

1830

1840

1850

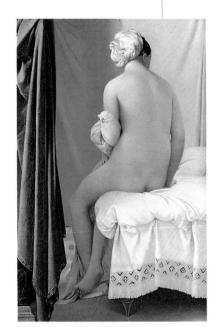

JEAN-AUGUSTE INGRES, THE BATHER, 1808

Ingres became the "high priest" of Neoclassicism in France. He had a special preference for the backs and necks of his nudes, often making them into prominent features of his paintings and frequently distorting or elongating them in order to suit the needs of his highly sophisticated compositions. This was typical of the Neoclassical painters, for whom control over subject matter was central to their whole approach to art. Ingres's distortions went even further than in this example, but they were nearly always achieved in such a way as to make anatomical "falsehoods" seem as plausible as reality itself (p.256).

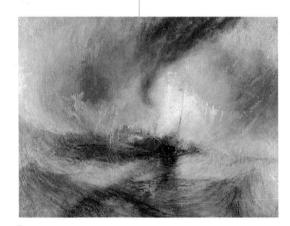

J.M.W. TURNER, STEAMBOAT IN A SNOWSTORM, 1842

In Turner's seascapes we see the emotive power of Romantic art at its most intense. Yet, like all truly great artists, Turner retains control over what is happening in this painting. Here he shows a ship in mortal danger in a storm at sea. No matter how imaginative or extreme the subject, he is still aware of perspective and its imperatives (p.265).

ROYAL ACADEMY

In contrast to the Royal Academy in France, which was under state control, the British Royal Academy was self-governing. The Instrument of Foundation of the Royal Academy was signed by King George III in December 1768. Joshua Reynolds became the first president and was assisted by a committee of eight members. The basic aims of the academy were to promote the arts of design, to provide free teaching, and to hold public exhibitions.

THE BRITISH SCHOOL

In British painting of the 18th century, there was a mixture of both the Romantic and the Neoclassical tendencies. On one hand, there was the marvelous lyricism of Thomas Gainsborough, always including the natural environment in his portraits, many of which hovered on the edge of being landscapes. On the other hand, there was the educated, classical approach of Sir Joshua Reynolds, appealing to the ideals of polite society of his time – which was known, then as well as today, as the Age of Reason.

One of the artists who led English painting into its great period was Thomas Gainsborough (1727–88). He called himself "a wild goose at best," and it was this ravishing originality, within the bounds of gentlemanly appeal, that made him so popular. A supreme portrait painter, his great love was the landscape, and his finest works give us both. His achievements in landscape painting paved the way for Constable's radically naturalistic approach to landscape, and for the English Romantic tradition (see p.264). Gainsborough's

landscapes are reminiscent of Watteau's *fêtes* galantes (see p.224): whimsical, idyllic scenes, peopled with delicate creatures. In Gainsborough, however, these are transformed into large-scale lyrical landscapes, refreshing in their truth to nature. The most famous of Gainsborough's early portraits is the unconventional *Mr. and Mrs.* Andrews (278). The young newlyweds pose in their ancestral fields, she in the height of fashion, scowling over her silks, he casual and somehow adolescent.

Wedgwood Pottery

Josiah Wedgwood (1730-95) was an important influence on the spread of Neoclassical taste in England. After early training in his brother's pottery works, Wedgwood rapidly extended his knowledge and skills and decided to employ the sculptor John Flaxman to create designs based on classical antiquities. By 1775 Wedgwood had developed the famous blue jasperware, which became a popular export and was bought by many of the European royal families. This vase (shown above) is an example of the relief work produced in the Wedgwood china works.

278 Thomas Gainsborough, Mr. and Mrs. Andrews, c. 1749, 47 x 28 in (120 x 71 cm)

A NEW STYLE OF PORTRAIT

The Andrews portrait takes its verve from its paradoxically real and unreal portrayal of the sitters, who appear doll-like and yet are nonetheless totally convincing, and from its strikingly original composition. Its originality lies in the positioning of its subjects off-center, flanked by an unidealized, genuinely 18th-century English landscape of farmland with its cornfield, sturdy oak tree, and changeable sky.

Their position emphasizes their status as landowners. They appear to be surveying the landscape around them, a landscape that plays an important part in its own right, no longer merely as a decorative, fanciful backdrop (as had been the custom for such outdoor portraits). The portrait is not finished. Mrs. Andrews is believed to have made the rather odd request that she be painted holding a pheasant, which probably accounts for the blank patch in her lap. Gainsborough clearly finds the couple comic, yet he paints with an admirably straight face.

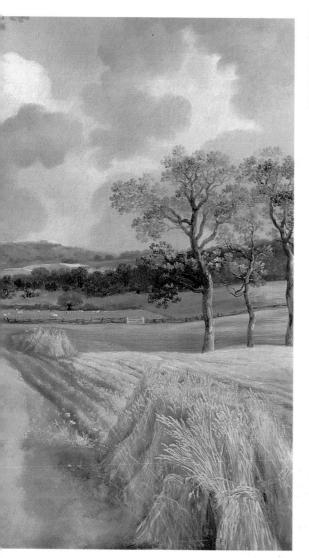

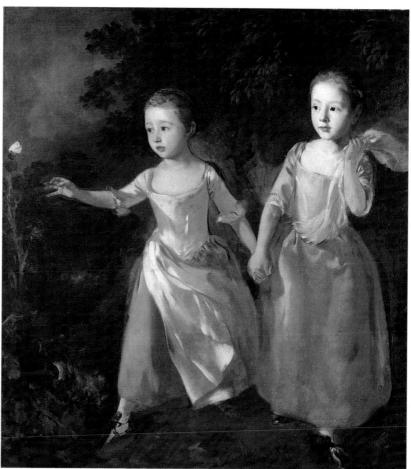

279 Thomas Gainsborough, The Painter's Daughters Chasing a Butterfly, late 1750s, 41 x 45 in (105 x 115 cm)

PATHOS AND CELEBRATION

As Gainsborough matured, his sensibility became more delicate, more "finely tuned," as did his confidence in his ability to catch a likeness. His lyrical landscape backgrounds, lightly sketched, became more idealized (though never unbelievable) and were executed with increasing freedom. Gainsborough is very sensitive to the pathos of beauty or heroism, graces that time will transform, and there can be a heartbreaking pensiveness in some of his portraits.

There is pathos, for example, in his repeated portraits of his two daughters, Molly (Mary) and Margaret, plain girls whom he dearly loved and whose future was to be unhappy – both were psychologically fragile. Our foreknowledge of their unhappiness to come seems sublimely shared in his enchanting picture of them in their childhood: *The Painter's Daughters Chasing a Butterfly (279)*. Only the young chase the butterfly: the adult knows sadly that it is hard to catch, and may die as a result. For children, the chase itself is sheer pleasure without misgivings, and Gainsborough subtly expresses, at one and the same time, the happiness of innocence and the sadness of maturity.

OTHER WORKS BY GAINSBOROUGH

Captain Thomas Matthew (Museum of Fine Arts, Boston)

John Smith, Clerk to the Drapers' Company (Queensland Art Gallery, Brisbane)

Crossing the Ford (Christchurch Mansion, Ipswich)

Mrs. Susannah Gardiner (Tate Gallery, London)

Mrs. George Drummond (Montreal Museum of Fine Arts)

Lady in a Blue Dress (Philadelphia Museum of Art)

A Lady (Bridgestone Museum of Art, Tokyo)

George III (Royal Collection, Windsor Castle)

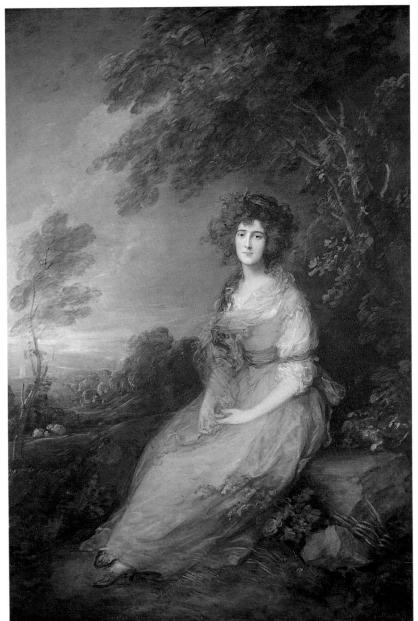

280 Thomas Gainsborough, Mrs. Richard Brinsley Sheridan, 1785/86, 5 ft ½ in x 7 ft 3 in (154 x 220 cm)

Mrs. richard brinsley sheridan

Elizabeth Linley (1754-92), a singer of great beauty and charm, had been known to Gainsborough since childhood. She eloped to France with the dramatist Richard Brinsley Sheridan (1751-1816) in 1772, and they married a year later. They settled in London, living much beyond their means until Sheridan became a successful playwright, as well as a member of Parliament.

THE PLAYWRIGHT'S WIFE

Pathos is again inherent in this portrait of *Mrs. Richard Brinsley Sheridan* (280). She had a tempestuous marriage with the great playwright Sheridan, and she was renowned for her singing voice and her unearthly beauty. Her loneliness and her elusive charm are conveyed to us in her portrait. Only the grave and lovely face is solid: all else is thin, diaphanous, unstable. Her mood is echoed by the wistful melancholy of the setting sun.

Full-length portraits, particularly of ladies placed in a natural setting, were a special tradition in 18th-century English and French painting; they were noticed on the continent, and copied, by Goya, among others (see p.248).

Gainsborough was one of the great "independents" and his influence on portraiture was only limited. However, his landscapes were important as models for the young John Constable (see p.268), who wrote, "I fancy I see Gainsborough in every hedge and hollow tree."

RAMSAY THE CATALYST

Perhaps the greatest portrait painter in 18th-century Britain is the unfairly forgotten Scot, Allan Ramsay (1713–84). The English writer Horace Walpole, one of the shrewdest men of his age, remarked that "Reynolds seldom succeeds in women," whereas "Ramsay is formed to paint them." A great Ramsay is usually treasured by the family that originally commissioned it, and he has fallen from critical view for far too long.

This portrait, Mrs. Allan Ramsay (281), is of Ramsay's second wife, Margaret Lindsay (1726–82). The first Mrs. Ramsay, Anne Bayne, had died in childbirth, thereby forever destroying Ramsay's confidence in the invulnerability of love. His second wife is very lovely, sweet, and fresh, but he paints her with a touching anxiety, a haunting fear that her beloved life may fade away as inevitably as the flowers at her side.

Ramsay's delicate style introduced a blend of Baroque Italian Classicism, with French Rococo charm, into English painting. His personality – contrasting so noticeably with that of Hogarth, the pragmatic social commentator – gave rise to change, and crystallized the active ingredients for this great period in British painting.

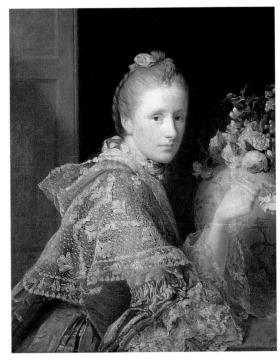

281 Allan Ramsay, Margaret Lindsay, Mrs. Allan Ramsay, early 1760s, 22 \times 27 in $(55\times68~cm)$

Mrs. Richard Brinsley Sheridan

The incompatible natures of the subject of this portrait and her husband (see column, p.242) meant that the former spent much of her time in the country, where she was happiest, while her wayward spouse stayed in London. She was an appropriate subject for Gainsborough's new, Romantic approach to portraiture, where all elements combine to express the gently melancholic mood of the sitter.

DISTANT TREE
A solitary tree in the distance has been superimposed over the sky. Its trunk is a few simple arabesques, and the fluffy clumps of foliage are all painted in the same direction. Pink underpainting is visible in the sky, which echoes the pinks and blues of her costume.

RHYTHM OF COLOR AND FORM

The lightly suggested feet are subordinate to the major rhythms of the composition. Gainsborough has worked largely wet-in-wet, with loosely woven layers of washes, a technique that produces softness of definition. At the speed of a glance, he has zigzagged his brush down the expanse of her dress to her feet. Our eye moves automatically to the distant tree and then up and down through the foliage behind her, where her diagonal pose begins the circular rhythm anew.

FACE

She is depicted as truly belonging in this environment, and her hair, caught by the wind, is treated in the same way as the leaves on the tree. Her plaintive expression (the focal point of the painting) and whole demeanor seem to express the wish she made to her husband to "take me out of the whirl of the world, place me in the quiet and simple scenes of life that I was born for." Her wistful mood is echoed by the setting sun.

In comparison to her face, her pale arms are relatively flatly painted, with virtually no modeling or shading. Her hands seem to lose themselves in the folds of her dress and scarf. The transparent scarf is composed of a network of fluid squiggles weaving in and out of her fingers. It unifies the figure into one single romantic gesture as it twists and tumbles down from around her shoulders and across her chest, falling through her arms

and onto her knees and feet.

SIR JOSHUA REYNOLDS

As the first president of the Royal Academy, established in 1768. Joshua Reynolds became the most important figure in English painting. In his 15 Discourses he argued that ethical improvement was possible only by painting the noble and sublime. He held a strong conviction that the life of an artist should be one of dignity. His academic doctrine of the "Grand Manner" (a belief in the rational ideal) is encapsulated in his portraits, which depict the sitter in a pose copied from classical sculpture. In 1789 he began to go blind and had to cease painting.

RAEBURN: BRILLIANT PORTRAITIST

Raeburn, a fellow Scot, was clearly influenced by Ramsay, and at his peak is practically his equal. One would love to know whether it was the Rev. Walker himself or Raeburn who hit upon the wonderful pose of the skater (282). This extraordinary image, with the dark outline of a minister in his somber black, intent upon balancing his movement across the ice, has the superb background of mist and mountains. The man is so solid, the world so nebulous. He fixes his gaze adamantly upon the unseen and skates his way forward. We can see the muscles in play as his skates score the ice, and yet where he is going, and why this image is appropriate, baffles us still.

REYNOLDS'S GRAND MANNER

Joshua Reynolds (1723–92), who was knighted for his great success as a portrait painter, is less sensitive than Gainsborough but more balanced. Unlike the latter, who had little formal education and preferred the company of actors and musicians to scholars, Reynolds was decidedly

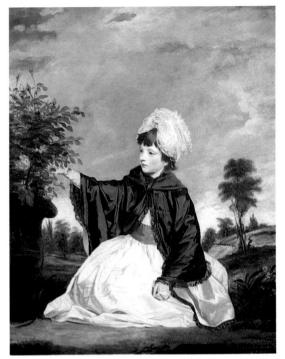

283 Sir Joshua Reynolds, Lady Caroline Howard, 1778, 44½ x 56 in (113 x 143 cm)

an intellectual. From early on in his training, Reynolds had immersed himself in the art of the Renaissance, and he shared an interest in antiquity with the Italian and French Neoclassical artists. These influences led to his revival of the "Grand Manner," set in a modern context (see column, left). He was, without question, considered the leading portrait artist in Britain in his day, although, like Gainsborough, his passion lay outside the field of portraiture.

History painting was for Reynolds the highest form of art, and he contrived to instill Classicism and heroism into his portraits of the English ruling class. The threat to Reynolds's standing in England – especially from Gainsborough's popularity – did not arise until fairly late in the day, and Reynolds's influence on English art endured for many years. He became the first president of the Royal Academy on its foundation in 1768, and his enormous influence formed the basis for academic painting (see column, left).

Reynolds was an influential theorist whose lectures at the Royal Academy still make useful reading, and he encapsulates the aristocratic dignity of his age. He can hover alarmingly on the edge of the sentimental, especially in his idealization of childhood, but when he catches youthful freshness, he is very appealing. Here is one of the best examples of his portraiture: *Lady Caroline Howard (283)*, with her rosebush and her general air of simplicity, has a pensiveness that does not make extravagant claims, but lets us enjoy this quiet and rosy child.

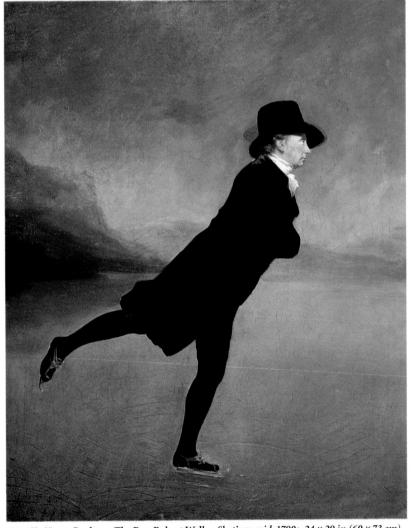

282 Sir Henry Raeburn, The Rev. Robert Walker Skating, mid-1790s, 24 x 29 in (60 x 73 cm)

AMERICA AND ENGLAND: A SHARED LANGUAGE

If the forgotten Ramsay (see p.242) is arguably the greatest portrait painter of the time, then the equally overlooked American artist Gilbert Stuart (1755–1828), 42 years his junior, may be the most original. Stuart, as his name suggests, was of Scottish ancestry. He arrived in London at the age of 20 and trained under a fellow American, the hugely successful history painter Benjamin West (see right).

Stuart was also a great success in London. His work was so acclaimed that at a later stage it was even confused with that of Gainsborough. This is a double-edged compliment: he has his own style, which is almost recklessly truthful. His time may be too early to speak of a specifically American style, but there is a homespun brilliance in his work that we do not find in European artists.

There is superb observation in his Mrs. Richard Yates (284): what other artist would have dared show her vestigial mustache? The gradations of facial color, too, and the alertness to the light glancing and dulling on her dress and cap, are all prophetic of the Impressionists (see p.294). After running into serious financial problems, Stuart returned to live in America permanently in 1793. He is probably known mainly because he painted George Washington, but despite his popularity he is not at his best as a public artist. It is the sheer domesticity of Mrs. Richard Yates, a merchant's wife, that calls out his reserves of sensitive observation.

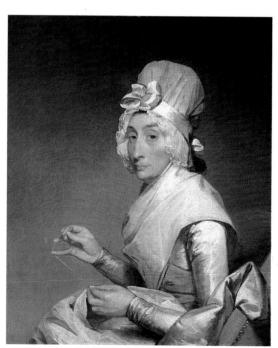

284 Gilbert Stuart, Mrs. Richard Yates, 1793/94, 25 x 30¼ in (63 x 77 cm)

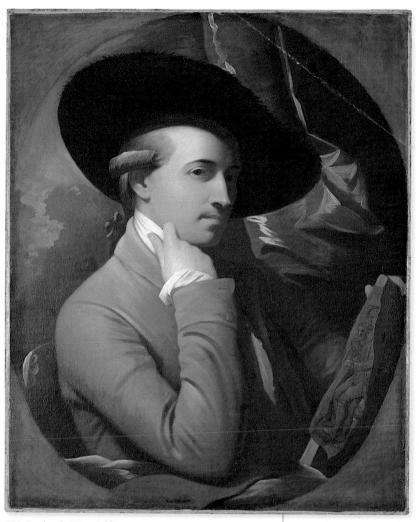

285 Benjamin West, Self-Portrait, c. 1770, 251/8 x 301/4 in (64 x 77 cm)

HISTORY PAINTING: A POPULAR GENRE

A more famous, though less interesting artist than Gilbert Stuart is Benjamin West (1738–1820), whose enormous reputation as a history painter was gained in England rather than his native America.

West's style relied very much on accuracy of detail and historical fact, and he was influenced by Neoclassical artists such as Anton Mengs (see p.248) when he was in Rome in 1760. West's great historical dramas, which so impressed his contemporaries, leave us rather unmoved. They seem to be generated from the mind rather than the heart.

But the heart is always involved in painting a self-portrait, and here we see him at his best (285). There is wishful thinking, perhaps, in this self-portrait – that of a quiet, elegant gentleman, dressed in the fashionable severity of urban style, contemplating us with aristocratic serenity. West's sketch seems an adjunct to his portrait and is in fact placed on the perimeter. Half his face and his body are deeply shadowed, with all this suggests of a divided and secretive persona.

ANGELICA KAUFFMAN

Angelica Kauffman was a friend of Joshua Reynolds and fellow member of the Royal Academy. She began as a fashionable portraitist,

then became more interested in historical subjects. In the 1770s she painted a series of decorative murals for the architect Robert Adam. In 1781 she remarried and moved to Rome. This piece of Neoclassical Meissen ware (fine porcelain) is decorated with a portrait of Angelica Kauffman.

AMERICAN INDEPENDENCE

A disagreement between the government in London and the American colonists over increases in taxes is seen as the initial catalyst of the American Revolution.

George Washington (1732–99, shown above) was appointed commander-in-chief of the army, and on July 4, 1776, the Declaration of Independence was signed. George Washington proved to be an excellent leader and was inaugurated as the first president in 1789.

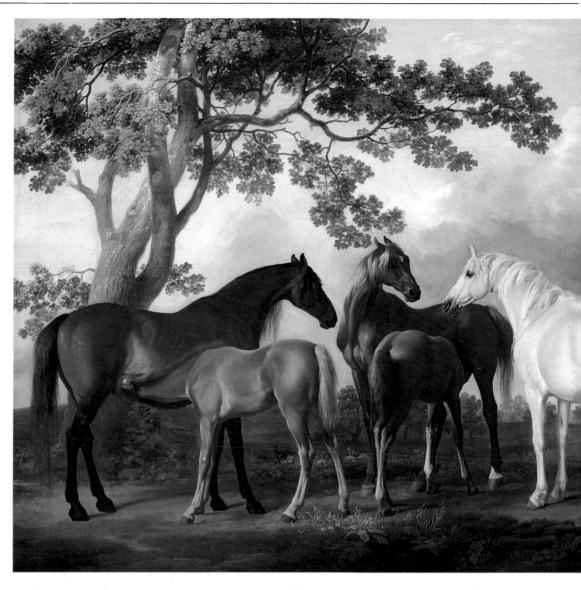

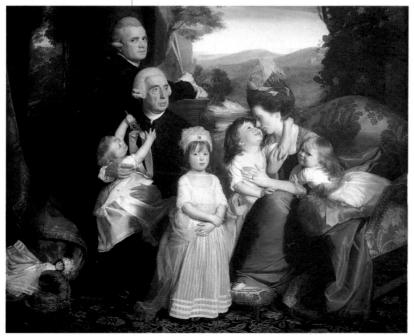

286 John Singleton Copley, The Copley Family, 1776–77, 9 ft 7 in x 6 ft 1 in (292 x 185 cm)

COPLEY: AN UNFULFILLED TALENT

If Britain gave West the opportunity he needed, it both rewarded and damaged John Singleton Copley (1738–1815). His American works show a realism and a truthfulness that are marvelously alive. Moving to England involved him in the elegance of Neoclassicism and gave him the influence of Reynolds's Grand Manner; but, for Copley, this was not a fruitful involvement.

The change is evident in *The Copley Family* (286). In this painting, which was carefully worked up from preliminary studies, his fatherin-law's face and hands and the glorious doll in the left-hand corner are examples of his early style. Here it is thrillingly convincing. For the remainder of the picture, Copley idealizes and abstracts, and the whole, though impressive, is somehow derivative: we have seen this kind of Grand Manner portraiture before in the work of Reynolds, Gainsborough, and West, for example. It remains a fascinating work, as much for its weakness as its strength. One of the weaknesses

287 George Stubbs, Mares and Foals, 1762, 75 x 39 in (190 x 100 cm)

that is paradoxically a strength comes from our uncertainty as to where this family group is located. Are they inside – as is suggested by the brocaded sofa and the gilt-edged curtain, not to mention the expensive carpet? Or are they assembled outside – as seems to be indicated by the backdrop, with its distant hills and intrusive foliage? The two settings are cleverly linked. The carpet is patterned with leaves and there is a flower motif on the sofa.

GREAT EQUESTRIAN PAINTING

The one great Anglo-Saxon master of the century, George Stubbs (1724–1806), was, like Gainsborough, a lover of the portrait and the countryside, but all his passion is concentrated on the horse. Stubbs does not merely look at horses: in his time he dissected them (literally), meditated upon them, and entered into every aspect of this noble but nonhuman being, as

if he himself were an honorary member of the species. Stubbs did not totally disdain to paint humans, who, after all, were the source of his equestrian commissions. But *Mares and Foals (287)* is one of his many pictures that has no human component. There is certainly no sentimentality either, yet these stately mothers and children, trustfully grouped together with artless poetry, evince a tender vision of nature at its most inspiring.

The horses group themselves with classic elegance against an archetypal English landscape. Stubbs is profoundly moved by their beauty, and he communicates to us his own secret conviction that it is they to whom the landscape truly belongs. Thick-limbed humanity, with its clumsy trapping of clothes and its intrusive apparatus for living, is so inferior to these bare, gleaming creatures of the wild that yet honor us with their comradeship.

(1724-1806) horse paintings are a testimony to the 18th-century gentleman's passionate interest in improved stock breeding techniques. The formal discipline of Stubbs' composition is Neoclassical in spirit, but the artist's romantic perception of the horse is demonstrated by his move toward Romanticism in his later years. The implied and described violence in paintings, such as

A Horse Frightened by

a Lion, appeal strongly

to our emotions.

HORSE PAINTINGS

George Stubbs's

288 George Stubbs, A Horse Frightened by a Lion, 1770, 49 × 37 in (125 × 94 cm)

Idyllic though it is, Stubbs does not cheat. The sky is darkening with storm clouds, and shadows already fall around the mares and foals. Only the very center of the meadow, where they actually stand, is still sunlit.

Stubbs was equally sensitive to the vulnerability of animal life. A Horse Frightened by a Lion (288) comes straight from a Freudian nightmare. Blown by the wind, under some heavenly spotlight that gleams with eerie fierceness on its terrified body, a white horse halts in abrupt horror as a leonine head looks out at it from the darkness. It is a frozen tableau of fear. He leaves its outcome to our imagination.

OTHER WORKS BY STUBBS

Otho with Larkin Up
(Tate Gallery, London)
Repose After Shooting
(Yale Center for British
Art, New Haven,
Connecticut)
Portrait of Lady
Laetitia Lade
(Royal Collection,
Windsor Castle)
Returning from
the Hunt
(Museum of Art,
San Antonio, Texas)

THE EARLY YEARS

This photograph shows the humble interior of Francisco Goya's birthplace. He was one of five children and was born (in March 1746) into a poor family in Fuendetodos, near Saragossa in northern Spain. Goya's first commission, at the age of 16 years, was to decorate a reliquary cabinet in the local church. It was not until he was 24 years old that he would depart for Italy in search of success at the academies.

JOHANN JOACHIM WINCKELMANN

Johann Winckelmann's (1717-68) doctrines on art theory were highly influential during the Neoclassical period. He developed a fervent love of classical antiquity and ancient art and wrote several treatises on the philosophy of art. He believed that classical art had "noble simplicity and grandeur" and argued that artists should apply ethical and aesthetic honesty to their work. One of Winckelmann's most ardent supporters and followers, who applied these doctrines to his own art, was Anton Mengs.

Goya

The greatest artist of the 18th century, without any qualification, was a Spaniard – Francisco Goya. He was a man of irrepressible originality and determination. After initially being influenced by the German-born Neoclassical artist Anton Mengs, he developed in his own way and painted, above all, with a truly Spanish vision.

Anton Raphael Mengs (1728–79) was a founder of Neoclassicism, in association with Johann Winckelmann (see column, left). He is more significant to us today, however, for his extremely influential style of Neoclassical portraiture. Perhaps even more importantly, he was also the court painter to King Charles III of Spain. The king was a committed antiquarian and social reformer, and he had a natural preference for Mengs's serious, dignified, and pragmatic approach, which is admirably demonstrated in Mengs's *Self-Portrait* (289). It was Mengs who invited Goya to Madrid – in 1771.

GOYA: A SPANISH GENIUS

The influence of Mengs can be seen in the early work of Francisco Goya (1746–1828), particularly in his first portraits. Beyond that Goya fits into no category: his career spanned some 60 years, undergoing several metamorphoses, changing, and maturing in new ways right up to the mid-1820s. Goya seems to have worked solely from the center of his own genius. With the hindsight of history we can see that his essentially personal

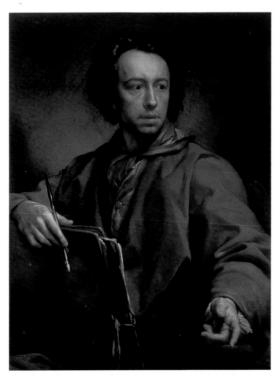

289 Anton Mengs, Self-Portrait, 1744, 22 x 29 in (55 x 73 cm)

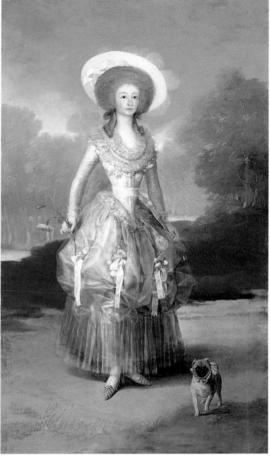

290 Francisco Goya, Marquesa de Pontejos, c. 1786, 50 x 83 in (127 x 210 cm)

vision of the modern world places him as an early Romantic (see p.259). His art was more in tune with the Baroque mixture of classical form and emotive personal expression – he cited Velázquez, Rembrandt, and Nature as his masters – than with the disciplined idealism of the Neoclassicists.

Goya possessed two outstanding gifts. He could pierce through the external facade of any sitter, to unmask the interior truth, a gift dangerous for any but the prudent. But he coupled it with a marvelous decorative sense, as is clear from his disarming portrait of the *Marquesa de Pontejos* (290). His work has such sheer beauty that even those almost pilloried in his portraits seem not to have grasped what had happened, being overwhelmed by wonder of the paint.

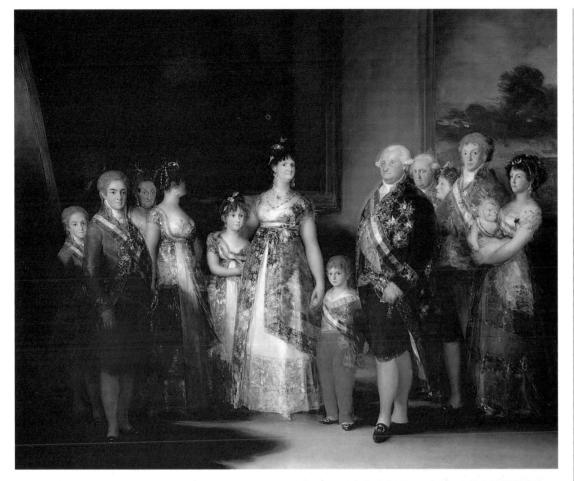

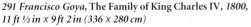

An ambitious family portrait

The Family of King Charles IV (291), a portrait of the ruling Borbón family, who were haughtily remote from their countryfolk, shows the sitters for what they are: vain and pompous. Yet they continued to patronize Goya throughout his career. The portrait is breathtaking in its cruel insight and its beauty. The royals are spread out like a frieze, heavy, dull-faced, and self-satisfied, squashed together with little elegance and no style. We wince for them, we pity the poor, stupid king and his vixenish queen, and sigh over the impenetrable crassness of their stumpy heir. Then we look again, at the dazzle of attire, the silks and laces, the infinite delicacy with which decoration, ribbons, jewels, and sashes are found to be glittering, gleaming, blazing out at us with undiminished glamour.

In every portrait, Goya puts his finger on the living pulse of the sitter. He does so with such intensity of power that we positively need the decorative qualities to offset the impact. When we look at his *Thérèse Louise de Sureda (292)*, our eyes dwell with continual fascination on the chair with its wonderfully inconsistent canary shade, and on the dress, which is a gleaming

292 Francisco Goya, Thérèse Louise de Sureda, c. 1803/04, 31 x 47 in (81 x 120 cm)

THE ROYAL FAMILY

In 1779 Goya was appointed to the position of first court painter under King Charles IV of Spain, who came to the throne in 1778. Court life under Charles IV was extravagant and self-indulgent, and full of personal intrigues. This miniature of the royal family in profile (above) was painted on silk by an unknown artist. It is of interest because of the way it shows the close resemblance between family members.

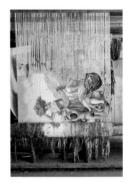

Tapestry cartoons

Goya worked at various times between 1774 and 1794 at the Royal Tapestry Factory, painting cartoons - the paintings from which the weavers copied their tapestries. Many of the cartoons have been lost, but 63 of Gova's are known today, either in their original form as cartoons or as the finished tapestries. This photograph shows a tapestry of Goya's cartoon The Vintage on the loom. Weavers worked the tapestry from the back. studying the cartoon through the threads.

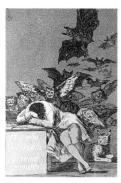

THE CAPRICES

Between 1797 and 1799 Goya produced a series of 80 satirical prints, known as the Caprices. Goya's friend Leandro Fernández de Moratín told Gova of some caricatures he had seen in England, and of how effectively they had ridiculed the establishment. This is an example of Goya's Caprices (above), entitled The Sleep of Reason. It was first sketched in 1797 and printed in 1798. In Spain such overt political criticism was not tolerated, and the Caprices were threatened with a ban by the Inquisition.

blue-black shot through with red and green — because the color makes it possible, through its seductions, for us to accept the force of the sitter's implacable gaze. Doña Teresa was a friend of Goya's in that her husband (also a painter) was one of Goya's drinking companions. But she was a "friend" mainly in the sense that Goya knew her and, we suspect, disliked her. She is well rounded, a compact bundle of womanhood, but she is tense and angry. She will not submit to the painter, challenging him with her glare and her uprightness, carefully coiffured but not for the warmth of love's embraces. There can be no comparable portrayal of a woman at once so attractive and so hostile.

Goya made his living by working for royalty and the establishment, and his political views appear confused: they may necessarily have been ambiguous. But it is impossible not to believe that he had an inborn hatred of tyranny. His art suggests a vehement independence, and perhaps his greatest painting is his version of a French war crime, the shooting of hostages after the Spanish people rose against Napoleon Bonaparte's rule in 1808. *The Third of May 1808 (293)* was painted six years after the event it portrays. This is only partly a patriotic picture, if it is that at all. It is not the French that Goya condemns but our

communal cruelty. It is humankind that holds the rifles, but humankind at its most utterly conscienceless. The victims, too, are Everyman, the huddled mass of the poor who have no defender.

Goya manages to make us feel that we are both executioners and executed, as if the dual potential for good or evil that we all possess were animated before us. Intensity of fear, pain, and loss on one side, and the extremity of brutality on the other: which fate is the worse? Who is really destroyed in this terrible painting, the depersonalized French or the individualized Spanish? Behind the dying rises a hillock, bright with light; the soldiers stand in a shadowy and sinister no-man's-land. Meanwhile, in the central background, the city endures.

This is a very dark painting, psychologically, but the really dark works were to be painted later, in Goya's sick old age, when he was deaf and lonely, a prey to the irrational fears that are subliminally present in all his work, giving it a secret bite. He used these fears to create images of our darkest imaginings – not just his own, or they would fail to produce their terrible effect. Goya's last works have a ghastly sanity in their insanity, as if all demarcations had gone, and we had all fallen through into the abyss.

Napoleon's invasion of spain

In December 1807 Napoleon Bonaparte (1769-1821) marched 130,000 French troops into northern Spain. By the spring of 1808, he had effectively taken control of Madrid, and by June he had deposed King Ferdinand VII, appointing his (Napoleon's) own brother Joseph as king of Spain. As a result a guerilla war began between the people of Spain and the French occupying forces. This culminated in the resistance uprising of May 2, 1808, and the execution of Spanish insurgents by French soldiers at various sites across Madrid on the following day.

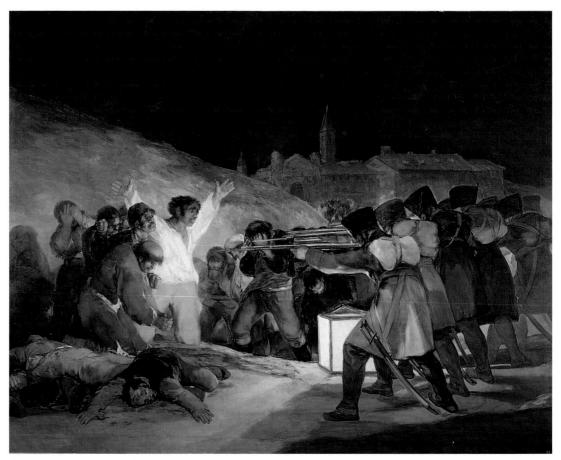

293 Francisco Goya, The Third of May 1808, 1814, 11 ft 4 in x 8 ft 6 in (345 x 260 cm)

THE THIRD OF MAY 1808

The Third of May 1808 is one of a pair of paintings focusing on the brutal suppression and subsequent mass executions of Spanish civilians who had risen against French troops on the May 2, 1808. Only when King Ferdinand VII was finally restored to power in 1813 did Goya quickly send him a petition asking to commemorate the "most notable and heroic actions or scenes of our glorious insurrection against the tyrant of Europe."

FIRING SQUAD

The soldiers are depicted as faceless automatons. Their bodies are locked together, like some form of destructive insect. They stand unfeasibly close to their victims, emphasizing the brutal and tragically ludicrous nature of the scene, and crudely mirror David's great Neoclassical painting, The Oath of the Horatii (see p.253). But while David's soldiers represent unity of will, Goya's represent only the mindless anonymity of the war machine.

CHRIST FIGURE

Our attention is immediately drawn to the man kneeling with outstretched arms, evoking the Crucifixion, about to be shot almost at point-blank range. However, his heroic gesture cannot detract from the overwhelming despair

range. However, his heroic gesture canndetract from the overwhelming despair and mortal terror that is depicted all around him, and we know his white shirt, brightly lit by the soldiers' lamp, will shortly be splattered with red.

"GLORIOUS INSURRECTION"

Despite his declared intention to immortalize the "heroic actions" of his countrymen, Goya has instead produced an image of a slaughterhouse. A dead man, lying facedown in a pool of blood, thrusts disturbingly into the foreground. He has been crudely foreshortened and appears twisted and mangled. His outflung arms suggest a supplication, mutely (and perhaps more eloquently) echoing the courageous, dramatic gesture of the next victim, who will shortly join

the pile of corpses in the foreground.

GOYA'S DEATH

By 1825 Goya's health had deteriorated. He spent his remaining years in exile at Bordeaux in France. In 1826 he made the long, hard journey to revisit Madrid, after which his eyesight became so weak that he had to paint with the aid of a magnifying glass. Goya died on the night of April 15, 1828, in Bordeaux, and remained buried there until 1901. when his body was moved to Madrid. Later, in 1929, it was exhumed again and moved to a tomb in the Hermitage of San Antonia de la Florida. This painting of the original Bordeaux tomb is by Gova's old friend Antonio Brugada.

OTHER WORKS BY

Don Manuela Silvela (Prado, Madrid) The Marqués de

Castro Fuerte
(Museum of Fine Arts, Montreal)

The Duke of Osuna (Frick Collection, New York)

The Duke of Wellington (National Gallery of New Zealand, Wellington)

Isabel de Porcel (National Gallery, London)

> Young Woman with a Letter (Musée Lille)

294 Francisco Goya, The Colossus, 1810–12, 41 x 45 in (105 x 115 cm)

The Colossus (294) has a subtitle, Panic. It shows all humanity in flight, streaming away like ants from unimaginable horror – an analogy for the monstrous destruction of war, one of the bloodiest in Spain's history (see column, p.250). Goya has visualized this dread for us, given it concrete form: a huge, hostile presence fills the sky, not yet looking down at the terrified masses below, merely flexing his muscles. Existence is not what we had thought: here are different rules and we do not know what they are. What we are contemplating is our common nightmare.

Goya gives this fear an awesomely convincing form. He is painting his own dreads, but his genius reveals them to be our own. They may in fact be more our own than we realize. The colossus is actually looking away from the fleeing people: are we perhaps seeing more of a threat in this mysterious form than is literally there? He can even be seen as a protective colossus, the native genius of Spain, arising in might to challenge Napoleon. Yet somehow this benign interpretation does not spring readily to mind.

There is a darkness in Goya, an anger, a wildness, that represents something within our hearts, repress it though we may. It is precisely this irrational fury of the imagination, prefiguring the Romantics – poets such as Shelley, Keats, and Byron, or composers such as Schumann or Berlioz – that gives Goya the edge over his contemporary, the great French Neoclassical artist Jacques-Louis David.

THE NEOCLASSICAL SCHOOL

Neoclassicism clearly proved to be a popular philosophy among artists in the middle of the 18th century. It manifested itself in a variety of national schools, in varying degrees of intensity. In England, it was found in a modified form, in the work of Reynolds and his followers. In Italy it was important, for Rome was the world center for Neoclassical thought, attracting such personalities as the first "true" Neoclassicist, Anton Mengs. But Neoclassicism did not really become established as a coherent movement in the arts until it emerged in quintessential form in the late 18th century, in France.

In the middle of the 18th century, as in the middle of the 17th (see p.216), artists turned to Classicism in reaction against the frivolity of art of the previous generation. The 18th-century Neoclassicist philosophy was reformist in character, calling for a revival of ancient standards of seriousness, morality, and idealism. It was taken up readily by artists and writers who found themselves in the midst of social and political upheaval.

With the French Revolution (see column, p.255) breaking out in 1789, its potential for use in propaganda was not wasted. Jacques-Louis David's (1748–1826) style is nobly classical, the whole image so integrated that each section supports the other and there is a fine concentration of significance. The first great Neoclassical painting, painted in 1784-85, *The Oath of the Horatii* (295) is theatrical, but it is honestly so.

THE OATH OF THE HORATII

An argument between the peoples of Rome and Alba threatened to lead to war, and so it was decided that each side (the Horatii and the Curatii) would send three men to fight for their city. After the battle only one man, Horatius, remained alive. He discovered that his sister had been betrothed to one of the enemy Curatii. In revenge he slew his sister and was found guilty of murder, but he managed to get a reprieve from the death sentence. In art, the three brothers are usually shown swearing a sacrificial oath in front of their father.

295 Jacques-Louis David, The Oath of the Horatii, 1784–85, 14 ft \times 11 ft (427 \times 335 cm)

296 Jacques-Louis David, Madame Récamier, 1800, 8 ft x 5 ft 9 in (244 x 75 cm)

NEOCLASSICAL SCULPTURE

The first fully Neoclassical sculptor was Antonio Canova (1757-1822), who began his career in Venice. He established a reputation as a unique modifier of the classical Greco-Roman style, his most famous piece being The Three Graces. He ran a large studio producing a wide range of pieces, including commissions for Napoleon and Wellington and the beautiful Psyche Revived by the Kiss of Love, illustrated above.

All elements in the painting are geared toward facilitating our understanding of the drama: three brave Romans are vowing their lives away for their country. The uprightness of their intent is shown in the straightness of their outstretched arms as they receive swords from their father. Great symmetrical arches stabilize their act of taking the vow, setting it in a noble context. The austerity and clarity of the colors emphasize the selflessness and totality of their fervor.

The men are hard, concentrated, active; across the room huddle the women, soft, distracted, passive. The contrast between them is absolute, and it is in this uncompromising climate of absolutes that David feels most at home. When David painted *The Oath of the Horatii*, the Revolution was not far away, and the picture contains a clear reference to this.

Probably the works of David that are most compatible with present-day sensibilities are his portraits. Here we have no need to set him in his historical setting before we can respond fully: he is wonderful in the sheer conciseness of his vision. There are no superfluities, yet the bareness has a confident rightness about it.

Madame Récamier (296) is the epitome of Neoclassical charm. We see that she knows she has charm and that she is almost consciously watching its effect upon the painter. Everything on and about her is sophisticatedly simple: she scorns, we feel, the vulgarity of devices, but she is all one living device, forcing us to accept her at her own valuation. David sees that she is lovely, and makes us see it as well: she reclines because she is sure of the power of her charm, secure behind the ivory chill of her pose. But he seeks to know her at a level below the conscious, and in that lies the forcefulness of the image.

A MARTYR OF THE REVOLUTION

The absoluteness of *The Oath of the Horatii* (see p.253), intrinsically overstated but subjectively real, is what makes *The Death of Marat* (297), a revolutionary icon. David was very involved in the Revolution, debating in the assembly with a furious excitement, and was intellectually swept away, along with many others. Marat, whom he here idealizes as a modern saint, was assassinated by the royalist Charlotte Corday, who prepared for her act with fasting and prayer.

She has been given the name *The Bather* in an attempt to make sense of her position and her cap, but Ingres hardly needs the trappings. It is that heavy, dimpled back he needs, too long in its luscious curvature, obsessing the artist and affecting the viewer through the force of his emotion. The same impossible curve distinguishes his Thetis. *Thetis Entreating Jupiter (300)*, in which the male is as impossibly broad as the female is supple, is a comic picture, quite unintentionally, because of this body fixation.

Ingres believed that "drawing is the probity of art," and his linear grace carries him magnificently through most hazards. But Thetis is stretching out an arm with elastic bones, a dislocated limb that halts us in our gaze and alerts us to the comely deformations the artist is trying to persuade us to accept. Ingres obviously feels that Jupiter has an iconic majesty, which has an odd truth to it, but the clamlike beauty at his knees undoes whatever faith we have managed for Jupiter. The picture fails, but so gloriously, so alarmingly, that it fascinates still.

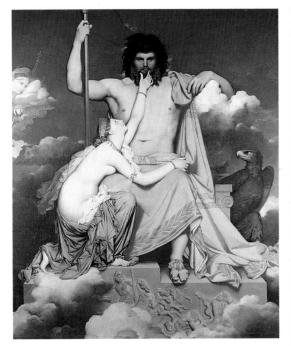

300 Jean-Auguste Ingres, Thetis Entreating Jupiter, 1811, 8ft 5 in × 11 ft 6 in (257 × 350 cm)

THETIS AND JUPITER

The legend of Thetis entreating Jupiter is told in the Iliad. Thetis, the mother of Achilles, is sent by her son to Jupiter with a petition concerning his quarrel with Agamemnon. In paintings the scene usually depicts Jupiter, scepter in hand, enthroned on Mount Olympus. Thetis kneels before him and is seen imploring with the god to intervene in her son's fate.

299 Jean-Auguste Ingres, La Grande Odalisque, 1814, 64 x 36 in (163 x 91 cm)

CONTEMPOARAY ARTS

1764

Mozart composes his first symphony at the age of 8 years

1792

Mary Wollstonecraft writes A Vindication of the Rights of Women

1804

The English Watercolour Society is founded

1813

Jane Austen writes Pride and Prejudice

1818

The Prado Museum is founded in Madrid

1826

The U.S. Academy of Design is founded

1837

Dickens's *The Pickwick Papers* is serialized

1862

Victor Hugo writes Les Misérables

MARIE ANTOINETTE

After marrying the Dauphin in 1770, Marie Antoinette (1755-93) became queen of France on the coronation of her husband Louis XVI in 1774. Unfortunately, the miseries of France became identified with her extravagances. As a feminist, Marie Antoinette supported female artists, including Vigée-Lebrun, and was involved in the march on Versailles in 1789. After the execution of her husband in 1793, she was placed under arrest and eventually guillotined.

THE FRENCH SALON

The Salon of 1667 was the first official art exhibition held in France and was limited to members of the Royal Academy. The term Salon derived from the Salon d'Apollon, in the Louvre, where the annual exhibitions were first held. Until the 19th century the limited number of artists who were allowed to show at these salon exhibitions

had a monopoly on publicity and sales of art. This painting, *L'Innocence*, is by Adolph-William Bouguereau (1825–1905), who was one of the key supporters of the 19th-century salon.

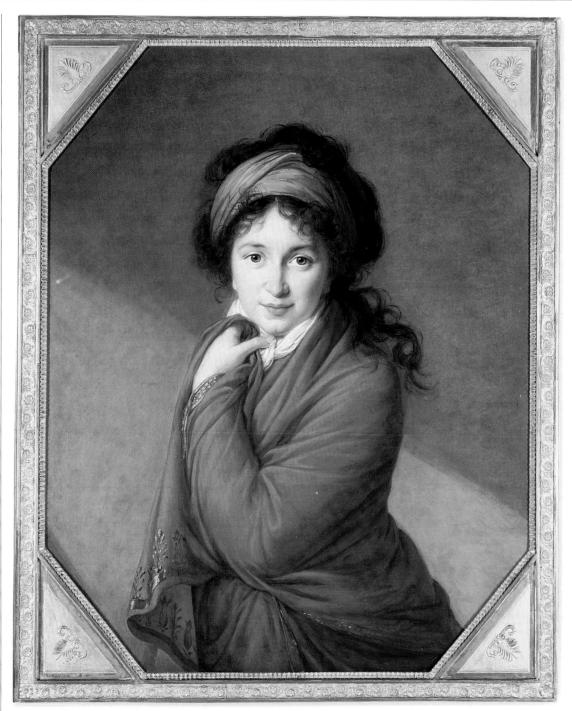

301 Elisabeth Vigée-Lebrun, Countess Golovine, c. 1797–1800, 26½ x 33 in (67 x 83 cm)

ROYALIST IN REVOLUTIONARY TIMES

(Marie) Elisabeth (Louise) Vigée-Lebrun (1755–1842) was a clear-minded supporter of the monarchy. She fits uncomfortably within the revolutionary climate that so excited David. She understood Neoclassicism but transcended its formalities, delighting in the freedoms of the Baroque, with its strong, contrasting colors. A charming woman, she made friends with Marie Antoinette and had an instinct for the socially acceptable. At times, her insight can take her beyond this, as in her fine portrait of the

Countess Golovine (301). It is impossible not to warm to the completely feminine frankness of this Russian aristocrat, her ingenuous gesture with her scarlet cape and the seductive simplicity with which her rosy face smiles out at us beneath the carefully disheveled black curls. This is a strong woman, for all her charm, and Vigée-Lebrun must have recognized an equal. At the outbreak of the Revolution, Vigée-Lebrun went into exile in Italy. She went to London in 1802, where she painted several important portraits, returning to Paris in 1805.

THE GREAT FRENCH ROMANTICS

If applied to the arts today, the word Romantic suggests a certain theatricality and sentimental idealism. Its original meaning, however, had very different associations. While Neoclassicism was associated with the culture of antiquity, the Romantic was associated with the modern world. Romanticism admitted the "irregular": the wild and uncontrolled aspects of nature (both animal and human, both beautiful and ugly). The necessary strategy for such expression was inevitably incompatible with the dogma of Neoclassicism and its established boundaries of beauty and subject matter.

The pastoral idyll suggested by some of the country scenes of Gainsborough (see p.240) was fast disappearing under the Industrial Revolution, while in France, revolution of a more violent kind brought irrevocable change to the social order. The grandeur and idealism of Neoclassicism were at odds with the realities and hardships of an increasingly industrial society. Prefigured by Goya (see p.252), Romanticism stands for an outlook, an approach, a sensibility toward modern life. France was its true home, and that of its earliest innovators, Théodore Géricault (1791–1824) and Eugène Delacroix (1798–1863).

If Ingres (see p.256) was the great Neoclassicist, these were the great Romantics. Their art was diametrically opposed to his, and in the bitter debate between the two schools, theirs proved the stronger. Ingres was concerned mainly with the control of form and with outward perfection as a metaphor for inner worth. The Romantics were far more interested in the expression of emotion – through dramatic color, freedom of gesture, and by their choice of exotic and emotive subject matter. *The Raft of the Medusa* (302) was enormously important as a symbol of Romanticism in art.

JEAN-JACQUES ROUSSEAU

Jean-Jacques Rousseau, (1712-78) the political philosopher and author, had a great influence on the Neoclassical period. It was not until 1750 that he made his name as a writer with his Discourse on the Sciences and the Arts, which argued that there was a schism between the demands of contemporary society and the true nature of human beings. His argument for "Liberty, Equality, and Fraternity" became the battle cry of the French Revolution.

302 Théodore Géricault, The Raft of the Medusa, 1819, 23 ft 6 in x 16 ft 1 in (717 x 491 cm)

303 Théodore Géricault, Woman with the Gambling Mania, c. 1822, 26 × 30½ in (65 × 77 cm)

SCHOPENHAUER

In the 19th century, Arthur Schopenhauer (1788-1860) became a major influence on the philosophy of art. He argued that art was the only kind of knowledge that was not subservient to the will. He emphasized the active role of will as the creative but irrational force in human nature. After taking a teaching position in Berlin in 1820, he became a direct rival of Hegel but failed to attract enough people to his lectures. He retired to a reclusive life in Frankfurt, accompanied only by his poodle, but eventually he earned a reputation as a philosopher. He was to be very influential on future movements such

as the Existentialists.

GÉRICAULT'S RAFT

The raft carried survivors from a French naval ship, *La Méduse*, which sank en route to West Africa in 1816. The captain and senior officers took to the lifeboats and left a makeshift raft for the 150 passengers and crew. During 13 days adrift on the Atlantic, all but 15 died. Géricault's choice of this grim subject for a gigantic canvas went against traditional artistic rules. It also implied criticism of the government, for the appointment of this unseamanlike captain had been an act of political favoritism.

This radical work was accepted, but grudgingly, by the artistic establishment: the gold medal it won at the Paris Salon of 1819 was merely a way of denying Gericault the controversy he sought. Géricault forces us, almost physically, to accept the reality of human suffering and death. It is death in the most terrible conditions, anguished, tortured, long-drawn-out, without nobility or privacy. The drama is all in the physical details. It is as if Géricault eschews the use of color as

too trivial, too joyous, for such a scene. There is no space for the viewer in which to escape the terrible impact of that rough triangle of raft. It juts out at us, a blow in the solar plexus.

Disappointed with the painting's tepid reception in France, Géricault took it to England, where he stayed for a few years, deeply impressed by Constable (see p.268).

Géricault's life was short but intense. He sought after the real with a hungry passion, but it was to make the real transcendent that he sought. There is a hypnotic power in his portraits of the insane, such as *Woman with the Gambling Mania* (303). These tragic and haunted faces had some personal resonance for him. He is not regarding their sufferings objectively; there is a moving intensity of reaction. He makes us feel that the potential for these various imbalances are endemic to us all. It is our own possible future that we contemplate.

Delacroix: the great romantic

Géricault had a preoccupation with death and the morbid that is absent in his contemporary, Delacroix, whose characteristic is a sense of the romantic fullness of being alive. After Géricault's death in 1824, Delacroix was regarded as the sole leader of the Romantic movement, but his art was very much his own, and soon transcended Géricault's early influence. Like Géricault, Delacroix received a classical training (in fact they first met as students of the Neoclassicist Pierre-Narcisse Guérin) but, despite much

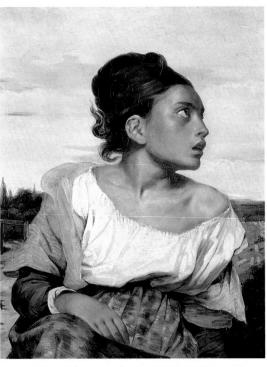

304 Eugène Delacroix, An Orphan Girl in the Graveyard, 1824, $21\frac{1}{2} \times 26$ in $(54 \times 65$ cm)

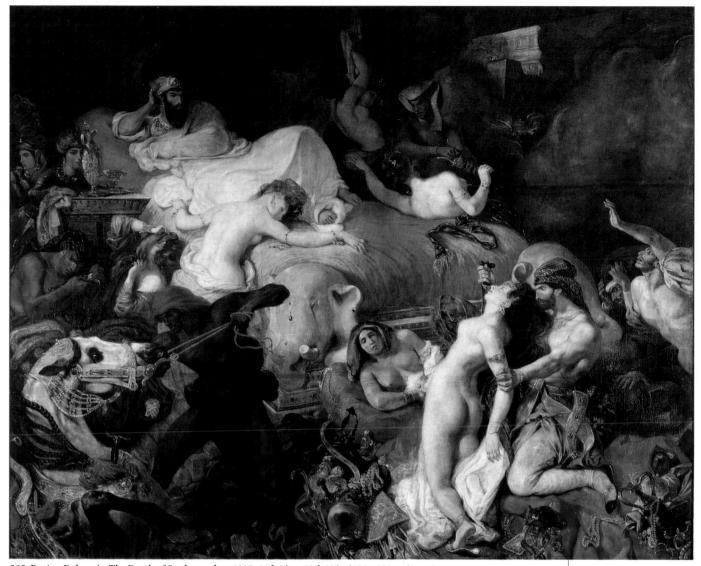

305 Eugène Delacroix, The Death of Sardanapalus, 1827, 16 ft 3 in x 12 ft 10 in (496 x 391 cm)

criticism from the salons, he went on to develop a uniquely animated and expressive style, greatly influenced by Rubens (see p.186), employing a characteristically vivid palette that places him as one of the great colorists. He has an almost Rubensian energy, a wild and sometimes reckless vitality that is the exact visual equivalent of Byronism. Like Byron (see column, p.262) he can be histrionic at times, but generally he exults with the vigor of the truly great and carries the viewer uncritically away.

Delacroix is an extremely active artist. When he paints *An Orphan Girl in the Graveyard (304)*, she is not a tearful or passive orphan, but a vibrant young beauty, avid for life, alarmed and alerted by the nearness of death, but slackmouthed and bare-shouldered as she looks away from the graves toward rescue. Her eyeballs have the gleam of a frightened horse, but the tenseness of her neck muscles is completely healthy. She is not a victim, despite her label.

The Death of Sardanapalus (305) shows Delacroix at his most brilliantly unpleasant – appropriately, for Sardanapalus was an Assyrian dictator. The gorge rises to see female slaves treated as chattels just like the horses and jewels. If sadomasochism is to be glorified, this is its glorification. Only Delacroix, with his almost innocent delight in movement and color, could even attempt to carry it off.

Like Géricault, Delacroix exulted in horses, especially those from the exotic wastes of Arabia or Africa. But he did not share the younger Romantics' interest in contemporary, local reality. When he deals with modern events he distances himself by setting them in a far away, exotic location. Such detachment sets him apart from the Romantic movement as such, though not from the Romantic attraction to the exotic. It also reveals his concern that art should still strive to attain the timelessness and seeming universality of the great art of the past.

OTHER WORKS BY DELACROIX

The Assassination of the Bishop of Liège (Louvre, Paris)

Education of the Virgin (National Museum of Western Art, Tokyo)

Hercules and Alcestis (Phillips Collection, Washington, DC)

Odalisque (Musée des Beaux Arts, Dijon)

Death of Valentino (Kunsthalle, Bremen)

The Lion Hunt
(Art Institute of Chicago)

Death of Ophelia (Neue Pinakothek, Munich)

LORD BYRON

One of Delacroix's great heroes was the poet George Byron (1788-1824). Byron had supported the Greeks in their struggle against the Turks since he visited Greece in 1809-10 and witnessed the terrible conditions in which they were living. With the outbreak of the War of Independence in 1821, Byron sailed to Argostoli to lead a private army of soldiers. Soon he became disillusioned with the internal fighting within his ranks, and his efforts were overshadowed by mutinies and illness. He died of a fever on April 19, 1824. This illustration shows Byron dressed in the national Greek costume.

TRAVEL JOURNALS

In the mid-19th century it became popular for artists to go on tours of distant countries. In 1832 Delacroix traveled to North Africa and filled seven notebooks with drawings and watercolor sketches like these studies (shown above) of the walls around Meknès. The experiences of his six-month tour of Morocco and Algeria fueled his imagination for the next 30 years.

Delacroix spent time in Tangiers and Morocco, and he remained in tune with this romantic world all his life. He felt a temptation to the violent, the extreme, and exorcised it in his paintings of the Near East, rather than of his own periodically turbulent country. Here, in a wild swoop of motion and a rolling swirl of color, he can show *Arabs Skirmishing in the Mountains* (306). He claimed to have seen these attacks and even taken part, but their truest origin is in his imaginative bonding with the warriors. He is himself in all parts of the picture,

in the frenzy of the horses, the maneuvers of the fighters, their pain and anger, their courage and despair. He is at one with the landscape, wild and high, desolate, infertile, yet fiercely loved.

The citadel on the cliffs, though, remains, above the smoke and the fury, and that, too, has a personal meaning. Delacroix never loses himself in his greatest works but, with instinctive tact, leaves always a place for detachment. There is an inner stability that keeps the work from bluster, however near the edge it may go.

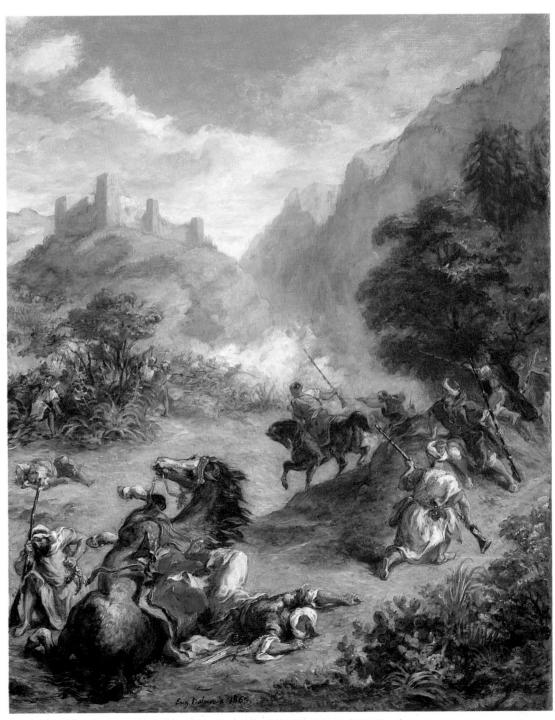

306 Eugène Delacroix, Arabs Skirmishing in the Mountains, 1863, 30 x 36½ in (75 x 92 cm)

Arabs Skirmishing in the Mountains

Delacroix produced this painting a few months before his death in 1863. It has been suggested that it depicts a battle between the Moroccan sultan's tax collectors and local rebels, and Delacroix may have come into contact with such incidents when he traveled to Meknès with the Moroccan foreign minister in 1832. (An entry in his diary of 1832 suggests this.) Historical details are, however, irrelevant to the real subject of the painting, which is a Romantic celebration of drama, color, and light, and of the exotic. It is primarily a storyteller's painting, reinvented 31 years after Delacroix's Moroccan journey, and whatever its connection with real events, it exists as a purely fictitious scene.

that leads our eye along his body, up the path described by vegetation to the line of kneeling riflemen, where the direction is reinforced by the emphatic diagonals of their rifles. The sweeping movement then continues on, led by the galloping horseman, into the more distant action.

DISTANT ACTION

The gunmen fighting in the distance are picked out largely by their headdresses and guns, within the brilliant cloud of dust, or possibly heat haze. The livid, broken surface of the horse's flank (below), which provides a sharp focal point for the foreground, gradually gives way to a broader, more relaxed application of paint as the action recedes, culminating in the ghostly fortress on the mountain.

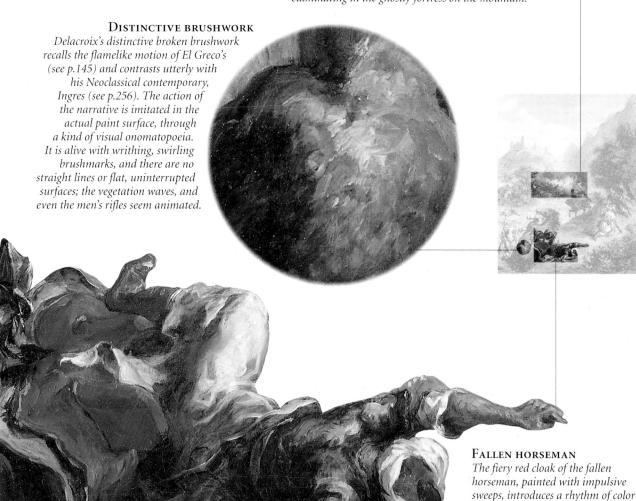

263

ROMANTIC LANDSCAPES

In their landscape paintings the Romantics gave free rein to their daring and their imagination. Art lovers in the 19th century may have lamented the lost rational serenity of the 17th-century master Claude Lorrain (see p.220), but many of them also saw that Turner was his equal. Turner's revelations of atmosphere and light answered the need for a new artistic language. Constable surprised the world with a new awareness of, and a new openness to, nature as it actually is, without idealized or stylized form.

The French were by no means the only Romantics: Germany was the original "land of the Goths." A touch of that heavy symbolism that so often characterizes German art is seen in Caspar David Friedrich (1774–1840). It is primarily the countryside that Friedrich sees as a symbol, a mute praise of its unseen and unseeable Creator. Germanic mysticism has never been very exportable, and Friedrich is only today

not easy to paint, but Friedrich succeeds. *Monk by the Shore (307)* has a daring simplicity. Three great bands stretch across it – sky, sea, land – with the one vertical note of the human being, who gathers the muteness of nature into himself and gives it a voice. "Monk" comes from the Greek for "alone," and it is this loneliness that Friedrich shares with us. In the sense of this picture, we are all monks and we all stand on the shore of the unknown.

being seen as a powerful, significant artist.

Religious art without an explicit religion is

True Romanticism – in the sense of the broad movement that was bound up with the demise of Neoclassicism – necessarily belongs to France. On the other hand, speaking strictly chronologically, a Romantic tradition had emerged earlier in

England than it did in France; in a way it had been there all along, in the form of a particularly English sensibility toward the landscape – exemplified in the paintings of Gainsborough (see p.240). This early sensibility reached its full Romantic expression in the works of England's two great landscape painters: Turner and Constable.

TURNER'S LANDSCAPES

Turner (Joseph Mallord William, 1775–1851) disturbed those who met him by conforming little to the accepted idea of a great artist. He remained an unrepentant Cockney, not overscrupulous about cleanliness or correct pronunciation, but passionately intent on the things that mattered to him. He was recognized as great from the beginning, and his career was a source of baffled but resoundingly affirmative reactions throughout his life. If his pourings and soakings of paint were beyond comprehension, they bore the certain stamp of genius.

We associate Turner with color, but his early work is dark, the actuality of the scene being an overriding concern, and beyond this, its inherent drama. In midcareer, it is light itself that has begun to fascinate him. Place never loses its necessity, but it is as a focus for the light, as a precious receptacle, that it matters.

He was friendly with a group of English watercolorists who were at that time developing an art that was very much based on the atmosphere of a place, as well as its topographical fact. This new art form was called the "picturesque." Turner's early training was as a watercolorist, and he would eventually come to realize watercolor's special potential for freedom of expression in his oil paintings, creating a completely unprecedented new language.

Mortlake Terrace (308) is without obvious drama. There is an early summer evening, the Thames flowing gently by, pleasure boats venturing out, tall trees lining the terrace and swaying lightly in the breeze. Shadows fall across the short grass, a few bystanders watch, a small dog leaps onto the parapet. Nothing really happens, yet the drama is as vibrant as ever. It is light that

JOHANN WOLFGANG VON GOETHE

Germany's greatest poet, Goethe (1749-1832) pioneered Romanticism in German literature in the 1770s. He believed that great art must simulate the creative force of nature. In his later life he also studied various sciences, including optics. Goethe's writings on art included a book on the theory of color, which opposed Newton's discovery that there were seven colors in the spectrum and argued that there were only six in natural daylight conditions.

307 Caspar David Friedrich, Monk by the Shore, 1810, 67 x 43 in (170 x 110 cm)

308 J.M.W. Turner, Mortlake Terrace, c. 1826, 48 × 36½ in (122 × 92 cm)

is the artist's preoccupation; all is a pretext for his enamored rendering of this delicacy of sunlight. Light quivers in the air, it bleaches the far hills, it makes the trees translucent, it throws a dark, diagonal patterning on the dull turf that takes on an entranced quality; light hides the world, and reveals it.

The Napoleonic wars ended in 1815, and the continent became accessible once more. Turner began his long series of travels in European countries. Particularly important were his trips to Italy: in 1819 he spent three months in Rome and then visited Naples, Florence, and Venice. He revisited Italy in 1829, 1833, 1840, and 1844. His understanding of the mechanics of light was greatly enhanced by the time he spent in Italy, especially Venice, and this is what marked the beginning of his last and greatest phase.

Steamboat in a Snowstorm (309) shows Turner at his most impassioned. We are presented with a whirlwind of frenetic energy, an almost tactile communication of what it means to be in a storm at sea, and a snowstorm at that. The opacity of the driven snow, the dense clouds

309 J.M.W. Turner, Steamboat in a Snowstorm, 1842, 48×36 in $(122 \times 91$ cm)

TURNER'S TECHNIQUE

This caricature by Richard Doyle, entitled *Turner Painting One of His Pictures*, was painted for the *Almanack of the Month* in 1846. It makes the point that Turner's love of chrome yellow, which he had used consistently since the 1820s, was still considered shocking by the public. Turner's use of luminous yellows, blues, and pinks was his most characteristic feature.

swirling from the smokestacks, the furious commotion of the water – all combine with almost frightening realism. And yet, take away the title, change the century, and we would think we were looking at an abstract.

This is the greatness of Turner, an almost reckless appreciation of natural wildness, controlled solely by the power of the artist's understanding. In controlling the scene, Turner seems to control nature itself, a godlike quality, and he communicates this orderliness to us. The viewer experiences the wildness, and yet is able to hold it in perspective. There can be few things more exhilarating than to encounter the full force of a great Turner.

EXHILARATION OF LIGHT

In Turner's work from this time until his old age, light has conquered so completely that all dissolves in its radiance. In these pictures, the Romantic glorification and love of nature's drama are shown to the fullest. It is here that the deeply poetic nature of Romantic painting first finds supreme visual form. As his rival John Constable (see p.268) put it, late Turners are as though "painted with tinted steam."

Approach to Venice (310) needs its title, since we are presented with a haze of colored nothingness, through which there loom the bright accents of what we make out to be boats and a far-off steeple. The water is golden with light, but so is the sky: where does one end and the other start? There is no perspectival depth, just space, height, clouds, dazzle, glory.

The impression given is of immense exhilaration, almost ecstatic in its power; the natural is allied with the spiritual. Turner has torn the world into paper shreds and thrown them up to the sun: there they catch fire and he paints them for us, crying "Alleluia!"

Not until the 20th century, with Pollock, Rothko, and de Kooning (see pp.368–372) was there such a daring disregard for realism. Yet Turner knew precisely what he was aiming at. The clouds of glory, the lakes of light, the stone and mortar transformed into citadels of Heaven: these are not inventions. Few people have not seen the extravagances of glory that the sun produces with casual ease morning after morning. It was Turner's special gift to know that these extremes of light and color demand from the artist an extremity of technique.

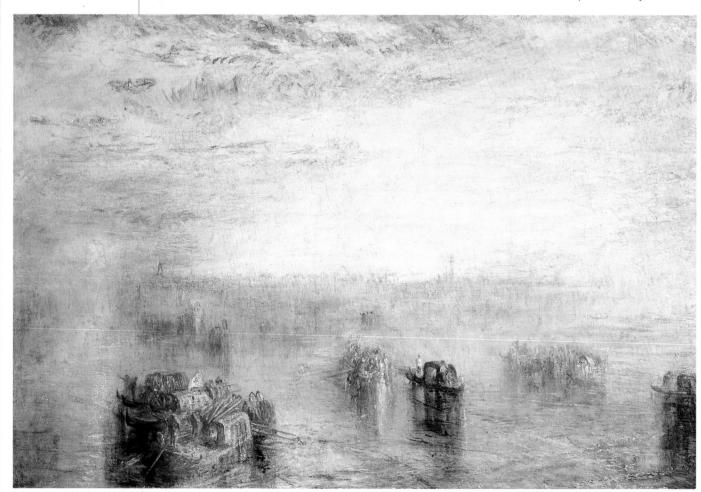

310 J.M.W. Turner, Approach to Venice, c. 1843, $37 \times 24\frac{1}{2}$ in $(94 \times 62 \text{ cm})$

Approach to Venice

Turner visited Venice several times. He painted *Approach to Venice* on what was probably his last visit there. As a late work it exceeds, stylistically, his earlier paintings of Venice, pushing further his daring with Romantic atmospherics and departing from the topographic reality of the Venetian sea- and townscape even more than before.

DARKENING SKY

Turner has created a canopy of orange and blue over the setting sun. These are the strongest touches of color in the painting and suggest that the colors of the sunset have not yet reached their peak of intensity before they finally disappear. Over a smooth (and now heavily cracked) surface, these "abbreviated" clouds have been quickly and lightly rendered, and Turner has created a wonderful sense of transition as the sky moves rapidly from day to night.

Beyond the ostensible subject matter of Approach to Venice, with its important-looking barges sailing toward Venice, is the real subject of the painting: the duel between sunset and moonrise. To the right of the canvas, the sun is setting in a spread of diffused, pale lemon light. To the left, casting its cooler reflection down the length of the picture, is the ascending full moon. When Turner first exhibited this painting, he accompanied it with these lines from a poem by Byron:

> "The moon is up, and yet it is not night, The sun as yet disputes the day with her."

DISTANT CITY

The mysterious and unnamed procession of barges moves silently through water that, more than anything, resembles liquid gold, toward the shimmering, floating city of Venice. The distant city seems to be dissolving, no more on firm ground than the barges themselves, and takes on the quality of a mirage. Indeed, when this painting was exhibited in London, a critic for the weekly magazine The Spectator wrote: "beautiful as it is in color, it is but a vision of enchantment."

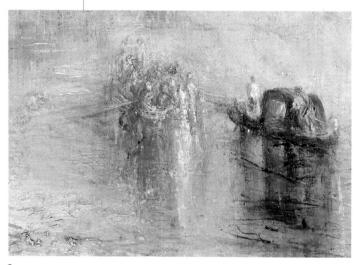

LAYERED SURFACE

Turner habitually prepared his canvases with a thick layer of white oil ground, which would largely obliterate the "tooth" of the canvas. Over this smooth surface he would apply thin, pale washes of those colors that were to be used full strength later. This resulted in a fresh, glowing surface over which he built up subsequent layers. To the barge on the left he has added thick, crusted paint, which, having a jeweled effect, catches natural light falling onto the picture and provides areas of focus. Conversely, the shadows of the dark barge on the right have been applied with thin washes of black so that they appear to sink within the surface.

NEOCLASSICAL ARCHITECTURE

The distinction between Greek and Roman architecture came to be better understood in the 18th century due to the rediscovery of early Doric temples in southern Italy and Sicily, and also because of the publication in 1762 of Stuart and Revett's Antiquities of Athens. Neoclassical architecture rejected the plasticity of the Baroque with its incorrect use of form and instead concentrated on perfecting the classical form. This photograph shows the Pantheon (a temple dedicated to all the Roman gods) in the gardens at Stourhead in southwest England.

LANDSCAPE GARDENS

During the course of the 18th century, the landscape gardens of England progressed from the Arcadian landscape (seen at Stourhead and Stowe), through the Ideal landscape, to the Romantic idvll. The greatest landscape artist of the period was Capability Brown (1716-83), who led the movement away from the formal toward the natural Brown used smooth lawns, lakes, dells, and ha-ha's (sunken fences that do not interrupt the view) to create a poetic whole with spatial variety and contrasting moods.

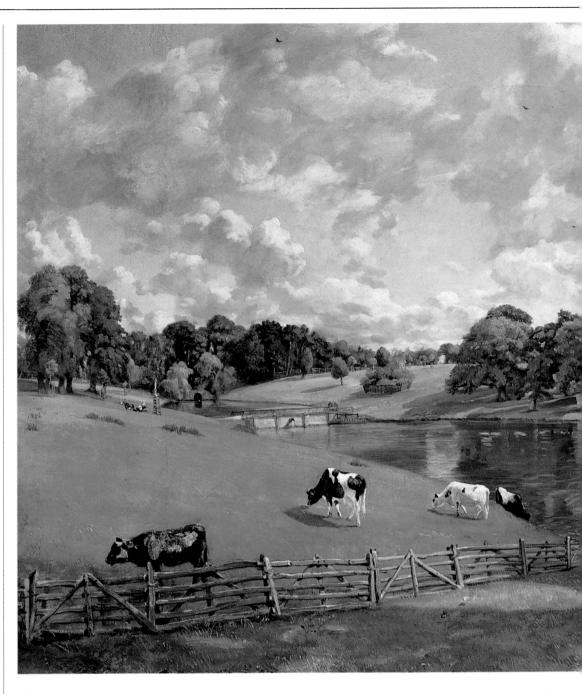

CONSTABLE - POETRY IN REALITY

Turner's Romanticism, though full of drama, is not melodramatic, and indeed "Romantic" does not preclude the humble and ordinary, as we have already seen in Turner's treatment of a quiet sunset at Mortlake (see p.265).

Constable (1776–1837) is as intense as Turner and, in his less obvious manner, fully as daring, but he always reveres the factuality of what he paints. Since he sees those facts as purely poetic, there is no loss of intensity. Turner loved the grandiose and the magnificent. Venice was his natural habitat. Constable loved the ordinary, and his love and natural dwelling place was the flat land of his beloved Suffolk. He is the natural heir to Gainsborough's lyricism (see p.240), but

while Gainsborough was still largely concerned with extracting the beautiful and harmonious in the natural landscape, Constable saw the long meadows and winding canals, the old bridges, and the slimy posts by the rivers as being inherently as lovely as anything the heart of man could desire. All his youth and all his hope of Heaven were intimately connected with these rural simplicities, already under threat from industry as he began his arduous and none too successful career as an artist.

Turner lived unmarried; Constable needed the solace of a wife to share his loneliness. Even shared, this loneliness is always discernible. The sun may shine and the trees wave in the breeze, but a Constable landscape carries a deep sense

311 John Constable, Wivenhoe Park, Essex, 1816, 40 x 22 in $(102 \times 56 \text{ cm})$

of loss and yearning. After the early death of his beloved wife, this yearning becomes even more apparent. Yet it is a resigned yearning and an acceptance of life as it is, and of the consolation given by the beauty of the material world, our nearest image of lost Eden.

The intensity of Constable's poetry was not obvious to himself: he believed that he was the most throughgoing of realists. Even an early work, though, like *Wivenhoe Park*, *Essex* (311), despite its conscientious fulfillment of the owner of the park's desire to illustrate every aspect of his property (which Constable found "a great difficulty") is still a work of imaginative ardor. The reality of all he portrays is evident: there fish the Wivenhoe tenants, on the fish-stocked

lake; there wander the dairy cows, belonging to the farm; there, tiny in the distance, is the family in the trap; there in the background is the stately home. Yet all this is bathed in a silvery sunlight, so that the waters shimmer and the shadows beneath the great, spreading trees entice the viewer toward their shade.

Over the earth and water towers a pale and clouded sky, hinting at rain to come, the blissful rain that every estate needs. Peace and silence, contentment and prosperity are all imagined and realized in the actual details, so that Wivenhoe Park is both real and ideal, both in our world and removed from it.

JOHN RUSKIN The art critic John Ruskin (1819-1900) took it upon himself to rescue Turner from obscurity. In 1843 he wrote his treatise Modern Painters in defense of Turner. He then developed it into a series of volumes concerning artistic tastes and ethics. Ruskin belonged to the Romantic school in his conception of the artist as inspired prophet and teacher. His personal life, however, was deeply unhappy, and he died a lonely Christian socialist, fighting against the onslaught of the Industrial Revolution.

OTHER WORKS BY CONSTABLE

Hampstead Heath (Fitzwilliam Museum, Cambridge, England)

View at Epsom (Tate Gallery, London)

Naworth Castle (National Gallery of Victoria, Melbourne)

Coast at Brighton, Stormy Weather (Yale Center for British Art, New Haven, Connecticut)

View of Salisbury (Louvre, Paris)

The Watermill (National Museum, Stockholm)

Wooded Landscape (Art Gallery of Ontario, Toronto)

Songs of innocence

As a child, the English poet William Blake (1757–1827) saw visions from which he drew lifelong inspiration.
One of William Blake's most significant inventions was the printed book in which the illustrations were completely integrated with the text, both being printed from a single metal plate.

The two mediums of poetry and engraving came together triumphantly in 1789 when he published his Songs of Innocence. This illustration shows the original title page. The fictional world of Songs of Innocence is Christian and pastoral, with the innocence of childhood celebrated as a spiritual force. Five years later, Blake wrote the antithesis of this idyll, the Songs of Experience. In his last years Blake produced some of his finest engravings, illustrating, among others, the book of Job.

312 John Constable, The White Horse, probably 1819, 74 x 51 in (188 x 130 cm)

THE UNTRADITIONAL CONSTABLE

"Constable's England" has become so familiar to us that it is difficult to understand the impression his paintings made on his contemporaries. His work has come to shape our conceptions of the beautiful in the English landscape, but his contemporaries were accustomed to a very different kind of representation of the natural landscape. There were set formulas, strictly adhered to, concerning the correct way to create

distance, harmony, and mood. Constable's naturalistic, vivid greens, for instance, totally upended these formulas, which were based on the use of warm browns in the foreground and pale blues in the far distance – and his depiction of the random or "unbeautiful" aspects of the landscape was counter to accepted standards of composition and to the conventions of appropriate subject matter.

When Delacroix (see p.260) visited England in 1825, he was enormously impressed with Constable's animated brushwork and the optical freshness that resulted from his use of broken color to create tone. On his return, Delacroix is believed to have reworked his large *Massacre at Chios*, enlivening the surface of the painting to make it echo its emotive subject.

It was his great "six-foot" canvases that Constable valued most, but modern taste finds even greater beauty in the studies and sketches with which he prepared for them. The wild passion of a Constable study has a marvelous vigor that the sedate control of the finished works may lack. White Horse (312) is such a magnificent picture, with the white streak of the horse uniting both sides of the river, the greenery almost palpable, the sense of actuality so piercing, that it is almost a shock to find that his oil sketches, such as Dedham from Langham (313), can be even more immediate and evocative, even more vital.

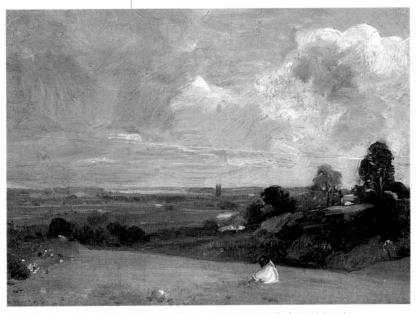

313 John Constable, Dedham from Langham, c. 1813, 7½ x 5¼ in (19 x 13.5 cm)

PREPARATORY SKETCHES

Constable adopted a systematic approach to painting from nature, making oil sketches on the spot, then later working them up into larger works. *Dedham from Langham* was one of a number of preliminary sketches of the same scene. Constable said of it, "Nature is never seen, in this climate at least, to greater perfection than at about nine o'clock in the morning of July and August when the sun has gained sufficient strength to give splendor to the landscape 'still gemmed with the morning dew.'"

ENGLISH MYSTICISM

Romanticism provided an outlet for the spiritual expression and individuality that Neoclassicism, with its emphasis on the ideal and on stoic heroism, largely denied.

Both William Blake and Samuel Palmer worked primarily as watercolorists rather than as oil painters, yet both have the peculiarly English quality of nostalgic realism that is so pronounced in Constable. Both were poets, Blake (1757–1827) literally so (see column, p.270) and Palmer temperamentally, and there is a haunting awareness of time and its passing in their works.

Blake's *Job and His Daughters* (314) is a clumsy, archaic vision that is nevertheless extremely powerful. Blake later went on to illustrate the book of Job. His strange, visionary art found a more sympathetic response after his death, and he achieved cult status among the Pre-Raphaelites of the 19th century (see p.276). Blake's wood engravings contained the crucial element of mystery and innocence that his followers also admired in the paintings of the German primitives and of the 18th-century Romantic group, the Nazarenes.

Samuel Palmer (1805–81) was an avid follower of Blake, nearly 50 years younger than him and influenced particularly by his few landscape works, which had been commissioned as illustrations

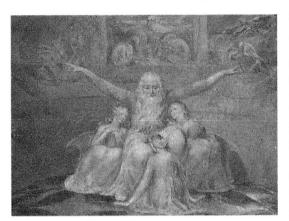

314 William Blake, Job and His Daughters, 1799–1800, 15 x 10½ in (38 x 27 cm)

315 Samuel Palmer, Coming from Evening Church, 1830, 8 × 12 in (20 × 30 cm)

for a school edition of Virgil's *Eclogues* (see p.218). Palmer's *Coming from Evening Church* (315) is just as naively independent of styles and schools as Blake's art and has much the same spiritual innocence. Palmer developed a way of working with mixed media – such as Indian ink, watercolor, and gouache – that resulted in an intense luminosity, reminiscent of the medieval illuminated manuscripts (see pp.28-34).

Constable was an artist in the largest sense, as Blake and Palmer were not, but his influence continued in their work – in their particularly English strain of deeply personal love of the land, and in their awareness of its mystical importance to our spiritual well-being.

THE ANCIENTS

In 1826 Samuel Palmer (1805-81) moved to Shoreham in England and founded a group of artists known as the Ancients. The name of the group was derived from their passion for the medieval world and their concentration on pastoral subjects with a mystical outlook. Palmer's work was largely forgotten until the Neo-Romantics rediscovered him during World War II.

THE AGE OF IMPRESSIONISM

In the middle of the 19th century, painters began to look at reality with a new alertness. Academic conventions had become so solidified and entrenched that artists such as Gustave Courbet could see no point in them. He painted peasant life as it truly was, thereby shocking and alienating the art world establishment.

The label for this reaction was Realism, but the next generation of artists ultimately found it too material a vision. Like the Realists they rejected idealized and emotional themes – but they sought to go much further. Studio painting in itself seemed unnatural to them when the real world was "out there." So it was there that they painted, outside, seeking to capture the fleeting effects of light and to give the real impression of a passing moment.

They were known as Impressionists, and their most characteristic figures were Claude Monet and Auguste Renoir, who captured the poetry of the here and now.

Age of Impressionism Timeline

Realism as a style was based upon a new attitude to social truth; it accepted the sordid conditions of real life. Impressionism was not social but personal, less "life" than "experience." If we want historical dates, it lasted from the first Impressionist exhibition of 1874 to the last in 1886, but artists escape these neat time boxes, and Impressionists reach back to the Realists and forward to the Post-Impressionists.

SIR JOHN EVERETT MILLAIS, OPHELIA, 1851–52

The Pre-Raphaelites were a group of English artists who rejected the studio conventions of their day and harked back to medieval simplicities. Ophelia is a fine example of their weird amalgam of specific detail and Romantic theme (p.276).

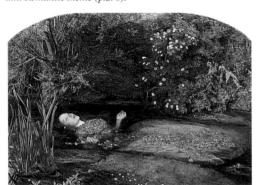

JEAN-FRANCOIS MILLET, THE GLEANERS, 1857

The village of Barbizon was the home of a group of artists who shared a common desire for a greater naturalism in landscape painting than that provided by Romanticism or academic painting. Millet shared this desire, painting peasants with a strong sense of their dignity, imbued with compassion for their laborious lifestyle (p.281).

CAMILLE COROT, VILLE D'AVRAY, C. 1867–70 Corot's long career began in the 1820s, during the Romantic era, and this painting is an example of his late work. It shows his deeply poetic response to the timeless qualities of classical landscapes, that nostalgic world of the lost paradise from which we are all inevitably barred. He taught the Barbizon painters how to see this world and make it real, and the Impressionists learned from him too (p.280).

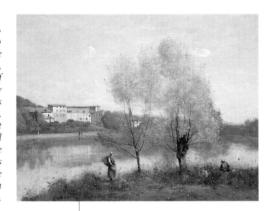

1850 1860 1870

Gustave courbet, bonjour monsieur courbet, 1854

Courbet, like the Pre-Raphaelites, believed in the importance of the specific, but far more flamboyantly. He himself was the center of his art, and we see him here splendidly confident. It is not theories that make his paintings work, but sheer artistic power (p.283).

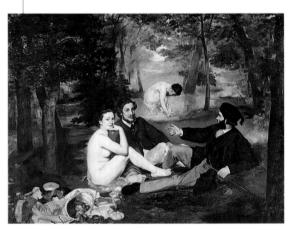

EDOUARD MANET, LE DEJEUNER SUR L'HERBE, 1863 Manet painted with a naked truth that stripped away the social pretenses of his time. It was not the subject of his work that was startling (a picnic in the woods was a well-established theme), but its alarming realism, its refusal to pretend, to hide in an antique guise. He was not specifically an Impressionist, but his artistic discoveries were an enormous influence on Impressionism (p.284).

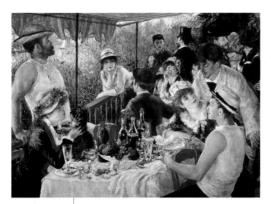

Auguste renoir, the boating party lunch, 1881

While other Impressionists were fascinated with the ever-changing patterns of nature, Renoir was more interested in people. He took simple pleasure in whatever met his good-humored attention and aimed to give the impression, the sensation, of his subject matter. This painting shows Renoir's skill in capturing delightful scenes of modern life and recording how the Parisans spent their leisure time. He also shows relationships between people – such as that of the pair on the right (p.298).

Alfred Sisley, Meadow, 1875

Sisley came from an English family living in France, and can be considered the one true Impressionist. He never developed beyond it. His landscapes are not as robust as Monet's, but are subtle, lyrical, and peaceful. The place shown here is unimportant, but Sisley catches the quality of light and the changing shadows perfectly (p.301).

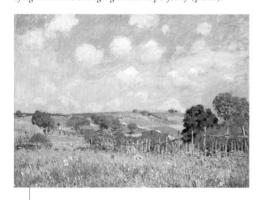

EDGAR DEGAS, FOUR DANCERS, C. 1899

Degas often exhibited with the Impressionists, although he studied the Old Masters throughout his life and was a superb draftsman. This late work is a good example of how he could seize upon the unbalance of an actual scene in the real world, and make art from what he had found. He learned this from photography and the strange magic of the Japanese printmakers (p.292).

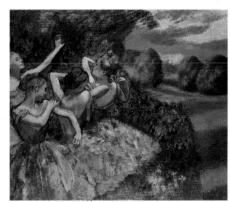

1880 1890 1900

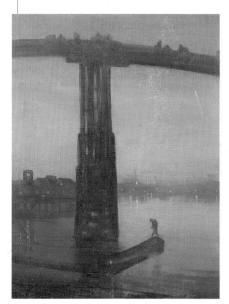

James whistler, nocturne in blue and gold: old battersea bridge, 1872–75

American by birth, Whistler moved to Europe and lived first in Paris, then London. Nocturne in Blue and Gold reveals his debt to the Impressionists. He had looked at them, but also, and more significantly, at the Japanese, in their use of a nonrealistic, seemingly two-dimensional composition, and the skillful choice of a few highly significant details. Whistler was interested in the Realist and Impressionist movements, but took from them what he needed to create a decorative style that was his alone (p.302).

CLAUDE MONET, THE WATERLILY POND, 1899

A quintessential work of Impressionism, this is one of Monet's numerous waterlily studies, some of which border on the abstract with their floating shapes and surface reflections (p.296).

THE PRE-RAPHAELITES

The Pre-Raphaelite Brotherhood was founded in London in 1848. Members initially included Rossetti, Holman Hunt, and Millais. Soon the group included seven artists. The initials PRB were first used on Rossetti's painting The Girlhood of Mary Virgin in 1849 and were quickly adopted by the other artists. John Ruskin (see p.269) initially criticized the brotherhood, but later recognized the echoes of his own values in their work and printed a spirited defense in The Times of London. Ruskin was the most articulate supporter of the movement and had a profound influence on the artists.

OPHELIA

Shakespeare's plays provided a wonderfully rich sourcebook for Victorian painters and had a great influence on several Pre-Raphaelite painters. Shakespeare's tragic story of Ophelia driven to madness and suicide by Hamlet's murder of her father, Polonius, was carefully re-created by Millais in 1851. The exquisite flowers floating on the surface of the water are not simply decorative and naturalistic; they were chosen for their traditional symbolic meanings: poppies - death daisies - innocence roses - youth violets - faithfulness and early death pansies - love in vain.

THE PRE-RAPHAELITES

Toward the middle of the 19th century, a small group of young artists in England reacted vigorously against what they felt was "the frivolous art of the day": this reaction became known as the Pre-Raphaelite movement. Their ambition was to bring English art (such as it was) back to a greater "truth to nature." They deeply admired the simplicities of the early 15th century, and they felt this admiration made them a brotherhood.

While contemporary critics and art historians worshiped Raphael (see p.125) as the great master of the Renaissance, these young students rebelled against what they saw as Raphael's theatricality and the Victorian hypocrisy and pomp of the academic art tradition. The friends

decided to form a secret society, the Pre-Raphaelite Brotherhood, in deference to the sincerities of the early Renaissance before Raphael developed his grand manner. The Pre-Raphaelites adopted a high moral stance that embraced a sometimes unwieldy combination of symbolism and

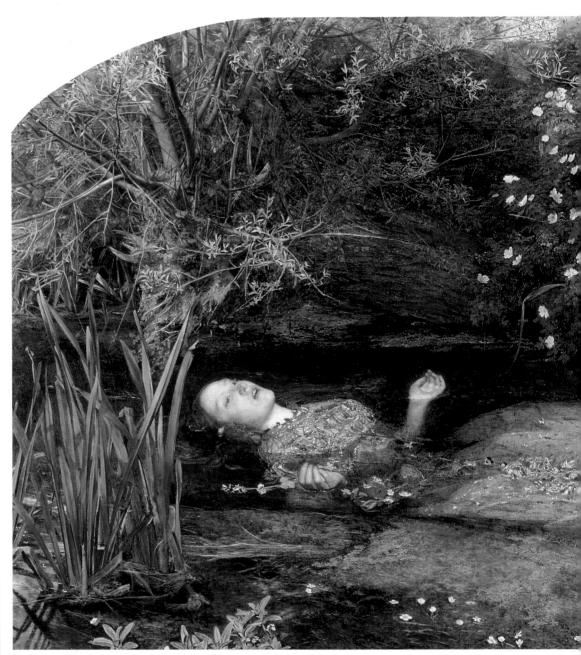

316 Sir John Everett Millais, Ophelia, 1851-52, 44 x 30 in (112 x 75 cm)

realism. They painted only serious – usually religious or romantic – subjects, and their style was clear and sharply focused. It entailed a unique insistence on painting everything from direct observation.

The group initially caused outrage when the existence of their secret brotherhood became known after their first works were exhibited in 1849. They also offended with their heavily religious and realist themes that were so unlike the popular historical paintings. However, the Royal Academy continued to exhibit Pre-Raphaelite paintings, and after 1852 their popularity burgeoned. Their work, though certainly detailed and for the most part laboriously truthful, became progressively old-worldish, and this decision to live

317 William Holman Hunt, On English Coasts, 1852, 23 x 17 in (58 x 43 cm)

in the past, while deploying the judgments of the present, makes the work of an artist such as John Everett Millais (1829–96) appear disturbingly unintegrated. His Ophelia (316), Hamlet's drowned lover, was modeled with painstaking attention on a real body in water, surrounded by a ravishing array of genuine wildflowers (see column, p.276). Millais spent four months painting the background vegetation on the same spot in Surrey, England. He then returned to London to paint his model, Elizabeth Siddal, posing in a bath full of water, so determined was he to capture the image authentically. The result is oddly dislocated, as if the setting, woman, and flowers did not belong together, each keeping its own truth and ignoring that of the others.

Luminous color

William Holman Hunt (1827–1910), a fellow art student and friend of Millais, was more alerted to the theatricalities of his age, and *On English Coasts (317)* is a political allegory on the theme of strayed and unprotected sheep. Yet the weirdly acidic colors, even though honestly come by, strike unpleasantly on the eye. We are constrained into belief, but against our will: the bright yellow is so garishly bright, and so are the aggressive greens of the sea.

The Pre-Raphaelites achieved such intense luminosity in their work by painting pure colors onto a canvas that had been prepared with white paint, sometimes reapplied fresh before each day's work, so as to give the hues added brilliance.

CHARLES DICKENS

The English author Charles Dickens (1812-70) is considered one of the greatest novelists of the 19th century. His early life was one of poverty and hard work, but he managed to educate himself and find a job as a journalist for the Morning Herald. His first printed book, Sketches By Boz, was published in 1836, and from this date onwards he became a prolific writer and completed many serialized novels, including Hard Times, published in 1865 (illustrated above). Dickens also found ready listeners for his criticism of Millais's Christ in the House of His Parents. He objected to the imagery and style of the Pre-Raphaelites' work, calling it "mean, odious, repulsive and revolting.

WILLIAM MORRIS

William Morris (1834-96) became a lifelong friend of Edward Burne-Jones while they were studying at Oxford University. Along with several other craftsmen, Morris founded a manufacturing and decorating firm in 1861. The firm produced works based on the ideal of a medieval guild, in which the artists both designed and executed the work. Products included furniture, stained glass, tapestries, carpets, and wallpaper (illustrated above).

DANTE GABRIEL ROSSETTI

Rossetti (1828-82) was born into an intellectual and creative Italian family but spent most of his life in London. Throughout the 1840s his poetry and painting prospered, and he completed many symbolic historical paintings. He met Elizabeth Siddal in 1850: he married her in 1860 after a troubled courtship. His wife, however, was weak and died only two years later, leaving Rossetti a broken man. For her burial Rossetti insisted on placing his complete poetry manuscripts in her coffin, which he then retrieved in 1869 by exhuming her body. He fell into depression and in 1872 attempted suicide but did not die. He lingered on in a alcoholic and druginduced haze until his death in 1882.

LITERARY INFLUENCES

Dante Gabriel Rossetti (1828–82), the third founding member of the Pre-Raphaelites, became the recognized leader and even formed a second grouping of the brotherhood in 1857, after Millais and Hunt had gone their separate ways. Rossetti came from an artistic and versatile Italian family, and it was perhaps the confidence engendered by this background, and his dynamic personality, rather than his artistic talent, that earned him his prominent position.

Rossetti was a poet as well as a painter, and in common with the other Pre-Raphaelites, his art was a fusion of artistic invention and authentic renderings of literary sources. The brotherhood drew heavily from Shakespeare, Dante, and contemporary poets such as Robert Browning and Alfred Lord Tennyson – Rossetti in particular was greatly attracted to Tennyson's reworkings of the Arthurian legends. He specialized in soulful maidens of extraordinary looks for his romantic themes, using his beautiful but neurotic wife Elizabeth Siddal as his model. Her striking face, with its long-nosed, languid expression, appears in many pictures. After Elizabeth's

318 Rossetti, The Day Dream, 1880, 36½ x 63 in (92 x 160 cm)

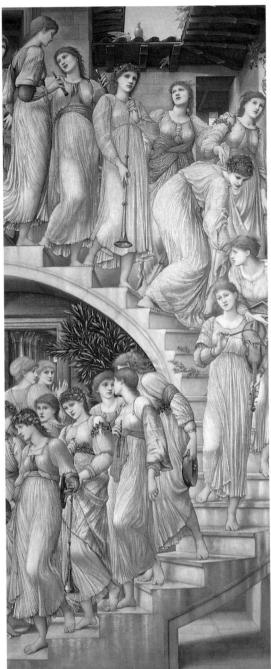

319 Edward Burne-Jones, The Golden Stairs, 1876–80, 46 x 106 in (117 x 270 cm)

death, Rossetti's model was William Morris's wife Janey (a Siddal look-alike). She is the one we see in *The Day Dream (318)*.

Edward Burne-Jones (1833–98), who was a great influence on the French Symbolists (see p.321), was a friend of Rossetti and Morris. He places his introspective, medievalized heroines in *The Golden Stairs* (319) in a dreamlike neverneverland that comes close to his own unworldly convictions. This romanticized world may cloy, but there are many who feel at home in the serious play of the Pre-Raphaelites and have no difficulty in responding to their themes.

REALISM IN FRANCE

Neither a Romantic nor a Realist, it was Camille Corot who, early in the 19th century, showed that these two approaches were not necessarily in opposition. He united great truth with great lyricism, but it was his astonishing truthfulness that ultimately made the greater impact. Honoré Daumier began to look at the social realities of his day with a boldness he had learned from Corot, and so did the Barbizon School of painters. This Realism, now fully deserving its capital R, came to its full maturity in the astonishing work of Gustave Courbet.

After the emotional extremes of the Romantics (see p.259), it comes almost as a relief to enter the gentler world of Corot's imagination (Jean-Baptiste-Camille, 1796–1875). Corot's style was far removed from the heroics of the Romantics. He saw the world, both natural and manmade, with an innocent truthfulness that greatly influenced the Barbizon School of artists, as well as practically every painter of landscape in the latter half of the 19th century.

In 1825 Corot went to Italy, a journey that influenced his approach to painting for the rest of his life; subsequently, it affected the whole development of modern landscape painting. It was in Italy that Corot first experienced the benefits of painting *en plein air* (see column, right), and his authentic depiction of light and nuance set a new precedent in French landscape painting.

He came to place great importance on the Italian practice of making sketches *in situ*, valuing these for their spontaneity, truthfulness, and atmosphere. He was deeply responsive to the timeless serenity of the classical landscape; its quietness found a response within, and his Italian landscapes express this profound and lovely silence.

A View near Volterra (320) was not painted on the spot: Corot saw this view as he traveled in this strange region of Italy, and some years later, referring to his original sketch, he painted it both as what he remembered and for what it meant to him. The truth then is emotional rather than factual, but it is truth nonetheless: the quiet rocks and sunlit foliage bear within them a sense of the antique. Many generations have lived on the sites of the ancient Etruscans

PAINTING EN

The French landscape painter Charles Daubigny (1808-79) was one of the earliest exponents of plein air (open air) painting and was to have a significant influence on the later Impressionist painters. The invention of metal paint tubes allowed longterm storage of oil paints, making trips into the countryside feasible using the new portable easeis. Many of the Impressionists settled and painted in the riverside communities along the banks of the Seine River. This illustration shows Camille Corot (1796-1875) painting en plein air under an umbrella.

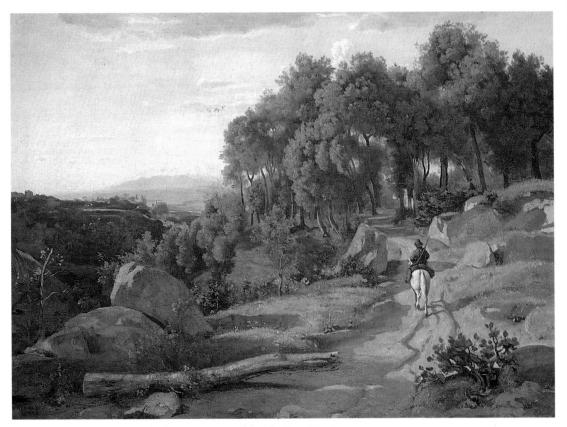

320 Camille Corot, A View near Volterra, 1838, 37½ x 27½ in (95 x 70 cm)

OTHER WORKS BY COROT

Morning near Beauvais (Museum of Fine Arts, Boston) La Rochelle

La Rochelle (Cincinnati Art Museum)

In the Dunes (Rijksmuseum, The Hague) Souvenir of Palluel (National Gallery, London)

The Ferryman (Louvre, Paris)

Landscape at Orleans (Bridgestone Museum of Art, Tokyo)

> Canal in Holland (Philadelphia Museum of Art)

The Happy Island (Museum of Fine Arts, Montreal)

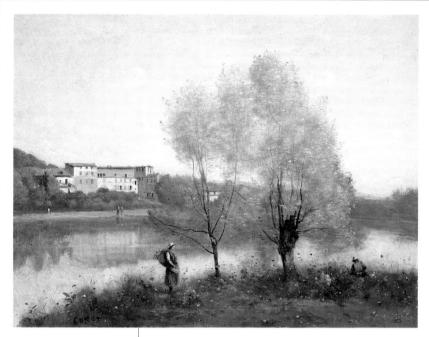

321 Camille Corot, Ville d'Avray, c. 1867–70, 26 x 19½ in (60 x 40 cm)

Daumier cartoons

Honoré-Victorin Daumier (1808-79) was a great caricaturist and is regarded as one of the most successful satirists of all time. His work ranges from the early antigovernment drawings of 1831 to the more gentle humor of his later cartoons. The example shown above was drawn in 1865 during the heyday of the Impressionist movement and has a punchline that reads "One landscape artist copies nature, the second copies the first." With this comment Daumier is ridiculing all the inferior artists who copy landscape paintings; simultaneously he is making a general comment on the dishonesty of many artists of the time.

(see p.18), and their presence still lives on subliminally. Corot paints the place and its feel, evoking our own memories to unite with his. The place is dreamlike, yet fundamental in its solidity. No artist ever made mere substance so spiritual as did Corot.

Corot can be so unassuming that his true greatness is missed. He never dramatizes or exaggerates, never strikes any kind of attitude. Few painters have ever had such a mastery of tone, of the imperceptible gradations by which one color melts into another. His landscapes are often small but perfect, with a simplicity so profound as to be totally satisfying. He may not have beautified his undramatic countrysides, but the excitement is in the veracity of his vision.

Corot's early and less critically successful landscapes paved the way for Impressionism. In his later years, he would modify his art, painting again and again an entrancing forest glade, dappled and peaceful. This is the fashionable Corot, and this too is lovely, but it is a declension from the unique magic of his disregarded early work. A typical and lovely example of late Corot is *Ville d'Avray (321)*: feathery trees, pale sky, pure white of the distant houses, silvery water, and young people bright amid all the flowers and grasses. The one abiding component is a contemplative stillness that Corot never lost.

Daumier the satirist

We do not know what Corot thought of the French painters Daumier and Millet, but he gave financial help to Daumier in his blind old age, and to Millet's widow. Honoré Daumier (1808–79) was greatly influenced by Corot's work – though the caustic wit and the overtly sociopolitical content of Daumier's caricatures and lithographs (see column, left) would appear to have little in common with the serenity of Corot's art. Though he was acknowledged as one of the most important cartoonists of the 19th century during his lifetime, it is only since his death that Daumier's qualities as a serious painter have been recognized. His directness of vision and lack of sentimentality in the way he painted actual experiences make his works some of the most powerful examples of Realism.

While Corot was comfortably well off and never had to earn his living, Daumier struggled throughout his career as a satirist to support himself, suffering censorship and imprisonment because of the subversive nature of his art. He was a committed Republican with an intense political passion for the poor, drawing such strong caricatures that his own contemporaries found it hard to take him seriously as a fine artist. He gave Corot his painting Advice to a Young Artist (322) in gratitude for an act of generosity by Corot that released Daumier from financial worry in his final years. Two men are alone in the studio, the unmade bed the only sharp color. The young man is tense, the older man intent, perhaps marking time while he finds the encouraging yet sincere words to offer as advice. The stress is wholly on personal interaction, with the entire context conjured up out of just a few props.

322 Honoré Daumier, Advice to a Young Artist, probably after 1860, 12 x 16 in (33 x 41 cm)

MILLET AND THE BARBIZON SCHOOL

In the 1830s a group of landscape artists moved out of Paris to the small village of Barbizon on the outskirts of the Forest of Fontainebleau, where they were often joined by Corot. He was a great influence on the group, but they were also affected by Constable's landscapes (see p.268) in their desire for a greater naturalism and a truthful depiction of the countryside.

Jean-François Millet (1814–75) settled in Barbizon in 1849 and was soon associated with the school. Although in later life he turned to painting pure landscape, he is more famous for his peasant pictures, the truth of which arises from his own personal experience as the son of a farm laborer. Some now think these paintings sentimental, but they were considered radical in their day for their social realism. Millet was a sad and laborious painter, apt to see life as very dark – the temperamental opposite of Corot, with his luminous world of serenity and light – but people clearly responded to his art, although

they were still baffled by Daumier's. Millet's style was simplified, diluted, yet powerful, imbuing the ordinary with a strong sense of dignity and a monumental weight.

Millet's most famous work is probably The Gleaners (323). We see three peasant women at work in a golden field: two of them are bowed in measured toil, assiduously gathering the scraps left behind by the harvesters, while the third binds together her pathetic sheath. Millet makes inescapable the realization that it is hard, backbreaking work. The women's faces are not only darkened by the sun, but seen as almost brutish, with thick, heavy features. Yet, beasts of burden though they are, he regards them with reverence. We feel awed at their massive power and the sheer beauty of the classical frieze they create silhouetted against the meadow. This is a setting of great natural loveliness: golden corn, peaceful sky, the rhythmic movement of distant laborers. The background is a pastoral idyll; the foreground a pastoral reality.

MILLET'S SKETCHES

Jean-François Millet (1814–75) was the most famous painter of rural life in 19th-century France. Although renowned as a painter, some of Millet's

best works are his drawings, which invest the ordinary with depth and dignity. Millet is known to have said that he aimed "to make the trivial serve to express the sublime." Millet was admired by many artists, including van Gogh (see p.316).

323 Jean-François Millet, The Gleaners, 1857, 44 x 33 in (111 x 83 cm)

THE PARIS COMMUNE

In July 1870 the French declared war on Prussia. After only two months the French leader Napoleon III was forced to surrender and an angry, humiliated mob declared the Third French Republic. Patriotic radicals in Paris sought to republicanize the country and elect a municipal council, the Commune. Barricades were established by the Communards and the State French troops had to retake the city by force. By the end of the conflict, 20,000 Parisians had been killed and the Communards had shot many high-ranking hostages. This illustration shows a female gas bomber defending the barricades.

THE PAINTER'S STUDIO

Dissatisfied with the space allotted to him at the Universal Exhibition of 1855, Gustave Courbet decided to establish his own pavilion, called Le Realismé, to show his works. One of the paintings exhibited was The Painter's Studio, which proved that secular art could now convey the deep seriousness previously expected only from religious paintings. There were many interpretations of the painting, including a theory that it was a covert denouncement of Napoleon III. Courbet, however, stated that it shows "all the people who serve my cause, sustain me in my ideal, and support my activity."

COURBET, THE GREAT REALIST

The Pre-Raphaelites' (see p.276) concept of Realism was a fundamentally different one, their work often displaying a superficial, outward impression of nature and expressing sentiments quite removed from reality. The greatest Realist, in a much truer sense, was the brash, anti-intellectual, and largely self-taught artist Gustave Courbet (1819–98). He was by nature prone to rhetorical flourishes and was not as down-to-earth as he himself thought, but he had no tincture of the dreamy hankering after the past that characterizes the Pre-Raphaelites. Courbet's defiantly nonconformist stance and his commitment to concrete reality was an important influence on a subsequent generation of artists.

Courbet lived by his belief that artists should paint only "real and existing things," striding resolutely into the future and taking, he generally felt, possession of it. He was impressed by Caravaggio's robust expression (see p.176) and by the Dutch masters Hals (p.210) and

Rembrandt (p.200). Their influences can also be traced in Courbet's own admirers. His landscapes are always vital with a savage sort of power, and he prided himself on this uninhibited zest. The son of a rural bourgeois landowner, he was by nature a rough, coarse, and passionate man, and he sublimated these qualities in his art. He called himself "a socialist, a democrat, and a Republican, and above all a realist, that is to say a sincere lover of genuine truth."

Courbet's work has a heavy realism that is unflinching in its restless scrutiny. All his qualities, including an indefinable something that eludes the viewer, are present in his masterpiece, *The Painter's Studio (324)*. This is an intensely personal work, yet it keeps its secrets: nobody has ever quite discovered what is meant by its full title – *A Real Allegory Summing Up Seven Years of My Artistic and Moral Life*. Courbet claimed to have assembled, imaginatively, in this one canvas, all the significant influences of his life, some generalized and some apparently

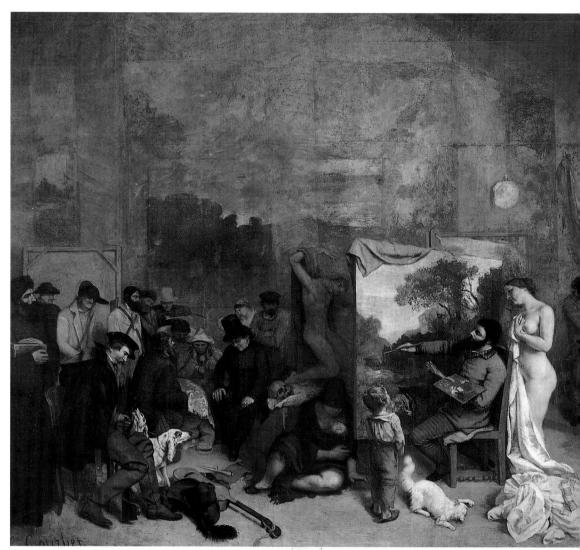

324 Courbet, The Painter's Studio, 1855, 19 ft 17 in x 11 ft 10 in (597 x 361 cm)

personified. The people are of all kinds and conditions, all totally authentic, all centered on the artist himself, who paints a ravishing landscape while a nude model presses herself affectionately against his chair. These visitors are all guests whom he seems to have invited for a purpose. Courbet actually described this strange allegory in a letter to his friend, the novelist Jules Champfleury, writing that the figures on the left were those who "live on death," while the figures on the right "live on life."

Although the portraits on the right are identifiable – Champfleury himself is depicted among the onlookers, along with other elegant Parisian friends of Courbet, such as the journalist and socialist Pierre Proudhon and the poet Charles Baudelaire (see p.286) – the characters on the left, veiled in semidarkness, could represent people from Courbet's past or previous influences in his life: there may even be a disguised portrait of the Emperor Napoleon III. We may smile at this naive self-importance, yet we are also

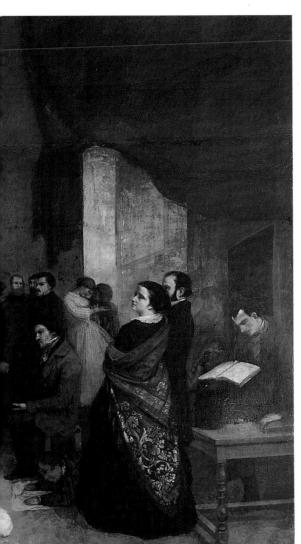

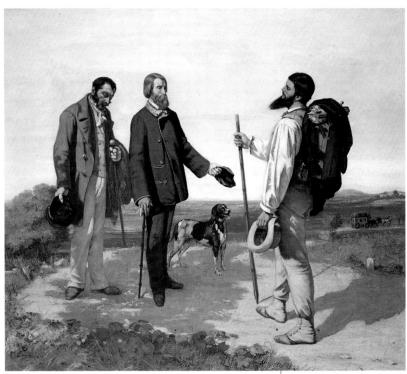

325 Gustave Courbet, Bonjour Monsieur Courbet, 1854, 59 x 51 in (150 x 130 cm)

impressed. Courbet had every right to see himself as a major painter who understood materiality so profoundly as to make it appear to become more than it really was.

THE OMNISCIENT ARTIST

Courbet's vanity is not rare in those with creative talent, but few have put their weakness to such effective use. Bonjour Monsieur Courbet (325) shows the painter as he saw himself, very handsome and virile, detached from the softness of civilized living, striding forth along a country lane. Courbet's devoted patron, Alfred Bruyas, and his servant, bow reverentially to the artist as if he is their superior, and it is clear that Courbet heartily agrees. There is an innocent conceit in the tilt of the artist's noble head, in the condescension of his affable smile. The dusty path, the bordering weeds and grasses, the dog – every detail of this wholly ordinary part of France is grasped completely in its truth and left undramatized. We are drawn into what Courbet saw and smelled and heard, not through any dramatic overemphasis but from his enormous painterly conviction.

This self-image of the artist existing above and beyond the mediocrities of "bourgeois" civilization was to find full expression in the works and lives of the next generation of painters, particularly Manet and Degas, who benefited from Courbet's artistic advances and laid the foundations of "modern" expression.

OTHER WORKS BY COURBET

Hunters in the Snow (Musée des Beaux Arts, Besançon, France)

Reflection of a Gypsy (National Museum of Western Art, Tokyo)

Landscape (National Museum, Stockholm)

Girls on the Banks of the Seine (Petit Palais, Paris)

The Waterfall (National Gallery of Canada, Ottawa)

Woman with a Parrot (Metropolitan Museum of Art, New York)

The Grotto of the Loue (Kunsthalle, Hamburg)

THE NEW PARIS

When Napoleon III became emperor in 1851, he set about making Paris the new center of Europe. Napoleon employed the architect Baron Haussmann (shown above) to redesign and rebuild central Paris, using a new network of interconnecting tree-lined boulevards. During the rebuilding he also created new parks, squares, and municipal buildings. Haussmann's ruthless plans displaced over 350,000 people and led to more social problems, including increased visibility of prostitutes on the wide-open boulevards.

SALON DES REFUSES

The "salon of the rejected" was formed after the official 1863 Salon turned down more than 4,000 paintings. The alternative salon was ordered by the Emperor Napoleon III, and many artists, including Manet, Cézanne, and Whistler were happy to find a place to show their rejected works. When the Salon des Refusés opened in May 1863, over 7,000 people visited on the first day, but the exhibition received very little critical acclaim. The Salon des Refusés inspired other artists to develop their own salons and increased the influence of art dealers. This illustration shows a contemporary cartoon parodying the jury system of the Salon.

THE INFLUENCE OF MANET & DEGAS

Courbet's richness of color and insistence on his own personal vision were immensely influential on other artists, teaching them to believe only what they could see with their own eyes. Manet abandoned the conventional practice of subtle blending and polished "finish," using instead bold colors to explore the harsh, realistic contrasts created by sunlight. Degas, influenced by photography and the simplicities of Japanese prints, adapted his skills as a draftsman to create startlingly new compositions with his figures.

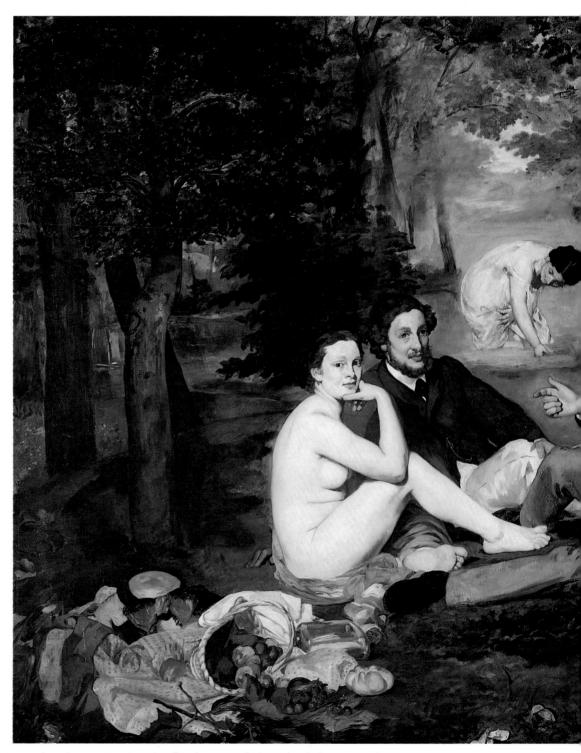

326 Edouard Manet, Le Déjeuner sur l'Herbe, 1863, 8 ft 8 in x 6 ft 10 in (265 x 206 cm)

Edouard Manet (1832–83) took Courbet's realism one step further, so blurring the boundary between objectivity and subjectivity that painting has never recovered from his quiet revolution. After Impressionism, art can never return to a dependence upon a world that exists "out there" apart from the individual artist. Yet it was a quiet revolution only in that Manet was a reticent, gentlemanly artist who desired nothing better than conventional success at the Paris Salons

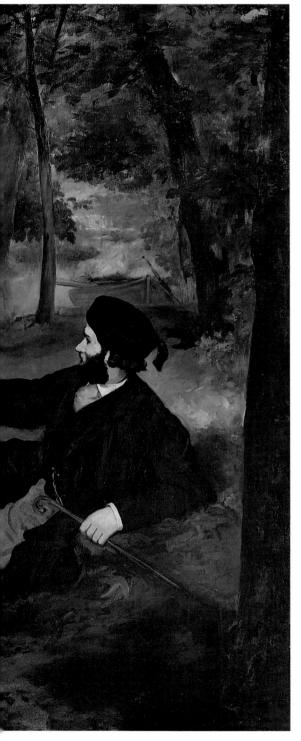

(see column, p.284). Temperamentally Courbet's opposite, with his very fashion-conscious, witty, and urbane attitude, Manet was the archetypal *flâneur* (see column, right) and was well liked. To the end he could not understand why his work was so reviled by the Parisian art world and seen as an offense. Fortunately a private income enabled him to pursue his course without undue financial distress, but one cannot imagine even a starving Manet ever compromising.

"The father of modern art"

In the past Manet has been included in the allembracing term of Impressionism, but his art is Realist rather than Impressionist. It was Manet's attitude that influenced the group of younger painters who subsequently became known as the Impressionists. They were also affected by his radical use of strong flat color, broken brushwork, harsh natural lighting, and the generally "raw," fresh appearance of his paintings.

Manet was an extremely cultured and sophisticated man from a well-to-do bourgeois background, yet he painted with a simplicity that is startling. His painting *Le Déjeuner sur l'Herbe (326)* is the work of an educated artist. The central group is based upon a print that is itself based upon a work by Raphael – nothing Pre-Raphaelite about Manet – and a picnic in the woods was a well-established artistic subject.

What shocked the critics and the public was the startling modernity of it all: the naked woman had a timeless body, but her face and attitude were unmistakably contemporary. One wonders whether the scandal would have been less if the men too had been unclothed. Manet made his subject seem so startlingly likely, a scene that might greet the eye of anyone taking a stroll in the woods.

Ironically, it was the very power of this painting that made it a popular failure, coupled with Manet's highly idiosyncratic use of perspective. The girl bathing in the brook is neither in the picture, nor out of it. Her proportions are "wrong" in relation to the others, so that the three picnickers are enclosed within what seem like two distinct styles of painting: the stooping bather seems flattened and too remote, while the superb still life of carelessly spilled clothes and fruit looks overpoweringly real.

In the center, Victorine Meurent, Manet's favorite model, looks out unabashed and shamelessly at the very intruder each viewer fears might be himself or herself. That classical nymphs should feel at ease with their bodies had long been accepted, but in portraying a modern, fleshly woman realistically, Manet stripped away the social pretenses of his time.

THE FLANEURS

During the heyday of the Impressionist movement, the streets and cafes of Paris became the setting for fashionable posing by artists and writers. A flâneur was a particularly Parisian phenomenon: an elegant gentleman idler who paid meticulous attention to his appearence but still maintained serious artistic or literary concerns. Manet was renowned in Parisian circles for his style-conscious appearance and held a life-long love for fashion in all its variety and detail.

Contemporary arts

1851

The Great Exhibition is held in Hyde Park, London

1865

Lewis Carroll publishes Alice in Wonderland

1867

Karl Marx publishes Das Kapital

1877

The Rijksmuseum is built in Amsterdam

1887

Sir Arthur Conan Doyle writes the first Sherlock Holmes story, A Study in Scarlet

1892

Tchaikovsky composes the *Nutcracker Suite*

THE FRANCO-PRUSSIAN WAR

At the onset of the Franco-Prussian war. Manet and Degas joined the French National Guard while other Impressionist artists, such as Monet, Sisley, and Pissarro, fled to England. After only a couple of months, the French army was forced to surrender and the Germans, under Bismarck, took the French province of Alsace and most of Lorraine. The French were forced to pay an indemnity of five billion francs. This illustration shows a contemporary cartoon parodying the abilities of all the leaders involved.

While Courbet sought to shock, Manet considered such a deliberate intention ill-bred and was suprised at the reaction to this work. Yet we can also sympathize with any incomprehension on the viewer's part: Manet is still not an easy artist. What we find so amazing is the blindness shown by his contemporaries to the great beauty of his art. The strong yet soft image of a young body set against the bosky magic of the woods – this is so entrancing that it remains a mystery why so few could actually "see" what was portrayed.

PARISIAN AVANT-GARDE

Manet was a close friend of the innovative French poet Charles Baudelaire (1821–67), whose essay *The Painter of Modern Life* – challenging artists to capture the great spectacle of life in the modern city – was an enduring influence on Manet's work. In each of Manet's paintings we can perceive a constant challenge to his contemporaries to see, as he did, the grandeur, beauty, and tragedy of modern life; urging artists to look at the world around them, instead of to the past, for their inspiration. He painted philosophers in the guise of modern beggars, street entertainers, prostitutes, courtesans, and people on the edges of society, as well as those situated comfortably within it. He was particularly sensitive to urban alienation and the constantly changing and

evolving nature of cities. As such, Manet's contribution to modern "expression," and to the history of modern art, is profound. For all this, his art still maintained firm links with the past – particularly Velázquez (see p.194), Goya (p.248), and the Dutch masters (p.200) – learning from them in a modern context. These links were finally broken by the Impressionists in their entirely new approach to visualizing the physical world around them.

It could seem that Manet's main interest was the figure, but in fact it was the material world as actually seen, as experienced at one fleeting moment, in sunlight or shadows, and created anew. His still lifes are particularly moving. In Still Life With Melon and Peaches (327), the light gleams upon the incandescent white of the tablecloth. Its texture is firmly distinguished from the soft white of the rose that lies on it. The picture not only plays with white but runs through an exhilarating gamut of luminous greens and yellows. The strong black of the bottle and the table, mixed from many colors, creates a dramatic contrast with the bright hues, while Manet's dexterous brushstrokes give life and vitality to these blocks of strong color. He shows us a world at its most vulnerable and yet its most lovely.

EMILE ZOLA

Emile Zola (1840-1902) was a supporter of Manet's work, and in return the artist painted a portrait of Zola in 1867-68. The pair would meet regularly at the Café Guerbois to discuss topical subjects. Zola produced a pamphlet defending Manet's work and remained friends with several Impressionist artists until 1886, when he published his novel L'Oeuvre. The novel centered on an artist-hero (based on a mixture of Manet and Cézanne) who dreams of success but finds only failure.

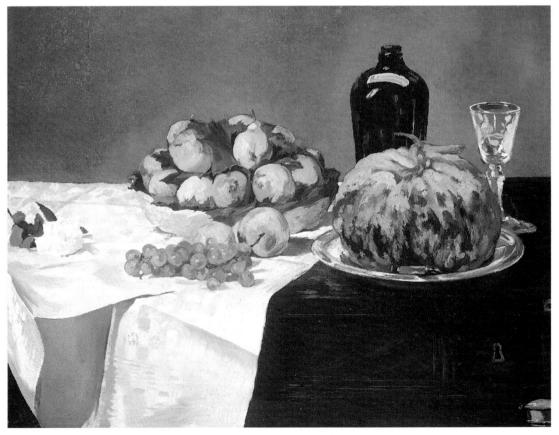

327 Edouard Manet, Still Life with Melon and Peaches, c. 1866, 36½ x 27 in (92 x 69 cm)

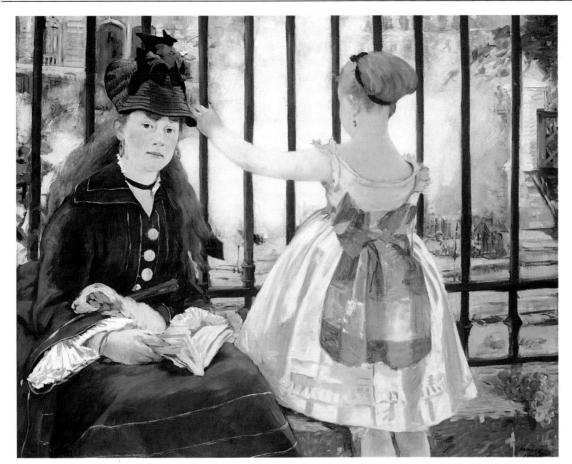

328 Edouard Manet, Gare Saint-Lazare, 1873, 45 x 37 in (115 x 94 cm)

CONTEMPORARY THEMES

Yet the human figure remains central to Manet's work. Victorine Meurent, that insouciant young beauty, continued to be his favorite model. Ten years after *Le Déjeuner sur l'Herbe*, Meurent is still undaunted, still self-contained and at ease with her body in *Gare Saint-Lazare (328)*. This work takes the theme of a train station (which might seem mundane to the modern mind) and treats it with a compelling sense of adventure, yet also with an offbeat humor.

Always responsive to avant-garde developments, Manet was in turn influenced by the younger group of Impressionists and in particular by Monet (see p.294), with whom he became good friends. Although he never became an Impressionist, *Gare Saint-Lazare* reflects Manet's growing interest in their art and marks an important progression in his own artistic methods: Manet made his initial studies for the painting inside his studio using posed models and then worked *en plein air* on site to finish the picture.

Meurent is at the far left in *Gare Saint-Lazare*, unsymmetrical, as is usual in real life. Under a gorgeous confection of a hat, her mass of red hair streams down unrepentantly and she is dressed with a flourish of Parisian chic. Little crinkles of lace froth around her sensual throat,

a velvet band draws our attention to the neat triangle above her trim body, and she holds on her lap a book, emphatically unread, and a winsome puppy, dozing above her frilly cuffs. She enchants us with her unconcerned air. Equally unconventionally, the other character in the picture shows us only her

spacious back, large swathes of starched white and a huge blue sash on which light and shade flicker and fade; the little girl is as expensively dressed as her companion, but posed to appear unaware of our presence; her whole attention is on the station, always an intriguing place for children. Manet keeps the focus of our attention on this little girl by obscuring from us what she sees, beyond a blur of smoke and the dimly lit atmosphere of the station.

It is the young girl's rapt, childish excitement, her sense of wonder at the modern world before her, that is the theme of this painting, and her attitude is made all the more evident in the boredom of the adult beside her who waits casually, passing the time away, concerned mainly with herself. Manet keeps our attention wholly where he wants it to be: on the dull, swirly background, the intense and particularized personalities, and

OTHER WORKS BY MANET

The Suicide (Bührle Foundation, Zürich)

Portrait of Armand Brun (Bridgestone Museum of Art, Tokyo)

Olympia (Musée d'Orsay, Paris)

The Spanish Singer (Metropolitan Museum of Art, New York)

> The Waitress (National Gallery, London)

House at Rueil (National Gallery of Victoria, Melbourne)

Philosopher with a Hat (Art Institute of Chicago)

The Artist's Wife (Nasjonalgalleriet, Oslo)

HOMAGE TO DELACROIX

This painting by Fantin-Latour (see p.289), completed in 1864, shows a gathering of the artistic and literary avant-garde and is entitled Homage to Delacroix. The painting shows Fantin-Latour, Baudelaire, Manet, and Whistler, among others, grouped around a portrait of their artistic hero, Delacroix. In spite of his association with progressive artists, Fantin-Latour was a traditionalist, and produced meticulous portraits and lithographs in his later years.

The Bar at the Folies-Bergere

In his review of Manet's last great work, *The Bar at the Folies-Bergère*, the French art critic Paul Alexis described the barmaid as "standing at her counter, a beautiful girl, truly alive, truly modern." A dedicated urbanite to the very end, Manet re-created the fashionable world he knew and loved best, in all its splendor, and its failures.

TRAPEZE ACT

It can come as a surprise to discover, tucked away in an upper corner, above the white glare of the electric lights, the bizarre presence of a pair of legs in little green boots. This is in fact the reflection of a trapeze act. The Folies-Bergère was a Parisian music hall that pioneered "variety" entertainment; its promenades were frequented by prostitutes.

Manet was accused of ignorance of the laws of perspective, for we see the reflection of a customer who seems to be conversing with the barmaid, but his bodily presence is missing — which we would expect to see, considering his position in reflection. Manet's critics failed to see the subtlety of his invention: we, the viewers, are in the position that the "customer" would rightly occupy, and so we take his place.

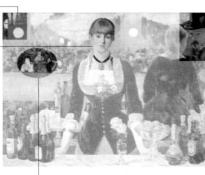

Suzon

The Bar at the Folies-Bergère was painted in the year before Manet's death, when he was already seriously ill. There is an unmistakable sadness beneath the bored expression of the barmaid, Suzon, who, though surrounded by gay electric lights (a new, very modern feature of the Folies-Bergère), is remote and distracted. As with much of Manet's work, the superficial gaiety of the busy Paris night life is offset by a sense of private alienation.

Manet's friends

Apart from the utterly solid figure of Suzon and her bar laden with refreshments, the rest of the painting is a mere reflection. Wisps of blue-gray paint, trailed over the surface of the canvas, evoke the smoky atmosphere and indicate the flatness of the mirror's surface. Cameo portraits of Manet's friends (Méry Laurent and Jeanne Demarsy) can be picked out in the blur of the teeming audience.

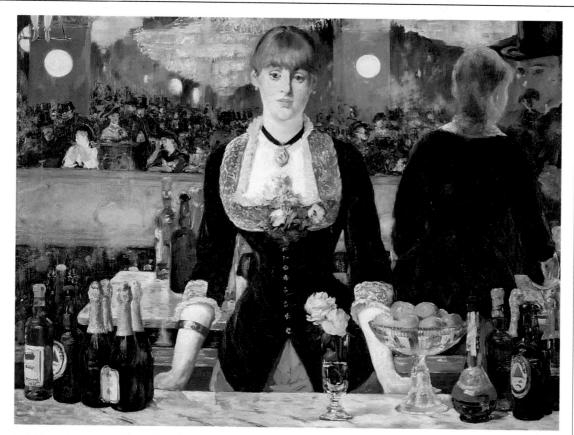

329 Edouard Manet, The Bar at the Folies-Bergère, 1882, 51 x 38 in (130 x 97 cm)

the vague impressions of a foreground. It is this new sensitivity to the fleeting, mobile reality of time that Manet gave to other artists, and which was so important to the progress of the Impressionist movement.

THE FINAL MASTERPIECE

This sense of the small, fleeting moment held perpetually still is supremely conveyed in The Bar at the Folies-Bergère (329). Manet also plays with the deceptiveness of space: there are reflections that reflect falsely, and it is hard to locate ourselves in the work. The barmaid looks out with the sad dignity of the exploited, as much a comestible as the wine in the bottles or the fruit in the bowl. Like the exquisite vase of flowers on the bar, she seems to have been plucked and set before the viewer. Manet died relatively young, and knowing this, we find his late flower studies to be among his most poignant works. There we find fragile flowers, so lovely yet so mortal, contrasted with their vases, also lovely but capable of indefinite existence. There are deep emotions in Manet, but never on the surface.

It is impossible to overestimate the haunting beauty with which Manet embraces every detail of this last great canvas, his valediction to the world of high art, and it is fitting that this final work is a scene from modern Parisian life.

Fantin-latour – a painter of still lifes

Manet had a particularly wide circle of friends and artists, including Monet, Renoir, Cézanne, and Bazille, an early Impressionist painter who died in 1870 in the Franco-Prussian war (see column, p.286). There were other artists who were friends with the Impressionists, but who never quite crossed over into the fleetingness of their world. Henri Fantin-Latour (1836–1904), for example, who was especially famous for

the exuberant beauty of his flower arrangements, always remained a Realist, painting his flowers with the objectivity achieved from prolonged contemplation. Flowers and Fruit (330), with its meticulous detail, shows little awareness of the way Manet, Monet, or Renoir would dissolve the blooms into iridescence. His group portrait Homage to Delacroix (see column, p.287) reveals Fantin-Latour's friendship with some of the most advanced artists of the day, yet the dark, brooding colors and the substantial feel of each figure confirm his preference for consistent, realistic images.

ANTONIN PROUST Manet and Proust were schoolboys and students together and were to remain lifelong friends. In 1850 Manet and Proust joined Thomas Couture's art academy in Paris and there developed their animosity toward the art establishment. Proust's Souvenirs de Manet, published in 1897, is the source usually quoted for some of Manet's earliest sayings. It celebrates their unfailing friendship and expounds the glories of Manet's genius. Manet died in April 1883 after six months of constant pain. Proust was a main speaker at his funeral, which was also attended by many famous artists including Monet, Renoir, Pissarro, and Sisley.

330 Henri Fantin-Latour, Flowers and Fruit, 1865, 22½ × 25½ in (57 × 64 cm)

331 Berthe Morisot, The Harbor at Lorient, 1869, 29 x 17½ in (73 x 44 cm)

JAPANESE INFLUENCE Mary Cassatt (1845-1926) was an enthusiastic collector of Japanese prints and altered her work to accommodate the influences of Japanese ukiyo-e prints. Motivated by an exhibition that she saw in 1890, Cassatt produced a set of prints using the Japanese techniques. The work illustrated above, Woman with a Mirror, is a woodblock print by Kitagawa Utamaro (1753-1806), who inspired many of the themes in Cassatt's paintings and prints.

BERTHE MORISOT

The Morisot family was part of Manet's social circle, and his brother (Eugène Manet) eventually married the beautiful Berthe (1841–95). Morisot learned from Manet how to catch the passing hour and make it stay still for her, how to render the exquisite delicacy of light without hardening it into what it is not. During her early years she was taught by Corot and was also in contact with Charles-François Daubigny, an artist of the Barbizon School (see p.281). She was influenced by their honesty in capturing the true, changeable atmosphere of the landscape as it truly appeared before their own eyes.

Morisot enjoyed an intense, mutually respectful relationship with Manet. This influence was offset by her affiliation with the Impressionist group, with whom she exhibited regularly (while Manet remained aloof). Her eventual adoption of a lighter Impressionist palette was itself of considerable influence on Manet's late works. Morisot is not a strong painter in the Manet sense, but only a strong woman could have forced this work through: women's art was universally derided at that time. The Harbor at Lorient (331) is one of her finest paintings, a truly Impressionist work, in which the landscape is not subordinate to the figure and all is painted with the same care and the same ease. Great areas of contrasting blue

shimmer as still water reflects unstill sky, powerfully geometric diagonals anchoring the picture, and the wonderful freshness of the morning as a girl sits on the embankment, a blithely blurred image under her pink parasol. The world hovers at the corner of the eye, delightful and unobtrusive.

MARY CASSATT

The other important woman Impressionist, Mary Cassatt (1845–1926), was as upper-class as Morisot, but her family lived in Pittsburgh, Pennsylvania, not in Paris. It was after she came to France in 1868 to paint and exhibit with the Impressionist group that she became modestly well known. Her art has an amplitude, a solidity very different from Morisot's, and gender is one of the few things they have in common.

Cassatt's grave dignity is never over emphatic. Her *Girl Sewing (332)* is made beautiful by the sheer variousness of the soft light. It pinkens the path behind the young woman, glows red in the flowers, and plays with a cascading grace over her simple frock. We are held by her attitude of childlike endeavor, lips set in concentration, and by the sheer brilliance with which her physical presence is captured. Cassatt was also an accomplished and gifted printmaker, and the widespread influence of Japanese prints is especially evident in her prints and drawings.

332 Mary Cassatt, Girl Sewing, 1880–82, 25 x 36½ in (63 x 92 cm)

Cassatt's art shows her interest in physicality. This is very understandable since it was Degas, not Manet, who was Cassatt's mentor. Degas (Hilaire-Germain-Edgar, 1834–1917), a cynic in later life and a misogynist at every age, was condescendingly surprised at Cassatt. He admitted her power, quite against his will. Yet this power of draftsmanship, and the ability to make a body palpably real, is very much his own.

DEGAS AS DRAFTSMAN

Degas is a far greater painter than Cassatt, and his graphic powers have never been excelled: his genius for line combined with a rich color sense to produce work that will always ravish the viewer. Like Manet, he was separate from the Impressionist group (though unlike Manet, he did exhibit with them). He was skeptical of studying nature for its own sake and was instead drawn to Classicism.

Degas remained remote from life as much through his wealthy upbringing as his temperament. That his temperament was that of a voyeur seems certain: he looked on, not only from a distance, but from a height. This was so instinctive to him that it rarely offends us. Such a curiosity is shown in *Madame René de Gas (333)*, painted when he visited a branch of the family in New

Paris opera house

The new Paris Opera House, designed by Jean Garnier, opened in January 1875, and Degas was a frequent visitor. He had held a season ticket to the old opera house, where he studied ballet classes. With the opening of the new opera house, his interest in ballet grew and became a major subject of his work in the late 1870s.

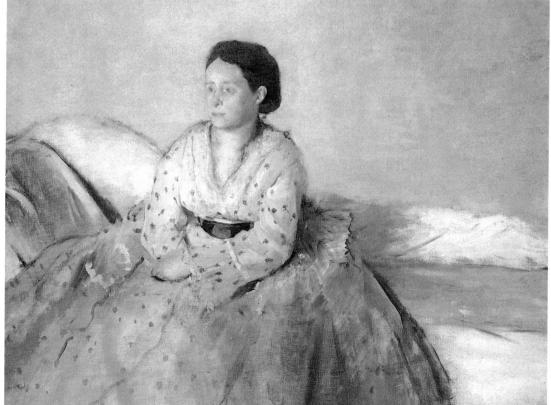

333 Edgar Degas, Madame René de Gas, 1872/73, 361/2 x 29 in (92 x 73 cm)

after his death).

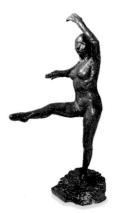

DEGAS'S DANCERS

Over half of Degas's paintings depict the young ballerinas who performed between the main acts at the Paris Opera (see p.291). Although Degas painted the dancers in intimate

the dancers in intimate behind-the-scenes situations, he viewed them with a cool detachment. Only one of Degas's ballet sculptures was exhibited (in 1881), and at the time it was considered unusually realistic because Degas dressed the sculpture in real clothes. This illustration shows a bronze sculpture of a young dancer, based on a number of pencil sketches.

DEGAS AND HORSE RACING

In the mid-19th century, horse racing became extremely popular in Parisian society. Both Manet and Degas were part of the well-bred racing fraternity and attended many of the races at Longchamp in the Bois de Boulogne. Degas preferred to depict the moments before the race began, such as those in the painting illustrated above. He produced over 300 works of art on the racecourse theme.

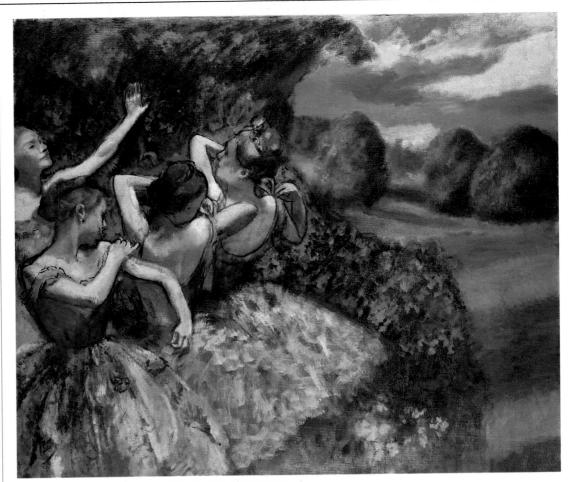

334 Edgar Degas, Four Dancers, c.1899, 71 x 59½ in (180 x 151 cm)

Orleans. His brother René had married a woman who went blind; Edgar Degas at least did not need to fear that the intensity of his stare would disturb her. He shows her gazing blankly, plump and well dressed, and we sense what her darkened world is like. The picture is strangely indistinct except for the face, where she is truly "herself." For the rest, she exists in cloudy spaciousness, her skirts spreading widely around her, the couch a sketchy background, nothing on the wall except light. The tight constraint of her hairstyle, unbecomingly scraped back, gives a certain pathos. Degas is sensitive to her situation, yet full of admiration: "My poor Estelle... is blind. She endures this in an amazing way; she is seldom helped around the house."

There is a tragic irony in the fact that Degas himself was to suffer from poor eyesight and eventually became unable to paint at all. His later work, mostly painted in the more direct medium of pastel, has a wild, instinctive rightness, as if his hand "knew" what his eye could barely see. Four Dancers (334) is not in pastel, but the oil is used with a pastellike freedom. He makes no attempt at obvious design. The dancers move out of the painting backward so that we just glimpse them as they move away. This unbalanced

composition, learned from photography (see column, p.293) and Japanese prints, shows Degas's understanding of perspective. The viewer is intrigued, forced to accept the painter's logic rather than that of convention. The colors, too, are vivid, insistent, glaringly bright, and this is part of Degas's theme: the stage is at all times artificially lit and our distance from it makes the colors become both loud and blurred, creating an impression of distance and glamorous dazzle.

Unidealized nudes

For one who so openly professed contempt for women, Degas was strangely fascinated by the female nude. But he also brutally demystifies it: the women he depicts are wholly unideal and lacking in individuality. Instead, his interest is in form, the figure reduced to an animating agent. He loved, he said, to paint as if "through the keyhole," catching his subjects when they thought themselves unobserved. The pastel painting *Girl Drying Herself (335)* is typical. We see only the back of this young woman as she stands with gawky tension upon her clothes. It is the rosy gleam of the light that provides romance and the hollow and swell of her muscles as she dries herself with animal vigor.

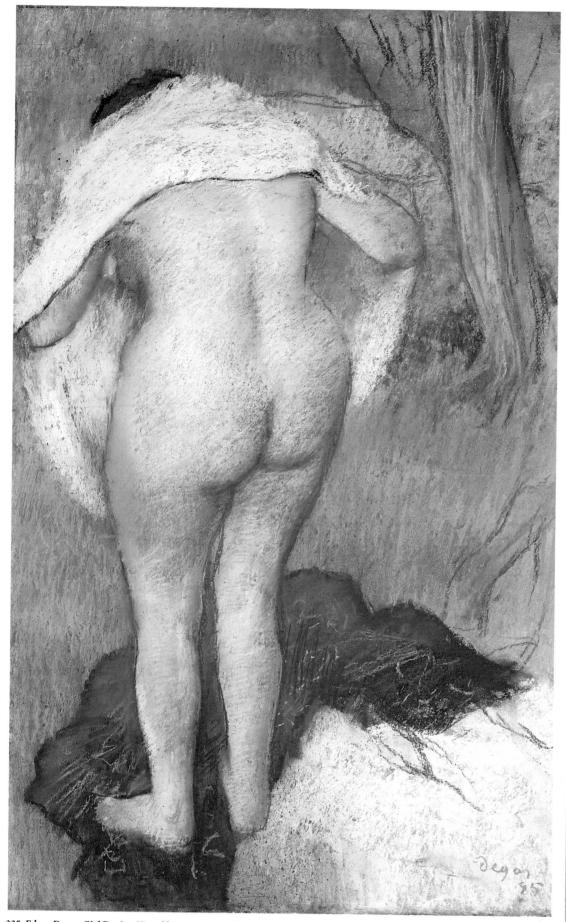

335 Edgar Degas, Girl Drying Herself, 1885, $20 \times 31\frac{1}{2}$ in $(50 \times 82$ cm)

DEGAS AND PHOTOGRAPHY

By the time of the Impressionists, technical advances had led to the development of the "snapshot" camera. The availability of instant unposed photography, with blurrings and accidental cropping off of figures, created a sense of spontaneity that the Impressionists also sought to achieve. Edgar Degas was inspired by the pioneering photographer Eadweard Muybridge, whose freeze-frame photographs of humans and animals in motion revolutionized the depiction of movement in art. This illustration shows the type of camera used by Degas.

OTHER WORKS BY DEGAS

Dancers in Pink (Museum of Fine Arts, Boston)

Woman Arranging Her Hair (Ordrupgaard-Samlingen, Copenhagen)

Dancers in the Foyer (Art Institute of Chicago) The Repetition (Burrell Collection,

Glasgow)

Jockeys
(National Gallery of

Canada, Ottawa)

After the Bath
(Bridgestone Museum of Art, Tokyo)

The Rehearsal of a Ballet (Musée d'Orsay)

Nursemaids (Norton-Simon Museum, Pasadena)

THE BIRTH OF IMPRESSIONISM

The term "Impressionism" appeared after the first group exhibition of 1874, when a journalist, Louis Leroy, made a sarcastic attack on Monet's painting entitled Impression: Sunrise. Leroy's satirical review argued "wallpaper in its embryonic state is more finished." The term was quickly adopted by others and soon lost its derisive overtones. The first show was held in Paris in the empty studios of the photographer Nadar, and this was followed by seven more exhibitions.

THE GREAT IMPRESSIONISTS

Impressionism was officially "born" in 1874, when the term was applied to a diverse collection of artists who exhibited at the Salon des Refusés that year. Many of the works had a comparatively coarse, unfinished appearance, which gave a strong sense of immediacy that incensed the critics. Although these artists were all individualistic, with disparate ideas and attitudes, they were united in their desire to achieve a greater naturalism in art, and their work revealed a startling new freshness and luminosity.

Critics found the independent exhibitors an easy target, especially the younger artists, Monet, Renoir, Morisot, and Sisley. These artists established a pictorial style that continued to the end of the decade and, after their first shows, consciously adopted the "Impressionist" label (see column). Cézanne, Pissarro, Degas, Gauguin - even some mainstream Salon painters - also exhibited at the Impressionist shows. Degas, though he had little stylistic affiliation with the

Impressionists, wanted to support an alternative salon that would undermine the monopoly of the official Salons and provide a public arena for an innovative kind of painting, based on real life.

Degas's concentration on formal line rather than on the effects of color make him quite different from his contemporaries, Monet and Renoir. Claude Monet (1840-1926), in particular, is the quintessential Impressionist, and as such his world is exhilaratingly beautiful. Monet's style, like that of the other Impressionists, was characterized by a light, colorful palette, and he often applied unmixed paints directly onto a canvas prepared with a pure white coating. This bright surface enhanced the luminosity of each color and increased the broken, disharmonious

appearance of the picture.

What fascinates Monet in Woman with a Parasol (336) (also called Madame Monet and Her Son) is not the identities of the models, but the way the light and breeze are held upon the canvas for our perpetual delectation. One summer's day a young woman stood on a small rise in the ground, grass and flowers hiding all sight of her feet. She seems to have floated here, borne along by her dappled sunshade, radiant in the sheer brightness of the hour. Her dress is alive with reflected hues, gleaming gold or blue or palest pink. The colors never settle down, any more than do her pleats and folds, which swirl against the glitter of the clouds and the intense blue sky. Monet saw this, held it still, and made it pictorially accessible to our eyes. We look up over the variegated grass with its luminous shadows, and we are dazzled.

THE SERIES PAINTINGS

Monet's contemporaries were used to controlling the motionless images they painted in their studios, so that their work corresponded not with what was actually seen in real life - which was never still - but with what was thought to be seen. Monet took away these comforting labels of certainty. He did this most alarmingly in his great series paintings, where he surveyed the same subject in different weather conditions at different times of day or seasons. As the

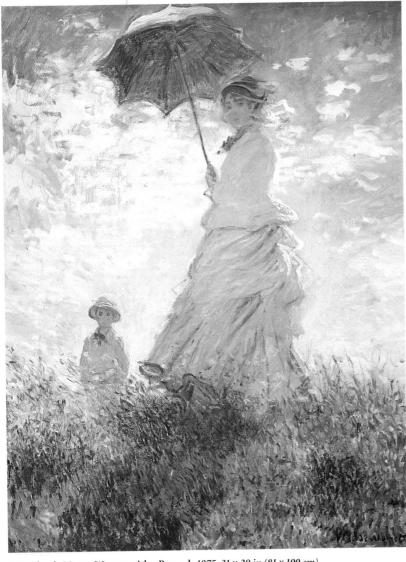

336 Claude Monet, Woman with a Parasol, 1875, 31 x 39 in (81 x 100 cm)

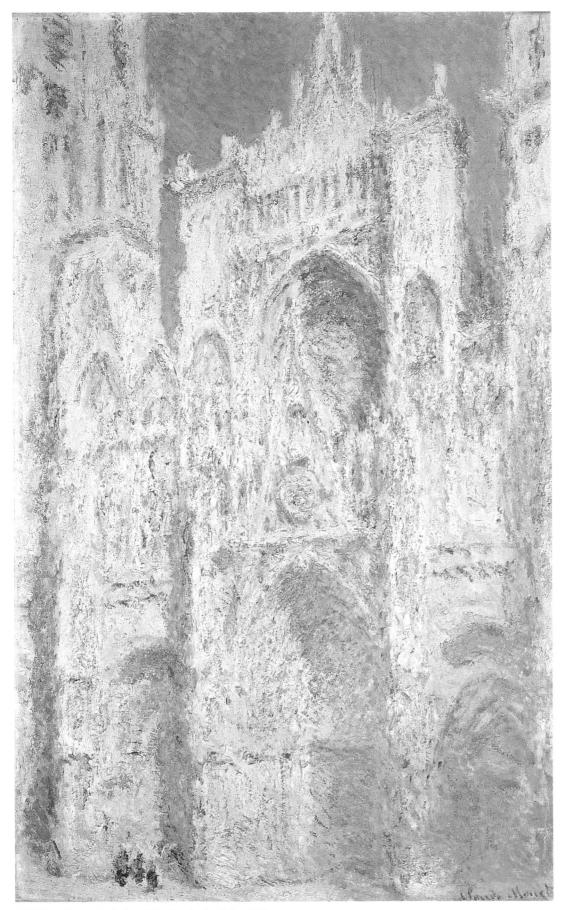

337 Monet, Rouen Cathedral, West Façade, Sunlight, 1894, $26\times39^{1/4}$ in $(66\times100~cm)$

Rouen Cathedral, The Portal Seen from the Front (Harmony in Brown)

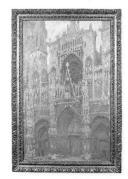

Rouen Cathedral, The Portal, Gray Weather (Harmony in Gray)

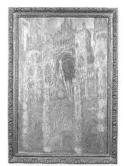

Rouen Cathedral, Morning Sun (Harmony in Blue)

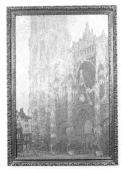

Rouen Cathedral, The Portal and the Saint-Romain Tower, Morning Effect (Harmony in White)

Monet at argenteuil

The suburb of Argenteuil, only a 15-minute train journey from Paris, was a popular destination for excursions. Monet lived in the town from 1871-78 and produced 170 paintings. Following the example of the earliest en plein air painter, Charles-François Daubigny, Monet had a studio boat built (replica illustrated above). The boat had a cabin and a shaded open deck so Monet could work outside. Monet never sailed far in the boat and tended to moor on quiet stretches of the Seine. During his time at

Argenteuil, the town hosted many international sailing regattas, providing inspiration for much of Monet's work. enveloping light changes, so do the forms that had hitherto been thought constant and permanent. Monet used his brilliant palette to capture the optical effects created by natural light across a landscape or a townscape, paying little attention to the incidental details and using highly visible, sketchy, "undiscriminating" brushwork to capture the scene quickly.

Rouen Cathedral had seemed an unchangeable reality, but as Monet painted that identical west front with its spires and entrance arches – always from the same viewpoint – he saw how it was constantly transformed by the light: now richly ruddy, the thick, crusty paint echoing the rough stonework, the welcoming gates very visible, the great picture window a mystery of dark appeal; then pale, shimmery, fluid, and shifting, almost without detail in the richness of the glare. He usually worked on several canvases at once, softening the stonework in dull weather with a harmonious palette of gray and heightening

it with white and cobalt blue when the sun was at its most brilliant. *Rouen Cathedral, West Façade, Sunlight (337)* makes its statement solely through this light. It was this sensitivity to the changing, transforming light – in the strictest sense, creative light – that was Monet's greatest gift as a painter. This, of course, was for him the great fascination of the series paintings, and he explored this fascination to the utmost.

Monet extended his pleasure to the mechanics of water gardens during the final years of his life, working directly with nature: at last he had the time and the money to create his own garden and paint it. Some of his final waterlily murals, painted on enormous canvases, are almost abstract, with their floating shapes and surface reflections, but *The Waterlily Pond* (338) is held firmly in the world of actuality by the Japanese bridge that curves across the center. Even here, without that unifying curve, we might read this riot of greens, blues, and golds as an abstraction.

OTHER WORKS BY MONET

Vétheuil (National Gallery of Victoria, Melbourne)

Heavy Sea at Trouville (National Museum of Western Art, Tokyo)

The Artist's Garden at Giverny (Bührle Foundation, Zurich)

The Beach at Pourville (Museé Marmottan, Paris)

La Grenouillère (Metropolitan Museum of Art, New York)

> Field of Poppies near Giverny (Museum of Fine Arts, Boston)

The Japanese Bridge (Neue Pinakothek, Munich)

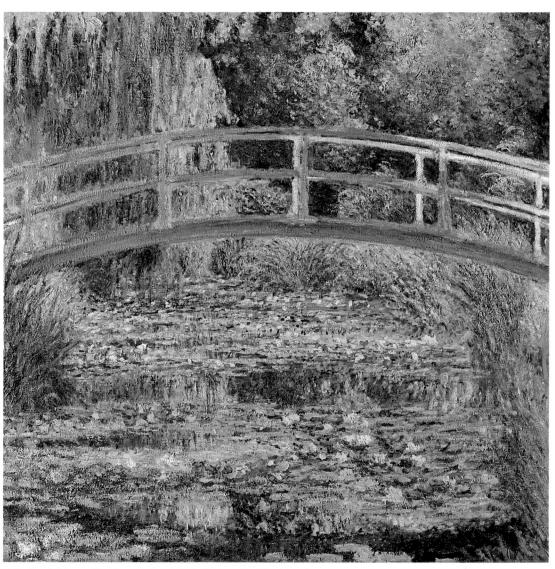

338 Claude Monet, The Waterlily Pond, 1899, 36½ x 35 in (92 x 90 cm)

THE WATERLILY POND

Monet moved to a house at Giverny in northwest France in 1883 and lived there for the rest of his life. His garden was his main source of inspiration during his remaining years, and in 1893 he increased its area by purchasing an adjoining site that contained a pond. Here he created his celebrated water garden. This is one of 18 paintings belonging to Monet's late series, in which the arched, Japanese-style bridge that he had constructed over his waterlily pond forms the central motif.

THE JAPANESE BRIDGE In this detail we can see Monet's characteristic "dry" paint surface. A heavily loaded brush was dragged over the canvas where previous applications were allowed to dry first. The result is a richly textured, encrusted surface, built up over time, which attracts light falling onto the canvas. The thick crust of paint imitates the solid structure of the bridge, standing out in sharp definition against the amorphous vegetation and transient light.

Monet's signature

The effect of The Waterlily Pond is an overwhelming sense of life, blocking out the sky and pushing in from all directions, almost vulgar in its lushness. Within the gloom of a deep shadow, not immediately visible amid such vibrancy, Monet's signature and the date of the painting can be found. The signature has been added in red, which has also been used to pick out individual flowers.

VERTICAL BRUSHWORK

This version of the waterlily pond reveals the garden in full summer, with dense, bright green foliage. Beyond the tense, arching curve of the bridge, the foliage is a soft mass of confusion: greens, blues, pinks, and purples merge in and out of one another, and definition is almost nonexistent. However, the vertical rhythm of the brushwork prevents the foliage from melting into incoherence, and it helps maintain the strong formal structure, repeating the verticals of the bridge and the sides of the canvas.

HORIZONTAL BRUSHWORK

The vertical rhythms of the foliage are continued into the deep shadows and bright reflections in the water. However, the unified downward movements of this brushwork are counterbalanced by bold horizontal brushstrokes, running from side to side across the canvas, which describe the receding bands of waterlilies stretched across the pond. These bands of color are applied with thick sculptural paint over the top of the reflections and shadows in the water, "anchoring" them by asserting the flatness of the water's surface. This continuous crisscross interplay of brushwork maintains a lively tension between the painting's two-dimensional abstract properties and its illusion of three-dimensional space.

339 Auguste Renoir, The Boating Party Lunch, 1881, 69 x 51 in (175 x 130 cm)

THE BOATING PARTY LUNCH

Renoir began this painting of his friends on the terrace of the Restaurant Fournaise in the summer of 1881. The restaurant was located in a village called Chatou, which was a fashionable destination for outings on the Seine. We can identify most of the people: Monsieur Fournaise, the proprietor, standing on the left; Aline Charigot, Renoir's wife-to-be, seated on the left; Baron Barbier, in the top hat in the distance; and at the front right, Gustave

Caillebotte, the artist.

CONTEMPORARY LIFE

Auguste Renoir (1841–1919) and Monet worked closely together during the late 1860s, painting similar scenes of popular river resorts and views of a bustling Paris. Renoir was by nature more solid than Monet, and while Monet fixed his attentions on the ever-changing patterns of nature, Renoir was particularly entranced by people and often painted friends and lovers. His early work has a quivering brightness that is gloriously satisfying and fully responsive to what he is painting, as well as to the effects of the light.

Renoir seems to have had the enviable ability to see anything as potentially of interest. More than any of the Impressionists, he found beauty and charm in the modern sights of Paris. He does not go deep into the substance of what he sees but seizes upon its appearance, grasping its generalities, which then enables the spectator to respond with immediate pleasure. "Pleasure" may be decried by the puritanical instinct within us all, but it is surely the necessary enhancer that

life needs. It also signifies a change from Realism: the Impressionists' paintings have none of the labored toil of Millet's peasants, for example. Instead they depict delightful, intimate scenes of the French middle class at leisure in the country or at cafés and concerts in Paris. Renoir always took a simple pleasure in whatever met his good-humored attention, but he refused to let what he saw dominate what he wanted to paint. Again he deliberately sets out to give the impression, the sensation of something, its generalities, its glancing life. Maybe, ideally, everything is worthy of attentive scrutiny, but in practice there is no time. We remember only what takes our immediate notice as we move along.

In *The Boating Party Lunch* (339), a group of Renoir's friends are enjoying that supreme delight of the working man and woman, a day out. Renoir shows us interrelationships: notice the young man intent upon the girl at the right chatting, while the girl at the left is occupied with her puppy. But notice too the loneliness, however relaxed, that can be part of anyone's

experience at a lunch party. The man behind the girl and her dog is lost in a world of his own, yet we cannot but believe that his reverie is a happy one. The delightful debris of the meal, the charm of the young people, the hazy brightness of the world outside the awning – all communicates an earthly vision of paradise.

RENOIR'S PORTRAITS

One of Renoir's early portraits, A Girl with a Watering Can (340), has all the tender charm of its subject, delicately unemphasized, not sentimentalized, but clearly relished. Renoir stoops down to the child's height so that we look at her world from her own altitude. This, he hints, is the world that the little one sees – not the actual garden that adults see today, but the nostalgic garden that they remember from their childhood. The child is sweetly aware of her central importance. Solid little girl though she is, she presents herself with the fragile charm of the flowers. Her sturdy little feet in their sensible boots are somehow planted in the garden, and the lace of her dress has a floral rightness; she also is decorative. With the greatest skill, Renoir shows the child, not amid the actual flowers and lawns, but on the path. It leads away, out of the picture, into the unknown future when she will no longer be part of the garden but an onlooker, an adult, who will enjoy only her memories of the present now depicted.

340 Auguste Renoir, A Girl with a Watering Can, 1876, 29×39 in $(73\times100~cm)$

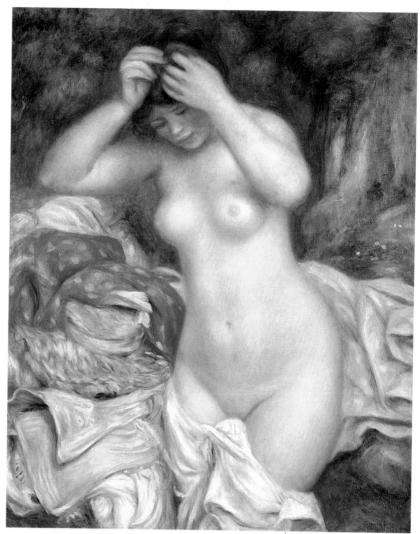

341 Auguste Renoir, Bather Arranging Her Hair, 1893, 29 × 36½ in (74 × 92 cm)

RENOIR'S LATE STYLE

Although he may seem a happy hedonist, Renoir was in fact a serious artist. At one stage he changed his whole style, feeling that he had gone as far as he could with Impressionism and was in danger of becoming superficial. His late style is firmer, with a cleaner edge to his figures, and the last works have a classical solidity. In Bather Arranging Her Hair (341), he has preserved the solid feel of the bodily form and irradiated it with luminous color. The girl's lovely body is set out amid the disarray of her many-colored garments: her corset, her hat, the white material draped around that round and rosy flesh. Renoir persuades us that the girl herself does the stripping and the presenting, and we feel she loves her body, as she should. He gazes worshipfully, not at her, the person, but at her body, the outer her, and he delights in painting her soft, glowing skin. Her bright but concentrated expression hints that the distinction would not mean much to her; she is an innocent country beauty.

DURAND-RUEL

Paul Durand-Ruel (1831-1922) was the first art dealer to give consistent support to the Impressionists. He was introduced to Monet by the artist Daubigny while in England during the Franco-Prussian war and became the sole financial backer of a number of the Impressionist artists. In 1886 he achieved a breakthrough with an exhibition of Impressionist works in New York. In 1905 his exhibition of hundreds of paintings brought the artists' work to London. Monet's international acclaim was entirely due to the support and investment of Durand-Ruel during the 1870s.

OTHER WORKS BY

Winter Landscape (National Museum of Western Art, Tokyo)

The White Frost (Musée d'Orsay, Paris)

A Corner of the Meadow at Eragny (Tate Gallery, London)

Place du Havre, Paris (Art Institute of Chicago)

View from My Window, Eragny (Ashmolean Museum, Oxford)

Bather in the Woods (Metropolitan Museum of Art, New York)

The Pont de Pierre, Rouen (Art Gallery of Ontario, Toronto)

Summer Landscape, Eragny (Philadelphia Museum of Art)

342 Camille Pissaro, Orchard in Bloom, Louveciennes, 1872, 22 x 171/2 in (55 x 45 cm)

CAMILLE PISSARRO

Camille Pissarro is seen as the patriarchal figurehead of the Impressionist movement and is the only artist to have had work shown at all eight of the Impressionist exhibitions. During the Franco-Prussian war (see p.286), Pissarro joined Monet in England and was influenced by the English landscape tradition of Turner and Constable. In 1872 he returned and settled in Pontoise, where he became a friend and mentor of Cézanne. Pissarro's art centers on the people who work the soil, and he is renowned for his paintings of peasant girls going about their daily chores.

CAMILLE PISSARRO

Camille Pissarro (1830–1903) was the patriarch of the Impressionists, not only because he was slightly older, but because of his benign and generous character. After meeting Corot in 1857, Pissarro was encouraged to abandon his formal training to paint in the open air and, despite his age, he became one of the most receptive of the Impressionists to new ideas. He was a passionate champion of progress, sometimes to the detriment of his own individual expression. He was the only artist to have shown work at all eight Impressionist exhibitions.

Pissarro was a dedicated painter and enormously prolific. He tended to stray in and out of pure Impressionism as the spirit took him, unconcerned with the rigors of style. He was the outsider of the group, perhaps, a man of mixed blood (Portuguese, Jewish, and Creole), and he was instinctively reponsive to the underlying architecture of nature. His paintings, with their almost naive simplicity and unpolished surface, influenced Gauguin (see p.322), van Gogh (p.316), and Cézanne (p.310), who called himself the "pupil of Pissarro."

343 Camille Pissarro, Peasant Girl with a Straw Hat, 1881, 24 x 29 in (60 x 73 cm)

Orchard in Bloom, Louveciennes (342) is a work with bones under the painterly flesh: the path that we notice in the foreground leads us with a real sense of distance through the flowering brightness of impressionistic trees. There is a

sunlit gentleness peculiar to this balanced, wise artist with his sense of freedom and restrained exhilaration. *Peasant Girl with a Straw Hat (343)* has a beautiful simplicity, a fullness of form not contradicted but given significance by the haze of the background. Pissarro himself was a very good human being, and even without knowing this, we do seem to find a lovely wholesomeness in his people and places. The girl is supremely unpretentious, unconcerned with herself, her whole being – sun-reddened nose and all – illuminated by the strong, bright light of day.

In his fifties, Pissarro became fascinated by the Neo-Impressionists and their great interest in the science of optics. He experimented with the Divisionist techniques of Seurat (see p.314) with, for Pissarro, a relative unsuccess. The work was not appreciated by the public either, and he converted back to the spontaneity of true Impressionism. He was a major Impressionist – Cézanne considered him their leader – though he has been somewhat overshadowed by Monet and his other great "pupils."

ALFRED SISLEY

Alfred Sisley (1839–99) was something of an outsider because his family, though permanently resident in France, was English. Sisley, however, has been called the most consistent of the Impressionists. All the others, even Monet in his late, great semi-abstractions, moved on from, or at least through, Impressionism. Sisley, once he saw the meaning of the movement, stayed with it. While other Impressionists sought their inspiration in Paris, he preferred, like Pissarro, to live in the countryside and paint rural scenes.

Sisley's art was not as robust as Monet's, but his paintings are some of the most subtly beautiful of the Impressionists, and they are heavenly in their peaceful celebration of nature. *Meadow* (344) lies quietly under the sun, vibrant with variety and chromatic glory. It is a scene that is easy to look at, a strip of field and a humble fence, yet Sisley has seen that it is alive all over with the intensity of being. The miracle is that the intensity is so completely without tension; Sisley seems to dream in paint.

ALFRED SISLEY As an artist Alfred Sisley is known to have felt like an outsider from the main group of Impressionist painters. However, many of his landscapes are considered among the most lyrical and harmonious works of Impressionism. Born of English parents, he moved to France and joined the studio of Charles Gleyre in 1862, where he met Renoir and became close friends with Monet.

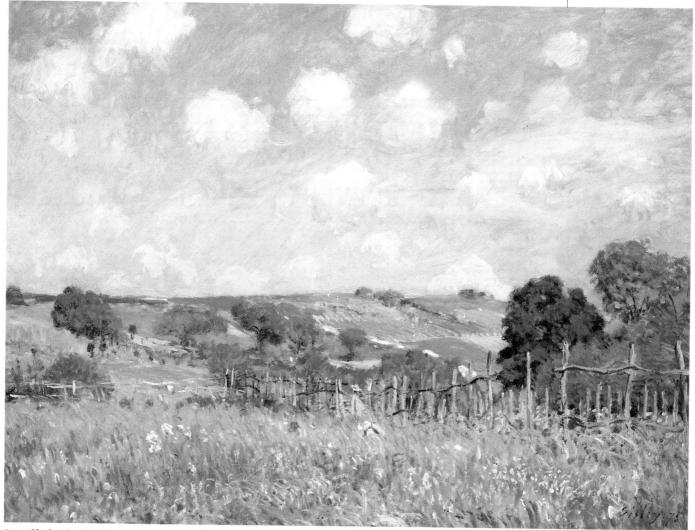

344 Alfred Sisley, Meadow, 1875, 29 x 22 in (73 x 55 cm)

American Vision

should stand alone, and appeal to the artistic sense of eye or ear, without confounding this with emotions entirely foreign

James Whistler

Impressionism became a worldwide movement, as international as the Gothic style of ages past, and artists as far away as Japan and Australia began to paint modern-day subjects in the open air. American artists such as James Whistler, Thomas Eakins, and Winslow Homer traveled to Europe to study painting. Skillfully, they took from Realism and Impressionism what each of them personally needed.

James Abbott McNeill Whistler (1834–1903), though he lived in London by choice, was an American. A flamboyant character, he was one of the most well-known and colorful figures of the European art world in the 19th century.

In 1855 Whistler left America and traveled to Paris to train as an artist. He entered the studio of Charles Gleyre, an advocate of Realism, and became, for a time, an enthusiastic follower of Gustave Courbet (see p.282). He was a dandy

and a wit, very much at home as a Parisian *flâneur* like his two contemporaries, Manet and Degas. When his early work received more success in England, he left Paris in 1859 and moved to London, where he began to paint a favorite and enduring subject, the Thames.

AN AMERICAN ENGLISHMAN

Whistler hovered on the brink of Impressionism during the 1860s and at one stage came close to painting mere "sensation." But it was Japanese prints that influenced his style, and he was one of the first artists to understand and absorb the lessons of Japanese art, rather than imitate it. He translated the two-dimensional qualities, cool tones, and significant details of *Japanisme* into a highly individual treatment of color harmony and tone on a flat, decorative surface.

Nocturne in Blue and Gold: Old Battersea Bridge (345) shows Whistler's interest in harmonious arrangements of color and pattern. Its musical title gives emphasis to the sparse notes of color that blaze on a dimly seen background, suggesting that we are given only an impression of what is seen, not its actuality; his elongated bridge is far more reminiscent of the stylistic imagery of Japonisme than of the real Old Battersea Bridge. Yet despite its apparent vagueness, the painting has genuine power. This is how London would have looked in the days of smoking chimneys. We catch a sense of mystery, even glamour, the last perhaps an index of Whistler's American nature: the transatlantic traveler, as we know from the novels of Henry James (see column, p.305), finds London far more romantic than the average Londoner.

Whistler is at his best when he plays with shapes and colors and it is their intrinsic interaction that delights him, rather than the play of light itself. *The White Girl (346)* is a great piece of decorative art. Jo Heffernan, his mistress, pleasingly occupies the center of the picture. There is a marvelous subtlety in the different whites – the thick hanging of the patterned curtain; the soft whiteness of her dress; the rose she holds in her hand – while her dark, beautiful face in its rough cascade of auburn hair is sadly enigmatic.

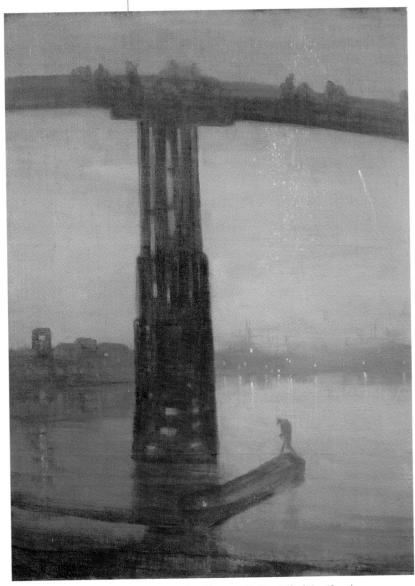

345 James Whistler, Nocturne in Blue and Gold, 1872–75, 20 x 27 in (50 x 68 cm)

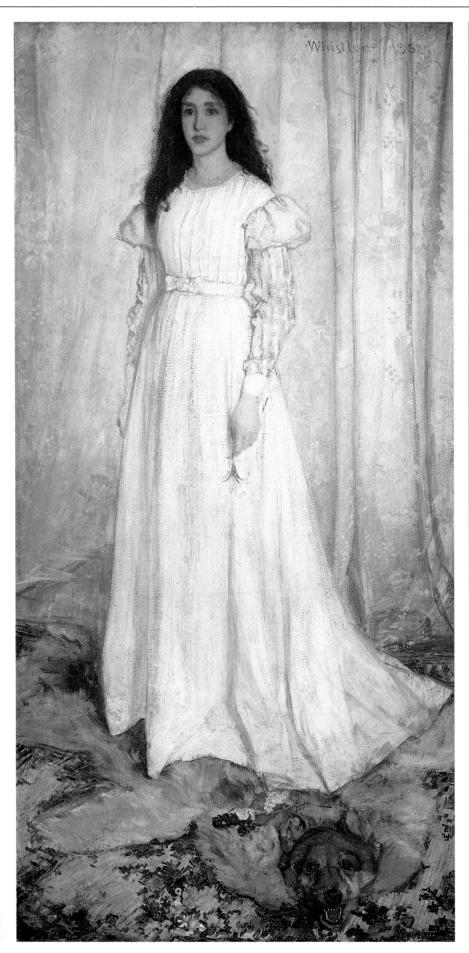

346 James Whistler, The White Girl, 1862, 42½ x 84 in (108 x 213 cm)

OSCAR WILDE

The playwright, novelist, poet, and wit Oscar Wilde (1854-1900) was one of Whistler's closer friends. While traveling to the United States on a lecture tour in 1882, Wilde is reported to have said, when asked if he had anything to declare, "Only my genius." He married in 1884, and in 1891 wrote the novel *The* Picture of Dorian Gray, in which the main character was apparently based on his male lover, the poet John Gray. His most famous work, however, was The Importance of Being Earnest, written for the theater in 1895. Wilde's brief but brilliant career ended in ruin when he was sentenced to two years in prison for homosexual practices.

Other works by whistler

Old Westminster (Museum of Fine Arts, Boston)

Gray and Green: the Silver Sea (Art Institute of Chicago)

Nocturne: River Scene (Glasgow University)

Three Figures: Pink and Gray (Tate Gallery, London)

A Woman (National Museum of Western Art, Tokyo)

Self-Portrait (Detroit Institute of Art)

Man with a Pipe (Museé d'Orsay, Paris)

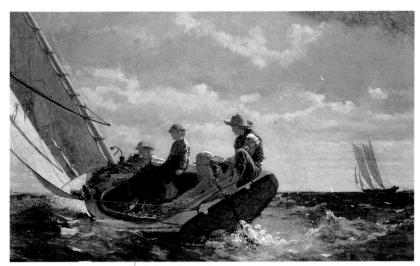

347 Winslow Homer, Breezing Up, 1876, 38 x 24½ in (97 x 62 cm)

Winslow Homer

Winslow Homer (1836–1910) was only lightly touched by Impressionism. He visited Paris in 1867, and was also impressed by Manet's broad tonal contrasts, but he explored light and color within a firm construction of clear outlines. Whistler's art seems a rejection of all that Homer represents, with his emphasis on clarity and objective, convincing solidity. Homer's watercolors have an incandescent brightness, his oils are beautifully solid, and he is better described by Realism than Impressionism.

Breezing Up (347) has a spectacular vividness. The sea (Homer's favorite subject) frisks and sways almost palpably under the keel of the small boat, the three boys and the fisherman brought before us by the slightest of touches.

America and her leaders

In the late 19th century the US was undergoing economic and social changes that would have repercussions across the whole world. Between 1880 and 1900 the population of the country doubled with the arrival of nine million immigrants. The country was also emerging from a period of economic depression and was stimulated by industrialization, the growth of the railroads, and the discovery of more silver and gold in the West. The election in 1880 produced a compromise president, James Garfield (1831-81), shown above, but interparty strife led to his assassination by a disappointed and deranged office seeker on July 2, 1881.

348 Thomas Eakins, The Biglin Brothers Racing, c. 1873, 36 x 24 in (91 x 60 cm)

This is one particular day when the wind begins to rise at sea with all the emotions fresh at hand for the painter. The sun shines and the air of excitement runs all along the horizon, ending with the filling – and balancing – sails that punctuate the far right of the picture.

THOMAS EAKINS

If Homer is a supreme watercolorist, then Thomas Eakins (1844–1916) is a supreme oil painter of the American Realist tradition. *Breezing Up* is wonderful, but it seems just that slight shade less convincing than *The Biglin Brothers Racing* (348), one of Eakins's greatest works. Eakins persuades us that we too would have seen this, had we stood in Philadelphia one summer's morning to watch the racers exercise.

349 John Singer Sargent, Mrs. Adrian Iselin, 1888, 37 x 61 in (93 x 154 cm)

We would not have seen this scene, of course: the Biglin brothers would have vanished from sight before we had time to notice how the sunlight catches doublet and oar, or how the distant riverbank is as dim and dense as foliage. Eakins has held the image and created a work of such atmosphere that when we look at the painting the moment seems full and long — not at all like a snapshot. In the light of this comparison, Homer's glimpsed sailors begin to seem far more impressionistic than at first sight.

SARGENT THE SOCIETY PAINTER

John Singer Sargent (1856–1925) is essentially known as a society painter and, except for his marvelous watercolors of nature, he painted almost only high society. Often there was a great swagger of fashionable dress, but *Mrs. Adrian Iselin (349)* is too elite for such embellishments. She glitters before us in austere black with the domineering haughtiness of a grande dame. For those who think Sargent pandered to his sitters, he has faithfully depicted her large and ugly ear. At his best, Sargent could be as ruthless as Goya, and with something of his technical brilliance.

HENRY JAMES

In the work of the American writer Henry James (1843–1916), we see a change of subject matter as the author moved through three creative phases. In the first phase, which produced one of his most famous novels, The Bostonians (1886), James was concerned with the impact of American life on the more established European societies. In 1876 James moved to England and devoted his novels to the issues of English society. His novel The Ambassadors unites Anglo-American attitudes in his last period of creativity. Although an American, he was very much an Anglophile and became a British citizen during World War I.

JOHN SINGER SARGENT

The outstanding portrait painter of his time, John Singer Sargent (1856-1925) was an American citizen with a French education who came to work in England in 1885. His move to England was prompted by the scandal surrounding his exhibit at the 1884 Paris Salon. The painting, Madame X, was considered provocatively erotic by the judges and was also obviously the portrait of a real woman, Madame Gautreau. Her mother begged Sargent to remove the picture, but he fled to England. In his later years he was made official British war artist of World War I.

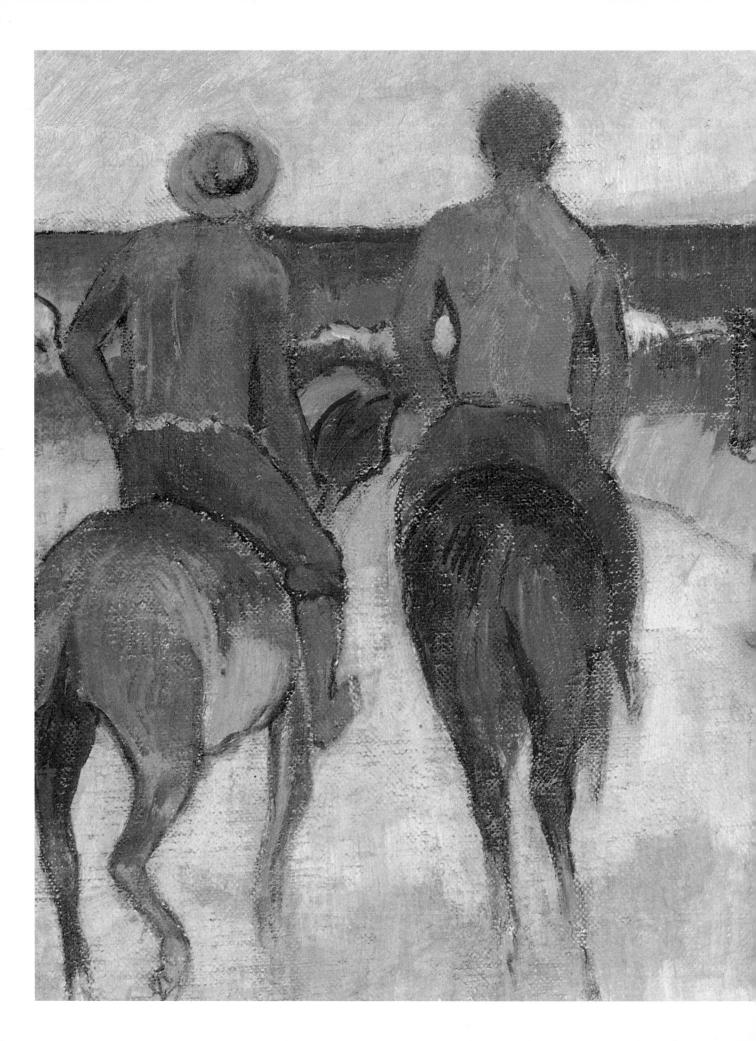

POST-IMPRESSIONISM

Art history loves labels, and Post-Impressionism is the label for the diverse art that immediately followed Impressionism (this label roughly covers the period between 1886 and 1910). The Impressionists had destroyed forever an artistic belief in the objective truth of nature. Painters now understood that what we see depends on how we see, and even more when we see: the "objective view" is in fact subject to both perception and time. We live in an essentially fleeting and uncontrollable world, and it is the glory of art to wrestle with this concept.

The greatest of all wrestlers was Paul Cézanne, who understood, as no artist before him ever had, the personal need of the artist to respond to what he saw and make a visual and enduring image of its wayward and multi-dimensional beauty. Another Post-Impressionist giant, Georges Seurat, sought a more scientific analysis of color in his painting, though his art transcended his theories. Other artists chose to portray the world, not just by its physical, outward appearance, but by its inner, less tangible realities, exploring new symbolic associations with color and line.

POST-IMPRESSIONISM TIMELINE

Post-Impressionism is the name given to a group of painters in the last two decades of the 19th century. They have very little in common except their starting point – the Impressionists. Paul Cézanne, Paul Gauguin, and Vincent van Gogh are all geniuses of a high order, but the movement we call Post-Impressionism also embraces, in its capacious sweep, small groups like the Nabis.

VINCENT VAN GOGH, THE ARTIST'S BEDROOM, 1889

Van Gogh used color to convey emotion more than to represent objects: this painting carries a poignant message of loneliness, hinted at by the extra chair, waiting for an eagerly expected companion – Gauguin. This room is in the house at Arles that van Gogh shared with Gauguin from October to December 1888. He painted this scene in 1888 and made two copies of it in 1889 (this is one of them), when he was in the asylum at St. Rémy (p.316).

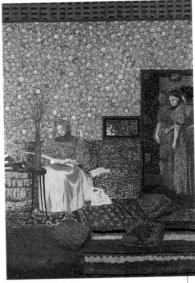

EDOUARD VUILLARD, THE READER, 1896

To the Nabi artists, it was important to show beauty in simple scenes, such as this superbly decorative painting with its assemblage of patterned fabrics (p.328).

1885

1890

1895

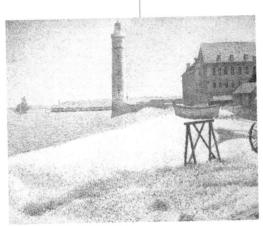

Georges seurat, the lighthouse at honfleur, 1886

Seurat was that rare thing, both scientist and artist. He was enthralled by the newly emerging science of optics and developed a style of painting called Pointillism, which used innumerable dots of color. The eye combines these as we do in real life, but his vision was of a world supremely pure and controlled, painfully different from actuality (p.315).

HENRI DE TOULOUSE-LAUTREC, RUE DES MOULINS, 1894

The witty, searching art of Lautrec often depicted nightclub and drinking scenes or portrayed the denizens of Parisian lowlife. Here, two prostitutes are shown lining up for a medical examination, and the sadness and shame of their position in society are held up to our gaze. Lautrec was influenced by the Japanese and their complete freedom from conventional notions of composition; the center of attention was often off-center. His style was perfectly suited to poster art, to which he brought great new zest and life. In all his work there is a fluidity and passion that captures the vitality of city life (p.320).

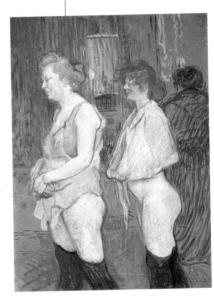

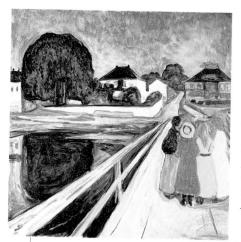

EDVARD MUNCH, FOUR GIRLS ON A BRIDGE, 1889-1900

Munch was a strange man who experienced overwhelmingly gloomy emotions. It was to express the intensity of these emotions that his art was directed. Personally he found the pain of life too much to bear, but artistically he struggled to express this pain and make beauty out of it. Symbolism struck a deep chord within him: with its high color and formal simplicity, it offered him a refuge from his fears. This Nordic gloom lived on to influence Expressionism, which dominated Germanic art after World War I (p.325).

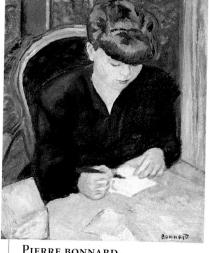

Pierre Bonnard, the letter, c. 1906

Bonnard was a leading member of the Nabis, who in some ways were a transitional movement between Post-Impressionism and the art of the 20th century. Bonnard was interested in oriental philosophy and mysticism. He was influenced by Japanese art, imitating the graphic simplicity of Japanese woodcuts. The Letter is a typical example of his many paintings of everyday life. The model is one who frequently appears in Bonnard's pictures, his lover and, later, wife, Marthe. She is portrayed with a wonderful concision, and Bonnard takes an uncomplicated pleasure in the patterns into which the image falls (p.326).

Paul cezanne, le chateau noir, 1900/04

At all stages of his career and with all types of subject, Cézanne was a supreme master. This picture is a fine example of the Post-Impressionist tension between reality and invention. We are forced to read it not only as a wooded landscape with a château, but equally as a flat plane, upon which colors of different chromatic and tonal values have been arranged (p.312).

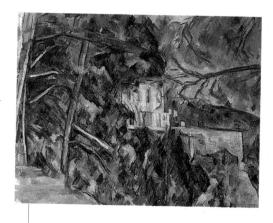

1900

1905

1910

Paul Gauguin, Nevermore, 1897

The English title Nevermore, appearing in the corner of this painting, is the name of a poem, "The Raven" by Edgar Allan Poe, which was a favorite of the French Symbolists. However, the painting is not exactly an illustration of the poem. What Gauguin hoped to create was an image of "a certain long lost barbaric luxury," and for him the girl is the main feature in the painting, and the bird is reduced to a toylike caricature. Gauguin strove to show the capacity of art to escape from rationality and naturalism, in order to describe more accurately the inner workings of the heart and mind (p.324).

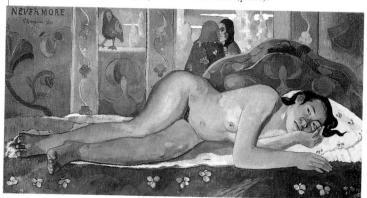

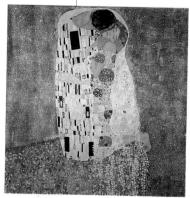

Gustav Klimt, the Kiss, 1907/08 Gustav Klimt came from a family of artists and craftsmen; his father was a gold engraver. As one of Austria's most prominent artists, he helped found two radical groups, the Vienna Secession and the Vienna Workshop. The Kiss is a gloriously decorative work, a fusion of two figures into one, with a suggestion of anxiety in the tense grip of the hands and the averted face of the girl (p.325).

Post-Impressionist Artists

Like the Renaissance, Impressionism made an irreversible difference, the viewer naturally senses that all art since that time has been "after Impressionism." The artists who rejected Impressionism toward the end of the 19th century painted not only what they observed, but what they felt, finally setting painting free to deal with emotions as well as material reality. They experimented with new subjects and techniques, moving art closer to abstraction and winning tremendous freedom for the next generation of artists.

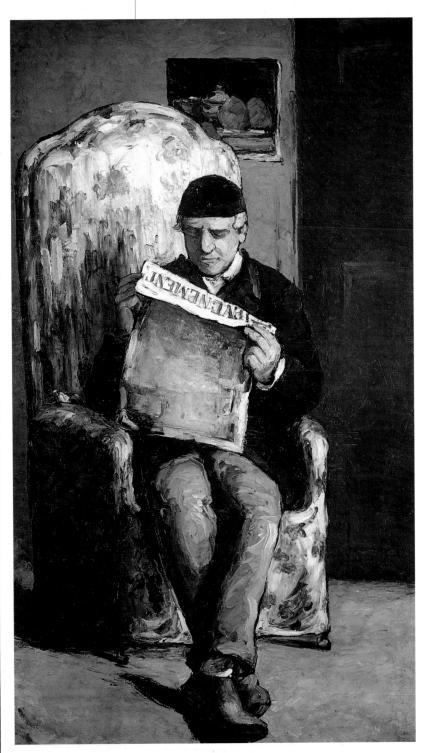

350 Paul Cézanne, The Artist's Father, 1866, 47 x 78 in (119 x 199 cm)

Post-Impressionism was never a movement – the term was unknown to the artists involved during their own lifetimes (see column, p.311). It encompasses a group of artists with diverse styles and ideals who became dissatisfied with the limitations of Impressionism and departed from it in various directions. Never again could it be so taken for granted that painting has a direct relation to the exterior world.

CEZANNE'S EARLY WORK

Paul Cézanne (1839–1906) is certainly as great an artist as any that ever lived, up there with Titian, Michelangelo, and Rembrandt. Like Manet and Degas, and also Morisot and Cassatt, he came from a wealthy family – his was in Aix-en-Provence, France. His banker father seems to have been an uncultivated man, of whom his highly nervous and inhibited son was afraid. Despite parental displeasure, Cézanne persevered with his passionate desire to become an artist. His early paintings display little of the majesty of his late work, though today they are rightfully awarded the respect that he never received for them.

His early years were difficult and his career was, from the beginning, dogged with repeated failure and rejection. In 1862 he was introduced to the famed circle of artists who met at the Café Guerbois in Paris, which included Manet, Degas, and Pissarro (see p.300), but his awkward manners and defensive shyness prevented him from becoming an intimate of the group. However, Pissarro was to play an important part in Cézanne's later development.

One of the most important works of his early years is the portrait of his formidable father. *The Artist's Father* (350) is one of Cézanne's "palette-knife pictures," painted in short sessions between 1865 and 1866. Their realistic content and solid style reveal Cézanne's admiration for Gustave Courbet (see p.282). Here we see a craggy, unyielding man of business, a solid mass of manhood, bodily succinct from the top of his black beret to the tips of his heavy shoes. The uncompromising verticals of the massive chair are echoed by the door, and the edges of the

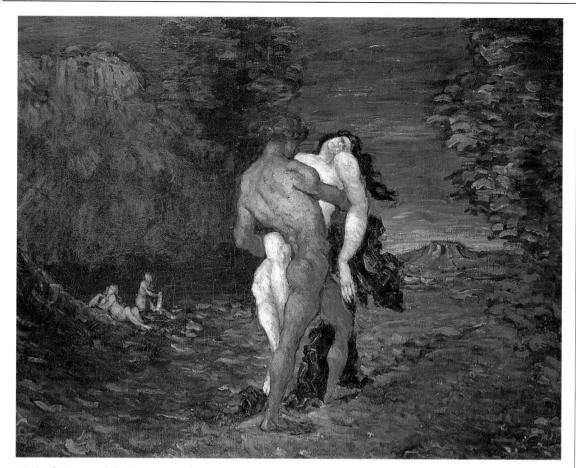

351 Paul Cézanne, Abduction, c. 1867, 46 x 35 in (117 x 90 cm)

small still life by Cézanne on the wall just behind: everything corresponds to the absolute verticals of the edges of the canvas itself, further accentuating the air of certainty about the portrait. Thick hands hold a newspaper – though Cézanne has replaced his father's conservative newspaper with the liberal L'Evénement, which published articles by his childhood friend Emile Zola (see p.286). His father devours the paper, sitting tensely upright in the elongated armchair. Yet it is a curiously tender portrait too. Cézanne seems to see his father as somehow unfulfilled: for all his size he does not fully occupy the chair, and neither does he see the still life on the wall behind him, which we recognize as being one of his son's. We do not see his eyes – only the ironical mouth and his great frame, partly hidden behind the paper.

Mystery of nature

Cézanne was in his twenties when he painted *The Artist's Father*. Wonderful though it is, with its blacks and grays and umbers, it does not fully indicate the profundity of his developing genius. Yet even in this early work, Cézanne's grasp of form and solid pictorial structures, which came to dominate his mature style, are already essential components. His overriding concern

with form and structure set him apart from the Impressionists from the start, and he was to maintain this solitary position, carving out his unique pictorial language.

Abduction, rape, and murder: these are themes that tormented Cézanne. *Abduction* (351), an early work full of dark miseries, is impressive largely for its turgid force, held barely under his control. These figure paintings are the most difficult to enter into, they are sinister, with passion in turmoil just beneath the surface.

Cézanne's late studies of the human body are most rewarding, his figures often depicted as bathers merging with the landscape in a sunlit lightness. This became a favorite theme for Cézanne, and he made a whole series of pictures on the subject. This mature work is dictated by an objectivity that is profoundly moving for all its seeming emotional detachment.

It was before nature that Cézanne was seized with a sense of the mystery of the world to a depth never expressed by another artist. He saw that nothing exists in isolation – an obvious insight, yet one that only he could make us see. Things have color and they have weight, and the color and mass of each affects the weight of the other. It was to understand these rules that Cézanne dedicated his life.

ROGER FRY The term Post-Impressionism was coined by the English art critic Roger Fry (1866-1934) to describe the group of artists who came immediately after the Impressionists. These artists were centered in Paris and chose to reject the Impressionists' concentration on the external, fleeting appearances of their world. Fry was curator of the Metropolitan Museum of Art in New York between 1906 and 1910 and introduced the Post-Impressionists to Great Britain by exhibitions that he arranged at the Grafton Galleries in 1910 and 1912. Artists he displayed included Gauguin, Cézanne, and van Gogh.

OTHER WORKS BY CEZANNE

Basket of Apples (Art Institute of Chicago)

Mont Sainte Victoire (Courtauld Institute, London)

Still Life of Fruit (Barnes Foundation, Marion, Penn.)

The Card Players (Metropolitan Museum of Art, New York)

Poplars (Musée d'Orsay, Paris)

Self-Portrait (Bridgestone Museum of Art, Tokyo)

L'Estaque (Bührle Foundation, Zurich)

Mont sainte-victoire

The Sainte-Victoire mountain near Cézanne's home in Aix-en-Provence was one of his favorite subjects, and he is known to have painted it more than 60 times. Cézanne was fascinated by the rugged architectural forms in the mountains of Provence and painted the same scene from many different angles. He would use bold blocks of color to achieve a new spatial effect known as flat-depth to accommodate the unusual geological forms of the mountains. Cézanne traveled widely in the Provence region and also enjoyed painting the coast at L'Estaque.

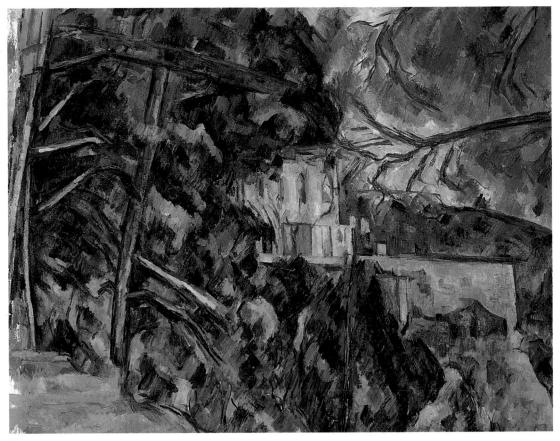

352 Paul Cézanne, Le Château Noir, 1900/04, 38 x 29 in (97 x 74 cm)

STRUCTURE AND SOLIDITY

From 1872, under Pissarro's influence, Cézanne painted the rich Impressionist effects of light on different surfaces and even exhibited at the first Impressionist show. But he maintained his concern for solidity and structure throughout,

to the flickering light as an Impressionist might; he draws that flicker from deep within the substance of every structure in the painting. Each form has a true solidity, an absolute of internal power that is never diminished for the sake of another part of the composition.

It is the tension between actuality and illusion, description and abstraction, reality and invention, that makes Cézanne's most unassuming subjects so profoundly satisfying and exciting, and which

provided a legacy for a revolution of form that

and abandoned Impressionism in 1877. In Le

Château Noir (352), Cézanne does not respond

led the way for modern art. The special attraction of still life to Cézanne was the ability, to some extent, to control the structure. He brooded over his apples, pitchers, tables, and curtains, arranging them with infinite variety. Still Life with Apples and Peaches (353) glows with a romantic energy, as hugely present as Mont Sainte-Victoire (see column). Here too is a mountain, and here too sanctity and victory: the fruits lie on the table with an active power that is not just seen but experienced. The pitcher bulges, not with any contents, but with its own weight of being. The curtain swags gloriously, while the great waterfall of the napkin absorbs and radiates light onto the table on which all this life is supported.

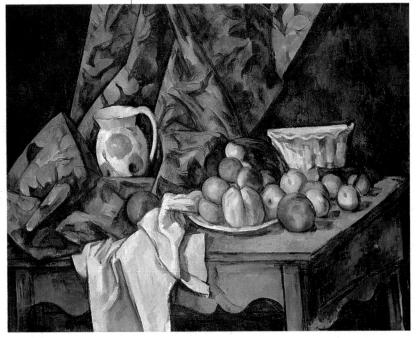

353 Paul Cézanne, Still Life with Apples and Peaches, c. 1905, 40 x 32 in (100 x 81 cm)

Le Chateau Noir

The château in this painting gets its name from rumors about its owner, rather than from its appearance. It was built in the 18th century by an industrialist from Marseilles, who manufactured lampblack paint (derived from soot) and also used it to decorate the interior walls and furniture of the château. As a result, he was associated with black magic among the local people, who believed that the château was also home to the devil.

PATCH OF SKY

The deep blue of this patch of sky, visible through the trees, is painted with no concessions to illusory depth. The strong blue of the sky "jumps" forward, over the quieter colors of the surrounding foliage, insisting that we read the picture not only as a wooded landscape with a château, but equally as a flat plane upon which colors of differing chromatic and tonal values have been arranged.

This detail shows us Cézanne's characteristic diagonal brushwork and the way in which he counterbalances the disjunctures created by his abstract treatment of space (see above) with a unifying application of paint. Cézanne thus realizes his belief that a painting should be both structurally convincing and formally independent. The slanting, generally equal-sized brushmarks range across the surface of the canvas and, as such, must do the job of describing form through relative values of color alone, in a process that Cézanne called modulation.

BROKEN LINE

Again, Cézanne emphasises the physical, plastic reality of the painting. The jagged lines describing the overhanging branches are fragmented, beginning and ending in midair. They are valued as much for their formal role in maintaining the strong vertical, horizontal, and diagonal balance of the composition as for their descriptive function: Cubism's debt to Cézanne is paramount (see p.346). The impossibly rich, deep blues and greens of the sky, applied right up to and overlapping the branches, fight for dominance, creating a continuous tension between decorative flatness and spatial depth.

THE CHATEAU

The slender, Gothic-arched windows of the château reveal nothing but the intense blue of the sky. The complementary relationship of the yellow building and the blue windows emphatically affirms the color harmony of the work, and its ambiguity between "solid" sky and "ephemeral" stone. The building seems impressively permanent, yet also a shallow facade through which the blue hills and sky are visible. It is an intensely blue painting, made even bluer by the intervals of yellow ochre, and united by the more neutral greens.

LES POSEUSES

Seurat painted Les Poseuses using preparatory sketches to demonstrate his belief in premeditated art. in contrast to the spontaneity of Impressionism. The nude model is shown in three different positions within a room in which one wall is filled by Seurat's painting La Grand latte. The same models are believed to have been used in both paintings, allowing the viewer to experience a fluid connection between the formality of fashion in La Grand Jatte and the classical naked form in Les Poseuses.

SEURAT AND DIVISIONISM

It is possible, though perhaps improbable, that Georges-Pierre Seurat (1859-91), had he lived longer, might have been in the league of Cézanne. Like the great Masaccio at the beginning of the Renaissance (see p.82), like Giorgione (p.129) and Watteau (p.224), he died tragically young yet after just a few years of painting he left us some marvelous work. He believed that art should be based on a system and developed Impressionism toward a rigorous formula. He invented a method he called optical painting – also known as Divisionism, Neo-Impressionism, or Pointillism - in which dots of color laid beside one another blend together in the viewer's eye. He believed that these dots of intense color, placed schematically in precise patterns, could imitate the resonant effects of light falling onto various colors more accurately than the more random, intuitive practice of the Impressionists. Seurat's systematic approach was based on his study of the new theory of color science. As a theory it sounds daunting, and in the hands of imitators it does daunt, being a theory that is more poetic than literal in its truth. A silent and secretive young man, Seurat perhaps needed this theory psychologically, and he made wonderful use of it in his paintings.

Seurat differed from the Impressionists in more than just his scientific approach. He was influenced by Ingres (see p.256) and the great Renaissance artists, and his work has a gravity that relates more to the classical tradition than to the casual intimacy and transience of Impressionism. And though, like the Impressionists, Seurat worked on small studies in the open air so that he could faithfully record the effects of light on the landscape, his large compositions were produced entirely in the studio according to his own strict laws of painting. To the themes already well mapped out by the Impressionists, such as city life, seascapes, and

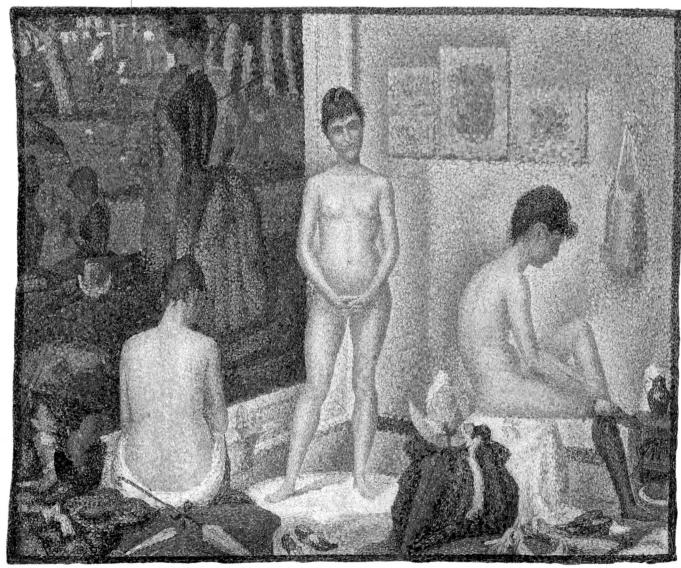

354 Georges Seurat, Les Poseuses, 1888, 19½ x 15½ in (49 x 39 cm)

355 Georges Seurat, The Lighthouse at Honfleur, 1886, 32 x 26½ in (82 x 68 cm)

entertainment, Seurat added a sense of mystery and even monumentality, as well as a controlled geometry. In Les Poseuses (354), there is a sense of exquisite rightness, of flesh in all its individuality still beautifully conforming to a pattern. These images of a classical female nude are nymphlike in their delicacy, but with an austerity that is unique to Seurat.

ART REPLACING NATURE

Les Poseuses was painted in Seurat's studio in artificial light, and the large landscape serving as a backdrop to it is Sunday Afternoon on the Island of the Grande Jatte, a summer scene he painted between 1884 and 1886 of strollers at a favorite Parisian retreat.

La Grande Jatte is important, both within Seurat's limited oeuvre and historically. This was the painting that he hung at the last Impressionist show in 1886, despite the reluctance of the other, older exhibitors. Seurat represented a new generation of painters who heralded the disintegration of the Impressionist ideal, and whether the older painters liked it or not, a new order was rapidly being established. Pissarro alone fought for Seurat's right to exhibit with them and saw his color theory as the progressive step

Impressionism needed. Pissarro briefly adopted Divisionism himself, but found it too inhibiting and soon abandoned it.

Seurat's landscapes also heroically subdue nature to the "dot" of his color theory, and they have an interior quiet that prevails magnificently over natural confusion. Seurat organized what he saw, but he did so with the tact of genius. We realize that no landscape ever really looked so clean, so uncluttered, and so integrated, but he makes us suspend our disbelief.

Everything in the landscape painting The Lighthouse at Honfleur (355) is arranged with such formal perfection that removing any one element would destroy the balance. Pale, magical, severe, it absolutely needs the wooden structure in the foreground. This geometric form of sharp angles allows Seurat to move spaciously back into the far glimmer of the sea, rhyming all the other horizontals and verticals delicately with it: one upright like the lighthouse tower, redeployed by the boathouse; one flat like the boat, echoed by the top bar of the sawing frame. The sun bleaches the whole scene, so that color, too, rhymes and is compatible. This is how life ought to be, he tells us, and nature is replaced by art.

POINTILLISM

This triple magnification of the canvas taken from Seurat's La Grande Jatte shows minute dots of color. This use of small, even touches of pure color, which react together optically when seen from a distance, is called Pointillism. If certain colors are placed side by side in close proximity, they enhance one another and give the painting an iridescence and depth. The term Pointillism was first used by the critic Félix Fénéon to describe Seurat's La Grande Jatte in 1886.

OTHER WORKS BY SEURAT

Beach at Gravelines (Courtauld Institute, London)

The Circus (Musée d'Orsay, Paris)

Woman with an Umbrella (Buhrle Foundation, Zürich)

View of the Seine (Metropolitan Museum of Art, New York)

La Grande Jatte (Art Institute of Chicago)

The Beach at Honfleur (Walters Art Gallery, Baltimore)

THE EARLY YEARS

Vincent van Gogh (1853-90) began his career as a clerk in his uncle's art dealership in The Hague. In 1873 he was transferred to the London offices and fell in love with his landlady's daughter, who was already engaged to be married. This first experience of unrequited love is believed to have precipitated the religious fanaticism that led to his mental breakdown in later life. After a brief time in London as a teacher for the Rev. Slade-Jones, van Gogh returned to Holland in 1876, where he immediately encountered more failure.

Van gogh

Seurat was one kind of genius, contained and silent. The other kind we find in a Dutch-born painter, Vincent van Gogh (1853–90), whose turbulent, seeking life everyone knows. The sad tale of van Gogh cutting off his ear is now part of common genius mythology. The unhappiness documented in a flood of letters to his brother, Theo, is transformed in his art into a passionate search for stability, truth, life itself. He has the rare power, something like that of Rembrandt (see p.200), to take the ugly, even the terrible, and make it beautiful by sheer passion.

Van Gogh's formative years as a painter reveal his confusion and restlessness. He worked in various jobs in search of a meaningful existence. At 20 he left Holland for England, then lived for a short time in Belgium as a missionary, and in 1886, aged 33, he left for Paris. Through Theo's work as an art dealer (see column, p.317), he met other artists – Degas (p.291), Pissarro

(p.300), Seurat (p.314), Lautrec (p.320) – and learned about Impressionist techniques. He arrived at his artistic vocation by a slow and tortuous route, but it wasn't until he had fully absorbed the influences of Impressionism and *Japonisme* (see column, p.290) and made his own experiments with color (see column, p.317) that he discovered his true genius.

VAN GOGH AT ARLES

In 1888, leaving Theo in Paris, he went to Arles, in Provence, where, in the last two years of his life, he produced his most remarkable works. *The Artist's Bedroom (356)* has the utmost power and poignancy (this is a copy he painted to comfort himself while in the asylum at St. Rémy; see column, p.318). Two pillows and chairs hint at his eager anticipation of Gauguin's arrival (see p.322). It was his dream that Arles would become a center for painters, but Gauguin's reluctant visit ended in disaster.

356 Vincent van Gogh, The Artist's Bedroom, 1889, 35 x 28 in (90 x 71 cm)

357 Vincent van Gogh, Farmhouse in Provence, 1888, 24 x 18 in (61 x 46 cm)

Farmhouse in Provence and La Mousmé were painted in the year van Gogh moved to Arles. If Seurat subdued nature to reflect his intellect, van Gogh heightened it to echo his emotions. Farmhouse in Provence (357) has a terrible, life-threatening fertility about it. Wheat surges about the farm on all sides; the flaming ears of grain almost overwhelm the small figure who wades through them. The wall suddenly comes to an end, devoured by the encroaching army of ripening wheat, red flowers, and vegetation.

The farm has a beleaguered air, taking some trees into its protection; elsewhere, out in the field, trees are stunted and sparse. Farm buildings huddle together while the sky maintains an utter neutrality. Nature always comes to van Gogh in this threatening manner, yet he never gives in: he wrestles with it, capturing its wildness on his canvas. The sheer attention he has given to every blade of wheat gives him a moral ascendancy over such power.

La Mousmé (358) is of "a Japanese girl – provincial in this case – 12 to 14 years old," as van Gogh explained to Theo. He labored on this work, lured by the simplicity and tautness he so admired in Japanese art, and he presents this dull-faced adolescent solely in terms of decorative masses. Her dress is built up of curving stripes above and solid red dots on blue below.

The chair sweeps round her in schematic arches; hands and face are an opaque pinky brown, seemingly boneless hands dangle from her sleeves, and her face is doll-like. Her body curves flatly against a background of mottled green. So much

358 Van Gogh, La Mousmé, 1888, 24 x 29 in (60 x 73 cm)

USE OF COLOR

Van Gogh used a wide variety of colors throughout his career including, red lake, vermilion, ultramarine, cobalt violet, emerald green, and viridian. However, many of these colors were not lightfast. Van Gogh was probably aware of the transient nature of some of his choices of pigments. Van Gogh was also interested in complementary colors (see glossary, p.390) and their effects on the canvas. To this end he owned a box of colored varn which he would braid together to experiment with complementary color vibrations. As an artist he was not concerned with painting in naturalistic colors. Instead he tried to convey a range of emotions through the use of dramatic and vibrant colors.

THEO VAN GOGH

In 1886 Vincent van Gogh arrived in Paris to stay with his brother Theo. As an art dealer Theo was friendly with the Impressionist group and the Parisian avantgarde, such as Pissarro, Bernard, and Gauguin. It was through Theo's contacts that Vincent became part of the Post-Impressionist group and began to experiment with brighter colors. The brothers had a strained relationship, and Theo was not always convinced by the quality of Vincent's work. During his life Vincent wrote more than 750 letters to his brother. When he died, a final tragic letter addressed to Theo was found in his pocket.

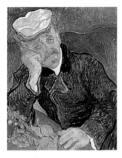

THE DECLINE

The clear signs of van Gogh's mental instability appeared while he and Gauguin were sharing the Yellow House in Arles in 1888. One evening he threatened Gauguin, lost control and cut off his own right earlobe. He presented it to a local prostitute. He was then taken to the hospital suffering from loss of blood and hallucinations. By May 1889, van Gogh had left Arles and had voluntarily committed himself to the asylum in St. Rémy. During two years in the asylum, van Gogh produced over 200 paintings. In 1890 Pissarro persuaded him to move to Auvers, where he was placed in the hands of Dr. Gachet (shown above). However, within a couple of months van Gogh fell ill, and in July 1890 he committed suicide.

OTHER WORKS BY VAN GOGH

The Farmhouse (Rijksmuseum, Amsterdam)

Sunflowers (National Gallery, London)

Portrait of Dr. Paul Gachet (Musée d'Orsay, Paris)

Windmills at Montmartre (Bridgestone Museum of Art, Tokyo)

Two Peasants (Buhrle Foundation, Zurich)

Bed of Irises (National Gallery of Canada, Ottawa)

Hospital at St. Rémy (Hammer Collection, Los Angeles) about *La Mousmé* is pathetic. She looks out at us so warily that we too feel slightly uncomfortable. Her eyes are alive, brown, and hurt, as if she knows that life will not treat her well. Van Gogh directs on the child such a force of passionate attention, such a totality of respect, such confidence in the power of vision to raise him up from the hell of existence, that the picture is an awesome success. Qualities like beauty or grace become irrelevant. To make us see through his eyes is the triumph of the painter, and van Gogh triumphs often.

VAN GOGH'S SELF-PORTRAITS

Few artists have been as interested in the self-portrait as van Gogh. *Self-Portrait* (359) is overpowering in its purity and realism: this is the real face of the artist, with a rough, red beard, unhappy mouth, and hooded eyes. His is an identity barely held in existence under the pressure of the whirling blue chaos. His face may be solid enough, but his clothes lose their identity as the lines swirl and jostle and deconstruct, showing us just how he felt as a mentally tormented and suffering individual.

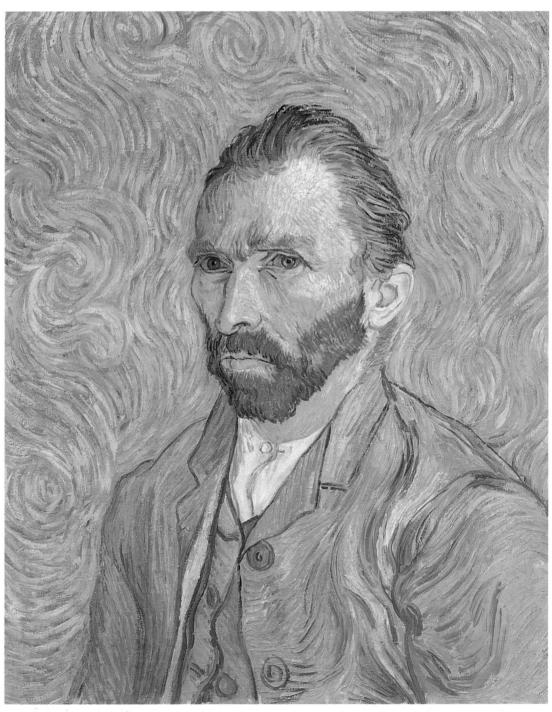

359 Vincent van Gogh, Self-Portrait, 1889, 21½ x 26 in (54 x 65 cm)

Self-Portrait

In May 1889, after his violent breakdown in Arles, van Gogh entered the asylum at St. Rémy. With his brother Theo's financial assistance, van Gogh was able to have his own bedroom, and also a studio where – whenever his condition and the asylum authorities allowed – he could continue to paint. It was at the asylum, just six weeks after another severe breakdown, that van Gogh painted this very beautiful self-portrait in September 1889. It is one of two self-portraits van Gogh painted that month, both of which are notable for their calm and dignified portrayal and their sense of fortitude, despite the misery of his situation. The skillful use of contrasting colors, the sensitive draftsmanship, and the sense of mature control all point to a superior mind, however disturbed the artist's feelings.

SWIRLING BACKGROUND

Within the overall cool harmonies of silver-gray, silver-green, and blues, van Gogh's head glows like a flame. Here is a painting of great contrasts. Everything outside the vivid head is subdued. The disturbed background hints at the precariousness of his own stability, symbolized by his neat vest and his shirt buttoned to the neck, and by his pose, suggestive of stillness and calm. The background can be distinguished from the figure only by the texture of the swirling brushstrokes, which are otherwise virtually identical in color to the body.

THE EYE

Perhaps the strongest note of color in the painting is the surprisingly vivid patch of green under the eye. It acts as a focal point, drawing our attention to van Gogh's steady and penetrating gaze. The structure of the eye is emphatically "level"; a straight, dark, horizontal line defines his heavy brow, and every detail of the eye is clearly delineated. But while the set features show resoluteness, at the same time the acid greens in the face, clashing against the reds of the hair and beard, suggest passion held under restraint.

paintings "by a wedding of two complementary colors, their mingling and their opposition, the

mysterious vibrations of kindred tones."

TOULOUSE-LAUTREC
Toulouse-Lautrec came
from an aristocratic
family but was physically
deformed as a result of
inbreeding and a childhood
accident. This selfparodying photograph
shows Lautrec dressed
as a samurai warrior.

TOULOUSE-LAUTREC'S PARIS

If van Gogh escaped from his overwhelming burdens by committing suicide, Henri de Toulouse-Lautrec (1864–1901) escaped into the sordid nightlife of Paris. Only there, submerged within a raucous and raunchy crowd, could he forget that he was a scion of one of the noblest families in France – with an unfortunate disability. A model once said he had "a genius for distortion," but his genius, though acid, was not embittered or dark. His deformity set him free, paradoxically, from the need to accept any normal responsibilities, and though he killed himself with his excesses, he also created a witty, wiry art that still attracts. His paintings and prints reveal the strong attraction to Japanese art that he shared with van Gogh, he employed typically oblique Japanese perspectives with an off-center focus, and his art is characterized by a self-assured

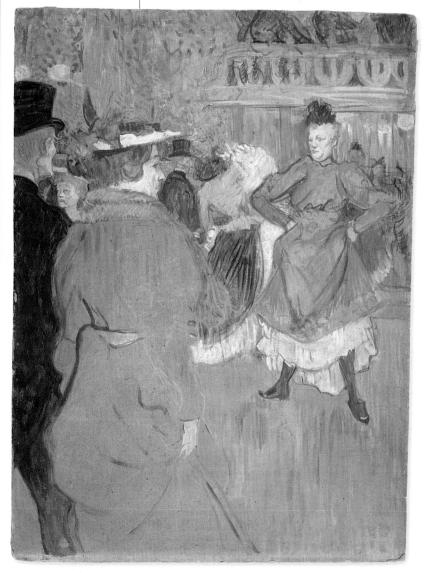

360 Henri de Toulouse-Lautrec, Quadrille at the Moulin Rouge, 1892, 24 x 31 in (60 x 80 cm)

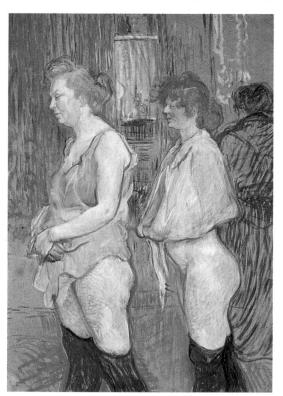

361 Henri de Toulouse-Lautrec, Rue des Moulins, 1894, 24 × 33 in (61 × 83 cm)

simplicity of line, dramatic color, and flat shape. Lautrec's art was well suited to poster design and, aided by newly perfected techniques for printing posters, he revolutionized the discipline, breathing a new vibrancy and immediacy into it. In all his work there is a fluidity and passion that captures the vitality of city life.

Quadrille at the Moulin Rouge (360) has a rough energy that contrasts with the controlled vigor of the artist's line. There is life here, but no joy. However, there is also no self-pity, and though the life he shows us is horrible, it is at least lived with determination. Gabrielle, a dancer at the Moulin Rouge nightclub and one of Lautrec's favorite models, faces us with an almost comic expression of tipsy intentness as she stands aggressively in the center of the hall.

Lautrec does not often go deep, but when he does, he can appall. The two prostitutes in *Rue des Moulins* (361) are not seeking business (this he paints with a very wry laugh). They are lining up for the obligatory medical examination for licensed prostitutes, and their raddled faces are painfully pathetic. The first is aged of body, with loose, wrinkled thighs and fallen bosom. The other appears slightly younger, and although her body is less ravaged, her face is cruelly worn. Even the background of this picture is a lurid red. Vice is killing them both, despite the state medical intrusions. Lautrec does not glorify his whores; his world is one of harsh reality.

THE INFLUENCE OF SYMBOLISM

Symbolism began as a literary movement that championed the imagination as the most important source of creativity. It soon filtered into the visual arts as another reaction to the limited, representational world of Realism and Impressionism. Inspired by the Symbolist poetry of the French poets Stéphane Mallarmé, Paul Verlaine, and Arthur Rimbaud, the Symbolist painters used emotive colors and stylized images to float their visions and moods into the viewer's consciousness, sometimes painting exotic, dream-like scenes.

Though it was toward the end of his career that Symbolism became artistically significant, it is still fair to regard Gustave Moreau (1826–98) as a precursor of Symbolist ideals and a patriarchal figure. In age he was much closer to Realism (his dates are almost contemporary with those of Manet, see p.285, or Courbet, p.282), but he ignored both Realism and Impressionism to pursue his own, distinctively individual style.

There could sometimes be a lurid and rather sickly strain in Symbolist work: the story of Salome, for example, with all its Freudian implications of woman destroying man, crops up continually. Moreau's *Salome* (362) is one of the more playful versions of this deadly myth, and we can enjoy its intense light and color without thinking too much of its sinister

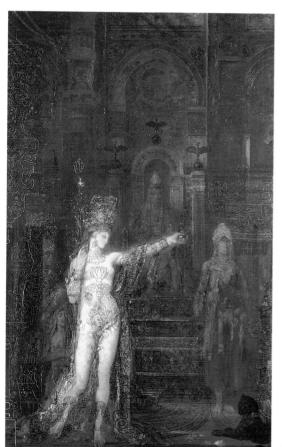

362 Gustave Moreau, Salome, 1876, 40½ x 56 in (103 x 143 cm)

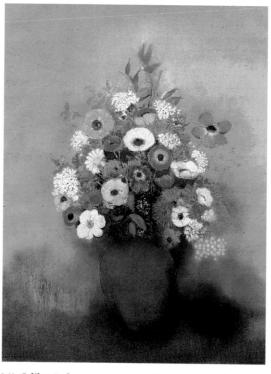

363 Odilon Redon, Anemones and Lilacs in a Blue Vase, after 1912, $23\frac{1}{2} \times 29$ in $(60 \times 74 \text{ cm})$

implications. Many of Moreau's other pictures are populated with strange beasts and mystic figures, and this escape from the world of reality, coupled with his idiosyncratic temperament, made him a significant figure among the other Symbolists.

REDON'S FLOWER PAINTINGS

Odilon Redon (1840–1916) is another escapee into a land of dreams. He did not have a major gift, but the pleasure of his art is pure and deep. He used color in a completely personal and inhibited way, but it was his themes, so elusive and fantastical, that made him a quintessential Symbolist. Like Moreau, he had a haunting imagination, but his exquisite bunches of flowers are his greatest achievement. *Anemones and Lilacs in a Blue Vase (363)* is typical of the soft, delicate imagery he could produce using iridescent pastels. These are radiant flowers, picked and preserved and glowing eternally for the viewer.

STEPHANE MALLARME

Stéphane Mallarmé (1842-98) was a leading Symbolist poet and friend of many of the Symbolist artists. The basic principles of the artistic movement were to express ideas through color and line and to concentrate on mystical or fantastical images. This illustration shows an etching of Mallarmé, completed by Gauguin, with a raven in the background. The raven is believed to be a direct reference to Edgar Allen Poe's influential Symbolist poem The Raven, which was published in 1875. In 1886 the French poet Jean Moréas published the Symbolist's Manifesto, which was inspired by Mallarmé's poetry.

PAUL SERUSIER

The painter and art theorist Paul Sérusier (1863–1927) had a great influence on the Symbolist and Nabis movements (see p.326). The painting shown above is of the Bois d'Amour at Pont-Aven, where Sérusier painted while being advised on color by his friend Gauguin. The painting is also known as The Talisman because the younger painting generation saw it as the symbol of new artistic freedom and possibilities. Sérusier published his treatise on art in 1921.

OTHER WORKS BY

Bathers at Tahiti (Barber Institute, Birmingham, England)

By the Sea (Ny Carlsberg Glyptothek, Copenhagen)

> The Drinking-Place (Fujikawa Gallery, Osaka, Japan)

Breton Peasant Women (Musée d'Orsay, Paris)

Forest Interior (Museum of Fine Arts, Boston)

Primitive Tales (Folkwang Museum, Essen, Germany)

Tropical Vegetation (National Galleries of Scotland, Edinburgh)

At the Café (Pushkin Museum, Moscow)

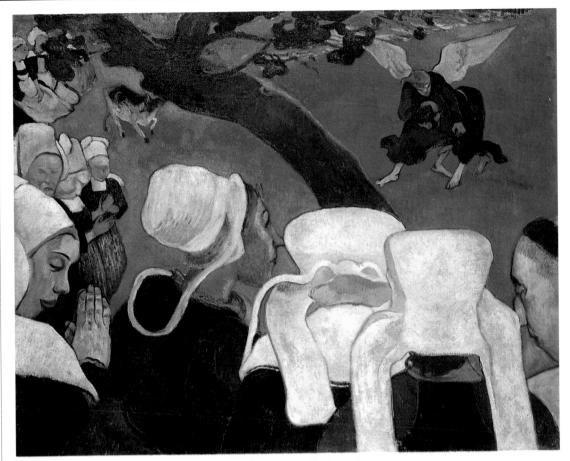

364 Paul Gauguin, The Vision After the Sermon, 1888, 36½ x 29 in (92 x 73 cm)

Cloisonnism

Emil Bernard's Buckwheat Harvest (shown above) is a good example of the technique known as Cloisonnism (cloison is French for partition). This style of painting is associated with the Pont-Aven school and is characterized by dark outlines enclosing areas of bright, flat color, similar to the effect achieved by stained glass. Gauguin and Bernard (1868-1941) worked together at Pont-Aven between 1888 and 1891, and Bernard is believed to have had a stimulating effect on Gauguin's work.

A unique vision

Paul Gauguin (1848–1903) is best known for the art he painted after he fled to the South Seas to escape Europe and his family, but essentially he drew the inspiration for his work from within himself. Though he took to painting as a professional quite late, his early development as an amateur was influenced by the Impressionists, especially

Pissarro (see p.300), whose systematic, broken brushwork Gauguin adopted. Gauguin was introduced to the Impressionists as a rich Parisian stockbroker and began to buy their art; he even exhibited his own work at some of their shows from 1879. Yet when he finally became a full-time artist in 1883, he was already feeling the constraints of the Parisian art scene.

Gauguin sought to be untrammeled by any conventions in his art. The Impressionists were influenced by nature; Gauguin was influenced by his own version of nature. He found freedom and quiet at Pont-Aven, Brittany, where he soon became the major figure in the Pont-Aven group of artists (see column, left). It was in this isolated region that he developed the distinctive symbolic and primitive elements of his art.

Inspired by medieval stained glass and folk art, he began to paint simplified shapes heavily outlined in black. The Breton peasants, with their simple faith and archaic lifestyles, also appealed to him and became a recurrent theme.

The Vision After the Sermon (364) was painted two years before he left for Tahiti, but it is as primitive as anything Tahitian. Gauguin blended reality with the inner experience of a vision and heightened it with symbolic color. He offered the painting to the local Breton church, but the priest was suspicious and thought he was being mocked. Only today does the spiritual power of the painting become vitally clear.

LAST YEARS IN FRANCE

Gauguin had long since abandoned his Dutch wife and children, and in 1888 he agreed to visit van Gogh in Arles. It seems fitting that the two were friends, though perhaps "friend" is not the right word: both were solitary men, desperately seeking healing companionship. It was the breakdown of their shaky relationship that drove van Gogh, the more fragile, to the hysterical mutilation of his own ear. Gauguin spent his remaining two years in France moving around restlessly, and left in April 1891 for Tahiti, where he spent much of the rest of his life.

VISION AFTER THE SERMON

Gauguin depicts a sermon that has just been preached on the subject of Jacob wrestling with the angel, an Old Testament story. Probably religion had an exotic fascination for Gauguin, though he could only see its mysteries from without. He imagines Jacob at dawn, struggling to overcome his superhuman opponent and make him reveal his name. Gauguin felt he was up against the superhuman, and he too wrestled with his demon-angel to find his real identity.

PRAYING PRIEST

There is no literal contest here, as we can guess from the downcast eyes of the women and the priest: it is in their imaginations that life and death meet in battle. Their tightly grouped heads are magnified so that we feel like part of the crowd; we have to peer over the tops of their heads to see the vision. Much of the painting is conceived as completely flat planes of color; only the curving forms of the women's headdresses are painted in a three-dimensional style – the white folds have a heavy, sculptural feel.

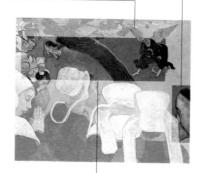

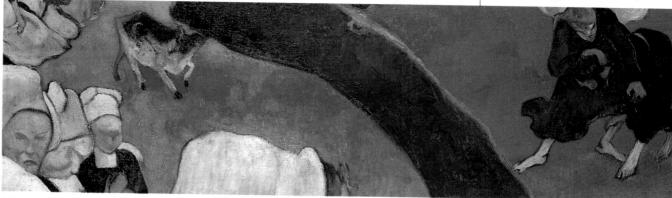

THE TWO HALVES OF THE CANVAS

Gauguin makes his composition all absolutes and opposites: brilliant reds screaming against blazing whites; hordes of women and one sole male (the priest, in the lower right-hand corner), violence and meditation, enveloping garments and bare faces. A great tree trunk

slices the picture diagonally into two separate halves, with the real world on the left, containing the simple Breton women and a straying cow that paws the red earth, and the visionary world on the right, where the angel and the man wrestle. The man won, however, as Gauguin expected his viewers to remember.

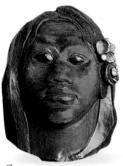

GAUGUIN AND TAHITI Gauguin arrived in Tahiti in 1891. Disappointed by the appearance of the main town of Papeete, he moved to a more remote part of the island. Initially his art concentrated on the influence of Western culture on native life, but in his later works he chose to emphasize the rapidly disappearing primitivism of the island. This wood carving was produced by Gauguin in 1892. The model for the sculpture is believed to be Teha'amana, Gauguin's 13-year-old mistress. Gauguin left the island in 1893, but after encountering several problems in Paris he returned to Tahiti in 1897. In 1901 he traveled to the

remote Marquesa Islands,

where he died in 1903.

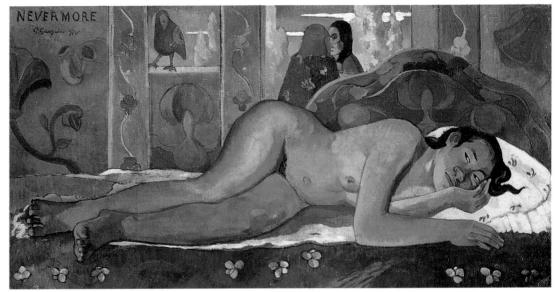

366 Paul Gauguin, Nevermore, 1897, 45 x 24 in (115 x 60 cm)

Gauguin escaped to the South Seas in search of a primitive lifestyle where his art could flourish. Despite his disgust at the entrenched colonial society he found there (see column), he painted the Polynesian people as images of his heavenly state of total freedom. Gauguin impresses his own version of nature upon us, creating stylized, flattened shapes and using intense, exotic colors with what seems like reckless abandon, but which are carefully calculated for the greatest effect. In *Riders on the Beach (365)* he paints the sands pink not, we feel, because he actually

"saw" any pinkness there, but because only pink sands could express his feelings. Yellow would have been too intrusively real: it is not a logical scene but a magical one, and the peace and joy are symbolic, not literal. It is a painting of an idyllic state of life, gentle and radiant people effortlessly in control of their horses, freedom on every side, intoxicating seascape, wide, clouded skies, man and woman in perfect amity.

SINISTER UNDERCURRENTS

Although Gauguin transformed the Polynesian women into goddess figures – obeying no rules but those of his imagination – he also knew well the sad depravations of their real lives, and produced some dark and disturbing images in response to what he saw.

The young girl depicted in *Nevermore* (366), painted after he had lived in the South Seas for several years, shows how he had come to terms with the haunted otherness of the interior life the women led. The girl is spread out before us, her golden body a sinister green as she ponders the mystery of her existence. A sightless raven, painted as a decorative detail, perches outside her window as a symbolic "bird of death" (inspired by the poem "The Raven" by Edgar Allan Poe, a favorite of the Symbolists).

Two women speak urgently together while the girl lies isolated and afraid on her splendid yellow pillow. The semi-abstract patternings we can see in paintings such as this are expressions of internal, psychological rhythms rather than outward events. Gauguin's skill lies in refusing to explain this complex mystery, even though he suggests there may be an answer. However long we contemplate *Nevermore*, it retains and in fact deepens its mystery before us.

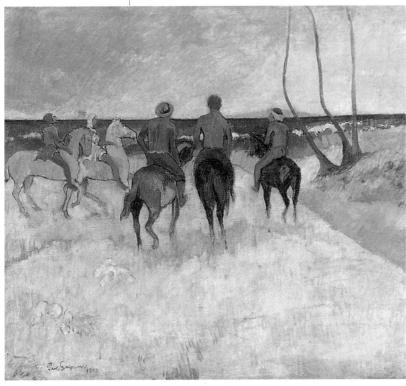

365 Paul Gauguin, Riders on the Beach, 1902, 361/2 x 29 in (92 x 73 cm)

MUNCH'S INTENSE EMOTIONALISM

Symbolist painting was not restricted to France alone. The Norwegian artist Edvard Munch (1863–1944) was a gloomy man, perpetually haunted by illness, madness and death, who used all his psychic weakness to create electrifying art.

Munch began painting in Oslo, where the predominant style was social realism, and it was only when he went to Paris in 1888 that he began to experiment. Van Gogh's swirling, emotive brushwork is detectable in Munch's more disturbing paintings, but he was also attracted to the work of Gauguin and the Symbolist painters, and he became close friends with the Symbolist poet Stéphane Mallarmé (see column, p.321).

He began to use the Symbolists' stylized forms, decorative patterning, and highly charged colors to express his own anxieties and pessimism. A precursor of Northern Expressionism (see p.340), he was one of those great artists whose main intention was to make an emotional statement, and who subdued all the elements of a picture to that end.

Munch can paint what seems an innocuous image. There are many versions of *Four Girls on a Bridge* (367), a theme which clearly stirred something deep within him, and each work has a sinister undertone. The girls are all young and slender, passively leaning toward or away from the water. We feel uneasily that the water must represent something: time? Their coming sexual power? They are on the "bridge," the dark, heavy shapes of the future at the far side of the bridge looming ahead. Yet to spell out the full meaning is to diminish it. Munch is a Symbolist whose ideas work at a subliminal level.

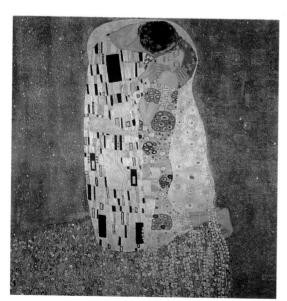

368 Gustav Klimt, The Kiss, 1907/08, 71 x 71 in (180 x 180 cm)

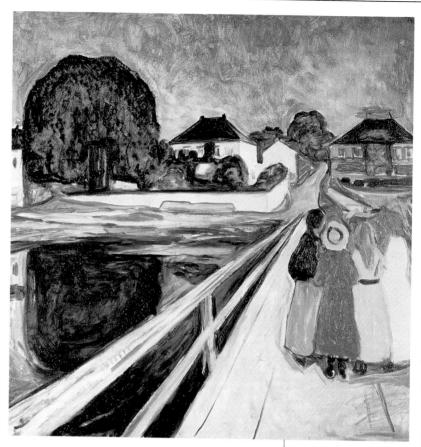

367 Edvard Munch, Four Girls on a Bridge, 1899–1900, 49½ × 53½ in (126 × 136 cm)

The greater his unhappiness, the more overtly autobiographical his art became. In the 1890's he produced a series of paintings called the *Frieze of Life* which he described as "a poem of life, love, and death." In 1908 he suffered from a severe mental illness, and though he never left Norway again, his undisputed originality made a great impact on the next generation of artists.

GUSTAV KLIMT

Just as Munch can be associated with both Symbolism and Expressionism, so the art of the Austrian painter Gustav Klimt (1862–1918) is a curious and elegant synthesis of Symbolism and Art Nouveau (see column, p.327). The Austrians responded enthusiastically to the decorative artifice of Art Nouveau, and Klimt is almost artifice incarnate. He painted large ornamental friezes of allegorical scenes, and produced fashionable portraits, uniting the stylized shapes and unnatural colors of Symbolism with his own essentially harmonious concept of beauty. The Kiss (368) is a fascinating icon of the loss of self that lovers experience. Only the faces and hands of this couple are visible; all the rest is a great swirl of gold, studded with colored rectangles as if to express visually the emotional and physical explosion of erotic love.

CONTEMPORARY ARTS

1880

Rodin produces The Thinker

1886

The Statue of Liberty is dedicated to the American people

1889

The French begin the construction of the Eiffel Tower

1890

Oscar Wilde publishes
The Picture of
Dorian Gray

1895

Tchaikovsky's *Swan Lake* is performed in
St. Petersburg

1900

Puccini's opera *Tosca* is performed in Rome

1901

The first Nobel prizes are awarded

THE NABIS

In the 1890s a group of French artists who had been inspired by the work of Gauguin met at the Académie Julien in Paris, Sérusier (see p.321), who had met Gauguin at Pont-Aven in 1888, encouraged the other artists, including Maurice Denis (see column, p.329) and Vuillard, to form a group that became identified as the Nabis. The simplification of forms into large-scale patterns and the purity of colors used by Gauguin was known as Synthetism and had a great influence on the group. The group produced poster designs, stained-glass designs, theater designs, and book illustrations.

THE NABIS

Two French artists straddle the gap between Post-Impressionism and the moderns: Pierre Bonnard and Edouard Vuillard. Difficult to place artistically, they are thought of as Intimists, and leaders of a group known as the Nabis. Both painters lived well into the 20th century, yet, with their love of the gentle domesticities of life that was such a feature of the work of the Nabis, neither seems truly to belong to the world of modern art.

Inspired by Sérusier's painting *The Talisman* (see column, p.321), Pierre Bonnard (1867–1947) and Edouard Vuillard (1868–1940) formed a group known as the Nabis (Hebrew for seers or prophets) in 1892. The decorative was the keynote to their art: as their associate Maurice Denis (see column, p.329) wrote, "A picture, before being a warhorse, a nude, or some anecdote, is essentially a surface covered with colors arranged in a certain order." Disillusioned with Paris and Impressionism, the Nabis admired Gauguin and Japanese art and embraced many aspects of oriental mysticism, endeavoring to express the spiritual in their work.

THE JAPANESE NABI Bonnard (1867–1947) –1940) formed a Hebrew for seers ecorative was the associate Maurice with colors The Letter (369) has a Japanese-like simplicity, the young woman so intent upon her writing and the tilt of her head suggesting the depth of her concentration. But that bent head is wonderfully feminine, with its glowing clumps of chestnut brown, the elegance of the small comb, the neat little nose, snub and flirtatious, and the expressive curves of her mouth.

the young woman so intent upon her writing and the tilt of her head suggesting the depth of her concentration. But that bent head is wonderfully feminine, with its glowing clumps of chestnut brown, the elegance of the small comb, the neat little nose, snub and flirtatious, and the expressive curves of her mouth. Bonnard is concerned with this woman less as a personality than as an enchantment – a very Japanese trait. He has walled her in deliciously for his own delight, with a gorgeous rim of crimson seatback, an interestingly variegated wall, and on the open, free side, a box and an envelope of entrancing hues. The green box is the palest color in the painting, directing our eves upward toward the deep, rich blues of her modest dress and her downturned head. Bonnard makes no great statement about life or about this particular living creature. He looks at her instead with the most delicate and uncomplicated pleasure.

Bonnard, like Japanese artists, was interested in painting everyday life, in freezing the intimacies of a personal scene. Many of his paintings show images of the same model. This was Marthe, a sadly neurotic woman whom he eventually married, and who separated him from all his friends, yet who seems to have provided him with endless visual interest.

Fortunately, Marthe always loved to be painted, especially while in the bath, and many of his major paintings show her fully submerged in the water. There is an almost ecstatic brightness in the sensuous shades of her body and the water in *The Bath (370)*, and it has too often been thought that Bonnard's art is just a last dying effulgence of Impressionism. But he goes further, daringly and powerfully. Bonnard is not

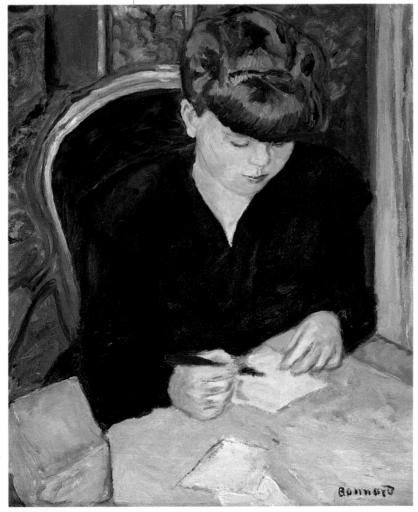

369 Pierre Bonnard, The Letter, c. 1906, 19 x 22 in (48 x 55 cm)

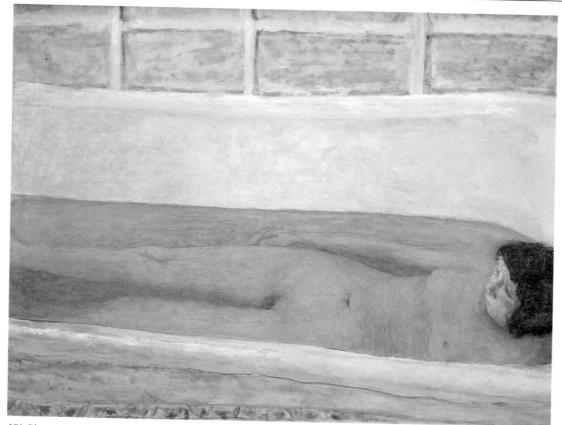

370 Pierre Bonnard, The Bath, 1925, 47 x 34 in (120 x 86 cm)

interested in the atmospheric nuances of light, as the Impressionists were, but rather in rhythm, shape, texture, color, and the endless decorative possibilities of the visual world.

CEZANNE'S INFLUENCE

The Nabis all shared an admiration for Cézanne (p.310), certainly the dominant influence on all early 20th-century artists. Maurice Denis's work *Homage to Cézanne* (see column, p.329) shows Bonnard and Vuillard clearly visible among several artists as they gather around one of Cézanne's paintings. When Bonnard paints a landscape he shows us not only what we can see but what the landscape feels like: he makes a leap into otherness, into sensation.

Stairs in the Artist's Garden (371) was painted near the end of his life, and it is an extraordinary picture, like all his great variations on the theme of the garden. The stairs lead up the center and then vanish as the grandeur of the blossoms overwhelms us. Exuberant colors mass to the left; huge fountains of springtime green erupt to the right. Ahead is a sunburst of bright bushes, piercingly golden and incandescently red, and there are more flowers overhead, allowing the intense blues of the skies to act as a backdrop. It is theatrical, a stage set, and the stage is set not for a play but for life. Bonnard wants to stir us into accepting the wonder of being alive. We are

liberated from our factual limitations into this radiant freedom. Taking Cézanne's chromatic majesty a step further, he etherealizes the weightiness that Cézanne felt essential, and is a great enough artist to succeed at this.

ART NOUVEAU

In the 1890s a new decorative art movement known as Art Nouveau developed, inspired by naturalistic, organic forms. The movement was developed by sculptors, jewelry makers, potters, and, most importantly, poster artists. The roots of the movement were in England, but French artists, such as Bonnard and Vuillard, were also influenced by the swirling shapes and bright colors of the new style. This illustration shows a brooch designed in 1904 by Paco Durrio, a Spaniard who worked in France. It perfectly encapsulates the spirit of Art Nouveau – a sensuous subject and a fluid form.

371 Pierre Bonnard, Stairs in the Artist's Garden, 1942/44, 29 x 25 in (73 x 63 cm)

JAPANESE INFLUENCES

Vuillard's early paintings, as a member of the Nabis group, were highly influenced by the Japanese sketches that he had seen at the Ecole des Beaux Arts in 1890. The role of drawing, and particularly of silhouette, in achieving simplification of form was crucial to much of Vuillard's work. The sketch illustrated above was produced by Vuillard in 1890 using Indian ink and a Japanese brush. The artist was also closely involved with the theater and was employed by the theater mogul of Paris, Coquelin Cadet, to capture backstage scenes in the traditional Japanese style.

OTHER WORKS BY VUILLARD

In Bed (Musée d'Orsay, Paris) Girl in an Interior (Tate Gallery, London)

Woman Before a Mirror (Bridgestone Museum of Art, Tokyo)

Portrait of Madame Bonnard (National Gallery of Victoria, Melbourne)

Woman Seated on a Sofa (Art Institute of Chicago)

The Dining Room (Neue Pinakothek, Munich)

The Lady in Green (Glasgow Art Gallery)

VUILLARD'S INTIMATE ART

By comparison, Bonnard's friend Vuillard may seem modest. His art is certainly more delicate, and he is interested less in coloristic fireworks than in the gentle, muted subtleties of textures and patterned cloth. His mother, with whom he gladly lived for much of his life, was a dressmaker, and he spent much of his time among women as they worked away in small rooms, absorbed and talkative. The happy, unforced charm of his art never cloys, never becomes obvious, and always remains tender and alive. His works are for the most part very small, as humbly befits their theme.

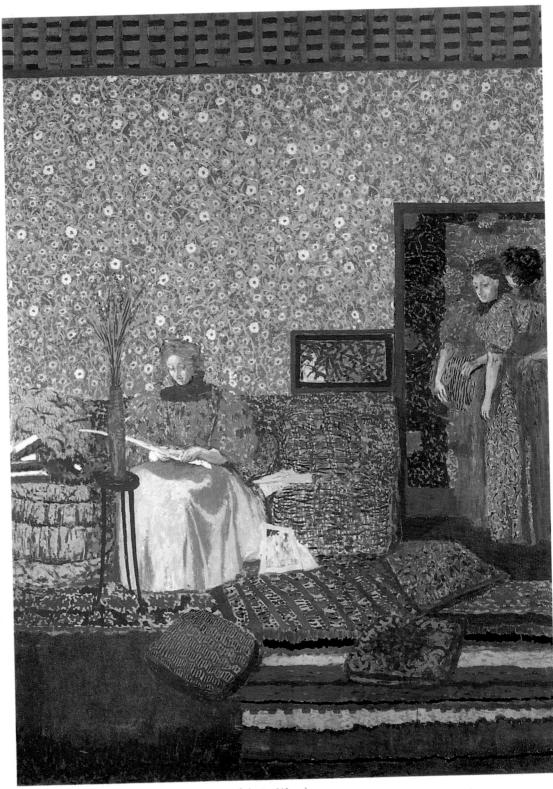

372 Edouard Vuillard, The Reader, 1896, 5 ft 1 in \times 7 ft (155 \times 213 cm)

373 Edouard Vuillard, Vase of Flowers on a Mantelpiece, c.1900, $12 \times 14\frac{1}{2}$ in $(30 \times 36$ cm)

Vuillard's lifelong exposure to dress materials through his mother's work, as well as the textile designs of his uncle, was clearly a formative influence on his art. The Reader (372) is one of a series of panels that he painted for a friend's library, and for this reason it was atypically large. Here we see how the furnishings of a room, its wallpapers, carpets, and upholstery, can nearly submerge the human presence there. We almost tremble for the reader, so bravely intent upon her book amid the jungle of the interior, and perhaps the women watching her from the doorway tremble too. Yet Vuillard cannot but paint from love, and the threat of so many clamoring designs is diffused, held at bay by the warm charm of his color.

SMALL-SCALE INTERIORS

Vase of Flowers on a Mantelpiece (373) is exquisitely modest by comparison. We cannot see the whole mantelpiece, merely a section of it; nor can we see the entirety of the armchair beneath, merely part of the curve of its back, with the pattern of its upholstery. Vuillard stops short of painting the fire too, though the pink roses in a vase suggest that this is not the season for fires. But neither is it the season for emptiness: the mirror reflects a small, dimly lit, furnished room, and the genius of Vuillard is to keep us engrossed as we try to read what we half see. The one unmistakable area of clarity is the vase of flowers itself, one large rose surrounded by its clustering companions. It is a picture in which

nothing seems to happen, yet which is perpetually a fascinating scene. We are drawn, irresistibly, into the encompassing warmth of Vuillard's own love of the ordinary.

WALTER SICKERT

The English painter Walter Sickert (1860–1942) was not one of the Nabis, but was influenced by this group, particularly Bonnard and Vuillard, and he was important as a link between English and French art at the end of the 19th century. Although he was a pupil and studio assistant of Whistler (see p.302) in the 1880s and worked with Degas (p.291) in Paris in 1883, Sickert's paintings also show an intimism comparable to the Nabis' work, and a shared interest in unusual compositions.

Some of Sickert's paintings are Victorian England's equivalent of the Nabis' quiet images of bourgeois French culture. But Sickert also painted dark, and sometimes sinister, images of the underworld. *La Hollandaise* (374) demands no knowledge of art history to announce this woman's profession. Poor, unidealized creature that she is, she nevertheless has the whore's appeal. Sickert paints her with an economy that is almost cruel, obliterating the features of her face to expose her naked body and scraping the paint thinly across her flesh: Sickert is clearly as interested in what she is as with how she looks, and he conveys both brilliantly.

374 W. Sickert, La Hollandaise, 1906, 16 x 20 in (40 x 50 cm)

HOMAGE TO CEZANNE

This painting was completed by Maurice Denis (1870-1943) in 1900 to commemorate Cézanne's first one-man exhibition, held in 1895. The painting shows a group of artists, including Redon (to the left of the composition), Vollard (behind the easel), and many of the Nabis gathered around a Cézanne still life that was once owned by Gauguin. Cézanne and the Nabis were linked by Vollard, who had begun to deal in the Nabis' paintings and was also having great success in selling much of Cézanne's work.

CAMDEN TOWN MURDER SERIES

In September 1907 Emily Dimmock, a wellknown north London prostitute, was found dead with her throat cut in her lodgings in Camden Town. The body was found by her lover when he returned from his night shift. A commercial artist. Robert Wood, was accused of her murder but was acquitted after a long and exciting trial. Sickert, who is known to have followed the trial reports, adopted the name Camden Town Murder as a general designation for several series of etchings, paintings, and drawings. Each painting in the series features a naked woman and a clothed man who personify the tragedy of poverty and deprivation.

THE 20TH CENTURY

It has been calculated that there are more artists practicing today than were alive in the whole Renaissance, all three centuries of it. But we are no longer following one storyline: we are in a new situation, where there is no mainstream. The stream has flowed into the sea and all we can do now is trace some of the main currents.

Twentieth century art is almost indefinable, and ironically we can consider that to be its definition. This makes sense, because we live in a world that is in a constant state of flux. Not only is science changing the outward forms of life, but we are beginning to discover the strange centrality of our subconscious desires and fears. All this is completely new and unsettling, and art naturally reflects it.

The story of painting now loses its way temporarily. It enters upon an encounter with the unknown and the uncertain. Only the passage of time can reveal which artists in our contemporary world will last, and which will not.

20TH-CENTURY TIMELINE

We have dates in the 20th century, and pictures to attach to them, but there is no longer a coherent time sequence. This can be irritating to the tidy-minded, but it is in fact exciting in its adventurous freedom. With so many dynamic artists, covering a broad spectrum of intention and experience, there is only space to touch briefly on those who seem, to many, to be part of the story, and not just footnotes.

PABLO PICASSO, LES DEMOISELLES D'AVIGNON, 1907

This picture is the one work that can be considered essential to the art of the 20th century. From its bizarre malformations and hideous energy have flowed a torrent of creative and innovative power. It startled Georges Braque, and it startles us still: it is a supreme and repulsive masterpiece (p.347).

Wassily Kandinsky, improvisation 31 (sea battle), 1913

It seems to be agreed that Kandinsky was the first totally abstract artist of the modern period. His art matured to an almost formal geometry, but initially, as here, it had a wild and wonderful connection with the real world, with shapes that are symbols of an imaginary sea battle (p.354).

PAUL KLEE, DEATH AND FIRE, 1940

Klee is a great colorist and an endlessly creative painter, both enchanting and profound. Only he can depict death and fire with a smile and a sacred tremor. This is characteristic of his unique approach, both to the matter and the manner of painting (p.358).

1900

1910

1920

1930

1940

HENRI MATISSE, THE CONVERSATION, 1909

Equal with Picasso (if not indeed greater), Matisse is the great master of our century. He is a skillful simplifier of form and a marvelous manipulator of color, though he never uses these talents for their own sake, but always to create a design that at every point has a meaning (p.337).

MONDRIAN,
DIAMOND PAINTING IN RED,

YELLOW, AND BLUE, C. 1921/25 Mondrian is the great purist of art. He limited himself to a few basic colors, arranged in solemn squares. His art is profound, expressing in this bare form a noble conception of life (p.360).

SALVADOR DALI, THE PERSISTENCE OF MEMORY, 1931

Some artists are greatly gifted, but have little to express. This is not entirely true of Dali, but it can be said that what he wanted to express was his own self-importance. Sometimes his experience coincides with our own, which is why this picture of melting watches – time going into a flux – is so unforgettable (p.364).

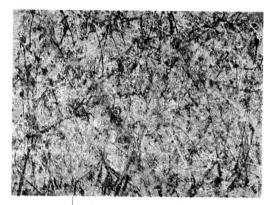

Jackson Pollock, NUMBER 1, 1950 (LAVENDER MIST), 1950

Picasso and Matisse dominated the first half of our century. In the second half, the major figure is probably Jackson Pollock. Whether for good or ill, he "liberated" artists from the palette and the brush, from design and intention. He splattered his paint, swirling it out from its cans as he danced on the horizontal canvas. It was an innovation of genius and surprisingly personal to Pollock himself (p.369).

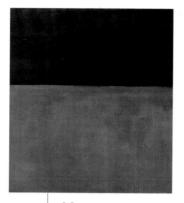

Mark rothko, untitled (black and gray), 1969

For some decades, Rothko has held his position as one of the great spiritual artists of our time. His mature work is always of the same format: there is a large canvas in which two rectangles of color hover before us. We sense deep emotion, but though the critics have spoken about "the veil of the temple" and other mystical metaphors, no explanation is completly convincing (p.370).

LUCIAN FREUD,

STANDING BY THE RAGS, 1988-89 Although it is stretching a point to speak of a School of London, it is still true that a group of figurative artists is at work there. Lucian Freud is perhaps the most significant, a ruthless and clinical observer of humanity who dissects his subject on the canvas with memorable power. Such vulnerability would be unbearable to contemplate were there the slightest touch of criticism or even of distancing. It is himself Freud dissects, and us with him. Here he shows us a nude standing against a background of paint rags from his studio. He makes everything that could be made of both these subjects, and of the many contrasts between them (p.386).

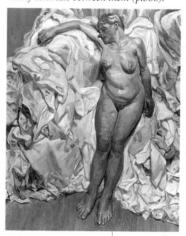

1950

1960

1970

1980

1990

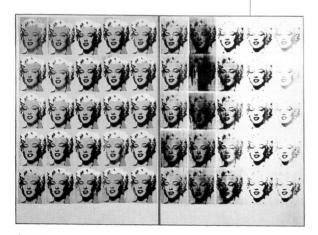

Andy warhol, marilyn diptych, 1962

There are still two vociferous attitudes toward Warhol. Is he a genius or a mountebank? Perhaps looking at the Marilyn Diptych we may feel that he is both: an artist who capitalized on his natural vulgarity and laziness, and used them to create icons for our times. One weakness – obsessive interest in the movie stars – is here set to work. He makes a subtle comment on the reality of this interest while conveying its fascination (p.380).

Jasper Johns, Dancers on a plane; MERCE CUNNINGHAM, 1980

Jasper Johns is a difficult artist, and none of his works is simple or easily comprehensible. There is always a concept controlling what he creates. Yet these creations are so supremely beautiful that they can be enjoyed even without full understanding. There is a reason behind every mark in Dancers on a Plane, and if we learn to love it we may want to investigate these secret complexities. But it is the love that matters (p.381).

THE FAUVES

The advent of Modernism is often dated by the appearance of the Fauves in Paris at the Salon d'Automne in 1905. Their style of painting, using nonnaturalistic colors, was one of the first avantgarde developments in European art. They greatly admired van Gogh, who said of his own work, "Instead of trying to render what I see before me, I use color in a completely arbitrary way to express myself powerfully." The Fauvists carried this idea further, translating their feelings into color with a rough, almost clumsy style. Matisse was a dominant figure in the movement; other Fauvists included Vlaminck, Derain, Marquet, and Rouault. However, they did not form a cohesive group, and by 1908 a number of painters had seceded to Cubism (see p.346).

AFRICAN INFLUENCES

Many of the Fauvists were inspired by African art and had their own collections of masks and statues. The fashion for tribal art had been started by Gauguin, and the African influence can be seen in several of the paintings Matisse completed around 1906. This Kwele mask, shown above, closely resembles a famous piece once owned by André Derain. The whitened face suggests that it may have been part of the ancestors cult in central Africa.

FAUVISM

Between 1901 and 1906, several comprehensive exhibitions were held in Paris, making the work of Vincent van Gogh, Paul Gauguin, and Paul Cézanne widely accessible for the first time. For the painters who saw the achievements of these great artists, the effect was one of liberation, and they began to experiment with radical new styles. Fauvism was the first movement of this modern period, in which color ruled supreme.

375 Maurice de Vlaminck, The River, c. 1910, 28¾ x 23½ in (73 x 60 cm)

Fauvism was a short-lived movement, lasting only as long as its originator, Henri Matisse (1869–1954), fought to find the artistic freedom he needed. Matisse had to make color serve his art, much as Gauguin needed to paint the sand pink to express an emotion (see p.324). The Fauvists believed absolutely in color as an emotional force. With Matisse and his friends, Maurice de Vlaminck (1876–1958) and André

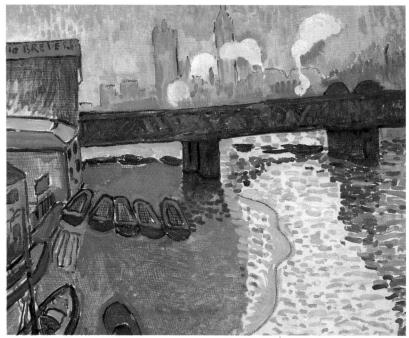

376 André Derain, Charing Cross Bridge, 1906, 39 x 32 in (100 x 80 cm)

Derain (1880–1954), color lost its descriptive qualities and became luminous, creating light rather than imitating it. They astonished viewers at the 1905 Salon d'Automne: the art critic Louis Vauxcelles saw their bold paintings surrounding a conventional sculpture of a young boy, and remarked that it was like a Donatello "parmi les fauves" (among the wild beasts). The painterly freedom of the Fauves and their expressive use of color gave splendid proof of their intelligent study of van Gogh's art (see pp. 316-18). But their art seemed brasher than anything seen before.

VLAMINCK AND DERAIN

During its brief flourishing, Fauvism had some notable adherents, including Rouault (p.341), Dufy (p.339), and Braque (p.350). Vlaminck had a touch of wild-beastishness, at least in the dark vigor of his internal moods: even if *The River* (375) looks at peace, we feel a storm is coming. A self-professed "primitive," he ignored the wealth of art in the Louvre, preferring to collect the African masks that became so important to early 20th-century art (see column, p.334).

Derain also showed a primitive wildness in his Fauve period – *Charing Cross Bridge* (376) bestrides a strangely tropical London – though as he aged he quenched his fire to a classic calm. He shared a studio with Vlaminck for a while, and *The River* and *Charing Cross Bridge* seem to share a vibrant power. Both reveal an unself-conscious use of color and shape, a delight in the sheer patterning of things. This may not be profound art, but it does give visual pleasure.

Contemporary ARTS

1902

Chekov writes The Three Sisters

1907

Stravinsky composes his first symphony

1908

Constantin Brancusi completes his sculpture *The Kiss*

1916

Frank Lloyd Wright designs the Imperial Hotel in Tokyo

1922

James Joyce writes Ulysses

1927

The first "talkie," The Jazz Singer, is produced

1928

Eugene O'Neill wins the Nobel prize for literature

1931

The Empire State
Building is completed
in New York City

must be thwarted just as one prunes the branches of a tree so that

it will grow better. **99**

Matisse, Master of Color

The art of our century has been dominated by two men: Henri Matisse and Pablo Picasso. They are artists of classical greatness, and their visionary forays into new art have changed our understanding of the world. Matisse was the elder of the two, but he was a slower and more methodical man by temperament, and it was Picasso who initially made the greater splash. Matisse, like Raphael (see p.124), was a born leader and taught and encouraged other painters, while Picasso, like Michelangelo (see p.120), inhibited them with his power: he was a natural czar. Each demands his own separate space, and we start with Matisse.

377 Henri Matisse, Madame Matisse, Portrait with a Green Stripe, 1905, 12¾ x 16 in (32.5 x 40.5 cm)

THE GREEN STRIPE

Matisse painted this unusual portrait of his wife in 1905. The green stripe down the center of Amélie Matisse's face acts as an artificial shadow line and divides the face into two distinct sides. Instead of dividing the face in the conventional portraiture style, with a light and a dark side, Matisse divides the face chromatically, with a cool and a warm side. The natural light is translated directly into colors, and the highly visible brushstrokes add to the sense of artistic drama.

378 Henri Matisse, The Conversation, 1909, 7 ft 1½ in x 5 ft 9¾in (217 x 177 cm)

Matisse's art has an astonishing force and lives by innate right in a paradise world into which Matisse draws all his viewers. He gravitated to the beautiful and produced some of the most powerful beauty ever painted. He was a man of anxious temperament, just as Picasso (see p.346), who saw him as his only rival, was a man of peasant fears, carefully concealed. Both artists, in their own fashion, dealt with these disturbances through the sublimation of painting: Picasso destroyed his fear of women in his art, while Matisse coaxed his nervous tension into serenity. He spoke of his art as being like "a good armchair" - a ludicrously inept comparison for such a brilliant man - but his art was a respite, a reprieve, a comfort to him.

Matisse initially became famous as the "King of the Fauves" (see p.334), an inappropriate name for this gentlemanly intellectual: there was no wildness in him, though there was much passion. He is an awesomely controlled artist, and his spirit, his mind, always had the upper hand over the "beast" of Fauvism.

In his green stripe portrait of his wife (377), he has used color alone to describe the image. Her oval face is bisected with a slash of green and her coiffure, purpled and top-knotted, juts

against a frame of three jostling colors. Her right side repeats the vividness of the intrusive green; on her left, the mauve and orange echo the colors of her dress. This is Matisse's version of the dress, his creative essay in harmony.

THE EXPERIMENTAL YEARS

Matisse's Fauvist years were superseded by an experimental period, as he abandoned threedimensional effects in favor of dramatically simplified areas of pure color, flat shape, and strong pattern. The intellectual splendor of this dazzlingly beautiful art appealed to the Russians, and many great Matisses are now in Russia. One is The Conversation (378), in which husband and wife converse. But the conversation is voiceless. They are implacably opposed: the man – a selfportrait - is dominating and upright, while the woman leans back sulkily in her chair. She is imprisoned in it, shut in on all sides. The chair's arms hem her in, and yet the chair itself is almost indistinguishable from the background: she is stuck in the prison of her whole context. The open window offers escape; she is held back by an iron railing. He towers above, as dynamic as she is passive, every line of his striped pajamas undeviatingly upright, a wholly directed man.

AFRICAN TRAVELS In January 1912 Matisse set off on the first of two

set off on the first of two trips to Morocco. His appetite for African primitive art had been whetted by a visit to Tangiers in 1906, and he was eager to go back to capture the wonderful light and vitality of Africa, When Matisse arrived in Morocco, it had been raining for two weeks and the rain was to continue for some time. These unusual climatic conditions left the landscape green and verdant, which in turn affected Matisse's paintings. This photograph shows a piece of traditional Moroccan textile owned by Matisse.

HENRI MATISSE

Matisse's artistic career was long and varied, covering many different styles of painting from Impressionism to near Abstraction. Early on in his career Matisse was viewed as a Fauvist (see p.334), and his celebration of bright colors reached its peak in 1917. when he began to spend time on the French Riviera at Nice and Vence. Here he concentrated on reflecting the sensual color of his surroundings and completed some of his most exciting paintings. In 1941 Matisse was diagnosed as having duodenal cancer and was permanently confined to a wheelchair. It was in this condition that he completed the magnificent Chapel of the Rosary in Vence.

GUILLAUME APOLLINAIRE

The French poet and art critic Guillaume Apollinaire (1880-1918) played a key role in the development of artistic movements in Paris in the early 20th century. He was among the first to recognize the skills of Matisse, Picasso, Braque, and Rousseau, and published a paper in 1913 supporting the Cubist movement. He is also believed to be the first person to use the word 'surrealist" (in 1917), and, through his friendship with André Breton (1896–1966), he exercised a direct influence on the Surrealist school. His own literary works were typical of the Modernist literature of the period. This illustration shows a cartoon drawing of Apollinaire by Picasso.

OTHER WORKS BY MATISSE

Woman with a Red Chair (Baltimore Museum of Art)

The Pink Studio (Pushkin Museum, Moscow)

Odalisque (Bridgestone Museum of Art, Tokyo)

Two Models Resting (Philadelphia Museum of Art)

Woman with a Violin (The Orangerie, Paris)

The Snail (Tate Gallery, London)

Oceania, the Sea (Musées Royaux des Beaux Arts, Brussels)

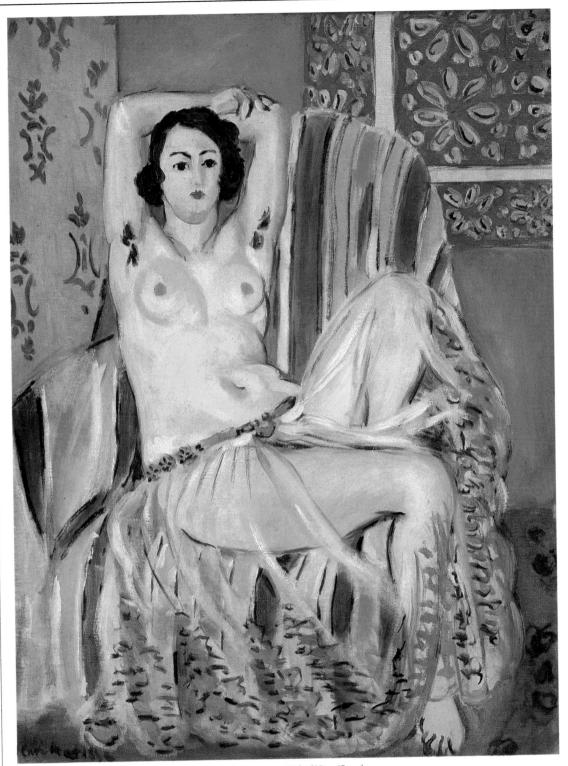

379 Henri Matisse, Odalisque with Raised Arms, 1923, 19¾ \times 25 in (50 \times 65 cm)

His neck thickens to keep his outline straight and firm, an arrow of concentrated energy. The picture cannot contain him and his head continues beyond it, into the outside world. He is greater than it all, and the sole "word" of this inimical conversation is written in the scroll of the rail: *Non*. Does he say no to her selfish passivity? Does she say no to his intensity of life? They deny each other forever.

SUPREME DECORATION

But denial is essentially antipathetic to Matisse. He was a great celebrator, and to many his most characteristic pictures are the wonderful odalisques he painted in Nice (he loved Nice for the sheer quality of its warm, southern light). Though such a theme was not appreciated at the time, it is impossible for us to look at *Odalisque with Raised Arms* (379) and feel that Matisse is

exploiting her. The woman herself is unaware of him, lost in private reverie as she surrenders to the sunlight. The splendid opulence of her chair, her diaphanous skirt, and the intricately decorated panels on either side all unite in a majestic whole that celebrates the glory of creation. It is not her abstract beauty that attracts Matisse, but her concrete reality. He reveals a world of supreme decoration: for example, the small black patches of underarm hair on the odalisque serve as witty quotation marks around the globes of her breasts and the rose pink center of each nipple.

SCULPTING IN PAPER

Picasso and Matisse were active to the end of their lives, but while Picasso was preoccupied with his aging sexuality, Matisse moved into a period of selfless invention. In this last phase, too weak to stand at an easel, he created his papercuts, carving in colored paper, scissoring

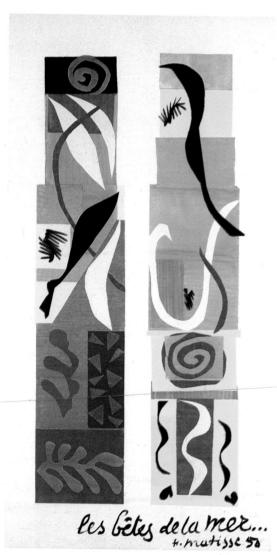

380 Henri Matisse, Beasts of the Sea, 1950, 5ft ½ in x 9 ft 8 in (154 x 295.5cm)

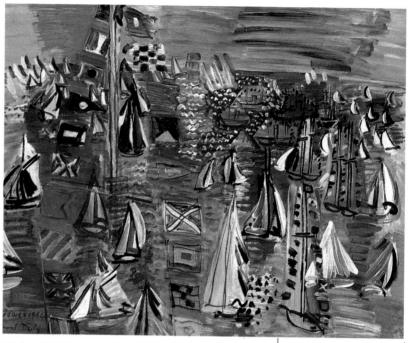

381 Raoul Dufy, Regatta at Cowes, 1934, 39 x 32¼ in (190 x 82 cm)

out shapes, and collaging them into sometimes vast pictures. These works, daringly brilliant, are the nearest he ever came to abstraction. *Beasts of the Sea (380)* gives a wonderful underwater feeling of fish, sea cucumbers, sea horses, and water-weeds, the liquid liberty of the submarine world where most of us can never go. Its geometric rightness and chromatic radiance sum up the two great gifts of this artist, and it is easy to see why he is the greatest colorist of the 20th century. He understood how elements worked together, how colors and shapes could come to life most startlingly when set in context. Everything of Matisse's works together superbly.

Dufy's joyous art

One painter who truly found his artistic self through Matisse and the Fauves was another Frenchman, Raoul Dufy (1877-1953). He is still hard to categorize, one of the important painters about whom the critics have not yet entirely made up their minds. His art seems too light of heart and airy, unconcerned with any conventions that would persuade the doubter of his seriousness. He is in fact utterly serious, but serious about joy, about the need to be free and disinterested, with no personal stake in life. His painting Regatta at Cowes (381) leaps with glorious unconcern across the canvas, so superbly organized that it almost seems artless. If some later artists have tried to imitate Dufy's apparent incoherence, none has had his profound purity that makes everything cohere. This kind of art either comes naturally, or fails.

BEASTS OF THE SEA

Matisse chose to challenge the traditional beliefs of the artistic establishment by turning to the use of bright, colorful collage. His first use of scissors and paper was in 1931, but it was purely as a design approach for his larger paintings. However, when he became ill, he turned to collage as an art in itself. In 1950, when he was over 80 years old, he cut one of his most beautiful collages in memory of the South Seas, which he had visited 20 years earlier. Beasts of the Sea includes symbols of aquatic life on the ocean bed, on the surface of the water. of the island itself, and of the sky above. By playing the bright colors against one another, Matisse achieved tonal resonances that would have a great influence on the color painters of the 1960s.

Expressionism

The term "Expressionism" can be used to describe various art forms, but, in its broadest sense, it is used to describe any art that raises subjective feelings above objective observations. The paintings aim to reflect the artist's state of mind rather than the reality of the external world. The German Expressionist movement began in 1905 with artists such as Kirchner and Nolde, who favored the Fauvist style of bright colors but also added stronger linear effects and harsher outlines.

DIE BRÜCKE

In 1905 a group of German Expressionist artists came together in Dresden and took the name Die Brücke (The Bridge). The name was chosen by Karl Schmidt-Rottluff to indicate their faith in the art of the future, toward which their work would serve as a bridge. In practice they were not a cohesive group, and their art became an angst-ridden type of Expressionism. The achievement that had the most lasting value was their revival of graphic arts - in particular, the woodcut using bold and simplified forms.

EXPRESSIONISM

In the north of Europe, the Fauves' celebration of color was pushed to new emotional and psychological depths. Expressionism, as it was generally known, developed almost simultaneously in different countries starting in about 1905. Characterized by heightened, symbolic colors and exaggerated imagery, it was German Expressionism in particular that tended to dwell on the darker, sinister aspects of the human psyche.

382 Georges Rouault, Prostitute at Her Mirror, 1906, 23½ \times 27½ in (60 \times 70 cm)

Although Expressionism developed a distinctly German character, the Frenchman Georges Rouault (1871–1958) links the decorative effects of Fauvism in France with the symbolic color of German Expressionism. Rouault trained with Matisse at Moreau's academy and exhibited with the Fauves (see p.335), but his palette of colors and profound subject matter place him as an early, if isolated, Expressionist. His work has been described as "Fauvism with dark glasses."

Rouault was a deeply religious man, and some consider him the greatest religious artist of the 20th century. He began his career apprenticed to a stained-glass worker, and his love of harsh, binding outlines containing a radiance of color gives poignancy to his paintings of whores and fools. He himself does not judge them, though the terrible compassion with which he shows his wretched figures makes a powerful impression: Prostitute at Her Mirror (382) is a savage indictment of human cruelty. She is a travesty of femininity, although poverty drives her to primp miserably before her mirror in the hope of getting work. Yet the picture does not depress, but holds hope of redemption. Strangely enough, this work is for Rouault – if not exactly a religious picture – at least a profoundly moral one. She is a sad female version of his tortured Christs, a figure mocked and scorned, held in disrepute.

THE BRIDGE TO THE FUTURE

Die Brücke (The Bridge) was the first of two Expressionist movements that emerged in Germany in the early decades of the 20th century. It was formed in Dresden in 1905.

The artists of Die Brücke drew inspiration from van Gogh (see p.316), Gauguin (p.322), and primitive art. Munch was also a strong influence, having exhibited his art in Berlin from 1892 (p.325). Ernst Ludwig Kirchner (1880–1938), the leading spirit of Die Brücke, wanted German art to be a bridge to the future. He insisted that the group, which included Erich Heckel (1883–1970) and Karl Schmidt-Rottluff (1884–1976), "express inner convictions... with sincerity and spontaneity."

Even at their wildest, the Fauves had retained a sense of harmony and design, but Die Brücke abandoned such restraint. They used images of the modern city to convey a hostile, alienating world, with distorted figures and colors. Kirchner does just this in *Berlin Street Scene (383)*, where the shrill colors and jagged hysteria of his own vision flash forth uneasily. There is a powerful sense of violence, contained with difficulty, in much of their art. Emil Nolde (1867–1956), briefly associated with Die Brücke, was a more profound Expressionist who worked

383 Ernst Ludwig Kirchner, Berlin Street Scene, 1913, 37½ x 47½ in (95 x 121 cm)

in isolation for much of his career. His interest in primitive art and sensual color led him to paint some remarkable pictures with dynamic energy, simple rhythms, and visual tension. He could even illuminate the marshes of his native Germany with dramatic clashes of stunning color. Yet *Early Evening (384)* is not mere drama: light glimmers over the distance with an exhilarating sense of space.

DEGENERATE ART With the rise of Hitler and the Nazi party in the 1930s, many contemporary artists were discredited and forced to flee Germany or go into concentration camps. The term "degenerate art" was coined by the authorities to describe any art that did not support the Nazi Aryan ideology. The first degenerate art exhibition opened in Munich in 1937, with paintings by van Gogh, Picasso, and Matisse torn from their frames and hung randomly among the work of asylum inmates. The exhibition was so successful that it went on a propaganda tour throughout Germany and drew millions of visitors. Many artists were deeply affected by being labeled "degenerate," and Ernst Ludwig Kirchner actually committed suicide as a result in 1938.

384 Emil Nolde, Early Evening, 1916, 39½ x 29 in (101 x 74 cm)

World war I

World War I broke out in 1914 following the assassination of Archduke Ferdinand (heir to the throne of Austria-Hungary) in Sarejevo by nationalists. This single event ignited localized problems that spread into an international conflict. Within months, all of Europe and parts of North Africa were in conflict. Austria-Hungary declared war on Serbia (believing the Serbians had devised the Sarejevo plot), and Austria's ally Germany declared war on Russia and France, then immediately invaded Belgium. In response, Britain declared war on Germany, and the stage was set for five years of incessant fighting and for the death of 10 million people. By April 1917 the allies included Britain, France, Russia, Japan, Italy, and the US. Many artists were influenced by the war, particularly Max Beckmann, who was deeply affected by his work as a medical orderly on the front lines.

OTHER WORKS BY BECKMANN

Souvenir of Chicago (Fogg Art Museum, Cambridge, Mass.)

Two Women (Museum Ludwig, Cologne)

The Dream (Staatsgalerie Moderner Kunst, Munich)

> Masquerade (Art Museum, St. Louis)

Carnival (Tate Gallery, London)

Sea Lions in the Circus (Kunsthalle, Hamburg)

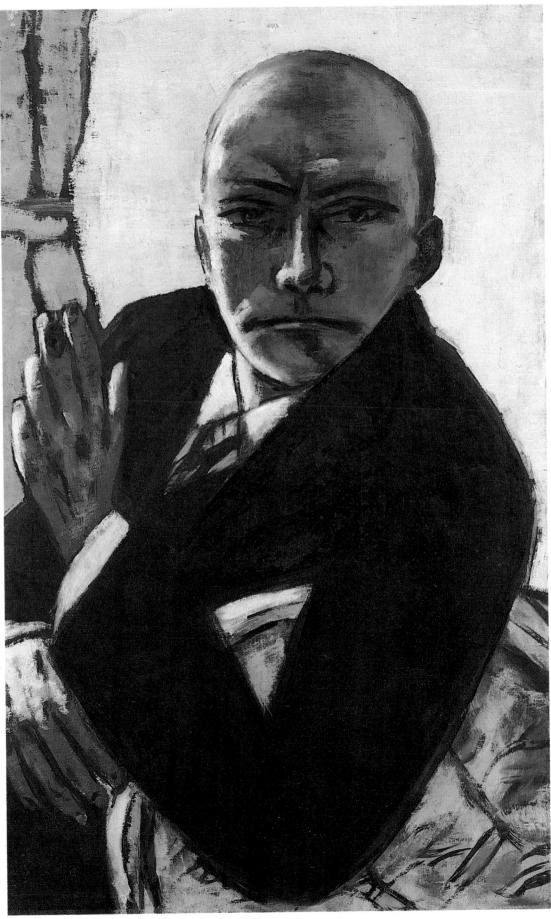

385 Max Beckmann, Self-Portrait, 1944, 23½ x 37½ in (60 x 95 cm)

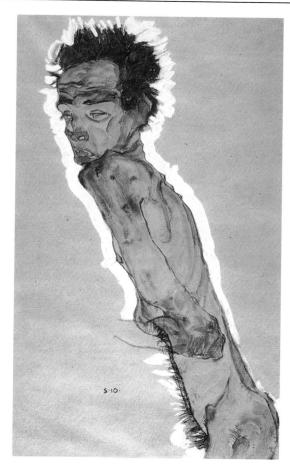

386 Egon Schiele, Nude Self-Portrait, 1910, 141/4 x 43 in (35.5 x 110 cm)

Die Brücke collapsed as the inner convictions of each artist began to differ, but arguably the greatest German artist of the time was Max Beckmann (1884–1950). Working independently, he constructed his own bridge, to link the objective truthfulness of great artists of the past with his own subjective emotions. Like some other Expressionists, he served in World War I and suffered unbearable depression and hallucinations as a result. His work reflects his stress through its sheer intensity: cruel, brutal images are held still by solid colors and flat, heavy shapes to give an almost timeless quality. Such an unshakable certainty of vision meant that he was hated by the Nazis, and he ended his days in the United States, a lonely force for good. He is just discernible as a descendant of Dürer in his love of self-portraits and the blend of the clumsy and suave with which he imagines himself. In Self-Portrait (385), he looks out, not at himself, but at us, with a prophetic urgency.

AUSTRIAN EXPRESSIONISM

The Austrian Expressionist painter Egon Schiele (1890–1918) died when he was only 28, and we do not really know whether he would have developed beyond the self-pitying adolescent

angst that was the main theme of his work. Self-Portrait (386), however, is a most moving theme in itself: a pathetic and yet powerful exposure of Schiele's vulnerability. He is mere skin and bone, not yet fully there as a person. He has outlined his body with a glowing line of white to indicate to us both his sense of imprisonment and his limitations: notice how his arm disappears almost at the elbow - yet paradoxically it also suggests growth and potential. He is an unhappy, scrawny youth, the wild and exaggerated expanse of pubic hair perhaps indicating the center of his unhappiness. His may seem too individualistic a view, yet in his hysterical way he is expressing the fears and doubts of many young people. He is wonderful, unsettling, and strangely innocent.

Oskar Kokoschka (1886–1980) was another Austrian artist of enormous Expressionist power. He said of his art, "It was the Baroque inheritance I took over unconsciously." He rejected harmony, but insisted on vision, and his art stakes its all on this visionary intensity, which plays havoc with more staid conventions.

In 1914 he fell passionately in love with Alma Mahler, the widow of the Austrian composer Gustav Mahler. In its wild, dreamy way *Bride of the Wind (387)* commemorates the emotional storms and insecurities of that relationship with a sophisticated psychological insight: Alma, the "bride," sleeps complacently, while Kokoschka, flayed and disintegrating within the twisting brushstrokes and sinuous ribbons of color, agonizes alone in silence.

Oskar kokoschka

Oskar Kokoschka first made a name for himself in 1909-10 with his psychological portraits, in which the sitter's soul was believed to be exposed to the world. His paintings changed radically after his traumatic experiences in World War I, and he began to paint Expressionist landscapes. In 1914 Kokoschka began an affair with Alma Mahler, Gustav Mahler's widow, which inspired one of his most powerful paintings, Bride of the Wind. This relationship ended in 1915, but Kokoschka could not accept the break. He is known to have made a life-size doll of his lover, which he carried around with him at all times. His obsession with Alma was brought to an abrupt end in 1922, and he smashed the doll's head after a night of heavy drinking.

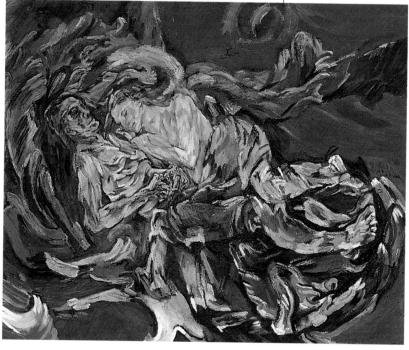

387 Oskar Kokoschka, Bride of the Wind, 1914, 7 ft 3 in x 5 ft 111/4 (221 x 181 cm)

La ruche

During this period many artists in Paris lived in an unusual building known as La Ruche (The Beehive). The building acquired its name from the row of small studios and the buzzing creative atmosphere. It was originally built for the 1900 World's Fair, but was then torn down and rebuilt in the Dantzig Passage area of Paris to shelter artists. The first floor contained sculpture studios, and painters, such as Chagall, Soutine, Léger, and Modigliani, all took studios on the second and third floors.

ARTISTIC EMIGRES

As the center of artistic interest, Paris attracted many foreign painters in the early 20th century, and within a few years of one another three Jewish émigrés, Chaim Soutine, Marc Chagall, and Amedeo Modigliani, had all arrived in the city. Though they became friends and gained inspiration from the recent innovations in art, they were all highly original artists and their paintings stand alone, defying categorization and imitation.

The three painters that we look at here were all born outside France, and they remained outsiders to the Parisian art scene for more than merely cultural reasons (Soutine and Chagall were both Russian and Modigliani was Italian). These painters shared the isolation of being "other," never truly belonging to any group or adhering to a single manifesto.

A PASSIONATE EXPRESSIONIST

Chaim Soutine (1894–1943) came to Paris in 1913. He was the only painter in the city who was in the least like Georges Rouault (see p.341), and as a Parisian Expressionist, he belonged to

the "School of Paris." Soutine's style of applying thickly encrusted paint was quite different from Rouault's, but his wild, chaotic spirit, sorrowful and vehement, is like that of the Frenchman. Just as Rouault, despite his Fauvist connections, is seen as inherently Expressionist, so Soutine was a natural, though unique, Expressionist.

Soutine's religion was the earth. He painted the sacredness of the country with a passion that makes his art hard to read. *Landscape at Ceret* (388) is so dense that it could be abstract, and it does take enormous liberties with the earthly facets, but when we do "read" it, hill and tree and road take on a new significance for us.

388 Chaim Soutine, Landscape at Ceret, c.1920-21, 33 x 22 in (84 x 56 cm)

DREAMS OF THE HEART

Marc Chagall (1887–1985) arrived in Paris in 1914 penniless, like Soutine. He combined his fantasies with sensuous color and modern art techniques he learned in France. He played with reality in a completely original and even primitive way. At heart he was a religious painter, using the word in its widest sense: he painted the dreams of the heart, not the mind, and his fantasy is never fantastic. It speaks beyond logic to the common human desire for happiness.

His early work in particular seems lit up from within by a psychic force that flows from his Jewish upbringing in Russia. *The Fiddler (389)* is a mythic figure, the celebrant of Jewish births, marriages, and deaths, but he bears this weight of the community alone, almost alienated from the common lot – notice the luminous green of the fiddler's face and how he hovers magically, unsupported in the air.

Modigliani's mannered art

The third great "outsider" among the émigrés in Paris died all too soon. The Italian Amedeo Modigliani (1884–1920) destroyed himself through drink and drugs, driven desperate by his poverty and bitterly ashamed of it. Modigliani was a young man of fey beauty,

390 Amedeo Modigliani, Chaim Soutine, 1917, 23½ x 36 in (60 x 91 cm)

389 Marc Chagall, The Fiddler, 1912/13, 5 ft 2 in × 6 ft 2 in (158 × 188 cm)

and his work has a wonderful slow elegance that is unusual, but compelling. Through the influence of the Rumanian sculptor Constantin Brancusi, he fell under the spell of primitive sculpture, especially from Africa. He went on to develop a sophisticated, mannered style built upon graceful, decorative arabesques and simplified forms. It is hard for us to imagine why his art did not attract patrons. He is famous now for his elegant, elongated nudes, but it is his portraits that are the most extraordinary.

Chaim Soutine (390), whose own art was so offbeat, appeals to Modigliani for what he is bodily and for what he could become spiritually. Soutine rears up out of the frame like a gawky pillar. His nose is brutish in its spread, his eyes asymmetrical, his hair a shaggy mess. All this uncouthness is contrasted by his slender wrists and hands, by an impression we have of a man yearning for a homeland, set upon forming one out of his own substance if no place is provided. There is sadness here, but also determination; the thick red mouth is resolutely closed.

OTHER WORKS BY CHAGALL

The Cattle-Dealer (Öffentliche Kunstsammlung, Basel)

The Juggler (Art Institute of Chicago)

The Eiffel Tower
(National Gallery
of Canada, Ottawa)

War (Pompidou Center, Paris)

The Martyr (Kunsthaus, Zurich)

The Blue Circus (Tate Gallery, London)

Peasant Life (Guggenheim Museum, New York) art of painting original arrangements composed of elements taken from conceived rather than perceived reality.

Guillaume Apollinaire, The Beginnings of Cubism, 1912

Picasso and Cubism

After Cubism, the world never looked the same again: it was one of the most influential and revolutionary movements in art. The Spaniard Pablo Picasso and the Frenchman Georges Braque splintered the visual world not wantonly, but sensuously and beautifully with their new art. They provided what we could almost call a God's-eye view of reality: every aspect of the whole subject, seen simultaneously in a single dimension.

It is understandable that Pablo Picasso (1881–1973) found Spain at the turn of the century too provincial for him. Picasso's genius was fashioned on the largest lines, and for sheer invention no artist has ever bettered him– he was one of the

most original and versatile of artists, with an equally powerful personality. Throughout the 20th century people have been intrigued and scandalized by Picasso's work, uncertain of its ultimate value.

391 Pablo Picasso, Family of Saltimbanques, 1905, 7 ft 7 in × 7 ft (230 × 213 cm)

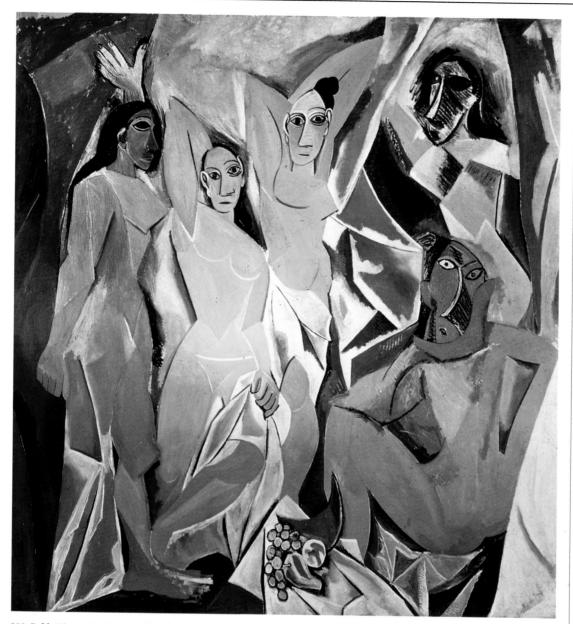

392 Pablo Picasso, Les Demoiselles d'Avignon, 1907, 7 ft 8 in × 8 ft (234 × 244 cm)

THE EARLY YEARS

Picasso's Blue Period, from 1901 to 1904, sprang from his initial years of poverty after moving to Paris and modulated into a Rose Period as he slowly began to emerge into prominence. Although still only in his youth when he started painting, Picasso had overwhelming ambition, and his Family of Saltimbanques (391) was, from the start, meant to be a major statement. It is a very large, enigmatic work from the Rose Period, revealing his superb graphic skill and the subtle sense of poverty and sadness that marked those early years. The five itinerant acrobats are strained and solitary in the barren, featureless landscape; the lonely girl seems not to belong to their world, though she too is melancholy and belongs by right of mood. There is something portentous about the picture, some unstated

mystery. We feel that Picasso, too, does not know the answer – only the question. Already art is an emotional medium for Picasso, reflecting his moods and melancholia as he seeks to find fame as an artist.

THE FIRST CUBIST PAINTING

While still in his twenties, but finally over his self-pitying Blue and Rose periods, Picasso fundamentally changed cognitive reality with a work his friends called *Les Demoiselles d'Avignon* (392) after a notorious place of prostitution. These demoiselles are indeed prostitutes, but their initial viewers recoiled from their advances with horror. This is the one inevitable image with which a discussion of 20th-century art must be concerned. It was the first of what would be called the Cubist works, though the boiled pink

PICASSO'S PHASES

Pablo Picasso (1881-1973) had several distinct phases during his long career, including his Blue Period, and his later Rose Period. He began his blue paintings in 1901, reflecting his sadness at a friend's death. Picasso felt that blue was the color of solitude and melancholy, which certainly reflected his own bleak circumstances at the time. Directly after his Blue Period Picasso moved on to his Rose Period in 1905. Some believe that the warm tones of this period of work were influenced by Picasso's habit of smoking opium. One of Picasso's most creative phases took place between 1908 and 1912 and is known as Analytical Cubism (see p.348). In this style, which he developed with Georges Braque, Picasso used disintegrated and reassembled forms in shades of black and brown.

CUBISM

This movement in painting was developed by Picasso and Braque around 1907 and became a major influence on Western art. The artists chose to break down the subjects they were painting into a number of facets, showing several different aspects of one object simultaneously. The work up to 1912 concentrated on geometrical forms using subdued colors. The second phase, known as Synthetic Cubism, used more decorative shapes, stenciling, collage, and brighter colors. It was then that artists such as Picasso and Braque started to use pieces of cut-up newspaper in their paintings.

OTHER WORKS BY PICASSO

Still Life with Three Fish (Musée Picasso, Antibes)

> Landscape (Musée Picasso, Barcelona)

Woman Reclining Reading (Musée Picasso, Paris)

Cup and Spoon (Bridgestone Museum of Art, Tokyo)

Woman with a Guitar (Norton Simon Museum, Pasadena)

Harlequin (Museum of Modern Art, New York)

Nude with Clasped Hands (Art Gallery of Ontario, Toronto) color of the hideous young women is far removed from later Cubism, with its infinite subtleties of gray and brown. It is almost impossible to overestimate the importance of this picture and the profound effect it had on art subsequently. The savage, inhuman heads of the figures are the direct result of Picasso's recent exposure to tribal art, but it is what he does with their heads – the wild, almost reckless freedom with which he incorporates them into his own personal vision and frees them to serve his psychic needs – that gives the picture its awesome force.

Whether he did this consciously or not we do not know, since he was a supremely macho man: *Les Demoiselles* makes visible his intense fear of women, his need to dominate and distort them. Even today when we are confronted with these ferocious and threatening viragoes, it is hard to restrain a frisson of compassionate fear.

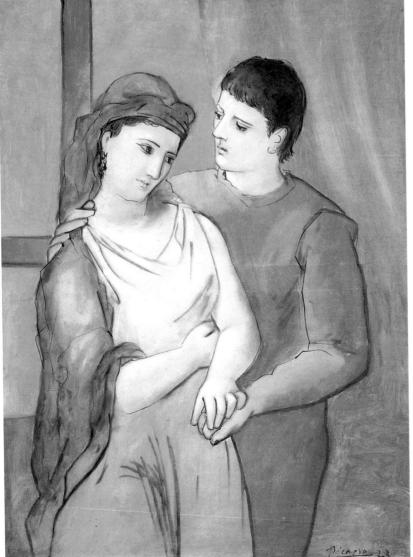

393 Pablo Picasso, The Lovers, 1923, 38 x 51 in (97 x 130 cm)

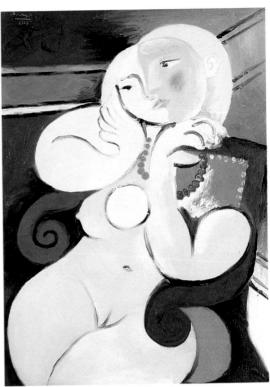

394 Pablo Picasso, Nude Woman in a Red Armchair, 1932, 38 × 51 in (97 × 130 cm)

At first Picasso did not dare to show the painting even to his admirers, of whom there were always many. But Georges Braque (see p.350) was haunted by its savage power, and eventually he and Picasso began to work out together the implications of this new kind of art. Cubism involved seeing reality simultaneously from all angles, of meshing the object in the network of its actual context. As Cézanne had indicated, there were to be no boundary lines to truth, but a form emerging from all different aspects intuited together (see column, p.347). The results are hard to read, even though the Cubists confined themselves mostly to unpretentious and familiar objects such as bottles and glasses of wine, or musical instruments (see p.350).

BEYOND CUBISM

Picasso would have scorned any thought of limiting himself to a single style. He experimented continually, his versatility and creativity always amazing his contemporaries. Whenever he seemed to have settled in a particular mode of seeing, he changed again almost overnight.

Picasso soon became a wealthy man, and when the scandal of his early artistic methods had died down, he revived it with his subject matter. He is an even more autobiographical artist than Rembrandt or van Gogh, and it was the women in his life who provided the changing drama. Each new relationship precipitated a

new wave of creativity, with a new model and a new vision. *The Lovers* (393) shows him in a classical vein, soberly and simply giving substantial form to an almost theatrical drama. This was the period of his infatuation with Olga Kokhlova, the well-bred Russian ballerina whom he rashly married and whose elegant influence on him was soon to be angrily denied as their relationship faltered. There is a balletic grace in *The Lovers*, and, because he was pictorially thrifty, Picasso never completely discarded the styles as he did the women.

THE ARTIST'S PLEASURE

The mistress who inspired the most enchanting art in him was Marie-Thérèse, a large, pacific girl with whose rounded body shapes he loved to play on canvas. Picasso was so various an artist, so astonishing in his inventions that every viewer may well have a favorite period, yet (though this may be too subjective a reaction) the work inspired by Marie-Thérèse seems to come from a depth that is untouched in his other work. *Nude Woman in a Red Armchair* (394) is the last time we see Picasso relatively benign. There is something in Marie-Thérèse's willing vulnerability, in her material fecundity of shape, that Picasso finds positively reassuring.

All the Marie-Thérèse paintings – at least until the affair began to disintegrate - are remarkably satisfying: rich, gracious, almost sweet, and yet deeply challenging. Picasso toys with both the rotundity of her body and with the powerful paradox of her extreme youth (she was only 17 when they met), yet the physical satisfaction that she brought him, succoring and nurturing him, was as though this simple child was, in a sense, a mother figure to him. Nude Woman in a Red Armchair, with its luminous physicalities - which even the armchair seems to share as it curls and glows around her body still expresses the dichotomy of Marie-Thérèse's double role in Picasso's treatment of her face. She is both full moon and crescent moon, full face and in profile. It is impossible not to feel the thrilling communication of the artist's pleasure. This sense of fulfillment, rare in Picasso at any stage, never reappeared after he lost interest in Marie-Thérèse and her warm charms.

PICASSO'S LATER MISTRESSES

Subsequent mistresses such as Dora Maar, an intellectual, or François Gillot, another artist – both fiercely determined women – brought out Picasso's cruelty, his determination not to be impressed. Even in his old age, when he was cared for by his second wife, Jacqueline Roque, Picasso still used her as ammunition in his battle

against fate. He raged against his loss of sexual power in these final years and sought to compensate for it through the phenomenal weight of his artistic powers.

Picasso's portrait of Dora Maar, Weeping Woman (395), painted the same year as his great picture Guernica, has a terrible power. It is a deeply unattractive picture, the shrill acids of its yellows and greens fighting bitterly and unrelentingly with the weary reds, sickly whites, and sinister purples. But it is also unattractive in the sense that it conveys Picasso's venomous desire to mutilate his sitter. Dora Maar's tears were almost certainly tears caused by Picasso himself. They reveal her anguished need for respect; Picasso repays her with a vicious savagery.

Power was Picasso's special gift. He had the ability to turn even the most incidental of themes into powerful works with an often overbearing force. If we accept that all beauty has power, we can arrange artists along a line, at one end or the other. Vermeer, Claude, and Matisse would be at the beauty end, and Rembrandt and Poussin at the power end, together with Picasso.

GERTRUDE STEIN

Gertrude Stein (1874-1946) was one of the most influential art collectors living in Paris in the early 20th century. The Stein family became friendly with Matisse after buying his painting Woman with a Hat. but Gertrude Stein preferred the work of Picasso. Stein's career as a novelist ran parallel to Picasso's career as a painter, and their friendship was mutually beneficial, resulting in a portrait of Stein by Picasso and a short essay on Picasso's work by Stein. Stein was also associated with Juan Gris, whom she began to collect in 1914. The Stein family collected hundreds of paintings and had a major influence on many artists.

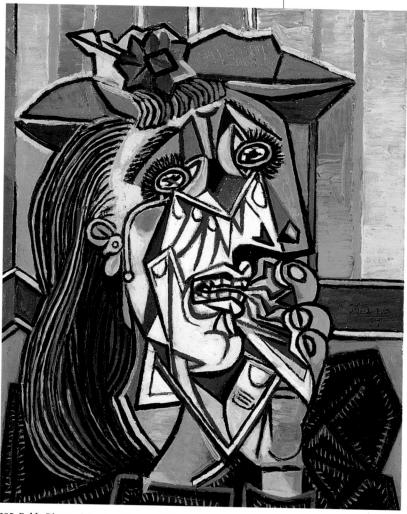

395 Pablo Picasso, Weeping Woman, 1937, 18 x 21½ in (46 x 55 cm)

PAPIER COLLÉ AND COLLAGE

The technique of papier collé (pasted paper) was invented by Georges Braque in 1913. He cut out squares from a roll of imitation-wood paper, stuck them onto cardboard and then sketched a still life. The technique was adopted by Picasso and Matisse. It usually involved using imitation wood engraving, stenciled lettering, and fake marble stuck in layers onto the canvas. Braque also pioneered the technique of mixing sand with his paint to achieve a more textured effect. The collage (pasting) technique begun by the Cubist painters was later used by Max Ernst and other Surrealists. A wide variety of effects were created, using paper, news clippings, and photographs.

396 Georges Braque, Still Life: Le Jour, 1929, 58 x 45 in (147 x 115 cm)

GEORGES BRAQUE

Georges Braque (1882–1963) was the only artist ever to collaborate with Picasso as an equal. He admitted that they were like climbers roped together, each pulling the other up. From 1907 they worked so closely together, exploring the planes and facets of the same subject matter, that some of their work appears almost identical. Although they developed their own natural autonomy as artists, they carried Cubism to another, more brilliant level.

Their joint discovery was remarkably brief for the effect it has had. Braque never excelled in these early works, though he never fell below Picasso's standards either. His Synthetic Cubist painting (see column, p.347) of *Still Life: Le Jour* (396) is restrained in color, is hardly playful at all, and is somehow less exuberant than Picasso's Cubist work – though Braque delights in the originality of the shapes and textures. But by this time the two artists had long parted, and their innate differences are clear.

JUAN GRIS

There was a third great Cubist, the Spaniard Juan Gris (1887–1927). He died young and never moved on from the style, though he progressively brightened and clarified it. With this single-mindedness, Gris can be thought of as the one absolute Cubist. *Fantômas* (397) has a harlequinish gaiety with its shifting planes and witty celebration of newspapers, magazines, and entertainment. With its stylish sophistication, we would never think it was a Braque or Picasso.

397 Juan Gris, Fantômas, 1915, 29 x 23½ in (73 x 60 cm)

THE AGE OF MACHINERY

Interest in and appreciation of machinery was clearly in the air in the early decades of the 20th century. For a group of young Italian Futurist artists, the progress offered by machinery epitomized their increasing fascination with dynamic speed and motion. Though they translated this idea of progress into a frenetic exultation of the glory of war and the destruction of museums, their visual understanding of motion remained exciting.

The Italian Futurists, like the members of Die Brücke in Germany, aimed to free art from all its historical restraints and celebrate the new beauty of the modern age (see column, right). Umberto Boccioni (1882–1916), Gino Severini (1883–1966), and Giacomo Balla (1871–1958), who all joined Futurism in 1910, wanted to express the onrush of events in the world with pictures of motion, dynamism, and power.

In *Street Noises Invade the House (398)*, Boccioni attempts to give this sensation and succeeds remarkably well. Noise becomes something seen, something literally invasive of privacy. Boccioni said of the picture, "all life and the noises of the street rush in at the same time as the movement and the reality of the objects outside." The surging incoherence of the forms is both chaotic and ordered.

398 Umberto Boccioni, Street Noises Invade the House, 1911, 42 x 391/4 in (107 x 100 cm)

FUTURISM

The Italian avant-garde movement was founded in 1909 by the poet Marinetti. It included many painters such as Boccioni, Carra Russolo, and Severini. The aim of the movement (which included writers, architects, photographers, and musicians) was to break with academic restrictions and to celebrate the dynamism of modern technology. The name "Futurism" was first used by Marinetti in the French newspaper Le Figaro in February 1909, but the movement only lasted until the death of Boccioni in 1916.

THE MANIFESTO

The general manifesto announced in the newspaper Le Figaro was followed by several other manifestos, including that of 1910, which highlighted the violent and challenging aesthetic of Futurism. The artists who signed this manifesto believed that "universal dynamism" must be rendered as dynamic sensation. Their support of war and violence anticipated the politics of Fascism, which would arrive in Italy with Mussolini in 1919. Both Boccioni and Marinetti praised World War I as the "hygiene of civilization" and saw the growing industrialization of the world as a vital force. The artistic importance of Futurism as a modern movement, is overshadowed by the extreme right-wing politics of its members.

ORPHISM

The term "Orphism" was coined by Apollinaire with reference to the singer and poet of Greek myth, Orpheus, who reflected the desire of artists to bring a new lyricism into their work. This type of art has been attributed to Delaunay, who concentrated on the power of color over form. He managed to achieve a fusion of Cubism, Fauvism, and Futurism, to produce the first real forerunner to abstract art. Apollinaire viewed such esoteric paintings as the only "pure" art, as they are created entirely by the artist without recourse to any outside influences.

399 Fernand Léger, Two Women Holding Flowers, 1954, 52 x 38 in (132 x 97 cm)

400 Robert Delaunay, Homage to Blériot, 1914, 8 ft 3 in x 8 ft 2½ in (251 x 250 cm)

FRANCE AND THE MACHINE AGE

Fernand Léger (1881–1955) was initially influenced by Cubism, but after his experience of trench warfare in World War I, he converted to Socialism. Like the Futurists, he admired the harmonious union of man with modern machinery. He developed an unusual blend of abstraction and representational imagery that conveyed something of the smooth, ordered quality of machines. Two Women Holding Flowers (399) shows the simplicity and power of this later style, though it is still only partially realistic. The full, schematic forms of the women were meant to be easily assimilable to ordinary people, for whom Léger felt immense respect, though it is the great bright blocks of color that give his women their true interest. All the same, there is a sort of epic splendor in this art to which most people find themselves responding instinctively.

The machine age inspired not only Léger and the Futurists, but Robert Delaunay (1885–1941). Homage to Blériot (400) shows Delaunay's intoxication with the airplane and Blériot, the first pilot to fly the English Channel. Initially, it may seem to be an abstract picture, but it is full of visual clues. Blériot's plane whirls high above the Eiffel Tower, while figures and planes dazzle in and out of swirling multicolored circles, reminiscent of a propellor (see column, left).

TOWARD ABSTRACTION

In 1911, a new group of German artists began exhibiting their work to the public. Der Blaue Reiter was to become the high point of German Expressionism, but it also opened the way toward abstraction with its stand for free experimentation and originality. It is Wassily Kandinsky, the most influential member of the group, who is most often credited with the distinction of painting the first "abstract" picture, in 1910.

Der Blaue Reiter (The Blue Rider) was formed in 1911 and succeeded the first Expressionist movement, Die Brücke (see p.340), which dissolved in 1913. The group included Franz Marc (1880–1916), Wassily Kandinsky (1866–1944), and August Macke (1887–1914), and celebrated the art of children and primitives, but had no

precise artistic program. The most active proponent of this essentially romantic and rather spiritual view of art (see column, right) was Franz Marc, a young artist who was killed in World War I. Marc saw animals as the betrayed but uncontaminated guardians of what was left of innocence and unspoiled nature.

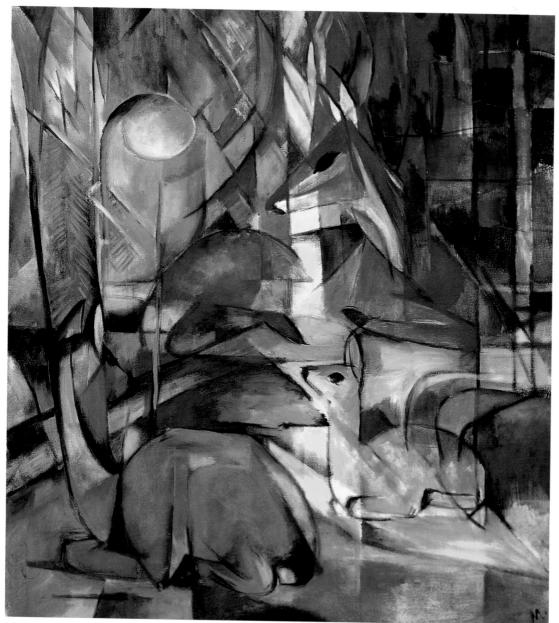

401 Franz Marc, Deer in the Forest II, 1913/14, 39% x 43½ in (100.5 x 110.5 cm)

THE BLUE RIDER

This was the name given, in 1911, to a group of Munich Expressionist artists by the two most important members, Franz Marc and Wassily Kandinsky. Two touring exhibitions of paintings were transported around Germany, with other artists, such as Macke, Klee, and Braque, also represented. This illustration shows the front cover of Der Blaue Reiter, published in 1912 by Marc and illustrated with a woodcut by Kandinsky.

Тнеоѕорніѕтѕ

The term "theosophy" is derived from the Greek words theos, "God" and sophia, "wisdom." As a religious philosophy, theosophy can be traced back to ancient roots, but it reemerged in the late 19th century and influenced artists such as Kandinsky and Mondrian. The classic formulation of theosophical teachings is The Secret Doctrine written by Madame Blavatsky, an American theosophist. She argues that the "essence" of an object is more important than the attributes of the object. The new artists, like Kandinsky, believed their abstract art would lead the people to spiritual enlightenment.

RUSSIAN REVOLUTION

The Russian Revolution of 1917 had its origins partly in the inability of the existing order to manage the Russian role in World War I. There were two main groups of revolutionaries: the liberals, who believed that Russia could still win the war and create a democracy; and the Bolsheviks, who thought the war was lost and wanted to transform the whole economy. The avant-garde movement was adopted by the state (though not for long) and became a major vehicle for "agitprop" (a mixture of agitation and propaganda). Artists were encouraged to design for posters and political rallies. Like August Macke, Marc chose to express these feelings with emphatic, symbolic colors. He painted animals with a profoundly moving love: a love for what they represented and could still experience, unlike humanity. Deer in the Forest II (401) is made up of a dense network of shapes and lines that border on the abstract. Together they create a forest of experience through which we can see, as if emerging from the undergrowth, the small forms of the deer. The animals are utterly at peace, at home in the forest of the world. It is a stylized and luminous vision of a species that can live without the angers of the ego.

August Macke, who was also to be killed in the coming war, was another artist with a gentle, poetic temperament. He took a simple delight in the joys common to us all, which makes his senseless destruction especially painful. Woman in a Green Jacket (402) floats onto the canvas, blissfully detached and pacific. Of the group, he was the most sensitive to form and color, and the hues in this picture glow gently within strong shapes to create sensuous areas of light.

403 Wassily Kandinsky, Improvisation 31 (Sea Battle), 1913, 47 x 55 in (120 x 140 cm)

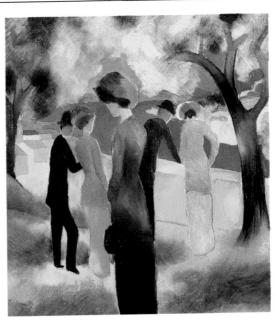

402 August Macke, Woman in a Green Jacket, 1913, 17 × 17¹/₃ in (43.5 × 44 cm)

KANDINSKY AND ABSTRACTION

However, neither Marc nor Macke were abstract painters. It was Kandinsky who found that "interior necessity," which alone could inspire true art, was forcing him to leave behind the representational image. He was a Russian who had first trained as a lawyer. He was a brilliant and persuasive man. Then, when already in his thirties, he decided to go to Munich in 1897 to study art. By the time Der Blaue Reiter was established, he was already "abstracting" from the image, using it as a creative springboard for his pioneering art. Seeing a painting of his own, lying on its side on the easel one evening, he was struck by its beauty – a beauty beyond what he saw when he set it upright. It was the liberated color, the formal independence, that so entranced him.

Kandinsky, a determined and sensitive man, was a good prophet to receive this vision. He preached it by word and by example, and even those who were suspicious of this new freedom were frequently convinced by his paintings. *Improvisation 31 (403)* has a less generalized title, *Sea Battle*, and by taking this hint we can indeed see how he has used the image of two tall ships shooting cannonballs at each other and abstracted these specifics down into the glorious commotion of the picture. Though it does not show a sea battle, it makes us experience one, with its confusion, courage, excitement, and furious motion.

Kandinsky says all this mainly with the color, which bounces and balloons over the center of the picture, roughly curtailed at the upper corners, and ominously smudged at the bottom

right. There are also smears, of paint or of blood. The action is held tightly within two strong ascending diagonals, creating a central triangle that rises ever higher. This rising accent gives a heroic feel to the violence.

These free, wild raptures are not the only form abstraction can take, and in his later, sadder years, Kandinsky became much more severely constrained, all trace of his original inspiration lost in magnificent patternings.

Accent in Pink (404) exists solely as an object in its own right: the "pink" and the "accent" are purely visual. The only meaning to be found lies in what the experience of the picture provides, and that demands prolonged contemplation. What some find hard about abstract art is the very demanding, time-consuming labor that is implicitly required. Yet if we do not look long and with an open heart, we shall see nothing but superior wallpaper.

404 Wassily Kandinsky, Accent in Pink, 1926, 31¾ x 39½ in (81 x 101 cm)

KANDINSKY AND MUSIC

Kandinsky, himself an accomplished musician, once said, "Color is the keyboard, the eyes are the harmonies, the soul is the piano with many strings. The artist is the hand that plays, touching one key or another, to cause vibrations in the soul." The concept that color and musical harmony are linked has a long history, intriguing scientists such as Sir Isaac Newton. Kandinsky used color in a highly theoretical way, associating tone with timbre (the sound's character), hue with pitch, and saturation with the volume of sound. He even claimed that when he saw color he heard music.

OTHER WORKS BY KANDINSKY

Improvisation Deluge (Lenbachaus, Munich)

In the Black Squeeze (Guggenheim Museum, New York)

Heavy Circles (Norton Simon Museum, Pasadena)

The Gray (Pompidou Center, Paris)

The Whole (National Museum of Modern Art, Tokyo)

Cossacks (Tate Gallery, London)

And Again (Kunstmuseum, Berne) Color
and I are
one. I am a
painter.
Paul Klee

Bauhaus architecture

The Bauhaus school of art and architecture was developed by Walter Gropius (1883–1969) around the old Weimar Academy in 1919. The early teachers at the school included artists such as Klee and Kandinsky, and a close relationship was established between the artists and local industry. Many products, including furniture and textiles, were chosen for large-scale production. In 1925 the Bauhaus moved to Dessau and established a group of large cooperative buildings (illustrated above). The Bauhaus style was impersonal, severe, and geometrical, using a strict economy of line and pure materials. Gropius left the Bauhaus group. After moving to Berlin in 1932, the Bauhaus was closed down by the Nazis. This dissolution of the group actually encouraged individuals to travel and helped disseminate Bauhaus ideas throughout the Western world.

PAUL KLEE

Paul Klee was an introverted Swiss painter who spent most of his adult life in Germany until he was expelled by the Nazis in 1933. His work is impossible to clarify, except to say that it is hardly ever entirely abstract – but equally, it is never truly realistic. He had a natural sensitivity to music, the least material of the arts, and it runs through all his work, clarifying his spellbinding color and dematerializing his images.

Paul Klee (1879–1940) was one of the greatest colorists in the story of painting, and a skilled deployer of line. His gravest pictures may have an undercurrent of humor, and his powers of formal invention seem infinite. After making

an early choice whether to pursue painting or music as a career, he became one of the most poetic and inventive of modern artists. He taught at the Bauhaus in Weimar and Dessau (see column, left) and then at the Düsseldorf

405 Paul Klee, The Golden Fish, 1925/26, 271/4 x 193/4 in (69 x 50 cm)

Academy. Until his explusion from Düsseldorf by the Nazis, Klee painted and drew on a very small scale, yet the small size of his pictures does not effect their internal greatness.

The Golden Fish (405) glides through the kingdom of its underwater freedom, all lesser fish leaving a clear space for its gleaming body. This is a magical fish with runic signs upon his body, scarlet fins, and a great pink flower of an eye. He hangs majestically in the deep, dark blue magic of the sea, which is luminous with secret images of fertility. The great fish draws the mysteriousness of his secret world into significance. We may not understand the significance, but it is there. The sea and its creatures are arranged in

406 Paul Klee, Diana in the Autumn Wind, 1934, 19 × 24¾ in (48 × 63 cm)

glorious homage, belittled but also magnified by this bright presence. This quiet nobility, the brightness, the solitude, the respect: all these qualities apply to Klee himself. Whether the art world knew it or not, he was their "golden fish."

IMAGES OF DEATH AND FEAR

Klee painted with intense rapidity and sureness, and it is impossible to indicate the full breadth of his range, his unfailing magic, and his poetry. *Diana in the Autumn Wind* (406) gives a hint of his sense of movement. Leaves flying in a moist breeze are, at the same time, the Virgin goddess on the hunt, and yet also a fashionably dressed woman from Klee's social circle. The eeriness of the dying year takes shape before our eyes. And beyond all this are lovely balancing forms that exist in their own right. This work is strangely pale for Klee, yet the gentle pallor is demanded by the theme: he hints that Diana is disintegrating under the force of autumnal fruitfulness.

BOOK BURNING

At the peak of Klee's career in the early 1930s, he came under surveillance from the chamber of culture. Joseph Goebbels, the Nazi minister of propaganda, organized hundreds of book burnings in German university towns. Thousands of books were destroyed for being "nonconformist to the spirit of a new Germany," including many by Marx and Freud. Hundreds of intellectuals and artists were forced to flee the country, including Kandinsky (who fled to France), and Klee (who went to Switzerland). Other left-wing intellectuals were not so fortunate and died in concentration camps.

DER STURM

Der Sturm ("the storm") magazine and art gallery was established by Hewarth Walden (1878-1941) in Berlin to promote the German avant-garde movement. The gallery ran from 1912 to 1924 and the magazine from 1910 to 1932. Der Sturm became the focus of modern art in Germany and promoted the work of the Futurists and the Blaue Reiter group (see p.353). Klee's first contribution to the magazine was a reinterpretation of a Robert Delaunay painting completed in January 1913. Klee also exhibited in the showrooms of Der Sturm between 1912 and 1921.

OTHER WORKS BY KLEE

Old Sound (Öffentliche Kunstsammlung, Basel)

Garden Gate (Kunstmuseum, Berne)

The Dancer (Art Institute of Chicago)

Flower Terrace (National Museum of Modern Art, Tokyo)

Fire at Evening (Museum of Modern Art, New York)

Watchtower of Night Plants (Staatsgalerie Moderner Kunst, Munich)

Land of Lemons (Phillips Collection, Washington, DC)

407 Paul Klee, Death and Fire, 1940, 171/3 x 18 in (44 x 46 cm)

Klee died relatively young of a slow and wasting disease, his death horribly mimicked by the death of peace that signified World War II. His last paintings are unlike any of his others. They are larger, with the forms often enclosed by a thick black line, as if Klee were protecting them against a violent outrage. The wit is gone and there is a huge sorrow, not personal, but for foolish and willful humanity.

Death and Fire (407) is one of Klee's last paintings. A white, gleaming skull occupies the center, with the German word for death, *Tod*, forming the features of its face. A minimal man walks toward death, his breast stripped of his heart, his face featureless, his body without substance. Death is his only reality, his facial features waiting there in the grave for him. But there is fire in this picture too: the sun, not yet set, rests on the earth's rim, which is also the

hand of death. The upper air is luminous with fire, presenting not an alternative to death, but a deeper understanding of it. The man walks forward bravely, into the radiance, into the light. The cool, gray-green domain of death accepts the fire and offers wry comfort.

Three mysterious black stakes jag down vertically from above, and the man strikes the skull with another. If fate forces him down into the earth, he does not go passively or reluctantly: he cooperates. Death's head is only a half-circle, but the sun that it balances in its hand is a perfect globe. The sun is what endures the longest, what rises highest, what matters most, even to death itself. Klee understood his death as a movement into the deepest reality, because, as he said, "the objective world surrounding us is not the only one possible; there are others, latent." He reveals a little of that latent otherness here.

PURE ABSTRACTION

Shapes and colors have always had their own emotional force: the designs on ancient bowls, textiles, and furnishings are abstract, as are whole pages of medieval manuscripts. But never before in Western painting had this delight in shape, in color made independent of nature, been taken seriously as a fit subject for the painter. Abstraction became the perfect vehicle for artists to explore and universalize ideas and sensations.

Several artists claimed to be the first to paint an abstract picture, rather as early photographers had wrangled over who had invented the camera. For abstract art, the distinction is most often given to Wassily Kandinsky (see p.354), but certainly another Russian artist, Kasimir Malevich, was also among the first.

Russian suprematism

Although Chagall and Soutine (see p.344) both left Russia to seek inspiration in France, the early 20th century saw an amazing renewal in Russian art. Since the far-off days of the icon painters (see pp.27–28), there had been nothing in this great country but the monotony of academic art. Now, as if unconsciously anticipating the coming revolution of 1917, one great painter after another appeared. They were not universally welcomed in their homeland, and more than one artist sought a response elsewhere, but some of the most significant painters dedicated their lives and their art to their country.

They are difficult artists. Kasimir Malevich (1878–1935), who founded what he called Suprematism (see column, right), believed in an extreme of reduction: "The object in itself is meaningless... the ideas of the conscious mind are worthless." What he wanted was a non-objective representation, "the supremacy of pure feeling." This can sound convincing until one asks what it actually means. Malevich, however, had no doubts as to what he meant, producing objects of iconic power such as his series of *White on White* paintings or *Dynamic Suprematism* (408), in which the geometric patterns are totally abstract.

Malevich had initially been influenced by Cubism (see p.347) and primitive art (p.334), which were both based on nature, but his own movement of Suprematism enabled him to construct images that had no reference at all to reality. Great solid diagonals of color in *Dynamic Suprematism* are floating free, their severe sides denying them any connection with the real world, where there are no straight lines. This is a pure abstract painting, the artist's main theme being the internal movements of the personality. The theme has no precise form,

and Malevich had to search it out from within the visible expression of what he felt. They are wonderful works, and in their wake came other powerful Suprematist painters such as Natalia Goncharova and Liubov Popova.

SUPREMATISM

Kasimir Malevich's art and his Suprematist manifesto are among the most vital artistic developments of this century. Most of his paintings are limited to geometric shapes and a narrow range of colors, but the pinnacle of his Suprematism was his White on White series. He claimed to have reached the summit of abstract art by denying objective representation.

408 Kasimir Malevich, Dynamic Suprematism, 1916, 261/2 x 40 in (67 x 102 cm)

The Gray Tree (409) foreshadows the abstractions that were a halfway house to his geometrical work, yet it also has a foothold in the real world of life and death. The Gray Tree is realist art on the point of taking off into abstraction: take away the title and we have an abstraction; add the title and we have a gray tree. He claimed to have painted these pictures from the need to make a living, yet they have a fragile delicacy that is precious and rare. Mondrian sought an art of the utmost probity: his greatest desire was to attain personal purity, to disregard all that pleases the narrow self and enter into divine simplicities. That may sound dull, but he

66 The important task of all art is to destroy the static equilibrium by establishing a dynamic one ?? Piet Mondrian in Circle,

NEO-PLASTICISM

Although a founding member of De Stijl ("the style") group of artists, Piet Mondrian preferred his art to be viewed as Neo-Plasticism. The first De Stijl journal, published in 1917, emphasized the importance of austere abstract clarity, and Mondrian's work certainly followed this agenda. In 1920 he published a Neo-Plasticism, pamphlet, asking artists to denaturalize art and to express the ideal of universal harmony. Mondrian restricted his paintings to primary colors, black, white, and gray, using lines to divide his canvases.

409 Piet Mondrian, The Gray Tree,

composed with a lyrical sureness of balance that makes his art as pure and purifying as he hoped. Mondrian imposed rigorous constraints on himself, using only primary colors, black and white, and straight-sided forms. His theories and his art are a triumphant vindication of austerity. Diamond Painting in Red, Yellow, 1912, 42½ x 31 in (108 x 79 cm) and Blue (410) appears to be devoid of threedimensional space, but it is in fact an immensely Mondrian's abstract purity dynamic picture. The great shapes are dense Kandinsky's late style had a geometrical with their chromatic tension. The varying tendency and Suprematist abstraction thicknesses of the black borders revolved largely around the square, contain them in perfect balance. but the real artist of geometry was They integrate themselves the Dutchman Piet Mondrian continually as we watch, (1872-1944). He seems to be keeping us constantly the absolute abstract interested. We sense artist, yet his early that this is a vision landscapes and of the way things still lifes were are intended relatively to be, but realist. never are. 410 Piet Mondrian, Diamond Painting in Red, Yellow, and Blue, c. 1921/25, 56 x 561/4 in (142 x 143 cm)

ART OF THE FANTASTIC

Between the two World Wars, painting lost some of the raw, modern energy it began the century with and became dominated by two philosophical movements, Dada and Surrealism, which arose partly as a reaction to the senseless atrocities of World War I. But artists were also becoming introspective, concerned with their own subconscious dreams: Sigmund Freud's psychoanalytical theories were well known by this time, and painters explored their own irrationalities and fantasies in search of a new artistic freedom.

One artist who prefigured the Surrealists' idea of fantasy with his fresh, naive outlook on the world was the Frenchman Henri Rousseau (1844–1910). Like Paul Klee (see p.356), he defies all labels, and although he has been numbered among the Naïves or Primitives (two terms for untrained artists), he transcends this grouping. Known as *Le Douanier*, (customs officer) because of his lifelong job in the Parisian customs office, Rousseau is a perfect example of the kind of artist in whom the Surrealists believed: the untaught genius whose eye could see much farther than that of the trained artist.

Rousseau was an artist from an earlier era. He died in 1910, long before the Surrealist painters championed his art. Pablo Picasso (p.346), half-ironically, brought Rousseau to the attention of the art world with a dinner in his honor in 1908 – an attention to which Rousseau thought himself fully entitled. Although Rousseau's greatest wish was to paint in an academic style, and he believed that the pictures he painted were absolutely real and convincing, the art world loved his intense stylization, direct vision, and fantastical images.

Such total confidence in himself as an artist enabled Rousseau to take ordinary book and catalog illustrations and turn each one into a piece of genuine art: his jungle paintings, for instance, were not the product of any firsthand experience, and his major source for the exotic plant life that filled these strange canvases was actually the tropical plant house in Paris.

Despite some glaring disproportions, exaggerations, and banalities, Rousseau's paintings have a mysterious poetry. Boy on the Rocks (411) is both funny and alarming. The rocks seem to be like a series of mountain peaks, and the child effortlessly dwarves them. His wonderful stripey garments, his peculiar mask of a face, the uncertainty as to whether he is seated on the peaks or standing above them – all come across with a sort of dreamlike force. Only a child can so bestride the world with such ease, and only a childlike artist with a simple, naive vision can understand this elevation and make us see it as dauntingly true.

METAPHYSICAL PAINTING

Giorgio de Chirico (1888–1974) was an Italian artist who originated what we now call Metaphysical painting (known as *Pittura Metafisica*), which also influenced the Surrealists' art. It was World War I and its brutalities that shocked de Chirico and his fellow Italian, Carlo Carrà (see column, p.362), into a new way of looking at reality in 1917. De Chirico painted real locations and objects within strange contexts and from unusual perspectives. The result is an uneasy assemblage of images in a peculiarly silent world.

is destructive, but it destroys only what it considers to be shackles limiting our vision.

Salvador Dali in Declaration, 1929

411 Henri Rousseau, Boy on the Rocks, 1895/97, 18 x 21¾ in (46 x 55 cm)

METAPHYSICAL ART

Giorgio de Chirico believed he had achieved a unique interpretation of the world by "combining in a single composition scenes of contemporary life and visions of antiquity, producing a highly troubling dream reality." He called this new art "Metaphysical," and the paintings he created between 1912 and 1915 were to have a profound influence on Surrealism. The Italian artist Carlo Carrà (1881-1966) had a fundamental effect on the art of the interwar period with his Futurist, and, later, Metaphysical paintings. Carrà first met de Chirico in a military hospital in Ferrara, Italy, in 1915. He created about 20 Metaphysical works in his lifetime.

412 Giorgio de Chirico, The Uncertainty of the Poet, 1913, 37 × 41¾ in (94 × 106 cm)

The Surrealists saw in de Chirico's paintings the importance of the mysterious world of dreams and the unconscious. They were influenced by the quality of enigma in his work, and especially by the unexpected juxtapositioning of objects, which became a distinguishing factor of much

Surrealist art. De Chirico hoped to rise above the bare facts in his art, transmitting the magical experience beyond reality: he wanted his vision to be shown through reality, but not limited by it in any way.

De Chirico's theories do not really explain the power of his work, and in fact he found this art hard to sustain, so that it dwindled surprisingly soon into a brilliant but imitative classicism of a kind. While at his brief best, however, de Chirico is as magical as he hopes, and *The Uncertainty of the Poet (412)*, with its melancholy, deserted piazza, the suggestively scattered bananas, and the great bulk of the twisted, headless female bust is a genuinely unsettling picture.

FROM DADA TO SURREALISM

Max Ernst (1891–1976) is hard to categorize: he invented one new method after another during his career, including frottage (laying paper over textured surfaces, making a rubbing with graphite, and using the marks as chance starting points for an image). Untrained as an artist, Ernst originally studied philosophy. In 1919 he founded the Cologne branch of the Dada group (see column, left). Dada appeared in Paris the same year and though it lasted only until 1922, it became a precursor of Surrealism.

Dada art

This European movement was established as a reaction against the futility of World War I and was labeled "anti-art." The movement. established by Hugo Ball, Emmy Hennings, and Tristan Tzara (shown above) at the Cabaret Voltaire in Zurich in 1916. concentrated on the absurd and exaggerated in art and performance. The members of the group carried their absurdist principles as far as the collective name for the group, "Dada" chosen randomly from a German dictionary and meaning nothing more than "hobbyhorse."

413 Max Ernst, The Entire City, 1934, 24 x 19¾ in (61 x 50 cm)

414 Joan Miró, Woman and Bird in the Moonlight, 1949, 26 × 32 in (66 × 81 cm)

Dada reflected the mood of the time. It was a literary and artistic movement of young artists who, like de Chirico, were appalled and disillusioned by the atrocities of World War I. They expressed their sense of outrage by challenging established art forms with irrational and imaginative concepts in their work so that it frequently appeared nonsensical.

In 1922, Ernst settled in Paris, and he became instrumental in the evolution of Surrealism from Dada by using childhood memories to influence his subject matter. His mind was extraordinarily fertile, which attracted a group of Surrealist writers, and after Dada ended, he became an intimate with this group.

Ernst took from de Chirico the idea of unconnected objects in strange, atmospheric settings, and turned them into pictures in a more modern context, full of fear and apprehension. He is an uneven artist, but his best works have a personal sense of mythology to them. *The Entire City (413)*, with its uncanny streaks of frottage and the great clear moon above with its vacant center, strikes an unhappy chord of recognition. Although we recognize the familiar floorboard pattern, Ernst makes us feel the sad likelihood that we are also receiving a preview of our future.

Surrealism began officially in 1924 with a manifesto drawn up by the Surrealist writer André Breton (1896–1966). Called "Surrealists" to stress the idea of being above or beyond reality, the group combined the irrationality of

Dada with the idea of pure, unreasoned thought through subconscious dreams and free association – a concept heavily inspired by Sigmund Freud's theories on dreams. The group took a sentence from the poet Lautréamont to explain their search for the fantastical: "Beautiful as the chance encounter of a sewing machine and an umbrella on an operating table."

MIRO AND MAGRITTE

Surrealist artists placed great value on children's drawings, the art of the insane, and untrained amateur painters whose art sprang from pure creative impulses, unrestrained by convention or aesthetic laws. Surrealism generally took the form of fantastic, absurd, or poetically loaded images. It was a potent, if inexplicable, force in the work of many artists, of whom Joan Miró (1893-1983), is perhaps the most uncanny. An introspective Spanish artist, he was one of the truly major Surrealists. His art appears far more spontaneous than that of Ernst or Dali (see p.364) in rejecting traditional images and devices in painting. Woman and Bird in the Moonlight (414) is a personal celebration of some deep joy. The figures tumble together with instinctive sureness, magical shapes that move in and out of recognition as if the woman and the bird could at any time exchange identities.

The Belgian René Magritte (1898–1967) was a practitioner of realist Surrealism, pressed into imaginative servitude. He began by imitating the avant-garde, but he genuinely needed a more poetic language, which was influenced

ANTONI GAUDÍ

Before Surrealism had been created at the beginning of the 20th century, the Spanish architect Antoni Gaudí (1852-1926) had already demonstrated the power of abstract forms and Surrealist fantasy in architecture. His most famous creations all encompass fluidity of form, with organic and abstract shapes, often using mosaic tiling to create arabesque decoration. The detail illustrated above is taken from the Parque Güell in Barcelona, designed by Gaudí in 1900-14 for his patron Don Basilio Güell. Several of the Surrealist artists, including Joan Miró, acknowledged drawing inspiration from Gaudí and other Catalan art.

415 René Magritte, The Fall, 1953, 391/3 x 311/2 in (100 x 80 cm)

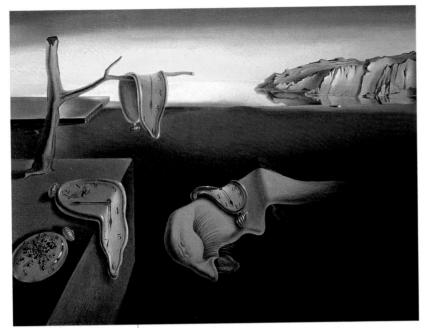

416 Salvador Dali, The Persistence of Memory, 1931, 13 x 9½ in (33 x 24 cm)

SURREALIST FILMS

In collaboration with Luis Buñuel, Salvador Dali produced the first Surrealist film, Un Chien Andalou, in 1929. The film has no real plot (Buñuel commented, We relentlessly threw out everything that might have meaning"), but the interaction between image, sound, and motion is designed to show the result of conscious psychic automation. The main psychological device used by the film director is "shock montage," and many of the scenes in the movie show bizarre and shocking images. The scene illustrated above is one showing a hand covered in ants forcing its way through a woman's door. This film was followed in 1930 by L'Age d'Or, which attacked all that was sacred to the bourgeoisie. In response, an exhibition of paintings connected with the film, including work by Ernst and Miró, was destroyed by right-wing radicals. The film was withdrawn.

by de Chirico's Metaphysical paintings. He had a mischievous mind, and his weirdly bowler-hatted men in The Fall (415) drop through the sky with complete composure, expressing something of the oddity of life as we know it. His art, painted with such clarity that it appears highly realistic, typifies the Surrealist love of paradoxical visual statements, and though things may seem normal, there are anomalies everywhere. The Fall has a weird rightness about it, and it is in tapping our own secret understanding of sublunar peculiarity that Surrealism appeals.

Dali's dream photographs

Salvador Dali (1904-89), whose graphic gifts were never affected by his mental imbalance, painted profoundly unpleasant and yet striking images of the unreality in which he felt at home. But he painted the unreality with meticulous realism, which is why they are so disturbing. He described these works as "hand-painted dream photographs," and their power lies precisely in their paradoxical condition as snapshots of things that, materially, do not exist.

It is easy, in theory, to disregard Dali, but difficult in practice. The Persistence of Memory (416), with its melting watches and the distorted face (like a self-portrait) in the center, has an intensity and an applicability that we cannot shrug off. Dislike it though we may, this sense of time gone berserk, of a personal world deflated under the pressure of the contemporary, has an inescapable power. And distasteful though it is, The Persistence of Memory is one of the great archetypal images of our century.

DUBUFFET AND ART BRUT

Though not a Surrealist as such, Jean Dubuffet (1901-85) shared some of the Surrealists' influences, in particular children's drawings, art of the insane, and the absurd and irrational. He had a large collection of work by psychotics, which he called Art Brut - Raw Art.

Although he was still a young man when he trained as an artist in Paris, Dubuffet was in his forties before he began painting in earnest. On the surface, his art bears very little obvious relation to that of the Surrealists, though he painted with a Surrealist philosophy. His pictures are crude and rough, totally devoid of the illusionist trickery or persuasiveness employed by Dali and Magritte. Nor do they possess the Surrealist tendency toward enigma and mystery. Instead, his art was, as he would say, Art Brut aggressively unsophisticated "outsider art."

We can be taken aback by a work such as Nude with a Hat (417). It seems to have been gouged out of a primitive material context. The nude glares out at us, her big eyes, confrontational mouth, and huge, flat, egotistical hat making her a powerful and dynamic icon. Only the two small circles in the center remind us that this is a nude and these are her breasts. Dubuffet is concerned with a whole different scenario: woman as demon, as a psychic force. It is the great flat hat that matters, not her nakedness. It is this reversal of the accepted and the conventional on which Dubuffet builds his art. It is wonderful stuff, but deeply challenging.

417 Jean Dubuffet, Nude with a Hat, 1946, 25 x 31½ in (64 x 80 cm)

418 Giorgio Morandi, Still Life, 1946, 18 × 14¾ in (46 × 37.5 cm)

ISOLATION AND OBSESSION

In this period between the two world wars, Giorgio Morandi and Alberto Giacometti stood apart from their artistic contemporaries. Both painters absorbed the broad influence of Surrealism early in their careers, but soon abandoned these affiliations to pursue their own singular and intensely individual languages. Morandi was Italian, Giacometti Swiss, and like their cultural disparities, their art has little common ground. However, they share the trait of being obsessive artists, returning to the same subject again and again.

Giorgio Morandi (1890–1964) was one of the real geniuses of Italian 20th-century painting. He was an unusual man who lived a very quiet life in Bologna, and his own quiet personality is the predominant trait in his art. His early paintings are influenced by de Chirico's Metaphysical paintings, but he soon evolved his own unique vision – one that he did not deviate from for the rest of his life. He painted still lifes – often the same group of bottles, jugs, and other humble domestic ware – and they quiver on the canvas with an almost breathless reverence. Still Life (418) has the inner peace of visual prayer. For him, these are objects of the deepest mystery, and he has that rare artistic power of making us understand just what he experiences as he contemplates them.

THE HUMAN FORM IN SPACE

Alberto Giacometti (1901–66) spent a large proportion of his career as a sculptor and returned to painting at a relatively late stage. Like Morandi, his early paintings – especially those made in Paris, where he settled in 1922 – were essentially Surrealist, with their disturbing, aggressively ambiguous vein. He later abandoned this form of expression to work directly from

life, thus severing all points of contact with the Surrealists. Giacometti spent the rest of his life engaged in one long, ongoing struggle to convey the solid presence of the human form in space. He tended to work obsessively on a series of paintings, working continuously on one particular image at a time. His tendency to wipe out every night what he had created during the day gives a poignancy to what has survived. *Jean Genet* (419), for example, the Parisian thief-turned-writer, intrigued Giacometti in both aspects of his unique personality.

Giacometti was fascinated both by the creative Genet, the writer, and by the obsessive Genet, the thief. Something of Giacometti's double fascination is apparent in this portrait. Genet looks up almost blindly into the world of mysterious materiality. This is the world from which he was excluded, and which he yet longs to possess. All of these subtleties are present in Genet's portrait of a small, tense figure, blindly intent upon a world that eludes him. There is mastery here and menace, as well as a sense of the magical.

OTHER WORKS BY DALI

Christ of St. John of the Cross (Glasgow Art Gallery)

Disappearing Bust of Voltaire (Dali Museum, St. Petersburg, Florida)

Illumined Pleasures (Museum of Modern Art, New York)

Metamorphosis of Narcissus (Tate Gallery, London)

The Colossus of Rhodes (Kunstmuseum, Berne)

The Spectral Cow (Pompidou Center, Paris)

The Temptation of St. Anthony (Museés Royaux des Beaux Arts, Brussels)

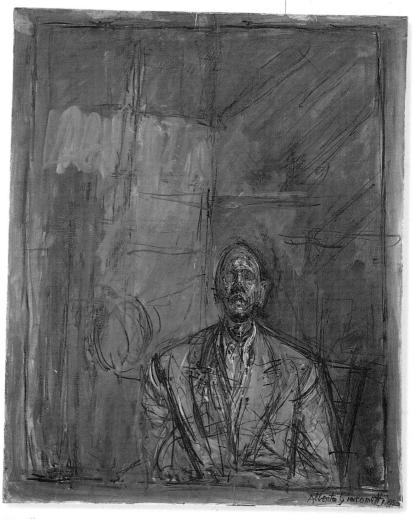

419 Alberto Giacometti, Jean Genet, 1955, 211/4 x 251/2 in (54 x 65 cm)

AMERICAN SCENE PAINTING

Edward Hopper (1882-1967) painted American landscapes and cityscapes with a disturbing truth, expressing the world around him as a chilling, alienating, and often vacuous place. Everybody in a Hopper picture appears terribly alone. Hopper soon gained a widespread reputation as the artist who gave visual form to the loneliness and boredom of life in the big city. This was something new in art, perhaps an expression of the sense of human hopelessness that characterized the Great Depression of the 1930s.

THE FEDERAL ART PROJECT

Introduced by President Franklin D. Roosevelt as part of his New Deal in 1935, the Federal Art Project aimed to alleviate the worst effects of the American Depression. At its peak, the Federal Art Project employed 5,000 people across the country to decorate public buildings and to create new art centers and galleries. Lasting until 1943, the project employed virtually all the major American artists of the period, either as teachers or practitioners.

PRE-WAR AMERICAN PAINTING

There have always been interesting American artists, and at least two 19th-century painters, Thomas Eakins and Winslow Homer, influenced the course of future art in the United States. During the 1920s and 1930s, Edward Hopper and Georgia O'Keeffe emerged as inspirational new painters of distinctive American traditions. Hopper's work was strongly realist, his still, precise images of desolation and isolated individuals reflecting the social mood of the times. O'Keeffe's art was more abstract, often based on enlarged plants and flowers, and infused with a kind of Surrealism she referred to as "magical realism." She may not have been a great painter, but her art was highly influential.

420 Edward Hopper, Cape Cod Evening, 1939, 40 x 301/4 in (102 x 77 cm)

Edward Hopper (1882–1967) has something of the lonely gravity peculiar to Thomas Eakins (see p.305), a courageous fidelity to life as he feels it to be. He also shares Winslow Homer's (p.304) power to recall the feel of things. For Hopper, this feel is insistently low-key and ruminative. He shows the modern world unflinchingly; even its gaieties are gently mournful, echoing the disillusionment that swept across the country after the start of the Great Depression in 1929 (see column, right). Cape Cod Evening (420) should be idyllic, and in a way it is. The couple enjoy the evening sunshine

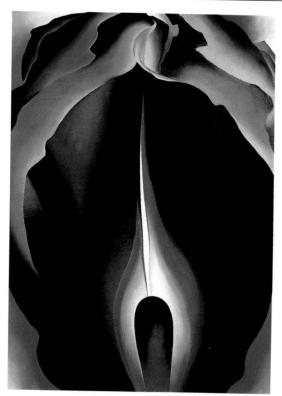

421 Georgia O'Keeffe, Jack-in-the-Pulpit No. IV, 1930, 30 x 40 in (76 x 102 cm)

outside their home, yet they are a couple only technically, and the enjoyment is entirely passive as both are isolated and introspective in their reveries. Their house is closed to intimacy, the door firmly shut and the windows covered. The dog is the only alert creature, but even it turns away from the house. The thick, sinister trees tap on the windowpanes, but there will be no answer.

Georgia O'Keeffe (1887–1986), like Mary Cassatt (see p.291) and Berthe Morisot (p.290), is a female artist who no story of painting can neglect: like them, she added something. She married the photographer Alfred Stieglitz in 1924, and his close-ups of vegetation and New York skyscrapers inspired her own art.

Her Jack-in-the-Pulpit series starts with a highly realistic image, which is abstracted and magnified until the last work shows just the "jack," the stamen. Perhaps the fourth in the Jack-in-the-Pulpit (421) series has the greatest impact. We are confronted by a great blaze of intense blue, haloed by a jagged outline of luminous green and centered by a radiant candle. An ardor of white flame soars upward. seemingly imprisoned and yet intimately connected with the light at the leaf's edges. The inner flame burns somehow out of sight, triumphing. Her ability to make the real become mystically unreal had few immediate imitators, but O'Keeffe has steadily influenced art for much of this century.

GEORGIA O'KEEFFE

The artist Georgia O'Keeffe (1887-1986) was one of the pioneers of Modernism in the United States. She was a member of the circle surrounding the photographer and art dealer Alfred Stieglitz (1864-1946), whom she married in 1924. O'Keeffe is best known for her close-up, quasiphotographic images of flowers, which have generally been judged to be sensuous and sexually suggestive. From the 1930s she spent every winter in New Mexico, where she was inspired by the desolate beauty of the desert landscape. After her husband's death in 1946, she moved to New Mexico permanently.

THE GREAT

This term describes the economic slump which affected the United States and Europe between 1929 and 1939. In the US, the economic boom of the 1920s ended with the Wall Street crash of October 1929. By 1932 one out of every four American workers was unemployed. By 1933 the total value of world trade had fallen by more than half as countries abandoned the gold standard and stopped importing foreign goods. President Roosevelt developed the New Deal, which included many social and economic reforms. However, it was not until World War II and the ensuing growth of the arms industry that any true recovery was established.

ABSTRACT EXPRESSIONISM

The painters who came to be called Abstract Expressionists shared a similarity of outlook rather than of style - an outlook characterized by a spirit of revolt and a belief in freedom of expression. The main exponents of the genre were Pollock, de Kooning, and Rothko, but other artists included Guston, Kline, Newman, and Still. The term Abstract Expressionism was first used by Robert Coates in the March issue of the New Yorker in 1936. The movement was hugely successful, partly due to the efforts of the critics Harold Rosenberg and Clement Greenberg, who also originated the terms Action painting and American Style.

JACKSON POLLOCK

It has been suggested that Pollock was influenced by Native American sand paintings, made by trickling thin lines of colored sand onto a horizontal surface. This illustration shows a Navajo sand painting called The Whirling Log. It was not until 1947 that Pollock began his Action paintings, influenced by Surrealist theories of "psychic automatism" (expression of the unconscious). Pollock would stick his canvas to the floor and drip paint from a can using different objects to manipulate the paint.

Abstract Expressionism

However great a disaster World War II was, it did at least mean that artists such as Piet Mondrian and Max Ernst, in leaving Europe for the safety of the United States, greatly extended their artistic influence. It is impossible to estimate how much they affected American art, but the fact remains that in the 1940s and 1950s, for the first time, American artists became internationally important with their new vision and their new artistic vocabulary, known as Abstract Expressionism.

The first public exhibitions of work by the New York School of artists – who were to become known as Abstract Expressionists – were held in the mid '40s. Like many other modern movements, Abstract Expressionism does not describe any one particular style, but rather a

general attitude; not all the work was abstract, nor was it all expressive. What these artists did have in common were morally loaded themes, often heavyweight and tragic, on a grand scale. In contrast to the themes of social realism and regional life that characterized American art of

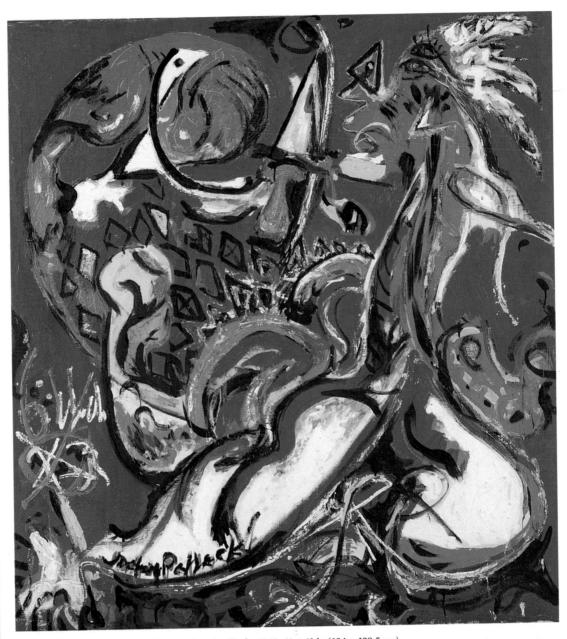

422 Jackson Pollock, The Moon-Woman Cuts the Circle, 1943, 41 x 43 in (104 x 109.5 cm)

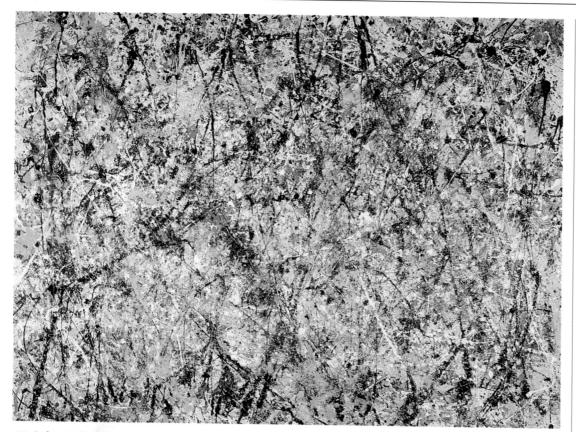

423 Jackson Pollock, Number 1, 1950 (Lavender Mist), 1950, 9ft 10 in × 7ft 3 in (300 × 221 cm)

previous decades, these artists valued, above all, individuality and spontaneous improvisation. They felt ill at ease with conventional subjects and styles, which could not convey adequately their new vision. In fact, style as such almost ceased to exist with the Abstract Expressionists, and they drew their inspiration from all directions.

Breaking the ice

It was Jackson Pollock (1912–56) who blazed an astonishing trail for other Abstract Expressionist painters to follow. De Kooning (see p.371) said, "He broke the ice," an enigmatic phrase suggesting that Pollock showed what art could become with his 1947 drip paintings (see column, p.368).

The Moon-Woman Cuts the Circle (422) is an early Pollock, but it shows the passionate intensity with which he pursued his personal vision. This painting is based on an American Indian myth. It connects the moon with the feminine and shows the creative, slashing power of the female psyche. It is not easy to say what we are actually looking at: a face rises before us, vibrant with power, though perhaps the image does not benefit from labored explanations. If we can respond to this art at a fairly primitive level, then we can also respond to a great abstract work such as Lavender Mist (423). If we cannot, at least we can appreciate the fusion of colors and

the Expressionist feeling of urgency that is communicated. *Moon-Woman* may be a feathered harridan or a great abstract pattern; the point is that it works on both levels.

ACTION PAINTING

Pollock was the first "all-over" painter, pouring paint rather than using brushes and a palette, and abandoning all conventions of a central motif. He danced in ecstasy over canvases spread across the floor, lost in his patternings, dripping and dribbling with total control. He said, "The painting has a life of its own. I try to let it come through." He painted no image, just action, though "Action painting" seems an inadequate term for the finished result of this creative process. Lavender Mist is 10 ft long (nearly 3 m), a vast expanse on a heroic scale. It is alive with colored scribbles, spattered lines moving this way and that, now thickening, now trailing off to a slender skein. The eye is kept continually eager, not allowed to rest on any particular area. Pollock has put his hands into paint and placed them at the top right – an instinctive gesture reminiscent of cave painters (see p.11) who did the same. The overall tone is a pale lavender, made airy and active. In his own time Pollock was hailed as the greatest American painter, but there are already those who feel his work is not holding up in every respect.

the floor I am more at ease, I feel nearer, more a part of the painting, since this way I can walk around in it, work from the four sides and be literally 'in' the painting.

OTHER WORKS BY POLLOCK

White Light (Museum of Modern Art, New York)

The Deep (Pompidou Center, Paris)

Blue Poles (Australian National Gallery, Canberra)

No. 23 (Tate Gallery, London)

> Watery Paths (Galleria d'Arte Moderne, Rome)

Eyes In the Heat (Guggenheim Foundation, Venice)

Untitled Composition (Scottish National Gallery of Art, Edinburgh)

MEXICAN MURALISTS

Following the 1910 revolution in Mexico, art became the main cultural manifestation of the political ideologies of the nation. Many Mexican artists chose to show their support by creating powerful murals for public buildings. One established artist was David Siqueiros (1896-1974), who created a new Muralist Manifesto. Between 1935 and 1936 he ran a workshop in New York (attended by Pollock) to demonstrate his new materials and "drip" technique. Even better known, and a great influence on contemporary Americans, was José Clemente Orozco. The third Muralist was the formidable Diego Rivera, the most powerful influence of the three, revered, imitated, or reacted against by all his contemporaries.

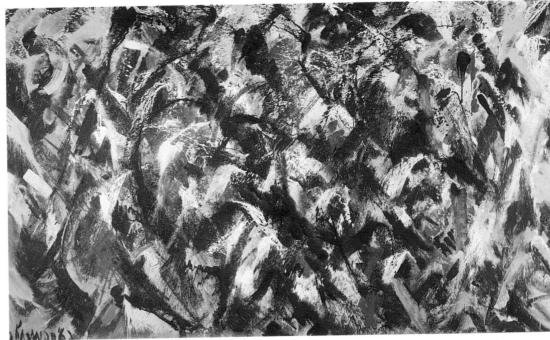

424 Lee Krasner, Cobalt Night, 1962, 13 ft 2 in × 7 ft 91/3 in (401 × 237 cm)

Lee Krasner (1908–84), married Pollock in 1944, but was not celebrated at all during Pollock's lifetime (cut short in 1956 by a fatal car crash), but it was actually she who first started covering the

canvas with a passionate flurry of marks. The originality of her vision, its stiff integrity and great sense of internal cohesion, is now beginning to be recognized. *Cobalt Night* (424) at 13 ft (4 m) is even larger than *Lavender Mist* and has the same kind of heroic ambition.

Mark rothko

The other giant of Abstract Expressionism is the Russian-born Mark Rothko (1903-70). Just as there are some who feel a little uneasy about the status of Pollock, and others who would fiercely defend it, so too with Rothko. Like Pollock, he was initially influenced by Surrealism and its capacity for freedom of expression, but his greatest works are his mature abstracts. These paintings are often not hung as he originally intended. He wanted dim lighting and an atmosphere of contemplation; he rarely gets it. He rejected the extreme religious connotations given to his great walls of color, saying that his work had an essentially emotional rather than mystical meaning. He insisted that the theme, the subject, was different and could only be communicated by personal involvement in an atmosphere of solitude. Yet to many it appears that all Rothkos have identical formats: oblongs of delicate color held floating in a colored setting, the edges raveled like heavenly clouds. Those who love Rothko consider him one of the most important painters of the 20th century.

Rothko's art represented an alternative Abstract Expressionism to Pollock's: he placed greater emphasis on color and gravity than on the excitement of gesture and action. Such

425 Mark Rothko, Untitled (Black and Gray), 1969, 6 ft 4 in \times 6 ft 9½ in (194 \times 207 cm)

demarcations, however, can be dangerous, since the Abstract Expressionists rarely aligned themselves into such rigid camps. *Untitled (Black and Gray) (425)* was painted the year before Rothko killed himself. The chromatic luminosities of the earlier years had long been quenched by a deepening sadness, the emotion conveyed here is of deep sorrow. We must take what comfort we can in recognizing that the gray area is greater than the black and that though the black has a heavy, deadening solidity, the gray is still shot through with undershades, with potential.

ARSHILE GORKY

It may have been his soul-shattering early experiences as an Armenian refugee, and the resulting insecurities, that made Arshile Gorky (1905-48) begin his artistic career so heavily under the influence of Picasso (see p.346) that it seemed an individual style would never emerge. Born Vosdanig Manoog Adoian, Gorky emigrated to the US in 1920, moving to New York in 1925 to study and then teach art. Before he too killed himself (see column, right), Gorky did indeed find his own voice, released partly through his contact with Surrealism in America. Waterfall (426) shows a lovely tumble of free images, the sweetly floating flat patches of color and shapes of his maturity. Strangely, the images do truly resemble a waterfall: something in the

426 Arshile Gorky, Waterfall, 1943, 44½ x 60½ in (113 x 154 cm)

427 Willem de Kooning, Woman and Bicycle, 1952–53, 49 x 76 in (124 x 194 cm)

surge down the canvas suggests a great sweep of water, the sunlight dazzling on hidden rocks behind. There is a springtime freshness about Gorky's work that gives his suicide an added poignancy. It is as if only in his art did he find happiness, freedom, and acceptance.

DE KOONING

Gorky was an important influence on the development of Abstract Expressionism and also on one of its most vital figures, his friend Willem de Kooning (1904–). De Kooning was born in Holland, but has lived mainly in the US.

TRAGIC LIFE

Arshile Gorky was a potent force in American art, forging a link between Surrealism and Abstraction. At the peak of his powers, he suffered from a series of tragedies. In 1946 a fire destroyed many of his paintings and he was diagnosed as having cancer. In 1948 he broke his neck in a car accident and his wife left him. Soon afterward he hanged himself.

the laws of fear, became as one with vision.

And the Act, intrinsic and absolute, was its meaning, and the bearer of its passion.

''Clyfford Still

Though there were many Abstract Expressionists, the most vital seems to be de Kooning: even in Pollock's lifetime, de Kooning was hailed as his major rival. His ability to take a theme, whether landscape or portrait, and treat it with wild and wonderful freedom still impresses. His northern European background and the impulsive passion of his style, however, still bear some resemblance to Chaim Soutine (see p.344).

We are shaken with a visceral shock when we encounter de Kooning's women. Woman and Bicycle (427) is all teeth, eyes, and enormous bosom. She sits like a mantis, with a gleeful expectancy lighting her wedge of a face. This is a woman totally devoid of glamour, let alone charm, yet the poor giantess is dolled up in her tasteless finery, waiting for her prey. We shrink, we smile (such hideousness), we feel a little afraid. She is, above all, impressive and wickedly so. It is as much a tribute as a taunt.

At his lyrical best, de Kooning can overwhelm us with his beauty. *Door to the River* (428) balances most delicately on the cusp of abstraction. Great thick bars of color that slash and sprawl across the canvas create an unmistakable door; through

429 Clyfford Still, 1953, 5 ft 8½ in x 7 ft 9 in (174 x 236 cm)

the vertical bars gleams the intense blue of the distant river. This is not de Kooning delighting us with his wit, but rather drawing us right into the heart of great art. A work of art is great to the extent that to encounter it is to be changed. *Door to the River* passes this test triumphantly.

CLYFFORD STILL

With Clyfford Still (1904–80), landscape moved majestically over the cusp and into pure abstraction. Still is set apart from other artists of the New York School by the fact that for most of his career he lived and worked at a distance from the art world of New York – although he lived and taught in the great city during the height of Abstract Expressionism in the mid-1950s.

Still rejected references to the real world in his art and attempted to sever color from any links and associations. Most of his paintings are variations on a theme. He made grandiose claims for his work as being transcendent and numinous, and a painting such as 1953 (429) does suggest why he felt able to make such claims. An objective viewer might feel he overstates his case, and yet this is a wonderful painting. The expanse of blue is dotted with black, two passionate streaks of red at the base, and great jagged slashes of color at the top. It is as if the mountains have opened to show us both the brightness and the darkness within, and it is this power to suggest a psychic significance that distinguishes Still's art.

428 Willem de Kooning, Door to the River, 1960, 5ft 10 in x 6ft 8 in (178 x 205 cm)

430 Franz Kline, Ballantine, 1948–60, 6 ft x 6 ft (183 x 183 cm)

FRANZ KLINE

If Franz Kline (1910–62) suggests urban landscapes in his art, it is only in the sense of girders set against the sky. It is as if the struts of a bridge or some unsupported scaffolding had inspired him to see the sheer majesty of pure, isolated shape. His work resembles nothing more than oriental calligraphy writ large. Much of it is black and white, with all the subtle shadings and blurring that distinguish great Chinese calligraphy. There is a sort of passionate rightness about a work such as *Ballantine* (430) that is immediately convincing. This personal building of a shape like a bridge, with an Eastern freedom of handling, may not be especially profound, but it remains immensely satisfying.

BARNETT NEWMAN

Barnett Newman (1905–70) was one of the most prestigious of the New York School painters. Originally an art critic, he was an ardent supporter of the Abstract Expressionists, explaining and popularizing their work across America. Everyone was surprised when he suddenly blossomed forth as a painter himself, producing enormous "color field" canvases: often a solid block of a single color punctuatéd by what Newman called "zips." Yellow Painting (431) is a perfect example: two straight white lines that differ slightly in width (though their length is identical) zip vertically through the painting at either edge. Their pristine whiteness makes us aware of the rich canary yellow, that, we discover on inspection, is bisected by another zip, this time yellow, faintly outlined in places with a shadowy white. The sheer size of the painting and its baffling simplicity keep us looking. The longer we look, the more aware we are of the strength and purity of the

yellow, and indeed of the white. This is a strangely uplifting experience, as though color draws us into itself while enlarging our horizons. With these works, Newman prefigures both the decorative panels of the Colorists (see p.375) and the spartan canvases of the Minimalists (see p.377).

ROBERT MOTHERWELL

Although his work has a monolithic simplicity, Newman was a noted intellectual. So indeed was Robert Motherwell (1915–91), the youngest of the Abstract Expressionists and a philosopher whose work exerts an enormous, though fundamentally mysterious, moral power.

Motherwell has said that "without ethical consciousness a painter is only a decorator." This remark makes sense in the context of the series that he painted as an emotional response to the Spanish Civil War of 1936–39. These works are elegies mourning the self-inflicted death of

THE IRASCIBLES

Discontented with the Metropolitan Museum of Art's stance on avant-garde painting, a group of American artists, including, Newman, Pollock, Still, and Rothko, wrote a letter to the museum announcing that they would not exhibit in the gallery. After an article in the New York Herald criticized their tactics, the group became known as "The Irascible 18." The most vocal of the group was Jackson Pollock, who argued that each era must choose a different artistic style to express the thoughts of contemporary culture.

431 Barnett Newman, Yellow Painting, 1949, 52% x 5 ft 7½ in (133 cm x 171 in)

THE SPANISH CIVIL WAR

In July 1936 General Franco organized a violent revolt against the Popular Front government in Spain to protest against the anticlerical and Socialist principles of the leaders. As a result Spain became an ideological battleground for Fascists and Socialists from all countries. Both Italy and Germany sent troops to assist Franco. Aid for the Republicans came partly from Britain and France, but mainly from the Soviet Union. The fall of Barcelona in January 1939 led to the end of the civil war and the inauguration of General Franco. The poster above was printed by a trade union as part of the Socialist campaign. Motherwell describes his work as a tribute to the Spanish people.

432 Robert Motherwell, Elegy to the Spanish Republic No. 70, 1961, 9ft 6 in x 5 ft 9 in (290 x 175 cm)

a great civilization. Heavy swags of black, like a bull's testicles, hang down the picture space, reminding us that this is the land of bullfights that end with a noble beast slaughtered. There is a somber dignity and emotional grandeur to *Elegy to the Spanish Republic No. 70 (432)*, and at first sight we may only be aware of a massive area of black against the luminous pallor of the background: yet the background shades are

subtle grays and a pale blue. The solid black swings up and falls down heavily, fissured by thin and ominous dark lines. Even without the title we would know this is an elegy. Motherwell is mourning, but his grief – a very Spanish touch – has a great nobility of restraint.

PHILIP GUSTON

Philip Guston (1913–80) began painting as an Abstract Expressionist, and there are probably still some people who regard the delicate grace of those works as his best. But he underwent a conversion, suffering a revulsion against what he had come to feel was too pretty, and started what we could call a second career as the most plebeian of figurative painters.

The Painter's Table (433), painted toward the end of his life, could be described as uniquely autobiographical: there is the ashtray and stillsmoking cigarette; there are the books to keep a painter's mind alert, and there is a paint box with solid squiggles of paint on the lid – a witty reminder of an earlier career as an abstract artist. But the box is closed, pressed down by one of the solid boots that became almost his trademark: life is a heavy business and we are not borne miraculously through it. Dead center is a wonderful eye, the essential requisite of the painter. Notice, though, that the eye looks through the table into infinity, the painter's task, and that the nail he has driven into the table casts a bleeding red shadow. There are mysterious shapes, too, in the picture, that tease our imaginations; why should a painter's life be fully explicable?

433 Philip Guston, The Painter's Table, 1973, 7 ft 6 in x 6 ft 5 in (229 x 196 cm)

AMERICAN COLORISTS

Abstract Expressionism, although it developed increasingly serious implications with its interior subject matter and artistic gaze, also liberated a wonderful flood of abstract art in the next generation of American painters. But to call these artists "the second generation" of Abstract Expressionists is perhaps unhelpful. They reacted against the "self-importance" and theoretical "spirituality" of painters such as Barnett Newman, seeking to free the artistic image from the obsessively metaphysical and make it a purely optical experience.

The painters that followed the Abstract Expressionist movement were less intense in their concentration, but wider and more diverse in the effects they sought. The Abstract Expressionists were profoundly serious — tragedy was essentially their theme — while the Colorists, or "Stainers," used color to express joy rather than sorrow. They stained canvases with paint or created large areas of color to communicate visually the wonder of human existence. Color has an effect on us all: it communicates meaning in its very being, irrespective of image or theme. It was this elementary power that the Colorists relied upon, bypassing the intellect to appeal to a deeper self.

HELEN FRANKENTHALER

American art has several great Colorists. One is Helen Frankenthaler (1928 -), whose method of staining the canvas with paint had such a wide influence on painting. She was influenced by Pollock's "all-over" painting (see p.369), and her innovative approach is in some ways an extension of Pollock's pouring and dripping process, though the effect is very different. She mixed thin washes and transparent stains and impregnated the bare, untreated canvas with them so that the color no longer sat on the surface of the canvas, but became the picture surface itself. Wales (434) shows her technique in its lovely simplicity, yet the more we look, the more subtle it is. Frankenthaler demands a place in art history as a pioneer of the staining technique, but this seems relatively unimportant compared with the end to which she put this means. Her style has been well imitated, but never with such inspired power. The eye moves over Wales with continual pleasure: it is a superb example of a work that has no "meaning" and yet provides profound intellectual satisfaction.

Morris Louis

When Morris Louis (1912–62) visited Frankenthaler's studio in 1954, he learned from her the technique of using stains as a means of creating, not on the canvas, but in it, making the work seem to

434 Helen Frankenthaler, Wales, 1966, 45 x 113 in (114 x 287 cm)

between
Pollock and all
possibilities. ""

Morris Louis on Helen Frankenthaler in 1953

STAIN PAINTING

From 1952 a new genre of painting known as "Stain painting" was developed by Helen Frankenthaler, who had evolved her own style of Abstract Expressionism (see pp.368-74) under the influences of Jackson Pollock and Arshile Gorky. The technique she developed involved using thinned paint to cover a whole unprimed canvas. The colors, having lost their glossy coating, float into and away from the surface creating nebulous but controllable space. At the same time, the spectator's awareness of the texture of the canvas denies the sense of extended illusion. In 1963 Frankenthaler started to use acrylic paints, which produced the same density of color saturation but were more controllable.

ACRYLIC PAINTS

The paintings of Morris Louis mark an important turning point in the use of new pigments and the innovative exploration of color and light. In 1953-54 Louis began to use a new form of acrylic paint that was plastic-based and water-soluble. It was designed to give a revolutionary flat surface once applied to the canvas. Louis reached the peak of his creativity with this medium between 1960 and 1962 with his series of Unfurleds. The effect on the canvas is created by allowing the liquid paint to flow over the surface of a small area of the canvas (see right).

435 Morris Louis, Beta Kappa, 1961, 14 ft 5 in × 8 ft 7 in (439 × 262 cm)

436 Richard Diebenkorn, Ocean Park No. 64, 1973, 6 ft $8\frac{3}{4}$ in \times 8 ft $3\frac{1}{2}$ in $(206 \times 253 \text{ cm})$

emerge from its own necessities. *Beta Kappa* (435) (the works are distinguished by Greek letters so that no shade of interpretation may creep into our experience of the paintings) is a late work, one of Louis's series of *Unfurleds*, where diagonal stripes across the canvas create a purely decorative effect. The painting is over 14 ft (4 m) long, yet the area in the center of the picture has been left daringly bare. We cannot take in, with just one look, the pourings down either side, so we must move between the edges, seeking an integration. Finally, we are forced to submit to the challenging nothingness of the picture, which its colored borders only make more evident.

RICHARD DIEBENKORN

Not all the great American painters live in New York. Richard Diebenkorn (1922–1994) has lived for many years in San Francisco, and his famous *Ocean Park* series is named after a suburb there. The wonderful rectangles he paints are both similar to one another and yet completely different. He has found, as Mark Rothko did (see p.370), a format that sets him free to explore the nuances of color, and it is serious play.

Stripes and diagonals divide *Ocean Park No.* 64 (436) into three sections, differently hued and sized. The absolute verticals highlight the swimming softness of the blue background and the subtle shifts and variations of paint application, so that in this work we really do recall the varying depths of the Pacific Ocean. But this is also a park, fenced in and bounded both at every edge and from within. Diebenkorn uses color so creatively that we begin to understand the world a little better.

MINIMALISM

If Abstract Expressionism dominated the 1940s and 1950s, Minimalism belonged to the '60s. It grew out of the restrained, spartan art of Abstract Expressionists such as Mark Rothko and Barnett Newman. A broad concept, Minimalism refers either to the paring down of visual variation within an image, or to the degree of artistic effort required to produce it. The result is an art form that is purer and more absolute than any other, stripped of incidental references and uncorrupted by subjectivity.

Ad Reinhardt (1913–67) could be said to be the quintessential Minimalist. He began as an "all-over" painter (see p.379) in the 1940s, but he matured into what he called his "ultimate" paintings in the 1950s: hard-edged, severely minimal abstract works. He darkened his palette and suppressed the contrast between adjacent colors to such an extent that after 1955 his art

was restricted to the slow tonalities of deep black and almost-black colors. An inspirational teacher and outspoken theoretician, he believed passionately in reducing art to its purest form and, by extension, to its most spiritually pure state. Within the great luminous expanse of *Abstract Painting No. 5 (437)*, and its smooth, deep, blue-black surface, the artist's hand has

437 Ad Reinhardt, Abstract Painting No. 5, 1962, 5 x 5 ft (152 x 152 cm)

CONTEMPORARY

1946

Eugene O'Neill writes The Iceman Cometh

1949

Bertolt Brecht founds a theater company in Berlin

1953

Le Corbusier builds city of Chandigarh, India

1962

Benjamin Britten composes the War Requiem

1976

Christo completes his Running Fence sculpture across 25 miles (40 km) of Californian coastline

1982

Steven Spielberg creates the film *ET – The Extraterrestrial*

AD REINHARDT

In the 1940s Reinhardt passed through his stage of "all-over" painting into a style close to certain of the Abstract Expressionists, particularly Robert Motherwell (see p.374), with whom he jointly edited Modern Artists in America in 1950. During the 1950s he turned to monochromatic (usually all-black) paintings, and this reduction of his work to pure aesthetic essences reflects his fundamental belief that "Art is art. Everything else is everything else." Reinhardt's radical reduction of art to a simple chromatic abstraction was not initially accepted by the critics, but fellow artists understood his need to liberate art from the confines of contextual judgment.

objective, non-representational, non-figurative, non-imagist, non-expressionist, non-subjective.

describing Minimalist painting in 1962

STELLA AND MINIMALISM

The trend in minimal art developed in the 1950s in the United States. Only the most simple geometric forms were used. The impersonal nature of the genre is seen as a reaction to the high emotiveness of Abstract Expressionism. In his early work from 1958 to 1960, Frank Stella produced a kind of painting that was more abstract than any before. He confined himself to single colors, at first using black, and then aluminum paint, as in Six Mile Bottom, shown here. The artist chose the metallic paint because it has a quality that repels the eye, creating a more abstract appearance. Another striking aspect of Stella's work is that the structures appear to follow the shape of the canvas.

438 Frank Stella, Six Mile Bottom, 1960, 5 ft 11½ in × 9 ft 8 in (182 × 300 cm)

deliberately made itself invisible. We can see, just emerging, the faint outlines of a cross – almost as though Reinhardt himself has not painted it. This is not a Christian cross; if it is a religious icon, it is in the broadest sense, with an infinite vertical and an infinite horizontal – the unfathomable dimensions of the human spirit.

FRANK STELLA

Frank Stella (1936–) became a pivotal figure of 1960s' American art. In 1959, he produced a series of controversial pictures for the exhibition "16 Americans" at the Museum of Modern Art in New York. The works he presented were "allover" unmodulated pictures dissected by strips of untouched canvas, creating severe geometric patterns. He consciously eliminated color, using black and then silver-colored aluminum paint to reduce the idea of illusion; even his painting process became systematic and Minimalist. His art ignores the rectangular limits of traditional canvases, reminding us that whatever connotations his paintings may evoke, they remain essentially colored objects. Often considered merely a shaped pattern, Six Mile Bottom (438) is a highly successful work, and one could claim that it implies a central order in worldly affairs. The geometric bareness of Stella's early work has been influential, but he developed into such a colorful, exuberant, multidimensional artist, continually experimenting and challenging, that one wonders at the stately purity of his early work. Was Stella's explosive buoyancy as yet undiscovered in 1959, or does it lurk within those strange rigidities of Six Mile Bottom?

440 Agnes Martin, Untitled No. 3, 1974, 6 ft x 6 ft (183 x 183 cm)

MARTIN AND ROCKBURNE

There is never going to be universal agreement over contemporary painters, but there are some that, to this writer, are of unmistakable greatness: the Canadian Agnes Martin (1912–) is one. *Untitled No. 3 (440)* is simply a 6 ft (183 cm) square in which a fragile, almost noncolor, border encloses three great strips. The palest of pinks lies in the middle, bordered by two rectangles of watery purple or blue. The gentleness and delicate serenity of this work is exposed to our gaze without anything, as it were, seeming to happen. One has to stay with a Martin, looking as if into the waters of a lake, until the work begins to open up and flower.

With Dorothea Rockburne (1922–) there is much more to grasp and hold. She is a profoundly intellectual artist, often taking her inspiration from Old Masters, and she combines powerful austerity with a great lyrical insight. Some of her most wonderful work has been with oil and gold leaf (like the medieval illuminators) on linen prepared in a traditional way with gesso. She folds and creates geometric majesty from these simple means in *Capernaum Gate* (439), using the utmost splendor of saturated hues and making us see her work as iconic, as something sacred.

ALL-OVER PAINTING

The term "all-over" painting was first used to describe the drip paintings of Jackson Pollock (see p.368). However, since then the term has been applied to any art where the overall treatment of the canvas is relatively uniform in color or pattern. Often the traditional perception of the canvas having a top, bottom, or center is no longer viable, and the painting becomes purely an experience.

POP ART

The term "Pop Art" was first used by the English critic Lawrence Alloway in a 1958 issue of Architectural Digest to describe those paintings that celebrate post-war consumerism, defy the psychology of Abstract Expressionism, and worship the god of materialism. The most famous of the Pop artists, the cult figure Andy Warhol (shown above), re-created quasiphotographic paintings of people or everyday objects.

Pop Art

It is a moot point as to whether the most extraordinary innovation of 20th-century art was Cubism or Pop Art. Both arose from a rebellion against an accepted style: the Cubists thought Post-Impressionist artists were too tame and limited, while Pop Artists thought the Abstract Expressionists pretentious and overly intense. Pop Art brought art back to the material realities of everyday life, to popular culture (hence "pop"), in which ordinary people derived most of their visual pleasure from television, magazines, or comics.

Pop Art emerged in the mid-1950s in England, but realized its fullest potential in New York in the 1960s, where it shared, with Minimalism (see p.377), the attentions of the art world. In Pop Art, the epic was replaced with the everyday and the mass-produced awarded the same significance as the unique; the gulf between "high art" and "low art" was eroding. The media and advertising were favorite subjects for Pop Art's often witty celebrations of consumer society. Perhaps the greatest Pop artist, whose innovations have affected much subsequent art, was the American Andy Warhol (1928–87).

Warhol's Prints

Opinions, in the past, have differed wildly as to whether Warhol was a genius or a con artist extraordinaire. Having begun his career as a commercial artist, he incorporated commercial photographs into his own work, at first screen printing them himself and then handing the process over to his studio (known as "The Factory"): he devised the work, they executed it. In the *Marilyn Diptych* (441), the image has deliberately been screen-printed without any special skill or accuracy, and the color printing on the right is, at best, approximate. Yet the

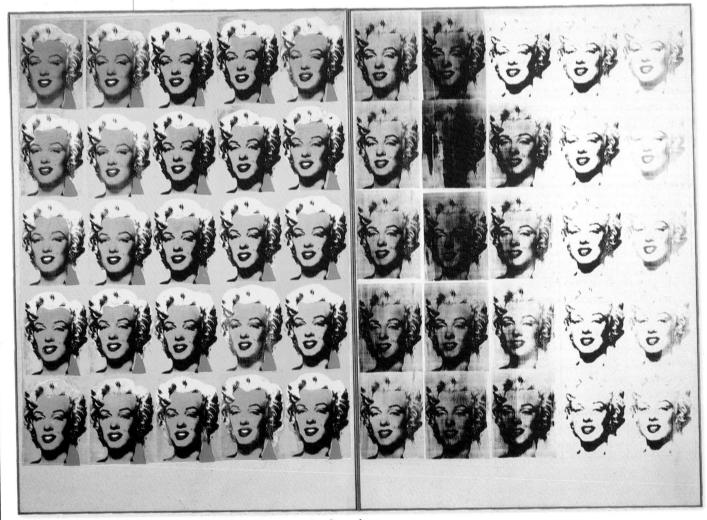

441 Andy Warhol, Marilyn Diptych, 1962, 57 x 80¾ in (145 x 205 cm) each panel

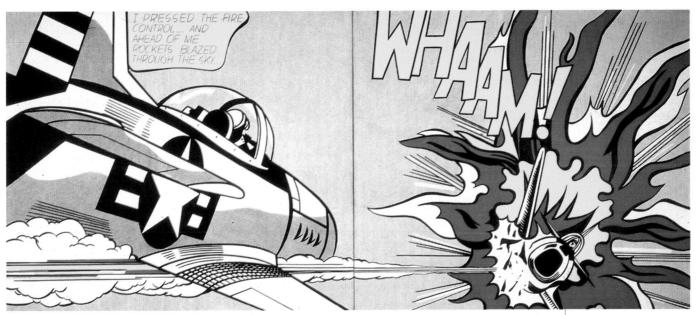

442 Roy Lichtenstein, Whaam, 1963, 13 ft 4 in x 5 ft 8 in (406 x 173 cm)

Marilyn Diptych is an interesting and impressive work, rising from something deep within Warhol's psyche. He was an avid fan of the famous and understood the ephemeral nature of this fame, but he was even more interested in the idea of the American public's devotion to fame as a cultural symbol of his times. In giving herself up to the publicity machine, Monroe was destroyed as a person, and Warhol's utterly detached documentary style of portraiture echoes the impersonality and the isolation of this fame. In Marilyn Diptych a sea of Monroe faces, alike and yet subtly different, confront us with an iconic mask. It is an unforgettable work.

Roy Lichtenstein

Ironically, Warhol's first venture into Pop Art was based on images taken from comic books, but the dealer to whom he showed his work was not interested: he had already been won over by the art of fellow American Roy Lichtenstein (1923–), another of Pop Art's major figures.

There is of course an element of nostalgia in work such as Lichtenstein's – the comic book world is that of childhood and early adolescence, with all its innocence and hopes. Lichtenstein saw the iconic dimensions of these images and re-created them on the grand scale favored by the Abstract Expressionists. His *Whaam* (442) is not an actual transcription from a comic book but an image he has taken and reduced to its essentials, to its streamlined power. *Whaam* is about violence and about how we can remove ourselves from it. The image is a narrative diptych: on one side are the powers of good, the avenging angel of the airplane; on the other, the powers of evil, the enemy destroyed

in a stylized blaze of punitive power. Lichtenstein uses simple shapes and colors and copies the dot process used in printing to restore us to the simplified world of moral black and white, and to our nostalgic childhood simplicities.

JASPER JOHNS

Dancers on a Plane; Merce Cunningham (443), is Jasper Johns's (1930–) tribute to the work of Merce Cunningham, the avant-garde American choreographer. Visually, Dancers on a Plane is extremely beautiful; conceptually, it is extremely

443 Jasper Johns, Dancers on a Plane; Merce Cunningham, 1980, 5 ft $3\frac{1}{2}$ in \times 6 ft 7 in $(162\times200$ cm)

SILK-SCREEN PRINTING

The process of silk screening (serigraphy) was developed in the early 20th century to be used for commercial textile printing. The basic technique involves forcing color through a stencil made of fine mesh that has been stretched over a wooden frame. This process was adopted by Warhol, who aimed to create uniform of images with subtle variations in color density.

OTHER WORKS BY WARHOL

Two Dollar Bills (Museum Ludwig, Cologne)

Campbell's Soup (Museum of Modern Art, New York)

Elvis No.1 (Art Gallery of Ontario, Toronto)

Electric Chair (Moderna Museet, Stockholm)

Double Mona Lisa (Menil Collection, Houston, Texas)

Self-Portrait (National Gallery of Victoria, Melbourne)

Large Flowers (Stedelijk Museum, Amsterdam)

JOHN CAGE One of the most influential figures in 20th-century music was the composer John Cage (1912-92), who created some highly controversial pieces of "music." His most famous piece is called 4'33" - four and a half minutes of silence, inspired by some of Robert Rauschenberg's blank paintings. Cage also produced "prepared piano" pieces by distorting the sound from the piano by placing objects on the piano strings.

complex. Johns's supreme gift is to create a demanding concept visually – he so delights the eye that he leads us into mental exploration of this concept. *Dancers on a Plane* shows the complexities of religious fulfillment (how the earthly side of life, the left side, will be divinely transformed after death, the right side) and sexual relationships, the four-dimensional nature of dance movement shown on one plane, the flat canvas, with the steps matching one another in a partnership. It is a thoroughly rewarding picture, which repays the time devoted to its contemplation. Equally, it gives pleasure on the merest glance; Johns satisfies on all levels.

ROBERT RAUSCHENBERG

The influence of Dada and Surrealism on Robert Rauschenberg (1925–) led him to a wholly new art form, using commonplace objects in unusual juxtapositions. Called "combine" paintings, they are Rauschenberg's specialty. *Canyon* (445) is one such work. He has assembled a bewildering mélange of images and techniques: oil painting combined with screen-printed photographs, newspaper text, and sheer painterly scrawl. But below this hubbub of intense life hovers the gaunt, outstretched wings of a dead bird. There is a vertiginous sense of soaring, of taking off into the canyon of the unknown. We feel that

444 David Hockney, A Bigger Splash, 1967, 8 ft x 7 ft 113/3 in (244 x 243 cm)

445 Robert Rauschenberg, Canyon, 1959, 5 ft 10½ in × 7 ft 2½ in × 22¾ in (179 × 220 × 57.5 cm)

the canyon is not so much in the picture as below it: it is not out there, safely framed, but in here, in our own personal space. The ledge on which the bird perches juts out into the viewers' world at a diagonal, and hanging limply from it is a cushion, tightly composed into two saclike bags that seem weirdly erotic and pathetic. All the elements of the work, two-dimensional as well as three-dimensional, combine into a sense of closure, as though we were truly trapped within the high blank walls of a stone canyon. There can be an inspired lunacy in Rauschenberg that does not always come off, but when it does his images are unforgettable.

DAVID HOCKNEY

Technically, it is true to say that the Pop movement started with Richard Hamilton and David Hockney (1937–) in England. Hockney's early work made superb use of the popular magazinestyle images on which much of Pop Art is based. However, when Hockney moved to California in the 1960s, he responded with such artistic depth to the sea, sun, sky, young men, and luxury that his art took on a new, increasingly naturalistic dimension. Though one might consider A Bigger Splash (444) a simplistic rather than a simplified view of the world, it nevertheless creates a delightful interplay between the stolid pink verticals of a Los Angeles setting and the exuberance of spray as the unseen diver enters the pool. There is no visible human presence here, just that lonely, empty chair and a bare, almost frozen world. Yet that wild white splash can only come from another human, and a great deal of Hockney's psyche is involved in the mix of lucidity and confusion of this picture.

European Figurative Painting

While Abstraction obsessed American artists for decades, the human figure never lost its significance in European painting. England eventually challenged American pride in the 1970s with a school of painters that included Lucian Freud and Frank Auerbach. British artists on the whole do not form "schools," and tend to work alone – which is perhaps indicative of a national tendency toward eccentricity.

The strangely disturbing figurative art of Balthus (1908–), a Frenchman of Polish descent, has never been linked to a European school or movement. Balthus, the nickname used by Count Balthasar Klossowski de Rola since the age of 13, works in isolation with a classic majesty that can seem quite incongruous in our hectically unaristocratic age. His art is effective because this quiet sense of hierarchy comes naturally to him. Haunted by the griefs of our modern times, he chooses to deal with them obliquely, rather as Matisse did. His art is enigmatic, infused with a dignified stillness and monumentality.

BALTHUS

In the most sensitive and subtle of ways *The Game of Cards (446)* is concerned with awakening sexuality. Both young people have childlike bodies, but their facial expressions indicate that they are on the verge of entering a new world of sexual interplay. Their innocence, soon to be lost in bodily consciousness, moves Balthus, and he shares with us his emotional sympathy and his pleasure in their "game."

The Game of Cards is obviously about far more than the title suggests: the young people cannot look at one another directly without flirtatious timidity. Both reach out with one

THE MYSTERIOUS BALTHUS

The interest in figurative painting in the 1940s was signified by the unusual work of Balthus (1908-), a French painter of aristocratic Polish descent. As a young man he was influenced by Derain and Bonnard, who were both family acquaintances. Little is known about Balthus - he leads a relatively private life, but the apparent banality of his compositions seems to reflect a tragic universe of silence and solitary despair. Balthus paints images of awakening female sexuality, and The Game of Cards is an excellent example of his preoccupation.

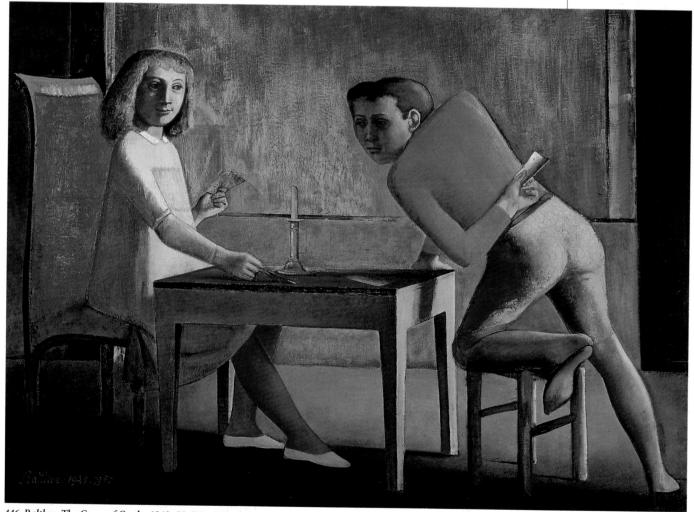

446 Balthus, The Game of Cards, 1948-50, 76 x 55 in (194 x 140 cm)

In 1945 British art was unreservedly violent,

reawakened by the arrival of Francis Bacon. Many of Bacon's paintings were showing isolation and despair, using smudged paint and distorted human figures. Bacon proclaimed that the violence was inherent in the act of painting itself in the struggle to remake reality on the canvas.

hand while drawing back with the other. The girl offers not only her hand but her delicate feet in her white sneakers, edged toward the boy. The boy is barricaded behind a table, determined to keep his secrets to himself (his unshod feet point away from her), and yet, as the angle of his body suggests, he is deeply attracted to her.

Everything in this picture is symbolic: the protective chair against which the girl does not lean, the low, unprotected stool that is all the young male has for support, even the mysterious brightness of the upper background and the shadows in which the activity is taking place. Is the candle at the center of the table a sacred image, a votive candle, or is it a phallic image, indicative of what is to come? It is certainly not a source of light because it is unlit. There are clear ambiguities present here, but no answer is given. Balthus does not prophesize.

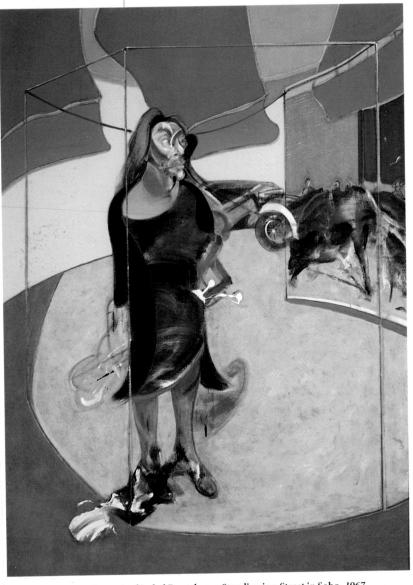

447 Francis Bacon, Portrait of Isabel Rawsthorne Standing in a Street in Soho, 1967, 58 x 78 in (147 x 198 cm)

FRANCIS BACON

By the 1970s a London School had emerged, though it did not share the same qualities as the Pre-war Paris or Post-war New York Schools, where the artists frequently met and shared their ideas. It included several major artists, of whom the best known is the Irishman Francis Bacon (1909-92), who moved to London in 1925.

Bacon is under reassessment: is his work a terrible indictment of the human condition, or did he wantonly create chaos for the wicked fun of it? Bacon, however, is very far from fun. His early works most certainly convey a great weight of grief and doubt, while his later paintings are overwhelmingly oppressive. Balthus's art reveals a secretive world full of obsession; Bacon's work exposes a world riddled with horror and anxiety.

Portrait of Isabel Rawsthorne Standing in a Street in Soho (447) has a deliberately longwinded title. The picture is tightly framed, with Bacon's friend entrapped like a bull in a ring, an arena. The curved wheel of a passing car suggests the horn of a bull at the same time. The woman presents an image of wary tension as she looks around quickly, her skirt aswirl with motion. The dullness of the long title adds force to her plight: a street in London's Soho - and such anxiety? Her face is hideous with brooding concentration, yet we can see that she is beautiful. She is ready to break loose from her cage.

Bacon developed a unique and inimitable technique, which included rubbing the canvas with various cloths, chosen for their different textures, to smudge and blur the paint. He also used dramatic contrasts of thin and thick paint, which he applied to the canvas with a violence akin to defacement. In this picture, Bacon has splattered wet paint in several places to indicate the role of chance, of uncertainty and risk. Not even this great coiled spring of a female can be certain of her freedom. By involving us emotionally, he shows the mark of a great painter.

LEON KOSSOFF

Two other British artists are of European-Jewish origin. Frank Auerbach (1931-) and Leon Kossoff (1926-) were both taught by the painter David Bomberg, whose art went neglected by the world until after his death (see column, p.385). Both are awesomely dedicated, working full-time . in their studios, Auerbach encrusting his early work with more and more paint until it comes alive and Kossoff incessantly repainting the same familiar places and people. Both work from life; Bacon painted from memory, believing that the elusive qualities of the human presence were more honestly re-created by an equivalent painterly ambiguity.

Kossoff is like the great Swiss sculptor and painter Alberto Giacometti (see p.365), who each night scratched out the day's work, never satisfied. For Kossoff too, painting becomes a repeated exercise, and he gains new insights through his experimentation. Then, suddenly, he understands visually and the picture is begun and finished very quickly. The sweep of his hurried paint is clearly visible as he drives himself to catch the truth before it vanishes once more. In a sense it is his own truth that he forever pursues, since the things he paints are the intimate companions of his own life.

Kossoff's aged parents are portrayed in *Two Seated Figures No. 2 (448)*, a subject that he has brooded over productively for years. Every part of their body language is intelligible to him, but he must make visual sense of it and portray this couple with fitting dignity. Unembarrassed, Kossoff paints with a keen observation: his father, a hard-working man, is now too old to be a true consort to his wife. He crouches awkwardly in his chair, seemingly unsure of himself.

Kossoff has said that his parents "obsessed" him as a subject. Here he is coming to grips with the changes in parental dominance as he has previously known it, and with the changes in the marital relationship itself. But he looks on with the steady love of the observer, admitting no grief, playing with no explicit memories. It is a marvelously reticent painting, and all the more moving for that restraint.

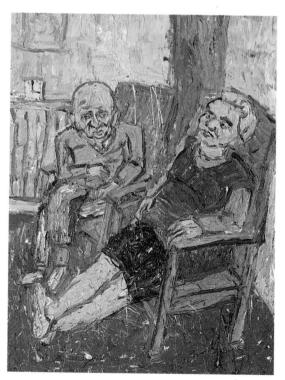

448 Leon Kossoff, Two Seated Figures No. 2, 1980, 6 ft × 8 ft (183 × 244 cm)

449 Frank Auerbach, The Sitting Room, 1964, 501/3 x 501/3 in (128 x 128 cm)

Frank auerbach

Auerbach, like Kossoff, paints only deeply loved, personal things. He tries with passion to capture their essence and always fails. But he fails gloriously. He spent nearly a year on *The Sitting Room* (449), in the home of E.O.W., one of his few constant models, and he painted her there three times a week. Here is where they are most intimate, the model in one chair and her daughter in another, where every object has meaning for both of them. What he wants to show is not the bare sight of the room, but the sense of it seen anew each time.

Auerbach's images are built up of flat shapes of solid color, so that the depth in each picture has to be sought for. The surfaces of his early paintings are built up to the degree of a sculpted relief, the gouges and mounds of paint taking on an almost independent reality. The earthy colors in *The Sitting Room* have an emotional rightness, for this is his soul's soil, from which his art grows. He has painted and repainted endlessly, refusing to dramatize or play the illusory games of an illustrator. Suddenly the image coheres and moves forward from its obscurity. The human memory is never reliably sharp: the certainty is vital but the forms often cannot be strictly delineated.

AUERBACH AND BOMBERG

The art dealer Henry Roland and the Beaux-Arts Gallery owner Helen Lessore both promoted figurative art in Britain during the 1950s. Many figurative art exhibitions were mounted, showing, among others, Auerbach, Bacon, and Kossoff. The latter two were pupils of David Bomberg (1890-1957) who had developed his expressive methods in the 1920s and 1930s. Between 1945 and 1953 Bomberg taught parttime at the Borough Polytechnic in London, but he was not highly regarded by the establishment, who thought his teaching techniques - allowing students to follow a highly personal, organic course - were dubious. Auerbach's portrayal of chaotic London scenes using thick impasto paint echo this eccentric philosophy.

VENICE BIENNALE

The 40th Venice Biennale (an art festival) in 1980 marked the establishment of the Transavantgarde, a movement, masterminded by Achille Bonito Oliva. His argument was that painting no longer had a history. It had become free, able to use whatever influences it chose. Oliva considered national characteristics outmoded. There was only a world art, drawing from all traditions. It imitated, it subverted, it pastiched at will. Although supposedly international, the core of this movement was Italian, but it does have an international application (prominent Transavantgardists are the Germans Anselm Kiefer and Georg Baselitz).

LUCIAN FREUD

Lucian Freud, like Francis Bacon, has a serious claim to be considered as part of the story of painting. He has painted landscapes, still lifes, and portraits, but his most powerful art deals with the naked human body. He sees it in all its chromatic wonder and its astonishing vulnerability. He almost seems to paint what is underneath the skin, exposing the secret truth of his models, all of whom are people he knows well. His desire is not to create paintings that are like the subjects, but that are the subjects, so that there are two realities, one on the canvas, one walking free.

LUCIAN FREUD

Lucian Freud (1922–), grandson of the German psychoanalyst Sigmund Freud, is a resolutely realist artist, and frighteningly so. He began by painting tightly controlled, Surrealist-influenced portraits and still lifes, and rarely painted nudes before 1965–66; yet he subsequently painted some of the most powerful and original nude pictures in Western painting. Freud developed an increasingly "fleshy" style, seeking ways of conveying the physical reality of humans in a

concrete world with ever greater intensity, and with an increasing interest in the wonder of skin tones. He directs a clinical eye on his subject that is chilling in its objectivity.

Standing by the Rags (450) is a recent work and a superb example of Freud at his greatest. He shows us a woman in all her raw fleshiness standing in the full exposure of the sunlight. It is almost as if Freud paints beneath the skin, with his dazzling sensitivity to the variations in her skin tone. These pinks, blues, and yellows

450 Lucian Freud, Standing by the Rags, 1988–89, 541/3 x 661/2 in (138 x 169 cm)

451 Anselm Kiefer, Parsifal 1, 1973, 7 ft 2½ in x 10 ft 8 in (225 x 320 cm)

are visually extraordinary – have we ever seen skin like this before? The woman plunges down toward us; the floorboards beneath her feet provide the only perspective and are so vertiginous that we instinctively move back, as if she would fall out on top of us. Despite their wild disarray, the rags are safely tucked away behind her, barricaded by her bent arm and the weighty flesh of her body. These rags are among some of the most beautiful things Freud has ever painted. They gleam with a soft luminosity, their whiteness extending from deep shadows of gray through all possible intermediate tones up to a sharp pallor. The firm human flesh is played off against the loose compression of the rag pile. The woman is limited by the definition of her shape; the rag pile extends indefinitely in three directions. Every aspect of this disjuncture delights Freud's painterly heart.

Anselm kiefer

Among today's German artists, many critics would back Anselm Kiefer (1945–) for his staying power: he is a romantic painter, an expressionist in the German Expressionist tradition with a deep need to give visual form to the idea of repentance. His subject matter largely revolves around the terrible injustices suffered by the Jews in Germany, and it may be that the

importance of his theme obscures our judgment here. Only time will tell. *Parsifal 1 (451)* is from a series based on the Wagner opera. The theme is a weighty one, and critics have seen these works as an expression of the rough-hewn nature of the true Germanic spirit, as well as a meditation on the nature and growth of an individual artist. Kiefer uses unusual techniques, so that the overlapping strips of wallpaper, laid horizontally across one another and painted black at the edges, look like floorboards of rough wood. This wood echoes the great forests of his native land, and every swirl and textural mark seems to bear some great significance for him.

GEORG BASELITZ

Those unacquainted with contemporary art may well feel an ironic gratitude to Georg Baselitz (1938-) because his work is immediately recognizable. His almost invariable inversion of his images has been criticized as a gimmick: why, after all, are the two figures in Adieu (452) upside down? The intention is in fact a serious and aesthetic one: he wants to use the human figure with an almost abstract freedom so that his work is not easily understood and, as too often happens, forgotten. As we puzzle over the upturned figures and the strange starter's flag of the background, we absorb something of the artist's power and his fascination and delight in evading familiar constructions. It is too early to know how important an artist he is, but he is a good example of an interesting contemporary about whom we can make up our own minds.

THE ART OF KIEFER

Kiefer's primary choice of subject matter at the beginning of his career was the portrayal of events from German history and mythology. By portraying the realities of German atrocities, he felt he could exorcise the past and perhaps show that some form of goodness could come through evil. Later in his career he started to use straw, lead, sand, and metal to create collages, and he even used blood as a pigment in the Parsifal series of four paintings, created in 1973 (see left). The one shown here relates to the birth and early years of the eponymous hero of Wagner's opera, hence the crib. When three of the paintings are hung as a triptych, this one forms the left-hand panel.

452 Georg Baselitz, Adieu, 1982, 9 ft 10 in x 6 ft 8¾ in (300 x 205 cm)

Epilogue

This is both an afterword and a foreword: hundreds and thousands of artists come after the disappearance of the "story line" into the maze of contemporary artistic experience and these same artists may of course, be the forerunners of a new story. In the

Robert Natkin is an established artist and a supreme colorist who has up until recently resisted being called an abstract painter. Clearly, to Natkin every part of his canvas is vital with what he calls narrative interest. A communication is being made visually: an experience is being enacted. But this event, so searching and enriching to the spirit, is carried out by means of shapes and colors, integrating into a wholeness. Natkin floats his colors on, denies them, deepens them, teases

present context of the end of the century, it is impossible to know which threads will lead us through the maze and which are dead ends. I can only give a very personal, subjective sample of contemporary art and single out just three artists who I hope will endure.

them into new complexities, always with a masterly elegance that is overwhelmingly beautiful. *Farm Street* (453) is one of a series inspired by worship at Farm Street, a Jesuit church in central London. The picture offers the viewer an entry into worship, not just the painter's, but our own. It is a humbling and uplifting work, with its wonderful luminosities. Yet Natkin offends many critics by being too beautiful, purity being suspect in these days of dilemma.

453 Robert Natkin, Farm Street, 1991, 72 x 60 in (183 x 152 cm)

454 Joan Mitchell, Sunflowers, 1990–91, 157½ x 110¼ in $(400 \times 280 \text{ cm})$

The great Joan Mitchell also offends with her beauty, but she saves herself in critical circles by drawing the beauty, not just from her own vision, like Natkin, but from the seen world. Her home for many years was in Giverny, where Claude Monet had made his home and miraculous garden (see p.297). But she asserted that she never looked at the view. The "view" is in her own house, the flowers on the table or in the garden, and she paints them with enormous grace and compassion. *Sunflowers* (454) has almost the sad glory of van Gogh's version. It is a theme that Mitchell has painted many times. She has said, "If I see a sunflower drooping, I can droop with it, and draw it and feel it until its death."

Modern religious art

The Renaissance marked the high point of religious art, but since then it has almost died out. It is therefore all the more astonishing, then, that contemporary Britain should produce an artist like Albert Herbert. A profoundly educated painter who paints from his own inner experience, his own need, he creates biblical images of astonishing conviction. Here is Jonah, happily journeying within the security of his whale, and real life, represented by its goose girl and her geese, threaten and alarm him. In *Jonah and the Whale (455)*, Herbert is using biblical imagery to express powerfully and magnificently a truth about the human heart.

455 Albert Herbert, Jonah and the Whale, c. 1988, 14 x 11 in (35 x 28 cm)

The story of painting continues, even if the chapter we are in is still being written. It will in the end be read and appreciated, just as we appreciate the art of the past. We have the adventure of looking at contemporary art without guidelines or labels, and that is a precious part of the story.

GLOSSARY

Abstract art Art that does not represent objects or people from the observable world.

Acrylic paint A type of paint made with a synthetic acrylic resin as the medium. It dries more quickly than oil paints (see column, p.376).

Altarpiece A religious work of art placed above and behind the altar.

Annunciation A popular subject in Gothic, Renaissance and Counter-Reformation art: the moment of the announcement to the Virgin Mary by the Angel Gabriel that she shall concieve and bear a son and that he shall be called Jesus (see column, p.63).

Byzantine Esssentially Christian art produced in the Eastern Roman Empire between the 5th century AD and 1453, when Constantinople fell to the Turks.

Chiaroscuro (Italian: "light dark") The technique of suggesting threedimensional form by varying tones of light and dark paint.

Complementary colour The true contrast of any colour. The complementary of each primary colour – red, blue, and yellow – is the combination of the other two. Red and green; blue and orange; and yellow and violet are the basic pairs. In painting, placing complementary colours next to each other makes both appear brighter.

Diptych A picture made up of two panels, usually hinged (see column, p.54).

Donor The commissioner of a painting, who in medieval and Renaissance art, is often portrayed within the painting.

En plein air (French: "in the open air") Painting out of doors.

Fetish An object, often sculpted, that was believed to be the embodiment of a spirit.

Foreshortening A technique for depicting an object at an angle to the plane of the picture by making use of perspective so that the object appears shorter and narrower as it recedes.

Fresco The wall-painting technique in which pigment, mixed with water, is applied to a layer of wet plaster. When dry, the wall and the colours are inseparable. This is known as *buon fresco* or true fresco. *Fresco secco* refers to the technique of applying paint to dry plaster.

Genre painting Paintings depicting scenes from daily life.

Grisaille A monochrome painting in shades of grey. Renaissance artists used it to imitate the look of sculptural relief.

Ground A preparatory surface of primer or paint applied to the canvas before painting.

Icon A painting on a panel depicting Christ, the Virgin Mary, or a saint in a traditional Byzantine style.

Immaculate Conception In Christian theology, the doctrine that the Virgin Mary was conceived without the stain of original sin.

Impasto A thick layer of paint.

Intimism A style adopted by a subgroup of the Nabis, in which bourgeois domestic interiors are depicted in an informal and intimate way.

Japonisme The influence of Japan on European art, in particular Impressionist and Post-Impressionist painting.

Maestà (Italian: "majesty") An altarpiece showing the Madonna and Child enthroned and surrounded by saints and angels.

Medium In paint, the vehicle (substance) that binds the pigment – for instance, in oil paint the medium

is an oil (poppy oil, etc.); in tempera the medium is egg.

Odalisque A female slave or concubine.

Oil painting Painting in which oils such as linseed, walnut, or poppy are used as the medium binding the pigment.

Painterly The rendering of form by means of colour rather than outline.

Palette-knife pictures Paintings in which the paint is applied and manipulated with a palette knife.

Panel A painting on wood (see column, p.75).

Passion The sufferings of Christ between the Last Supper and His Crucifixion.

Perspective A system of depicting a three-dimensional form on a two-dimensional surface. In linear perspective, objects are depicted in diminishing size and parallel lines converge with increasing distance.

Primary colours The three colours from which all others are derived – red, yellow, and blue.

Scumbling A technique in which a thin layer of paint is unevenly applied over another layer to create a broken effect as areas of the under colour show through.

Sfumato A soft, smoky effect, created by colours and tones overlapping and blending, changing imperceptibly from light to dark (see column, p.116).

Still life A painting or drawing of inanimate objects.

Tempera Paint in which pigment is dissolved in water and mixed with gum or egg yolk.

Tondo A circular painting.

Tooth The irregular texture of a canvas, which enables paint to adhere.

INDEX

References in bold italic refer to plate numbers.

Abstraction 337, 359-60, 371, 383, 353-5 Abstract Expressionism 368-374, 375, 377, 378, 380, 381 Actaeon 226 Action painting 368, 369 Actium, Battle of 20 Adam 55, 124 Adam, Robert 245 Aeneas 122 African influence 334, 335, 337, 345 Agamemnon 15 L'Age d'Or 364 Agnes, St. 146 Akhenaten 12, 13 Albert, Archduke 190, 191 Alberti, Leon Battista 82, 88, 89, 100, 104 On Painting 89 Alchemy 166 Alcuin 29 Aldus Manutius 112

Alexander the Great 19 Alexander VI, Pope 144 Alexander Mosaic 19, 21 Alexis, Paul 288 all-over painting 369, 375, 379 alla prima technique 211 Alloway, Lawrence 380 Altdorfer, Albrecht 166-7 Christ Taking Leave of

His Mother 167, 197 Danube Landscape 167, 198 Amenhotep III 12

Amenhotep IV (Akhenaten) 12, 13

American art 302-5, 366-82 pre-war 366-7 American Style 368 anatomy 94, 111, 118

Ancients 271 Andrea del Sarto 139-40 Portrait of a Young Man

140, 167 Andrew, St. 45, 136

Angelico, Fra 90-2, 93 The Beheading of St. Cosmas

and St. Damian 80, 90, 103 Virgin and Child Enthroned with Angels and Saints

90-2, 104

57, 72, 73

Anne of Cleves 160 Annunciation paintings 50, 63, 86, 92, 209 Anthony Abbot, St. 58, 99 Anthony the Hermit, St.

Portrait of a Young Man 111, 126 Virgin Annunciate 111, 127 Apocalypse 32 Apollinaire, Guillaume 338, 346, 352 Apollo 193, 196-7, 232 Aguinas, St. Thomas 44 Arcadia 218-19 Archaic period 16 Architectural Digest 380 architecture 40, 44, 48, 53, 82,104, 135, 176, 224, 231, 268, 335, 356, 363, 377 Arctinus 147

Antonello da Messina 67,

111, 112

Aristotle 94, 128, 131 Arnolfini, Giovanni 64-5 Arnolfo di Cambio 51 Art Brut 364 Art Nouveau 325, 327 Artemidorus 22 Ascanius 222

astronomy 146 attribution 203

Auerbach, Frank 383, 384, 385 The Sitting Room 385, 449 Avignon Pietà, Master of,

Pietà 39, 66, 79

Babel, Tower of 168-9 Bacon, Francis 141, 384, 385, 386

Portrait of Isabel Rawsthorne Standing in a Street in Soho 384, 447

The Baker and His Wife 22, 26 Ball, Hugo 362 Balla, Giacomo 351 Balthus 383-4

The Game of Cards

383-4, 446 banking, Italian 133

Baptistery, Florence 53 Barbier, Baron 298 Barbizon School 274, 279,

281, 290 Baroque and Rococo 173-235 Italian Baroque 216, 242

Spanish Baroque 193-9, 248 Bartholomew, St. 124

Baselitz, Georg 386, 387 Adieu 387, 452

Baudelaire, Charles 283, 286, 287

The Painter of Modern Life 286

Bauhaus 356 Bayeux Tapestry 33, 44 Bayne, Anne (Ramsay) 242 Bazille, Frédéric 289

Bearded Youth 22, 28 Beatus 32

Beccafumi, Domenico 144-5 The Fall of the Rebel Angels 145, 176

Beckmann, Max 342, 343 Self-Portrait 343, 385

Bellagambe, Jean,

Last Judgment 208, 209 Bellini, Gentile 106, 114

Bellini, Giovanni 106-11, 112, 114, 129, 131, 144, 152

The Agony in the Garden 107, 122

The Feast of the Gods 78-9, 110, 125

The Madonna of the Meadow 108-9, 127, 123 St. Jerome Reading 110, 124

Bellini, Jacopo 106, 107, 114 Bellini, Nicolosia 106

Bellotto, Bernardo 234 Benci, Ginevra de' 118-19

Berenson, Bernard 95 Berlin Painter, Pallas Athena 17, 13

Bernard, Emil 317, 322 Buckwheat Harvest 322 Bernini, Gianlorenzo 183

St. Teresa of Avila 176 Berry, Jean Duc de 55, 67 Bibles moralisées 34, 46 birth trays 130

Bismarck, Otto von 286 Bison (from Altamira cave) 10. 1

Black Death 55, 58, 82 Blake, William 270, 271

The Ancient of Days 34, 47 Job and His Daughters 271, 314

Songs of Innocence 270 Der Blaue Reiter

(The Blue Rider) 353-5, 358 Blavatsky, Helena,

The Secret Doctrine 353

Blériot, Louis 352 Boccaccio, Giovanni,

The Decameron 53

Boccioni, Umberto, Street Noises Invade the House 351, 398

Bomberg, David 384, 385 Bonaparte, Joseph 250

Bonito Oliva, Achille 386 Bonnard, Marthe 309, 326-7 Bonnard, Pierre 326-7, 329,

383 The Bath 326-7, 370 The Letter 309, 326, 369 Stairs in the Artist's Garden

327, 371 book burning 357

Book of Durrow 30

Book of Kells 30

books of hours 55, 151 Borbón family 249

Borgia, Lucrezia 144 Borromini, Carlo 176

Bosch, Hieronymus 66, 70, 72-5, 150, 168

Death and the Miser 74, 75, 90

The Path of Life 73, 88 The Ship of Fools 73-5, 89

The Temptation of St. Anthony 39, 73, 87

Botticelli, Sandro 93, 94-8, 133

> The Adoration of the Magi 98, 111

The Birth of Venus 95-7, 110 Primavera 80, 95, 96,

97, 109

San Bernabo Altarpiece 98 Boucher, François 175,

226-8, 230

Diana Bathing 226-7, 264 Venus Consoling Love 228, 265

Bouguereau, Adolph-William, L'Innocence 258

Boulle, André Charles 231 Bouts, Dieric, Portrait of a

Man 70, 85 Bramante 121

Brancusi, Constantin 345 Braque, Georges 332, 335,

338, 346, 347, 348, 350, 353 Still Life: Le Jour 350, 396

Breton, André 338 British School 240-7

Bronzino, Agnolo 133, 141 An Allegory with Venus and

Cupid 141, 170 Eleanora di Toledo 141, 169

Brown, Lancelot

Capability 268 Browning, Robert 278 Die Brücke (The Bridge) 340,

341-3, 351, 353 Brueghel, Pieter 166, 167-71

Gloomy Day 151, 169-70, 201

Hunters in the Snow 151, 171, 202

The Tower of Babel 168-9, 200

The Wedding Feast 148-9, 151, 168, 199

Brugada, Antonio 252 Brunelleschi, Filippo 82, 83, 84, 89, 93, 102, 104

Bruyas, Alfred 283 Brygos Painter,

"The End of the Party" 17, 14 Buckingham, Duke of 187 Buñuel, Luis 364

Burne-Jones, Edward, The Golden Stairs 278, 318 Byron, George Gordon, Lord 261, 262, 267 Byzantine art 24-7, 29, 37, 41, 43, 46, 50, 66, 145

Caesar Augustus 20 Cage, John 382 Caillebotte, Gustave 298 Calvin, Jean 165 Calvinism 215

camera obscura 210 Campin, Robert 60-2, 67, 71 Nativity 60, 62, 72

Portrait of a Woman 39, 61. 74

Virgin and Child Before a Firescreen 60-1, 73 Campin, Robert,

follower of, Madonna and Child with Saints in an Enclosed Garden 62, 75

Canaletto 115, 234 The Stonemason's Yard 234, 274 Venice: The Basin of San

Marco on Ascension Day 175, 234, 275

Canova, Antonio 254 Psyche Revived by the Kiss of Love 254

Caravaggio 176-9, 180, 182, 185, 186, 187, 193, 194, 223, 282

Bacchus 172-3, 177, 204 The Death of the Virgin 174, 177, 205 The Lute Player 176-7, 203

The Supper at Emmaus 178-9, 206

Carolingian empire 29 Carpaccio, Vittore 114-15 The Dream of St. Ursula

The Flight into Egypt 114, 133

Carrà, Carlo 351, 361, 362 Carracci, Agostino 182 Carracci, Annibale 182-3,

185, 216 Domine Quo Vadis? 182, 210

The Flight into Egypt 182-3, 211

Carracci, Ludovico 182 Carracci family 183-4 cartoons 280

Cassatt, Mary 290-1, 310, 367 Girl Sewing 290-1, 332

cassoni 114 Castiglione, Baldassare 143

Il Cortegiano 129 cathedrals 37, 40, 41, 53, 82, 91, 142 Catherine, St. 144 Catholic Church 186, 187 see also Christianity Cavallini, Pietro 44, 46 The Last Judgment 34, 48 cave painting 10-12 Cenami, Giovanna 64-5 ceramics 16-17, 99, 208, 224, 230, 240, 245 Cervantes, Miguel de, Don Quixote 193 Cézanne, Paul 284, 286, 289, 294, 300, 301, 307, 308, 310-13, 314, 327, 329, 348 Abduction 311, 351 The Artist's Father 310-11, Le Château Noir 309, 312-13, 352 Still Life with Apples and Peaches 312, 353 Chagall, Marc 344, 345, 359 The Fiddler 345, 389 Champfleury, Jules 283 Chardin, Jean-Baptiste-Siméon 230-1 The Attentive Nurse 230-1, 268 The House of Cards 231, Soap Bubbles 231 Still Life 175 Still Life with Game 231, 269 Charigot, Aline 298 Charlemagne, Emperor 29 Charles I, King of England 191, 192 Charles IV, King of Spain 249 Charles V, King of France 55 Charon 150 Chaucer, Geoffrey, The Canterbury Tales 59 Chi-Rho page (Book of Kells) 30, 40 Chi-Rho page (Lindisfarne Gospels) 30, 39 Un Chien Andalou 364 Chirico, Giorgio de 361-2, 364, 365 The Uncertainty of the Poet 362, 412 chivalry 61 Chloris 95, 96, 97 Christianity 29, 37, 108, 149, 176 see also Catholic Church Christina of Denmark 152, 160 Christopher, St. 32 Christus, Petrus,

The Man of Sorrows 66-7, 80

churches 40, 42 see also cathedrals Cima da Conegliano 112-13 St. Helena 113, 129 Cimabue 42-3, 46 Maestà 38, 43, 51 cinema 335, 364, 377 Circle 360 city states, Italian 110 Classical Greek period 17 Classicism 81 French 216-23 Claude Glass 222 Claude Lorrain 220-2, 264, The Judgment of Paris 220-1, 257 Landscape with Ascanius Shooting the Stag of Silvia 222, 259 Landscape with the Marriage of Isaac and Rebekah 220-1, 258 Cloisonnism 322 Clotaire, King 33 Clouet, François 164 Clouet, Jean, Francis I 164, 192 Coates, Robert 368 collage 350 Colleoni, Bartolommeo 116 Colorists 373, 375-6 Columbine 225 commedia dell' arte 225 Commune, Paris 282 Constable, John 240, 242, 260, 264, 266, 268-71, 281, Dedham from Langham 270-1, 313 The White Horse 239, 270, 312 Wivenhoe Park, Essex 269, 311 Constantine, Emperor 24 Copley, John Singleton, The Copley Family 238, 246-7, 286 Coquelin, Ernest Alexandre Honoré (Coquelin cadet) Corday, Charlotte 254 Corot, Camille 279-80, 281, 290, 300 A View near Volterra 279-80, 320 Ville d'Avray 274, 280, 321

Correggio 133, 141-2, 143

Catherine 142, 171

81, 142, 172

142

Assumption of the Virgin

The Mystic Marriage of St

Venus, Satyr, and Cupid

The Vision of St. John the Evangelist 142 Cossa, Francesco del, St. Lucy 113, 114, 131 Costa, Lorenzo 110 Counter-Reformation 145, 147, 174, 182, 187 Courbet, Gustave 273, 279, 282 -3, 284, 285, 302, 310, 321 Bonjour Monsieur Courbet 274, 283, 325 The Painter's Studio 282-3, 324 courtyard scenes 212 Couture, Thomas 289 Cranach, Lucas, the Elder 159, 164, 166 The Crucifixion with the Converted Centurion 150, 158, 185 Martin Luther 156 The Nymph of the Spring 156-7, 183 A Princess of Saxony 158, 184 Crivelli, Carlo 112-13 Madonna and Child Enthroned, with Donor 112, 128 Cross, legend of 102, 113 Crucifixion 39, 77 Cubism 313, 334, 338, 346-8, 350, 352, 359, 380 Analytical and Synthetic 347, 350 Cupid 95, 97, 133, 221 Cuyp, Albert, Herdsman with Cows by a River 214, 249

Dali, Salvador 363, 364 Declaration 361 The Persistence of Memory 332, 364, 416 Dante Alighieri, The Divine Comedy 44, 47, 278 Darius III 19 "Dark Ages" 28 Daubigny, Charles-François 279, 290, 296, 299 Daumier, Honoré 279, 280, 281 Advice to a Young Artist 280, 322 David (Old Testament) 64 David, Gerard 70 The Rest on the Flight into Egypt 71, 86

David, Jacques-Louis 252,

392

Dada 361, 362-3, 382

Dagobert, Prince 33

253-5, 256 The Death of Marat 254-5, 297 Madame Récamier 254, 296 The Oath of the Horatii 238, 251, 253-4, 295 David and Goliath (fresco) 28. 36 de Kooning, Willem 266, 368, 369, 371-2 Door to the River 372, 428 Woman and Bicycle 372, 427 The Death of Harold's Brothers (Bayeux Tapestry) 33 Debois, Robert and Gilles 230 Degas, Edgar 283, 284, 286, 291-3, 294, 302, 310, 316, 329 Four Dancers 275, 292, 334 Girl Drying Herself 292, 335 Madame René de Gas 291-2, 333 sculpture 292 Degas, Estelle 292-3 Degas, René 292 "degenerate art" 341 Deianira 185 Delacroix, Eugène 80, 259, 260-3, 270, 319 Arabs Skirmishing in the Mountains 262-3, 306 Death of Sardanapalus 239, 261, 305 Massacre at Chios 270 An Orphan Girl in the Graveyard 236-7, 261, 304 Delaunay, Robert 352, 358 Homage to Blériot 352, 400 Delilah 201 Demarsy, Jeanne 288 Demeter 18 Denis, Maurice 326 Homage to Cézanne 327, Derain, André 334, 335, 383 Charing Cross Bridge 335, Descartes, René 223

Diana 151

Dickens, Charles 277

Diebenkorn, Richard,

Dimmock, Emily 329

Dinteville, Jean de 161

Discus Thrower 17, 17

Domenichino 186, 216

Divisionism see Pointillism

Landscape with Tobias

Laying Hold of the Fish

Domenico Veneziano 100

Diogenes 128

183, 212

diptychs 54

Ocean Park 376, 436

St. John in the Desert 86-7, 100 Dominicans 91, 197 Donatello 59, 83, 85, 87, 93, 103, 116, 335 David 83 Judith and Holofernes 105 Donne, John 217 Dossi, Dosso 144 Circe and Her Lovers in a Landscape 144, 174 Dou. Gerard. The Hermit 215, 252 Dubuffet, Jean, Nude with a Hat 364, 417 Duccio 46, 50, 52, 83 The Calling of the Apostles Peter and Andrew 44-5, 47, 136, 54 The Holy Women at the Sepulchre 38, 43, 53 Maestà 43-5, 109, 52, 54 Dufy, Raoul 335, 339 Regatta at Cowes 339, 381 Dunstable, John 112 Durand-Ruel, Paul 299 Dürer, Agnes 152 Dürer, Albrecht 75, 152-6, 162, 164, 166, 343 The Four Apostles 154-5, 181 Four Books on Human Proportions 153 The Four Horsemen of the Apocalypse 153 Madonna and Child 150, 152-3, 180 The Painter's Father 156, Self-Portrait 152, 156, 179 Durrio, Paco 327 Dutch Protestant vision 200-15 dwarves 196

Eadfrith 30
Eakins, Thomas 302, 305, 366, 367
The Biglin Brothers Racing 305, 348
Early Christian art 24-7
Edmund, St 54
Edward III, King of England 54
Edward VI, King of England 159
Edward the Confessor 54
Elizabeth, St. 98-9, 217
Elsheimer, Adam 183
Elsheimer, Adam, after, Tobias and the

Archangel Raphael Returning

with the Fish 183,

213

embroidery, English 33 émigrés 344-5 engravings 235, 270 E.O.W. 385 equestrian painting 247 equestrian statues 116 Erasmus, Desiderius 82, 154, Ernst, Max 350, 362-3, 364, The Entire City 362, 413 d'Este, Isabella 143 etching 203 Etruscan painting 18 Eve 55 L'Evénement 311 Exekias. Dionysos in His Boat 16, 12 exploration 125 Expressionism 325, 340-3, 344, 387 Eyck, Hubert van 63, 64 Ghent Altarpiece 63 Eyck, Jan van 64, 66, 70, 71, 111, 163 Adoration of the Lamb 62-3, 76 Annunciation 63-4, 77

F

fantastic, art of 361-5
Fantin-Latour, Henri 287, 289
Flowers and Fruit 289, 330
Homage to Delacroix 287, 289
Farnese, Ranuccio 132-3
Fascism 351
Faust 171
Fauvism 334-5, 337, 340, 341, 344, 352
Federal Art Project 366

"The Arnolfini Marriage"

Ghent Altarpiece 62-3

39, 64-5, 78

Federigo da Montefeltro,
Duke of Urbino 100
Female idol from Amorgos
14, 8

Fénéon, Félix 315 Ferdinand, Archduke 342 Ferdinand "the Catholic," King of Spain 197

Ferdinand VII, King of Spain 250, 251

Fernandez, Gregorio, *Dead Christ* 198 Fernández de Moratín, Leandro 250

fêtes galantes 224, 225, 240 Feti, Domenico,

Claudio Monteverdi 182 Ficino, Marsilio E. 94, 112 Le Figaro 351 figurative painting, European 383-7 flâneurs 285, 302 Flaxman, John 240 Flémalle, Master of 61 Flora 95, 96, 97 Folies-Bergère 288 Fontainebleau, School of 151, Diana the Huntress 151, 164, 193 Fouquet, Jean, The Building of a Cathedral 40, 49 Fournaise, Monsieur 298 Fowling Scene 13, 5 Fragonard, Jean-Honoré 228-9, 230 Blindman's Buff 175, 228, 266 A Young Girl Reading 228, 267 Francis, St. 42 Francis I, King 120, 141, 151, 159, 164

159, 164
Franco, Francisco 374
Franco-Prussian War 286,

Franco-Prussian War 286 289, 299, 300 Frankenthaler, Helen,

Wales 375, **434**Frederick the Wise, Elector of Saxony 159

Frediano, St. 93 Fresco with dolphins (Palace of Knossos, Crete) 14, **9** frescoes 34, 38, 46, 47, 83, 142, 175, 232

Freud, Lucian 383, 386-7 Standing by the Rags 333, 386-7, **450**

Freud, Sigmund 357, 361, 386 Friedrich, Caspar David.

Friedrich, Caspar David, Monk by the Shore 264, 307

Froissart, Jean, *Chronicles* 54 Fry, Roger 311 Funeral mask

(Mycenae tombs) 15, 11 furniture 231

Futurists 351-2, 358

G

Gabriel, Angel 43, 63-4 Gachet, Dr. 318 Gainsborough, Molly and Margaret 241

Gainsborough, Thomas 238, 240-1, 245, 246, 247, 259, 264, 268

Mr and Mrs Andrews 238, 240-1, **278** Mrs. Richard Brinsley_

Sheridan 242-3, 280
The Painter's Daughters
Chasing a Butterfly 241, 279

Galileo Galilei 146 Garfield, James 304 Gaudí, Antoni 363

Gauguin, Paul 294, 300, 306-7, 308, 311, 316, 317, 318, 321, 322-4, 325, 326, 334, 335, 341

Nevermore 309, 324, **366** Riders on the Beach 324, **365** The Vision After the

Sermon 322-3, **364** Gautreau, Madame 305

Gay, John, *The Beggar's Opera* 235

Geese of Medum 12, 3 Genet, Jean 365

Gentile da Fabriano 56-7, 83, 106

The Adoration of the Magi 56, **67** The Presentation of the

Child in the Temple 57, **68** Gentileschi, Artemisia 180

Judith Slaying Holofernes 180, **209**

Self-Portrait as the Allegory of Painting 180, **208**

Gentileschi, Orazio,

The Lute Player 180, 207 George, St. 26, 57, 125

George III, King of England 240

Gerbier, Sir Balthasar 187 Géricault, Théodore 259-60 Death of Sardanapalus 239, 261

The Raft of the Medusa 259-60, **302**

Woman with the Gambling Mania 260, **303**

Ghiberti, Lorenzo 83, 88, 93, 103 Baptistery doors, Florence

Baptistery doors, Florence 102 Ghirlandaio, Domenico 124

The Birth of John the
Baptist 121, **141**St. Jerome 108

Giacometti, Alberto 365, 385 Jean Genet 365, 419

Gilot, Françoise 349

Giorgione 107, 110, 129-31, 133, 314

The Adoration of the Shepherds 131, **155** The Tempest 129-30, **153**

The Three Philosophers

130-1, **154** Giotto 34, 42, 43-4, 48, 52, 80, 82, 83, 178

campanile, Florence 48 Deposition of Christ 38, 47,

The Kiss of Judas 48-9, 57

Madonna and Child 46, 55 Giovanni di Paolo, St. John the Baptist Retiring

to the Desert 87, 101 Gleyre, Charles 301, 302 God the Father 84, 85, 124 God the Father as Architect 34,

Goebbels, Joseph 357

Goes, Hugo van der 70 The Adoration of the Shepherds 69 The Portinari Altarpiece

69, **83**Goethe, Johann Wolfgang von 171, 184, 264

Goliath 64 Golovine, Countess 258 Goncharova, Natalia 359

Gonzaga, Ludovico 104 Gonzaga family 104 Gorky, Arshile 371, 375

Waterfall 371, **426** Gossaert, Jan (Mabuse) 72, 163, 166

Danaë 163, **191** Portrait of a Merchant 163,

Gothic art 25, 37-77, 150 Goya, Francisco 242, 248-52,

259, 286, 305 Caprices 250 The Colossus 239, 252, **294**

The Dream of Reason 250 The Family of King Charles IV 249, **291**

Marquesa de Pontejos 248, 290 Thérèse Louise de Sureda

249-50, **292** The Third of May 1808

The Third of May 1808 250-1, **293** The Vintage 249

Graces, Three 95, 97

"Grand Manner" 244, 246 Grand Tour 215 Granvella, Cardinal 167-8

Gray, John 303 Great Depression 366, 367

Great Depression 366, 367 El Greco 20, 28, 145-7, 263

Laocoön 146-7, 178 Madonna and Child with St. Martina and St. Agnes

81, 145-6, *177* Greenberg, Clement 368

Gris, Juan 349, 350 Fantômas 350, **397**

Gropius, Walter 356 Grünewald, Matthias 75-7, 149

Crucifixion 39, 77, 163, **91** Isenheim Altarpiece 75-7 The Small Crucifixion 76,

92

Guardi, Francesco 234

A Seaport and Classical
Ruins in Italy 233, 273

Güell, Don Basilio 363

Guercino 218

Christ and the Woman
Taken in Adultery 185, 216

Guérin, Pierre-Narcisse 260

Guido da Como 46

guilds 68

Guston, Philip 368, 374

The Painter's Table 374, 433
Gutenberg Johannes 70

Gutenberg, Johannes 70

H

Haarlem, Academy of 165 Hades 18

haloes 45, 60

Hals, Frans 210-12, 282

The Laughing Cavalier 211

Portrait of Willem

Coymans 210, 245

The Women Regents of the Haarlem Almshouse 212,

246 Hamilton, Richard 382

Hanseatic League 71 Hapsburg dynasty 193, 194

Hapsburg dynasty 193, 19 Harlequin 225

Harold, King 33

Hasdrubal 114

Haussmann, Baron 284 Head of Nefertiti 13, 7

Head of Nefertiti 13, 7
Heckel, Erich 341

Heda, William, Still Life 206,

Heem, Jan de, Vase of Flowers 206, 241

Heffernan, Jo 302

Hegel, Friedrich 260 Helena, St. 102, 113

Hellenistic art 19-20, 21

Hennings, Emmy 362 Henry IV, King of France 188-9

Henry II, King of France 165 Henry VI, King of England 66

Henry VIII, King of England 150, 158, 160, 161, 162

Herbert, Albert, Jonah and the Whale 389, 455

the Whale 389, **455** Hercules 185

Hilliard, Nicholas 161 Hilliard, Richard 161

Hitler, Adolf 341 Hockney, David, *A Bigger*

Splash 382, 444

Hogarth, William 234-5, 242
Gin Lane 235
The Crah van Children 235

The Graham Children 235, 276

A Scene from the Beggar's

Opera 175, 235, 277 Hokusai, Katsushika 323 Holbein, Hans, the Younger 152, 158-62 The Ambassadors 161, 162, The Artist's Wife with Katherine and Philipp 162, Christina of Denmark 150, 160, 162 Edward VI as a Child 158-9, 186 Nicolaus Kratzer 161 Sir Brian Tuke 162, 189 Holofernes 104-5 Holy Roman Empire 157 Holy Spirit 63, 84, 100 Homer 15, 17, 257 Homer, Winslow 302, 304-5, 366, 367 Breezing Up 304-5, 347 Hooch, Pieter de, A Dutch Courtyard 212, 247 Hopper, Edward 366, 367 Cape Cod Evening 367, 420 Horatius, Horatii 253 horse racing 292 Huguenots 223 Humanism 80, 82, 95, 108, 129, 149, 152, 186 Hunt, William Holman 276, On English Coasts 277, 317 Huysmans, J.K. 76

icons 26-8, 43, 145, 359 illuminated manuscripts 28-34, 55 Impressionism 245, 272-305, 314, 321, 326, 327, 337 Industrial Revolution 269 Ingres, Jean-Auguste 256-7, 259, 263, 314 The Bather 239, 256-7, 298 La Grande Odalisque 256, 299 Thetis Entreating Jupiter 257, 300 Inquisition, Spanish 187, 193, 197 Intimists 326 "Irascible 18" 373 Isaac 220, 221 Isabella, Infanta 190, 191 Isabella of Castile, Queen 197

Issus, Battle of the 19

Italian Renaissance 78-147

Itet 12

Jacob 323 Jacobin Club 255 James, Henry 305 Japanese influence 275, 290, 292, 302, 308, 309, 316, 317, 320, 323, 326, 328 Jasperware 240 Jerome, St. 110 Jesuits 187 Iews 197, 387 John the Baptist, St. 54, 77, 98, 100, 101, 127, 217 John the Evangelist, St. 30, 47, 77, 84, 85, 154, 155 Johns, Jasper, Dancers on a Plane; Merce Cunningham 333, 381-2, 381 Jordaens, Jacob 190 The Four Evangelists 190, 191, 221 Joseph (Old Testament) 203-4 Joseph, St. 71, 114, 217 Joseph of Arimathea 47 Josephus 40 Judas 48, 49, 107, 135 Judith 104-5, 180 Julius II, Pope 121 Jung, Carl Gustav 73 Juno 191, 221 Jupiter 189, 257 Justinian, Emperor 25-6 Justinian and His Attendants 25-6, 31

Kandinsky, Wassily 353, 354-6, 356, 357, 359, 360 Accent in Pink 355, 404 Improvisation 31 (Sea Battle) 330-1, 332, 354-5, Kauffmann, Angelica 245 Kiefer, Anselm 386, 387 Parsifal I 387, 451

Kirchner, Ernst Ludwig 340, Berlin Street Scene 341, 383

Klee, Paul 353, 356-8, 361 Death and Fire 332, 358,

Diana in the Autumn Wind 357. 406

The Golden Fish 357, 405 Klimt, Gustav 325

The Kiss 309, 325, 368 Kline, Franz 368, 373 Ballantine 373, 430

Knights of Malta 132 Kokhlova, Olga 349 Kokoschka, Oskar 343

Bride of the Wind 343, 387 Kossoff, Leon 384-5

Two Seated Figures No. 2 385, 448 Kouros 17, 15 Krasner, Lee, Cobalt Night 370, 424 Kratzer, Nicolaus 161 Kritios 17

La Tour, Georges de 222-3 The Repentant Magdalen 223, 261

Kritios Boy 17, 16

Kublai Khan 44

Lamenting Women 12, 4 landscape gardens 268 landscape painting 101, 119, 127, 150, 151, 219

Northern 166-71 panoramic 53, 62 Romantic 264-71

Laocoön and His Two Sons 20,

Laurent, Méry 288 Laurentian Library 139 Le Nain, Antoine 222 Le Nain, Louis, Landscape with

Peasants 222, 260 Le Nain, Mathieu 222

Léger, Fernand 344, 352 Two Women Holding Flowers 352, 399

Leo III, Pope 27 Leo X, Pope 126 Leonardo da Vinci 80, 97, 116-20, 124, 126, 143, 179

Cecilia Gallarani 117, 137 Ginevra de' Benci 118-19,

The Last Supper 117 Mona Lisa 117-18, 136 Treatise on Painting 118 Virgin of the Rocks 80, 120, 139

Leroy, Louis 294 Lessore, Helen 385 Levey, Michael 46 Leyster, Judith 180

Lichtenstein, Roy, Whaam 381, 442 Limbourg, Pol, Herman

and Jean 55, 58 August 55, 65 The Garden of Eden 55, 66 Les Très Riches Heures du Duc de Berry 55, 65, 66

Lindisfarne Gospels 30 Lindsay, Margaret (Ramsay)

Linley, Elizabeth (Mrs. R. B. Sheridan) 242, 243 Lippi, Filippino, Tobias and the Angel 93, 107

Lippi, Fra Filippo 92-3 Annunciation 93, 106 Seven Saints 93, 108 Virgin and Child 92-3, 105 literature 44, 47, 51, 59, 112, 171, 193, 224, 257, 264, 277, 278, 285, 286, 303, 305, 321, 325, 335, 338, 349

London School 384 Lorenzetti, Ambrogio 55 Allegory of Good Government 36-7, 53, 62 The Charity of St. Nicholas of Bari 52-3, 63

Lorenzetti, Pietro, St. Sabinus before the Governor 52, 61 Lorrain, Claude 216

Lotto, Lorenzo, St. Catherine 144. 175 Louis, Morris 375-6

Beta Kappa 376, 435 Unfurleds series 376 Louis XIII, King of France

188, 216, 223 Louis XIV, King of France 183, 215, 218, 223, 231

Louis XV, King of France 225, 227, 230

Louis XVI, King of France 255, 258 Lucy, St. 113

Luini, Bernardino 120, Portrait of a Lady 120, 140 Luke, St. 30

Luther, Martin 154, 156, 159, 165, 169

Maar, Dora 349 Mabuse see Gossaert Macheath, Captain 235 Machiavelli, Niccolò 82 Il Principe 120 machine age 351-2 Macke, August 353, 354 Woman in a Green Jacket 354, 402 Maderno, Carlo 176 Madonna see Mary, Virgin Magi 56, 98, 130 Magritte, René 363-4 The Fall 364, 415 Mahler, Alma 343 Mahler, Gustav 343 majolica ware 99

Malevich, Kasimir 359 Dynamic Suprematism 359, 408 White on White series 359

Mallarmé, Stéphane 321, 325 Manet, Edouard 283, 284-9, 290, 291, 292, 302, 304,

310, 321 Le Déjeuner sur l'Herbe 274, 285, 287, 326 Gare Saint-Lazare 287-9, Still Life with Melon and Peaches 286, 327 The Bar at the Folies-Bergère 288, 289, 329 Manet, Eugène 290 Mannerism 20, 80, 81, 139-47, 150, 151, 173, 176, 256 Northern 163-5 Mantegna, Andrea 103-7, 111,

The Agony in the Garden 107, 109, 121 The Death of the Virgin 103, 117

112, 113, 114, 141

frescoes 103 Judith and Holofernes 104, 119, 120

Portrait of a Man 104, 118 Marat, Jean Paul 254-5 Marc, Franz 353-4

Deer in the Forest II 354,

Marcus Aurelius 116

Margaret, St. 69 Margaret of Anjou 66 Margarita Teresa, Infanta 195 Marie Antoinette, Queen 258 Marie-Thérèse (mistress of Picasso) 349 Marinetti, Filippo 351

Mark, St. 30, 154, 155 Marlowe, Christopher 171 Marquet, Pierre-Albert 334 Marsvas 193

Martin, Agnes, Untitled No. 3 379, 440

Martin V, Pope 55 Martina, St. 146 Martini, Simone 50-1, 52 The Angel and the

Annunciation 38, 51, 58 The Angel of the Annunciation 38, 56, 59

Christ Discovered in the Temple 51, 60

Marx, Karl 357 Mary II, Queen 215 Mary Magdalene, St. 47, 67, 69, 131, 177, 223

Mary, Virgin 26-7, 38, 40, 43, 47, 51, 54, 56, 57, 62, 63-4, 67, 71, 77, 83, 84, 85, 93, 98-9, 108, 109, 113, 114,

124, 126, 127, 142-4, 146, 152-3, 177, 217

cult of 51 Marzocco 87

Masaccio 59, 80, 82-6, 90, 100, 178, 314

Adam and Eve Expelled from Paradise 80, 83-4, 94 Brancacci Chapel frescoes 83, 85, 92-3 St. Jerome and St. John the Baptist 86, 98 St. Peter Healing with His Shadow 85, 96 The Trinity 84, 85, 95 The Virgin and Child 82, 83, 93 Masolino 86 Annunciation 86, 97 St. Liberius and St. Matthias 86, 99 Massys, Quentin 72 "Master of..." (as term) 61 Matilda, Queen 33 Matisse, Amélie 336, 337 Matisse, Henri 48, 131, 333, 334, 335, 336-9, 341, 349, Beasts of the Sea 339, 380 The Conversation 332, 337-8, 378 Madame Matisse, Portrait with a Green Stripe 336, Odalisque with Raised Arms 338-9, 379 Woman with a Hat 349 Matteo di Giovanni 101 Matthew, St. 29, 30, 84 Matthias, St. 96 Medici, Catherine de' 165 Medici, Cosimo de' 91, 93, 94, 98, 141 Medici, Lorenzino de' 97 Medici, Lorenzo de' 97, 126 Medici, Marie de' 188, 189, 191 Medici, Piero de' 93 Medici court 95, 98, 99, 121, 124, 133 medicine, medieval 76 Medusa 189 La Méduse 260 Memling, Hans 70, 71 Portrait of a Man with an Arrow 70, 84 Mengs, Anton 239, 245, 248, 253 Self-Portrait 248, 289 Mercury 95, 97 Metaphysical art 361, 362 Metropolitan Museum of Art, New York 373 Meurent, Victorine 285, 287 Michael, St. 58 Michelangelo Buonarroti 20, 80, 97, 102, 108, 116, 117, 120-4, 126, 130, 135, 139, 141, 163, 186, 187, 336 The Creation of Man

(Sistine Chapel) 124, 146 David 124 The Erythraean Sibyl (Sistine Chapel) 122, 123, The Holy Family (Doni Tondo) 121, 127, 142 Ignudo (Nude) (Sistine Chapel) 81, 122, 143 The Last Judgment 124, 145 Sistine Chapel ceiling 83, 120, 122-4 Millais, Sir John Everett 276, 277, 278 Christ in the House of His Parents 277 Ophelia 274, 276, 277, 316 Millet, Jean-François 280, 281, 298 The Gleaners 274, 281, 323 Milton, John 183 Minerva 189, 191, 221 miniatures 161 Minimalism 373, 377-9 Minoan art 14, 16 Minos, King 14 Miró, Joan 363, 364 Woman and Bird in the Moonlight 363, 414 Mitchell, Joan, Sunflowers 389, 454 Modern Artists in America 377 Modernism 338, 367 Modigliani, Amedeo 344, 345 Chaim Soutine 345, 390 Mondrian, Piet 353, 360, 368 Diamond Painting in Red, Yellow, and Blue 332, 360, 410 The Gray Tree 360, 409 Monet, Claude 286, 287, 289, 294-7, 298, 300, 301 Impression: Sunrise 294 Rouen Cathedral series 295, 296 Rouen Cathedral, West Façade, Sunlight 296, 337 The Waterlily Pond 275, 296, 297, 338 Woman with a Parasol 294, Monroe, Marilyn 381 Monteverdi, Claudio, Orfeo Morandi, Giorgio, Still Life 365, 418 Moréas, Jean, Symbolist's Manifesto 321 Moreau, Gustave 341 Salome 321, 362 Morisot, Berthe 290, 294, 310, The Harbor at Lorient

290, 331

Morra, Sebastiano de 196 Morris, Janey 278 Morris, William 278 mosaics 25-6, 27, 34, 46 Motherwell, Robert 373-4, Elegy to the Spanish Republic No. 70 374, 432 Mourning Women (tomb at Riva di Puglia) 18, 19 mummy case (Faiyum) 22, Munch, Edvard 325, 341 Four Girls on a Bridge 309, 325, 367 The Frieze of Life 325 Münster, Treaty of 186, 200 Muralists, Mexican 370 Murillo, Bartolomé Esteban 81, 198 The Holy Family 198, 232 Two Women at a Window 198, 233 music 63, 110, 112, 141, 224, 257, 285, 325, 335, 355, 377, 382 Muslims 197 Mussolini, Benito 351 Muybridge, Eadweard 293 Mycenaean art 15-16 Myron 17

Nabis 308, 309, 326-9 Nadar 294 Naïve (Primitive) art 361 Napoleon I, Emperor 250, 252, 254 Napoleon III, Emperor 282, 283, 284 Native American art 368 Natkin, Robert, Farm Street 388, 453 Nazarenes 271 Nazis 341, 343, 356 Nebamun 13 Nefermaat 12 Neo-Impressionism 301 Neo-Plasticism 360 Neo-Platonism 94, 145 Neo-Romantics 271 Neoclassicism 175, 216, 253-8 and Romanticism 236-71 Nessus 185 Neumann, Balthasar 231 New York Herald 373 New York School 368-74, 384 New Yorker 368 Newman, Barnett 368, 373, 375, 377 Yellow Painting 373, 431 Newton, Sir Isaac 264, 355 Nicholas, St. 52-3, 98-9

Nicodemus 47 Nicola da Urbino 99 Nolde, Emil 340, 341 Early Evening 341, 384 "Noli me tangere" 131 Norman Conquest 33 Northern Renaissance 148-171

Odo, Bishop 33
oil as painting medium 64,
111, 131
O'Keeffe, Georgia 366, 367
Jack-in-the-Pulpit 367, 421
Olivares, Count 194
opera 182, 183, 325, 387
Opera House, Paris 291
Ophelia 276
Orléans, Duc d' 225
Orozco, José Clemente 370
Orpheus 352
Orphism 352

Oscott Psalter 32, 42

Palazzo Pubblico, Siena 53 Palladio, Andrea 135 Pallas Athena 16, 17, 13 Palmer, Samuel 271 Coming from Evening Church 271, 315 panel paintings 75 papier collé 350 Paris (Trojan prince) 165, 220, 221 Paris, Matthew, St. Christopher 32, 41 Parmigianino 142-4 The Madonna with the Long Neck 142-4, 256, 173 Patinir, Joachim 163, 168 Charon Crossing the Styx 150, 166, 196 Paul, St. 135, 154, 155 Paul III, Pope 187 Paul IV, Pope 132 Paul the Hermit, St. 58 Peri, Jacopo, La Dafne 182 Persephone 18, 97 Perseus 107, 189 perspective 88-9, 103, 118, 288 Perugino, Pietro 124-5 Crucifixion with the Virgin, St. John, St. Jerome, and St. Mary Magdalene 125, 147 Peter, St. 32, 45, 49, 85, 136, 137, 154, 155, 182 Peter Martyr, St. 93 Petrarca, Francesco (Petrarch) Pharaoh Tuthmosis III 13, 6

Philip the Good, Duke of Burgundy 67, 69 Philip II, King 75, 133, 193 Philip III, King 193, 198 Philip IV, King 193-6 photography 293, 380 Picasso, Pablo 126, 333, 336, 337, 338, 339, 341, 346-9, 350, 361, 371 Les Demoiselles d'Avignon 332, 347-8, 392 Family of Saltimbanques 347, 391 Guernica 349 The Lovers 349, 393 Nude Woman in a Red Armchair 349, 394 Weeping Woman 349, 395 Piero della Francesca 86, 100-3, 111 The Baptism of Christ 100-1, 114 Misericordia altarpiece Resurrection of Christ 80, 102, 116 The Story of the True Cross 102, 115 Piero di Cosimo 98-9 Allegory 99, 113 Hunting Scene 99 Mythological Scene 99 Portrait of Simonetta Vespucci 99 The Visitation with St. Nicholas and St. Anthony Abbot 98-9, 112 Pierrot 225 pigments, grinding 143 Pilate, Pontius 225 Pisanello, Antonio portrait medal 57 The Virgin and Child with St. George and St. Anthony Abbot 57, 69 Pisano, Andrea 53 Pisano, Giovanni 44, 46 Pisano, Nicola 44, 46, 83 Allegory of Strength 47 Pissarro, Camille 286, 289, 294, 300-1, 310, 312, 315, 316, 317, 322 Orchard in Bloom, Louveciennes 300-1, 342 Peasant Girl with a Straw Hat 301, 343 Plato 94, 112, 128 plein air painting 279, 296 Pliny the Elder 16, 19 Poe, Edgar Allan, The Raven 309, 321, 324 Pointillism (Divisionism) 301,

308, 315

Pollaiuolo, Antonio,

Martyrdom of St. Sebastian Pollaiuolo, Piero 94 Pollock, Jackson 266, 368, 369-70, 373, 375, 379 The Moon-Woman Cuts the Circle 422 Number 1, 1950, (Lavender Mist) 333, 369, 423 Polo, Marco 44 Polygnotos, "Discus Thrower" Pompadour, Jeanne, Marquise de 227, 230 Pont-Aven school 322 Pontormo 139-41 Deposition 140, 166 Monsignor della Casa 140, 168 Poor Clares 190 Pop Art 380-2 Popova, Liubov 359 Portinari, Maria 69 Portinari, Tommaso 69 portraiture 150 Post-Impressionism 306-29, 380 Potiphar and his wife 203-4 pottery, Delft 208 Poussin, Nicolas 216-20, 222, 349 Et in Arcadia Ego 218-19, The Funeral of Phocion 220, 256 The Holy Family on the Steps 174, 217, 253 Self-Portrait 217, 254 Pre-Raphaelites 271, 274, 276-8, 282 Primaticcio, Francesco, The Rape of Helen 164 primitive art see Naïve art; tribal art printing 70, 112 Protestantism 193, 197, 200 Proudhon, Pierre 283 Proust, Antonin, Souvenirs de Manet 289 Proust, Marcel 210 Ptolemy 128 Pucelle, Jean 33 Puget, Pierre, The Assumption of the Virgin 216 putti 134 Pythagoras 94, 128

Raeburn, Sir Henry, The Rev. Robert Walker Skating 244, 282

185, 214

299, 341

294, 298-9, 301

Renoir, Auguste 228, 273, 289,

Bather Arranging Her Hair

The Boating Party Lunch

Ramose 12, 18 Ramsay, Allan, Margaret

Lindsay, Mrs Allan Ramsay The Rape of Persephone 18, 20 Raphael 80, 103, 106, 116, 121, 124-9, 131, 141, 163, 176, 185, 256, 276, 285, 336 The Alba Madonna 126-7, Bindo Altoviti 81, 128-9, 151 portrait of Castiglione 129 St. George and the Dragon 125, 148 The School of Athens 129, 128 Small Cowper Madonna 126, 127, 149 Raphael, archangel 183 Rauschenberg, Robert, Canyon 382, 445 Realism, French 279-83, 285, 321 Rebekah 220, 221 Redon, Odilon 321, 329 Mimosas, Anemones, and Foliage in a Blue Vase 321, Reformation 150, 169, 171, 176, 186, 187, 200 Reinhardt, Ad 377-9 Abstract Painting No. 5 377-9, 437 Rembrandt van Rijn 120, 131, 174, 200-6, 210, 215, 248, 282, 316, 348, 349 The Blinding of Samson 201, 234 "The Jewish Bride" 64, 204-5, 239 Joseph Accused by Potiphar's Wife 203-4, 238 Portrait of a Lady with an Ostrich-Feather Fan 202, Self-Portrait 202, 236 Self-Portrait at the Age of About 21 Years 202, 235 Renaissance 20, 38, 46, 217, 276, 314 early 82-105 High 103, 116-38, 139, 186, 216 Italian 38, 60, 79-147 Northern 38, 60, 148-71 in Venice 106-15 Reni, Guido 184-5 Deianira Abducted by the Centaur Nessus 185, 215 Susannah and the Elders

272-3, 275, 298-9, 339 A Girl with a Watering Can 299, 340 restoration 83 Revellers (from the Tomb of the Leopards, Tarquinia) 18, 18 Revolution, American 246 Revolution, French 228, 253, 255, 258 Revolution, Russian 354 Reynolds, Sir Joshua 238, 240, 244. 246 Discourses 244 Lady Caroline Howard 238, 244, 283 Rezzonico, Ludovico 232 Ribera, Jusepe de 193 The Flaying of Marsyas 193, 225 Richard II, King of England 54 Richelieu, Armand Jean Duplessis, Cardinal 216, 223 Riemenschneider, Tilman, The Virgin of Sorrows 154 Rimbaud, Arthur 321 Rivera, Diego 370 Della Robbia, Ambrogio 99 Della Robbia, Luca 91 Robert of Anjou 50 Roberti, Ercole de', The Wife of Hasdrubal and Her Children 114, 132 Robespierre, Maximilien de Rockburne, Dorothea, Capernaum Gate 379, 439 Rococo 174-5, 224-35 Rohan Hours, Master of the, The Dead Man before His Judge 58, 70 Roland, Henry 385 Roman painting 20-2, 34 Roman sculpture 23 Romanesque painting 34, 37, Romanticism French 259-63, 274 and Neoclassicism 236-58, Roosevelt, Franklin D. 366, Roque, Jacqueline 349 Rosenberg, Harold 368 Rossetti, Dante Gabriel 276, The Day Dream 278, 318 The Girlhood of Mary

Untitled (Black and Grey) 333, 370, 425 Rouault, Georges 334, 335, 341, 344 Prostitute at Her Mirror 341, 382 Rouen Cathedral 295-6 Rousseau, Henri 338, 361 Boy on the Rocks 361, 411 Rousseau, Jean-Jacques 255 Discourse on the Sciences and the Arts 259 Royal Academy (British) 240, 244, 277 Rubens, Peter Paul 186-91, 200, 225, 228, 239, 261 The Apotheosis of Henri IV and the Proclamation of the Regency 188-9, 219 Deborah Kip, Wife of Sir Balthasar Gerbier, and Her Children 187, 218 Descent from the Cross 174, 187, 217 The Judgment of Paris 189, 190-1, 220 Life of Maria de' Medici (cycle) 188-9, 225 Louis XIII Comes of Age 188 Marchesa Brigida Spinola Doria 191, 222 Rublev, Andrei, Trinity 28, 35 La Ruche 344 Rudolf II, Emperor 165 Ruisdael, Jacob van, Forest Scene 214, 250 Ruisdael, Salomon van 214 Ruskin, John 134, 269, 276 Modern Painters 269 Russian art 28 Russolo, Luigi 351 Ruysch, Rachel 180

Sabinus, St. 52 Saenredam, Pieter, The Grote Kerk, Haarlem 214-15, 251 St. Bartholomew's Day Massacre 165 St. Denis Missal 33, 45 St. Matthew (Harley Golden Gospels) 29, 37 St. Peter (Oscott Psalter) 32, 42 Salome 321 Salon des Refusés 284, 294 Salons, French 258, 260, 335 Samson 200, 201 sand paintings 368 Sargent, John Singer 305 Madame X 305 Mrs. Adrian Iselin 305, 349 Sassetta 58-9 The Meeting of St. Anthony

and St. Paul 58, 71 Saturn 189 Savonarola, Girolamo 98, 99 Savorgnan, Faustina 232 Schiele, Egon, Nude Self-Portrait 343, 386 Schmidt-Rottluff, Karl 340, 341 Schopenhauer, Arthur 260 Scrovegni, Enrico 48 sculpture 13, 14, 17, 20, 23, 41, 46, 47, 51, 83, 91, 102, 105, 116, 124, 176, 198, 216, 254, 292, 335, 345, 377 Sebastiano del Piombo 130 The Raising of Lazarus 120 Selve, Georges de 161 Sérusier, Paul 321, 326 The Talisman (Bois d'Amour) 321, 326 Seurat, Georges 301, 307, 314-15, 316 La Grande Jatte 314, 315 The Lighthouse at Honfleur 308, 315, 355 Les Poseuses 314, 315, 354 Severini, Gino 351 Seymour, Jane 160 sfumato 116, 119, 120 Shakespeare, William 183, 276, 278 Sheba, Queen of 102 Sheridan, Richard Brinsley 242, 243 sibyls 122, 123 Sickert, Walter 329 Camden Town Murder series 329 La Hollandaise 329, 374 Siddal, Elizabeth 277, 278 silk-screen printing 380, 381 Simeon 41 sinopia 103 Siqueiros, David 370 Sisley, Alfred 286, 289, 294, 301 Meadow 275, 301, 344 16 Americans exhibition 379 Sixtus V, Pope 176 Slade-Jones, Rev. 316 Social Realism 325 Socrates 128 Solomon, King 102 Soutine, Chaim 344, 345, 359,

Squarcione, Francesco 103

Landscape at Ceret 344,

Spanish Civil War 373-4

Spranger, Bartholomeus,

Vulcan and Maia 151, 165,

The Spectator 267

Rosso Fiorentino 139, 145, 164

Rothko, Mark 266, 368, 370-1,

Moses and the Daughters of

Virgin 276

Jethro 139, 165

373, 376, 377

stain painting 375 stained glass 40, 341 Steen, Jan, The Skittle Players Outside an Inn 212-14, 248 Stein, Gertrude 349 Stella, Frank 378, 379 Six Mile Bottom 378, 379, 438 Stieglitz, Alfred 367 De Stiil 360 Still, Clyfford 368, 372, 373 1953 372, 429 still life 179, 206, 231, 365 Still Life with Peaches 22, 25 Strozzi, Clarissa 132 Strozzi, Palla 56 Stuart, Gilbert, Mrs. Gilbert Yates 245, 284 Stuart and Revett, Antiquities of Athens 268 Stubbs, George 238, 247 A Horse Frightened by a Lion 247, 288 Mares and Foals 238, 247, 287 Der Sturm 358 Suprematism 359 Sureda, Thérèse Louise de 249-50 Surrealism 338, 361, 362-4, 366, 368, 370, 372, 382 Susannah 185 Suzon 288 Symbolism 321-5 symbols 62, 109, 161, 179, 276 Symbols of the Evangelists (Book of Kells) 30, 38 Synthetism 326

tapestries 66, 249 Teha'amana 324 Tennyson, Alfred Lord 278 theater 73, 141, 159, 183, 242,

328, 377 Theocritus 218 Theodora, Empress 26 Theodore, St. 26-7

theosophy 353 Thetis 257

Tiepolo, Giambattista 231, 232-3, 234 Allegory of the Marriage of

Rezzonico to Savorgnan 175, 232, 271 Queen Zenobia Addressing

Her Soldiers 232-3, 272

The Times 276 Tintoretto 116, 129, 134-7, 138

Christ at the Sea of Galilee 136-7, 161 The Conversion of St. Paul

81, 135, 159 The Last Supper 135-7, 160 Summer 137, 162 Titian 75, 107, 110, 111, 116,

129, 131-4, 135, 138, 143, Christ Appearing to the

Magdalen 131, 156 Ranuccio Farnese 132-3,

Self-Portrait 131 Venus and Adonis 81, 134, 158

Tobias 183 tomb painting

Egyptian 12-13, 16 Etruscan 18

Toreador Fresco (Palace of Knossos, Crete) 14, 10

Toulouse-Lautrec, Henri de 316, 320

> Quadrille at the Moulin Rouge 320, 360

Rue des Moulins 308, 319, 361

Traherne, Thomas 137 Trajan, Emperor 23 Trajan's Column (detail) 23,

29 Transavantgarde 386 travel journals 262

Trent, Council of 187 tribal (primitive) art 334, 335, 337, 348, 359

Trinity 84 trompe l'oeil 118 Tuke, Sir Brian 162 tulips 206

Tura, Cosimo, Madonna and Child in a Garden 113, 114,

Turner, J.M.W. 264-7, 268, 269, 300

Approach to Venice 266-7,

Mortlake Terrace 264-5, 268. 308

Steamboat in a Snowstorm 239, 265-6, 309

Tuthmosis III 13 20th century 330-87

Tzara, Tristan 362

Uccello, Paolo 88-9 The Hunt in the Forest 88-9,

Universal Exhibition (1855) 282

Ursula, St. 115 Utamaro, Kitagawa, Woman with a Mirror 290

Valengin, Marie de 69 Van Dyck, Anthony 190,

191-2 Charles I of England out Hunting 192, 194, 224 Marchesa Elena Grimaldi

191, 223

Van Gogh, Theo 316, 317, 319 Van Gogh, Vincent 281, 300, 308, 311, 316-19, 320, 322,

325, 334, 335, 341, 348 The Artist's Bedroom 308, 316, 356

Farmhouse in Provence 317, 357

La Mousmé 317-18, 358 Self-Portrait 318-19, 359

vanishing point 89 "vanitas" 223

Vasari, Giorgio 84, 98, 140, 141

Lives of the Painters 57, 85-6, 88, 94, 98, 99, 108, 111, 119, 120, 128, 129

vase painting 16-17 Vauxcelles, Louis 335 Velázquez, Diego 186, 190,

194-7, 198, 235, 248, 286, 291 Christ on the Cross 196, 227

The Forge of Vulcan 196,

Francisco Lezcano 174, 196, 228

Las Meninas 102, 194-5, 226

Surrender of Breda 196 Venetian painting 106-15 Venice Biennale 386

Venus 95, 96, 97, 133, 151, 191, 221, 225, 226 Verlaine, Paul 321

Vermeer, Jan 62, 174, 208-10, 212, 215, 349

Kitchen Maid 174, 210, 244 View of Delft 210, 243 Woman Holding a Balance 208-9, 242

Veronese, Paolo 116, 137, 138 The Finding of Moses 138,

St. Lucy and a Donor 138,

163 Verrocchio, Andrea del 116,

The Baptism of Christ 117, 135 bronze putto 134

Vesalio, Andrea, De Humani Corporis Fabrica 111

Vienna Secession 309 Vienna Workshop 309 Vigée-Lebrun, Elisabeth, Countess Golovine 258, 301 Virgil 19, 218 Aeneid 20, 122, 147

Virgin and Child Enthroned Between St. Theodore and St. George (icon) 26-7, 32

"Vladimir Madonna" (icon) 27. 34

Vlaminck, Maurice de 334,

The River 334, 335, 375 Vollard, Ambrose 329 Vuillard, Edouard 326, 327, 328-9

The Reader 308, 329, 372 Vase of Flowers on a Mantelpiece 329, 373 Vulcan 196-7

Wagner, Richard 387 Walden, Hewarth 358 Walker, Rev. Robert 244 wall painting

catacombs of Rome 24, 30 Villa of Livia, Rome 21, 24 Wall Street Crash 367

Walpole, Horace 242 Warhol, Andy 380-1 Marilyn Diptych 333,

380-1, 441 Washington, George 245, 246 Watteau, Jean Antoine 174, 224-6, 240, 314

"Embarkation for Cytherea" 175, 225, 262

Italian Comedians 225, 263 Wedgwood, Josiah 240 Wellington, Duke of 254 West, Benjamin 245-6

Self-Portrait 245, 285 Westminster Psalter 32, 41

Weyden, Rogier van der 60, 62, 70, 163 Deposition 39, 67, 68, 81

Portrait of a Lady 68-9, 82 The Whirling Log (Navajo sand painting) 368

Whistler, James 284, 289, 302-3, 329

Nocturne in Blue and Gold: Old Battersea Bridge 275, 302, 345

The White Girl 302, 346 Wilde, Oscar 303

William I, the Conqueror 33 William III of Orange, King 191, 215

Wilton Diptych 38, 54, 64 Winckelmann, Johann

Joachim 248 Witt, Johann de 215 Wood, Robert 329 wood carvings 154, 324 woodcuts 153, 340 World War I 342, 343, 351, 352, 354, 361 World War II 368 Wounded bison attacking a man (from cave painting at Lascaux) 11, 2 Wren, Sir Christopher 224 Wtewael, Joachim 164-5 The Judgment of Paris 151, 165, 194

Y

Yates, Mrs. Richard 245 Young Girl Gathering Flowers 20, 23

Z

Zenobia 233 Zenobio family 232 Zephyr 95, 96, 97 Zola, Emile 311 Zola, Emile, L'Oeuvre 286 Zurbarán, Francisco 196, 197-8

The Lying-in-state of St. Bonaventura 198, 231 Still Life with Oranges 197, 230

PICTURE CREDITS

Every effort has been made to trace the copyright holders, and we apologize in advance for any unintentional omissions. We would be pleased to insert the appropriate acknowledgement in any subsequent edition of this publication.

Introduction

1. Altamira cave/Ancient Art and Architecture Collection 2. Lascaux cave/Ancient Art and Architecture Collection 3. Hirmar Fotoarchiv 4. Tomb of Ramose, Thebes/Mary Jellife/Ancient Art and Architecture Collection 5. The Trustees of The British Museum, London 6. The Trustees of The British Museum, London 7. Tomb of Nefermaat, Medum/Ancient Art and Architecture Collection 8. National Archaeological Museum, Athens/Bridgeman Art Library, London 9. Palace of Knossos, Crete/Sonia Halliday Photographs 10. Museo Heraklion, Crete/Scala 11. National Archaeological Museum, Athens 12. Staatliche Antinkensammlung, Munich/ Bridgeman Art Library, London 13. Antiken Museum Basel und Sammlung Ludwig/Foto Clare Niggli 14. Colorphoto Hans Hinz 15. Museo Nazionale, Athens/Scala 16. Acropolis Museum, Athens 17. Museo delle Terme, Rome/Scala 18. Archiv für Kunst und Geschichte, Berlin 19. Museo Nazionale, Naples 20. Fratelli Fabbri, Milan/Bridgeman Art Library, London 21. Museo Nazionale, Naples/Scala 22. The Vatican Museum, Vatican/Ancient Art and Architecture Collection 23. Archaeological Museum, Naples/Bridgeman Art Library, London 24. Metropolitan Museum of Art, New York/Bridgeman Art Library, London 25. Museo Nazionale, Naples/Scala 26. Museo Nazionale, Naples 27. The Trustees of the British Museum, London 28. Ancient Art and Architecture Collection 29. Courtauld Institute Galleries, London 30. Catacombe di Priscilla, Rome/Scala 31. San Vitale, Ravenna/Scala 32. Monastery of Saint Catherine, Mount Sinai/Ancient Art and Architecture Collection 33. Duomo, Monreale/Scala 34. Gallerie Statale Trat'Jakov, Moscow/Scala 35. Gallerie Statale Trat'Jakov, Moscow/ Bridgeman Art Library, London 36. Museu Nacional d'Art de Catalunya/Calveras/Sagrista 37. By permission of The British Library, London 38. The Board of Trinity College, Dublin 39. The British Library, London/Bridgeman Art Library, London 40. The Board of Trinity College, Dublin 41. By permission of The British Library, London 42. By permission of The British Library, London 43. Bibliothéque Nationale, Paris 44. City of Bayeux/Bridgeman Art Library, London 45. By Courtesy of the Board of Trustees of the V&A, Victoria and Albert Museum, London 46. Österreichische Nationalbibliothek, Vienna 47. The Trustees of The British Museum, London 48. S. Cecilia Trastevere, Rome/Scala

GOTHIC

49. Bibliotheque Nationale, Paris/ Bridgeman Art Library, London 50. Saint Chapelle, Paris/Sonia Halliday Photographs 51. Uffizi, Florence/Scala 52. Museo dell'Opera Metropolitana, Siena/Scala 53. Museo dell'Opera Metropolitana/Scala 54. Samuel H Kress Collection, National Gallery of Art, Washington DC 55. Samuel H Kress Collection, National Gallery of Art, Washington, DC 56. Scrovegni Chapel, Padua/Scala 57. Scrovegni Chapel, Padua/Scala 58. Uffizi, Florence/Scala 59. Samuel H Kress Collection, National Gallery of Art, Washington, DC 60. Walker Art Gallery, Liverpool/Board of Trustees of the National Museums and Galleries on Merseyside 61. Courtesy of Board of Trustees The National Gallery, London 62. Palazzo Publico, Siena/Scala 63. Louvre, Paris/Bridgeman Art Library, London 64. Courtesy of Board of Trustees The National Gallery, London 65. Musée Conde, Chantilly/Giraudon/Bridgeman Art Library, London 66. Musée Conde, Chantilly/Giraudon/ Bridgeman Art Library, London 67. Uffizi, Florence/Scala 68. Louvre, Paris/@Photo Ph.Sebert 69. Courtesy of Board of Trustees The National Gallery, London 70. Bibliotheque Nationale, Paris/Courtauld Institute Galleries, London 71. National Gallery of Art, Washington, DC 72. Musée des Beaux Arts, Dijon 73. Courtesy of Board of Trustees The National Gallery, London 74. Courtesy of Board of Trustees The National Gallery, London 75. Samuel H Kress Collection, National Gallery of Art, Washington, DC 76. Cathedral of St Bavo, Ghent/ Giraudon/Bridgeman Art Library, London 77. Andrew W. Mellon Collection, National Gallery of Art, Washington, DC 78. Courtesy of Board of Trustees The National Gallery, London 79. Louvre, Paris/ Giraudon 80. By Permission of Birmingham Museum and Art Gallery 81. Museo del Prado, Madrid 82. Andrew W. Mellon Collection, National Gallery of Art, Washington, DC 83. Uffizi, Florence/Scala 84. Andrew W. Mellon Collection, National Gallery of Art, Washington, DC 85. Courtesy of Board of Trustees The National Gallery, London 86. Andrew W. Mellon Collection, National Gallery of Art, Washington, DC 87. Museu Nacional de Arte Antiga, Lisbon/ Bridgeman Art Library, London 88. Louvre, Paris/© Photo Ph.Sebert 89. Louvre, Paris/© Photo Ph.Sebert 90. Samuel H Kress Collection, National Gallery

of Art, Washington, DC 91. Colmar/Bridgeman Art Library, London 92, Samuel H. Kress Collection, National Gallery of Art, Washington, DC

ITALIAN RENAISSANCE

93. Courtesy of Board of Trustees The National Gallery, London 94. Branacci Chapel, Florence/ Scala 95. Santa Maria Novella, Florence/Scala 96, Chiesa del Carmine, Florence/Scala 97. Andrew W. Mellon Collection, National Gallery of Art. Washington, DC 98. Courtesy of Board of Trustees The National Gallery, London 99. National Gallery London 100. Samuel H. Kress Collection. National Gallery of Art, Washington, DC 101. Courtesy of Board of Trustees The National Gallery, London 102. Ashmolean Museum, Oxford 103. © Louvre, Paris/Photo Ph.Sebert 104. Museo di Marco, Florence/Scala 105. © Photo Ph. Sebert, Louvre 106. Courtesy of Board of Trustees The National Gallery, London 107. Samuel H Kress Collection, National Gallery of Art, Washington, DC 108. Courtesy of Board of Trustees The National Gallery, London 109. Uffizi, Florence/Scala 110. Uffizi, Florence/Scala 111. Andrew W. Mellon Collection, National Gallery of Art, Washington, DC 112. Samuel H. Kress Collection, National Gallery of Art, Washington, DC 113. Samuel H. Kress Collection, National Gallery of Art Washington, DC 114. Courtesy of Board of Trustees The National Gallery, London 115. San Francesco, Arezzo/Scala 116. Pinacoteca Communale Sansepolcro/Scala 117. Museo del Prado, Madrid 118. Samuel H. Kress Collection, National Gallery of Art, Washington, DC 119. The National Gallery of Ireland, Dublin 120. Photo Richard Carafetti, Widener Collection, National Gallery of Art, Washington, DC 121. Courtesy of Board of Trustees The National Gallery, London 122. Courtesy of Board of Trustees The National Gallery, London 123. Courtesy of Board of Trustees The National Gallery, London 124. Samuel H. Kress Collection, National Gallery of Art, Washington, DC 125. Widener Collection, National Gallery of Art, Washington, DC 126. Courtesy of Board of Trustees The National Gallery, London 127. Galleria Nazionale della Sicilia, Parma/ Scala 128. Samuel H. Kress Collection, National Gallery of Art, Washington, DC 129. Samuel H. Kress Collection, National Gallery of Art, Washington, DC 130. Samuel H. Kress Collection, National Gallery of Art, Washington, DC 131. Samuel H. Kress Collection, National Gallery of Art, Washington, DC 132. Ailsa Mellon Bruce Fund, National Gallery of Art, Washington, DC 133. Andrew W. Mellon Collection, National Gallery of Art, Washington, DC 134. Accademia, Venice/Scala 135. Uffizi, Florence/Scala 136. Louvre, Paris/@ Photo Ph.Sebert 137. Czartorisky Museum,

Art, Washington, DC 139. Courtesy of Board of Trustees The National Gallery, London 140. Andrew W. Mellon Collection, National Gallery of Art, Washington, DC 141. Santa Maria Novella, Florence/Scala 142. Uffizi, Florence/Scala 143. Sistine Chapel, Vatican/© Nippon Television Network Corporation 1994 144. Sistine Chapel, Vatican/© Nippon Television Network Corporation 1994 145. Sistine Chapel, Vatican/ Scala 146. Sistine Chapel, Vatican/ © Nippon Television Network Corporation 1994 147, Andrew W. Mellon Collection, National Gallery of Art Washington DC 148. Andrew W Mellon Collection. National Gallery of Art, Washington, DC 149. Photo José Naranio, Widener Collection, National Gallery of Art, Washington, DC **150**. Andrew W. Mellon Collection, National Gallery of Art, Washington, DC 151. Samuel H. Kress Collection, National Gallery of Art, Washington, DC 152. Stanze di Raffaello, Vaticano/Scala 153. Accademia, Venice/Scala 154. Kunsthistorisches Museum. Vienna 155. Samuel H. Kress Collection, National Gallery of Art, Washington DC 156, Courtesy of Board of Trustees The National Gallery, London 157. Samuel H. Kress Collection, National Gallery of Art, Washington, DC 158. Widener Collection, National Gallery of Art, Washington, DC **159.** Samuel H. Kress Collection, National Gallery of Art, Washington, DC 160. San Giorgio Maggiore, Venice/Scala 161. Samuel H. Kress Collection, National Gallery of Art, Washington, DC 162. Samuel H. Kress Collection, National Gallery of Art, Washington, DC 163. Samuel H. Kress Collection, National Gallery of Art, Washington, DC 164. Andrew W. Mellon Collection, National Gallery of Art, Washington, DC 165, Uffizi, Florence/Scala 166. Santa Felicità, Florence/Scala 167. Courtesy of Board of Trustees The National Gallery, London 168. Samuel H. Kress Collection. National Gallery of Art, Washington, DC 169. Samuel H. Kress Collection, National Gallery of Art, Washington, DC 170. Courtesy of Board of Trustees The National Gallery, London 171, Samuel H. Kress Collection. National Gallery of Art, Washington, DC 172. Louvre, Paris/© Photo Ph.Sebert 173. Uffizi, Florence/Scala 174. Samuel H. Kress Collection. National Gallery of Art, Washington, DC 175. Samuel H. Kress Collection, National Gallery of Art, Washington, DC 176. Pinacoteca Nazionale, Siena/ Scala 177. Widener Collection, National Gallery of Art, Washington, DC 178. Samuel H. Kress Collection, National Gallery of Art, Washington, DC

Krakow/Scala 138, Ailsa Mellon

Bruce Fund, National Gallery of

NORTHERN RENAISSANCE 179. Museo del Prado, Madrid 180. Samuel H. Kress Collection,

National Gallery of Art, Washington, DC 181. Blauel/ Gnamm Artothek, München Alte Pinakothek 182. Courtesy of Board of Trustees The National Gallery, London 183, Gift of Clarence Y. Palitz, National Gallery of Art, Washington, DC 184. Ralph and Mary Booth Collection, National Gallery of Art, Washington, DC 185, Samuel H. Kress Collection, National Gallery of Art, Washington, DC 186. National Gallery of Art, Washington, DC 187. Courtesy of Board of Trustees The National Gallery, London 188. Kunstmuseum, Basel/ Colorphoto Hans Hinz, Basel 189. Andrew W. Mellon Collection, National Gallery of Art, Washington, DC 190. Ailsa Mellon Bruce Fund, National Gallery of Art, Washington, DC 191. Joachim Blauel, Artothek/ München Alte Pinakothek 192. Louvre, Paris/@ Photo Ph.Sebert 193. Louvre, Paris/© Photo Ph.Sebert 194. Courtesy of Board of Trustees The National Gallery, London 195. Kunsthistorisches Museum. Vienna 196, Museo del Prado. Madrid 197. Courtesy of Board of Trustees The National Gallery, London 198. Blauel/Gnamm Artothek/München Alte Pinakothek 199. Kunsthistorisches Museum. Vienna 200. Kunsthistorisches Museum, Vienna 201. Kunsthistorisches Museum, Vienna 202. Kunsthistorisches Museum, Vienna

BAROQUE AND ROCOCO 203. Hermitage, St. Petersburg/Scala 204. Uffizi, Florence/Scala 205. Louvre, Paris/RMN, Paris 206. Courtesy of Board of Trustees The National Gallery, London 207. Ailsa Mellon Bruce Fund. National Gallery of Art, Washington, DC 208. The Royal Collection, Kensington Palace, London/© Her Majesty The Queen 209. Uffizi, Florence/Scala 210. Courtesy of Board of Trustees The National Gallery, London 211. Doria Pamphili Gallery, Rome/Scala 212. Courtesy of Board of Trustees The National Gallery, London 213. Courtesy of Board of Trustees The National Gallery, London 214. Courtesy of Board of Trustees The National Gallery, London 215. Louvre, Paris/RMN 216. By Permission of Governors of Dulwich Picture Gallery 217. Antwerp Cathedral/ Visual Arts Library 218. Andrew W. Mellon Fund, National Gallery of Art, Washington, DC 219. Louvre, Paris/RMN, Paris **220.** Courtesy of Board of Trustees The National Gallery, London 221. Louvre, Paris/@ Photo Ph. Sebert 222. Samuel H. Kress Foundation, National Gallery of Art, Washington, DC 223. Widener Collection, National Gallery of Art, Washington, DC 224. Louvre, Paris/@ Photo Ph. Sebert, Louvre 225. Musée Royaux des Beaux Arts du Belgique, Brussels 226. Museo del Prado, Madrid 227, Museo del Prado,

Madrid 228. Museo del Prado,

Madrid 229. Museo del Prado.

Madrid 230. Collection Contini

Bonacossi 231. Louvre, Paris/ RMN, Paris 232. Museo del Prado, Madrid 233. Widener Collection, National Gallery of Art, Washington, DC 234. Staatliches Kunstinstitut, Frankfurt/Arthothek 235. Staatliche Museen Kassel, Gemaldegalerie Alte Meister 236. Andrew W. Mellon Collection, National Gallery of Art, Washington, DC 237. Widener Collection, National Gallery of Art, Washington DC 238. Andrew W. Mellon Collection, National Gallery of Art, Washington, DC 239. Rijksmuseum Foundation, Amsterdam 240. Louvre, Paris/RMN, Paris 241. Andrew W. Mellon Fund, National Gallery of Art, Washington, DC 242. Widener Collection, National Gallery of Art, Washington, DC 243. Mauritshuis, The Hague 244. Rijksmuseum Foundation, Amsterdam 245. Andrew W. Mellon Collection, National Gallery of Art, Washington, DC 246. Frans Hals Museum, Haarlem 247. Andrew W. Mellon Collection, National Gallery of Art, Washington, DC 248. Courtesy of Board of Trustees The National Gallery, London 249. Courtesy of Board of Trustees The National Gallery, London 250. Widener Collection, National Gallery of Art, Washington, DC 251. Courtesy of Board of Trustees The National Gallery, London 252. Timken Collection, National Gallery of Art, Washington, DC 253. Samuel H. Kress Foundation, National Gallery of Art, Washington, DC 254. Louvre, Paris/RMN, Paris 255. Louvre, Paris/Giraudon 256. Earl of Plymouth: On loan to the National Museum of Wales 257. Ailsa Mellon Bruce Fund, National Gallery of Art, Washington, DC 258. Courtesy of Board of Trustees The National Gallery, London 259. Ashmolean Museum, Oxford 260. Samuel H. Kress Collection, National Gallery of Art. Washington, DC, 261, Ailsa Mellon Bruce Fund, National Gallery of Art, Washington, DC 262. Louvre, Paris/@ Photo Ph. Sebert 263. Samuel H. Kress Collection, National Gallery of Art, Washington, DC 264. Louvre, Paris/© Photo Ph.Sebert 265. Chester Dale Collection. National Gallery of Art, Washington, DC **266.** Samuel H. Kress Collection, National Gallery of Art, Washington, DC 267. Gift of Mrs Mellon Bruce in memory of her father, Andrew W Mellon, National Gallery of Art, Washington, DC **268.** Samuel H. Kress Collection, National Gallery of Art, Washington, DC 269. Samuel H. Kress Collection, National Gallery of Art, Washington, DC 270. Andrew W. Mellon Collection, National Gallery of Art, Washington, DC 271. Museo Ca Rezzonico, Venice/ Bridgeman Art Library, London 272. Samuel H. Kress Collection. National Gallery of Art, Washington, DC 273. Samuel H., Kress Collection, National Gallery of Art, Washington, DC 274. Courtesy of Board of Trustees The National Gallery, London 275. Courtesy of Board of Trustees The National Gallery, London

276. Courtesy of Board of Trustees The National Gallery, London 277. Paul Mellon Collection, National Gallery of Art, Washington, DC

NEOCLASSICISM

AND ROMANTICISM 278. Courtesy of Board of Trustees The National Gallery, London 279. Courtesy of Board of Trustees The National Gallery, London 280. Andrew W. Mellon Collection, National Gallery of Art, Washington, DC 281. National Gallery of Scotland, Edinburgh 282. National Gallery of Scotland, Edinburgh 283. Andrew W. Mellon Collection, National Gallery of Art, Washington, DC 284. Andrew W. Mellon Collection, National Gallery of Art, Washington, DC 285. The Baltimore Museum of Art: Gift of Dr. Morton K. Blaustein, Barbara Hirschhorn and Elisabeth B. Roswell, in memory of Jacob and Hilda K. Blaustein 286. Andrew W Mellon Fund, National Gallery of Art, Washington DC 287. Tate Gallery, London 288. Walker Art Gallery, Liverpool/Tate Gallery 289. Uffizi, Florence/Bridgeman Art Library, London 290. Andrew W. Mellon Collection, National Gallery of Art, Washington, DC 291. Museo del Prado, Madrid 292. Gift of Mr and Mrs P. H. B. Frelinghuysen in memory of her father and mother Mr. and Mrs. H. O. Havemeyer/National Gallery of Art, Washington, DC 293. Museo del Prado, Madrid 294. Museo del Prado, Madrid 295. Louvre, Paris/@ Photo Ph.Sebert 296. Louvre, Paris/© Photo Ph.Sebert 297. Musées Royaux des Beaux Arts de Belgique, Brussels 298. Louvre, Paris/© Photo Ph.Sebert 299. Louvre, Paris/RMN, Paris 300. Bernard Terlay/Musée Granet, Aix en Provence 301. University of Birmingham 302. Musée des Beaux Arts, Rouen/Giraudon, Paris 303. Louvre, Paris/@ Photo Ph.Sebert 304. Louvre, Paris/© Photo Ph.Sebert 305. Louvre, Paris/Giraudon 306. Chester Dale Fund, National Gallery of Art, Washington, DC 307. Staatliche Museen zu Berlin Preussischer Kulturbesitz Nationalgalerie 308. Andrew W. Mellon Collection, National Gallery of Art, Washington, DC 309. Tate Gallery, London 310. Andrew W. Mellon Collection, National Gallery of Art, Washington, DC 311. Widener Collection, National Gallery of Art, Washington, DC 312. Widener Collection, National Gallery of Art, Washington, DC 313. Tate Gallery, London 314. Rosenwald Collection, National Gallery of Art, Washington, DC 315. Tate Gallery, London

THE AGE OF **IMPRESSIONISM**

316. Tate Gallery, London 317. Tate Gallery, London 318. "By Courtesy of the Board of Trustees of the V&A" 319. Tate Gallery, London 320. Chester Dale Collection, National Gallery of Art, Washington, DC 321. Gift of Count Cecil Pecci-Blunt, National Gallery of Art, Washington, DC

322. Gift of Duncan Phillips, National Gallery of Art, Washington, DC 323. Louvre, Paris/Giraudon 324. Louvre, Paris/Giraudon 325. Musée Fabre, Montpellier 326. Louvre, Paris/Giraudon 327. Gift of Eugene and Agnes E. Meyer, National Gallery of Art, Washington, DC 328. Gift of Horace Havemeyer in memory of his mother Louisine W. Havemeyer, National Gallery of Art, Washington, DC 329. The Courtauld Institute Galleries, London 330. Musée d'Orsay/Sp A Harris 331. Ailsa Mellon Bruce Collection, National Gallery of Art, Washington, DC 332. Louvre, Paris/@ Photo Ph.Sebert 333. Chester Dale Collection, National Gallery of Art, Washington, DC 334. Chester Dale Collection, National Gallery of Art, Washington, DC 335. Gift of the W. Averall Harriman Foundation in Memory of Marie N. Harriman, National Gallery of Art, Washington, DC 336. Collection of Mr and Mrs Paul Mellon, National Gallery of Art, Washington, DC 337. Chester Dale Collection, National Gallery of Art, Washington, DC 338. Courtesy of Board of Trustees The National Gallery, London 339. Bridgeman Art Library, London/Phillips Collection, Washington, DC 340. Chester Dale Collection, National Gallery of Art, Washington, DC 341. Chester Dale Collection, National Gallery of Art, Washington, DC 342. Ailsa Mellon Bruce Collection, National Gallery of Art, Washington, DC 343. Ailsa Mellon Bruce Collection, National Gallery of Art, Washington, DC 344. Ailsa Mellon Bruce Collection, National Gallery of Art, Washington, DC 345. Tate Gallery, London 346. Tate Gallery, London 347. Gift of the W. L. and May T. Mellon Foundation, National Gallery of Art, Washington, DC 348. Gift of Mr. and Mrs. Cornelius Vanderbilt Whitney, National Gallery of Art, Washington, DC 349. Gift of Ernest Iselin, National Gallery of

POST-IMPRESSIONISM

Art, Washington, DC

350. Collection of Mr. and Mrs. Paul Mellon, National Gallery of Art, Washington, DC 351. Fitzwilliam Museum, University of Cambridge, England 352. Gift of Eugene and Agnes E. Meyer, National Gallery of Art, Washington, DC 353. Gift of Agnes and Eugene E Meyer, National Gallery of Art, Washington, DC 354. Courtesy of Board of Trustees The National Gallery, London 355. Collection of Mr and Mrs Paul Mellon, National Gallery of Art, Washington, DC 356. Musée d'Orsay/@ Photo Ph.Sebert 357. Ailsa Mellon Bruce Collection, National Gallery of Art, Washington, DC 358. Chester Dale Collection, National Gallery of Art, Washington, DC 359. Musée d'Orsay/Giraudon, Paris 360. Chester Dale Collection, National Gallery of Art, Washington, DC 361. Chester

of Art, Washington, DC 362. Musée Gustav Moreau, Paris/Giraudon 363. Musée du Petit Palais, Paris/Lauros/Giraudon 364. National Gallery of Scotland, Edinburgh 365. Museum Folkwang, Essen 366. Courtauld Institute Galleries, London 367. Christies Color Library 368. Fotostudio Otto 369. Chester Dale Collection, National Gallery of Art, Washington, DC 370. Tate Gallery, London 371. Ailsa Mellon Bruce Collection, National Gallery of Art, Washington, DC 372. Musée du Petit Palais, Paris/© Phototheque des Musées de la Ville de Paris 373. Ailsa Mellon Bruce Collection, National Gallery of Art, Washington, DC 374. Tate Gallery,

THE 20TH CENTURY 375. Chester Dale Collection, National Gallery of Art, Washington, DC/@ ADAGP, Paris and DACS, London 1994 376. John Hay Whitney Collection, National Gallery of Art, Washington, DC/© ADAGP, Paris and DACS, London 1994 377. Statens Museum für Kunst Copenhagen/© Sucession H Matisse/DACS 1994 378. Museo dell'Ermitage, Leningrad/Scala/© Sucession H Matisse/DACS 1994 379. Chester Dale Collection, National Gallery of Art, Washington, DC/© Sucession H Matisse/DACS 1994 380. Ailsa Mellon Bruce Collection, National Gallery of Art, Washington, DC/© Sucession H Matisse/DACS 1994 381. Ailsa Mellon Bruce Collection, National Gallery of Art, Washington, DC/@ DACS 1994 382. Musée National D'Arte Moderne/@ ADAGP, Paris and DACS 1994 383. Brücke Museum/"Copyright Dr Wolfgang and Ingeborg Henze-Ketterer, Wichtrach/Bern" 384. Offentliche Kunstsammlung, Kunstmuseum, Basel/ @ Nolde Stiftung Seebüll 385. Artothek/Staatsgalerie moderner Kunst, Munich/© DACS 1994 386. Albertina Graphics Collection, Vienna/Bridgeman Art Library, London 387. Offentliche Kunstsammlung Kunstmuseum, Basel, Ph Martin Bühler/© DACS 1994 388. Tate Gallery, London 389. Chester Dale Collection, National Gallery of Art, Washington, DC 390. Artothek Stedelijk Museum/@ADAGP, Paris and DACS, London 1994 391. Picasso/Chester Dale Collection, National Gallery of Art, Washington DC/© DACS 1994 392. Museum of Modern Art. New York/Giraudon, Paris, © DACS 1994 393. Chester Dale Collection, National Gallery of Art, Washington, DC/© DACS 1994 394. Tate Gallery, London/© DACS 1994 395. Tate Gallery, London/© DACS 1994 396. Chester Dale Collection, National Gallery of Art, Washington, DC /ADAGP, Paris and DACS, London 1994 397. Chester Dale Fund, National Gallery of Art, Washington, DC 398. Sprengel Museum, Hannover 399. Tate Gallery, London/@ DACS 1994 400. Offentliche Kunstsammlung Kunstmuseum, Basel, Ph Martin Bühler/ADAGP, Paris and DACS, London 1994

401. Staatlichen Kunsthalle Karlsruhe EV 402. @ Rheinisches Bildarchiv/ Museum Ludwig, Cologne 403. Ailsa Mellon Bruce Fund, National Gallery of Art, Washington, DC/@ ADAGP, Paris and DACS, London 1994 404. Musée National D'Arte Moderne/@ ADAGP, Paris and DACS, London 1994 405. Kunsthalle, Hamburg/DACS 1994 **406.** Paul Klee Stiftung, Kunstmuseum, Bern/© DACS 1994 407. Paul Klee Stiftung, Kunstmuseum, Bern/© DACS 1994 408. Artothek, Museum Ludwig, Cologne 409. Collection Haagsgemente Museum, The Hague/International Licensing Partners, Amsterdam 410. Gift of Herbert and Nanette Rothschild, National Gallery of Art, Washington, DC/International Licensing Partners, Amsterdam 411. Chester Dale Collection, National Gallery of Art, Washington, DC 412. Tate Gallery, London/ @DACS 1994 413. Tate Gallery, London/© SPADEM/ ADAGP, Paris and DACS, London 1994 414. Tate Gallery/@ ADAGP, Paris and DACS, London 1994 415. Private Collection Houston/ Bridgeman Art Library/© ADAGP, Paris and DACS, London 1994 416. Metropolitan Museum of Art, New York/© DEMART PRO ARTE BV/DACS, London 1994 417. Moderner Museet Stockholm/© ADAGP, Paris and DACS, London 1994 418. Tate Gallery, London/© DACS 1994 419. Tate Gallery, London/© ADAGP, Paris and DACS, London, 1994 420. John Hay Whitney Collection, National Gallery of Art, Washington, DC 421. Alfred Stieglitz Collection, Bequest of Georgia O'Keeffe, National Gallery of Art, Washington, DC/© 1994 The Georgia O'Keeffe Foundation/ Artists' Rights Society (ARS), New York 422. Musée National d'Arte Moderne, Paris/Lauros Giraudon/@1994 Pollock-Krasner Foundation/ Artists' Rights Society (ARS), New York 423. Ailsa Mellon Bruce Fund, National Gallery of Art, Washington, DC/© 1994 Pollock-Krasner Foundation/ Artists' Rights Society (ARS), New York 424. Gift of Lila Acheson Wallace, National Gallery of Art, Washington, DC 425. Gift of the Mark Rothko Foundation, National Gallery of Art, Washington, DC/© 1994 Kate Rothko-Prizel and Christopher Rothko/ Artists' Rights Society (ARS), New York 426. Tate Gallery/@ ADAGP, Paris and DACS, London 1994 427. Whitney Museum of American Art, New York, © 1994 Willem de Kooning/ Artists' Rights Society (ARS), New York 428. Whitney Museum of American Art, New York, Purchased with Funds from the friends of the Whitney Museum of American Art/© 1994 Willem de Kooning/ Artists Rights Society (ARS), New York 429. Tate Gallery, London/Mary Boone Gallery, New York 430. L.A. County Museum of Art/Visual Arts Library, London/© Estate of Franz Kline/ DACS, London/ VAGA, New York 1994 431. "Reproduced Courtesy of

Dale Collection, National Gallery

Annalee Newman insofar as her rights are concerned" National Gallery of Art, Washington, DC 432. Visual Arts Library, London/ Museum of Modern Art, New York/© Robert Motherwell/DACS, London/VAGA New York 433. Gift (Partial and Promised) of Mr. and Mrs. Donald M. Blinken, in Memory of Maurice H. Blinken and in honor of the 50th anniversary of the National Gallery of Art, Washington, DC 434. Anonymous Gift, National Gallery of Art, Washington, DC 435. Gift of Marcella Louis Brenner, National Gallery of Art, Washington, DC 436. The Carnegie Museum of Art, The Henry L. Hillman Fund in honor of the Sarah Scaife Gallery 437. Tate Gallery, London/The Pace Gallery 438. Tate Gallery, London/© 1994 Frank Stella/ Artists © 1984 439. © Dorothea Rockburne/Artists' Rights Society (ARS), New York 440. The Pace Gallery/Des Moines Art Center 441. Tate Gallery, London/The Andy Warhol Foundation for the Visual Arts Inc. 442. Tate Gallery, London/© Roy Lichtenstein/DACS 1994 443. Tate Gallery, London/© Jasper Johns/DACS, London/ VAGA, New York, 1994 444. Tate Gallery, London/Tradhart Ltd 445. The Sonnabend Collection, New York/© Robert Rauschenberg/DACS, London/ VAGA, New York, 1994 446. Provenance: Fundacion Collection Thyssen Bornemisza/ © DACS 1994 447. Staatliche Museen zu Berlin - Preussischer Kulturbesitz, Nationalgalerie 448. Tate Gallery, London/ Anthony d'Offay Gallery 449. Tate Gallery, London/ Marlborough, Fine Art, London 450. Whitechapel Gallery, London 451. Tate Gallery, London/Private Collection 452. Tate Gallery, London/Derneburg 453. Gimpel Fils, London 454. Robert Miller Gallery, New York 455. Courtesy of England and Co Gallery, London

ACKNOWLEDGMENTS

Dorling Kindersley would like to thank: Colin Wiggins for reading the manuscript; Frances Smythe at the National Gallery of Art. Washington, DC; Miranda Dewar at Bridgeman Art Library Gillian M. Walkley and David Stirling-Wylie; Julia Harris-Voss and Jo Walton; Simon Hinchcliffe, Tracy Hambleton-Miles, Tina Vaughan, Kevin Williams, Sucharda Smith, Zirrinia Austin, Samantha Fitzgerald, and Kirstie Hills.

SIDE COLUMN PICTURE CREDITS

40. t Giraudon: b @ Sonia Halliday and Laura Lushington 41. t Photo © Woodmansterne; b Courtauld Institute Galleries, London 42 Giraudon/Bridgeman Art Library, London 43. © William Webb 44. Mary Evans Picture Library 46. Courtauld Institute Galleries, London 47. t Scala; b The Mansell Collection 48. t Bridgeman Art Library, London; b Scala 51. t Courtauld Institute Galleries, London; b Biblioteca Ambrosiana, Milan/Bridgeman Art Library, London 53. Courtauld Institute Galleries, London 54. Bibliotheque Nationale Paris/Bridgeman Art Library, 55. t Bibliotheque Nationale, Paris/Bridgeman Art Library, London; b Mary Evans Picture Library 57 National Gallery of Art, Washington, DC 58. Osterreichische Nationalbibliothek, Vienna/Bridgeman Art Library, London 59 By Permission of The British Library, London/Bridgeman Art Library, London 60 © William Webb 61 © Michael Holford 63. Giraudon/Bridgeman Art Library, London 64. © Bibliotheque Royale Albert 1er Bruxelles 66 "Courtesy of the Board of Trustees of the V&A" 67. © Bibliotheque Royale Albert 1er Bruxelles 68. By Permission of The British Library, London /Bridgeman Art Library, London 70. t © DK; b Courtauld Institute Galleries, London/ Memling Museum, Bruges 71. t Staatsarchiv/Bridgeman Art Library, London; b © Christopher Johnston 73. Bibliotheque Nationale, Paris/Sonia Halliday Photographs 75. t Bridgeman Art Library, London; b Picture Book of Devils, Demons, and Witchcraft by Ernst and Johanna Lehnen/Dover Book Publications Inc, New York 76. Lauros/Giraudon 82 Scala 83. Museo Nazionale (Bargello), Florence/Bridgeman Art Library, London 85. Phillip Gatward © DK 87. Bargello/Scala 88. The Trustees of The British Museum, London 89. Gabinetto dei Disegni e delle Stanipe/Scala 91. Sp Alison Harris/Museo dell' Opera del Duomo J. Paul Getty Museum, Malibu California/Bridgeman Art Library, London 94. Courtesy of Board of Trustees The National Gallery, London 95. Dover Publications Inc, New York 97. Uffizi/Scala 98. The Trustees of The British Museum, London 99. t Museo del Bargello/Scala; b Ashmolean Museum, Oxford 100. t Bridgeman Art Library,

London; b Pinacoteca Communale Sansepolcro/Scala 102. Sp Alison Harris/ Museo dell'Opera del Duomo 103. Scala 103. 3caia 104 t Bridgeman Art Library, London; b Giraudon/Bridgeman Art Library, London 105. Sp Alison Harris/Palazzo Vecchio, Florence 106 © DK 107. The Trustees of The British Museum, London 108. Chiesa di Ognissanti/Scala 110 National Gallery, London/ Bridgeman Art Library, London 111. Fratelli Fabri, Milan/ Bridgeman Art Library, London 114. Courtauld Institute Galleries, London 116. Campo. S. Zanipolo, Venice/Scala 118. t Bulloz, Institute de France; b Mary Evans Picture Library 120. Sp Alison Harris/ Palazzo Vecchio, Florence 121. National Gallery of London/Bridgeman Art Library, London 124. Accademia, Firenze/Scala 125. Germanisches National Museum 126. Uffizi/Scala 129. Giraudon/Bridgeman Art Library, London 130. "By Courtesy of the Board of Trustees of the V&A" 131. Museo del Prado, Madrid 133. t Dover Book Publications Inc, New York, Pictorial Archives: Decorative Renaissance Woodcuts, Jost Amman; b The Trustees of The British Museum, London/Bridgeman Art Library, London 134. Sp Alison Harris/Palazzo Vecchio, Florence 135. San Giorgio Maggiore, Venezia/Scala 143. *t* "By Courtesy of the board of Trustees of the V&A"; *b* Ali Meyer/Bridgeman Art Library, London 144. Appartmento Borgia, Vaticano/Scala 146. Museo della Scienza, Firenze/Scala 153. Picture Book of Devils, Demons and Witchcraft by Ernst and Johanna Lehnen /Dover Publications Inc. New York 154. t © Wim Swann: b Universität Bibliothek, Basel 156. Museo Poldi Pezzoli, Milan/ Bridgeman Art Library, London 159. Museum der Stadt, Regensburg/Bridgeman Art Library, London 160. Reproduced Courtesy of the National Gallery, London 161. t "By Courtesy of the Board of Trustees of the V&A"; b Giraudon/Bridgeman Art Library, London 164. The Bowes Museum, Barnard Castle, County Durham 165. t "By Courtesy of the Board of Trustees of the V&A"/ Bridgeman Art Library, London; b Mary Evans Picture Library 166. Mary Evans Picture Library 169. Mary Evans Picture Library 171. Picture Book of Devils, Demons and Witchcraft by Ernst and Johanna Lehnen/Dover Publications Inc. New York 176. Santa Maria della Vittore, 180. Museum Boymans Van

Beuningen, Rotterdam/ Bridgeman Art Library, London 182. Accademia, Venice/Scala 187. Mary Evans Picture Library 190. Mary Evans Picture Library 191. Mary Evans Picture Library 193. Index/Bridgeman Art Library, London 194. Joseph Martin/Bridgeman Art Library, London 197. Index/Bridgeman Art Library, London 203. Rembrandt Etchings/Dover Publications Inc, New York 208. Fitzwilliam Museum, University of Cambridge/Bridgeman Art Library, London 210. Science Museum, London 215. t Mary Evans Picture Library; b The Trustees of The British Museum, London 216. Giraudon/Bridgeman Art Library, London 218. Mary Evans Picture Library 222. © DK 223. t Mary Evans Picture Library; b Mary Evans Picture Library 230. Bonham's, London/ Bridgeman Art Library, London 231. "By Courtesy of the Board of Trustees of the V&A" 233. Tiepolo/Dover Publications Inc, New York 235. Engravings By Hogarth/ Dover Publications Inc, New York 240. Hanley Museum and Art Gallery, Birmingham 245 Victoria and Albert Museum/Bridgeman Art Library, London 246. Mary Evans Picture Library 248. t Casa Natal de Goya Fuendetodos; b Mary Evans Picture Library 249. t @ DK Museo Municipal, Madrid; *b* Real Fabrica de Tapices, Madrid 250. t Calcografia Nacional, Madrid; b Mary Evans Picture Library 252. Real Academia de Bellas Ares de San Fernando, Madrid 254. Giraudon/Bridgeman Art Library, London 255. t Bibliotheque Nationale, Paris; b Mary Evans Picture Library 258. t Lauros-Giraudon/ Bridgeman Art Library, London; b Christies, London/Bridgeman Art Library, London 259. Mary Evans Picture Library 262. t Mary Evans Picture Library; b Musée Condé, Chantilly/Giraudon 264. Mary Evans Picture Library 266. National Portrait Gallery, London 268. Bridgeman Art Library, London/John Bethell 269. Mary Evans Picture Library 270. Library of Congress, Washington, DC/Bridgeman Art Library, London 277. Reproduced by courtesy of the Dickens House Museum, London 278. "By Courtesy of the Board of Trustees of the V&A" 279. Bibliotheque Nationale, Paris 280. 120 Great Lithographs of Daumier/Dover Publications Inc, New York 281. Giraudon, Paris 282. Bibliotheque Nationale, Paris 284. t © DK; b Bibliotheque Nationale, Paris

285. Bibliotheque Nationale, Paris 286. t Giraudon, Paris/Bridgeman Art Library, London; b Bibliotheque Nationale, Paris 287. Musée d'Orsay/Sp A. Harris 289. Bibliotheque Nationale, Paris 290. By Permission of The British Library/Bridgeman Art Library, London 291. t Edifice; b Bibliotheque Nationale, Paris 292. t Musée d'Orsay, Paris/Sp. Ph.Sebert; b Musée d'Orsay, Paris/ Sp Ph.Sebert 293. Musée Français de La Photographie Fond et Anime Depuis 1960 par Jean et André Fage/Photo Sp A.Harris 295. Musée d'Orsay/Sp Alex Saunderson 296. Sp Alex Saunderson, Replica of Monet's floating studio, built for the Société d'Economie Mixte d'Argenteuil-Bezons by the Charpentiers de Marine du Guip, en L'ile-aux-Moines (Morbihan) for Monet's 150th anniversary 300. Musée Marmottan Sp S.Price 301. Bibliotheque Nationale, 303. By Courtesy of the Board of Trustees of the National Portrait Gallery, London 304. Mary Evans Picture Library 305. Mary Evans Picture Library 311. Photo: Alice Boughton/By Courtesy of the Board of Trustees of the National Portrait Gallery, London 312. Photo: Alison Harris 315. © DK 318. Musée d'Orsay, Paris/Photo Sp Ph.Sebert 320. Bibliotheque Nationale, 321. t Private Collection; b Musée d'Orsay, Paris/Photo Sp Ph.Sebert 322. Collection Josefowitz 324. Musée d'Orsay, Paris/ Sp. S. Price 327. © Photo RMN 328. Bibliotheque de L'Institute de France/Sp Alison Harris 329. Photo RMN 334. Robert and Lisa Sainsbury Collection, Sainsbury Center For Visual Arts, University of East Anglia, Norwich/Photo James Austin 337. Musée Matisse, Nice 338. Explorer Archives 341. Mary Evans Picture Library © Collection Viollet 353. Archiv für Kunst und Geschichte, Berlin 354. Museum of the Revolution, Moscow/Bridgeman Art Library, London 356. Archiv für Kunst und Geschichte, Berlin 362. © Collection Viollet 363. © Hurn/Magnum 364. BFI Stills, Posters and Designs 368. Horniman Museum 374. Mary Evans Picture Library 380. Hulton Deutsch Collection 382. Hulton Deutsch Collection 384. John Minilan Photo, Hulton Deutsch Collection 386. Hulton Deutsch Collection